MATISSE

THE LIFE

Hilary Spurling

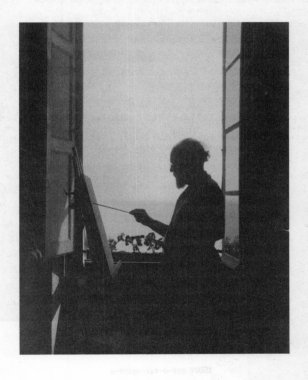

PENGUIN BOOKS

PENGUIN BOOKS

Published by the Penguin Group
Penguin Books Ltd, 80 Strand, London WC2R ORL, England
Penguin Group (USA), Inc., 375 Hudson Street, New York, New York 10014, USA
Penguin Group (Canada), 90 Eglinton Avenue East, Suite 700, Toronto, Ontario, Canada M4P 2Y3
(a division of Pearson Penguin Canada Inc.)
Penguin Ireland, 25 St Stephen's Green, Dublin 2, Ireland (a division of Penguin Books Ltd)
Penguin Group (Australia), 250 Camberwell Road, Camberwell, Victoria 3124, Australia
(a division of Pearson Australia Group Pty Ltd)
Penguin Books India Pvt Ltd, 11 Community Centre, Panchsheel Park, New Delhi – 110 017, India
Penguin Group (NZ), 67 Apollo Drive, Rosedale, North Shore 0632, New Zealand
(a division of Pearson New Zealand Ltd)
Penguin Books (South Africa) (Pty) Ltd, 24 Sturdee Avenue, Rosebank,
Johannesburg 2196, South Africa

Penguin Books Ltd, Registered Offices: 80 Strand, London WC2R ORL, England

www.penguin.com

First published 2009

1

Typeset in Bembo 11/12.6pt by Palimpsest Book Production Limited,

Pr

A CIP catalog

Contents

List of Illustrations

All images by Henri Matisse are Copyright © Succession Henri Matisse.
AM: Archives Matisse

INTEGRATED BLACK AND WHITE IMAGES

COLOUR PLATE SECTIONS

Preface

No artist has written more perceptively about how to paint a portrait than Henri Matisse. He insisted on close observation and minute accuracy. Nothing should be distorted or left out. Prejudice and preconception were the prime enemies. Matisse's notes on portrait painting supplied the blueprint for my biography. I began by attempting to clear away the myths, misunderstandings and false assumptions about his life that have increasingly affected the way we look at key areas of his work. This exploratory process uncovered much that could not have been suspected at the start ('If my story were ever to be written down truthfully from beginning to end,' said Matisse, 'it would amaze everyone'.) But thoroughness, precision and lack of prejudice provide no more than the starting point for a biography. 'Exactitude is not truth,' as Matisse often said, quoting Delacroix. Too many details, too much analysis, an overload of background information can blur the outlines and obscure the inner core of a written life as much as of a painted portrait. 'If I close my eyes, I can see my subject better than with my eyes open,' said Matisse. 'I see it stripped of incidental detail – and that is what I paint.' My biography was initially published in two volumes, which contained between them roughly 4,000 footnotes outlining the primary research that provided basic underpinning. *Matisse: The Life* is the relatively short, sharp, clear portrait I should have liked to paint in the first place.

Everything in it is based directly on contemporary documents, letters, memoirs, interviews and eyewitness accounts. Detailed source notes, further information and fuller explanations may be found in the original edition: *The Unknown Matisse. A Life of Henri Matisse, Vol.1, 1869–1908* (London and New York, 1998) and *Matisse the Master: A Life of Henri Matisse, Vol. II, 1909–54*

(London and New York, 2005). The many people who helped me to achieve this reconstruction are listed in full in those two volumes. Here, I would simply like to acknowledge once again the great debt I owe Matisse's heirs – Claude Duthuit, Jacqueline and Paul Matisse, the late Gérard Matisse and the late Peter Noel Matisse – for their generous support, and in particular for giving me unprecedented and unrestricted access to their family papers, together with permission to quote freely from this invaluable unpublished record. I should also like to renew my thanks for practical and moral backing over many years to the late Lydia Delectorskaya, to Wanda de Guébriant, Dominique Fourcade and Rémi Labrusse in Paris; to Georges Bourgeois in Bohain-en-Vermandois and Dominique Szymusiak in Le Cateau-Cambrésis; to John Elderfield and Jack Flam in New York; and to Natalia Semenova in Moscow. In London, I am truly grateful to my editors, Simon Prosser and Juliette Mitchell at Hamish Hamilton, and to Penguin's indomitable picture researcher, Grainne Kelly. Lastly my thanks go above all to John Spurling, without whom this book would not exist.

PART I

Man of the North

1. *The Prisoner (1869–91)*

Henri Matisse compared his development as a painter to the growth of a seed. 'It's like a plant that takes off once it is firmly rooted,' he said, looking back at the end of his life: 'the root presupposes everything else.' He himself was rooted in north-eastern France, on the great Flanders plain where his father's family had been weavers as far back as anyone could remember. Henri Emile Benoît Matisse was born in a weaver's cottage belonging to his grandmother on the rue du Chêne Arnaud, in the textile town of Le Cateau-Cambrésis, at eight o'clock in the evening on the last night of the year, 31 December 1869. He said long afterwards that rain fell through a hole over the bed in which he was born.

His parents, who worked in Paris, were paying a New Year visit to their home town. They called their first child Henri after his father, following a family tradition that went back four generations. The first Henri Matisse was a linen-weaver, whose son, Jean Baptiste Henri, gave up the humble weaver's trade in the 1850s to become a factory foreman in one of the town's new mechanized woollen mills. His son in turn would leave home and abandon textiles altogether. This was Emile Hippolyte Henri Matisse, the painter's father, who found work in his twenties as a shop-boy in Paris. By January 1869, when he married Anna Héloïse Gérard, the daughter of a tanner in Le Cateau, he had been promoted to trainee buyer in ladies' underwear. He worked for the Cour Batave on the Boulevard Sébastopol, a new and fashionable department store specializing in lingeries, trousseaux, ladies' stockings, bodices, blouses, personal and household linen. Long after he had moved back to set up his own business nearer home, Hippolyte Henri continued to take pride in his Parisian training. It sharpened his eye for quality, confirmed

his distaste for slack or shoddy performance, laid down the exacting standards by which he judged himself, his world, and especially his eldest son ever afterwards.

Anna Gérard had also gone to Paris in her early twenties to work in a hat-shop. Warmhearted, outgoing, capable and ener-getic, she was small and neatly built, with fair skin, broad cheekbones and a wide smile. 'My mother had a face with generous features, the highly distinctive traits of French Flanders,' said her son Henri, who spoke of her with particular tenderness all his life. Born in 1844, the fourth of eight children, Anna belonged to a large and cohesive family of Gérards, established for 300 years in and around the rue du Chêne Arnaud as tanners, furriers, leather-dressers and skin-merchants. Her brother Emile, who would mechanize and modernize the family tanning works, stood godfather to her son Henri. The boy grew up surrounded by a protective network of aunts and uncles, first, second and third cousins, as well as more distant connections related by blood or marriage, all originally based in Le Cateau but spilling out in his own and his parents' generation into the countryside, several taking the train to find jobs 100 miles south in Paris.

Henri Matisse was eight days old when his parents moved twelve miles away to Bohain-en-Vermandois to take over a general store on the corner of the rue Peu d'Aise and the main street, or rue du Château. The shop sold everything from seeds to hardware and house paints. Anna specialized in colours, advising her neighbours on decorative schemes and mixing the pigments herself. Under Hippolyte Henri the seed-merchant's counter grew into a streamlined wholesale and retail operation, with a fleet of delivery wagons supplying seed, fertilizer and fodder to beet-growers all over the surrounding plain. Young Henri Matisse was groomed to succeed his father at the head of a rapidly expanding business in an industrial boom. Once a sleepy weavers' village deep in the ancient forest of the Arrouaise, the Bohain of his childhood was a modern manufacturing centre, with 10,000 clanking looms installed in the town and its surrounding villages. The population, which had taken forty

years to grow from 2,000 to 4,000 before Matisse was born, would very nearly double again in the twenty years before he ran away from home to be a painter.

The town's principal products were sugar-beet and textiles. The windmills and belfries that traditionally dotted the rolling flatlands of the Vermandois were far outnumbered in Matisse's youth by the smoking chimneys of sugar refineries and woollen mills. The streams on these chalky downs – Bohain stood high in the centre of a triangle marking the sources of the Somme, the Selle and the Escaut – ran with chemical refuse on leaving the towns. The streets were slippery with beet pulp in autumn, and the air was rank all winter with the stench of rotting beets. Visitors from the outside were shocked by the drabness of the town itself, and by the stark, newly deforested land all round. 'Where I come from, if there is a tree in the way, they root it out because it puts four beets in the shade,' Matisse said sombrely.

The memories he recalled with pleasure from his boyhood in Bohain were mostly of the countryside. He remembered parting the long grass in spring to find the first violets, and listening to the morning lark above the beet fields in summer. In later life he never lost his feeling for the soil, for seeds and growing things. The fancy pigeons he kept in Nice nearly half a century after he left home recalled the weavers' pigeon-lofts tucked away behind even the humblest house in Bohain. Matisse said that for all the exotic specimens in the palatial aviary constructed for him in the 1930s, the best songbirds were still the robin and the nightingale, which could not survive captivity. They sang freely in the copses round Bohain, and in the ruins of the medieval castle where he played as a boy within a stone's throw of his father's shop. An underground passage led from the castle to the Chêne Brulé, or Blasted Oak, a vast, spreading, ancient tree scarred by marauding Spanish soldiers who had tried to burn it down in the seventeenth century. Henri Matisse climbed it as a child, painted it as a young man, and recalled it with affection at the end of his life. It was the town's chief landmark, and figured endlessly in fireside stories recounted by

the old people he remembered sitting out their lives in the chimney corner, reminiscing about Russian soldiers entering Bohain in 1815 after Waterloo.

In his own childhood, the invaders were Prussian. German soldiers (who occupied Bohain three times in Matisse's lifetime) marched past the seed-shop on the rue du Château for the first time on New Year's Day, 1871, the day after his first birthday. The whole region had been waiting for them in a state of increasing tension since the French Emperor's defeat at Sedan four months earlier. After a brief flurry of sniper fire, Bohain responded with grim resignation. The population retreated behind sealed doors and windows for nearly three uneasy weeks while French and German forces massed for the final battle, which took place sixteen miles away on 19 January outside the local market-town of St-Quentin. The citizens stood on their town walls all day, watching the French army beaten, and barricaded themselves in their cellars as the survivors withdrew through the streets that night. A few hours later, when fleeing French soldiers stumbled into Bohain – filthy, famished and exhausted – they found the inhabitants waiting on their doorsteps in the snow with food and lanterns to light their way.

Several thousand Germans, still covered in mud with eyes starting from their heads like caged beasts unleashed, poured through the town in pursuit on 20 January. France capitulated the same day. The occupation lasted just over a month. A curfew was imposed in Bohain and people waited sullenly on their unwelcome lodgers. 'We gave them or let them take whatever they wanted,' wrote a compatriot, describing the shame and suppressed fury of that wretched winter. Henri himself was almost fourteen months old, just beginning to walk and talk, when the Germans left. On his first visit to their country nearly forty years later, he said that the only words he knew in German were *Brot* and *Fleisch*, or bread and meat. He never forgot his mother repeating like a grace at meals: 'Here's another one the Germans won't lay their hands on!' The phrase would become a familiar refrain throughout French Flanders for the next seventy-five years.

The day the invaders marched away in February 1871 was celebrated by the whole of Bohain in the town square. Children who were babes-in-arms that day were never allowed to forget it. They were reared on stories of blood-soaked fields around St-Quentin and village cemeteries filled with soldiers' graves. They sang warlike songs ('Children of a frontier town,/ Born to the smell of gunpowder . . .') and carved defiant messages ('Death to all Prussians!' and 'Frenchmen never forget!') on walls and doors. They learned to handle guns in shooting booths at town and country fairs, where Henri became and remained a crack shot. Boys at primary school in Bohain had it drilled into them that theirs was the generation destined to retrieve the lost honour of their country.

Henri and his classmates grew up in a world detaching itself jerkily from a way of life in some ways unchanged since medieval times. The coming of the railway had put Bohain on the industrial map, but local people still travelled everywhere on foot or horseback. They drew water from the well and lit lamps or went to bed at nightfall. The Matisse household rose before dawn, which meant 4 a.m. in summer, ready for the working day to start at five. Life was hard, monotonous and effortful for Henri's parents, who lived in rented rooms behind the shop, and drove themselves regularly to the brink of exhaustion and beyond. In July 1872, Anna bore a second son, who died just before he reached the age of two, by which time she was already pregnant again with her third and last child, Auguste Emile, born on 19 July, 1874. His mother's workload meant that Henri was often sent away to stay with his grandmother Gérard in the cottage in Le Cateau where he was born, and where he said he was always happy.

His childhood memories were of stern and single-minded application. 'Be quick!' 'Look out!' 'Run along!' 'Get cracking!' were the refrains that rang in his ears at home. Throughout his life his conversation was peppered with down-to-earth sayings that looked back to a rural world where money was scarce, rations skimpy, work backbreaking and repetitive. Survival itself depended on harsh discipline and self-denial. This was the legacy

Matisse meant when he insisted at the end of his life, after living
for forty years in Nice, that he was still a man of the North. He
looked back to the winters of his youth when piled snow lined
the streets, ice covered the cobblestones several inches deep, water
froze overnight indoors in jugs and basins. Snowstorms, blizzards,
freezing fog and bitter winds raked the high plateau on which
Bohain stood exposed, shorn of its protective forest, ringed by
underground springs that welled up as soon as the ice thawed,
flooding the streets knee-deep in mud. Children who survived
these ordeals (many did not) had to be tough, wary and defen-
sive; and it was their fathers' job to make them so. In the
traditional culture of the North, the father was all-powerful and
often impossible to please, the mother indulgent and supportive.
Henri's mother took his part all her life, while his father reined
him in and spurred him on.

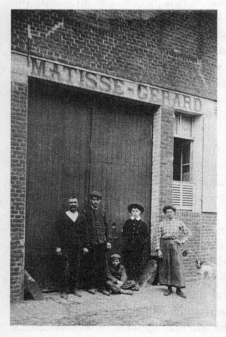

*The Matisse family (with a
young friend or cousin) outside
the side entrance of the
seed-store on the rue Peu d'Aise*

Henri was by his own account a dreamy child, docile and obedient but inattentive and not outstandingly bright. His own delicate health and the loss of his middle brother made his mother specially attentive, and he in turn urged himself to special efforts for her sake. She was always the first person to whom he showed his early paintings ('My mother loved everything I did'), and on the rare occasions when she seemed less than enthusiastic, the effect on him was devastating. Matisse said he got his colour sense from his mother, who was herself a painter, working on porcelain in gouache (a single plain white salad bowl survives, decorated with great charm and delicacy in a severely simple pattern of dark blue dots and lines). Her kitchen remained always a source of warmth and comfort. The life of the household revolved around the big stove, kept permanently alight with a pot of coffee on the hob, between the shop on one side and the yard on the other with its washhouse, well and vegetable plot. There was stabling for the horses, space for the wagons, and storage in the loft for crates of chemicals, sacks of seed, rice, grain and cattle cake. Anna Matisse had a tiny pair of brass scales with which she weighed out birdseed and fish food for the fancy cage-birds and ornamental goldfish that were part of a seed-merchant's stock-in-trade. Both would reappear in her son's life and work.

For a child growing up in Bohain in the late nineteenth century, contact with the outside world was still largely confined to pedlars, tinkers and bands of gypsies selling baskets, telling fortunes, sometimes leading a chained dancing bear. They came in spring and summer, as soon as the roads were passable, with the fairmen who set up their sideshows on the square, selling toys, gingerbread, striped humbugs and sticks of twisted barley-sugar. The bigger boys dressed up as knights and staged mock battles while the little ones rode on the merry-go-round, with a donkey to turn the wheel that made the wooden horses go up and down on their painted poles. There were grand annual fairs in the big towns, with clowns, tumblers and fast-talking

salesmen who were also seasoned Grand Guignol performers in shows as colourful as they were brutal and macabre. The whole region was, according to Matisse's fellow-countryman, the painter Amédée Ozenfant, 'as Flemish as a Breughel painting'.

It was a society that offered little imaginative outlet beyond its fairs, the occasional travelling circus and games of knights-on-horseback. Matisse said long afterwards that his twin ambitions as a child had been to be a clown or horseman. He experienced early the overriding need to escape, to perform, to draw and hold an audience, and he described his need in terms of the travelling showmen of his youth: 'If there were no public, there would be no artists ... Painting is a way of communicating, a language. An artist is an exhibitionist. If you took away his audience, the exhibitionist would slink off too, with his hands in his pockets ... The artist is an actor: he's the little man with the wheedling voice who needs to tell stories.'

The young Matisse was a champion mimic who could always reduce his friends to helpless laughter with his imitations of pompous or overbearing elders. Street life fascinated him. As an art student in Paris in the 1890s, he filled his sketchbooks with city scenes – cabmen with their fares and horses, passers-by, music-hall performers – drawn with an agile, observant line and a sardonic eye for detail. He could sing or chant all the cries and calls of the Latin Quarter, a habit he picked up as a boy on the streets of Bohain, which rang with the cries of competing knife-grinders, salad-sellers, toffee-makers, men offering to mend broken umbrellas, glue cracked crockery, recane chair-seats or cobble shoes. As a small boy he played in and out of the neighbours' houses, listening to the women gossiping at their spinning-wheels or on their doorsteps on warm evenings.

His inseparable companion was the boy next door, Léon Vassaux, who was two years younger. Léon would remain Henri's firm friend and follower – in time of crisis his faithful supporter – for the rest of their lives. He was kind, clever, independent and as much of a deadpan comedian as Henri himself. They roamed the countryside together in summer, and played in winter

in the Matisses' loft or the Vassaux' kitchen. 'I can see us still,' Léon wrote, 'seated at the kitchen table performing manoeuvres with a squad of lead soldiers – and our fright when we heard my mother ring the bell.' Léon was a loyal assistant in the great artistic enterprise of their childhood, which was Henri's toy theatre. It was made from a crate lined with wrapping paper from the seed shop, and the parts were played by characters cut out from strip cartoons and glued on to strips of cardboard. Henri's greatest triumph was the sensational eruption of Vesuvius, for which his father provided sulphur and saltpetre. The volcano went up in smoke and flame against a background of blue-paper waves edged with painted foam to represent the Bay of Naples. 'The decor was signed Matisse, and the musical effects were provided by your violin,' Léon wrote long afterwards in what remains the only extant account of this remarkable premiere. 'The price of the seats was within everybody's reach: a trouser button, and I believe our parents ended up mystified by the increasing scarcity of that sartorial accessory.'

Henri's two best friends at school were Gustave Taquet, an expansive and entertaining grocer's son who looked forward (unlike the seed-merchant's son) to taking charge of his father's shop, and Louis Joseph Guilliaume, a weaver's son who went on to be the town's first photographer. Taquet and Guilliaume slipped readily into the roles allotted to them, both achieving worldly success long before Henri did (or Léon either, for that matter), and both living out their lives as pillars of the community in Bohain. The other two escaped as soon as they could to Paris. Léon planned to become a doctor, did brilliantly in his examinations and enrolled at eighteen in the medical faculty. Henri dreamed and dawdled through his school career with no aim in view. Constant rote learning was the rule in the three local schools he attended under teachers who lashed out freely with the cane or ruler. So did the private violin teacher he shared with Léon, Monsieur Pechy, leader of the town's military band, who beat his pupils with his violin bow. The two boys, both highly musical, retaliated by playing truant. When

Père Pechy knocked on the Matisses' door, Henri would climb
over the Vassaux' party wall so that the teacher had to go next
door in search of Léon, who was also missing, both boys having
by now hopped back over the wall on to the Matisses' side.
Léon always insisted that Henri was the more gifted of the two,
and that if it hadn't been for Père Pechy, he could have become
a great virtuoso violinist. Certainly this episode rankled with
Matisse, for whom the violin remained always an image of
artistic achievement, the alternative path he might have taken.
Years later he obliged his own reluctant son to practise the
violin for hours each day, explaining that he himself bitterly
regretted having opposed his father on this and other fronts.

As Matisse grew older, he came increasingly to understand
and sympathize with a side of his father he had rebelled against
with his whole being as a boy. In the last years of his life he
looked with new eyes at his father's problems: the precarious-
ness of his achievement in the early years, the anxiety and
labour involved in setting up any kind of enterprise, the constant
effort required to keep it going. He saw the pain he caused his
father by refusing to learn the violin even though, a few years
later as a student, he couldn't be parted from his fiddle. He had
day-dreams of being a jockey, but learned to ride only after his
father's death in spite – or perhaps because – of the fact that
Hippolyte Henri had loved horses, ending up at the height of
his success with at least ten in his stables: mighty, gleaming dray
horses, harnessed five abreast, to draw the great wagons loaded
with his stock all over the département. Hippolyte Henri also
kept a light barouche with a fast, fine-paced mount for his
personal use, one of the few luxuries he allowed himself in a
life of unremitting toil.

His sons were brought up as good Republicans and Roman
Catholics according to the custom of their class and time.
Baptized at seven days old before he left Le Cateau, and
confirmed with all the other children of his year in 1881, Henri
dismissed his Catholic upbringing ever afterwards as part of the
harsh authoritarian apparatus that had curbed and controlled

his youth. He was sent as a small boy to Bohain primary school, transferring briefly round about the age of ten to his father's old secondary school, the college of Le Cateau. He attended as a day-boy, living with his grandmother Gérard in the rue du Chêne Arnaud, where the Cateau tanneries produced a stench as powerful as the beet refineries of Bohain. Cholera, malnutrition and alcoholism ravaged the region in those years. Men, women and children in the textile mills worked up to twelve hours a day, with a single fifteen-minute break. Immigrant labourers crouched in long lines bent double, nose to ground, all day to weed the beet-fields. Resentment simmered and flared in the workforce throughout the 1880s. A strike in Le Cateau in December 1883 erupted into a riot the day after Henri's fourteenth birthday. Strikers stormed the woollen factory installed in the old archbishop's palace (now the Matisse Museum), smashing doors, breaking windows and threatening to kill the managing director. Memories like these lay behind the images of physical violence that often startled Matisse's admirers later when he talked about his working methods. He told the Hollywood film-star Edward G. Robinson that the only thing that drove him to paint was the rising urge to strangle someone. 'I've always worked like a drunken brute trying to kick the door down,' he said, discussing the designs for his chapel in Vence at the end of his life.

Matisse's brutal metaphors went back to the remorseless, mind-numbing, unending drudgery he had seen on all sides as a child. Weavers had feverish eyes, pale faces and gaunt, etiolated bodies from spending all the hours of daylight shut up in cramped and often humid spaces. Long after the neighbouring towns had switched to mechanization, the men of Bohain kept their handlooms, working at home or in back-street workshops crammed with anything from three or four to twenty times as many looms. There were half a dozen of these weavers' and embroiderers' shops in and around the rue Peu d'Aise. Matisse himself was just old enough to remember the mid-century vogue for Kashmir shawls which had brought Bohain its first

taste of prosperity, but it was Parisian high fashion that lay behind the town's astonishing economic turnaround after the defeat of 1871. By the time Henri was ten, all but a handful of the town's textile workshops had switched to furnishing or dress materials, working directly for the big Paris fashion houses that supplied modern department stores like the Cour Batave. The weavers of Bohain were famous in those years for the richness of their colours, for their unerring sense of design, imaginative daring and insatiable thirst for experiment. They worked to order for the top end of the market, supplying handwoven velvets, watered and figured silks, merinos, grenadines, featherlight cashmeres and fancy French tweeds for winter and, for summer, sheer silk gauzes, diaphanous tulles, voiles and foulades in a fantastic profusion of decorative patterns, weaves and finishes.

Bohain's silk weavers had few rivals and no superiors. Their tradition was independent, radical and subversive. Their craving to escape from the hardship of their own lives found a practical outlet in the fierce aesthetic satisfaction they got from the unheard-of delicacy and boldness of their fabrics. Weavers vied with one another to produce ever more ambitious, subtler and more opulent effects, ranging from sumptuous brocades to filmy shot silks and gauzes which took on the tone and texture of a watercolour. 'Each shuttle . . . performs the function of a paintbrush which the weaver guides at will and almost as freely as the artist himself,' wrote a contemporary. Matisse grew up familiar from infancy with the sound of clacking shuttles, and the sight of his neighbours plying coloured bobbins, hunched over the loom like a painter at his easel day in, day out, from dawn to dusk. Textiles remained ever afterwards essential to him as an artist. He loved their physical presence, surrounding himself with scraps and snippets of the most beautiful stuffs he could afford from his days as a poor art student in Paris. He painted them all his life as wall hangings, on screens, in cushions, carpets, curtains and the covers of the divans on which he posed his models of the 1920s in flimsy harem pants, silk sashes and jackets,

ruffled or embroidered blouses, sometimes in *haute couture* dresses made by Parisian designers from the sort of luxury materials still produced in those days for Chanel in Bohain.

Throughout the single most critical phase of his career, in the decade before the First World War when he and others struggled to rescue painting from the dead hand of a debased classical tradition, textiles served Matisse as a strategic ally. Flowered, spotted, striped or plain, billowing across the canvas or pinned flat to the picture plane, they become in his hands between 1905 and 1917 a disruptive force mobilized to subvert the old oppressive laws of three-dimensional illusion. Attacked for being a decorative artist, he defined luxury in the old democratic weavers' sense as 'something more precious than wealth, within everybody's reach'. He remained to the end a true son of the weavers of Bohain, whose fabrics astonished contemporaries by their glowing colours, their sensuous refinement, their phenomenal lightness and lustre.

Matisse said he had dreamed from his earliest years of the radiant light and colour he finally achieved in the stained-glass windows of the chapel at Vence in 1951: 'It is the whole of me . . . everything that was best in me as a child.' He told his grandson, who was taken aback to find almost every feature of a conventional church interior missing from the chapel, that his whole life had been in some sense a flight. 'I come from the North. You can't imagine how I hated those dark churches.' One of the effects that pleased him most in the Vence chapel was a blue he said he had seen before only in the glint on a butterfly's wing, and in the purity of burning sulphur: the flames of the volcano that first erupted in a toy theatre in Bohain more than sixty years before. 'Even if I could have done, when I was young, what I am doing now – and it is what I dreamed of then – I wouldn't have dared.'

The young Henri took all he could from his native region, which had its own peculiar poetry, harsh, dry and unromantic but full of energy and wit, a style encapsulated in the lullaby adopted as the national anthem of the North, 'Petit Quinquin'.

Quinquin is a poor lace-maker's child whose crying keeps his mother awake at night until she shuts him up with a thrashing. 'A remedy for insomnia that strikes me as less than ideal, and I shouldn't care to prescribe it for you,' Léon wrote genially to Henri in the 1950s. But a smack was the traditional answer for most childish troubles in their youth. Matisse said that a drawing should have the decisiveness of a good slap. Patois songs like 'Quinquin' confronted head-on the actuality of impoverishment and want, covering everything from the latest gruesome crime or accident to cold, hunger, hangovers, marital troubles, unruly wives and unwanted children. 'It's no good heading for the grave with your eyes shut,' as Matisse was fond of saying. He liked the blunt, self-mocking pop songs of his native region. Ironic, intensely realistic, flat in tone and richly detailed, a sung equivalent to Flemish genre painting, they suited the matter-of-fact, caustic and irreverent side of his nature which he never lost.

It served as undertow or counterweight to his rich dreams. Matisse's art, even at its purest and most transcendental, is anchored in a realism without self-pity. He summed up the two sides of his nature in a strange story he told several times about his childhood. The episode took place in the summer of 1884, when Henri was fourteen years old, in the Golden Lion Hotel kept by his mother's elder sister, his aunt Joséphine Mahieux. Its central figure was a travelling Belgian hypnotist called Donato, already a celebrity in the North, fresh from well-publicized encounters in Paris and Warsaw with eminent sceptics whose attempts to unmask him invariably ended in triumph on his part and humiliation on theirs. Billed as a man-tamer, he stupefied his audiences with his apparently effortless ability to dominate all-comers. People in Bohain a century later still had a dim folk memory of the foreign hypnotist who made fools long ago of the town's great and good. One of them was forced to urinate in public, another to ride a broomstick through the streets. The third was Henri's aunt, a highly respected widow in her late forties who found herself parading down the stairs and through

her own front hall carrying a brimming chamber-pot in front of an incredulous crowd of gawping fellow citizens.

Power and submission were the point of Donato's act and his speciality was adolescent boys. He liked nothing more than ten to twenty youths, the cockier the better, who ended up on stage shaving one another with invisible razors, mending non-existent shoes and stitching spectral patches on their trousers before finally stripping to their underpants and plunging into an imaginary river. Henri himself described what happened when he and his friends were 'donatized' into believing that they stood in a buttercup meadow beside a burbling stream: 'They would stoop to pick the flowers, they would try to drink the water, so powerful was the hypnotic suggestion. When it came to him, however, just as he was beginning to fall under the spell, something seemed to snap and through the grass and the stream he saw the carpet on the floor. "No," he cried, "I can see the carpet."' The episode remained ever afterwards a yardstick for Matisse, who said that 'however far fantasy might take him, he never lost sight of the carpet'. Journalists regularly compared Donato at the height of his powers in the 1880s to a wild beast, or *fauve*, but he met his match that night at Bohain's Golden Lion in a will more powerful than his own, and an imagination that would one day exert its spell on a scale no one present could have envisaged.

The town of St-Quentin, with a population seven times as big as Bohain's, was the traditional meeting place between the flatlands of Flanders and the rest of France. It rose like an amphitheatre above the marshy valley of the Somme on a hilltop crowned by a graceful medieval collegiate church visible from the plain for miles around. The school was a grim barracks near the prison on the town's old parade ground: a sort of militarized monastery ruled by the drumbeat and the drill yard. When Henri transferred there a year or two before his encounter with Donato, the boys slept in unheated dormitories in winter temperatures of up to eleven degrees below zero. By day they worked at a curriculum still firmly centred on Greek and Latin

grammar. The lycée's art department studied drawing only, reduced like a classical dead language to a series of prescribed routines for copying plaster models of abridged or abbreviated Greek and Latin originals.

The deputy art master, supposedly in charge of the lower school, was Xavier Anthéaume, who taught from diagrams on the blackboard, failing completely to impose order on huge classes jammed into a converted dormitory high up under the roof. Anthéaume's manner was dry, fussy and defensive. He was asthmatic, and his rambling instructions were frequently interrupted by a violent hacking cough. His art class became a weekly riot. Henri's sharpest memory of his schooldays was of leaning over the banister outside the art-room, watched by a whole crowd of boys, and spitting on the top hat of Père Anthéaume puffing up the spiral stairs below. It was a repeat of his earlier revolt against Père Pechy. Behind it lay a disillusionment still vivid more than half a century later when Matisse told this story. He said he had discovered by chance in the school art-room an innate ability to draw, and his indignation with the mechanical exercises that blocked it off was deep and fierce.

At home, Henri's future was beginning to pose problems. 'I was a child with my head in the clouds,' he said, describing how his mother found him practising to be an acrobat, doing headstands among the seed-sacks, when she came to fetch him for a confrontation with his father. 'I was very submissive. I would do whatever they wanted.' His refusal or inability to comply with demands that he take an interest in the family business surfaced in regular bouts of illness, when he had to be put to bed – 'the crises lasted a month, a month and a half, sometimes two months' – suffering from what seemed to be some blockage or inflammation of the gut. The complaint was painful, inoperable, curable only by bed rest, probably spasmodic in origin (as many of Matisse's later health problems would be, according to Dr Vassaux), caused by acute nervous distress. His periodic collapses did at least solve the problem of who was to

take over the seed-store. The family reluctantly accepted that
Auguste would have to step into the shoes of an older brother
whose intestinal troubles prevented his standing up for long, let
alone humping heavy sacks for delivery like their father.

Henri was seventeen when he left school abruptly in the
middle of the summer examination term of 1887. His recol-
lections of this ignominious finale were patchy and confused.
All he could remember was a walk in the beet-fields round
Bohain, where his exasperated father suggested he might make
himself useful by working as a lawyer's copying clerk. A place
was found with the family solicitor in an office a little further
up the rue du Château, and Henri's father was agreeably
impressed when the boy himself proposed a year studying law
in Paris. By his own account he spent the whole year in a
stupor of misery and boredom. He passed his preliminary exam-
inations at the law faculty in August 1888, explaining afterwards
that all you had to do was demonstrate that you had actually
opened a lawbook and knew how to use the index.

He returned from Paris as a newly qualified lawyer's clerk
to work for a leading advocate in St-Quentin, a job his father
fondly hoped might lead to some sort of ministerial office.
Henri went back to copying out interminable lawyers' briefs,
escaping at weekends to see the family and go dancing with
his friends. He had a reputation as one of the lads in Bohain,
a joker liable to go off the rails in the giddy nights of carnival,
but beneath his bravado lay something close to desperation.
Although he grew a beard, like his father's, and acquired a
clerk's top hat, unhappiness made him awkward and repellent.
'Matisse at eighteen was far from good-looking,' said a girl who
remembered dancing with him at a ball in Bohain town hall:
'Skinny and shy with a wispy beard ... he looked ugly as a nit,
a real nit.'

For most Frenchmen military service provided the only
glimpse they would ever get of the world beyond their own
home towns. In Bohain's military culture, the call-up ceremony
in the town hall, with its annual drama of selection and rejection,

was a high point when the whole town turned out to watch
the successful conscripts in red-white-and-blue cockades
parading through the streets behind the band. Henri was one
of the rejects of his year in 1889. He succumbed to the last
and by far the most serious of his breakdowns, struck down
by what he later called appendicitis, typhlitis or ulcerative
colitis. In fact, it was a hernia, probably brought on by helping
out in the seed-store, but Matisse talked afterwards as if the
mysterious blockage in his gut was standing in for an obstruc-
tion that paralysed his will. Looking back later, he never
underestimated the gravity of what he and his family both
recognized as a rejection of the world into which he was born.
He was dismayed by the apathy and fecklessness of his younger
self, and hoped that his own sons would one day appreciate
his attempts to train and guide them. 'That is what happened
to me personally with my father,' he wrote sadly in his sixties
to one of them: 'I should have liked to tell him so, but it is
too late.' At the time, his conflict with his father demanded all
his strength, leaving him drained and exhausted. Sometimes it
seemed to him that he spent the better part of his twentieth
year bedridden.

The revelation that rescued Matisse from total disintegration
became part of his personal legend. It started with a neighbour
whose hobby was copying Alpine landscapes in oils from
coloured reproductions, or chromolithographs. 'Seeing that I
was becoming a burden to myself during my convalescence,
my friend advised me to try the same distraction. The idea
didn't please my father, but my mother took it upon herself to
buy me a paint-box with two little chromos in the lid, one
showing a water mill, the other the entrance to a hamlet.'
Matisse remembered his neighbour copying a Swiss chalet with
pine trees and a stream, the sort of chromo – simple, charming,
sentimental – that was all the rage with the younger generation
in Bohain at the time. The picture still survives in the family
of this amateur painter, Léon Bouvier, who might be said to
have changed the face of twentieth-century art. The son of a

local textile manufacturer, Bouvier claimed there was no better form of relaxation after a hard day at the office than coming home to paint a landscape. Henri, sitting up in bed with a canvas propped against his knees, copied the water mill and signed it with his name spelt backwards – Essitam – as if he saw himself reflected in a looking glass:

Before I had no interest in anything. I felt a great indifference to everything they tried to make me do. From the moment I held the box of colours in my hand, I knew this was my life. Like an animal that plunges headlong towards what it loves, I dived in, to the under-standable despair of my father ... It was a tremendous attraction, a sort of Paradise Found in which I was completely free, alone, at peace.

He was twenty years old. From now on he worried about the time he had already wasted, and the need not to waste another minute. He bought a popular do-it-yourself handbook, Frédéric Goupil's *General and Complete Manual of Painting in Oils*, and set to work on what he called *My First Painting*: a pile of scuffed leather-bound books arranged alongside a small opaque glass lampshade in a pottery saucer on a crisp sheet of newspaper with an artfully placed tear. He copied it from another popular chromo, signed it 'Essitam' and dated it June 1890. His second painting was an arrangement of the everyday objects most readily to hand for a lawyer's clerk: more books and a brass candlestick on a red woven table-cover. Matisse said ten years later that it came so close to containing everything he had done since then that it hardly seemed worth having gone on painting. The picture, which looks to the observer like a standard Flemish still life, remained for Matisse a mirror that reflected the first passionate, almost animal uprush of feeling released by his mother's paint-box. 'I realized, thinking about it, that what I recognized in it was my personality. But I also told myself that if I had only ever done that canvas, this person-ality would have remained unnoticed because it would never have developed.'

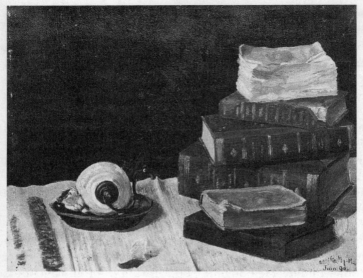

Matisse, 'Still Life with Books (My First Painting)', *1890*

On his recovery, Matisse went to work for yet another lawyer, Maître Derieux, in St-Quentin. He treated the job as no more than a minor inconvenience, enrolling without his father's knowledge in classes at the free art school installed a two-minutes walk away in the attics of the ancient Palais de Fervaques. Classes were held before and after work, from 6 to 8 in the morning and 7:30 to 10 at night. Looking back more than half a century later, Matisse made a sketch of Maître Derieux's half-open office door, part revealing, part concealing an inner frosted-glass door with an engraved copper plate. It was the first in a long line of doors and windows that would open for him all his life, even if they had to be kicked in first. 'This is what I find so particularly expressive,' he said to a young cinéaste who wanted to make a film about his early life, '*an open door* like this, in all its mystery.'

Founded by the pastellist Quentin Delatour in 1782 for the training of poor weavers, the Ecole Gratuite de Dessin Quentin

de la Tour had become by the late nineteenth century a provin-
cial outpost of the Ecole des Beaux-Arts in Paris. The director,
Jules Degrave, saw it as his mission to tend the sacred flame of
classicism by means of strict imitation. Clerks and boys from
the lycée, who copied documents all day into ledgers or exer-
cise books, spent their evenings copying printed sheets of
engravings, then architectural bits and pieces, and finally classical
statuary. Live human models were unknown. Drawing from
nature was banned to all but exceptionally advanced students.
Colour was out of the question. Selected members of the top
class were permitted to copy pastel portraits of eighteenth-
century courtiers by the founder himself, Quentin Delatour,
housed in the art-school attics. Matisse said he looked at these
portraits so closely that, by the time he left the building, his
jaws ached from the answering courtly smile he had uncon-
sciously kept clamped across his face for hours. For
psychological truth, he ranked Delatour above all other portrait-
ists except Rembrandt.

Degrave was a despot who crushed incipient revolt with
ruthless speed. Matisse's enrolment coincided with, and perhaps
helped to precipitate, a potentially serious threat posed by a
young assistant, Emmanuel Croizé, newly posted from Paris in
October 1890. Optimistic, energetic and inexperienced, Croizé
quickly gathered round him a band of the art-school's ablest
and most adventurous pupils. Within two months of his arrival
he had cooked up a scheme with the new deputy art master at
the lycée to found a brand-new academy of painting. Matisse
was the star pupil of the new academy, officially inaugurated
that winter in the attic above Croizé's modest lodgings at 11
rue Thiers. The studio was just about big enough to hold fifteen
students crammed in with their stools and easels, their two
instructors, and the live model promised as a prime attraction.
The fees were a modest fifteen francs per month, and hours
were from 1 to 5 p.m. daily so as not to conflict with sessions
at the Ecole de la Tour.

Accounts of Matisse over the next few months suggest an

exuberant energy in sharp contrast to the despairing lassitude of the previous year. Between painting sessions the whole class responded joyfully to his impersonations, or joined in the refrain of the latest patois pop song, which he sang to his own accompaniment on the fiddle. Round about this time he consulted the only living painter of any standing in St-Quentin, a veteran specialist in barnyard scenes called P.L. Couturier, who gave him guarded encouragement. But it was Croizé who insisted that Matisse could be a painter, advising him not to hesitate between art or music as a career, and to forget about the law. If the last was no longer a viable option by this time, the first two posed a genuine dilemma. Matisse, who prided himself on a natural musicality and a fine bowing technique, never lost the sense of waste, sharpened by regrets about his father, that underlay his feelings about the violin.

But painting was already a consuming passion. From now on he was haunted by lost time. He rose before dawn in winter for drawing sessions at the art school, gave up his lunch hour for Croizé's painting class, and hurried home to his rented room in summer to slip in another few hours' painting before the light failed. By his own account he ate only after dark and sleepwalked through his time at the office, where he had now been promoted to head clerk. He remembered being paralysed by stage fright on his only court appearance ('All I had to do was to pronounce one sentence: "We ask that the case be postponed for a week." And I could never manage to get it out'). He said he was so bad at locating papers that his employer found it easier to fetch them himself, and eventually gave up asking him for help. Maître Derieux put up patiently with his head clerk's growing eccentricity and the shortcomings of his filing system, even covering up for him with his father, now a highly successful local seed-merchant, whose custom perhaps the lawyer valued.

If Hippolyte Henri Matisse had his suspicions, he had as yet no hard evidence that his son was going off the rails again. Croizé encouraged his pupils to paint out of doors, setting out with the whole class on summer evenings to catch impressions

of the setting sun. At some point in the summer of 1891 word
of his assistant's unorthodox methods reached Degrave, who put
a sudden and violent stop to the academy. The students were
packed off back to the drawing board with their palettes
confiscated and colour once more out of reach. Croizé himself
was publicly disgraced. Three of the older students rose up against
Degrave, laying plans to escape rather than capitulate. The ring-
leader of this group – known locally as 'the Three Renegades'
– was Matisse. His companions were Louis van Cutsem, the
twenty-year-old son of a Belgian gunsmith, and an eighteen-
year-old called Jules Petit, whose father kept a shop selling
baskets. Their scheme was to leave for Paris to study for an art
teaching diploma that would qualify them to work in state
schools. All three knew well enough that their attempt to bypass
the Beaux-Arts system in defiance of Degrave meant that their
chances of survival in the art world were virtually nil.

None of this could do anything but confirm the worst fore-
bodings of the three renegades' parents. 'There were no painters
in my family, there was no painter in my region,' said Matisse.
He was the first and for a long time the only artist Bohain had
produced, and his family was appalled. Without its backing, he
would not last long as an independent art student in Paris, and
the full weight of family authority was now invoked against him.
It would be hard to exaggerate the shock of Matisse's defection
in a community that dismissed any form of art as an irrelevant,
probably seditious and essentially contemptible occupation
indulged in by layabouts, of whom the most successful might at
best be regarded as a kind of clown. Henri was already well
known in Bohain as an invalid unfit to take over his father's shop.
Now he had failed as a lawyer, too, and was about to become a
public laughing-stock. 'The announcement of his departure was
a scandal for Matisse's parents,' wrote a contemporary; 'they felt
their son's folly to be a catastrophe that brought shame on the
whole family.' Matisse himself was painfully aware later that his
decision to leave Bohain called his father's whole life in question.
'My father had paid for my legal studies. When I said: "I want

to be a painter," it was the equivalent of saying to the man: "Everything you do is pointless and leads nowhere."'

Now that the conflict between father and son was at last out in the open, there were no holds barred. All accounts agree that it was a ferocious fight. Hippolyte Henri threatened to cut off supplies and see his son starve sooner than change his mind ('It's a career for down-and-outs, d'you hear, you'll die of hunger'). Henri himself described his resistance always with the same stonewalling phrase: '*J'ai tenu bon* [I held my ground].' In this final struggle between father and son, Anna Matisse was a tireless mediator, arguing with her inflexible husband ('"Give him a year," my mother said'), coaxing and cajoling her no less obdurate son. Nothing could change Henri's mind, but under steady pressure from his wife, Hippolyte Henri relented sufficiently to make his son a minimal allowance of 100 francs a month for a single trial year in Paris.

Dramatic accounts of the affair circulated long afterwards in Bohain. Rumour reported Matisse's father shaking his fist and shouting threats as the train pulled out of the station. Matisse himself said he slipped away without telling anyone. It would be a long time before he returned, longer still before he could admit that there was something to be said for his father's point of view. 'He did right,' Matisse declared cordially nearly half a century later; 'he wanted to see if it would take ... It was a seed. It had to grow, to put out a shoot. Before, nothing interested me. Afterwards, I had nothing in my head but painting.'

2. *The Runaway (1891–7)*

The three renegades from St-Quentin reached Paris by October 1891, in time for the start of the autumn term at the Ecole des Beaux-Arts. The centralization of the French state meant that the Beaux-Arts was for all practical purposes the only route to a successful artistic career. By failing to secure the backing of their home town, Matisse and his companions had already bungled the first qualifying round in an elaborate programme of tests, examinations and competitions for medals and prizes culminating in the annual contest for the Prix de Rome which, as Matisse said bitterly, was the only outlet for those caught up in a bottleneck system expressly designed to eliminate most of the candidates.

Over the next few years Matisse's two friends followed the rule. Louis van Cutsem abandoned painting altogether, retiring to St-Quentin to marry a brewer's daughter and make a career as a sugar-broker. Jules Petit stuck it out in Paris with Matisse (who admired him as a painter), sharing the same lodgings, working in the same studio, eventually passing the Beaux-Arts examination in the same year, and even managing to get a painting accepted twice running at the official Salon. But he, too, went home to St-Quentin after eight years, disillusioned and worn down by the struggle for survival, to die at the age of twenty-six in February 1899, two months before van Cutsem's wedding.

Matisse himself said that in his early years in Paris he felt like someone stumbling about in a dark wood with no clear idea where he was heading. He began by presenting a letter of introduction given him by P. L. Couturier to William Bouguereau, the President of the Paris Salon, who was among the most powerful as well as one of the wealthiest painters in Europe. Being received by him meant that the young postulant had

been granted an audience with the pope of the French art world, whose word could make or break a career. Over the years Matisse developed this encounter into a comic star turn, relishing the master's pomposity and the undertone of menace beneath his absurd nasal whine. But at the time it reinforced a growing conviction that he could never compensate for lack of early training, no matter how hard he tried. Matisse enrolled on 5 October in Bouguereau's drawing course at the private Académie Julian. The year's fees – 306 francs – must have been stumped up by his father on the understanding that a stint at Julian's was the recognized preliminary to acceptance by the Beaux-Arts.

Bouguereau told the new boy in his first class that he couldn't draw and would never learn. Matisse was sent back to the kind of mechanical exercise that had driven him wild at school, copying plaster casts with the help of a plumb line. The latter stuck with him, to his friends' incredulous amusement. 'It took me several years to get the plumb line into my head, the sense of the vertical,' he said more than half a century later, by which time Bouguereau's academic plumb line had become for Matisse a moral as much as a structural principle, symbolizing clarity, strength and equilibrium.

But this was the extent of what he learned at Julian's. After only two correction sessions Matisse switched to studying under Gabriel Ferrier, an excitable little man who took one look at his drawing of a plaster cast and told him to stop wasting his time. This time the new pupil was held up to the whole class as a true artist who would outstrip all the rest once he started drawing from the live model. Matisse overcame his private doubts – 'I daren't, I'm still a beginner' – only to be utterly demoralized when Ferrier damned his study of a nude the week after. 'It's bad, so bad I hardly dare tell you how bad it is.' Overcome by emotion at his first sight of a naked girl, Matisse had started with the hands, rubbed out the head, and generally botched the standard procedure laid down in a sequence of separate manoeuvres to be carried out in an

approved order at a specified rate of progress. Ferrier responded with the factitious rage of a sergeant major goading a clumsy recruit. 'He seemed a crackpot to me,' said Matisse, who skipped the correction classes from then on, struggling to cope on his own with a sense of hopeless inadequacy.

Conditions at Julian's were gruelling. Too many students crammed without supervision into airless, overheated studios produced an earsplitting din. They flicked paper pellets, over-turned one another's easels, lobbed missiles, and generally relieved their frustrations by horseplay and ragging, especially of newcomers. Worse than anything else for Matisse was 'the torment of not being able to paint like the others'. Isolation made him retreat in on himself. 'I was like someone who arrives in a country where they speak a different language. I couldn't melt into the crowd, I couldn't fall into step with the rest.' Driven by the need to catch up, and dread of what might happen when his father found out he had been right after all, Matisse pored over the highly finished, technically brilliant, emotionally void canvases of his more successful fellow students. 'I couldn't see any reason to paint that way. On top of which I hadn't the faintest notion how to set about doing it.' In January 1892 he submitted a nude drawing, or *académie*, endorsed as a matter of form by Bouguereau and Ferrier, for the first round of the Beaux-Arts entrance examination, which he failed. 'It's a good drawing,' he said, looking at his entry again sixty years later: 'I don't draw any better now, I draw differently.'

At some point in the New Year he took the train to meet his father on neutral ground well away from Bohain at one of the great regional seed markets held in Lille. The confrontation was bleak. Both were disappointed, one still as uncomprehending, the other as obstinate as before. The possibility of cutting off Henri's allowance loomed over this encounter, as it would do for the next ten years whenever the two met for a serious talk about the future. Matisse was fighting his own self-doubt as well as his father's lack of confidence. 'I believed I would never be able to paint because I didn't paint like the others. Then I

saw the Goyas at Lille. That was when I understood that painting could be a language; I thought that I could become a painter.' The pictures that spoke his language in the Lille museum were Goya's *Youth* and *Age*. Matisse said Goya gave him the gift of life, using the same metaphor he applied to Croizé's art class in St-Quentin. 'It was an open door. Back at Julian's was a closed door.' He felt as if everything had been back-to-front up till then. 'He was desperate,' said his son Pierre. 'He couldn't understand the academic method, a touch of grey, then a darker tone, all their tricks and dodges – and then there was Goya. He said: "Ah, that I can do." And his father went home without having understood anything.'

Hippolyte Henri left Lille with a heavy heart, but his son travelled back with renewed resolution to Paris, where a friend advised him to bypass Bouguereau by trying a back way into the Beaux-Arts. The only one of the school's three painting studios prepared to take on students regardless of their examination results was run by Gustave Moreau, who immediately accepted Matisse. Fifty years later he drew Moreau as a stick figure with arms flung wide in welcome. Exuberant energy possessed him. Unable to count on his father's continuing support, he decided to make sure of a second year in Paris by halving his outgoings. Living or eating out, even in the sleaziest student dosshouse, was now beyond him. After the trip to Lille, he moved with Jules Petit to two slum rooms at 12 rue du Maine in Montparnasse, where they did their own housekeeping and lived on next to nothing. Once Matisse's father sent up a sack of rice from the shop and the pair kept open house, serving plain boiled rice to friends who played their pipes and fiddles and roared out popular songs while they waited for a second plateful. Throughout his six years at Moreau's, Matisse belonged to a band of hardheaded, pipe-smoking, beer-drinking northerners who stood out for their toughness as much as for their sardonic humour, their love of music-making and their flat accents.

Moreau's relatively permissive approach meant that his pupils rampaged out of control at times, making such mayhem that

the studio had to be closed down briefly in Matisse's first year. Six months later the police were called to a Bal des Quat'z' Arts at the Moulin Rouge, perhaps the first and only one of these balls Matisse attended, disguised as an Arab in a bedsheet with burnt-cork make-up (the fancy-dress Quat'z' Arts revellers were male art students accompanied by their female models, who could expect to lose what little they wore in the first hour). Moreau's students, armed with revolvers, joined in the street fighting that engulfed the Latin Quarter for the next three days, with police baton charges against barricades built from ripped-up paving stones. For Matisse, living on half rations and determined to work twice as hard as anyone else, this was a time of excess. He was famous for wrecking a music-hall performance at the Gaîté de Montparnasse, and collecting a crowd by shamming drunk in the street afterwards. People who knew him later found it hard to credit that anyone so self-contained could ever have lost his inhibitions so completely, but Matisse said that innate turmoil was precisely the reason for the iron discipline of his later years. 'I . . . was born disorderly,' he wrote, 'never doing anything unless I really wanted to, dropping and breaking anything for which I had no further use, never making the bed except on the day when the sheets were changed, etc., etc.'

He moved down to the Left Bank of the frozen Seine in the bitterly cold winter of 1892–3, sharing a dank unheated studio at 350 rue St-Jacques with a sculptor called Georges Lorgeoux, who taught him how to handle clay ('I can still see Lorgeoux kneading the clay for me'). Matisse's earliest surviving sculptures are a pair of terracotta medallions, bearing portrait heads of the girl who was Lorgeoux's model. Her name was Caroline Joblaud, but she was always known as Camille. She was nineteen years old, a vivid, graceful, fine-boned creature with an appealing air of fragility and vulnerability. Matisse said she had shoulders as wide as the people in Egyptian frescoes, and she moved in such a way that, even in profile, she gave the impression of facing outwards. Pale and slender with long dark

hair and large dark eyes ('the eyes of a true odalisque', said
Matisse), Camille was lighthearted and outgoing. 'She loved life,
and she made you want to live.' She laughed at Matisse's clown-
ing, and at Lorgeoux's lightning caricatures. For a time the three
went everywhere together, often accompanied by Léon Vassaux,
now a medical student at the Sorbonne. Camille remembered
constant outings attended by a troupe of friends. To the end of
her life she told stories of her bohemian days on the Left Bank,
the fun they had at cabarets and concert halls, the excitement
of being young and beautiful and admired by a band of penni-
less but promising artists. Matisse seldom spoke afterwards about
these years, save to say that he hadn't needed imagination at
twenty-five to know what it felt like to be in love. Vassaux, also
hopelessly in love with Camille, accepted her decision philo-
sophically when she rejected both him and Lorgeoux in favour
of Matisse.

*Camille Joblaud, courted for her wit
and elegance by both Matisse and his
best friend, Léon Vassaux*

Like so many of the women in Matisse's life, Camille worked in a hat-shop. She was born in April 1873 in the Allier, the orphaned child of a village carpenter, and taken in by nuns who taught her fine sewing. Camille had clever fingers and a feel for the stuffs which even in those days Matisse could not do without. Surrounded by textiles at home, missing their physical presence in Paris, he began collecting threadbare scraps of embroidery or tapestry-work picked up for a few sous from the junk stalls round Notre-Dame. Camille made her own clothes, and designed hats for herself and her friends. She embodied French chic and what another of Matisse's models called English panache, or the critical importance of style in face of atrocious conditions. Both formed part of the generous, libertarian outlook Matisse had inherited from the weavers of Bohain, for whom luxury itself was 'something beyond price, available to all': a philosophy that would become in his hands an essentially spiritual defence against physical or moral squalor on all levels. 'The most mysterious thing about him,' Louis Aragon wrote long afterwards, contemplating the weight and power that can be felt but not seen behind Matisse's apparent facility as a draughtsman, 'is, perhaps, that he understands better than anyone else the way fabric lies against flesh, and how the straps and ribbons cross and slip in a woman's garments, how they wind about her waist or close to her armpit or under the curve of her breast: so many secrets that are not to be found in any dictionary.'

In the early 1890s Matisse made up for lost time by studying the old masters in the Louvre with a determination that impressed everyone from Moreau downwards. When his son failed the Beaux-Arts examination for the second time, Hippolyte Henri's disquiet flared up again and had to be damped down by a letter from Moreau, urging him not to worry, and by Matisse's assurance that he had enrolled for a teaching diploma at the Ecole des Arts Décoratifs. Under-equipped and overcrowded, this was a craft school offering free training to local school-leavers on half the budget of the

Beaux-Arts. Older and less prepared to be pushed around than
the rest, Matisse made a stir in his first class that winter by
refusing to remove his hat for the master, and was promptly
suspended for two weeks for insolence.

The only thing he took from the school was a lasting alli-
ance with two younger boys, Henri Manguin and Albert
Marquet. From now on the three worked side by side, swapping
criticism, advice and encouragement, in Paris and on the Medi-
terranean coast, throughout the struggles that convulsed the
French art world – and painting itself – in the years leading
up to and away from the great Fauve revolution of 1905. 'The
Marquet of my youth . . . was a fighter, reliable, rock-steady, a
sure companion,' said Matisse, who might have said the same
of Manguin in the first decade of the century. His two new
friends had little in common except their determination to
paint. Manguin was handsome, dashing, self-assured and as direct
as he was energetic. He whistled and sang at his easel, urging
himself on at the top of his voice, bursting into snatches of
Beethoven when things went well, seething and fuming if they
didn't. Solitary and small for his age, Marquet, whose years of
persecution at school had given him a horror of authority, was
as elusive as a blob of mercury. In Moreau's large class he took
on the role of studio mascot, nicknamed Quéquet, 'a little
limping gnome whose presence put everyone in high spirits'.
But Marquet had another side, the bitter, mocking spirit that
had learned to forestall other people's jeers by making them
burst out laughing first. A born dissident, he was captivated by
the courage and confidence that made Matisse keep his hat on
in class the first day they met. Matisse understood Marquet's
pride and reticence, his need to distance himself from other
people, the defensive shell that strangers mistook for coldness.
Their lifelong compact had its roots in these years when Matisse,
who was five years older, took practical charge of his unworldly
friend, protecting him against student bullies as he would defend
him later from unscrupulous collectors and greedy dealers: 'He
had no friends. He only really had me. I'd do what he wanted.

We could live close together without having to talk.' Marquet evoked a side of Matisse unknown to Manguin, who could make nothing of the need to cut loose that drove the other two, their periodic urge for risk and renewal in flight.

All three of them were shaped as painters at the start of their careers by Gustave Moreau. Already in his sixties when he took up his first teaching post in the year Matisse joined his class at the Beaux-Arts, Moreau turned out to be one of those teachers whose minds expand on contact with the young. He embarked with his pupils on a learning curve that made him acutely conscious of straddling the gap between the art of the past and the future. The young Henry James saw Moreau as the Gustave Flaubert of painting, 'full of imagination and, if not of first-class power, at least of first-class subtlety'. His subtlety – a rich, fluid ambivalence that dissolved other people's certainties – was one of Moreau's great gifts. 'He didn't set his pupils on the right road, he took them off it,' said Matisse. 'He made them uneasy.' He corrected his students' work twice a week, accompanying them afterwards to the Louvre, where his teaching took fire from the Dutch and Italian masters. 'He didn't show us how to paint,' said Matisse, 'he roused our imagination in front of the life he found in those paintings.'

It was the gift Matisse first got from the Goyas at Lille. 'I was a student of the galleries of the Louvre,' he said. Between 1892 and 1898 Moreau's students fanned out through the galleries, setting up their easels, moving camp from one picture to another, breaking off alone or in groups for what Matisse called 'a little session of comparative painting', swapping notes, paying calls, collecting their friends and descending in a body to investigate a new arrival, or an old hand with a fresh experiment in progress. Contemporary accounts of their comings and goings, their mutual curiosity and openness to new ideas, suggest an atmosphere closer to Sundays in Bohain – when the weavers left their looms and crowded into one another's houses to inspect the latest discoveries – than to the mechanical, repetitive copying favoured by the Beaux-Arts. 'You can say of

any particular artist that his texture is like velvet, or satin, or taffeta,' said Matisse. 'The method ... you can't tell where it comes from. It's magic. It can't be taught.'

The master to whom Matisse returned again and again in these years was J. B.Chardin, who imbued him as deeply as Goya with a sense of mystery and power. The first painting he ever copied in the Louvre was Chardin's *The Pipe*, which baffled him with an elusive blue on the padded lid of the box in the middle of the canvas: a blue that looked pink one day, green the next. Matisse tried everything he could think of to pin down the secret of this painting, using a magnifying glass, studying the texture of the paint, the grain of the canvas, the glazes, the objects themselves and the transitions from light to shade. He even cut up his own oil sketch and stuck bits of it to Chardin's canvas, where each separate bit was a perfect match until he put them together, when there was no longer any correspondence at all. 'It is a truly magical painting,' he said, adding that this was the only copy he ever had to abandon. He painted a *Still Life with Apples* for Vassaux, who called it 'my little Chardin', and kept it to remind him ever afterwards of the moment when his friend's work opened out.

Matisse copied Chardin four times. His hardest struggle was with *The Skate*, a majestic painting of fish and oysters on a kitchen slab, dominated by the great rearing arch of a gutted skate. Matisse's confrontation with this canvas lasted in the end six and a half years, almost exactly the same length of time as his apprenticeship to Moreau, and the result was a triumphant affirmation of Moreau's belief that the strength of a painting came from within, and could not be applied from without: 'Be sure to note one thing: which is that colour has to be *thought*, passed through the imagination ... The painting that will last is the one that has been thought out, dreamed over, reflected on, produced from the mind, and not solely by the hand's facility at dabbing on highlights with the tip of the brush.' This was the lesson Matisse learned by precept from Moreau, and in practice from Chardin, in the years when he said he despaired

of ever acquiring enough confidence to move on from still life to the human figure.

The second painting Matisse copied in the Louvre was Jan Davidsz de Heem's *Dessert*: a fiendishly complex showcase designed to test everything he had ever learned about handling still life from textiles to glass, polished wood, porcelain and mother-of-pearl, gleaming silver, dull pewter, chased gold and beaten copper, not forgetting a profusion of exotic fruits with their contrasting colours, textures and blooms. The painting, selected by Moreau, was a shrewd choice for an ambitious young pupil who had just been forced to admit himself beaten. Unlike Chardin's *Pipe*, with its elusive subtlety and simplicity, de Heem's *Dessert* called for the showiest skills to be deployed in the soberest manner. Invited to demonstrate the traditional virtuosity of his native Flemish region, Matisse rose to the challenge, retreating this time to the far side of the gallery and approaching the canvas as if he were working from nature. For Matisse, de Heem's *Dessert* always retained the character of a test piece. He would return to the same theme three times, using it as the starting point for his battle with Impressionism in 1897, as the basis for a foray into Abstraction in 1908, and again in 1915 for the closest he came to a direct skirmish with Cubism.

Matisse said that it took a strong character to stand up to Moreau, but that he always preferred students who did. The studio stars were Georges Rouault – 'a pale, skinny boy with red hair like flames', said Matisse – and a short, shy, silent prodigy called Simon Bussy. Rouault was already too senior, too close to Moreau and too intent on his own evolution to make any great impact on Matisse, but Bussy became a lifelong friend. Seven months younger than Matisse, already well ahead on the professional ladder, he had six years' studying in the capital behind him, having arrived with a scholarship at sixteen and passed the Beaux-Arts exam at his first try. Bussy was bright-eyed, black-haired and bullet-headed, reserved in public but phenomenally sure of himself and his judgement in private. Born into

a family of cobblers in the Jura, he was, like Matisse, the first
in his family to look beyond his home town. They shared the
same stubborn resolve, but in these early years it was Bussy – by
far the more successful of the two with a brilliant career
confidently predicted ahead of him – who believed in and
backed Matisse. Forty years later, when their respective positions
had long since been reversed, Matisse would still send for Bussy
whenever he needed a critical assessment of his latest work.
There was no trace in his attitude of the protective element
that always coloured his feeling for Marquet. He looked up to
Bussy, who had singled him out when they were both penni-
less students ('Matisse, one day you will make a great pile of
money!') for a future that seemed crazily unlikely at the time.

*Simon Bussy, 'Self-portrait',
c. 1895: the far more successful
contemporary who believed in
Matisse from the start, and remained
a close friend to the end*

 In the summer of 1894 Matisse moved to 19 quai St-Michel,
a massive stone apartment block, more like a vertical village
than a single dwelling, where he had once briefly shared a
windowless attic with Petit. Cold running water came from
communal taps on the long corridors. Everything else had to

be carried up 102 stone steps to Matisse's room on the fifth floor, into which he squeezed an easel, a cast-iron stove, a couch, a cupboard and a small table for still-life arrangements. This was the first studio of his own he had ever had, and in it he set up house with Camille Joblaud. 'I returned to the quai St-Michel, where I had a studio with a view of the Seine,' said Matisse. 'There I got married.' The couple had a tiny bedroom under the roof in the same building, but marriage was not a practical possibility in anything but name. However much he wanted to, Matisse could not legally have married without parental consent before his twenty-fifth birthday, nor could he have survived on even the most ruthless economizing without his father's allowance. The decision to put their relationship on a firmer footing followed Camille's discovery that she was expecting a child. From his family's point of view, this should have been the signal to part. Paying off a son's girlfriend as soon as she became pregnant was standard practice in respectable society, and Hippolyte Henri Matisse saw it as his duty to oppose by any available means the imposition of an additional crushing burden on his semi-destitute dropout of a son. Although he could not finally bring himself to cut off supplies, he drew up a document blocking the automatic right of his sons (and their descendants) to inherit, signing it the day before the birth of his first grandchild.

Marguerite Emilienne Matisse, known as Margot, was born on 31 August 1894. She would grow up sensitive and highly strung like her mother, with the same touching fragility and the same underlying resilience, the same delicate bone structure and the same deep, dark, odalisque's eyes. She had her father's passionate will, his courage and pride, his horror of compromise and his stubborn sense of duty. Matisse's attachment to her was the deepest and most durable of his life. She was a studio child, born and bred among brushes and canvases, brought up with the smell of oil paints, accustomed from infancy to the constraints of posing and watching her father paint. Her response to his work remained always more important to him than anyone

else's. His art would become the central supporting pillar of her life, the one certain good which never played her false, and to which she committed herself unconditionally.

Camille's love for her daughter was painfully ambivalent. Marguerite was too like her mother, and had cost her too much, for relations between them ever to be straightforward. It would be hard to exaggerate the punitive sanctions imposed in those years by a society that saw unmarried mothers as a threat to its fabric. A single girl expecting a baby could expect to be rejected by her family, sacked from her job and thrown out on the street by the concierge of even the humblest Parisian lodging-house. Camille was haunted in nightmares to the end of her life by the shock and shame of being pregnant, and of giving birth to her daughter in the workhouse hospital at 89 rue d'Assas. At the time she recovered with the gaiety and courage of youth, supported and made much of by Henri's friends. Chief among them was Léon Vassaux, who became the young couple's staunchest ally, and received in return an inscribed copy of one of the two sculpted medallions of Camille. Another of their closest friends, a fellow Northerner called Henri Evenepoel, painted Marguerite as a plump, grave, curly-headed toddler in dotted muslin with a ribbon sash.

Matisse passed the Beaux-Arts entrance examination at his fifth attempt in March 1895. A few months later he painted his first landscape – a lowtoned, green and grey-brown view of the Seine with a broad, gleaming expanse of watery reflections at the bottom of the canvas – in response to a big Camille Corot exhibition in Paris that spring. 'I was afraid I should never do figures,' he said nearly half a century later, looking back to the access of confidence that pushed him forward at this point, 'then I put figures into my still lifes.' What Matisse called his 'revelation of the life in portraits' came, like the first momentous revelation of the paint-box, from his mother. He said he was doodling while waiting for a telephone call one day in a post office in Picardy, when he saw to his surprise that his mother's generous features had materialized on the

Henri Evenepoel, 'La Petite Matisse', 1896: Marguerite at eighteen months

telegraph form beneath his hand. His first painted portrait was a picture of Camille reading in the studio, seated in a black dress against a dark wall with her back turned so that light falls on the nape of her neck and on the white pages of her book. In a second, smaller painting, he posed her against a pale ground in a poppy-patterned dress, turning her towards him so he could paint her Egyptian profile.

Matisse's luck changed with these paintings. The Salon de la Société Nationale des Beaux-Arts accepted five of his canvases for exhibition at its gallery on the Champ-de-Mars in May 1896. His portrait of Camille, *Woman Reading*, was bought by the State, and singled out for the first and almost the last public recognition Matisse received in his lifetime from his native region. 'One senses in him a true temperament,' wrote the *Journal de St-Quentin*, adding indulgently, 'There are some lawyers with artistic leanings who may well allow their clerks to please themselves by opening

a little window on the ideal.' Perhaps the choice of metaphor came from the artist himself, or perhaps it was this article that first suggested the image of a window opening on to another world which would exert such a powerful pull ever afterwards on Matisse's imagination.

The first time Matisse painted a door or window opening from a darkened interior on to a brighter world beyond was in the summer of 1896, looking out through the wooden double door of a cottage in Brittany. For him this was a revolutionary painting: it contained no figure, no trace of still life, no landscape to speak of, only an austere geometrical arrangement of lines and angles framing the source of light at the centre of the canvas. He painted his *Open Door, Brittany* on Belle-Ile-en-Mer, a small island guarding the entrance to the Bay of Biscay off the Atlantic coast, where, in the course of three consecutive summers – 1895, 1896 and 1897 – he made drastic changes to both his life and his work.

He paid an initial visit to the island in 1895 with one of his neighbours at 19 quai St-Michel, a fellow art student called Emile Wéry. Matisse by his own account had never before travelled beyond the inland plain of Flanders, and he chose for his first sight of the sea the wildest coast in Europe. The Bretons, who had lived almost completely isolated from the rest of France until the railway opened up their territory in the 1880s, shared their houses with cows, pigs and poultry, eating meat rarely and such fish as they could catch to supplement a staple diet of gruel and coarse pancakes. They slept in wooden box-beds, and hung their few possessions – baskets, cradles, strings of onions, salted hams – from the rafters. Chickens ran in and out of their cottages from the dung heap at the door. 'I was *demoralized*,' Matisse wrote after this first trip: 'I imagined that all you had to do, on arrival in Brittany, was to set up your canvas and go to work as easily as you could on the quays of the Seine, or at the Ecole. So I produced nothing, or very little. I spent my time tearing my hair to force myself to work.'

It was Wéry's approach to painting that worried Matisse far

more than the ruggedness of the place or the people. Like most of the young artists who converged on Brittany each summer, Wéry used a palette loosely derived from the Impressionists, whose experiments were anathema to Moreau. Like all his other pupils, Matisse had been strictly protected from their nefarious influence. When he painted the interior of a bar in the port of Le Palais on Belle-Ile, the result was a Flemish genre scene in shades of grey, dimly lit and peopled with drab, huddled peasants. Wéry's *Interior of a Country Café* was an altogether more colourful affair, a bucolic tribute to Edouard Manet's *Bar at the Folies Bergères*, with light pouring in from the top left-hand corner of the canvas, silhouetting a customer perched high up at the bar and bouncing back off gleaming red, orange and green bottles lined up behind the counter. Matisse felt the ground shake under him on Belle-Ile. 'I was so upset that I left after ten days. Everything seemed to me highly original, highly individual, but colossally difficult ... I remember how shocked and crushed I felt.' He took the boat back to the mainland, retreating northwards with Camille and the baby to Pont-Croix in Finistère, where they found lodgings in the kind of impromptu artists' colony that sprang up all over Brittany with the coming of the railways.

Camille loved the easygoing holiday atmosphere, and the group excursions to local beauty spots. Henri visited Pont-Aven, which had become by this time an unofficial open-air annexe to the Académie Julian, swarming all summer with would-be academicians. He left again after a single night, unimpressed by the conformists of Pont-Aven and actively repelled by the town's most ferocious nonconformist. 'I never saw Gauguin,' he explained. 'I recoiled instinctively from the theory he had already worked out, for I was a student of the galleries of the Louvre.' The paintings Matisse brought back from Brittany in 1895, and most of those he made there the year after, were Flemish in tone and treatment: old-fashioned still lifes, figure studies, flat landscapes rendered in bistres and bitumens with low houses, stunted trees and stumpy windmills punctuating a canvas half filled with pearly, cloud-scudded sky.

These sober, silvery grey Breton landscapes represented every-
thing most admired by Matisse's friend Henri Evenepoel. The
two were beginning in these months to build up a friendship
which Matisse looked back on later as one of the best things
in his life. Evenepoel was the bolder painter of the two at this
stage, with a far more robust sense of colour. He had already
made a name for himself with his *Man in Red*, a swashbuckling,
Whistlerian, very nearly life-size portrait of his friend Paul
Baignières wearing a scarlet suit, deliberately designed to smack
the eye of the public when it went on show at the Champ-
de-Mars in 1895. Evenepoel was brilliant, sensitive and
immediately sympathetic. Flemish by birth and inclination, like
Matisse, he fought a running battle all his life against the social
and academic pressures forcing them to toe the line. He, too,
had a girlfriend who had borne him a son to the fury of his
father, a senior Belgian civil servant as appalled as Hippolyte
Henri Matisse by his son's determination to stand by mother
and child. The babies were the same age, and their fathers
organized regular musical evenings in the studio with Evenepoel
at the piano accompanying Matisse on violin. Each recognized
a streak of iron in the other.

Moreau had a soft spot for Evenepoel but it was Matisse
who, after a slow start, was clearly being groomed as one of
Moreau's highfliers. In the spring of 1896 the master came
himself to inspect work in progress at 19 quai St-Michel, a
privilege reserved for few and favoured pupils. 'At last we
reached the little studio crammed with bits of tapestry and
ornaments grey with dust,' wrote Evenepoel, who helped the
old man up five flights of stone stairs to Matisse's room. 'Moreau
said to me: "We two will be the jury." He sat on a chair, with
me beside him, and we spent an exquisite hour. He explained
to us the whys and wherefores of all his likes and dislikes ...
He has remained astonishingly youthful, he's not a professor, he
hasn't the slightest trace of pedantry, he's a friend.' Nearly half
a century later Matisse could not speak without tears in his
eyes of this encounter, which ended with Moreau asking how

old they were: Evenepoel was twenty-three and a half years old, Matisse just twenty-five, Moreau a month short of his seventieth birthday.

Evenepoel seemed to Moreau to personify all the weaknesses – unfortunate taste for low life, stubborn individuality, love of garish colour – of the Flemish temperament. Matisse exemplified its strengths. When Matisse included Paul Baignières in his *Studio of Gustave Moreau*, he painted him in a plain black suit on a low-key canvas that shows what Evenepoel meant when he enthusiastically described Matisse as 'master of the arts of *grey*'. It was accepted at the Salon de la Nationale in 1896 (along with *Woman Reading*, a *Pig-Minder* from Brittany, and two still lifes) as a more serious declaration of intent than Evenepoel's eye-catching scarlet man of the previous year. The Société elected Matisse to associate membership, an unusual honour for someone who had never even exhibited before, carrying with it the right to hang up to ten paintings at the annual Salon without consulting the selection committee. Matisse sent home a list of the nineteen new associates with his own name underlined.

At least one of the paintings he had started in Brittany was finished off on a visit to Bohain, where he also painted several still lifes. This was the first time he had returned home, or at any rate worked there, since his flight to Paris in 1891. The successes of 1896 went far to rehabilitate Matisse in the eyes of his parents, who both came to Paris to see his work hanging at the Champ-de-Mars. His mother brought a present of fine wines. His father, looking as always to the future, was disconcerted by Moreau's assurance that his son was too intelligent to bother with the Prix de Rome. But Hippolyte Henri roped in a cousin, a Parisian textile-merchant called Jules Saulnier, who bought a still life and showed signs of wanting more. So did Matisse's uncle and godfather, Emile Gérard, who had added a margarine factory to the family's tanning works, and was now the prosperous owner of the grandest mansion in Le Cateau. On the strength of his Parisian triumphs, young Henri was commissioned to design a decorative scheme for his uncle's

panelled dining room at 45 rue de la République. He painted
the ceiling himself, picking out the plasterwork in gold, red
and midnight blue, and filling the embrasures with copies of
works by the Louvre's urbane eighteenth-century masters:
Boucher's *Pastorale*, Fragonard's *The Music Lesson*, Chardin's
Pyramid of Fruits and Ribera's *The Man with a Clubfoot*. It was
an auspicious return for the prodigal who had left home so
ignominiously five years before. Including Uncle Emile's copies,
Cousin Saulnier's canvas and two purchases by the State (*Woman
Reading* and a copy of Annibale Carracci's *The Hunt*), Matisse
made more sales in the first six months of 1896 than in his
entire previous life. Camille said that Henri presented her with
a bunch of violets that spring each time he sold a picture.

By the end of June the heat was stifling, especially for anyone
living under the roof in a Parisian tenement block. Matisse took
to rising before seven to join Evenepoel (who worked in his
own top-floor studio in underpants) with his easel on the
riverbank below the quai: 'The Seine is marvellous at that hour:
a milky landscape, sky brimming with light, gilded, pink- and
blue-tinted at the same time, the quais deserted!' By ten the
sun beat down so hard they retreated indoors to prepare for
the highly competitive end-of-year school show. Evenepoel's
submission included the portrait of his friend's daughter Margot,
La Petite Matisse. Her father took third prize for composition,
the first and last official recognition he ever got from the Ecole
des Beaux-Arts. On 15 July Matisse left Paris with the usual
Brittany-bound band of summer painters, drawn back reluctantly
to Belle-Ile in spite of his demoralization the year before. He
and Camille rented a room above the harbour in Le Palais
before settling for the summer at Kervilahouen, a scattered
hamlet six and a half kilometres away across flat, furze-covered
scrubland on the far side of the island, where they stayed in
the same house as the Wérys. They had an uninterrupted view
out to sea from the top floor of a stone 'pilot's house' beside
the track leading to a great granite lighthouse on the headland,
barricaded in by axe-blade-shaped rocks rising from the sea.

Matisse and Wéry were part of a steady stream of painters drawn to Kervilahouen by 'the Englishman's castle', built on the clifftop a quarter of a mile away by the Australian John Peter Russell, the son of a Sydney iron-founder with a comfortable private income. Russell was a painter whose life had been transformed byVincent van Gogh when they were both students at Fernand Cormon's academy in Paris. Russell shared his studio with van Gogh, painted his portrait and wholeheartedly agreed with him that the new art they were working towards would need a stability and seclusion impossible to find in Paris. In 1886, eighteen months before van Gogh left Paris to found his legendary 'studio of the south' in Arles, Russell set up his 'studio of the north' on Belle-Ile. By the time Matisse reached the island ten years later, van Gogh's experiment had ended in unconditional failure while Russell's continued to flourish. He and his wife had built a solid stone house above the sheltered inlet of Goulphar, with terraced gardens, tennis court, stables, cow-byre and workshops on the hinterland behind, a slipway to the beach below, and spectacular views of the Atlantic in front from the huge central studio round which the life of the household revolved. Besides a permanent retinue of children, maidservants, a coachman, tutors, governesses and gardeners, Russell attracted a floating population of visiting painters who either stayed at the big house or found lodgings, like Matisse and Wéry, at Kervilahouen.

Autocratic, high-handed and hot-tempered, a red-bearded patriarch with a commanding presence and a carrying voice, Russell at thirty-eight was said to be so powerful he could force a stray horse to its knees, or lift a man off his feet with a single punch. He fished, swam, sailed and rode round the island in all weathers. Auguste Rodin (who came to stay the year after Matisse's last visit to the island) called him 'a triple Triton' and shuddered at his daredevilry in a boat. The Russells laid on regular mussel-gathering parties, picnics, bonfires and excursions for the family and friends like the Matisses, who stayed three months on this second visit, instead of the one originally intended.

If the painters enjoyed themselves, so did their wives and girl-friends. Camille had nothing but happy memories of Belle-Ile. She liked and admired the Italian Mme Russell, a statuesque ex-model generally held to be the only person capable of controlling her husband's violent mood-swings.

Russell endlessly painted his wife and children playing, swimming or sitting on the beach. He also painted the island and its people, its yellow gorse and purple heather, its slatey orange rocks, its purply green seas, and its black fishing boats with square ochre-coloured sails. He worked out of doors on huge canvases roped down against the wind. His methods were as dramatic as everything else about him, and their impact on conventionally trained, relatively unsophisticated young artists could be overwhelming. Matisse maintained later that the transformation of his palette – 'the bistre-based palette of the old masters, especially the Dutch' – came from watching Wéry squeeze his colours straight from the tube, like Russell, in the order of the prism. 'Working beside him I noticed that he was getting more luminous results with his primary colours than I could with my old-fashioned palette.' He made a good story about how the two swapped over, Matisse returning to Paris with a passion for all the colours of the rainbow, having bequeathed to Wéry his former love of bistre and bitumen.

But for the greater part of the summer he worked cautiously, turning his back on the romantic coastline, concentrating instead on the same sort of humdrum motifs rendered in the same muted colours as the year before: the group of long, low white-washed cottages opposite his lodgings, the peasants' farms, mills and furze-stacks, and the nearby creek at Goulphar where they beached their boats. The turning point came with a picture of a woman stooping over a table laid with bread, wine and a rumpled white cloth. *Breton Serving Girl* was painted on a trip a few miles up the coast to one of Belle-Ile's prime tourist sites, the Grotte de l'Apothicairerie, a vast cave at the foot of a sheer cliff-face, opening among foaming seas and perilous rocks like a nineteenth-century stage set. Painters working on

the motif stayed overnight at a simple clifftop café. Matisse put his baby in the picture (Marguerite, two years old that summer, would be partially painted out later) together with the café waitress, Clotilde, in her flat-topped coiffe and streamers. For all its Flemish realism, the canvas already shows the flood of light, the bare luminous expanses, the loosening up of tone and texture evident in *The Open Door, Brittany* and the seascapes Matisse began painting that summer at Goulphar.

Matisse himself said it was Russell who introduced him to the Impressionists' theories of light and colour – in particular to the innovations of Claude Monet – and devised exercises to help him assimilate them in practice. Russell had met Monet on Belle-Ile in 1886, and owned at least one Monet seascape. His large collection also included twelve drawings made specially by van Gogh to give his old friend some idea of each of the major canvases painted in the first season at Arles. For two summers running Matisse now became Russell's pupil, sending 'wildly enthusiastic' letters to fellow art students from Belle-Ile about the primacy of colour and the need to be guided solely by feeling, principles worked out by Russell himself a decade earlier in arguments with van Gogh. Matisse even catches the authentic Australian accent of bluntness and subversion: 'We painters shouldn't be galley slaves . . . Pay no attention to anything except what interests you . . . Work with white, blue, red, paint with your feet if you want to, and if anyone doesn't like it, send him packing.'

Russell deliberately restricted his own palette to six basic colours, with a predilection in his Belle-Ile seascapes for cobalt blue combined with *garance foncé*, or deep purply crimson madder lake. At the end of the summer, Matisse was visited by a fellow student, Victor Roux-Champion, who had only ever known him as an impeccably correct Flemish painter: 'O surprise! I found him at his window, making a little study of the view along the harbour. His palette was now based on cobalt and *garance*: there was no trace left of the blended, restrained and sombre tones he had favoured up till then . . . Matisse had set out intrepidly on

the new road which so frightened me.' Matisse was working on
Port de Palais, End of the Season, which showed a stretch of sloping
roof with the quay beyond blocked off by the neighbour's wall:
a rich mix of colours with scattered crimsons and cobalts radi-
ating vigorously out from the red splodge marking the door of
the custom house in the centre of the canvas. The painting
embodied both Matisse's new red-white-and-blue formula, and
the determination that went with it to send his critics packing.
In three months on the island, Russell had set him on what
would prove a collision course with Moreau.

*Matisse photographed
in Brittany by Emile
Wéry, 1896*

The works Matisse brought back towards the end of October
1896 were dubiously received in Paris. Moreau suggested it was
time for his star pupil to put aside childish self-indulgence, and
demonstrate the genuine progress he had made in the last five
years in the traditional way with a single, large-scale show-work
or 'masterpiece'. Matisse bought a canvas considerably bigger
than anything he had tackled before and set to work. He called
his picture *The Dinner Table*, or *The Dessert* in tribute to de
Heem's *Dessert*. The painting's actual starting point was a study

made the year before, in the hotel at Pont-Croix in Brittany, of the dining table set out for a party. He or Camille re-created a corner of the table-setting (which was all there was room for in his studio), laying out borrowed cutlery and buying fruit and flowers. This was the first but not the last time Matisse spent money he could ill afford on hothouse produce so that he could paint summer in a freezing Paris winter. In order to make the costly fruit last as long as possible, he worked in overcoat and gloves in an unheated studio, while Camille took the pose of the serving girl in the masterpiece that was to have set the seal on his success at the 1897 Salon.

The Dinner Table, initially undertaken as a formal testimonial to Moreau, turned into an unofficial acknowledgement of Russell's influence. Marquet took it in his stride ('Marquet and I were the studio dropouts,' said Matisse), but the shimmering light, free-floating colours and fluid forms were too much for Bussy. Even Evenepoel was horrified: 'Everything seems to be falling apart around me: Matisse, my friend, is at this moment doing Impressionism and swears only by Claude Monet . . . One doesn't really know where one is any more!! All the painting you see, good or bad, starts dancing in front of your eyes, it's turmoil!' Everyone who saw Matisse's painting in the studio that winter must have realized that it meant the end of any hope of sales or promotion. Camille, by Matisse's own account, begged him not to throw his career away. She wept, protested, pleaded, urged him to pull himself together, to make an effort, to do as other people did and take his work more seriously, like his friends. Bussy was advancing from strength to strength that spring. Evenepoel had a London gallery in the offing, and a mixed show in Brussels scheduled for the autumn. Wéry was about to win his first medal at Bouguereau's official Salon on the strength of his prudent change of style. Intent on his new palette, and increasingly obsessed by Monet, Matisse remained unmoved. Camille was replaced as model by a wooden dummy.

Bussy did what he could by providing an introduction to another of Russell's friends, Camille Pissarro. Matisse had tears

in his eyes again at this first meeting, when Pissarro passed on
to him the encouragement he had himself received as a nervous
youth showing his own work to Corot: 'Very good, my friend,
you are gifted. Work, and don't listen to anything anyone tells
you.' The two went together to see Gustave Caillebotte's collec-
tion of Impressionist paintings, which opened at the Luxembourg
galleries to howls of derision from the art world. 'Basically they
may rage, but we are in the right,' said Pissarro. 'At least I for
my part am convinced we are.' Matisse maintained that the first
time he really saw the Impressionists was at the Caillebotte
show with Pissarro, who had known them all, worked with
most of them, and suffered greater material hardship for the
sake of his art than any of the others. There were seven Pissarros
on show, together with three small Cézannes and eight Monets
(including *Rocks on Belle-Ile*, which Matisse would attempt to
reconstruct on canvas that summer).

The visit took place within a few days of the opening of
the Salon de la Nationale on 24 April 1897, when Matisse
needed all Pissarro's stoicism to face the reaction to his own
Dinner Table. The painting was humiliatingly badly placed by an
outraged hanging committee. Matisse's father came up from
Bohain to see the show, staying in the quai St-Michel studio
where his son found him early one morning half-dressed, in
shirt-sleeves with his braces hanging down, contemplating a
row of canvases lined up against the wall. Matisse's first tentative
moves towards a more impressionistic style looked to his father
hopelessly sketchy and unfinished. At the Salon, Hippolyte Henri
stationed himself beside *The Dinner Table* to watch people stop-
ping to tell one another how bad it was. This second scandal
was a replay of the first, when Matisse had been slung out of
St-Quentin for breaking academic rules six years before. For
the rest of his life he remembered his father saying that 'people
saw germs at the bottom of my decanters'.

If attacks like these made Matisse feel like a moral typhoid
carrier, he must have looked plague-stricken to Camille well
before the Salon opened. On 10 February 1897 – the week

after a first sight of *The Dinner Table* had made Evenepoel feel
sick and giddy – Matisse signed paternity papers, legally
acknowledging Marguerite as his daughter. She was baptized
the same day, with Léon Vassaux standing godfather, without
the knowledge of her staunchly atheist father. According to
Marguerite, her baptism took place in secret at the instigation
of her Matisse grandmother, whom she dearly loved. It would
have been inconceivable in those days for even the most liberal
parent in Bohain to acknowledge a son's mistress openly, and
it was scarcely less so to accept an illegitimate grandchild as
Matisse's parents did. He himself moved out of the room he
shared with Camille that spring, keeping his studio but renting
a place to sleep at 10 rue de Seine. Their life together had
degenerated into tears and scolding on the one side, stubborn
resistance on the other. Camille could never get used to the
gap between bohemian life in fiction, or on the stage of the
Opéra-Comique, and the uncomfortable, disruptive, antisocial
ways in which artists behave in fact.

By the end of May Matisse was in plaster and on crutches
after a bicycle accident. He and Camille managed to patch up
their differences, fleeing together from a blistering heatwave
in June to spend another summer on Belle-Ile. But after *The
Dinner Table*, Camille never apparently posed for him again.
Anyone could see that the strange, bright, highly simplified
paintings Matisse produced on the island in 1897 were frankly
unsaleable. He was preoccupied with Monet, whose *Rocks on
Belle-Ile* he took apart and re-created much as he had once
tried to do with Chardin's *Pipe*, setting up his easel at the same
spot, painting the same jagged silhouette against the same shim-
mering sea-surface with the same narrow band of sky across
the top edge of the canvas. Matisse's friends were struck by the
melancholy of his Belle-Ile seascapes, together with the force
of the emotion they contained.

He painted rocks, landscapes and the lighthouse, exploring
his new palette with mounting confidence. Even the most
mundane subjects took colour. The simple Breton mill, rendered

two years before in an elegant gamut of greys, now became a conflagration of sharp cobalt and crimson, yellow and green brushstrokes flickering like flames across a white ground. The urgency of paintings like this one would reappear in the work Matisse produced under a Mediterranean sun the following spring, when for the first time he attempted to grapple with van Gogh on canvas. The Dutchman had sold a single painting before he shot himself at the age of thirty-seven in July 1890. Apart from a tiny memorial exhibition of sixteen canvases two years later, nothing had been shown or sold since then. In 1897 the shock of his death was still raw, and the story of his life harrowing for his friends. Both offered a grim warning to another penniless, pig-headed, largely self-taught young north-erner starting out without support on the same uphill path to isolation and rejection. Russell, who may or may not have possessed paintings by van Gogh, certainly talked about them to Matisse. He also gave his young visitor one of his van Gogh drawings – something he had never done for anyone before, and would never do again, which suggests that he found in no one else the depth and strength of Matisse's response.

The summer of 1897 marked a decisive break in Matisse's life as in his work. He dated the onset of his life-long insomnia to this turning point on Belle-Ile, when he embarked as a painter on a course that spelt madness to his family and friends. Evenepoel warned him that he was putting his health at risk. Camille nagged him about his inability, or refusal, to sleep at night and his corresponding failure to rise early, rested and refreshed for work, next morning. Her own nerves were increasingly on edge that summer. Herself a perfectionist, fastidious and highly critical, she had stood by Henri for five years, during which the couple would have been hard put to survive without her earnings as a shopgirl. She had posed for the painting that brought his first Salon success, seen her patience handsomely rewarded, and watched him wantonly throw overboard everything he had worked so hard to gain. All agreed that she had a sharp tongue and a fierce temper. Matisse himself said that

her character was even stronger than his own. She became shriller and more desperate as she watched their relationship fall apart that summer. She was fighting not only for her own and her child's future but for his: everyone from his teachers to his family and all his closest friends (except Marquet) foresaw disaster unless he could be brought to make some sort of compromise. Matisse said she made such perpetual scenes that in the end it became impossible to live with a neurotic. But it was Camille who finally decided she could no longer face a future of trying to make ends meet on a dwindling pittance in a garret with a small child who had to be kept quiet for the sake of an obstinate insomniac, who for almost twelve months had refused to listen to a word of reason. Her courage snapped and she walked out on him that summer. 'She always regretted having left him,' said a friend who knew her in old age, 'it had been the happiest time of her life.'

Matisse returned to Paris without her in the middle of October. The seascapes he brought back from the island caused uproar. 'Matisse in a raging storm of youth overturned the teachings of Gustave Moreau's studio far more definitively and completely than Rouault,' said Roux-Champion. Moreau, who was seventy-one and already mortally ill (he would die six months later), saw in Matisse's canvases a vision of art itself about to disintegrate and decompose. 'He let rip with bitter remonstrations – one could well use a stronger term – against the wretched students who took liberties with the brush,' wrote a sympathetic fellow pupil, Jules Flandrin, on 19 November. 'The first to suffer was Matisse, who brought back an enormous holiday canvas impregnated with the country and fresh air . . .' Matisse said that this latest onslaught was the culmination of twelve months at odds with Moreau, who had nothing more to teach him.

It was an irony not lost on Matisse that just as he himself began at last to turn to colour, Evenepoel was moving in the opposite direction: 'He had a great talent. Evenepoel's paintings were fresh, full of life and colour . . . I admired them very much.

Then he changed. He began painting in greys.' For Evenepoel
this new sobriety represented the victory of French refinement
and restraint over the native sense of colour that both he and
Moreau associated with coarse materialism. Matisse, who was
both French and Flemish, would combine the two traditions,
bringing a lover's passionate feel for colour to the profoundly
contemplative classicism central to French painting from Poussin
to Cézanne. For him the influence of Russell, Monet and
Pissarro was crucial but short-lived. They taught him a way of
seeing: the first inklings of the pursuit of colour for its own
sake that would draw on his deepest emotional and imaginative
resources. Impressionism came to seem too slack, too formless,
too dependent on superficial accidents of time and place to
satisfy his needs for long, but there was no turning back from
the door that had opened for him on Belle-Ile.

3. The Revelation of the South (1898–1902)

Matisse left Belle-Ile for the last time to be best man at the marriage of an old school friend on 16 October 1897, bringing with him as a wedding present a *Still Life with Apples*. He gave his next still life that autumn to the girl who had been the bride's maid of honour, with the inscription: 'To Mlle Amélie Parayre, 1897.' The couple were placed next to one another at the marriage feast, which was a lavish and lively affair with wine flowing freely and the guests competing to see who could catch and stow most bottles at his place beneath the table. By the end of the party Matisse had beaten all the rest. He never forgot the characteristically incisive gesture with which his neighbour stretched out her hand to him as she rose to go. He took the hand she offered, and whenever they met over the next few weeks, he presented Mlle Parayre with a bunch of violets.

For her part, she said long afterwards that she had sworn never to marry a redhead, or a man with a beard, let alone a painter, but that from the day they met she knew that she would break her vow in favour of Henri Matisse, who was all three. She pressed and mounted his violets. It was Matisse's boldness that attracted her, the glint of devilry that overcame him all his life at moments when the lure of risk and danger compelled him to stake everything, both personally and professionally, on an uncertain future. She said that this first encounter hit her like a bolt from the blue. Each recognized and responded to the other at the deepest level. Matisse was more isolated that autumn than he had ever been, infected by doubt and too continually uneasy to stand his own company for long. Beneath his tough exterior, he desperately needed someone to believe in him and – perhaps more important – in what he was doing. 'Mademoiselle, I love you dearly,' he declared, determined to

avoid misunderstanding from the start, 'but I shall always love painting more.'

Nothing could have been better calculated to fire Amélie Parayre, who had spent much of her life searching for a cause in which to put her faith. She was twenty-five years old, impulsive, proud and direct. Born in Toulouse in south-western France, she had the dignity and dark good looks native to the women of her region, together with a capacity for loyalty passed on by her formidable mother, Catherine Parayre. Amélie and her younger sister, Berthe, had both inherited their mother's erect carriage, her firmly chiselled features and, even as girls, something of her regal presence. 'All the women in that family looked like Spanish queens.' Matisse said he found Mlle Parayre absolutely ravishing. He was touched by the combination of shyness and stateliness in her bearing, and by 'the mass of black hair which she put up in a charming style, especially at the nape of the neck. She had lovely breasts and very beautiful shoulders. She gave the impression, in spite of the fact that she was timid and reserved, of being a person of great goodness, power and sweetness.'

Amélie Parayre at the time of her marriage to Henri Matisse, 1898

The Parayres were an eloquent, witty and tempestuous clan who had migrated from Toulouse in a body to seek their fortunes in Paris when Amélie was a small child. Her father had been a schoolmaster in the village of Beauzelle, on the river Garonne just outside Toulouse, where she was born in 1872. She inherited from him her frankness and fearlessness together with her instinctive faith in radical innovation. Armand Parayre was a protégé of the Republican deputy for Haute-Garonne, Gustave Humbert, a law professor at Toulouse University already increasingly involved in national politics. Humbert spent the holidays with his family in Beauzelle, where the young schoolmaster became his trusted disciple and Latin tutor to his son, Frédéric. In the summers immediately before and after Amélie's birth, her father and the ambitious local deputy met night after night in the Humberts' house beside the church to plot tactics for a political new dawn. These were heroic times for the rising Republican party, which fought titanic battles in the 1870s against monarchists, Bonapartists, congregationalists and reactionaries of every stripe. Gustave Humbert was made a senator, or lifelong member of the parliamentary upper house, under the constitution of the new Third Republic in 1875, going on to hold the country's highest legal offices, eventually becoming Keeper of the Seals, or Minister of Justice, in 1882. Parayre threw up his job at this point to become a full-time Humbert aide. The new Justice Minister's principal private secretary was his son, Frédéric, himself a prospective socialist deputy who took over a radical campaigning newspaper, *L'Avenir de Seine et Marne*, and installed Parayre as editor. The paper was based in Frédéric's constituency of Melun, where Amélie went to boarding school, and where for more than a decade her father was in his element as a crusading left-wing journalist.

From childhood on, Amélie Parayre grew up surrounded by freedom fighters vowed to the cause of liberty, democracy and progress. A keen reader of boys' adventure stories and romantic novels, she flourished in an atmosphere of constant

drama, lofty purpose and decisive action. Her sister Berthe, the younger and more studious of the two girls, chose to train as a teacher like her father. Amélie, always the wild and reckless tearaway, defied her schoolteachers in a series of confrontations over discipline that ended with her walking out for good at the age of sixteen in 1888. The fate she dreaded above all was to be shut up for life within the stifling confines of a conventional bourgeois marriage.

She went home to her parents, whose marriage was a partnership of equals. If Amélie's father was Frédéric Humbert's chief confidant and ally, her mother fulfilled the same function for Frédéric's wife, Thérèse, a remarkable character now approaching the high point of a sensational career. Thérèse Humbert was famous for being heir to one of the greatest fortunes in France. She was also one of the most astute, extravagant and manipulative figures of the Third Republic, keeping considerable state in Paris, attended by a retinue of cabinet ministers, bankers and businessmen. The President of the Republic, Félix Faure, was a regular guest at her table. So were his two predecessors, at least five prime ministers and the greater part of France's diplomatic, social and legal upper crust. The powerful prefect of the Paris police, Louis Lépine, and the leader of the Paris bar, Henri du Buit, were Mme Humbert's personal friends. From the late 1880s onwards, her goodwill was critical to 'anyone seeking a place in the Republican sun', and the only access to her favours lay through her trusty second-in-command, Mme Parayre.

Amélie's mother presided over the gilded marble halls of the palatial Humbert mansion at 65 avenue de la Grande Armée with a staff of twenty under her, and an annual budget said to amount to 200,000 francs. Many of Amélie's uncles and cousins held key posts at the Humbert court. All belonged to the band of eager youths who had sat at the feet of 'good old Papa Humbert' in Toulouse, and gone on to become his daughter-in-law's picked men. All prospered until a brief resurgence of right-wing sentiment brought a temporary slump in

Humbert fortunes. When *L'Avenir* folded in 1894, Parayre found himself unemployed with two marriageable daughters, aged twenty-two and eighteen, and no savings to fall back on. Berthe took a job as a schoolteacher in 1895 in a village near Toulouse. Amélie went to work for her Aunt Nine Bouticq, who ran a high-class hat-shop on the boulevard St-Denis. When the Humberts returned to power a few years later, they reinstated Parayre as general factotum and director of their new savings bank, the Rente Viagère. In 1898, the year after this sudden change of fortune, Berthe Parayre gave up her job as a village schoolmistress to enter the prestigious Ecole Normale Supérieure at Fontenay-les-Roses. Amélie married Henri Matisse.

The wedding took place on 10 January 1898, less than three months after the couple had first met. Henri marked the day in his pocket diary: '*Vive la Liberté!*' Amélie was married from the Humbert house on the avenue de la Grande Armée, itself an extension of the Champs-Elysées. Her wedding present was a bag of jewels, her outfit came from Madame Humbert's own dressmaker, Maison Worth, and the ceremony took place in the Humberts' parish church, the ultra-fashionable St-Honoré-d'Eylau. Matisse's new in-laws moved in circles quite unlike anything he or his painter friends had known before. His prosperous uncle Gérard and his cousin Saulnier were witnesses at the wedding. Nothing could have gone down better in Bohain or Le Cateau.

A week later, the couple left Paris for London. The new Mme Matisse began as she meant to go on, keeping faith with a family of visionaries who had passed on to her their belief in a glorious future to be achieved by hard work, dedication and self-sacrifice. Painting had played no part in her life up to this point, but Matisse's view of his vocation supplied the austere purpose she had craved from girlhood. 'I didn't know much about what he was doing,' she said, 'but I knew that whatever he did would be good.' She picked London as a honeymoon destination so that her husband could inspect the

contents of the National Gallery, in particular the paintings of
J. M.W. Turner, revered as a forerunner by both Russell and
Pissarro. The galleries turned out to be so dimly lit that some-
times Matisse could barely make out the Turners he had come
to see, but even, or perhaps especially in this wintry light, they
gave him precisely what he needed at this liberating moment.
'Turner lived in a cellar,' Matisse said, looking back on the first
stage of his honeymoon: 'Once a week he had the shutters
suddenly flung open, and then what incandescence! what
dazzlement! what jewels!' After a fortnight the couple returned
briefly to Paris before catching the train again to Amélie's
native south, where Matisse painted the Mediterranean spring
as van Gogh had done before him, launched at last on a course
the Dutchman himself had foreseen ten years before, when he
declared his belief that a new school of colourists would arise
in the south: 'The painter of the future will be such a colourist
as has never yet been seen.'

They sailed from Marseille to Corsica on 8 February, landing
at Ajaccio next morning in brilliant sunshine. Matisse said it
was there that he first encountered the marvel of the south,
and that he owed its discovery to his wife. The five months
he spent in Corsica came to seem to him in retrospect another
of the pivotal points on which his whole life turned. He found
himself jolted out of ways not only of seeing but also of
thinking and feeling that had been second nature until now.
He was permanently affected by the clear southern light, so
different from the cloudy, vaporous atmosphere that had condi-
tioned him as a painter in Bohain, Paris and Brittany. He liked
Corsica, and especially its people, whose frank and generous
hospitality made him feel at home. In his subsequent accounts,
everything about that rapturous, revelatory spring is suffused
by a sense of freedom and well-being. He and Amélie estab-
lished in Ajaccio a basic pattern that would barely change
throughout their lives together: a routine of work, rest, walks
and modelling sessions into which she fitted the day-to-day
practical running of her household whenever she had time or

energy to spare. This was for both a period of conscious preparation. Both spoke of it afterwards with a high, almost Napoleonic sense of destiny.

They found two rented rooms in a villa just below Napoleon's Grotto, a rocky cave on the western outskirts of Ajaccio where the future emperor was said to have brooded as a boy on his own destiny. The Matisses' tiny attic rooms gave access by a tower stairway to a flat roof above the bay. Here Henri set up his easel to paint the nearest building (which was the local hospital) rather than the picturesque prospect looking westwards along the coast. The Villa de la Rocca combined convenience with privacy and peace, essential factors in the pattern the Matisses would re-create with minor variations wherever they went afterwards. Theirs was the last house in town, built on newly cleared scrubland, or *maquis*: the dense, prickly, aromatic mat of flowering arbutus, myrtle, broom, lavender, rosemary and rockroses that covered the island. Matisse had brought with him two wooden crates packed with small-to medium-sized blank canvases and, in just over five months in Ajaccio, he produced fifty-five paintings, all done in or within easy walking distance of his lodgings.

He painted the bedroom with his jacket hanging from the bedpost, his hat tossed down on the narrow wooden bedstead and a single canvas propped against the bare wall to underline his stern devotion to his purpose. He painted still lifes in the little kitchen, where the pots and pans started to decompose and discolour exactly as Moreau had predicted. He painted a delicate, impetuous, pink and green *Peach Tree in Bloom*, and a single sunset, a burst of explosive lemon yellow on a pink-streaked green sky that owes something to van Gogh and still more to Turner. But the approach is the opposite of the cool analytical enquiry in his Louvre studies. This is the work of a man emerging from a cellar, a man in the grip of the kind of urgent, instinctive, almost animal uprush of feeling Matisse described when he first held his mother's paint-box in his hands. He painted light, warmth, colour itself rather than the scenic

splendour of the island. 'Soon there came to me, like a revela-
tion, the love of materials for their own sake,' he said, describing
this year of liberty that was his wife's gift to him: 'I felt growing
within me a passion for colour.'

The passion can be seen growing in the three paintings he
made of Amélie in the first year of their marriage, beginning
with a back view and gradually turning her to face him as his
style became looser, less representational and more impression-
istic. She posed for him for the first time in a heliotrope-coloured
dress with her hair pinned up, in the way he found so charming,
by a big blond tortoiseshell comb. In this most conventional of
the three canvases, she sits reading with her back turned and a
still life laid out on a table to her left, in much the same
arrangement as Camille had presided over two years earlier. In
the next canvas she is seated sideways, sewing in profile at the
kitchen table of the Villa de la Rocca: the dabs of pale blue
and reddish pink which indicate her apron, or the sewing in
her lap, intermingle in an unruly patchwork of brushstrokes
with the pinky reds, yellows and blues on the tabletop. Matisse
painted her for the third time in *The Invalid*, which was
completed in January 1899, after the couple had left the island
for Toulouse. Here Amélie lies in bed, reclining full face on her
pillows, unrecognizable and off-centre, but unmistakably the
focal point in a composition of glowing, semi-liberated colours
enveloping both the figure in the bed and the room itself, with
its draperies and hangings, its padded orange chair, the bright
shadows on the white cloth covering the bedside table, and the
tangle of pink, deep blue, orange, yellow and green brushstrokes
that might be a workbox or a rug at the right on the bottom
of the canvas.

Matisse painted the hospital just below his rooftop terrace
five times, returning again and again to its red-tiled roof and
its long whitewashed garden wall, which turned pink, blue and
violet on his canvas. But he found his favourite motifs in the
garden of the old mill, a few minutes' walk from the Villa de
la Rocca across the *maquis* to the south-west. The mill was a

traditional horse-driven stone olive press, standing in a walled courtyard on a little knoll. The garden, open to all comers, contained groves of orange and mandarin, flowering orchards of peach, nectarine and almond, palm trees and shady alleys of ancient olives as well as formal flower-beds. The Matisses spent many hours each day in this garden, establishing what became another regular pattern whereby he worked while she watched, sewed or meditated at his side. Matisse explained to the collector Pierre Lévy, more than forty years later, that the chromatic explosion which transformed his work in 1905 originated in Corsica, in the view looking westwards from his lodgings towards the Iles Sanguinaires (so called because the setting sun stained their granite peaks blood red). 'It was there that he felt the first shock of what would become Fauvism, he told me so himself.'

The shock erupted not in paintings of sunlit peaks or glittering blue sea, but rather in a dozen or more studies of the gnarled, grey olive trees growing near the old mill. Round about this time, Matisse read Guy de Maupassant's preface to his novel *Pierre et Jean*, which explores the concept of originality, and the artist's need to work solely from his own observation 'without bias, without preconceived opinions, without academic ideas, with no allegiance whatsoever to any artistic group'. Ten years later Matisse would develop the same thesis, sometimes in almost the same words, in his own 'Notes of a Painter'. At the time he became obsessed with passages like this one about fire and trees:

What you have to do is look at what you wish to express long enough and with enough attention to discover an aspect of it that has never been seen or described by anyone before. There is something unexplored in everything, because we have grown used to letting our eyes be conditioned by the memory of what others have thought before us about whatever we are looking at . . . To describe a blazing fire and a tree on a plain, we must stay put in front of that fire and that tree until for us they no longer resemble any other

tree or any other fire. That is the way in which you will become original.

The motif to which Matisse returned more often than to any other was a single olive tree, or group of trees, which caught fire in a blaze of colour on his canvas, becoming sometimes almost incandescent beneath his prodding, probing brushstrokes. This was the battle he began to fight alone and in seclusion on the island, the heroic battle Turner and van Gogh had fought before him, the struggle to rid himself of even the memory of other people's ways of looking.

In the spring of 1898, and for many years to come, Matisse's Corsican paintings were too disturbing to be shown to his contemporaries except in private. Evenepoel said they looked as if they had been done through gritted teeth. Matisse had posted him in May a package of four rolled-up canvases, including what sounds like an early draft for *The Invalid*. It took Evenepoel a week to recover from the shock of opening the parcel ('all I can see is the tablecloth with emerald green reflections, and a human figure green one side, and red the other, as if lit up by the glass bottles in a chemist's window!!'), and pull himself together sufficiently to be able to write calmly to his friend. But like many others after him, he found himself grudgingly forced to admit that Matisse's painting somehow managed to kill everything else in the vicinity stone-dead. 'My bits of stuff, my ornaments, everything became grey, grey and neutral beside it! Your study struck the deep notes, sonorous and brilliant, of a resplendent stained-glass window!!'

Matisse, who was missing his friends as much as they missed him, responded to this letter by taking the train himself to Paris with a further batch of Corsican paintings. He had left the capital without telling anyone about his precipitate courtship and marriage. Neither Marquet nor Evenepoel had yet met the new Mme Matisse. Henri needed to drum up funds in Paris but, more even than money, he needed reassurance. He said that after a few months he began to feel bored and lost in

Corsica. He would report the same reaction on first reaching Morocco in 1911, Nice in 1917 and Tahiti in 1930. On each occasion a realignment taking place far below the conscious surface of his mind filled him with unease and foreboding. In Ajaccio in 1898, Matisse sent advance warnings about these latest canvases to Evenepoel, to whom, sure enough, they looked like the work of 'a mad and epileptic Impressionist'. He felt that Matisse's career was over before it had properly begun ('It's crazy, he had such charming qualities as a painter!!'). Others were less pessimistic. Matisse gave two of his boldest studies of olive trees to Marquet, a third to Jules Flandrin and a couple more to Léon Vassaux, who hung one of them – *The Courtyard of the Old Mill* – over his bed so he would see it first thing each morning when he opened his eyes. The other was a pathway lined with olive trees which Vassaux kept to the end of his life, confessing as an old man to Matisse that he could never find the courage to part with it.

Matisse himself was reluctantly seduced in a shop on the rue de Rivoli that June by a pressed butterfly with wings as blue as the sulphur flame that had lit up his toy theatre in Bohain. He gave a comical account of how his iron determination not to waste his money on anything so futile was undermined by this butterfly ('blue, but such a blue! It pierced my heart') for which he paid fifty francs, or half his whole month's allowance, salving his conscience by including it among the presents he brought back from Paris for his wife. This was precisely the kind of recklessness Amélie could never resist in her husband. The two had made a romantic pre-nuptial compact that, like a knight preparing for battle or a sportsman before a key fixture, Henri should not dissipate his energy in these first momentous months dedicated to a new life and a new art by sleeping with his wife. But in spite of their best efforts, Amélie was four months pregnant by the time the Matisses left Corsica in July.

They spent the next six months visiting her relations in and around the village of Beauzelle in the Roussillon where she

was born. Matisse swam (and once very nearly drowned) in the
clear waters of the river Garonne, threaded with whirlpools,
running over treacherous, shifting gravel banks and collecting
in *les Gourgues*, great fishy pools shaded by majestic screens of
poplar planted along the banks. He made bold, rapid, sometimes
almost abstract colour sketches of *les Gourgues* that summer,
rhyming the poplars with their watery reflections in confident
homage to Monet. His dialogue with van Gogh continued in
paintings of the landscape round Toulouse, and in terse, calli-
graphic drawings of his wife.

The name of Parayre carried great weight in these parts
on account of the family connection with the Humberts. The
tomb of Senator Humbert (who had died in 1894) dominated
the churchyard in Beauzelle and the whole region was mesmer-
ized by his daughter-in-law, Mme Humbert, whom the
villagers remembered as a simple local girl long before her
spectacular transformation into a power in the land. *La Grande
Thérèse*, born Thérèse Daurignac in nearby Aussonne, had
galvanized the peasants from her earliest years with strange
stories and wild escapades. Even as a child she could wind
anyone round her little finger. One of the first to fall under
her spell was Amélie's mother, who formed a lifelong bond
with Thérèse years before she married the schoolmaster at
Beauzelle. Amélie herself was six years old when the village
was turned upside down for the wedding of her father's ex-pupil,
Frédéric Humbert, to her mother's best friend, Thérèse
Daurignac. Beauzelle had never seen anything like this
wedding, with its carriage procession, triumphal arches,
fireworks, gun-salutes and peasants streaming in from miles
around to join the dancing.

Afterwards the young Humberts, shortly followed by the young
Parayres, moved to Paris, where Thérèse became the central figure
in one of the most bizarre lawsuits of the nineteenth century.
Almost infinitely complex legal arguments dragged on for two
decades in appeal and counter-appeal through virtually every
court in France. The case turned on a fortune of a hundred

million francs in bearer bonds, left to the young Thérèse by an American millionaire called Robert Henry Crawford in a will contested by his two nephews. The colossal stake at issue meant that each fresh court hearing was followed in the press like the latest instalment in a nationwide soap opera. What inflamed the public imagination most was the strongbox containing the disputed Crawford bonds, which was kept in a locked room on the third floor at 65 avenue de la Grande Armée. Access was through Amélie's mother, a notorious dragon to the suppli-cants and social climbers who besieged the Humberts' door. But in private, with people whom she trusted, Catherine Parayre was warm and profoundly unconventional. She made intuitive judgements, like her daughter, and stuck to them whatever the consequences. When they were both young, she had given her unconditional allegiance to Thérèse, and in the course of their subsequent, often stormy life together, it never occurred to her to take it back.

Henri Matisse found in Mme Parayre the courage and constancy he prized in Amélie. Few mothers would have welcomed a son-in-law with no means of providing for a wife, no immediate prospect of earning even his own living, and no apparent future in his chosen profession, but both Parayres cordially endorsed Amélie's choice. Matisse loved his parents-in-law and never forgot that they had accepted from the start a situation his own family found hard to stomach. Armand Parayre was as expansive and impetuous as his wife was steady and inscrutable. Dauntless and choleric, full of wild enthusiasms checked by an ironic sense of humour and a flashing wit, he had brought up his daughters to believe in the power of the mind and the imagination, and to make light of material hardship. The whole family were used to great expectations with no security in either the present or the future. They lived like everyone else at 65 avenue de la Grande Armée in confident anticipation of the day when the Crawford case would finally be resolved in Mme Humbert's favour. But during the waiting period, funds ran low and confidence grew

shaky. The magnificent Humbert façade was more make-believe than real, a front put up and maintained by Thérèse's indomitable will. She could not have kept it going without the courage and resourcefulness of the Parayres, who had committed Armand's small family inheritance to the Humbert cause, and who drew no salary themselves for twenty years. Money played no real part in their calculations. A successful outcome to the lawsuit would mean a victory for truth and justice, the defeat of Madame's enemies, an opportunity to forward the greater cause of progress and democracy.

The open, tolerant, forward-looking spirit Matisse encountered in his father-in-law was part of the atmospheric change he found so congenial in the south after the extreme conservatism of his native region, where artists ranked as social misfits along with Freemasons, Protestants, Jews and outsiders of all sorts. In the summer of 1898 he read three fighting articles published in *La Revue Blanche* by Paul Signac, a practising anarchist who saw the liberation of painting as part of the liberation of mankind itself. Signac's argument was forceful, his style simple, clear and unpretentious. He believed passionately in the basic colour theory of Neo-Impressionism, or Divisionism, which meant applying pure colours, each divided from but harmonizing with its complementary colour, to the canvas in separate dots or dabs of paint, unsullied by white, and mixed only on the retina of the observer's eye. Signac claimed to obtain a new brilliance and sumptuosity by the application of simple scientific rules. His presiding hero, the father of pure colour, in Signac's book the first and greatest of all Neo-Impressionists, was Delacroix, who looked back to Turner and forward to the colourists of the future: 'He urges them to dare all, to have no fear that their harmonies could ever be too full of colour.'

This manifesto could hardly have been more timely for Matisse, who needed a way of bringing his lucid, orderly intelligence to bear on the disorderly impulses of his imagination. He set about exploring the possibilities of Neo-Impressionism

as vigorously as he had once tackled Impressionism itself in *The Dinner Table*, using the same vehicle of still life. He laid out classical compositions of his trusty standbys: glasses, bottles, a carafe, a knife and plate, cup, coffeepot and fruit stand, replacing the usual apples with oranges, which he first saw growing in Ajaccio. 'The fact is that orange is a special colour. It evokes light and reflected light with a unique directness,' wrote Lawrence Gowing of these Toulouse still lifes. 'Matisse made it his special property just as Turner took possession of yellow; oranges, which had been rare in painting before, became his chosen subject.' All through the autumn and winter of 1898–9, Matisse worked out his response to this first encounter with the south in a set of variations on a theme of Delacroix, quoted by Baudelaire and reaffirmed by Signac: 'Everyone knows that yellow, orange and red inspire and represent ideas of joy, of riches, of glory and of love.'

The Matisses moved to Toulouse that autumn to await the birth of their first child in the house of Amélie's grandparents. Jean Gérard Matisse was born on 10 January 1899, twelve months almost to the day after his parents' marriage. His birth marked an end as well as a beginning, for now that he had a family to support, Matisse recognized that his time was up. The year in the south, which had saved him as a painter, ran out in January 1899. 'The period of studying was over,' he said, looking back. 'It was time to earn a living.' In February or March, he and Amélie left their baby with a wet nurse in Toulouse to travel north in search of work. The studio on the quai St-Michel was let in order to bump up their meagre income. In the grey light and frigid temperatures of a Paris winter, Henri embarked on what would become over the next months and years an increasingly disheartening round of job-hunting, visits to dealers, and unsuccessful attempts to interest buyers in his work. There was something far from reassuring about Matisse at this stage, in his shabby corduroys with his southern suntan, his roll of crazy paintings under his arm, and his abrasive manner. No one liked the canvases he showed at the Salon de la Nationale in

May. He sold nothing and found no work. On 16 May he put his name down at the Louvre for permission to copy works by Claude Lorrain and Luca Signorelli, complaining bitterly that the state purchasing committee only ever bought faithful copies made by the mothers, wives or daughters of the museum attendants, and that, hard though he tried, it was beyond him to run off the sort of copies that provided them with a nice little income on the side.

His head was still full of his attempts to absorb the impact of Turner and van Gogh, and to come to grips with Divisionism. He was less interested in the Louvre than in Ambroise Vollard's tiny new gallery, where everything seemed provisional, with little or nothing on show except a few canvases turned to face the wall, as if the owner were permanently in the middle of a move. Matisse tried and failed that spring to persuade his brother to buy van Gogh's *L'Arlésienne* from Vollard (Auguste Matisse spent his savings on a chainless bicycle instead). By the time he nerved himself to go back for the painting on his own account, the price had risen from 150 to 500 francs. Vollard explained that art was a buyer's market controlled by purses larger than anything dreamed of by a poor art student. Matisse returned a third time in May to buy van Gogh's *Les Alyscamps*, but before Vollard could even fetch out the canvas, he had lost his heart to another, smaller work that made the van Gogh look tame. The painting was Cézanne's *Three Bathers*, and it was as much as Matisse could do to resist buying it on the spot.

At this point a telegram arrived from Toulouse, where his five-month-old son Jean was gravely ill with enteritis. He returned at once with Amélie, remaining in the south for a month and a half until the child was out of danger. Staying with his in-laws and brooding on the hopelessness of his position in Paris, Matisse watched the local boys swimming in the river Garonne and thought of the bathers in Cézanne's painting, with its yellow fall of sunlight and the blue and green volumes of its riverbank. 'Cézanne used blue to make his yellow tell but he used it with a discrimination, in this case as in all

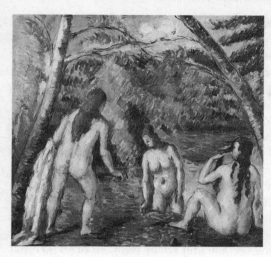

*Paul Cézanne, '*Three Bathers*', c. 1879–82*

others, that no one else has shown,' Matisse told his students in 1908, by which time he had lived for nine years with the *Three Bathers*.

His resistance to the painting's strong and sober beauty failed him as he walked beside the Garonne, and he wrote to ask Marquet to make an immediate offer on his behalf. Haggling with Vollard went on for months until Matisse finally secured the painting (with a plaster portrait bust by Rodin thrown in) for 1,600 francs, or nearly half as much again as his annual income. The clinching factor in this purchase was his wife. Amélie knew nothing about Cézanne, but she had understood the affair of the blue butterfly the year before, and she was not a Parayre for nothing. The plan was to raise the down payment on the *Three Bathers* by pawning a magnificent emerald ring which had been a Humbert wedding present, and was now one of Amélie's prize possessions. She never forgot the pang it cost her when her husband eventually returned to the pawnshop to redeem the ring only to find that his pawn ticket was out-of-date. She loved jewels, and she mourned the loss of this one all her life.

But although it took many years before Amélie too came to love her husband's painting by Cézanne, she understood in her bones the importance of this kind of sacrifice. Over the next three decades their small Cézanne canvas would exert a powerful pull over all the Matisses, representing to the parents an act of blind faith in the future, symbolizing to the children everything they had been brought up to believe in, sustaining the whole family with a mysterious life of its own. 'In the thirty-seven years I have owned this painting, I have come to know it fairly well, though I hope not entirely,' Matisse wrote when he finally presented the *Three Bathers* at his wife's suggestion to the city of Paris in 1937. 'It has supported me morally at critical moments in my venture as an artist; I have drawn from it my faith and my perseverance.'

In 1899 there remained the immediate problem of an income. Henri's solution, whenever the family's finances touched rock bottom, was to suggest giving up painting for some more lucrative activity. Amélie countered with a plan to support the family herself. She proposed to start a hat-shop, always an obvious remedy for a Parayre in trouble. Business expertise, advice and contacts would come from her Aunt Nine at the hat-shop on the boulevard St-Denis, start-up capital (or at any rate credit and clients) from her Humbert connections. Returning with Henry and the baby to Paris at the end of June, she found premises at 25 rue de Châteaudun, near the Opéra and the banks, at the heart of Humbert territory in the commercial hinterland of an affluent society with new money to spend and new tastes to gratify. The next turning but one along from Amélie's luxury boutique was the rue Lafitte, lined with dealers in art and antiques. Clients wanting paintings had wives who needed hats. Prospects looked hopeful for anyone starting out with the goodwill of Mme Humbert, whose hats turned heads wherever she went in a new creation of fruit, flowers or peacock feathers, and who had accounts with all the most exclusive modistes of the day. Matisse, who still had his work space at 19 quai St-Michel, moved with his family into a couple of servants'

rooms on the top floor of 25 rue de Châteaudun. The scheme was for the sale of hats to keep the family going and buy Henri time to paint, while he waited for collectors to find their way to him as they were beginning to do at last to the Impressionists. He put his name in the business directory, or *Bottin*, under 'Artists', launching himself as a professional painter in a style that reflected the world of his in-laws rather than the hand-to-mouth way he had lived up till now.

Matisse's relations were still by no means easy with his parents, or with his daughter, who was four years old when he returned to Paris in the summer of 1899. Marguerite had been left in the care of her mother, with weekly visits from her father whenever he was in town. Lodgings or a job would have been hard, if not impossible, for an unmarried mother to find except by concealing the existence of her child, or handing it over to be fostered. Marguerite remembered this as a time of misery, fear and frantic attempts to get back to her old life as it had been before her parents separated. Her years alone with her mother left vivid memories of tears and slaps. She never forgot a visit to 19 quai St-Michel which ended with her pulling away from her mother's hand to dart back across the road to her father, and being knocked down by a hansom cab. She described her father coming to see her in hospital and giving her his cane when the time came to leave because, as he said, 'You know I never go anywhere without my cane.'

Matisse said long afterwards that his unwanted or neglected canvases inspired in him a special tenderness, 'like you feel for a child when it is unhappy'. Marguerite was always on his mind. One of the things he warned his future wife about when they first met was that he wasn't free to marry because he already had a daughter. 'That's not a problem,' replied Amélie, as unconventional as her mother. By the time she finally achieved a home of her own above the shop in the autumn of 1899, her son Jean was nine months old, and she herself was pregnant for the second time. Matisse had resumed regular visits to his daughter, but the child's unhappiness, her mother's

resentment and his own divided loyalties made for constant strain between the two households. A working girl without a protector could neither pass as a married woman nor continue for long to hide the fact that she had a child. When tension stretched to breaking point, it was once again Amélie who took decisive action, announcing that Marguerite needed a family and offering to take her as a daughter. Matisse, who acted as go-between for the two women, said that his wife's offer was a source of bitter grief to Camille, although she knew she had no choice but to accept.

If losing her child was the price of a new life for Camille, Amélie, too, now put herself beyond the social pale by openly defying one of society's strictest taboos. Asked why she did it by Gertrude Stein long afterwards, Mme Matisse politely fobbed her off by saying she had read a romantic novel about a heroine sacrificing her own reputation to bring up her husband's illegitimate child. But if the Parayres had a history of striking heroic poses in noble causes, they also had a habit of making their dramatic gestures work. Amélie Matisse meant what she said when she offered to be a mother to Marguerite, and the child responded with passionate intensity. Over the next twenty years and more, Marguerite grew to be a linchpin holding the whole family together: essential to her father's well-being, looked up to by her young half-brothers and profoundly attached to her adoptive mother. Amélie and Marguerite became and remained for the rest of their lives closer than most mothers and daughters, bound together by mutual affection and reliance in a relationship grounded in their commitment to Matisse's work. The two of them became his first critics, the audience to whom he showed everything he did and whose approval he could not do without.

After his marriage Matisse looked to his family rather than his friends for primary support. Bussy was increasingly absorbed in his own affairs by this time. Evenepoel, who had made a hit with a one-man show in Brussels, was planning to marry his girlfriend and settle in Belgium when he died suddenly of

typhoid fever on 27 December 1899. Matisse received the news with incredulity. 'I climbed the stairs at 19 quai St-Michel ... with the telegram in my hand, stopping every other minute, repeating in stupefaction, "Evenepoel is dead!"' He had lost his closest friend, who was also the last link with his youth as a Flemish painter. It was eight years since he had left home with Louis van Cutsem and Jules Petit (who had also died, after a short life of effort and disappointment, a few months before Evenepoel). Matisse's thirtieth birthday on New Year's Eve marked the start of a new century, and he seemed to himself to have got nowhere.

Even his attempts to find a teacher prepared to take him on came to nothing ('I was turned away from everywhere,' he said, having tried three different drawing classes). When he eventually enrolled at Camillo's Academy in Montparnasse, his fellow students all recalled the impression he gave of banked, smouldering, sometimes barely contained fires. 'You were the Genie of the Lamp who releases sometimes demons, sometimes dancing girls,' Jean Puy wrote to Matisse forty years on. At the time, it was more often demons than dancing girls that rose up to haunt Matisse: demons of rejection, isolation, financial desperation, worst of all the blind demons of custom and familiarity that fought him inch by inch in the long struggle to break through to fresh ways of seeing. He was by far the oldest and most forceful member of Camillo's small school on the rue de Rennes. It provided him with a live model and, once or twice a week when funds permitted, correction sessions with Eugène Carrière, ranked by contemporaries alongside van Gogh and Seurat as one of the major prophets of the new age. Carrière believed passionately in a free and equal future for humanity. His paintings were veiled, reticent, opaque, reserving their disclosures beneath a sheen of swirling, silken brushstrokes in toneless browns and greys from which colour had been virtually eliminated.

They could hardly have been more different from the studies of nude models that preoccupied Matisse. These were unlike

anything he had done before, and their impact was literally
stunning to timid, conventionally trained young painters like
Puy. An English boy called Vernon Blake remembered Matisse
erupting like a stone flung into Carrière's peaceful little class
in 1900. The master was as taken aback as his pupils by the way
the new arrival could transform an elderly, stooped, slack-bellied
model into a bloody-minded troublemaker, an 'astonishing
medley of immense feet, and generally distorted representation
of the pose in strong and . . . sombre strife of purple and carmine
flesh-tones set off by viridian greens'. All his companions remem-
bered ever afterwards the ferocity of Matisse's attack, his harsh
but miraculously harmonious colours, the slashing brushstrokes
that never compromised the solidity and balance of his compo-
sition. Another of Carrière's students, Maurice Boudot-Lamotte,
put these nude studies – 'blazing with pure colour and coor-
dinated by great strokes of ultramarine, the work of a superb
colourist' – among the best paintings Matisse ever made.

He became once again the centre of a band of younger
painters as he had been a decade earlier in St-Quentin. He
brought out his violin, sang anti-clerical north-country songs,
told scurrilous stories about everything and everyone the others
had been taught to hold dear. He startled them both by his
daring as a painter and by his reliance on old-fashioned devices
like the black glass (traditionally used for testing balance in a
composition), tape measure, chalk stick and his faithful plumb
line. Matisse was never more rigorously scientific than in these
months when, confronted daily at home by the essentially
architectural power of Cézanne's *Three Bathers*, he struggled to
penetrate for himself the secrets of light and mass.

Of all his companions in Carrière's class, the one who in
the end owed and gave most to Matisse was André Derain, a
big, broad-shouldered boy who kept to himself and seldom
spoke. 'Derain was eighteen when I met him,' said Matisse. 'I
was already over thirty . . . I realized that Derain . . . didn't work
like the others. He interested me. Little by little we began to
talk.' Their dialogue was conducted on canvas as much as by

word of mouth. From the first, each responded to an answering boldness in the other. The Louvre, which had been their training ground, now became an experimental laboratory. 'Already he painted magnificently,' said Matisse. 'We got to know one another at the Louvre, where his copies appalled both the attendants and the museum visitors. My Derain couldn't have cared less . . .' Derain was equally impressed by Matisse's ruthlessness. He finally completed his majestic copy of Chardin's *The Skate* ('Cézanne was behind it,' said Matisse), transposed Philippe de Champaigne's *Dead Christ* in the style of Manet, and started on a strange black-and-white inversion of Delacroix's *The Abduction of Rebecca* 'in which the values were reversed as in a photographic negative'.

Outside class he went about with Marquet and a new friend, Charles Camoin, who had been Moreau's last pupil in the weeks before his death in 1898. The three met in the crowded base-ment bar of the Soleil d'Or on the Left Bank, or in the quiet, shabby Café Procope, where you could sit and draw all evening for the price of a single coffee. They took their sketchbooks by horse bus up to the Cirque Medrano and the rough, cheap music halls of Montmartre (Matisse's work would be visited at intervals for the next thirty years and more by the chain of dancers leaping round the floor in the farandole at the Moulin de la Galette). They patrolled the streets and parks drawing cyclists, strollers, shoppers, cabmen and their horses, competing to see who could catch a likeness quickest. They made a curious trio. Matisse's sturdy build, his greater weight of years, his profes-sorial beard and gold-rimmed spectacles gave him an air of almost exaggerated sobriety in the company of the gnomelike Marquet and the even younger Camoin. Slight, shy, ingenuous, 'part faun, part white-faced clown', Camoin at twenty with his long nose and tentative moustaches had a melancholy waifish charm. All three were on their uppers. Marquet charged twenty sous for a picture. Boudot-Lamotte remembered Matisse himself accepting five francs for three paintings from the owner of a junk-stall on the Boulevard Raspail. He bought his paints on

tick (some said he owed his colour-merchant 4,000 francs).
Marquet restricted himself to the cheapest colours: white, umber
and emerald green. It was a big day when he could lash out
at last on a tube of cadmium.

They wore the same shabby suits of workmen's corduroy
summer and winter, year in, year out. Matisse regularly pawned
his watch and overcoat (Marquet's had been stolen), and all
three drew passers-by or music-hall performers because even
Camillo's or Colarossi's modest charges for a professional model
were beyond them. Matisse attended Carrière's class for nothing
in return for performing the duties of *massier* (keeping the
register, collecting the fees and tending the stove). He looked
for work with Marquet, who recalled long afterwards late-
night sessions on the stairs at 19 quai St-Michel with 'the
Matisse of long ago, so alert, such a battler, always giving as
good as he got'. The pair of them compiled a list of potential
employers from the business directory and worked through it
over several days, radiating out from the quai St-Michel by
bus and on foot in ankle-deep mud and melted snow. They
were finally taken on as jobbing painters in a decorator's
workshop run by a well-known theatrical designer, Marcel
Jambon, in a draughty barracks on the rue Sacrestan, high on
the city's northern ramparts.

Here casual labourers worked a nine-hour day for one franc
an hour, bent double, crouched over canvases spread out on the
ground 'as if they were breaking stones', spurred on when they
faltered by kicks from their employer, whom nobody but Matisse
dared answer back. He was put to work painting a frieze of laurel
leaves to decorate the halls of the brand new Grand Palais for
the great Universal Exhibition of 1900. It was hard, mechanical,
repetitive work, but what shocked him was the wretchedness
of his fellow workers: unemployed waiters, errand-boys and
pavement-dwellers who taught him the basic rules of class warfare,
taking pity on his inexperience, explaining how to get through
each day with the least effort and the longest breaks. They called
him 'Doctor' because of his glasses, and once even fetched him

to attend to an injured workmate. Matisse developed a feverish head cold, always a response to strain in him since childhood. 'Shut your mouth, Albert, or I'll kill you,' he said when Marquet tried to cheer him up. Jambon, who found Matisse's brooding presence hard to stomach, sacked him after three weeks for insubordination. 'When it came to earning a living,' said Matisse, 'we didn't know which way to throw ourselves.'

Matisse returned to Bohain with his wife for the birth of their second child that summer. Pierre Louis Auguste Matisse was born on 13 June 1900 in the house of his Uncle Auguste, who had taken over the seed-store and was himself planning an advantageous marriage the year after to the daughter of a grain-merchant from St-Quentin. Matisse's parents had retired, but Hippolyte Henri still drove the horses himself on delivery rounds all over the region, often taking his elder grandson with him. Anna Matisse loved all her grandchildren, and warmly welcomed a daughter-in-law who felt as strongly about Henri as even she could have wished. But the visitors did not stay long in Bohain. The contrast between Auguste's rising fortunes and the lamentable prospects of his elder brother was not lost on the neighbours. Henri's old friends were all doing nicely. A gulf had opened between his world and theirs. He and Amélie soon returned to face the broiling streets of Paris.

Those of Henri's friends who knew little of his private life sometimes pitied a wife who now had two babies as well as a shop to look after, while her husband stayed out till all hours, shut up in his studio or visiting the Montmartre music halls. But Henri's driving sense of purpose, which drove hers, had been one of his great attractions from the day they met. Their marriage worked as a partnership, in which it was his business to paint while hers was to ensure that the smooth running of their daily lives freed him to concentrate on production. The attics where they lived above the hat-shop on the rue de Châteaudun were minute, and Amélie had no help at home except for the six-year-old Marguerite. But whatever the cost, then or later, she never allowed material hardship or domestic

duty to assume greater importance in her scheme of things than she was prepared to give them. As soon as they were old enough the two boys were sent to live with grandparents whenever their demands on Amélie threatened to conflict with her role as Matisse's wife. Jean's northern grandmother became his second mother. Pierre, who spent much of his early childhood with the Parayres, felt the same about his Aunt Berthe. The two boys were baptized in Bohain, with or without the knowledge of their stoutly anti-clerical father, on 20 January 1901 at a ceremony attended by both sets of grandparents. Jean, who was just two years old, had Hippolyte Henri Matisse and Catherine Parayre as godparents; Pierre, at seven months, had his Uncle Auguste and his Aunt Berthe.

With Amélie's encouragement, Henri abandoned his search for work after the Jambon fiasco, treating his predicament from now on as an absurd, elaborate joke. Once he staged a dramatic scene for the benefit of passers-by, putting on a mock fight with Amélie and Derain which ended with a body being hurled into the Seine (the victim was a dummy got up in the regalia of a Beaux-Arts professor). Another time they repaid the concierge, whose disobliging manner infuriated Matisse, by throwing a party at 19 quai St-Michel for 200 guests who arrived in a steady stream, each stopping to ask her for directions before disappearing up the stairs to Matisse's small studio, where they swapped hats and jackets, climbed out over the roof and in again through a friend's window on the fifth floor of the next-door building, then hurried downstairs to turn up once more as new arrivals at the concierge's street door. Matisse saw clearly enough in retrospect what lay behind these charades with their anarchic undertow of resentment, cold, hunger, want, and rage against the well-heeled bourgeoisie: 'We were in a profession without hope. So we amused ourselves with nothing . . . Joking, making up stories, sending everything up was all we could do. Painters? How were they supposed to know they would sell one day? There was only one way out: the Prix de Rome. Painters were lost souls.'

Chaos and dissolution lapped at Matisse's heels in Carrière's class in 1900. By his own account his provocations became so flagrant that the master ended, like so many others, by sending him packing. Matisse felt trapped and hunted, lost once again in the dark wood that had threatened to engulf him when he first reached Paris. He had signed on in desperation the year before for a free municipal evening class on the rue Etienne Marcel, where he copied a plaster cast of Antoine Louis Barye's *Jaguar Devouring a Hare* from the Louvre. Wrestling with the clay helped him organize and clarify his mind. His copy of Barye's *Jaguar* – a standard starting point for sculpture students – became over the next two years an exercise in self-dissection. Matisse had a phenomenal knowledge of anatomy, first acquired at a popular course given for Beaux-Arts students by Professor Mathias Duval of the medical faculty. Duval encouraged his students to work by feel, and Matisse modelled his jaguar blindfold, using touch alone, with the help of a mounted skeleton of a cat supplied by the Beaux-Arts anatomy room. Barye had caught the jaguar with legs braced, belly flattened, back raked and furrowed by muscle-tracks like claw-marks, taut neck strung to clenched jaws in the act of snapping the spine of the hare, whose long, limp ears and dangling forepaws accentuate the ferocious concentration of the whole. It was movement that mesmerized Matisse. He said he liked to finger his models so as to transmit his sensations directly through his fingertips to the clay. The sensation he transmitted to his *Jaguar*, squirming spread-eagled on its formless prey, vividly conveys how it felt to be Matisse himself clawing what he wanted out of Barye's elegant and alarming bronze table piece.

He began work on another sculpture in 1900, using the Italian male model he had painted to disquieting effect in Carrière's class. If his *Jaguar* is an image of devouring fury, this standing man – eventually called *The Serf* – ended up as an embodiment of stoical effort and endurance. The model, called Pignatelli and nicknamed Bevilacqua, had been a favourite with Rodin, who based his *St John the Baptist* and his famous *Walking*

Man on Pignatelli as a young man. Matisse drew, painted and modelled him over the next three years in well over 100 sittings (sometimes he put the figure at three or five times as much). Various female models would absorb him in the future to the exclusion of all else, but this was the only time he ever subjected a male body to the same brooding and possessive scrutiny. Soon after he started work on *The Serf*, Matisse called on Rodin himself for help, but could find nothing he needed in the master's exuberantly inventive naturalism. *The Serf*, according to Jean Puy, who watched it growing, 'started from a conception close to Rodin's but became something quite different, cruder and more formless, but exceedingly expressive'.

Matisse finally tracked down the teacher he had almost despaired of finding in Rodin's senior assistant, Antoine Bourdelle, himself on the verge of open revolt at this point. The grandson of a goatherd, born near Montauban in the same region of southern France as Amélie Parayre, Bourdelle was slight and sinewy, with a shock of black curly hair and the same fierce directness as Amélie's father. Matisse continued wrestling with his *Jaguar* and started the battle with his *Serf* in Bourdelle's evening sculpture class in 1900, moving in both works away from even rudimentary naturalism to a simpler, more abstract approach. Bourdelle was a brilliant teacher. 'The hand is never clumsy when thought is precise, when the spirit is not hesitant,' he told his students. 'You must create, between yourself and your object, a stronger and stronger bond ... always remembering this truth, that the design is not to be found in the model but in ourselves.' Bourdelle evolved his theories in collaboration with his charismatic friend Mécislas Golberg, a Russian–Polish–Jewish anarchist twice deported by the French authorities, who finally allowed him to return on condition he gave up politics. Instead he brought his subtle, searching, well-stocked mind and his extraordinarily refined sensibility to bear on the possibility of a new art for the new century.

The aim of the stripped and streamlined modern art which Golberg confidently predicted would emerge from Bourdelle's

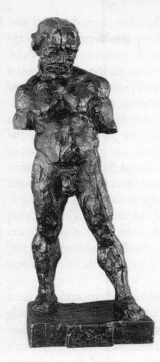

*Matisse, 'The Serf',
1900–c.1906*

studio was to express internal emotion, rather than to reproduce external reality. 'The progress of art lies in the concentration of movement, in its visible simplification and its formal domination,' he wrote. 'The more completely the artist is in possession of his form, the more he depersonalizes his feeling.' Variations on this theme would reappear in Matisse's 'Notes of a Painter', originally commissioned in 1907 by Golberg, who sensed the direction in which Matisse was moving almost before he did himself. The two first got to know one another in strange circumstances in Bourdelle's studio. Destitute, emaciated, spitting blood and struggling for breath, Golberg was already in the late stages of tuberculosis when he posed naked for the sculpture class in 1900. True to their Beaux-Arts training, Bourdelle's hard-boiled students arranged this living skeleton in the pose of a fighting gladiator.

The lesson they learned from Bourdelle – egged on by the sardonic Golberg, who treated his illness as a tormentor to be defied and derided in macabre exercises like this one – was the novel concept of portraying the model in whatever pose came naturally. 'Copy him as he slumps,' was Bourdelle's instruction. 'You will have a good drawing of a dying man in place of a bad drawing of a gladiator.' Bourdelle gave Matisse what he was looking for at this point. *The Serf*, which he pared down obsessively, eventually chopping off its arms in 1908, became in essence a powerfully concentrated self-portrait with the same sense of hunched and brooding frustration as the captive eagle that was Bourdelle's *alter ego*. The sculptor said that as a child, in the mountains of his native Roussillon, he had watched this eagle sitting huddled on its perch until one day it slipped its chain, spread its wings and flew. 'It is only after immense labour,' said Bourdelle, 'with ideas at last spread to their full extent, that the spirit of man can soar.'

Matisse painted two self-portraits in 1900. One canvas, filled with flying colour, depicts him as a workmanlike character with appraising eye and rolled-up sleeves, the researcher Puy remembered measuring everything that could be measured in Carrière's class. Sunny yellows and warm ochres envelop the figure, a purple stripe bisects the white shirtfront, green splodges invade the forehead and left shoulder, crimson brushstrokes lick vigorously up the trouser legs. On a second and more sombre canvas, the subject looms up as a dark, shadowy mass, threatened and threatening, against a turbulent purply blue and crimson ground. This was the aspect of Matisse that his contemporaries found so disturbing. More than forty years later, when he supervised the installation of the museum named for him in his birthplace of Le Cateau, he hung the drawing for this second self-portrait above the *Jaguar* in which he said he had 'identified with the sensations of the wild beast [or *fauve*]'. The side of himself that identified with the wild beast alarmed him, but he had gone too far to turn back now. 'So I charged forward, head down, working on the principle I had had drummed into me all

through my childhood, expressed in the phrase: "Get on with it!" ... Like my parents, I got on with my work, driven by I don't know what, by a force which I realize now was alien to my normal life as a man ...'

Misgivings about his own abnormality became one of the professional hazards Matisse learned to live with over the next decade and more. He showed seven pictures at the Indépendants and sold none of them. Marquet sold nothing either. Plodding home afterwards with Bevilacqua pushing a handcart full of their unwanted canvases, Marquet wished aloud that they might all be run over, which would at least have meant some hope of financial compensation. In the late spring or early summer of 1901, Matisse joined his family from Bohain on holiday in Switzerland, where he painted his future sister-in-law, Jeanne (or Jane) Thiéry, seated with her back half-turned to the spectator at the writing table in her hotel room. *Swiss Interior (Jane Matisse)* is full of light and air, organized in animated blocks of colour, pinks, blues and greys with splashes of violet and lemon yellow against a darker ground. The canvas is lit by the clear blue rectangle of a long window opening on to a veranda on the left, and balanced on the right by a basket chair, or rather by a shorthand notation of curving yellow and pink brushstrokes, which aerates the whole canvas in a way that looks forward to the hotel paintings Matisse would make nearly twenty years later in Nice.

By 1901 it was clear that, after studying for ten years in Paris, Henri was further than ever from achieving official recognition in his profession. It was also clear that the family business could not continue subsidizing him forever at the rate of 100 francs a month. The family gathering became a confrontation. July was the date set for Auguste's marriage to Mlle Thiéry, whose relations took a dim view of an unemployed, apparently unemployable brother-in-law imposing any further financial strain on the young couple's prospects as partners in the Bohain seed-store. Justice required that Auguste's marriage portion should match the 15,000 francs

so far expended on training Henri. It was a substantial outlay, made worse by trouble in Le Cateau, where their uncle Emile Gérard faced closure of his factory and prosecution over a public health scandal. Hippolyte Henri Matisse had lent his brother-in-law 10,000 francs in a last-minute effort to stave off ruin. Now that he had to raise at short notice sufficient capital to cover both this loan and his younger son's marriage settlement, he had no option but to cut off the allowance to his elder son. Matisse for his part saw no possibility of change or capitulation. *A têtu, têtu et demi*, as one of his admirers put it (meaning that a father obstinate as a mule produces a son half as obstinate again). Back in Paris, he attempted to make good the shortfall by applying for work backstage at the Opéra-Comique. He failed to get this job, or any other. There was nothing for it but to make do on the proceeds of Amélie's hat-shop, without relying on his own wages from the sort of work that would in any case have been in her eyes a betrayal.

In the same week as his brother's marriage, which took place in the north on 8 July, Matisse's six-year-old daughter Marguerite fell ill in Paris with diphtheria or croup. She turned blue, fought for breath and would have died if the doctor had not slit her throat in an emergency tracheotomy. Her father was obliged to hold her down for the operation without anaesthetic on the kitchen table at 25 rue de Châteaudun. Afterwards, Marguerite was admitted to the Hôpital Bretonneau in Montmartre, where she contracted typhoid fever. Although she recovered, she had from now on to wear a black ribbon round her neck to hide the three-inch scar, and she would be plagued by problems arising from a damaged trachea for much of the rest of her life. Matisse's feeling for his daughter was deepened and darkened ever afterwards by memories of this traumatic episode. He painted her for the first time that year, wearing a striped pinafore and looking directly at the spectator from cavernous black eyes set in a white face. It is a powerful portrait, simple and expressive as a child's painting, combining the

strength and directness of the young sitter with a poignant adult sense of her extreme fragility.

Some time that autumn or winter Matisse met Berthe Weill, a gallery owner on the verge of becoming – almost without knowing it, as she said herself – a dealer in modern art. In December 1901, on the strength of a small inheritance set aside for her dowry by her mother, Mlle Weill put on her first mixed show of contemporary artists. Her second show, the following February, included Matisse and Marquet. The only picture to find a purchaser was a snow scene by Marquet, but in April Weill sold a Matisse still life for 130 francs to one of Armand Parayre's journalistic colleagues from Toulouse, the art critic Arthur Huc. A smaller study went for 70 francs. These were Matisse's first professional sales since he had given up trying to please anyone but himself five years before, and Weill invited him to take part in another of her mixed shows in June. He had at last acquired both a gallery and a champion who not only grasped what he was doing but asked nothing better than to fight for it. The knowledge did nothing to lessen his inner perturbation. He slashed one of his paintings with a palette knife round about this time. His old enemy, insomnia, returned to plague him. He remembered sleepless nights that spring in a cheap hotel beside the Bois de Boulogne, where the battles he fought by day on canvas had to be paid for afterwards in nervous tension. Amélie, his invariable companion on painting expeditions, established what became another regular pattern of their working life by reading to him in the small hours, continuing until either dawn broke or he fell asleep.

Matisse had weathered his father's withdrawal of funds the year before with his wife's support. The four years of their marriage had turned out to be the richest and most productive period of his artistic life. In the spring of 1902 he was painting with greater audacity and confidence than ever before. His colours had finally broken free from the constraints of naturalistic description, and were beginning to negotiate independently

on their own terms. He had successfully resolved a long series of views of Notre-Dame, painted from his studio window, in which over the past seven years he had moved from silvery grey naturalism to bold synthetic compositions of pure colour: turquoises, violets, tart greens and crimson pinks which function in relation to one another and to the whole, not so much evoking or describing morning or evening river light as producing a pictorial equivalent. At the same time, he made a parallel set of small, vibrant, high-summer or autumnal land-scapes. In the so-called *Luxembourg Gardens* – painted, according to Amélie Matisse, in the park belonging to the Humberts' château at Vives-Eaux, where her parents spent their summers – the trees became patches of flat scarlet, or orange and purply blue, above jagged yellow streaks of sunlight on a pathway shadowed by indigo and pink. All the detonators for the Fauve explosion of 1905 were, as many commentators have pointed out, already present in Matisse's work by the end of 1901, or the beginning of 1902.

It was at this point that disaster struck. Amélie's parents, who had stood by the young couple throughout the difficult first years of their marriage, now found themselves overwhelmed by trouble of their own. Hostile elements were finally closing in on Mme Humbert. Two different lawsuits in October 1901 and February 1902 sparked off a series of steadily more virulent press attacks. The Humberts' creditors demanded their money back in increasing numbers. Public anxiety tinged with panic began to turn to mass hysteria. On 6 May the president of the Civil Tribunal formally ordered the opening of the famous strongbox containing the bearer bonds that guaranteed fabulous wealth to their ultimate possessor. The date was set for 9 May. On the night of the seventh Armand Parayre, dining for what turned out to be the last time with his employers, proposed a champagne toast to the downfall of Madame Humbert's enemies. Two days later a crowd of 10,000 filled the broad roadway in front of 65 avenue de la Grande Armée. Journalists from the national and international press turned out in force. All France

was agog. The Humberts were nowhere to be found, and neither of the Parayres could produce a key. After several hours of mounting tension, a locksmith broke open the strongbox, which turned out to contain nothing but an old newspaper, an Italian coin and a trouser button.

4. *The Dark Years (1902–4)*

The next two years have been labelled by art historians, starting
with Alfred Barr in 1951, Matisse's 'dark years'. As a painter he
turned back on his tracks, abandoning his reckless experimental
leaps almost in mid-flight, rediscovering the sober greys and
earth tones of his original palette, tackling conventional subjects
in the nearest he could get to a thoroughly conventional or at
any rate uncontroversial manner. Matisse scholars have tradition-
ally put the change down to native prudence, failure of nerve,
a bourgeois instinct to retrench rather than venture further into
uncharted ground. In fact, for months on end during the period
spanned by the Humbert scandal – from the beginning of May
1902 until the end of August 1903 – Matisse was in no position
to paint at all. His energies were absorbed by efforts to limit
the damage done to his own and his wife's families, which
disintegrated round him.

Shock and incredulity gave way to despair as Amélie's parents
surveyed the wreckage of their lives. They faced a bleak future,
'without financial resources since they weren't offered so much
as a parting gift; without hope since they are now too old to
work; with no prospect in short except the workhouse or the
street,' wrote F. I. Mouthon, the journalist whose investigative
campaigns in *Le Matin* had largely destroyed the Humberts, and
whose heart was touched by the bewilderment of these two
shipwrecked survivors. 'Ruined and disabused, Armand Parayre
today asks himself only how he is to eat tomorrow.' The
Humberts had disappeared without trace. While the police tried
in vain to track down the fugitives, the press and public, cheated
of any other scapegoat, rounded on Parayre.

The Humberts turned out to have made off with the pension
funds from the Rente Viagère, which was declared bankrupt.

The furious lamentations of 11,000 small investors, who had lost their life savings, added to the misery of the Parayres. Police ransacked their apartment on 14 May. Amélies hat-shop was searched by a police squad who raided Matisse's studio on the quai St-Michel the same day. These first police raids triggered a wave of further disappearances, enforced resignations, bankruptcies, bank closures and suicides. All the leading lawyers who had harvested rich pickings from years of *Humbert v. Crawford* litigation now faced ruin. The Crawfords themselves – the long-dead American millionaire who had left a will in Thérèse Humbert's favour, and the two nephews who had so tenaciously contested it – turned out to have been figments of Madame Humbert's imagination. There were no Crawford millions, no will and no inheritance. The teams of lawyers hired to argue Mme Humbert's case in interminable proceedings up and down the land had been opposed by no less ingenious legal minds, who (although they did not know it) were also in her pay. On the rare occasions when the Crawford nephews put in a personal appearance to dupe a creditor or brief an advocate, they had been impersonated by her brothers, Romain and Emile Daurignac.

For twenty years, Thérèse Humbert had traded on the credulity – in some cases the willing complicity – of her creditors: bankers and speculative financiers who had supported her precarious empire by first advancing money, then clawing it back at exorbitant rates of interest. The crash left a wake of violence and mayhem. Already in 1898 the Humbert affair had been described as 'the greatest swindle of the century' by René Waldeck-Rousseau, who became Prime Minister of France the year after. Waldeck-Rousseau successfully shut down another major scandal that had for years corroded public life in France by pardoning Captain Dreyfus in September 1899, but his efforts left him no appetite for opening up the Humberts' can of worms. By 1902, too many top politicians, too many high-ranking civil servants, too many bankers and far too many members of the judiciary had traded favours with Mme

Humbert for it to be in anybody's interest to spill her secrets.
Her close associates included the former Public Prosecutor of
the Republic, the presiding justice of the Court of Appeal, and
Police Chief Lépine, whose men were supposedly doing their
best to find the Humberts (their total lack of success in this
direction was felt at the time to be no accident).

Even those not personally involved feared for the survival
of the government, not to mention the honour of the Republic.
Although the original idea of the Crawford inheritance had
come from Thérèse, it was widely assumed that the brains behind
the scam belonged to her father-in-law, the former Minister of
Justice and pattern of Republican idealism, Gustave Humbert.
People said that the reason the Crawford fantasy turned out to
be so fabulously profitable was that it had been initially estab-
lished on a sound legal footing by 'good old Papa Humbert'.
From every point of view – historical, political, financial and
judicial – the Humbert Affair was a menace to the Republican
establishment.

Matisse was now the sole breadwinner (apart from his young
sister-in-law) for his wife, his three children and his wife's
parents. Amélie's hat-shop closed down after the Humberts fled,
and the police sealed off the house on the avenue de la Grande
Armée, leaving her parents homeless as well as destitute. 'Who
would have believed it?' cried Mme Parayre in an uncharac-
teristic outburst of emotion: 'Twenty years' salary vanished! And
here we are on the street. If it weren't for our poor little
daughter's wages, we'd be starving!' They took shelter with
Berthe, in her first job at the girls' teacher training college in
Rouen. The name of Parayre had become a dirty word in
France by this time. The strain of constant abuse and humilia-
tion exacerbated by their desperate financial plight bore down
on the whole family. Both Berthe and Amélie collapsed in the
end from nervous and physical exhaustion. By the autumn
Matisse himself, worn out by anxiety and overwork, was
confined to his studio on doctor's orders.

For the first time in his life he tried painting standard subjects

for the popular market, studying Salon practice and dressing up his models in fancy costumes. He painted two portraits of Bevilacqua incongruously kitted out as a toreador complete with guitar, and another of Amélie in white satin toreador pants, perched on a kitchen chair and strumming the guitar with an expression that struck Jean Puy as hardly human. The sittings took place in an atmosphere of tension so great that at one point Matisse kicked his easel down and his wife threw her guitar on top of the smashed wood, whereupon they both burst out laughing. He produced a series of flower pieces this year, small inexpensive bunches of yellow ranunculus or ragged sunflowers, arranged in improvised vases and painted in drab tones with a harshness that gave a wholly contemporary twist to the intimations of loss and mortality traditionally explored by Flemish flower painters. Puy, who stood by Matisse like all his friends, was struck by a flower piece 'remarkable for its nobility and bitterness: the portrait of a large metal coffeepot with some chrysanthemums just showing above the rim'. In his simplest efforts at photographic reality, banality eluded Matisse.

On 20 December 1902 the Parisian evening papers carried reports that the Humberts had been discovered in hiding in Madrid. The French police swooped on Berthe Parayre's house in Rouen the same day to arrest her father. On 21 December Armand Parayre was taken to Paris to face a crowd more like a lynch mob, surging forward on a station platform so densely packed that Amélie could not get near him. He was imprisoned in the Conciergerie on the Ile de la Cité, and charged with complicity in fraud and forgery. Matisse was the sole member of the family to keep his head at this point. From now on he took charge, calming his hysterical father-in-law (who protested his innocence by going on hunger strike), organizing a defence and confronting newspaper editors with threats to sue. Parayre regained his composure and emerged with dignity from a gruelling interrogation by the examining magistrate, which lasted throughout January. A series of theatrical courtroom confrontations was staged between the Parayres and the Humberts,

themselves also locked up under heavy guard in the Concier-
gerie. On 20 January, Armand was brought face to face with
his former pupil, for twenty years his employer, now the man
whose ruthless greed and treachery had landed them both in
the dock. One or other of the two was lying and, after 'an
extremely fierce exchange', it was Humbert who admitted
himself beaten. Two days later, in an atmosphere like a prize
fight, Parayre faced Thérèse Humbert. It was their first meeting
since the day of the flight eight months before and, when he
turned away contemptuously, refusing to take the hand she
offered, Mme Humbert flushed dark red. At the end of the
month Parayre was provisionally released, and Matisse himself
cracked up.

Reporters, who made the most of Parayre's Mediterranean
brio and instinct for striking poses, got no change out of his
son-in-law. But northern discretion and control exact a price.
By February Matisse was immobilized in Bohain, having been
warned by three different doctors to take no further risks with
a constitution dangerously undermined by over-exertion.
Matisse said that for three whole weeks he had not slept. His
doctors prescribed two months' total inactivity on a strict restor-
ative diet, forbidding him to work or even to write letters.
There was no question of a return to Paris, apart from a brief
foray to move out of the rue de Châteaudun and pack up the
hat-shop. The couple spent the rest of the winter lying low in
Bohain, holed up with their children in Matisse's parents' house.
He could hardly have picked a worse moment to take refuge
in his native region, where feeling ran higher against the
Humberts than anywhere else except Toulouse. Local papers
carried sensational daily bulletins. Twenty-five million francs
were owed to northern industrialists, who had not only lost
more than any other group of Humbert investors, but made
themselves a laughing stock for the rest of France. The citizens
of Bohain did not take kindly to the return of a prodigal who
had outstripped their worst fears, or to the fact that his wife
was the daughter of the Humberts' right-hand man. Matisse's

history spread round the town. Neighbours held him up as a warning to their children. Almost a century later, when I began retracing his footsteps in his native North, people in Bohain and St-Quentin still thought of him as a triple failure: unfit to take over his father's business, unable to complete his training as a lawyer, wretchedly inept by any normal standard even as a painter. Mocking stories circulated about his inability to produce lifelike pictures or paint a portrait anyone could recognize. They called him the village idiot, *le sot Matisse*.

The spring of 1903 marked his low point. Matisse wrote to Marquet in March, vividly describing the state of misery to which insomnia had reduced him, and which he feared might end in total breakdown. He said he had lost all desire to paint. For once Amélie, whose state of health worried her husband more than his own, could not lift his discouragement. He left his parents' house, moving with his family to a vacant property owned by his father, 24 rue Fagard, which had an attic floor beneath the sloping roof, poky and dark, lit by tiny skylights and a small north-facing casement window looking out on to a red-brick yard at the back. This became Matisse's studio. Here he painted a handful of drooping purple dahlias in a wineglass on a folding bamboo table, and a view of the attic itself – *Studio under the Eaves* – which showed work in progress on the easel, with the artist's palette on a packing case beside the folding table and its vase of dahlias.

Matisse scholars have recognized nightmarish overtones in the confined and sombre space of *Studio Under the Eaves*: a sense of claustrophobia heightened by the rectangle of preternaturally bright light beyond the window, which is the painting's focal point. But, to Matisse himself, this work and its pendant, *Bouquet on a Bamboo Table*, seemed in retrospect two of his best paintings. His only regret was that he had been obliged to stick to low-key colouring in order to bring out the tonal values. 'The values got the better of it in that one – what depths and suppleness in the shadows . . .' he wrote to his son Pierre, discussing *Bouquet on a Bamboo Table* in 1942: 'what became of the studio

where it was painted? forty years ago! You were still small. I
can see you now in a little striped blue suit your mother made
for you out of Vichy cloth. You were already sweet-natured.'

This was the first time the Matisses had lived together as a
family under their own roof without having to confide one or
other of the children to grandparents or wet-nurses, but pleasure
in his children's company was overshadowed for their father by
misgivings about their future. 'We are in great trouble,' he wrote
in July to Bussy. 'The various problems, great and small, more
great than small, of which – though I'm not all that old – life
has given me a fair share, the responsibilities I've made up my
mind to shoulder with courage, all this, coupled with the meagre
sums brought in by our profession, practically decided me to
give up painting altogether for a quite different job, dreary but
sufficiently lucrative to live on.' Pierre Matisse, who had his
third birthday in June 1903, remembered talk of his father going
to work as a colourist in a rug factory. Matisse's parents had
taken him in when he most needed it, but their courage and
generosity had been severely tested in the process. His mother's
belief in her son remained unshaken, but his father's initial
doubts had proved only too well founded. Hippolyte Henri
was sixty-three years old in 1903. His achievements, his position
in the town, the respect he had earned for the name of Matisse,
were being undermined through no fault of his own by deri-
sive laughter. 'My father told me a few days ago, very angry
and humiliated, that everyone took me for an imbecile, and yet
I wasn't one,' Matisse wrote to a friend. 'The worst of it is that
he held me responsible.' The conflict between the two reached
crisis point. More than forty years later, as an old man in his
eighties, Matisse could be moved to tears by memories of his
father, 'to whom he had caused great suffering, and who had
never had confidence in him'.

The two confronted one another with mutual bitterness and
frustration, each conscious of the other's distress but unable to
ease it by shifting his own position. The upshot was flight. Matisse
could not go on for ever occupying premises normally let out

to paying tenants in a town where his very presence brought shame on his relations. In July he found a house eight miles away in Lesquielles St-Germain, a country hamlet swollen into a dormitory town of sprawling brick hovels housing workers from the textile mills of Guise. Matisse proposed to live and paint here for a year with his wife and children on an income even more uncertain than a factory worker's wage. It was a dire solution to a desperate predicament. 'I have by now exhausted my family, who are frankly and purely bourgeois, and I can't count on them any longer,' Matisse explained on 31 July in a letter from Lesquielles to Bussy. His hope was that Amélie (whose health began to mend as soon as they left Bohain) would regain her strength over the next year, during which the family would scrape by on whatever he could raise by selling pictures.

According to Jean Puy, Matisse had made 1,200 francs at the end of 1902 from the sale of five or six studies to Vollard, who approved of his new, subdued and sober style. More sales might follow, but Vollard's cat-and-mouse tactics as a dealer meant that no one, least of all anyone as hard-pressed as Matisse, could pin much faith on his hints and half promises. Berthe Weill was rich in loyalty and enthusiasm but as short of ready money as her artists. A base in the country ruled out any possibility of extra earnings from the sale of Louvre copies, but Matisse's spirits lifted at Lesquielles. 'This place suits my wife and, as for me, I see an unlimited succession of paintings to be done,' he wrote to a friend on 31 July '– everything would be for the best if it weren't for this damnable want of cash.'

The Matisses' house on a bluff beside the church had a garden, and a magnificent view south over rolling chalk downs. Even the beet-fields glinted green in summer. For the first time in his life, Matisse painted the domestic life around him in his own house and garden as he would do so often in the future: a table laid for a meal out of doors, a warm-toned, Cézannesque still life of apples on a rumpled, red-and-white checked cloth, and a summer posy of yellow and purple pansies, which had none of the melancholy gravity that had touched his flower

pieces the year before. Some mornings he set off with his
knapsack to work in a park belonging to his cousin Saulnier
in the neighbouring village of Bohéries, where Matisse painted
the play of light and shadow in several low-toned, leafy, watery
landscapes. He expended much energy that summer trying to
interest collectors in a scheme to provide him with a modest
subsidy in return for a steady supply of paintings, but Saulnier
(who got two cut-price views of his small château) was the
only taker.

Matisse reluctantly dropped his plan for a collectors' syndicate,
and with it his dream of a year in the country, after a trip to
Paris in mid-August. Vollard – or *'fifi voleur'* ('Fifi the thief') as
Matisse rudely called him – bought more paintings, and offered
a one-man show which Matisse accepted without enthusiasm
('I guess he'd give me a dirty look if I were to abandon the
penal servitude they call the artist's life,' he wrote grimly: 'that
would be the first great joy of my life as a bourgeois'). He had
gone up to town for the Humbert trial in the assize courts of
the Seine. The house was packed for what *Le Matin* called 'one
of the most fantastic and most riveting judicial spectacles you
could hope to see'. Disappointed crowds had to be turned away
but the Humberts themselves seemed shrunk, crushed and
bedraggled. People rubbed their eyes and stared, like bystanders
in a fairy story when the gold turns out to be dry leaves. A
procession of bankers, lawyers and businessmen followed one
another on to the witness stand, marvelling aloud that they had
ever been bewitched or hypnotized into believing in the whole
preposterous farrago. Mme Humbert herself – pale, feverish,
heaving with emotion, raking the courtroom with blazing glances
from dilated eyes, sometimes cursing her tormentors, sometimes
talking at random in a voice 'like a death rattle' – struck more
than one reporter as a hunted beast. The whole world watched
with incredulity as she was cornered and brought down.

M. and Mme Parayre were called as witnesses in the second
week of the trial. Their evidence passed off, without drama or
revelations, so quietly that their son-in-law seized his chance

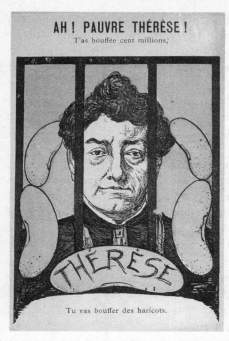

AH ! PAUVRE THÉRÈSE !

T'as bouffée cent millions,

THÉRÈSE

Tu vas bouffer des haricots.

'Ah, poor Thérèse! You've gobbled up 100 millions. Now you'll have to live by gobbling beans.'

to fit in a couple of sittings with Bevilacqua. No further suspicion attached to either Parayre or his wife, unanimously agreed to have been innocent stooges, whose integrity and genuine conviction had provided essential cover for the Humberts. Thérèse and her husband, each sentenced on 21 August to five years' solitary confinement, were generally considered to have been let off lightly. So were a great many more important people who might have found themselves in trouble if proceedings at the trial had been anything like as wide-ranging as the preliminary investigation. A collective sigh of relief went up all over France. The affair had uncovered a depth of cynical corruption best not thought about again. Mme Humbert served her sentence in the women's prison at Rennes, and her husband Frédéric was locked up at Melun. The Parayres moved back into their daughter's house at Rouen. Catherine Parayre never

recovered from the destruction of her faith in Thérèse Humbert, which had been for almost thirty years the core of her faith in herself. She died at the age of sixty, the year Thérèse left prison (Frédéric died in Paris in 1937, but nothing more was ever heard of Mme Humbert after her release in 1908). Armand Parayre lived to a ripe old age at the centre of his younger daughter's household, radiating intellectual curiosity, reading, writing, learning languages, much loved by Berthe's pupils and by his Matisse grandchildren.

The Matisses themselves returned to Paris in the autumn of 1903, leaving their sons in the north, Jean with the grandmother he loved in Bohain, Pierre in Rouen with Berthe and his other grandparents. Marguerite moved back, as she had always longed to do, to take up her old life again as a studio child at 19 quai St-Michel, where her father rented a new studio with three tiny rooms attached on the fifth floor. She was nine years old that autumn, and already beginning to be indispensable. She could sit quietly, watch carefully, and look after the apartment when her mother went out to work (the ordeals of the last sixteen months had drawn the two so close that both seem long since to have forgotten that Margot was in fact Amélie's adoptive daughter). Matisse marked the end of almost two years' disruption by modelling his daughter's profile in clay bas relief: from now on she would become scarcely less important to him as a model than his wife herself.

The new studio had two windows above the Seine, one looking directly across to Notre-Dame and the Palais de Justice, the other upstream to the Pont St-Michel, views which Matisse painted constantly from now on. He said that he began each morning alone in front of Cézanne's *Three Bathers*, rising early and padding into the studio on silent feet while his wife and daughter slept, so as to contemplate the painting by the first rays of the sun rising behind Notre-Dame. The upheaval it set in motion was profound and painful. Matisse absorbed Cézanne – as Cézanne himself had absorbed Poussin – into his bloodstream at so deep a level that, though the underlying

relationship is unmistakable, it is hard to pinpoint any specific visual resemblance. The influence was as much moral as visual. 'If Cézanne was right, then I am right,' Matisse repeated like a mantra in time of deep discouragement. 'And I knew that Cézanne was not wrong.' The older painter represented reason, lucidity and logic: the principle of light that would resolve the dark, formless conflicts of Matisse's own chaotic nature. He clung to the belief that an orderly canvas came from a well-ordered mind, and that the young painter must start by clarifying his responses. 'There were always so many possibilities available to Cézanne that he needed more than most to put his brain in order,' said Matisse.

Amélie had gone back to her old job, working as a modiste in her Aunt Nine's hat-shop. Matisse, too, was hunting for work that autumn. Word of his situation went round among his friends, who did what they could to urge him on. By far the most effective practical encouragement came from a close friend of Bussy's, Auguste Bréal, whose wife regularly invited the Matisses round for a square meal, and who himself bought two of the Lesquielles canvases for the princely sum of 400 francs. 'The money came in the nick of time for me,' Matisse reported to Bussy: 'high time, and more than time, for it vanished in a flash.' Bréal was the renegade painter son of Parisian intellectuals, closely connected through his wife with the English Strachey family, who treated the couple as the French end of what later became the Bloomsbury intelligentsia in London. Bréal offered to fix Matisse up with drawing pupils, something he had already done in London for Bussy (who had just married one of them, Lytton Strachey's sister Dorothy). But Matisse had, as he said himself, nothing on his plate but trouble. In October or November word came that his son Pierre was ill with bronchial pneumonia in Rouen. Survival was always problematic for sick children in northern winters when mortality rates rose steeply, and Matisse was not hopeful. 'I'm very much afraid this may end badly,' he wrote to Bussy towards the end of that dreadful year: 'My wife . . . has just left for Rouen to nurse little Pierre, who is my last born. He is three years old.'

This was the second time in two years that the Matisses came close to losing a child. When Pierre pulled through, Amélie brought him back to the quai St-Michel where she could keep him under her eye, with Marguerite to look after him. Matisse painted Pierre that winter, pale and stick thin, standing beside the studio still-life table and clutching his wooden horse, Bidouille. For the next ten years Pierre and Margot were studio children, the two who shared their parents' trials and hardships at home, and they never lost their closeness, or their unconditional commitment to their father's art. It was the children's aunt Berthe who collapsed next. She had carried on teaching, ignoring the threat of suspected TB, paying no attention to her growing exhaustion or her difficulties in breathing, until her health gave way in the New Year so completely that her doctor predicted, wrongly, that she would never return to teaching. Her sick leave stretched into the autumn, when her application for a transfer to Toulouse was turned down, because the authorities felt her connection with the Humberts made it unwise for her ever to return there. She was posted instead even further south, to Perpignan, where she settled with her parents, a move that would have crucial repercussions on Matisse's life and work.

31 October 1903 saw the inauguration of the Salon d'Automne, set up to pioneer a new and liberal approach to exhibiting young artists. Matisse, Marquet and Manguin had been plotting strategy and preparing their submissions for a month or more before the first exhibition opened, on a bitterly cold night in the unheated basement of the Petit Palais, in the teeth of hostile manoeuvres by the Beaux-Arts lobby and the Salon de la Nationale. The impact was electric. 'It was a revelation to me,' wrote the collector André Level: 'There was a boldness and youthfulness there which cut through the monotony and predictability of the grand annual salons ... I saw canvases there which seemed to me, without the slightest shadow of a doubt, to be the authentic art of our own age, and of the immediate future. I believed in it, I had faith.' Matisse was represented by *Tulips* and *Skeinwinder of Picardy*, a flower piece

and a sadly out-of-date Flemish interior which underlined his need to turn again to the art of the present and the future.

'You talk of my going south to the Midi,' he wrote to Bussy, who was settling with his English wife into a villa on the Mediterranean at Roquebrune: 'it is, alas, my dearest dream; but, *mon cher*, without money, what can you do? I think I should work twice as hard there as in the north, where the winter light is so poor – that will be for later, perhaps.' In the winter of 1903–4 Matisse met Paul Signac, who had a villa at St-Tropez in the Midi, and made a point of encouraging younger artists to join him there. Signac was vice-president of the Société des Artistes Indépendants, which, unlike any of the other Salons, never settled down into a conservative old age. Scruffy, flexible, down-at-heel, more or less nomadic, the Société was riding high in 1904 on the strength of its recent move into the Grandes Serres on the Seine, spacious light-filled glass-houses put up on a temporary basis to hold the horticultural section of the 1900 Universal Exhibition. The Indépendants was the only salon to have abolished the old competitive and hierarchical admissions system in favour of a democratic free-for-all. Matisse, who had served his time on the hanging committee and been nominated as one of Signac's deputies, sent in six canvases that spring. Camoin and Marquet sold everything they showed and left in triumph for the Midi on the proceeds. Matisse found buyers only for another flower piece and a second interior.

In the same week as the Indépendants opened, André Level officially set about forming a collection known as the *Peau de l'Ours*, intended 'to give young collectors a taste for the work of painters as young as themselves'. Level at forty was older than the other members of his syndicate: bankers and businessmen near the start of their careers who, according to Matisse, met regularly to play cards and had been persuaded by Level to hand over their winnings for him to invest in paintings. His buying committee of two – 'my bodyguards' – could prevent his making acquisitions but not force him to buy. One of his first acts was to climb with his bodyguards the 102 stairs to Matisse's studio

at 19 quai St-Michel, where he picked out a snow scene and a *Still Life with Eggs* painted in 1896. Forty years later Matisse's memory of being paid for his still life retained the clarity of a dream. 'He gave me 400 francs. I found myself holding four bills for one hundred francs in my hand! I couldn't get over it.' Before he could start worrying as to whether or not he had over-charged, an old friend from Moreau's studio, Charles Guérin, tapped on the door to ask how he was doing: 'I placed a one-hundred-franc bill on the floor. I stepped back one metre. I put down the second bill. Another metre. I put down the third. And then, one metre further back, the fourth. And Charles Guérin touched the bills with his foot, before asking me uneasily: "Have you killed someone?"'

Ambroise Vollard, who had suggested a show the year before, made no further move. Matisse hung about the gallery on the rue Lafitte, half exasperated, half fascinated by the dealer's inex-haustible fund of stories. As a raconteur, Matisse met his match in Vollard, whose drowsy lisp and heavy brooding presence he mimicked ever afterwards with a relish equalled only in his imitations of Bouguereau. An unrivalled champion of the older Impressionist generation, Vollard exasperated young painters by his tactics of somnolence and evasion, his habit of stonewalling customers, his extreme reluctance ever to part with a painting, or even to show up for an appointment with a collector in his half-empty shop with its canvases stacked against the wall. 'Dreaming and sleeping like this, alone in his shop,' wrote André Billy, 'Vollard was wasting no time ... Month by month, in solitude and silence, the prices of his pictures rose.'

Berthe Weill's attitude to time was the opposite of Vollard's. She liked to keep on the move, selling fast and cheaply. Matisse and his friends took part in a second mixed show at her gallery in April but, although virtually all the major modern artists in Paris passed through her hands, none of them stayed with Weill for long. She had no interest in long-term assets. Vollard dealt in patience and concentration, and Matisse had calculated correctly that if anyone could establish his reputation it was

Vollard. Each was banking on the future. The trouble between the two great gamblers, Matisse and Vollard, was that neither could give the other the secure base each had to have at this stage in order for his gamble to come off. Matisse, who needed guaranteed backing, sensed in Vollard the lack of confidence he dreaded in his own father. Vollard treated the young Matisse as not much better than a potboiler: a safe hand whose still lifes and landscapes could be relied on to keep the gallery ticking over while its owner waited for more serious stock to rise. Admittedly no one, except those who had explored the studio on the quai St-Michel, had yet seen anything that might have made Matisse seem a riskier proposition. For public exhibition, he was still drawing on a store of unsold work going back to Bohain and Belle Ile in the mid 1890s. When Vollard finally named a date for his show in June 1904, he showed forty-five paintings, mostly landscapes and silvery Chardinesque still lifes. Except for a handful of experimental canvases from Matisse's Corsican honeymoon five years before, all the rest were selected to show off what Vollard called 'his greys that appealed so strongly to the customers'.

The show was a reasonable, if not a resounding, critical success. Matisse seemed once again to be heading for the profes-sional acceptance that had been within his grasp until he deliberately rejected it eight years before by exhibiting *The Dinner Table*. Vollard now bought *The Dinner Table* himself for his usual price of 200 francs, and promptly re-sold it for 1,500 to a German collector. Matisse began to look like a paying proposition to other dealers, one of whom agreed to take as many academic still lifes as the painter could supply for 400 francs apiece. The snag was that, having managed for so long without a regular income, Matisse now found himself unwilling, if not unable, to make the compromises expected of him in return. However desperately he needed cash ('the hands of the butcher and the baker were outstretched waiting for the money'), he systematically destroyed – or set his wife and daughter to destroy – any canvas in which he detected the faintest trace of

blandness or conformity. Marguerite remembered scrubbing with aching arms and heart at more and more pictures, which had to be obliterated for fear her father's resolution might weaken when the dealer called the next day. It was a more violent replay of his revulsion against the tyranny of tradition in 1896. Once again he felt that he had swung too far in the direction of order and control.

He had written in May to Signac, who found him a fisherman's cottage in St-Tropez – two rooms up, two down – which was cheap to rent but too small for the whole family. The Matisses left Paris on 12 July with four-year-old Pierre, who needed sea air more than either of their other children. 'Our friend Matisse is here,' wrote Signac, who still thought of the new arrival as a conventionally trained Louvre copyist, 'a very good sort, intelligent and a real painter ... He talks to me about his plumb line, *chambre claire*, with all the colours, ochre, white and black ... that make up his range.' Matisse arrived in St-Tropez at the hottest point of the whole year, and promptly succumbed to the inertia that was his invariable initial response to a new place under a new light that would eventually bring about a profound imaginative readjustment. He blamed his guardian demon ('I've never had a guardian angel'), swearing that painting would drive him mad if he didn't give it up altogether. Isolation added to his troubles in a village where, apart from fishermen and wine-growers, there was no one for company but Signac himself.

Signac was master of St-Tropez. He had discovered it twelve years before and built himself a house, called *La Hune* (Crows' Nest), high above the town with a wild jungly garden and a commanding view. Expansive, sanguine, categorical, immensely sure of himself and of his aims, Signac was by temperament almost the opposite of Matisse. His vigour, vehemence and passionate conviction made him the fiercest of all the Neo-Impressionists, or Neos. For years he had preached the Neos' divisionist gospel of pure colour with quasi-religious fervour, briefly converting both van Gogh and Pissarro (van Gogh proved

at best an unreliable disciple: Pissarro's recantation after five years was regarded by Signac as rank treachery). There was nothing he liked better than a new recruit. He scanned the horizon constantly for the great genius of the future whose task the Neos had made easy: 'This triumphant colourist has only to show himself: his palette has been prepared for him.'

It was the joyful certainty of Signac's manifesto, *From Eugène Delacroix to Neo-Impressionism*, that had galvanized Matisse five years earlier ('painting had at last been reduced to a scientific formula'). In St-Tropez he could see at first hand how much energy and emotion were contained within that formulaic discipline. He readily responded to his host's liberating modernism, painting street-scenes, rooftops and boats in the harbour in singing colour, even making two versions of a *Still Life with Purro*, one of which was a divisionist transposition of the other. The breadth of Signac's knowledge was impressive, his generosity acted as a stimulant, and his work opened up dazzling possibilities. But there was a peremptory and author-itarian side to his personality that grated on Matisse, and exacerbated his already painful state of trepidation. He painted *The Gate to Signac's Studio* in large, pale, loosely impressionistic patches of flat colour. He also painted the narrow terrace in front of Signac's boathouse, with steps leading down to the sea and Amélie sitting sewing on a stool in the shade cast by the boathouse wall. *The Terrace, St Tropez* distilled the flowery light-filled essence of all the terraces Matisse would ever paint, but his method fell far short of strict divisionist regulations. Signac's brutal criticism of this canvas made the younger painter so angry that his wife had to take him for a walk to calm him down. Matisse's guardian demon took charge of what started out that afternoon as a family walk beside the sea. When Amélie sat down to give their small son his tea, Matisse dashed off a watercolour of the pair of them seated on the beach opposite a tall Scots pine beside the shining yellow, orange and scarlet path of the setting sun. Afterwards he worked up his sketch in an oil painting called *The Gulf of St-Tropez*: 'Since I got here,

I have produced only one canvas, size 15, painted at sunset, which gives me a little satisfaction,' he wrote to Manguin in September, 'and I still can't believe it was me that did it, although I've carried on working on it in a dozen sessions – it seems to me that it was by accident I got my result.'

The showdown with Signac over *The Terrace* supplied the explosive force Matisse needed to break through, or in his own words kick down, the successive barriers that blocked his way forward as a painter. *The Gulf of St-Tropez* precipitated him towards a junction where he had to choose between drawing spontaneously in colour (like Cézanne), or relying on Signac's tightly formulated notation. He chose the second path on his return to Paris that autumn for *Luxe, Calme et Volupté*, a canvas based directly on *The Gulf*, which was interpreted by both critics and fellow painters as a formal declaration of Divisionist allegiance. Divisionism provided logical grounds for separating the painter's ultimate goal – order, harmony, emotional stability achieved through form and colour – from its traditional dependence on the subject. This was a separation Signac never quite brought himself to complete, although he led many younger painters to the brink from which they could leap – as Matisse himself would do in the summer of 1905 – into a pictorial new world.

If Matisse's nervous strain was lost on Signac, it was immediately apparent to his neighbour, Henri Edmond Cross, who arrived back from Paris at the end of August. Cross described meeting 'the anxious, the madly anxious Matisse' to a friend that autumn. A northerner himself, prey like Matisse to agonizing self-doubt, Cross had guardian demons of his own, and Matisse confided in him with a freedom he rarely, if ever, showed to another older painter. There were just over thirteen years between them, but the gap seemed wider because Cross, prematurely crippled by rheumatism, was white-haired, with gnarled hands, stiff joints and brittle limbs like a wind-whipped tree. The two men dined together at a little pension on the harbour front at Cavalière, midway between St-Tropez and Cross's house

at St-Clair, where they discussed life, art and Matisse's decision to turn his back on professional success in favour of hardship and renunciation. 'I know well that the question of money for survival is disturbing, and constantly gets in the way of the other, higher question,' Cross wrote gently a year later: 'But, as you told me, you chose long ago the path of independence, the only noble path.'

The Matisses visited the Crosses in their pink house at St-Clair, set among vineyards and orchards at the foot of the mountains called les Maures. Madame Cross, who welcomed all three Matisses with especial warmth, was on the face of it an odd wife for her ascetic husband. She had been a worldly, stylish, streetwise Parisienne, much criticized by his friends for shallowness and frivolity, when she retired with her invalid husband to the south, watching over him, supporting him through gruelling courses of largely unsuccessful treatment in Paris, and making his enforced seclusion at St-Clair not only tolerable but productive. Amélie Matisse liked and sympathized with Irma Cross. Irma for her part grew increasingly to depend on Matisse's feeling for her husband, both as a man and as a fellow painter, and she lost her heart to Pierre, who was the only child in a party of six adults (both the Crosses and the Signacs were childless). Pierre was an adorable infant with big black eyes, golden hair and a mysterious air of gravity. A raconteur like his father, he could always make the grown-ups laugh. They called him little Tartine (literally Jam Sandwich, with an overtone of someone who tells stories), and surrounded him that summer with an affectionate warmth that went some way perhaps to make up for the chill shadow cast by the Humbert affair over almost half of his short life.

The two men talked about the work which was often a misery to them both. Matisse took comfort from Cross's assurance that it would be virtually impossible to suffer worse torments than he did himself. Divisionism, which had been for Cross a harsh geometric discipline of calculation, equation and deduction, was beginning at last to offer him the freedom it

gave Signac. The two neighbours were preparing that autumn
for successive one-man shows at Eugène Druet's new gallery
in Paris, and for both this was a period of energetic reassess-
ment, of reconsidering old canvases and rapidly completing new
ones. Matisse could hardly have asked for a more intensive
refresher course on Neo-Impressionist theory and practice. Cross
gave him a painting, *The Farm, Evening*, which was a pair to
one he had given Signac, *The Farm, Morning*. Both had been
painted ten years earlier in response to Signac's *The Age of
Anarchy* (later tactfully retitled *The Age of Harmony*), a grand
politico-cum-divisionist manifesto designed to celebrate a
personal and professional fresh start at a moment when Signac
and Cross, both newly married, were both embarking on new
lives in the south.

The anarchist ideal of freedom, justice and beauty – spread
throughout France from Russia via Kropotkin, Tolstoy and
Bakunin – appealed to the optimistic and combative instincts
of Signac's generation. His *Age of Anarchy*, which Matisse almost
certainly saw that summer at St-Tropez, was an Arcadian idyll,
peopled by handsome, half-naked men and lovely women (all
the couples were modelled by Signac and his wife), enjoying
a future of peace and plenty in which humanity was to be
freed at last from the tyrannies of industrial exploitation and
political repression. Matisse would paint an Arcadian dream of
his own that autumn, followed by another the year after ('The
description you sent me of your *Arcadia* is alluring,' Cross wrote,
discussing Matisse's *Bonheur de Vivre* in the winter of 1905–6).
For Signac, modern art was inextricably bound up with a
political new dawn. He believed that it was up to the artist of
today to provide the ordinary factory-worker or urban flat-
dweller with the equivalent of Delacroix's grand decorative wall
paintings. Matisse would work to Signac's blueprint for the rest
of his life: 'These canvases which restore light to the walls of
our urban apartments, which enclose pure colour within
rhythmic lines, which share the charm of oriental carpets,
mosaics and tapestries: are they not also decorations?'

In less than twelve months Matisse's pictorial experiments would reach a pitch at which colour itself felt to him like dynamite. For the moment he was content to explore the anarchists' pictorial vision of an earthly paradise in which moral and physical ugliness would melt away of their own accord rather than having to be blown apart. For Cross this meant in practice painting lightly draped or naked nymphs, reclining, picnicking, bathing or brushing their hair beside the sea in canvases that owed something to Puvis de Chavannes, something also to Poussin, but quite as much to a northerner's excitement on discovering the Mediterranean. He said that what had first enchanted him about the coast was its 'fairytale and decorative' aspect, and it was not long before Matisse, too, found fairytale and decorative elements invading his view of the seashore. Back in Paris in the autumn of 1904, he developed his *Gulf of St-Tropez* into a grander and more elaborate picture in which Mme Matisse, still wearing her fashionable hat and walking costume, presides over a picnic laid out on the beach for a boatload of naked nymphs who seem to have sailed in from another world.

Luxe, Calme et Volupté was Matisse's first attempt to combine realistic details – the figure of his wife, the teacups and the tablecloth, the Scots pine and the bay of St-Tropez – with anarchist fantasy. It was also a head-on confrontation with Divisionism, by far his largest and most ambitious work since he had grappled with Impressionism in *The Dinner Table* eight years before. He underlined its origins with a title taken from one of his and Signac's favourite poets. '*Là, tout n'est qu'ordre et beauté,/ Luxe, calme et volupté* [There all is order and beauty,/ Luxuriant, voluptuous and calm]' is the refrain from 'L'Invitation au Voyage' in Baudelaire's *Fleurs du Mal*, but at the time there was no telling the destination of the voyage Matisse embarked on in this strange, vibrant, uneasy painting, bulging with an energy that strained Signac's rules to the limit and beyond. *Luxe, Calme et Volupté* is full of the flagrant irregularities that made Cross predict, even before his friend left St-Tropez, that Matisse would not be restrained by Divisionism for long.

Dissatisfied and restless at the end of his St-Tropez summer, he planned nonetheless to return to the Mediterranean the year after. The couple were down to their last fifty francs (with another fifty saved for the return to Paris) when Amélie paid a visit to her sister Berthe, now settled in a new job at the teacher training school for girls in Perpignan. Continuing her journey in search of a cheap, unspoilt place to stay, she fetched up just short of the border with Spain in the fishing port of Collioure. Apart from Signac, who had landed there on his first painting trip to the Midi twelve years before, no painter had yet occupied Collioure, where the Matisses planned to return in the summer of 1905.

Back in Paris, Matisse showed fourteen relatively conservative canvases at the second Salon d'Automne. Winter was the season of intrigue, cabals and furious lobbying behind the scenes as different art-world factions drummed up support on the various committees that would control who showed what and how at next year's exhibitions. Matisse was co-opted by both the leading breakaway salons, remaining *sécretaire-adjoint* at the Indépendants and becoming a member of the Salon d'Automne's selection committee. As Signac's adjutant, he helped organize the first official exhibition ever held, in France or elsewhere, of the work of Vincent van Gogh. This was a retrospective of forty-five works put on as part of the Salon des Indépendants in March 1905, for which Matisse borrowed paintings as well as lending his own drawing. He said that, when Divisionist restrictions began to seem unbearable, it was van Gogh who (with Gauguin) enabled him to cut loose that summer.

In avant-garde circles at home and abroad Matisse at thirty-five carried increasing weight. His work had been reproduced by the young Sergei Diaghilev at the end of 1904 in the pioneering Russian art magazine, *Mir Iskusstva*. In Paris, Vollard relied implicitly on Matisse's judgement of their contemporaries, investing heavily in Marquet and Manguin as well as buying up the contents of both Derain's studio and Jean Puy's on Matisse's instructions (Derain said that the dealer didn't even

bother to open up the crates of canvases Matisse made him buy). But the public, which had got into the habit of treating modern painting as a freak show, responded violently to the 1905 Indépendants. 'From one end of the hall to the other you ... heard intemperate laughter, and sarcasms rising to open contempt,' wrote Berthe Weill (who put on her own mixed show of Matisse, Marquet, Manguin and Camoin in April).

Matisse himself showed eight paintings, causing a stir with *Luxe, Calme et Volupté*, and being warmly welcomed by the Neos as the movement's most prestigious convert since Pissarro. Signac expressed his pride and joy by purchasing Matisse's manifesto canvas himself at the end of the summer, the state bought a *View of St-Tropez* and the critics were markedly respectful. 'This young painter – another dissident from Moreau's studio who has mounted freely to the heights of Cézanne – now takes on, whether he likes it or not, the position of *chef d'école*,' wrote the critic Louis Vauxcelles. Older and more established painters grumbled among themselves, but the younger generation had no reservations. 'It was for me the greatest revelation,' said Raoul Dufy, who was twenty-six when he saw *Luxe, Calme et Volupté* in 1905: 'I understood instantly the mechanics of the new painting.'

5. *The Wild Beast (1905–7)*

In May 1905, as soon as the Indépendants and the show at
Berthe Weill's closed, Matisse and his friends headed south. The
Manguins left for a rented villa in St-Tropez, where Marquet
and Camoin followed them. The Matisses continued westwards
along the coast to stay in Perpignan with Berthe, who shared
a small house with her parents in which her sister's children
– *les petits Matissous* – were always welcome. On 16 May Matisse
alone completed the last leg of his journey, another fifteen miles
along the coastal railway skirting the edge of the eastern Pyrenees
where they ran down to meet the sea in Catalonia, a harsh,
vivid mountain country, long disputed and finally divided
between France and Spain. 'All of a sudden as you emerge on
the crest of a hill from a rocky corridor, Collioure! Radiant
with light on the curve of a small bay, hemmed in by the last
burnt foothills of the mountains, a blaze of reds and ochres,'
wrote a contemporary taking the train from Perpignan. 'Is this
still France, or already Africa, with its clumps of agave, and its
palm trees dotted here and there among the gardens?'

This stretch of the Catalan coast was the point at which
France came closest to North Africa. Traces of the Moors were
everywhere, from the construction of the houses – dark, dank,
almost lightless caverns shuttered against the sun – to the town's
crumbling fortifications and the orangey-pink bell-tower
(instantly recognizable in so many of Matisse's paintings). Banana
and date palms flourished alongside figs, oranges and lemons.
In spring, pomegranate, peach and cherry trees blossomed in
sheltered hollows round the town. A lush green growth of vines
covered the terraced slopes, and flowering asphodel grew on
the hills beyond. The town itself lay like an amphitheatre between
the mountains and the sea, its buildings limewashed in deep

bluish-pink, watermelon red and saffron yellow. Visitors were rare in Collioure, but the few who came agreed that the secret of the place lay in its light and colour. 'In the cool of the morning,' wrote Paul Soulier, a local wine-grower who became Matisse's staunchest supporter in the town, 'beneath the shade of the big trees . . . there are great hampers of cherries, pyramids of pears, tumbled masses of apricots; the sharp red of tomatoes and the pale yellow of cucumbers add their brilliant notes . . . Carts full of oranges pour their contents out into baskets of every shape, and the golden globes that roll free mingle with white and purple aubergines, like the mighty eggs of some unknown bird.' Matisse's *Interior with Aubergines* (1911) – one of the strangest and most sumptuous paintings of the period when he took more risks than ever before or after – was based on three aubergines from Collioure market. The groundbreaking *Bonheur de Vivre* took its title from the Catalan proverb: '*A Cotllioure fa bon viure!* [the living is good at Collioure].'

In 1905 Matisse was the first painter ever to set foot in Collioure's single hotel. Outsiders were not welcomed by the local people, who spoke Catalan, earned their living from the sea, and had known small contact with the world beyond the mountains until the coming of the railway. A strange, pale-skinned, blue-eyed, red-headed northerner stepping off the train for no apparent reason automatically aroused suspicion, but the landlady at the Hôtel de la Gare – the Widow Paré, always known as Dame Rousette – made an exception for Matisse on account of his workmanlike air and evident seriousness. Within a few days of his arrival, Monsieur Henri had not only moved in himself, but fetched his family and installed them upstairs as well. Life was simple, frugal and cheap. Most people in Collioure lived from hand to mouth, like the Matisses, who had been held up in Perpignan waiting for a payment from Berthe Weill that failed to materialize. In desperation, Matisse appealed to Manguin, who sent 100 francs by return of post. Money worries nagged at both painters throughout the summer. Camoin, whose own work was at last beginning to sell, sent what he could to

tide his friend over. Weill stumped up fifty francs on account in June. The state proposed to buy a picture, though payment was as usual indefinitely delayed. But even comparatively small windfalls like these represented serious purchasing power in Collioure, where a recent slump in market prices had reduced a fisherman's earnings to an unprecedented low of roughly a franc a day.

One of Matisse's first moves was to rent a room to work in above the Café Olo, overlooking the Port d'Avall, or Port d'Abaill, the most outlying of the town's three beaches. All the life of the port took place on the stony shore, where the population turned out each morning to watch the fleet return, and to size up the catch. The fish market was a noisy, quarrelsome daily drama performed on the sea-front, after which the fishermen dispersed to get ready for the next night's work beneath Matisse's window. He drew the boats lined up with sails hanging from the yard-arm to dry, and he drew them again with furled sails later in the day. He drew them leaving the harbour towards evening, their graceful triangular sails skimming over the surface of the water, or reduced to barely visible points above the horizon as the fleet approached its fishing grounds. He drew the nets laid out to dry after the night's fishing, and a few hours later he drew the owner of the nets carrying them rolled up in a bundle on his shoulders as he set off home to bed. The observation in Matisse's drawings and paintings is so accurate that a fisherman can tell the time of day, sometimes even the precise hour, when each was made. Carts and donkeys, women mending nets, men smoking, lounging or heaving at a capstan on the beach were all dashed down with a precision that went back to Matisse's boyhood on the rue Peu d'Aise in Bohain. All of them reappear in *Port d'Abaill*, the canvas painted in his Paris studio that autumn, which turned out to be his final and most frustrating confrontation with Divisionism.

Matisse's Collioure sketchbooks record the daily round of a people who had lived and worked on the seashore since antiquity. He told his son-in-law long afterwards that these ancient

patterns gave him energy for the *Dance*, the huge frieze of leaping scarlet figures on a flat blue and green ground that outraged the Paris art-world in 1910. He said he painted it bent double, crouching ready to spring like the Catalan fishermen he had joined one night on the beach in a dancing ring 'far more violent in movement and appearance than the *sardane*'. Collioure gave Matisse the kind of freedom he had first tasted in Ajaccio. There were no censorious pointing fingers here, and none of the preconceptions about painting that his work had violated in Bohain. The family settled into a routine, revolving as always around work, but including a daily swim from a pebbly cove called l'Ouille half an hour's walk round the headland. Matisse wore a straw hat and shirt-sleeves with his trouser legs rolled up. Amélie posed barefoot on the rocks in her Japanese kimono. The low hills where they walked every day beside the shore recur constantly in Matisse's paintings, and so does the sheltered bathing beach of l'Ouille, a perfect curve overhung with greenery which became the setting for *Bonheur de Vivre*. When heat drove him indoors, he painted the view from his rented room. *The Open Window, Collioure* is perhaps the richest and most radiant expression of Matisse's sense that painting gave access to another world: a mystery, glimpsed through an open door or window, which he had first contemplated as a boy in a dark northern law office.

If the adults felt liberated in Collioure, so did the two boys (Margot had been left behind with her Matisse grandparents in Bohain). Jean and Pierre ran wild, fishing, climbing, exploring the rocks and pools with their contemporaries from the village. Their parents worked as hard and lived as simply as the fishermen and their wives. Amélie's presence, so tentative in Matisse's paintings seven years earlier in Corsica, presides emphatically at the centre of the work done this summer in Collioure, where the images she inspired grew progressively more challenging. She became the key structural element in a semi-abstract composition of orange and violet, turquoise-green and red, her head surmounted by a blue-black mass of hair, her face bisected by

the broad green stripe that supplied the painting's title, *The Green Line*. This portrait of his wife shocked Matisse's contemporaries. 'He teaches you to see her in a strange and terrible aspect,' wrote an American journalist in 1910.

Almost a century later the strangeness and terror have given way to a powerful serenity embodied in the subject's steady gaze, the incisive curve of her eyebrows, the firm set of her chin, even the high-piled chignon that crowns her head. 'Matisse knew how to elicit from her a passion for his work,' said Lydia Delectorskaya, who became Matisse's companion in the last two decades of his life. 'He knew how to take possession of people, and make them believe they were indispensable. It was like that for me, and it was like that for Mme Matisse.' As the pace of his pictorial experiments accelerated until he seemed to himself to be losing all control over what he painted, Matisse needed his wife more than he had ever done before. The three and a half months he spent in Collioure in 1905 developed into an ordeal on which he looked back afterwards with horror and amazement. 'Ah, how wretched I was down there,' he said in retrospect. At the time, he felt himself cracking up. Sleep became impossible. If Amélie Matisse glows in these Collioure canvases with the courage and confidence her husband gave her, she in turn became a bulwark against his own mounting perturbation.

Not that his troubles started right away. The summer began innocuously enough with a round of hospitality from the artists of the region, who were few, widely scattered and avid for news from Paris. First on the scene was Etienne Terrus, who thought nothing of walking the seven miles from his native village of Elne. Terrus would become over the next ten years the closest of all the friends the Matisses made in Catalonia, exploring the Pyrenees with them, consoling Henri when anxiety threatened to overwhelm him, growing especially fond of Amélie, whose generosity and stubbornness belonged, like his, to this hard, dry, tough landscape with its dazzling play of light and colour. Blunt, stocky and square-headed, rugged as

the red earth from which he sprang, Terrus painted the coast and the rocky countryside in bold and subtle watercolour. He was a bachelor, living austerely in his brother's house, and entertaining other painters to convivial lunches on the terrace in front of his studio at Elne. Over the next few years the Matisses and their friends became regular visitors in this light-filled, white-washed studio set high into the Roman ramparts with views stretching to the sea on one side, and to the mountain of Canigou on the other.

The first trip the trio made together was to Banyuls, two stops along the railway from Collioure, where Terrus's friend, the sculptor Aristide Maillol, gave a lunch party in Matisse's honour on 22 May. Maillol still lived in the pink house where he was born above the port, with a stone terrace shaded by great pine trees, and a garden of tangled tropical vegetation falling steeply away below. Short and thickset, with fierce eyebrows and a bushy beard, Maillol not only looked as if he had stepped down from the pediment of a Greek temple, but dressed the part in thick-soled espadrilles like classical buskins and a shepherd's cloak. Antoine Bourdelle had been his mentor in Paris, as he was Matisse's. On the day of the Banyuls lunch-party, he was struggling to enlarge a small clay female nude into the lifesize plaster cast for what eventually became his marvellously balanced, stable and streamlined bronze, *La Mediterranée*: something he said he never could have managed without Matisse's help. Matisse for his part modelled a compact little nude clearly based on a Banyuls original, though the clay figures he made a year later have a tension wholly foreign to Maillol, who triumphantly achieved his aim of recreating as a twentieth-century Frenchman the tactile poise and harmony of the Greeks. 'Maillol's sculpture has the ripeness of a plump fruit which makes me want to reach out and touch it,' said Matisse, describing an art at the furthest remove from his own nervous and aggressive use of clay. 'We never discussed sculpture. For we could not understand one another. Maillol worked in masses like the ancients, and I worked in arabesques like

the Renaissance sculptors. Maillol didn't like taking risks, and I couldn't resist them.'

Risk beckoned him that day in the person of another of Maillol's lunch guests, the painter Daniel de Monfreid, who had been a close friend of Paul Gauguin. Matisse invited the whole party back to view his own work in Collioure, and went with Terrus in June to a weekend house party given by Monfreid to inspect his Gauguins. These were a batch of carved and painted wooden sculptures shipped directly from Tahiti four years earlier. Matisse had already seen the paintings in the greatest of all Gauguin collections, housed in the Paris apartment of Gustave Fayet, a wine-grower from Béziers whom he got to know that summer with Monfreid and Maillol. But nothing could have prepared him for the impact of Gauguin's gaudy and barbaric carvings. No other European had yet imagined anything like them. Matisse was astounded.

As a painter he was already flouting all known orthodoxies in works jabbed down on small oblong bits of card, depicting cliffs, rocks and sea in a choppy tumbling mass of coloured brushstrokes. By midsummer a crisis was approaching. Matisse, too uneasy as always to relish the prospect of facing it alone, had already written to his old painting companions at St-Tropez – Manguin, Marquet and Camoin – asking each of them to join him in Collioure. None accepted his invitation. On 25 June he sent a nervous and peremptory postcard to André Derain, who responded at once. He was twenty-five years old that month. He owed much to Matisse, who had regularly visited his studio, brought friends to inspect his work, and helped him through three gruelling years of military service. It was thanks to Matisse that he had exhibited for the first time that year at the Indépendants, and sold the contents of his studio to Vollard. Matisse and his wife, carefully disguised as a respectable bourgeois couple, had even made a special journey to Derain's home town to persuade his parents to let him be a painter. Derain senior was sufficiently impressed to hand over 1,000 francs, on the strength of which his son now set out for Collioure.

He arrived on 7 or 8 July, causing consternation at the Hôtel de la Gare, where no one knew what to make of this tall, lanky, down-at-heel Parisian dandy. 'An apparition,' said Mathieu Muxart, the hotel's potboy, who was sent to fetch Derain's luggage next day from the station, 'a sort of giant, thin, dressed all in white, with a long fine moustache, cat's eyes and a red peaked cap on his head. He had the whole handcart filled to overflowing with trunks, suitcases and a parasol bigger than a customs officer's umbrella.' Like other travellers visiting Collioure for the first time, Derain was bowled over by both light and colour. 'In effect, this place, its people with bronzed faces, skin colours of chrome yellow, orange, deeply tanned; blue-black beards,' he wrote, jotting down impressions pell-mell for his friend and painting partner Maurice de Vlaminck. 'Its women, with splendid gestures, in black jackets and mantles; pottery in red, green and grey, donkeys, boats, white sails, multi-coloured keels. But it's the light, a pale gilded light, that suppresses shadows. The work to be done is fearful. Everything I've done up till now strikes me as stupid.' Over the next two months Derain sent Vlaminck a stream of letters, vividly conveying his own and Matisse's gathering excitement over the supremacy of light, the elimination of shadow, the surrender to colour for colour's sake.

The hotel stood beside the railway on scrubland above the town at the top of the broad, new, sparsely built-up avenue de la Gare, as far away as it was possible to get from the din and animation of the port. The two painters worked furiously, often stationed side by side at favourite motifs, looking out over the roofs or on the rocks at l'Ouille (where Derain drew Amélie posing for her husband). They carried on working at the hotel in the evenings among the regulars in the public saloon, painting portraits of one another, and storing their painting materials in the attic of the house next door. Derain's absurd sense of humour, his energy and dash, his sudden switches from mood-iness to gaiety, made him difficult to resist. He captivated the whole Matisse family that summer. He swam, told stories, amused

the children and touched their mother with his boyish eager-
ness. Pierre, who adored him, rode everywhere on Derain's
shoulders. In July the Matisses moved down to the port, renting
the upper part of Paul Soulier's capacious old family house on
the beach called the Boramar, where Derain joined Matisse to
work in his new studio.

Many of the paintings they produced that summer look out
through the pillared balustrade of the studio's open window to
the views beyond, either straight out to sea, or down on to the
harbour with its ancient bell-tower on the left. The heat was
sweltering. The younger artist's fresh eye and painterly intelligence
were pushing Matisse once again, as they had done three years
earlier in the Louvre, fast and far in dangerous directions. Matisse
wrote uneasily to Signac, envying him his pictorial certainties,
worrying about the unresolved conflicts in *Luxe, Calme et Volupté*,
and contemplating with misgiving his own preparations for
another divisionist canvas, *Port d'Abaill*. His letter raised the
problem of rebellious colour, and his own inability to comply
with Signac's disciplinary rules. It was already clear that, much
as he liked and admired Signac, he was preparing not only to
chuck the regulatory machinery overboard, but to jump after it
himself into the unruly elements. Derain, rasher and far less
profoundly disturbed than Matisse, leapt first. By the end of July,
he was congratulating himself on having eradicated all trace of
Divisionism from his work. 'The night is radiant, the day is
powerful, ferocious and all-conquering,' he wrote on 1 August.
'The light throws up on all sides its vast and clamorous shout
of victory.' Confronting this light on canvas, both painters found
themselves by turns victorious and vanquished. Matisse asked
Signac to send him Cézanne's reassuring words (published in an
interview much discussed at St-Tropez the year before) about
reconciling line and colour. By the time the passage came, copied
out in Signac's hand on a postcard dated 14 August, it must have
seemed as if Cézanne himself endorsed what was happening in
Collioure: 'Line and colour are not distinct ... When colour is
at its richest, form takes on its fullest expression.'

Matisse's crisis lasted throughout the summer. In these final stages of a struggle he had once hoped Divisionism would solve, he turned, not to Signac, but to Henri Cross, who had long predicted that the solution Matisse was looking for lay in himself. In 1905, Cross faced the threat of blindness. Rheumatism endangered his left eye, flaring up at intervals in an excruciatingly painful inflammation of the iris. In April Matisse gave Cross a landscape, and received a bunch of parrot tulips in return. Warned by Marquet in late May that Cross was confined on doctor's orders to a darkened room at St-Clair, Matisse promptly posted off his purple, gold and crimson painting of the *Tulips*. Irma Cross, writing on behalf of her husband, who could no longer see to hold a pen, thanked him for this delicate attention, which greatly touched them both. The Crosses admired Matisse for his dogged courage as an artist but they loved him for the speed and sensitivity with which he responded to their predicament in spite of his own turmoil that summer. As his colours raged and flamed, emitting a strange light of their own all through July and August, Matisse sent accounts of work in progress at Collioure to the sightless Cross, blindfolded in his sickroom at St-Clair.

In retrospect, Matisse saw the conflagration that consumed himself and Derain as something awesome, even demonic. He told Bussy that colour had released an energy which seemed to come from witchcraft. His subsequent accounts emphasize the element of reckless defiance and deliberate destruction. 'We were ... like children before nature, and we let our temperaments speak ... I spoiled everything on principle, and worked as I felt, only by colour.' But at the time he was appalled by the destructive violence of his own liberating instinct. Cross's first impulse, on recovering his sight that autumn, was to reassure Matisse. He urged him to believe in himself, and not to feel he had betrayed his former friends ('It was precisely my great love, my great desire for liberty that made me tell you last year "that you would soon leave Divisionism behind"'). Forty years later Derain told Matisse's son-in-law, Georges

Duthuit, that the wholesale smashing of taboos in Collioure had been, for him as for Matisse, an ordeal by fire. 'There was no longer any way we could stand back far enough to see things clearly, and bring about our transposition at leisure. Colours became sticks of dynamite. They were primed to discharge light.'

Matisse painted Derain at Collioure, a delicate centrifugal composition of sharp spring colours – lemon yellow, turquoise, cherry red and chalky blue – exploding outwards from the bony tentative young face with its blank black eyes and drooping black moustache. Derain in his turn painted Matisse at least three times. He gave Amélie the most solidly constructed of these portraits, an impression, relatively conventional in colour (apart from the green shadow spreading like a bruise around one eye), of the kind and knowledgeable older man Derain learned from and looked up to: the dependable, bespectacled, pipe-smoking character who inspired confidence in people like Derain's parents. But Derain also knew and painted a far more unsettling aspect of his friend that summer. His *Portrait of Henri Matisse* – so lightly drawn that the ghostly body scarcely emerges from the bare canvas – catches his friend red-handed, clutching a paintbush dipped in red, white-faced with a red splodge encircling his neck, more like a ligature than a beard. Matisse kept this image of a man possessed, or blown out of his mind, to the end of his life. Duthuit described a tension so extreme in the summer of 1905 and its immediate aftermath that those closest to Matisse risked being sucked in with him to the verge of breakdown or vertigo. 'The obvious forebodings experienced by the painter – who is at the same time so prudent and so orderly that people call him "the Doctor" – made him tremble. During the few years when he was able to endure this vision, Matisse spent whole nights without sleep, nights of desperation and panic.' Matisse would never again be free from the corrosive insomnia that attacked him in Collioure, where Amélie read aloud to him through the interminable nights, sometimes until dawn.

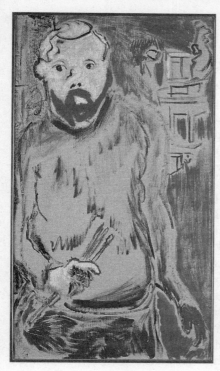

Matisse painted by Derain in the summer of 1905, when the colours in their hands became sticks of dynamite

It is not easy to understand today how paintings of light and colour, mediated through scenes of simple seaside domesticity – a view of fishing boats above pots of scarlet geraniums on the studio windowsill, Amélie wrapped in a towel or seated barefoot on the rocks – could have seemed at the time, both to their perpetrator and to his public, an assault that threatened to undermine civilization as they knew it. But Matisse was not simply discarding perspective, abolishing shadows, repudiating the academic distinction between line and colour. He was attempting to overturn a way of seeing evolved and accepted by the Western world for centuries, going back to painters like Michelangelo and Leonardo, and before them to the Greek and Roman masters of antiquity. He was substituting for their illusion of objectivity

a conscious subjectivity, a twentieth-century art that would draw its validity essentially from the painter's own visual and emotional responses.

He did it by following clues that were already present in the first painting he ever made as a lawyer's clerk in Bohain. 'I found myself or my artistic personality by considering my early works. I discovered in them something constant which I took at first for monotonous repetition. It was the sign of my personality, which came out the same no matter what different moods I passed through.' Matisse's fierce unrelenting interrogation of his own darkest moods and instincts felt at times like madness. It took all his resources of nerve and imagination to impose a previously unimagined equilibrium on what seemed the fevered images of a disordered brain. Sometimes he feared that the blazing colours he had let loose would end by making him go blind, like Cross. After their two hectic months in Collioure, he never worked again with Derain. In a sense it probably would not have mattered which of his friends answered the calls he sent out at the beginning of the summer. Derain brought youth, strength, boldness, a deep and cultivated understanding of the rules he and Matisse set themselves to break. Above all he gave, and took, the courage each needed from the other for the final passage that had to be made alone on canvas from the old world to the new.

The Matisses left for home at the beginning of September, stopping on the way to drop off Pierre with the Parayres in Perpignan. The two households had set up what became over the next decade and more a regular summer pattern of visits, Berthe accompanied by her pupils or her parents coming by rail to spend the day at the seaside in Collioure, the Matisse children travelling in the opposite direction. Pierre, who was asthmatic, would spend the next few winters in Perpignan so as to avoid the risk of another bout of pneumonia in Paris. Marguerite, whose damaged larynx made her particularly vulnerable, moved back to the quai St-Michel so as to be under her parents' eye that autumn, while Jean took her place with

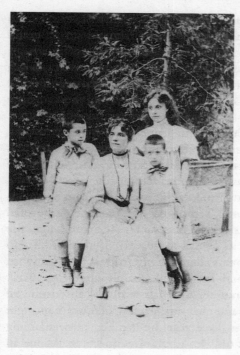

*Jean, Marguerite and Pierre
Matisse with their aunt
Berthe at Perpignan*

their grandmother at Bohain. Anna Matisse kept the household at the quai supplied with baskets of fresh produce and provisions from the shop, sent up on the train to Paris twice a month. Hippolyte Henri had long since accepted defeat in the battle to retain his elder son. Matisse reported that communication with his father had shrunk to little more than brief exchanges when he arrived for a visit, or left afterwards ('"Things going all right in Paris, are they?" "Yes." And that was all'). But without steady support, material as well as moral, from both sets of parents-in-law the painter's family could scarcely have survived these years of poverty and dispersal.

Matisse brought back with him from Collioure fifteen canvases, forty watercolours and 100 drawings. 'Matisse and Derain have done some stunning things,' Marquet reported to Manguin on

8 September. A week later Matisse received a visit from Signac's friend, Félix Fénéon, reputed to possess the best eye for modern art in Paris. A lifelong champion of new talent, with an ironic sense of humour and anarchic instincts, Fénéon was about to give up art criticism in order to launch a new contemporary section of the affluent and solidly respectable Bernheim Jeune gallery. In due course he would become the only dealer by whom Matisse never felt let down. 'Fénéon, as a good anarchist, planted Matisses among the bourgeoisie from the backroom at Bernheim-Jeune as he might have planted bombs,' wrote one of Moreau's pupils, Maurice Boudot-Lamotte.

Matisse's financial situation had once more touched rock bottom. He had accepted a proposal for a second one-man show in the spring of 1906 from Eugène Druet, an ex-barkeeper scarcely more prosperous at this stage than Berthe Weill. No further offer came from Vollard (who paid 3,300 francs to Derain that autumn, and continued steadily acquiring work from Manguin and Marquet). All Matisse's good intentions of bringing back saleable merchandise from Collioure had gone for nothing. For the past three years he had been living largely on a dwindling store of old work but, now that his relationship with tradition had finally been dislocated, he could no longer replenish his stock of relatively conventional landscapes, flower-pieces and still lifes. The position was so desperate that on a black day in the autumn of 1905 Matisse even contemplated selling Cézanne's *Three Bathers* (fortunately the Bernheims declined to buy on the grounds that the 10,000 francs at which Matisse valued his Cézanne was wildly unrealistic). Few of his friends were in any position to offer practical help except for Signac, who bought *Luxe, Calme et Volupté* for a handsome 1,000 francs.

Still a nominal Divisionist, Matisse now set to work in earnest on *Port d'Abaill*, the canvas planned since the beginning of the summer: 'I'm doing it in petit point,' he wrote to Bussy, 'which makes slow going, especially since it doesn't always work the first time.' The Divisionists' dots, or *points*, which twelve months

before had seemed to promise a glorious liberation from academic orthodoxy, had come to feel to Matisse by this time like repetitive, laborious hand-stitching, doggedly pursued according to fixed rules to a pre-arranged conclusion. The finished painting has its own subdued but golden light, together with a disarming comicality, as if the tiny figures turning the capstan or mending nets were only too well aware of the absurdity of their creator's plight. Work on *Port d'Abaill* dragged on too long for it to be included in the 1905 Salon d'Automne. When Matisse eventually took it home to Bohain to show his mother, she was not impressed. 'That's not painting,' she said, whereupon her son took a knife and slashed the canvas. *Port d'Abaill* was the field on which Divisionist theory had fought and lost him. His mother's verdict was as much a release as a rejection. Forty years later Matisse remembered painting another picture for her and 'putting into it, out of tenderness for her, everything that theory could not give him'.

The painting he completed at top speed to show at the Salon d'Automne instead of *Port d'Abaill* was *Woman in a Hat*, which looked to contemporaries like a crude piece of graffiti brutally slashed or smeared across the canvas. People who knew that the painter's wife had posed for it were frankly shocked. The public doubled up with laughter in front of it. The critics used the same insults in public as the people of Bohain uttered behind Matisse's back. Even young artists eager to identify themselves with everything that was new and forward-looking found this latest work hard to take. Matisse's painting became the Salon's star turn that year for spectators who treated the whole show as a circus. He himself had approached the opening with high hopes. For once he felt that he had expressed something of what he wanted in his work, and looked forward with modest confidence to putting it before the public. Others expected trouble. Arriving to inspect the Salon before it opened, the critic Louis Vauxcelles noticed a couple of academic sculptures incongruously surrounded in Room VII by the works of Matisse, Derain and their friends, and made what became a

famous wisecrack: 'A Donatello among the wild beasts [or *fauves*].' The popular hue and cry culminated in a double-page spread in the magazine *L'Illustration*, dominated by Matisse's *Woman in a Hat* and *Open Window*.

In retrospect Room VII looked liked the operations centre for glorious insurrection, 'invaded every evening by long lines of revolutionaries, pouring down from Montmartre . . .' according to the curator Raymond Escholier, 'much as a century earlier streams of rioters from the faubourg Antoine descended on the National Convention'. Pablo Picasso (who had not yet met Matisse) felt he had been decisively outflanked. Matisse himself cheerfully admitted afterwards that even the derogatory nick-name had done no harm at all ('Frankly, it was admirable. The name of Fauve could hardly have been better suited to our frame of mind'). But at the time the whole affair was a replay, acted out in the full glare of national publicity, of the jeers and pointing fingers Matisse had endured for years in Bohain. In spite of his best resolutions not to go, Matisse found himself constantly drawn back to the Salon, and to the sound of braying laughter inspired by his pictures in Room VII. He had dreamed as a child of growing up to be a clown, and now the dream had turned in reality to nightmare.

A week before the salon closed a telegram arrived, containing an offer for *Woman in a Hat* of 300 francs, or 200 francs less than the asking price. Nothing else had sold. Morale was lower and money tighter than ever before. It was typical of both parties that, whereas Henri's impulse was to accept, Amélie insisted on sticking out for the full amount. After several days of mounting tension, the original terms were accepted in a second telegram, which Matisse opened and read with such a strange expression that his wife was terrified. 'I was winking at you,' he said, 'to tell you, because I was so moved I could not speak.' The buyers were two Americans, a brother and sister, Leo and Gertrude Stein. They made a conspicuous pair – one tall and thin, the other short and stout – in their flat sandals and matching bright brown corduroy suits. They were already

beginning to be familiar in and around the rue Lafitte, where Berthe Weill had tried in vain to bring them to the point of buying ('Matisse interested them . . . they didn't dare. "Believe me, buy Matisse," I told them . . . but the paintings weren't quite ripe yet'). In fact it was Sarah Stein, the wife of Leo and Gertrude's elder brother Michael, who fell for the painting and managed after much argument to overcome the others' doubts. It was late November by the time the Steins finally plucked up courage to make their offer only to have it turned down by Amélie.

However demure Matisse's wife might seem in public, in private their partnership was already closer to an active collaboration than the unequal relationship between artist and muse promoted as the ideal of their generation. Amélie's recklessness matched and at times outdid her husband's. 'As for me,' she said with reason in old age, 'I'm in my element when the house burns down.' *Woman in a Hat* is among other things a portrait of Amélie's courage, her will and her passionate, exacting faith in the painter. When Picasso made a famously totemic *Portrait of Gertrude Stein* in 1906, he said, in answer to protests that the sitter did not look like his image of her: 'She will.' The same thing happened with Matisse's 1905 paintings of his wife, which seemed chillingly inhuman at first sight to both the public and the critics. Amélie's friends not only recognized the resemblance but insisted that, the older she grew, the more striking the likeness became. Matisse painted a third Fauve portrait that winter, *Interior with a Young Girl (Girl Reading)*. The canvas shows the eleven-year-old Margot in her working pinafore, absorbed in a book, with her head propped on one hand, at the table with the chocolate-pot and fruit-stand familiar from innumerable still lifes, in the studio on the quai St-Michel. This painting of his daughter is also in a sense a picture of the burning house that brought out the best in Matisse's wife: the house of art going up in flames along with its traditional fixtures and fittings. Marguerite posed at the still centre of a chromatic conflagration as Amélie had done in *Woman in a Hat*.

Matisse's eldest child was already the third pole around which
the life of the studio and the household revolved. Brave, reso-
lute and uncompromising, Marguerite could be (and was for
the rest of her life) relied on absolutely by her parents and her
brothers in small things and large. Even as a little girl, she took
over the shopping, cleaning and child-minding, all the jobs that
would have been performed in a less hard-up household by a
maid-of-all-work. It was Marguerite who ensured that Amélie
was free to pose, or rest after staying up into the small hours
reading to her husband. The child was nicknamed 'the Doctor',
like her father, and her life was shaped, as his was, by the pull
of duty. The fracture that had split her world when she was
three made her turn outwards, locating her sense of security
and self-respect in concern for other people. Her father's studio
represented, more perhaps for Marguerite than for any of the
others, a human and imaginative refuge from the long series
of ordeals that shook, and very nearly shattered, the Matisse
family at the beginning of the century.

They survived by closing ranks for mutual protection and
defence. Throughout the next decade, the years in which Matisse
took the greatest risks of his career, his family provided the
support system that made it possible for him to function as an
artist. His wife's determination never failed him. His children, at
home from infancy with Fauvism and Cubism, prided themselves
on being a wild beast's cubs. All the young Matisses responded
to the paintings in the studio frankly and directly. They were
taught from earliest years to look closely and to describe their
responses clearly to their father (who learned from what they
saw in his pictures as much as from what he found in theirs).
They grew up watching their parents engaged day in, day out,
in unremitting labour. Matisse's painting provided not only the
context of his children's life but its meaning. 'I know the place
your paintings occupy in our family,' Pierre wrote to his father
after he left home: 'each of them represents a period, a fresh
enrichment for all of us, each one takes a place whose importance
you don't fully realize until after it has disappeared.'

In October 1905, Matisse exchanged the cramped working conditions of the quai St-Michel for a larger room, rented cheaply in an abandoned nunnery, the Couvent des Oiseaux, on the corner of the rue de Sèvres and the boulevard Montparnasse. He needed more space to work on a portrait of Mme Signac, which was ironic, since the canvas that preoccupied him above all else in his new studio precipitated what turned out to be a final showdown with her husband. This was *Bonheur de Vivre [Joy of Life]*, the painting Matisse called 'my Arcadia'. It marked a decisive victory in the lifelong battle which was a struggle with himself – an attempt to lay to rest his own perturbed spirit – as much as with an outworn pictorial language. In this new canvas he finally broke through to the realm of sensuous and luxuriant calm that had eluded him in *Luxe, Calme et Volupté*. Nothing could be simpler, clearer or more restful than *Bonheur de Vivre*, with its Arcadian personnel of nymphs and lovers – embracing, dancing, making music or relaxing beside the sea – treated as decorative elements in a rhythmic pattern of flat areas of plain colour.

In *Bonheur de Vivre*, more than in any other single canvas, Matisse mastered the lesson he had set himself in his first summer at Collioure: 'how to make my colours sing'. The painting took its title from the town's Catalan motto, and its setting from the beach at l'Ouille. The ring of dancers in the middle ground looks back to the ancestral round dance of Collioure fishermen, and forward to the barbaric modernism of Matisse's own *Dance* in 1909. The colour is as exalted as only he could make it, and as earthy as the fruit and vegetables his friend Paul Soulier described in Collioure market ('you will rarely find another such image of abundance, of the ease of living, of well-being within everybody's reach'). This was the democratic concept of luxury Matisse had imbibed in infancy from the silk-weavers of Bohain. In the last years of his life he came to feel that his entire career might be construed as a flight southwards, away from the dark, narrow and constricted world of his northern upbringing. He recognized clearly enough the inner pressures

that demanded and denied him rest. But his art was grounded
to the end in the northern sensibility that gave him on the one
hand his matter-of-factness, his obstinacy and perseverance, on
the other the austere concentrated feeling he shared with the
great Flemish masters: an intensity released again and again at
crucial points in his development as a painter by the light and
colour of the south.

Signac, who was one of the first to see *Bonheur de Vivre* on
a visit to Matisse's new studio, was frankly appalled. 'Matisse ...
seems to have gone to the dogs,' he wrote on 14 January 1906.
'Upon a canvas of two and a half metres he has surrounded
some strange characters with a line as thick as your thumb.
Then he has covered the whole thing with flat, well-defined
tints which – pure though they may be – strike me as disgusting.'
Having reluctantly tolerated Matisse's aberrations at the Salon
d'Automne, Signac saw this new painting as a betrayal, and said
so in a recriminatory scene staged in public when the picture
went on show at the Salon des Indépendants in March. After
that relations between the two painters came to a full stop.
Bonheur de Vivre was Matisse's only submission to the Salon, a
gesture of courage and defiance that provoked the public even
more than *Woman in a Hat*. 'Matisse had the greatest success of
his career in terms of hilarity that year,' wrote Berthe Weill.
Half a century later the memory had not faded. 'Parisians who
can still remember the event say that from the doorway, as they
arrived at the salon, they heard shouts,' wrote Janet Flanner in
the 1950s, 'and were guided by them to an uproar of jeers,
angry babble and screaming laughter, rising from the crowd
that was milling in derision around the painter's passionate view
of joy.'

For the second time in less than six months Matisse had
been turned into a cabaret act or circus turn. One of the
imaginative young jokers who hung out with Picasso at the
Lapin Agile in Montmartre had the bright idea of defacing a
set of posters designed to warn against the toxic properties of
lead paint, so that handbills stuck up outside the local urinals

now read: 'Painters, stay away from Matisse!' 'Matisse has caused more harm in a year than an epidemic!' 'Matisse drives you mad!' The popular press weighed in with relish. More responsible critics were baffled or sardonic. A Matisse retrospective of some sixty works from the past decade opened, the day before the Indépendants, at Druet's enterprising and unexpectedly successful little gallery on the faubourg St-Honoré. Matisse had painted a cheerful placard with gaily coloured sailing boats bobbing about beneath a beaming sun to hang in Druet's window, but the only reviewer to notice the exhibition warned the public not to be taken in by the tricks of a meretricious showman. Druet was an inspired salesman with a cool head and a sharp nose for business. His response to outrage among potential clients was to lay in a stock of Matisse's latest work, for which he paid 2,000 francs in April. The painter grumbled that the original agreement had been for half as much again, but Druet was the first after Berthe Weill to specialize in young contemporaries (Marquet, Manguin and Camoin all showed with him) and his confidence was worth having. Competition stirred Vollard at last to snap up 2,200 francs' worth of Matisse's early work in the same month as Druet. Both could sense a tide on the turn well before the swell alerted other people.

Signs of impending change were small but discernible that spring. Matisse had shown the previous autumn with a little band of provincial pioneers at Troyes, and he showed again in May with the Modern Art Circle of Le Havre (newly founded by a local house-painter and decorator, Charles Braque, whose son Georges had already joined up as a Fauve in Paris). A trickle of similar invitations followed – scattered droplets rather than a steady stream at this stage – as friends and supporters among Matisse's contemporaries slowly wrested control of local art groups in towns and cities all over France. He took part for the first time that May in an international avant-garde exhibition, the Libre Esthéthique in Brussels, and he sent four canvases to a travelling German show described by the alert young Wassily Kandinsky as 'a bomb going off in the heart of Munich'.

Bonheur de Vivre meanwhile made two crucial conquests. The first was the Russian textile magnate, Sergei Ivanovich Shchukin, who visited the Indépendants accompanied by his eldest son, a twenty-one-year-old student from Moscow University, horribly embarrassed by his father's intent response to a painting that made everyone else laugh themselves sick. Something about the canvas transfixed Shchukin. He had been collecting modern art for the past eight years, starting with the Impressionists (he owned a dozen Monets as well as a roomful of Renoirs) and working his way steadily towards the present day. Shchukin looked to paintings as other men do to women for risk, challenge, the excitement of the chase and the lure of the unknown. His relationship with an artist's work went through successive stages: speculative interest, growing absorption, eventual satisfaction as each in turn disclosed its secrets, leaving him free to move on to the next. He was currently involved with Gauguin, whose work he kept discreetly hidden from prurient visitors to his Moscow mansion. He was a short shy man with a head too big for his body and a stutter that made him hard to understand at times. 'Here it is. A m-m-madman painted it,' he said, bringing out his first Gauguin to show to a friend at home, 'and a m-m-madman bought it.'

By 1906 he had already acquired a handful of early Matisses, none of which had so far claimed his full attention. Now he asked Vollard for an introduction to the painter, and paid a call that changed the lives of both men. Over the next decade, Matisse would gain from Shchukin not only the financial backing he could get nowhere else but also – at a time when he desperately needed both – a pictorial courage and ambition as exacting as his own. For the moment, the Russian did no more than pick a canvas to take away, explaining that he needed to test it out for a few days ('If I find I can stand it, and if it still interests me, I'll keep it'). The picture was *Dishes on a Table* from 1900: an early but audacious still life, chiefly startling at that date because of a large area of flat paint with no convincing naturalistic alibi – it might have been the tablecloth, or the

back of another painting propped against the table – filling one third of the canvas with rich, dense, animated red and purply-brown brushstrokes. Shchukin paid up ('I was lucky that he turned out to be able to stand that first ordeal with no problem,' Matisse said cheerfully), and disappeared with the painting back to Moscow.

The second major consequence of the Indépendants was still more encouraging. When the salon closed on 30 April, *Bonheur de Vivre* went home with Leo Stein, who had disliked it intensely at first sight, announcing only after several weeks' deliberation that 'the big painting was the most important thing done in our time'. Leo was thirty-four years old in 1906, a whole generation younger than Shchukin, who was fifty-six. A small but adequate inherited income, based on Californian streetcar stock, enabled him to make a full-time occupation out of his growing absorption in contemporary art. Touchy, boastful and contentious in the company of other men, he had a gift for explaining difficult things simply and clearly, especially to women, and most of all to his younger sister Gertrude. Intellectually and aesthetically the pair were not so much arrogant as righteous in the biblical sense. Both saw themselves as prophets, and neither was in the least surprised when their wild, turn-of-the-century prophecies eventually came true. Their seedy studio apartment at 27 rue de Fleurus would become a prime attraction on the avant-garde tourist trail between the two world wars, largely thanks to Gertrude, whose celebrity grew in direct proportion to the difficulty of reading, understanding or indeed obtaining her rarely published books. But their fame came initially from the legendary picture collection handpicked by Leo.

He said that the very first picture he ever bought (a small item by the mildest of English sub-Impressionists, Philip Wilson Steer) made him feel like a desperado. He acquired his first two works by French contemporaries (one was a *Standing Nude* by Henri Manguin) at the 1905 Indépendants, moving on that autumn to buy his first Picasso within weeks, perhaps days, of

his first Matisse. Over the next few years the Steins filled their walls with paintings, hung at first in a single line at eye height, later two deep, eventually frame to frame from floor to ceiling with as many as five canvases ranged one above another. Painters were fascinated by this unprecedented, unpredictable, constantly updated display. The sums disbursed were never large. When Matisse's prices rose beyond a few hundred francs (largely thanks to Shchukin's intervention), Leo dropped out of the running. But for eighteen crucial months, with no encouragement and no funds to speak of, the Steins bought nearly all the master-pieces Matisse produced. 'In later years people often said to me that they wished they were able to buy such things for such prices,' Leo wrote wryly nearly half a century later, 'and I had to remind them that they also were in Paris then, and had more money than I had.' Gertrude eventually turned against Matisse as her brother's interest in his pictures faded, but Matisse never minimized the debt he owed the Steins. Their belief in him at crisis point had meant as much as their financial backing. In public statements about his past, he placed them ever afterwards firmly at the head of his list of benefactors.

In private he made no bones about the fact that the Stein who mattered most to him, both professionally and personally, was neither Leo nor Gertrude but their sister-in-law Sarah. Matisse always held Sarah Stein personally responsible for the initial purchase of *Woman in a Hat*. She certainly bought *The Green Line* − Matisse's first portrait of his wife, widely held to be as demented as the second − and at least four more of his works that winter. Sarah was as fearless as Gertrude, and she had an eye as fine as Leo's. She delighted in the side of Matisse that struck others as bestial or worse. Her instinct was always for the riskiest, least reassuring canvases. Thirty years later Gertrude would drastically revise the history of the Stein family collections by exaggerating her own role at the expense of her brother's, and writing Sarah's out altogether. It was Matisse who insisted angrily that Sarah was the sharpest and most sensitive of the Steins, 'the one who had the instinct in that group'.

Intelligent, ambitious and hard-up, raised in a rapidly expanding, ruthlessly mercantile San Francisco with the minimal education considered appropriate for young ladies, Sarah reached Paris in her early thirties with a voracious cultural appetite and no academic inhibitions whatsoever. It was her reliance on intuition that spoke directly to Matisse, who had himself known what it meant to be so tormented by provincial narrowness that he charged headlong at the prospect of escape, like an animal plunging towards the thing it loves. After her first encounter with *Woman in a Hat*, Sarah wasted no further time. The full force of a magnetic personality went into furthering Matisse's cause. Many thought her stupid, if not insane. Others found her eloquence difficult to withstand. General bewilderment only increased her confidence in her own judgement. In the spring of 1906, Sarah became the first person to introduce Matisse to the United States, sailing back to visit San Franciso with two canvases that struck her fellow citizens as the gross, mad, monstrous products of a diseased imagination. She and her husband stored the rest of their canvases for the summer at the studio on the rue de Fleurus, where the American holiday tenant complained bitterly that his pleasure in art was spoiled for ever by the Steins' picture show. No wonder he was upset. His living room contained not only the two works by Matisse that had caused mayhem at successive salons, but Picasso's looming, lifesize, seven-foot-high *Boy Leading a Horse*.

The two artists were introduced by the Steins at or around the time of the Indépendants. Picasso, who was twenty-five years old, had moved three years earlier from Barcelona to Paris, where he barely spoke the language and had still not found a dealer. To Picasso and his gang of Montmartre supporters, Matisse seemed at this point even older than his thirty-six years: sleek, well-groomed, enviably fluent, 'the image of an established master'. On top of which, his was already a household name all over Paris (that was the point of scribbling it on posters in Montmartre: the joke would have fallen flat if 'Matisse' had been replaced by an utterly unknown name like 'Picasso'). Some

time in 1906 the Steins took Matisse and his little daughter to see the young Spaniard's portrait of Gertrude. Picasso was on his uppers. He worked, lived and slept with his mistress and a large dog in a cold, humid, barely furnished room in a block of Montmartre tenements, let out to impoverished artists for next to nothing and nicknamed the Bateau Lavoir.

Neither Marguerite nor her father can have been surprised by Picasso's studio with its chaotic clutter of easels, canvases, paints and brushes interspersed with heaps of ash and unemptied clinker from the stove. Marguerite had been brought up in just such a studio. After fifteen years of living from hand to mouth in Paris, Matisse knew all there was to know about squalor, privation, want of coal, food and oil paints. He had survived on handouts, windfalls and dead-end jobs, like the Bateau Lavoir artists, wearing the same cheap practical workmen's clothing as they did until the Humbert scandal forced him to exchange his shabby corduroys for a conventional suit. 'Matisse used to dress as carelessly as Picasso,' said Lydia Delectorskaya, 'it was Mme Matisse who rebelled, and persuaded him to dress correctly.' In the years when his wife's family faced ruin, Matisse – dealing willy-nilly with the police, with truculent crime reporters and intrusive newspaper editors, with prison gaolers, lawyers and court officials – had had no choice but to assume responsibility, and the trappings that went with it. He certainly subdued Picasso at this point. 'Matisse talks and talks,' the Spaniard explained to Leo Stein. 'I can't talk, so I just said *oui, oui, oui . . .*'

Picasso had been shaken by *Woman in a Hat*, and seriously perturbed by *Bonheur de Vivre*. A glance at the Steins' walls was enough to make his own most ambitious work to date look wan, even derivative. Whether or not each recognized from the start (as Picasso later claimed) that theirs was a two-man race, Leo certainly encouraged them to think so. He had singled them out as usual well before anybody else. 'Stein can see at the moment only through the eyes of two painters, Matisse and Picasso,' an apprentice art critic called Guillaume Apollinaire

jotted down on his Indépendants catalogue. But Leo's accolade was also a challenge. Both painters were well aware that, when they got back to Paris at the end of the summer, they would find Leo eagerly awaiting their respective next moves. Both left Paris in May for Catalonia, Picasso heading for Gósol in the mountains on the Spanish side of the border, Matisse for Collioure. He had been looking at the African carvings beginning to fetch up as souvenirs in Parisian curio shops, and he broke his journey at Marseille to take in an exhibition of tribal artefacts from the French colonies. On 10 May, after settling his family in Perpignan, and dropping his bags at the hotel in Collioure, he took the train on to Port-Vendres to board the ferry for what he insisted was a working trip to North Africa.

Backing for this expedition seems to have come from Gauguin's patron, Gustave Fayet, who switched to buying Matisse in bulk in 1906, and whose wine business kept him in constant contact with Algiers. Matisse's first impressions on landing were disappointing. The heat was torrid, the people demoralized, the Casbah full of predatory whores. Algiers itself was an infinitely dispiriting version of the worst aspects of Paris ('a filthy stinking Paris that has been inadequately cleaned for years,' Matisse wrote to Manguin). Trains were so slow and unreliable that Matisse reckoned at least half his fortnight in Algeria was spent travelling. He followed the tourist trail through copper-coloured mountains and dazzling white salt lakes to Batna, a journey chiefly memorable for an encounter on the train: 'I lunched opposite a magnificent Arab, a sort of Arab prince, fair-skinned with wavy hair and fine blue eyes, and a remarkable purity of expression.' The line ended at Biskra, fabled gateway to the Sahara, where Matisse arrived in drenching rain. He was oppressed by the inhumanity and immensity of the African landscape. When he finally saw the desert, it looked to him like a vast shimmering sandy beach unbounded even by the sea. 'Because of the sun – and it's nearly always like that – the light is blinding.'

In Biskra he visited one of the five famous oasis gardens,

which struck him as too rich and strange to paint. The town was already a sexual tourist trap, but Matisse was far less impressed by its substandard belly-dancers than by the carpets in its *souk*. Boldly patterned in red, black, white and yellow, woven on rudimentary handlooms on the desert sand, they were sold in covered arcades by merchants squatting over their wares all day, each with his bowl of goldfish set beside him on the ground. Textiles were paramount in a country rendered largely colourless by the bleaching effect of light. Matisse, born and bred among weavers, always a passionate and subtle lover of textiles, added several Biskran prayer mats to the collection he had started as a student haunting the junk-stalls of Notre-Dame.

Apart from these rugs and a few pots, he brought back little that was immediately useful to him as a painter. He said that much of his time passed in a daze of lassitude or boredom. 'I went from one surprise to the next – without being able to tell if my amazement came from the vastness of the country, or the new types of human being I was seeing, or from purely pictorial emotions.' He painted nothing but a single unpretentious street corner in Biskra. In retrospect he said that, though a fortnight was too short to acclimatize himself or his imagination to the country, it was long enough to leave him with a store of images that would last a lifetime. Some of them – the textiles, the goldfish, the princely Arab – would surface later in his work. At the time it was the blinding light, and how to paint it, that preoccupied him on his return to Collioure. 'Before I left for Africa I had found it slightly insipid, but as soon as I got back it gave me a furious urge to paint.' He got out his comfortable rope-soled sandals and set to work. He needed to regroup, to bring together and organize his impressions, to find out where he was going, and where he had come from ('I think constantly of the work I've done over the past ten years, and I tell myself that the main thing is to be yourself').

Above all he needed the support of other people. When Amélie joined him with all three children at Dame Rousette's hotel beside the station, the family was reunited for the first

time since their summer in Lesquielles three years before. Matisse sketched them all on a postcard for Sarah and Michael Stein: Amélie looking notably young, stern and resolute; himself peering out with a rather more quizzical expression from behind thin-rimmed spectacles above a bushy beard; Margot prepared to pose, serious and sedate in a pinafore and puffed sleeves with a ribbon in her hair; Jean and Pierre (with the caption 'the naughtiest of them all') ready for anything, with jug ears and shaven heads. On 6 June the two boys enrolled alongside the fishermen's sons at the local school. In mid-July Manguin arrived with his wife and children (who were the same age as the Matisse boys) to spend the rest of the summer in Collioure.

Matisse told Picasso it was round about this time that he began to pay attention to the boldness and spontaneity of his children's artwork. Pierre, who had his sixth birthday in June, copied his father's painting of a rose in a pottery jug brought back from Biskra (he sold it to Berthe Weill for fifty centimes, the first step on a path that would eventually make him one of the great twentieth-century dealers in modern art). He also invented a new colour, and remembered all his life how crushed he felt when his father pointed out that there was no such thing. Matisse was plagued as usual by money worries. 'Our children are with us,' he wrote, contemplating the spiralling financial responsibilities he saw no prospect of meeting, 'our three children. It's not up to them to lift their father's spirits when he's depressed.' Playing among the boats on the port that summer, Pierre was already learning to mend nets, splice ropes and tie knots like a professional. He planned to go to sea like his classmates as soon as he was old enough. Twenty years later Matisse still felt a pang at having dismissed his son's ambition to be a sailor as curtly as his father had once opposed his own desire to paint.

The family resumed its routine of swimming, walks and work. Matisse spent much time drawing in the garden of the Villa Palma, a luxuriant jungle filled with huge eucalyptus and magnolia trees, carobs, jujubes, pepper-plants, rare citrus fruit

and pomegranates, garlanded with flowering creepers and
festooned with sweet-scented old roses. Amélie and Margot
posed for him indoors, or on the outskirts of the town. The
Matisses had brought with them an Italian model from one of
the Paris art schools, Rosa Arpino, who had modelled for all
the female figures in *Bonheur de Vivre* the previous winter.
Something about her cheerfulness and vigour, her pert beaky
profile and sinewy body stimulated Matisse, and amused his
wife. Everyone liked Rosa, who was the first in a long line of
models to be adopted as honorary members of the family by
the Matisses. She posed with Marguerite for studies of a standing
or stooping nude washing or being dried in a tin tub, and with
Amélie for a series of women at their toilet. Posing nude was
a problem even for a professional model in Collioure, which
stuck so closely to a Spanish severity in morals that the only
way Amélie could model for her husband was by rising early
each morning, leaving the Hôtel de la Gare at six and walking
through the railway tunnel as soon as the Paris/Barcelona express
had passed, then climbing up into the woods on the mountain
slopes beyond. 'We've been there a dozen times, and we have
never been disturbed,' Matisse explained to Manguin. 'But it
means an hour's walk, and you have to come back at ten or
eleven in the great heat, which is hard.' He painted Amélie with
another naked nymph (presumably Rosa) and two small boys,
one playing a pipe like an Algerian goatherd or a stray reveller
from *Bonheur de Vivre*. He painted her seated in a clearing,
curled up on the grass or washing her feet in a stream, blocking
in her shape and her surroundings with swift impromptu brush-
strokes in flat swirling pools and patches of synthetic colour.

He also painted Marguerite, clutching her hat and veil in a
high wind on the fort above the town. The child posed for
whole days at a time in her first summer at Collioure, reading
in the studio in a high-necked lace-collared dress until the light
failed, when she took off her clothes and pinned up her hair
to pose for a *Standing Nude* in clay. Sculpture once again became
Matisse's testing ground. Everything about the little figure of

his daughter – its symmetrical stance, large head, long arms, short legs, prominent buttocks and belly – suggests how fast he was moving away from anatomical construction towards the radical reinvention of the human body that impressed him in African or Egyptian sculpture. At the end of the summer he made a set of variations on the theme of his *Standing Nude*, pushing it to the limit in opposite directions: in one, the figure was pared down to a classically regular, smoothly rounded torso, armless and headless with legs lopped off above the knee; in another, the clay has been roughed up and gouged out, the hollows of armpit, crotch and belly-button set off against the sharpened protuberances of buttocks, breasts and pinched-off arm-tops.

The original statuette provided a solid defining presence in one of the still lifes that were beginning to dissolve like the landscapes, forming patterns which had less and less to do with traditional distinctions between form and content, foreground and background, horizontal or vertical surfaces. This dissolution had its threatening aspect for the painter as well as for his public. In the still lifes of the next few years Matisse often included one or other of his little clay models of the human figure alongside the two-handled vase or the pottery jug from Biskra, the flowers, fruit and vegetables from Collioure market, which challenged him to impersonal semi-abstract confrontations he found steadily more daunting. 'I feel a fear of starting work in face of objects whose animation has to come from me, from my own feelings,' he would write to his son Pierre in 1940, when the anxieties of war made it almost impossible for him to concentrate on fruit and flowers. Even in his seventies, Matisse still needed human models to soften the harshness of his daily struggles on canvas. 'They keep me there in the middle of my flowers and my fruit, with which I manage to make contact little by little almost without realizing ... then all I have to do is wait for the inspiration that cannot help but follow.'

Inspiration – the phrase Matisse used was *coup de foudre* or thunderclap, which generally means love at first sight in French

– came in 1906 from the Algerian rugs which invaded his canvases that summer. This was the first but not the last time textiles conspired in his painting to disrupt the traditional canons of volume, form and perspective. Other bits of stuff were already beginning to catch his eye and stir his senses, especially what he called his *toile de Jouy*, first spotted from the top of a bus in the window of a Parisian junkshop. The *toile* to which Matisse lost his heart was a piece of strong white cotton cloth, printed with a stylised indigo-blue pattern of leafy arabesques and baskets of flowers. It first turns up as a conventional tablecloth or wall hanging in canvases like the *Guitarist* of 1903, the portrait of *Pierre with Bidouille* and a series of increasingly animated still lifes. In *Still Life with Blue Table-cloth* (1906), the cloth's overhanging skirts seem to rear up while its forking blue arabesques start to infiltrate the objects on the table, licking up the stem of the china fruit-stand, outlining the rim of the water-jug, collecting in a pool of blue beneath a saucer, finally spilling right off the edge of the table as a vivid blue streak in the sombre patchwork of colours filling the upper part of the canvas, which no longer makes any serious pretence at rendering a realistic interior. The subversive ghost of an Algerian prayer mat lurks in the background to this painting. In *Still Life with Red Rug*, painted in Collioure in 1906, the carpet hanging on the wall joins forces with two lengths of red and green material arranged in front of it to overwhelm the standard still life of plate, pan, book, fruit-bowl and watermelon, which ends up as no more than incidental detail in a sumptuous decorative whole.

Things were going so well that Matisse decided to stay on for the winter in Collioure. Amélie took the children back to Paris for the start of the school term in September, leaving her husband behind with Etienne Terrus for company. Matisse was painting, modelling in clay and experimenting with glazed pottery: fat-bellied, brightly coloured, spouted jars inspired by Catalan waterpots, and fired for him by a local factory. He returned briefly for the Autumn Salon to Paris, where even

before he arrived, word had spread about his work in progress. Vollard, primed by Leo Stein, wrote to ask for exclusive viewing rights only to find himself forestalled by Druet, who bought up in advance all the five canvases Matisse submitted to the Salon, and sold them immediately to Fayet. For the first time in the autumn of 1906 collectors competed for Matisse's work. The tides of opinion were flowing fast. The sensation of the Salon was its retrospective showing of Paul Gauguin, whose wood carvings went on display for the first time, and who was promptly adopted as their hero by a whole new generation of young painters. Matisse dropped in at Druet's gallery to find Sergei Shchukin in the act of buying eleven Gauguins, most of them from Fayet, who replaced them with eleven Matisses which he would sell on in turn at a profit. Much as he loved his pictures, Fayet loved even more to see them on the move. When news of Cézanne's death reached Paris in late October, the art world recognized the passing of a modern master. 'At the Salon d'Automne of 1905 people laughed themselves into hysterics before his pictures,' wrote Leo Stein, 'in 1906 they were respectful, and in 1907 they were reverent.'

Some time in the autumn of 1906, Matisse met Picasso at the Steins' studio on the rue de Fleurus, bringing with him a little Congolese Vili figure he had just bought round the corner on the rue de Rennes. Picasso's response was rapid. He dined with the Matisses, refusing to be parted all evening from the statue, and staying up afterwards in his studio at the Bateau Lavoir where the poet Max Jacob found him next morning, surrounded by drawings of a one-eyed, four-eared, square-mouthed monster which he claimed was the image of his mistress. Derain acquired a Fang mask from Gabon round about this time, and hung it in his studio with the Fauve landscapes that seemed to his friends to look like nothing on earth. Over the next few years, as the triple impact of Gauguin, Cézanne and African art finally unseated the old gods of custom, decorum and academic propriety, this sort of unearthliness would become a prime criterion for the new art. In the short term it solved

Picasso's problem with the *Portrait of Gertrude Stein*, which he had abandoned without a face after ninety sittings at the beginning of the summer. He completed it in the sitter's absence by painting in the mask-like features which, as he rightly said, she soon came to resemble.

Matisse for his part painted his Congolese figure only once, as part of a still life which he never finished. Gertrude Stein said that he absorbed the essence of African art (as he had assimilated the influence of Cézanne) internally rather than through his eyes: 'Matisse through it was effected more in his imagination than in his vision. Picasso more in his vision than in his imagination.' Henri returned south alone in November, stopping off for a week on the Mediterranean coast at l'Estaque to see a bunch of competitive young Fauves, including Derain, with whom he laid a bet as to which of the two could produce the finer blue nude. The challenge beckoned and tormented him all through that winter in Collioure, where his wife and daughter joined him in a rented house near the station on the outskirts of town. Marguerite had fallen ill again in Paris, as she was apt to do at the onset of winter. She had nearly died of typhoid five years earlier, so this time Amélie took her south as soon as she was well enough to travel. She never forgot the new painting hanging on the wall with its paint still wet to greet them, a sombre sculptural *Standing Nude (Nu au linge)*.

Matisse painted himself at Collioure with harsh jabbing brushstrokes, his head outlined in black and blue, greens scudding across his face like storm clouds. It was a self-portrait that seemed to his contemporaries to strip him bare emotionally as well as physically. When Sarah Stein bought it, Gertrude remarked 'that she felt it was "too *intime*" to be casually hanging upon one's wall'. Matisse persuaded a reluctant local boy to sit for a portrait that used the same smudged colour and scratchy abbreviated drawing. The slumped body and straddled legs of this *Young Sailor*, his drooping head, thick nose, full lips, the red and green shadows bruising his forehead and chin, all forcefully convey physical constraint, the difficulty of holding still, perhaps

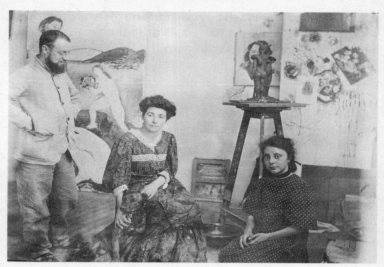

Matisse with Amélie and Marguerite in the studio at Collioure, 1907

the painter's own buried memory of how it felt to be a captive
adolescent. A second canvas, *Young Sailor (II)*, is a graceful, debo-
nair, rhythmically condensed transposition of the first. Matisse
also painted a still life, *Pink Onions*, which, like the *Sailors*, has
the directness of a child's painting. The drastic simplification of
these canvases made him so uneasy that he passed them off to
friends in Paris as the work of the local postman ('You're lying,
Matisse,' said Jean Puy as soon as he saw *Pink Onions*, 'you
painted it yourself').

The most extreme of Matisse's experiments grew from the
sculpture of a nude in a classical pose, leaning on one arm with
the other raised above her head, which he called *Aurora*, or *Dawn*.
Barely contained within the compass of her rectangular plinth,
Matisse's figure exudes energy from the crown of her jutting
hairdo through the sharply articulated twists of shoulder, hip and
thigh to the ball of her thrusting foot. He worked on this clay
figure for weeks. *Reclining Nude (Aurora)* absorbed him to the
exclusion of all else, until catastrophe struck in early January.

Alerted by a crash followed by cries from the room above, Amélie rushed upstairs to find the figure smashed to pieces on the floor. Her solution was to remove her husband bodily from the scene of disaster. She took him for a walk as she had done two years earlier, when he was beside himself after a row with Signac over a similar setback in St-Tropez. Once again the crisis seems to have cleared a mental blockage or, in Matisse's phrase, kicked the door down. Next morning, even before he set himself to pick up the clay pieces, he recaptured the essence of his figure with heightened confidence on canvas.

This was the *Blue Nude: Memory of Biskra*. The central figure combines the globular weight and fullness of African art with the equilibrium of Cézanne against a flat decorative frieze of fan palms. For all its compact, writhing pose, the clay *Reclining Figure* remains the naked body of a woman of the period with neat chignon and nipped-in waist. The *Blue Nude* is by comparison inhuman. It seemed prodigiously ugly and misshapen to virtually everyone who saw it. 'Matisse distorted more than he wanted to distort . . .' wrote Leo Stein. 'He told me that at every beginning of a picture he hoped that he could end without any distortion that would offend the public, but that he could not succeed.' On 12 February Manguin wrote to warn Matisse to keep his prices up, 'for Druet, Vollard and perhaps Fénéon will be haggling over your canvases'. Ten days later Fénéon offered a one-man show with Bernheim-Jeune, following his letter as soon as Matisse reached Paris with a visit to the studio, where he bought three paintings and proposed that Bernheim-Jeune should purchase the bulk of all future production in return for prior rights over other dealers.

Blue Nude: Memory of Biskra was the only canvas Matisse showed at the 1907 Indépendants in March. For the third time in eighteen months, he scandalized the public, bewildered the critics (who described the new work as indecent, atrocious or reptilian), and stopped the art-world in its tracks. Rumour said that Derain destroyed his own painting of blue nudes after seeing Matisse's. For the third time, the canvas that caused

greatest outrage at the Salon was bought by Leo and Gertrude Stein, who were learning to gauge the success of their collection by their friends' consternation. A twenty-three-year-old New York art student called Walter Pach visited the rue de Fleurus for the first time that year and found himself faced with one or other of Leo's two notorious Matisses, *Blue Nude* or *Bonheur de Vivre*. "'Does that interest you?' asked Picasso. "In a way, yes ... it interests me like a blow between the eyes. I don't understand what he is thinking." "Neither do I," said Picasso. "If he wants to make a woman, let him make a woman. If he wants to make a design, let him make a design. This is between the two.'"

6. *The Greatest of the Modern Men (1907–9)*

Sarah Stein bought the little clay *Reclining Nude* as well as the self-portrait that seemed to her sister-in-law too disturbing to hang in the house. She also bought *Pink Onions*, and the more challenging of the two *Sailors* for which Matisse disclaimed responsibility even to close friends. He was acutely aware of the incomprehension and disgust that cut him off from other painters. The more sensitive and highly trained the eye, the more it was repelled by his latest work. Young Walter Pach found reassuring echoes of El Greco and Toulouse-Lautrec in the Picassos he saw hanging at the rue de Fleurus, and he recognized the logical conclusion of a venerable tradition in Van Gogh and Cézanne. 'All three men were therefore easily connected with what I already knew,' wrote Pach: 'Matisse was of the present, and I fought it in my mind . . .' Coming to terms with Matisse meant jettisoning everything Pach had learned at art school as well as in the great museums of Europe, and the battle lasted a whole year.

It wasn't only his beard and glasses that made Matisse stand out from the crowd centred round Picasso at the Bateau Lavoir. The worrying thing about Matisse at this point was the fact that even the most iconoclastic youth could not make head or tail of his paintings. Picasso himself had gone to ground in the spring of 1907, shut up in his studio, working on a response to *Bonheur de Vivre* which became, after the opening of the Indépendants, an even more urgent answer to the *Blue Nude*. Few people saw this latest work in progress (it would not be officially known as *Les Demoiselles d'Avignon* until its first public showing almost a decade later). Those who did found it as baffling as the stuff Matisse was currently producing. Picasso, who had instantly seized the point of African art the year before,

seems to have been the only painter to take seriously Matisse's new interest in children's painting. When the two exchanged canvases in 1907, the Spaniard picked a portrait of the Frenchman's daughter painted with a child's expressive force and flatness, down to the name MARGUERITE printed across the top in shaky capitals. Picasso's friends assumed that his choice was part of their everyday routine of sending up Matisse and used the portrait of his daughter as a target for games of darts in their leader's studio. 'A hit! One in the eye for Marguerite!' 'Another hit on the cheek!' they cried (their darts were toy ones, with suction pads instead of steel tips, so that the players could relieve their feelings without leaving lasting wounds).

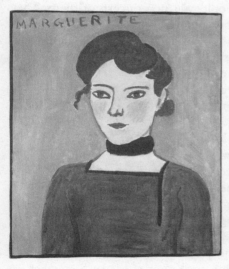

Matisse, 'Marguerite', 1907:
the painting Picasso's gang
used for target practice

Marguerite Matisse was thirteen years old in 1907. Her confidence, damaged in her early childhood and patiently rebuilt by her second mother, was bound up in her role as her father's model-cum-studio-assistant. She would have been a familiar figure to anyone visiting Matisse, as Picasso regularly did at this time, turning his famously rapacious gaze on each fresh development, even going so far as to adopt a thirteen-year-old

'daughter' himself in May (this was the orphan called Raymonde who had to be sent back to her orphanage four months later, when Picasso showed signs of the wrong sort of interest as a foster-parent). There was an element of schoolboy thuggery in Picasso's gang of acolytes, mostly in their early or mid-twenties, all hard up, ambitious and on the make. Matisse had come up against this kind of bullying all his life. Stigmatized at home as a disgrace to his family and the world he came from, he was now accused of being irredeemably bourgeois by a younger generation who knew nothing of his past, or the public scandal that had taught him to avoid exposure at all costs. The gnawing anxiety about his painting, for which Matisse sought constant reassurance from other people, was no concern of theirs. They saw him as a humourless bore, more like a lawyer than an artist, endlessly pleading the cause of his own work. This view would eventually find its fullest and most persuasive expression in Gertrude Stein's account of bohemian Paris, *The Autobiography of Alice B. Toklas*, published in 1933 when Matisse's protests at inaccuracies and distortions only served to reinforce the book's view of his stuffiness.

One of the few outside his immediate family who understood the implacable side of Matisse's nature – the wild beast or *fauve* concealed behind a protective screen of sobriety – was Sarah Stein. She had lost her heart to Matisse's *Woman in a Hat* so completely that she told him she could never again feel at home without his canvases hanging on her walls. Matisse said that Sarah's certainty sustained him in his worst crises of 'work, turmoil and anxiety' in the years up to and including the First World War. Their friendship took root after the Steins' return from San Francisco. Far from being deterred by the American reaction to Matisse's paintings, Sarah made up her mind to collect nothing else from now on, a proposal cordially seconded by her husband Michael. She spent the early months of 1907 weeding out their collection, selling or swapping canvases by other painters, and snapping up a dozen of Matisse's most recent works, including *The Serf*, the *Woman in a Hat* and the *Blue*

Nude, all bought or borrowed from Leo and Gertrude. Sarah and Michael put together in the end a spectacular display of more than forty paintings and at least half a dozen bronzes, mostly dating from 1905–8, the years in which the Steins could take their pick of Matisse's canvases 'even before they were dry' (this state of affairs stopped once Bernheim-Jeune started reckoning prices in thousands rather than hundreds of francs).

Matisse was intrigued by a collector who could keep pace with his boldest leaps into the unknown. Scarcely a week passed without her visiting his studio, or his bringing something for her to see. He showed Sarah his canvases, as he showed them to his family in the studio, newly finished, with the paint still wet, at the point when he most needed to know how they looked to other eyes. Sarah, who realized the extent of his inner turbulence, prized above all the purity, serenity and grandeur of Matisse's paintings: 'qualities which are yours par excellence,' she wrote to him in 1926. Her criticism meant as much to him as her admiration. If she did not like a painting – if something in it struck her as discordant or incomplete – she said so. Matisse trusted her instinct as he did his mother's. 'It penetrated my spirit and my heart at a single glance,' she wrote to him of his *Aubergines* in 1911. 'In looking at it, I felt that emotional completeness which convinces me of the reality of a work of art without the need to analyse it.' For three decades Matisse relied on Sarah's judgement, which grew, as he said, from 'an exceptional sensibility and a complete knowledge of the road I've travelled'. When she finally returned to America in 1935, he wrote sadly: 'It seems to me that the best part of my audience has gone with you.'

Their relationship spilled out from the start to include their families on seaside holidays and riding excursions in the Bois de Boulogne. The Steins' huge airy white-painted living room on the rue Madame became a private gallery, where Sarah took her visitors' breath away by hanging as many as twelve major Matisses on a single wall. 'I had never before seen such glowing colour, such living colour,' wrote the journalist Harriet Levy,

who followed the Steins to Paris from San Francisco. 'People came from all over the world to see them. This was the only place where one could see them.' Like Leo and Gertrude, Sarah and Michael were at home one night a week to streams of inquisitive visitors – mostly young, nearly all foreigners – who came to inspect what was widely held to be a freak show. Sarah, whose conviction was mesmeric at close quarters, taught that Matisse's painting opened the way to a new world that could be perceived only by a fundamental shift of vision.

The best account of her methods comes from her old friend Harriet Levy, who loathed the *Blue Nude*, with its bulbous breasts, protruding belly, flaunting buttocks and muscular thighs, until, one night alone with Sarah, she underwent a quasi-religious conversion. 'Something happened to the painting . . . It moved me as I had never before been moved by the extent of its grandeur, its beauty . . . it was a realization of power, of abstract power, beyond any I had ever seen expressed in natural figures or even in a tree. In fact I saw that the artist was searching within himself for the emotion of which he was not yet fully aware.' Over the next few years Harriet built up her own small but choice Matisse collection, and watched a whole procession of rich Americans reluctantly succumb to the spell of their hostess at the rue Madame. 'When they were with Mrs Stein they were hypnotized and ready to buy Matisses. When they left her, demesmerized, they did not understand or have confidence in them . . . They were afraid of the brilliant canvases. They couldn't bear the violence of them. They were afraid to buy them, they were afraid not to buy them. Afraid they would turn out to be the important paintings the Steins said they were.' Of all Sarah's conquests, perhaps the most impressive was the legendary connoisseur of Italian art, Bernard Berenson, who found the *Blue Nude* so repulsive that he nicknamed it 'the toad'. 'If you can ever convince me of any beauty in that toad, I'll believe in Matisse,' Berenson told Sarah, who promptly invited him to dinner with the painter. The two got on famously, debating comparative aesthetics, exploring a shared passion for

design, each recognizing in the other an eye so fine that, by the end of 1908, Berenson was writing to the New York press to champion Matisse, from whom he bought a painting himself the year after.

The Steins' converts commonly burned with missionary zeal when they returned to their own countries. Young Walter Pach would be one of the organizers of the Armory show in New York, which introduced Matisse and his fellow painters to America in 1913. Pach's German contemporary, the painter Hans Purrmann, had been as horrified as anyone else by *Woman in a Hat* at the Steins ('It was like a blow to the head'), until, by his own account, he too suddenly woke up and went home to contact dealers, drum up patrons and help put on Matisse's first German exhibition in 1908. It was Purrmann who acted as go-between for Matisse's first professional commission from the enterprising young German collector Karl Ernst Osthaus: a *Nymph and Satyr*, painted on glazed wall tiles for his new house at Hagen in Westphalia. Matisse had started working with ceramics the year before at Collioure and continued at André Metthey's pottery in Asnières, near Paris, where the Fauve painters were warmly invited to colour plain white faience pots and plates. He designed Osthaus's wall panel as simply and sparely as the pots, which he decorated with loosely brushed and highly stylized motifs – flowers, dancers, portrait heads – disposed at intervals on a white ground within the circular rim of a plate, or the curving surface of a vase. In the still lifes of the next few years, these highly recognizable pots would take their place alongside the textiles and clay figurines in the little band of familiars Matisse used to help him disrupt and reassemble established pictorial conventions of form and space.

On 30 April, even before the Salon closed, he hurried back to Collioure, where he had been working solidly with brief interruptions for a whole year. He left his small sons behind in Bohain but his wife and daughter came with him, together with one of his cousins, Germaine Thieuleux, a nineteen-year-old orphan who seems to have been taken in by Matisse's

mother as the daughter she never had. Germaine, who had been gravely ill, was sent down by her Aunt Anna to spend the summer convalescing in the sun and sea air that had done so much for Marguerite and Pierre. Matisse was working on a series of studies – *Music, La Coiffure, Three Bathers* – experimenting with human figures, suppressing their individuality, heightening their expressive force, reducing them to large flat simplified shapes within an overall design. Amélie and Marguerite posed for him, and perhaps his cousin did too. Germaine was handsome in the sturdy Flemish style of the Gérards, very different from the fine-boned delicacy of Marguerite or Amélie's dramatic southern looks, more like the stocky round-faced girl flanked by two others in *Three Bathers*, a strange little painting that would exert a powerful pull on Matisse's imagination.

The peaceful routines of summer at Collioure did not last long. Within ten days of her arrival, Germaine suffered a sudden brutal relapse, deteriorating rapidly, becoming paralysed, drifting in and out of consciousness. Amélie nursed her. Matisse watched in horror. His mother, who was sixty-three years old, made the long, slow, difficult journey across France alone in sweltering heat to find that Germaine had died of a brain tumour, barely three weeks after leaving home. Henri was ill for a month after his cousin died. It was Amélie who accompanied Anna Matisse – both women in black with mourning veils – back to the North, where, after a funeral in the dark church Henri had hated as a child, Germaine was buried in the family tomb. When Amélie finally returned to Collioure with her sons in early June, she collapsed herself. 'I don't think there is such a thing as real tranquillity,' wrote Matisse, attempting to come to terms with what had happened in a long, grimly detailed letter to Manguin, 'I have been pretty much shattered by the sight of my poor cousin.'

The family slowly regained health and spirits encouraged by the local painters, Terrus and Daniel de Monfreid, who laid on boating, fishing and mussel suppers. The whole party celebrated the feast of St John the Baptist in the traditional way with a

bonfire on the beach. When Michael and Sarah Stein arrived for a visit with their young son Allen, all of them went swimming from a dinghy in the bay. In July the Matisses left to visit Leo and Gertrude in Florence, dropping the children off with their aunt in Perpignan, and making a round of studio visits along the coast on the way. This Italian journey was planned as a treat for Amélie, and made possible by a payment of 18,000 francs from Bernheim-Jeune, which meant that for the first time since their honeymoon the couple could travel in style. Amélie told Gertrude Stein that for her the trip was a girlhood dream come true, but Henri himself was distracted rather than stimulated by the riches of the Uffizi galleries and the Pitti Palace. He found it hard to remain patient with Leo, who exasperated him with helpful tips about what he should look at and how. There had been tension between the two in Paris when Leo, who had started painting himself, asked for and got Matisse's frank opinion of his work. There was no actual breach, but Leo never bought another Matisse canvas after this Florentine encounter. The visitors went on to Venice, which proved a second disappointment. Matisse's confrontation with the Italian High Renaissance left him with an uneasy feeling of artifice and sensual excess. Venetian painting seemed to him fatally contaminated by the corrupt princes of church and state for whom it was produced. 'Yes, that comes from my soul,' he said sternly to the poet Guillaume Apollinaire a few months later, 'manufactured for the rich. The artist sinks to the same base level as his patron.'

It was the primitive painters of the fourteenth century who spoke deeply and directly to Matisse on this visit. Leo had taken him for the day to Arezzo to see the frescoes of Piero della Francesca, to Siena for Duccio's *Christ in Majesty* and to Padua for Giotto's Arena chapel. 'Giotto is the height of my desire,' Matisse wrote to Pierre Bonnard long afterwards. His response at the time was passionate and instinctive. 'When I see Giotto's frescoes in Padua, I don't worry about knowing which particular scene of the *Life of Christ* I have before my eyes,' he wrote

in 'Notes of a Painter' (which he began writing almost as soon as he got back from Italy), 'but I immediately grasp the feeling that comes from it, for that is in the lines of the composition, in the colour, and the title can only confirm my first impression.' Back in Collioure by mid-August, Matisse resumed his experiments on a larger scale than ever before, setting his own austere concept of luxury against the earthly delights of the Venetian Renaissance in a seven-foot-high canvas called *Le Luxe*. There are echoes here of Botticelli's Florentine *Birth of Venus*, but the anecdotal meaning of *Le Luxe* – a slender, dark-haired, long-necked woman with one attendant bringing her flowers while another bends to dry her feet – signified no more to its creator than the plot of Giotto's *Life of Christ*. Matisse's painting shows the heights above Collioure, looking across to the rounded hills on the far side of the bay, faithfully observed, even down to the faint pink penumbra which is a local trick of the light at certain times of day. Its point lies in the interaction of the figures with their background, made up of horizontal bands or waves of colour like an Italian fresco. In a second version of *Le Luxe*, Matisse heightened the fresco effect by mixing his paints with glue to make them glow.

In the ten years since he first alarmed public and critics with his *Dinner Table*, Matisse had arrived at an alternative style of extreme individuality and expressive force, combining elements from wildly discrepant sources. He listed some of them for Apollinaire that autumn: the ancient art of the Egyptians, the Greeks and the Peruvians, Cambodian stone carving and African tribal figures (he might have added Algerian textiles). He said he had taken what he wanted from the Western tradition, citing the Italian primitives and Rembrandt. He saw himself and his generation as heirs to the kingdom of European painting, stretching from the perfumed gardens lapped by the Mediterranean to the mighty seas of the continent's northern coast, stagnating at the start of the twentieth century in an interregnum from which instinct alone could find a way out. Well aware that his instincts provoked the public beyond bearing,

Matisse defended himself stoically against charges of crudity, aggression and gross indecency, insisting that all he was trying to do was construct a new plastic language free from outdated grammar and syntax, and that the last thing he had in mind was destruction.

His formal written 'case for the defence' was commissioned by his old friend Mécislas Golberg, who wrote in the summer of 1907, offering to devote the next issue of his small but prestigious art review entirely to Matisse. No one had ever suggested anything like this before. For the first time since he had plunged headlong into painting at the age of twenty, Matisse raised his eyes from the immediate struggle for long enough to look back at the ground he had already covered, and forward to the unknown territory ahead. He delivered his 'Notes of a Painter' on 10 September to Golberg, who forwarded the article straight to his printer. By this time Golberg had lost his race with death. Bedridden for two years in the sanatorium at Fontainebleau where Matisse visited him, he knew well enough that this forthcoming number of the *Cahiers de Mécislas Golberg* would be his last testament. The two men picked illustrations and planned an interview, agreeing that, since Golberg no longer had the strength to write anything himself, he should brief his assistant, whose knowledge of painting was rudimentary and whose art criticism had so far largely consisted of gossipy stories and puffs for his friends (chiefly Picasso).

Golberg's young sidekick was Guillaume Apollinaire, who did nothing for weeks, finally polishing off his interview too late over a hasty dinner with Matisse on 19 November. The result reads like a more or less direct transcription of the painter's answers to questions drawn up by Golberg, who lived just long enough to see his carefully prepared Matisse interview pirated by a rival paper, two weeks before he died at Fontainebleau on 28 December. Apollinaire launched his career as an art critic largely on the strength of this early scoop, pinched, although he never acknowledged it, from Golberg. Matisse's contempt for the poet's criticism (shared by many other painters,

including Picasso and Georges Braque) acquired a bitter twist from memories of this shabby episode.

'Notes of a Painter' remained for the moment unpublished. Its place was taken by Michel Puy's 'Les Fauves', a long and authoritative account of Matisse's development which relegated his fellow Fauves more or less to an afterthought at the end. Puy said that, however sketchy and unpolished Matisse's latest paintings might seem, he found (like his brother Jean) that he could not look away: their potent presence drained the life from everything else at the Autumn Salon. Matisse exhibited three of his new figure paintings: *Le Luxe (I)*, *Music (Sketch)* and a brilliantly decorative portrait of Amélie called *Woman in a Red Madras Robe*. Sarah and Michael Stein bought the last two and borrowed *Le Luxe* from the artist as well. He sold two more paintings to a German couple, the painter Oskar Moll and his young wife, Greta, who never forgot her first sight of Matisse with his glittering eyes, red spade-shaped beard and black sheepskin coat turned wool-side out. Purrmann took the Molls to the studio on the quai St-Michel, where they fell in love at first sight with the bright clear colours – red, yellow and blue – of *Three Bathers*, a small canvas so powerful that it looked to Greta far bigger than it actually was. It was their first purchase in what went on to become one of the finest Matisse collections of its time in Europe.

The pace of pictorial change was accelerating faster than ever, with Matisse generally singled out as its leader. Apollinaire called him the Fauve of Fauves. The Salon was awash with imitators who aimed at reproducing Matisse's style without, as he said, the faintest notion of its underlying structure or logic. Greta Moll remembered a canvas by a Russian woman 'which showed a squatting man sinking sharp teeth into his own leg – you could clearly see the blood running down'. Works like this one drove the Fauve of Fauves to despair. He said his self-styled supporters understood as little as the detractors who had seen germs in his *Dinner Table* ten years before. At some point that autumn Matisse went to the Bateau Lavoir to inspect *Les*

Demoiselles d'Avignon, which struck him as a mockery of every-thing he had fought so long and hard to achieve. Virtually everyone who saw the canvas shared his disquiet. Georges Braque said it made him feel as if he had eaten tow or swallowed petrol. Derain predicted gloomily that Picasso would end by stringing himself up in the studio behind his own *Demoiselles*. Within six months both Braque and Derain had reversed their initial impressions, switching allegiance from Fauvism to the new and still nameless counter-movement led by Picasso. By this time the most powerful propagandists for the modern school in Paris were beginning to split their support. Leo and Gertrude Stein had ceded most of their Matisses to Sarah and Michael, and Gertrude at least had thrown her massive weight behind Picasso. From now on she did what she could to encourage opposition between Matisseites and Picassoites.

The two artists had embarked on what would become a lifelong dialogue on canvas, a dialogue that was also a duel. Forty years later, looking back companionably with Picasso over their parallel careers, Matisse would compare his own slow process of absorption and assimilation with the enviable speed of Picasso's lightning raids. All ways were open to Picasso (who protested that for his part he had fought against facility all his life), while for Matisse there had only ever been one possible path. The polarity between the two, defined and fostered by the Steins, bred one of the richest and most productive rivalries in the history of Western art. Each pursued a goal that was the opposite of the other's. Matisse, born on a front line, familiar from infancy with the horrors of war, tormented all his life by ridicule, rejection and abuse, sought and obtained in his work the peace and stability he rarely found in his professional or private life. Picasso, relatively sheltered from the disasters of the twentieth century, surrounded from earliest years by admiration and approval, based his greatest art on disruption and disinte-gration. On a human level, Matisse tried above all to distance himself from derisive taunts of clown and charlatan. Clowning became Picasso's second nature. 'He's turning his back on his

own reality,' Matisse said shrewdly in 1951, when he was eighty-
one and Picasso just seventy: 'he's naturally refined; but he wants
to be a peasant, a breaker of clods in heavy working boots.'

In the autumn of 1907, Matisse's reponse to the kind of back-
handed homage that disturbed him quite as much as outright
derision was to redouble his attempts at explanation. He kept
open house in his studio at 19 quai St-Michel one afternoon a
week, when he would bring out his old work to show to visi-
tors, explaining where he had come from and answering
questions about where he was going. Anyone was welcome, but
those who turned up seem to have been mostly foreign art
students, like Purrmann and the Molls. Their unofficial leader
was Sarah Stein, who had started painting, like Leo, and now
persuaded Matisse to teach a small group of friends on a regular
basis. She and Purrmann rented a room in an abandoned nunnery,
the Couvent des Oiseaux, where Matisse already had a second
studio. He inspected their work once a week, giving his services
free (he had to start charging later, to avoid being overrun by
students flocking to a studio with no fees to pay). Most of his
class were or became family friends. Greta Moll, the youngest
at twenty-three, made friends with Mme Matisse and played
with the two studio children, Margot and Pierre (Jean had gone
back to school with his grandmother in Bohain). In December
she made a special German Christmas tree complete with span-
gles, silver balls and candles for the little Matisses.

This was their first Christmas in a new family home. After
fifteen years on one or other floor at 19 quai St-Michel, Matisse
finally moved out in early December 1907, installing himself
and his family in a second empty convent called the Sacré-
Coeur on the corner of the boulevard des Invalides and the
rue de Babylone in the artists' quarter of Montparnasse. The
nuns' huge high white-washed refectory served as his studio,
divided by a partition to make space for his students next door.
The ground floor of a handsome eighteenth-century building
in the convent grounds housed his family, who had never lived
anywhere in Paris except over the shop or in two tiny rooms

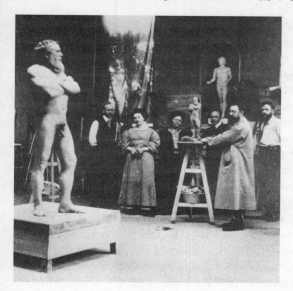

Bevilacqua posing for Matisse's class with Sarah Stein centre back, and Matisse on right flanked by Hans Purrmann and Patrick Henry Bruce

designed for a bachelor artist behind the studio. Nine-year-old Jean came back from Bohain to live at home on an everyday basis for the first time since he was born. His parents hung up paintings, and gave dinners for friends like the Steins and Molls with dishes cooked by Amélie, wines chosen by Vollard, and on special occasions the Italian model, Bevilacqua, dressed in a borrowed suit to wait at table. The nuns' parlour became Amélie's salon, eighteen feet long with tall windows looking out across the tangled garden to the Hôtel Biron (occupied by Auguste Rodin, afterwards the Musée Rodin). The whole place swarmed with hard-up painters and writers. Rainer Maria Rilke lived there at one point, and so did Jean Cocteau. Purrmann and an American called Patrick Henry Bruce moved in on the floor above the Matisses, and two Russian girls lodged in the attics.

Matisse was a daunting and demanding critic. 'Matisse thinks like a painter . . .' Purrmann wrote. 'There was nothing of the

teacher in him, he nearly always remained a student like us.' The advice he gave, based always on experience, involved him in what came close at times to a review of his own past: contemplating old problems, re-examining solutions, assessing the dangers he had faced and the risks still to be taken. The process was as exhilarating as it was nerve-racking for his students. He urged them to analyse form, to search for balance, to concentrate on essentials rather than surface detail. All his students agreed that he was at his most helpful and constructive when he was most practical. He made drawing seem as simple and inevitable as breathing. 'One must always search for the desire of the line, where it wishes to enter and where to die away.' His sense of composition was musical, and he expressed his conclusions in clear and cogent metaphors. Painting was like cooking or carpentry or constructing a house: 'You can see the colours of the skirting slabs, the cornice, the walls and shutters that build a unity, a living unity, which is what a painting needs.'

Much of this was hard for young artists to follow. Matisse made no concessions to their inexperience, and his students listened in silence as he took them step by step through the stages he himself had passed, making them copy classical plaster casts and sending them to the Louvre on Saturdays. He explained colour theory, and demonstrated what he meant in practice. In his own studio next door, in front of his current work in progress, he took down his collection of African batons and tribal figures, handling them one by one to demonstrate their sculptural quality, 'the supple palpitating fullness of form and equilibrium in them'. He showed his students with great pride the works he owned by his contemporaries – figure drawings by Maillol, black-and-whites by Rouault, and van Gogh's beautiful ink drawings. The high point was Cézanne's *Three Bathers*. 'His silence before it was more evocative and eloquent than words. A spirit of elation and awe pervaded the studio at such times.' The enthusiastic little class made up of no more than eight or ten people – all but one foreign, nearly all young,

many away from home for the first time – functioned more like an extended family than an academic institution. Matisse always worked best with his family around him. Later, as word spread and new students enrolled, the school lost both its intimacy and its exaltation. 'Never again was Matisse so open,' wrote Greta Moll, 'so overflowing with willingness to share his knowledge and experience, so stimulating in his clever teaching methods and his talk about art, artists and our own work, as in those first happy months.'

Matisse offered to paint Greta, who had blue eyes, pink cheeks and hair that made him think of honey or ripe corn. The initial sittings produced a striking likeness that infuriated the painter. 'In spite of my best efforts . . . I had got no further than the charming features which were not lacking in my model,' wrote Matisse, 'but I had not managed to catch her statuesque aspect.' He shut himself up with the canvas, eliminating the sitter's golden curls, squaring off her head and hairdo, thickening and coarsening her forearms to rhyme with the swollen arabesques of the *toile de Jouy* in the background. When they saw what he had done, Greta and her husband were appalled. Other models in similar circumstances later would burst into tears, or flatly decline to accept the portrait. The Molls retired to consider their position for two whole days, finally sending word with heavy hearts by Purrmann that they would buy the picture (which cost more than they could afford). 'The painting became ours, and we loved it more and more . . . It is one of Matisse's most beautiful and powerful works,' Greta wrote half a century later, quoting with satisfaction the response of the critic André Salmon to her portrait: 'I could kill the man who owns it in order to call it mine.'

Greta had posed in front of a huge canvas, nearly six feet high by over seven feet wide, bigger even than *Le Luxe*. This was *Bathers with a Turtle*, newly finished in February 1908. Egged on by Purrmann, Karl Ernst Osthaus (whose ceramic *Nymph and Satyr* was finally dispatched that month to Hagen) bought the new painting in March. In April, at the Salon des

Indépendants, Matisse met the Russian collector Sergei Shchukin, who had been buying Gauguins at their last encounter eighteen months before. Now he was ready for a fresh engagement. Invited to inspect the contents of the studio at 33 boulevard des Invalides he responded with passionate intensity to *Bathers with a Turtle.* 'Your picture nearly sent the Russian crazy,' Purrmann reported to Osthaus, 'he kept talking about the colour, and he wanted a duplicate but Matisse refused to paint one.' The austere and sombre canvas that drove Shchukin wild with longing was a drastically condensed and simplified version of *Three Bathers* from the year before. It shows three stylized, almost lifesize figures contemplating a small turtle (in fact a common Mediterranean tortoise) that provides the focal point at bottom centre of a canvas divided into three horizontal bands of colour representing grass, water and sky. 'I think all the time of your ravishing *Sea,*' Shchukin wrote after his return to Moscow: 'I can feel that freshness, that majesty of the ocean, that sense of sadness and melancholy.'

In the spring of 1908, the Russian was at a crossroads. Outwardly as composed and sober as Matisse himself, Shchukin's inner balance had been destroyed over the past three years by a succession of violent blows: the suicide of his youngest son, his wife's sudden death a year later, and finally the suicide of his younger brother, who shot himself in January 1908. He felt that he had lost everything that mattered in his old life, and that his efforts to fill the void by throwing himself into travel, philanthropy or business had come to nothing. In Paris he haunted the galleries of the Louvre, telling Matisse he found the same concentrated force in Egyptian funerary art as in Cézanne's paintings. His visit to Matisse's studio released a flow of frozen or suppressed emotion. Having at last found a living painter whose work spoke to him with such powerful immediacy, Shchukin embarked on what looked to Purrmann like a rampage, 'buying up everything by Matisse he can find in Paris'.

Dealers were stupefied by a collector prepared to shell out

for modern art prices approaching those reserved until now for Salon painting. Shchukin's patronage would transform Matisse's life from a material point of view, but theirs was from the start an imaginative rather than a strictly commercial partnership. No other collector ever nerved Matisse to such efforts as Shchukin, who commissioned three new canvases before he went back to Moscow. He wanted variations on the two works that belonged to Osthaus, *Bathers with a Turtle* and *Nymph and Satyr*, together with a huge decorative panel to hang in his dining room. The commissions could hardly have been better timed. Matisse started work immediately on a third sea-painting, once again setting three vertical figures – this time boys playing bowls – against flat horizontal strips of green grass, blue sky and bluer sea.

The *Game of Bowls* belongs to a sequence of wall panels more ambitious than anything Matisse had yet attempted. His close friends found them almost impossible to comprehend. Even Sarah Stein had hesitated over the vast, flat, daunting expanse of colour in *Bathers with a Turtle*. Shchukin had not only desired this canvas passionately at sight but, when he found he could not have it, immediately commissioned three more. The decorative panel for his dining room was to be more than twice as big, and predominantly blue in order to hold its own against the glowing yellows of sixteen Gauguins already hanging in the same room. The painting would test Matisse's powers to the limit, and for it he returned to the subject he had chosen a decade earlier when Gustave Moreau demanded a test-piece, *The Dinner Table*. All the old motifs reappear in the new version: the window, the upright chairs, the tabletop filling the bottom section of the canvas, the napery, fruit and flowers, the decanters of red and white wine, the maid in her dark dress and white apron. But this time the subject or essential fabric of the painting is the tablecloth itself, none other than the length of *toile de Jouy* that had already imparted its energy to several still lifes as well as to the newly finished portrait of Greta Moll. The blue-and-white cloth with its pattern of arabesques and flower-baskets

expanded to take over almost the entire surface of the canvas in the new *Dinner Table,* or *Harmony in Blue.*

Matisse worked on what he called his 'big still life' on and off throughout the summer of 1908. The family pattern of migration southwards was disrupted that year by the illness of Amélie's mother, who grew steadily weaker, nursed by her two daughters in Berthe's house in Perpignan, while Henri stayed behind in his new studio in Paris to work on the commissions for Shchukin. The completed *Harmony in Blue* was inspected by Vollard and photographed on 6 July by Eugène Druet. Almost immediately Matisse repainted the whole picture red. As the grandson and great-grandson of weavers who tried out their designs as a matter of course in first one colour then another, he insisted this was perfectly normal procedure, explaining to his friend Henri Cross that colour was the driving force in his experiments at this stage. 'He doesn't understand a thing,' Matisse said testily when someone said he had produced a wholly new work: 'It's not a different painting. I am seeking forces, and a balance of forces.' Almost the entire surface of the canvas, more than forty square feet, was now saturated in red paint: an even unaccentuated red seeping like a dye from the flattened tabletop to the wall beyond it, the whole bound together by an overall design in which everyday objects – apples, oranges, lemons, decanters, the elaborate épergne, even the maid fiddling with the fruit-stand – submerge their individuality like instruments in an orchestra within the looping rhythms of the cloth's blue arabesques.

Textiles in Matisse's native region went hand in hand with radical innovation. *Harmony in Red* used the richly decorative tradition into which Matisse was born as a means of overturning the Beaux-Arts ethic which, from his first days at art school, had sought to demean and diminish his commitment to pure colour. When Shchukin saw his eagerly awaited *Harmony in Blue* for the first time in Paris that autumn, he had no problem with the fact that it had become a *Harmony in Red.* People put his acquiescence down to the gullibility of an uncouth, ill-

educated boyar 'familiar with the blood red colour of old Russian icons'. But Shchukin's business was textiles. He had inherited a thriving company that expanded under his management into a textile empire, I.V. Shchukin & Sons, one of the leading industrial concerns in Russia. Accustomed for years to selecting fabrics and supervising design teams, Shchukin understood instinctively the syntax of the new pictorial language Matisse was evolving. He grasped not only the fluency and range of the decorative principle but also its expressive power. 'Decoration and expression are the same thing,' said Matisse, and Shchukin was one of the few who knew what he meant at this stage.

Matisse's laconic letters, reporting progress and setbacks that summer to Shchukin, were punctuated by bad news from Perpignan, where his mother-in-law lay hovering between life and death all through May and June. He was wrestling with the transposition from blue to red when she died in late July. The death of Mme Parayre drew a line beneath the Humbert scandal, which had fatally damaged her belief in herself, and come close to destroying her family. The affair was never again voluntarily mentioned by Matisse's friends or relations, but its legacy ran deep, leaving succeeding generations with a horror of anything that could be construed as an invasion of privacy. Mme Parayre's defiance of her tormentors in the press lived on in her descendants. So did her proud policy of silence and inscrutability, which came in the long run to seem more like bourgeois stuffiness to a world that had no inkling of anything hidden below the surface of the past. Matisse had loved his parents-in-law, and done everything in his power to protect them in time of need, but the private catastrophe round which the family closed ranks in self-defence would insidiously damage his public reputation. The tradition that acknowledges Matisse's greatness as a painter while simultaneously belittling him as a man – the view of him as self-centred, cold-hearted and mean-spirited prevalent in his lifetime and long afterwards – goes back to a collective urge for concealment so strong that, when

Mme Parayre went to her grave, her secret remained buried with her for another ninety years.

After the funeral, the family regrouped in Paris. Work resumed in the studio on submissions for the Salon d'Automne. Georges Braque, about to embark on a partnership with Picasso that would change the ground rules for all other artists, had every one of his canvases rejected. Matisse, who served on the selection committee, tried to describe one of them to the critic Louis Vauxcelles by sketching an arrangement of straight lines and crossbars: 'It's made of little cubes,' he said in a phrase history never forgot. His own showing at the Salon was a selection of work in progress centred on *Harmony in Red*. 'Suddenly I stood in front of a wall that sang, no screamed, colour and radiated light,' wrote a young Scandinavian art student, 'something completely new and ruthless in its unbridled freedom . . .' From now on Shchukin took over as Matisse's principal collector from Sarah Stein, who had pointed the way. Shchukin's early letters to the painter are peppered with references to Mme Stein's pictures, and to his desire to match her collection. He would own in the end thirty-seven Matisses, almost exactly the same number as passed through Sarah's hands, putting them on show to the public in his great house in Moscow, which became in the years before the Russian Revolution the world's first museum of modern art.

It was Matisse who took Shchukin in the autumn of 1908 to inspect Picasso's *Demoiselles d'Avignon* at the Bateau Lavoir. Initially repelled by what he saw, Shchukin turned himself over the next few years into Picasso's most dependable collector as Cubism grew harsher, more exacting and almost impossible to sell. The initial introduction was typical of Matisse, whose correspondence with friends and acquaintances is full of small unpublicized acts of generosity: he guided their submissions past the Salon jury, helped with hanging and selling, paid frequent encouraging visits to their studios and made a point, especially in these precarious early years, of bringing his own potential patrons with him to look at the work of struggling

younger artists. Manguin, Marquet, Puy and Derain all owed their success with Vollard in the first instance to Matisse, whose own financial position was beginning to grow less desperate, although still far from secure.

Relative affluence had not changed the family priorities. Matisse bought a Renoir from Druet and six Cézanne water-colours from Vollard that autumn. In the excitement of Shchukin's first purchases, Amélie Matisse told Greta Moll that she had bought bedsheets for her household at the Bon Marché department store on the same day as Matisse went shopping: 'A wonderful Persian carpet was too much for him. He couldn't get the pattern out of his head. "It's so beautiful! so beautiful!"' After living for twenty-four hours with this refrain, Amélie, who knew as well as her husband that their budget would not stretch to both sheets and carpet, returned her purchase and claimed a refund. It was the story of the blue butterfly all over again. Matisse got his magic carpet, and Greta remembered him sitting in front of it, puffing contentedly on a cigar, contem-plating the colours and patterns that he would shortly transmute on canvas into the beautiful *Still Life in Venetian Red*.

'Notes of a Painter' was finally published in the prestigious *Grande Revue* on 25 December 1908. Matisse's work had been shown for the first time that year in London ('Impressionism ... reaches its second childhood ... with M. Matisse, motif and treatment alike are infantile,' reported the critic of the *Burlington Magazine*), New York ('The French painter is clever, diabolically clever ... With three furious scratches he can give you a female animal in all her shame and horror'), and Moscow (where bewildered Russian art-lovers reacted, as Prince Sergei Shcherbatov nicely put it, 'like Eskimos to a gramophone'). Matisse ended the year with Purrmann and the Molls in Berlin for an opening at Paul Cassirer's gallery. The centrepiece was *Harmony in Red*, making its last stop in Western Europe on the way to take up permanent residence in Moscow. Even the boldest art-lovers were dismayed. Critics described the paintings as senseless, shameless, infantile monstrosities or sick and

dangerous messages from a madhouse. The French press had felt much the same. Harmony – the goal Matisse desired more passionately than any other – was the last thing his art conveyed to his contemporaries.

On New Year's Eve, 1908, he entered his fortieth year. Any toast to the future was at best tentative, but however much abuse he still had to endure, he could count on support from a small band of activists headed by Sarah Stein, Purrmann and the Molls. He already knew that Shchukin's backing would open the inner doors of his creative energy. Perhaps even more important, he had found in Picasso a rival whose phenomenally swift reactions and implacable eye would challenge him to the limit. Above all, he had learned to contain in his work the chaotic choking surges of emotion that had made him a painter in the first place. 'If there is order and clarity in the picture,' Matisse wrote, paying tribute to Cézanne in 'Notes of a Painter', 'it means that from the outset this same order and clarity existed in the mind of the painter, or that the painter was conscious of their necessity.'

This is the core of the rigorous theory of abstraction formulated in the 'Notes', explored in practice in the portrait of Greta Moll, and taken further still in *Harmony in Red*. At the beginning of a century of unprecedented disruption and dispersal, Matisse dreamed of 'an art of balance, purity and tranquillity, free from any nagging or disturbing element', an art that would offer an antidote to the tensions of the modern workplace or office. He said that art should be as soothing as a good armchair, a metaphor that has done him more harm ever since than any other image he might have chosen. In fact this passage reflects its obverse: Matisse's intimate acquaintance with violence and destruction, a sense of human misery sharpened by years of humiliation and exposure that could be neutralized only by the serene power and stable weight of art. With *Harmony in Red* – and yet more with its immediate successors, *Dance* and *Music* of 1909 – Matisse's work approaches the emotional intensity and purity of music.

On his way back from Berlin that January, he got off the train to visit Osthaus at Hagen, a few miles along the Ruhr

from Essen. The work Matisse stopped off to see was his own newly installed *Nymph and Satyr*, a relatively conventional set of three ceramic panels showing a stocky muscular nymph doing a stamping dance, then falling asleep and being tentatively approached by a hairy, hopeful satyr enclosed in a frieze of grapes and vine leaves. The painter had left behind in Paris a recently completed oil painting of the same subject. This time the satyr – more of a tame faun on Osthaus's glazed tiles – started out with a little beard and pointy ears but transmuted on canvas into something far more violent and raw. Matisse's final version is unequivocally human: a clumsy, graceless, lustful male advancing purposefully on a naked female huddled with her back turned at his feet. The man's pink, thinly painted flesh is outlined in red, the colour of arousal. So is the woman's, but every line of her expressive body – bent head, drooping breasts, collapsing limbs – suggests exhaustion, helpless weakness and enforced surrender.

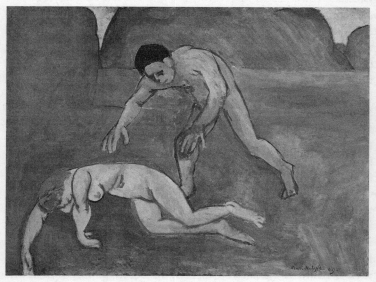

Matisse, 'Nymph and Satyr', 1908–9

This is the mood of Cézanne's *The Abduction* (or *The Rape*), where another masterful naked man carries off another pale, limp, fleshy female. The fierce erotic charge in both paintings is reinforced by harsh colour and rough handling. In Matisse's case, the texture of the paint was itself an outrage. The choppy stabbing brushstrokes, the landscape's crude contours filled with flat scrubby green, the blurry patches round the man's head, crotch, left hand and right knee, all convey extreme disturbance. His picture, like Cézanne's, is both personal and symbolic. Both suggest an image spurting up from some deep, probably unconscious level of the imagination on a tide of bitterness and rage. Matisse's satyr looks as if he means to strangle his victim with his outsize red hands. Matisse himself said long afterwards that this was how he always felt before he began a painting. He told the poet Louis Aragon that for him each painting was a rape. 'Whose rape?' he asked, startling his questioner (perhaps also himself) with the brutal image that surfaced in his mind during an interview that took place more than three decades after he painted *Nymph and Satyr*: 'A rape of myself, of a certain tenderness or weakening in face of a sympathetic object.' He seems to have meant that he relied on his female models to arouse feelings that fuelled the work in hand. He confronted whatever underlay that process head on in *Nymph and Satyr*.

This coarse, powerful, primitive painting was earmarked for Shchukin, who was about to commit himself as unreservedly as Matisse to the liberation of painting. On 9 January Shchukin followed Matisse to Paris and bought or commissioned six more paintings. Matisse said that in some ways he came to dread visits from the Russian because of his unerring knack for picking out the latest breakthrough canvas and carrying it off, sometimes with the paint still wet. The fact that *Nymph and Satyr* was an affront to decency and morals only increased the collector's impatience to possess it. This new canvas was quite different from the sexy pictures other men kept behind locked doors in their private rooms and cabinets. Matisse's painting commits pictorial and depicts actual rape. Its secret kick for a subversive

like Shchukin was precisely that it violated every sacred Beaux-Arts precept enshrined in the flawless public nudes that filled the Paris salons.

The contemporary incarnation of those precepts in the eyes of the fashionable art-world was Maurice Denis, currently making waves in Moscow with a set of painted panels for the home of Shchukin's friend and rival, Ivan Abramovich Morozov. Denis' subject was Cupid and Psyche. He pictured Cupid as a plump, life-size, naked youth, wearing wings to match his predominant colour scheme of pink, green and blue, in pursuit of a solid Psyche with cushiony breasts, buttocks and hips. The couple's sturdy build adds to the absurdity of their chaste embrace as they dangle cheek to cheek in midair with nothing touching below the waist. This is seduction with any hint of desire or danger airbrushed out. Denis' Cupid and Psyche series in Morozov's music room was considered such a masterpiece in Moscow that Shchukin followed it up by commissioning his own wall paintings from Matisse. The painter never forgot the lunch at the Restaurant Larue in Paris where the pair of them together hatched a plan to end all blue-pink-and-green decorative schemes peopled with dancing nymphs and piping fauns. Matisse's *Dance* and *Music* grew from their conversation at this lunch.

Matisse left Paris in early February to spend a month alone at Cassis on the Mediterranean coast. Walking along the cliffs above a steeply shelving shore, he studied air, water, light, sun glinting on spray and waves pounding on rocks. Movement preoccupied him in the run-up to the *Dance*. The violent swirling currents mirrored the inner 'clash of creative contrasts' he described in walks and talks with the Socialist deputy Marcel Sembat, an art-lover also taking a break in wintry sunshine at Cassis. Matisse was in training for an ordeal that would stretch him to the limit, as he explained in detail to a journalist who interviewed him for *Les Nouvelles* when he got back to Paris in March. He said it was time for painters of his generation to move on to a new and more expressive kind of art by going

back to basics, getting rid of superfluous detail, processing the raw material thrown up by naturalism and Impressionism. 'We must now begin the enormous job of organization.'

This kind of neck-or-nothing ambition was why Matisse's wife had married him. Amélie may have looked like a housewife to people who barely knew her but, beneath her demure exterior, she was profoundly unconventional. Her marriage had been a gamble in which money, security, social advantage played no part. Henri's painting gave shape and meaning to her life. She was an energetic partner in a high-risk enterprise she never doubted would one day succeed. Absolute trust was its core. 'The basis of our happiness . . . was that we built up this mutual confidence quite naturally from the first day,' Amélie wrote long afterwards to Marguerite. 'It has been for us the greatest good and the envy of all our friends, it meant we could get through the worst of times.' The two did everything together. Almost from the day they met, they were known as the Inseparables. The four weeks Henri spent in Cassis was probably the longest time they had been parted since their marriage eleven years before. The studio was the centre of their world, and it was her province as much as his. Amélie saw to everything from keeping the models happy to the ritual washing of the brushes every evening. She made records, organized paperwork and read aloud night after night when pressure of work bore down to stop Henri sleeping. Amélie had sat for or watched over every one of the paintings that seemed to contemporaries to spread mayhem and havoc in the four years since the Fauve explosion of 1905.

She could not have done it without help from Marguerite, herself also a practised model and apprentice studio manager. From a small girl she had largely taken over shopping, cooking, cleaning and keeping the boys quiet. Her parents kept her at home with them partly because they would have found it hard to do without her, but partly also as a precaution. Margot would be fifteen in the summer of 1909. She had learned to breathe through a tube inserted in her neck with an opening concealed

by high-necked blouses or a black velvet ribbon, but her adolescence was placing steadily increasing strain on the damaged windpipe that had not grown properly since childhood. Margot needed looking after.

The studio discipline laid down by Matisse's wife and daughter was less strictly observed by his students. In theory he taught at most two mornings a week, but his powerful presence behind the screen exerted a pull nobody could ignore. Numbers had exploded by 1909, with newcomers pouring in from all over Europe and America, many of them astonished to find little outward sign of the wild beast who had once loped about the streets in a shaggy black sheepskin coat. As his paintings grew bolder and more disturbing, Matisse's dress and manner became quieter and more restrained. He taught his students to rely on first-hand observation, and to be true to their own intuitive responses. The one thing he could not stand was showing off in paint. Anything flashy, meretricious or exaggerated had to be identified and ruthlessly cut out. Matisse's classes exhausted him, sometimes to the point at which he could no longer see straight. The trouble was that he treated all his pupils equally, applying himself to sorting out the difficulties of even the least gifted with the same concentration he brought to his own struggles on canvas. His student days were too recent for him to have forgotten how it felt to be a young painter newly arrived in Paris, cold, hungry, hard up and desperate for instruction.

Life was hard for the men, but harder on the women, who were outnumbered in the school by five to one. They had less freedom and faced more obstacles than their male contemporaries. No matter how poor they were, young women artists could not wander the streets alone at night or sleep on café benches. Decent landladies were suspicious of single women without the protection of male relatives or guardians. Most other art schools refused them entry. Matisse's female students all seem to have come with husbands or boyfriends, except for a couple of Russian girls who had arrived separately, unannounced, with

no apparent backing and nothing to live on but their wits. One was Maria Ivanovna Vasilieva, who had made her way to Paris via Munich leaving behind a solid bourgeois family of teachers, engineers and lawyers in St Petersburg. Vasilieva at twenty-five was extremely small, and as forceful as she was intrepid. Even in those days she had the determination and the battering-ram persistence that powered an impressive subsequent career as Marie Vassilieff, the Mother Courage of the Parisian avant-garde between the wars.

She shared rooms in the attic above the Matisse family lodgings with Olga Markusovna Meerson, who was six years older and already an established artist. Olga was a Russian Jew with high cheekbones, a shapely figure, creamy white skin, a mass of bright auburn hair and a personality as striking as her looks. She had turned up at the start of the summer of 1908, when Matisse was shut up alone in his studio, working furiously on *Harmony in Red*. Meerson was a high-flier who had just exhibited half a dozen pictures at the official Paris Salon, and Matisse was dubious about her to start with. He told her she had a rare gift for portraits, a rich sense of colour, and a generous feeling for design but that, if she became his pupil, she would have to start by unlearning everything she knew. When Meerson insisted that was what she wanted, Matisse sent her away for a fortnight to reconsider her position. She duly thought about it, and moved in two weeks later.

The academic training she now proposed to discard had been rigorous and thorough. A brilliantly precocious child, she had studied for eight years at the Moscow School of Art before finally running away from her family in Russia, at the age of twenty-one in 1899, to join the colony of avant-garde artists congregated round Vassily Kandinsky in Munich. Kandinsky painted her, dedicated a landscape to her and put her in charge of his famous Phalanx Class in 1902. Meerson met writers as well as painters in Munich, making tiny touching portraits of her best friend, Katia Mann, the wife of the novelist Thomas Mann, and Katia's brother, Eric Pringsheim: exquisite likenesses

of jewel-like brightness and clarity, built up on sections of enamel with brushstrokes so fine as to be barely visible to the naked eye. But this kind of outmoded expertise had no place in the art of the future endlessly debated in Munich, and in 1905 Meerson set out for Paris just in time to catch up with the Fauve explosion that autumn. When Kandinsky himself followed her to France the year after, she was one of very few visitors admitted to his lodgings at Sèvres, but after his return to Munich, she stayed behind and persuaded Matisse to accept her as his pupil instead.

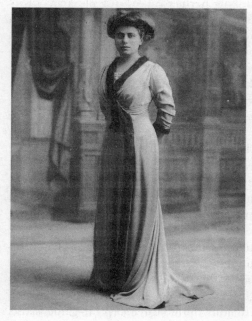

Olga Meerson in Paris at the time of her first meeting with Matisse

She personified the pride, courage and resilience Matisse prized all his life in his female models. In Paris before the First World War he painted an astonishing sequence of this kind of young woman: *Girl with Green Eyes, The Algerian Girl, The Spanish Girl with a Tambourine, Girl in Green, Girl with Tulips.* The sitters included professional models and any young female friend or

visitor bold enough to pose for him, starting with Greta Moll, in 1908. All the portraits play variations on the same simple formula, confronting the sitter in each case full-face, head-on at three-quarter length against a flat, coloured, sometimes elaborately patterned background. The effect, still brilliant today, was electric then. These paintings struck contemporaries as uncouth, outlandish and exceedingly offensive. Most people could make no sense of their thick black brushstrokes outlining what appeared to be an ugly jumble of patchy, strident, high-pitched colour. *Girl with a Black Cat* – a picture of Matisse's daughter wearing a pinafore dress and stroking her pet cat – hung in Sarah Stein's apartment and horrified her visitors. *Girl with Tulips* shows a soberly dressed young woman in a black skirt and plain shirtwaist, twisting her hands shyly in her lap, painted with a child-like frankness and simplicity that looked mad to the Muscovites who first saw her in Shchukin's house. *The Girl with Green Eyes* became a byword for grotesquerie when shown in Paris in the spring of 1910, going on to be the most virulently attacked of all the pictures in the notorious Post-Impressionist show at the end of the same year in London.

Roger Fry, who organized the show, energetically defended *The Girl with Green Eyes* in terms of line and colour harmony, but even he could make nothing of it as a likeness ('Regarded as representation pure and simple, the figure seems almost ridiculous'). It took courage to sit for Matisse in those days. Nice girls did not pose for paintings that would turn them into public targets to be insulted in the newspapers, sneered at by their friends and pointed out as ridiculous or worse by pitying strangers in the street. Matisse was reluctantly obliged to accept that the reactions his pictures provoked in the first people to see them were pretty much the opposite of the feelings he intended to convey. A century later, the young women whose expressions were once so difficult to decipher now gaze back coolly and with striking confidence at the spectator. It was their toughness, more even than their youth and innocence, that touched Matisse. There is nothing sensual or ingratiating about

his portraits. Independence (and the price that had to be paid for it) is implicit in everything about *The Girl with Green Eyes*, from her unconventional clothes to her straight nose, her thick black brows, her resolute red mouth, the steady look in her eyes and the firm set of her head on its uncompromising columnar neck. In *Portrait of Greta Moll*, Matisse said that what he tried to convey was her statuesque aspect, the innate force and dignity of her personality. When Meerson posed for him three years later, he painted the vulnerability underlying her wary pose, her tensely folded hands and the erect carriage of her head.

He had warned her on the day they met that her admiration for him would ruin her career and prevent her ever again painting a saleable picture. That first interview was followed over the next three years by many conversations about art and life, all conducted in the loftiest terms ('The aspirations of her soul are of the noblest,' Matisse wrote later). A few months after he met her he started work on *Nymph and Satyr*, a picture that aimed to violate the canons of academic art in its most sacred shape, the nude. Perhaps the two images – the actual girl and the generalized nymph of the classical Western tradition – merged into one. Art historians have certainly assumed that Meerson modelled for this painting, largely on the strength of the nymph's ginger hair, which seems flimsy evidence given that Meerson's hair was in fact brown with auburn or chestnut lights (no one has ever suggested she had red eyes, like Matisse's nymph, or for that matter that Matisse himself – who was a redhead – had black hair like the man in his picture). But something is clearly going on in this canvas, which is almost the only place where Matisse confronted actual or intended violence in his work.

Vassilieff's memoirs record a suggestive episode that occurred early in 1909, soon after she came to live in the convent. Matisse, who had moved up from the ground floor to sleep in the attic on the grounds that he needed air, woke her one spring morning by tapping at the glass door of her room in his pyjamas. 'Still

fast asleep, wearing nothing but a kimono, I opened the door . . .' When he explained that he had brought illustrations to go with the Russian translation she was making of his 'Notes of a Painter', she asked him to wait while she got dressed. 'He stood there in the open doorway looking at my still warm bed, and at me, pretty as I was in those days; and then, all of a sudden, he was gone.' Vassilieff was a first-rate fantasist whose testimony is unreliable, self-serving and recklessly selective. Even so this particular memory sounds a plausible enough account of the process Matisse himself described long afterwards when he said that for him all painting was a rape. Invited to be more specific about his relations with his female models, he explained that he could only achieve the extreme, impersonal, quasi-surgical concentration essential to the act of painting by working through his feelings for the model. He said he needed the physical presence of the young and pretty girls who posed for him all his life not so much for his eye to check what they looked like 'as to keep me in a state of emotion, a sort of flirtation that ends by turning into a rape. Whose rape? A rape of myself, of a certain tenderness or weakening in face of a sympathetic object.'

Matisse returned from Cassis in March 1909 in precisely the state of imaginative arousal he seems to be describing here. He found a letter waiting for him from Shchukin, asking for a colour sketch of the painted panel they had discussed as a decoration for his staircase. Matisse's *Nymph and Satyr* had already disappeared to Moscow, but the prostrate nymph rose up again in his mind's eye to join four others in a whirling, stamping dance. On 11 March he posted off a small sketch showing a ring of naked dancers, followed next day by another of women bathing. Shchukin was both delighted and dismayed, explaining that the strict, semi-oriental codes of polite society in Russia made it impossible for him to hang nudes on the stairs in his entrance hall. Already treated in Moscow as a butt on account of his crazy paintings, the collector begged the painter to drape his figures or, alternatively, to carry out the original scheme on

a smaller canvas that could be kept out of sight in his private quarters. But he swiftly got the better of his hesitations, confirming his original commission for two huge panels in a telegram dated 28 March. 'It took nerve to paint them,' Matisse said long afterwards, 'and it took nerve to buy them too.'

All his life Matisse worked on the human figure in two successive stages. The first consisted of close observation of external reality, which had to be thoroughly absorbed before it could be reshaped by the imagination in images that 'rise up from fermentation within, like bubbles in a pond'. Shchukin had initially suggested as a starting-point the ring of small whirling figures in the background of *Bonheur de Vivre* (a painting he had first seen surrounded by jeering, howling crowds at the Indépendants in 1906, and rediscovered two years later at the Steins). The sketch Matisse sent him in March gave shape to an image that had been fermenting at Cassis, though the elements that fed into it may well have included one or other of the girls who posed for Matisse in Paris. He painted a first version of his *Dance* in two or three days of frenzied concentration, and followed it up with another. By 11 April, Sarah Stein's friend, the Englishman Matthew Prichard, had seen a photograph of 'a ring of dancing women' that made him pronounce Matisse 'the greatest of the modern men'. On 12 April, *Les Nouvelles* published the interview in which the painter defined his aim as the expression of emotion 'as directly as possible and by the simplest means', citing his scheme for decorating a staircase as a case in point. He could hardly have signalled more clearly his intention to use this first major decorative commission as a launchpad for modern art. *Dance* and its companion, *Music*, represented a public declaration of faith from a collector who trusted the painter unconditionally. In Moscow that April, Shchukin told anyone who would listen that Matisse held the future in his hands.

Shchukin's support, material as well as moral, profoundly affected the painter's life and work. The 27,000 francs paid for *Dance* and *Music* put the family finances on a stable footing just

in time to avert disaster that spring when the Sacré Coeur convent was put up for sale, and its tenants given notice to quit. Driven to distraction by his students as well as by his growing notoriety, Matisse set about house-hunting as far away as it was possible to get without actually leaving Paris. He found a place to rent almost immediately on the city's south-western outskirts, perched above an industrial suburb still under construction at Issy-les-Moulineaux. By this time the family had been overtaken by a far worse blow. In late March Marguerite's struggles for breath became so acute that her doctors performed a second tracheotomy. The operation brought back terrible memories of the summer nine years before when her father had had to hold her down on the kitchen table of their tiny attic flat while the doctor cut into her windpipe. She recovered, but Matisse said his daughter's suffering left him little taste for anything, 'especially not for painting'. His old friends sent anxious messages asking after Margot, who faced a long convalescence and an uncertain future. Her parents planned to take her south for the summer to a seaside villa at Cavalière as soon as she was well enough to travel. All through April and May they dealt with the practicalities of packing, shifting furniture, storing work and organizing builders to erect a prefabricated studio big enough to hold the new panels for Shchukin.

Both husband and wife saw the move as a solution to their problems. The house and garden at Issy would provide them with the space and quiet impossible to find in central Paris. The new setting would free Henri from the constant demoralizing demands of pupils, critics, dealers and potential buyers, while restoring Amélie to her rightful place at the centre of their joint enterprise in the studio. It would enable the children to lead a more normal domestic life in a country setting, where Margot could recover, and the boys pursue their education at the local lycée. The whole family would flourish. Gertrude Stein was struck by Amélie's reckless happiness, which she celebrated that spring by taking a cab all the way to Issy and making it wait – 'Only millionaires kept cabs waiting in those

days' – while she picked spring flowers in the big, rambling garden that would be hers by autumn.

As soon as the school broke up for the holidays, Matisse escaped for a brief break with his oldest friend, Léon Vassaux, now a country doctor in Normandy. By mid-June he was in the Midi, settling into the Villa Adam at Cavalière with his wife and all three children. Mythical Mediterranean nymphs had invaded his canvases at moments of extreme pictorial transition in St-Tropez in 1904, and again in Collioure the year after. This time he brought a real nymph with him. Her name was Loulou Brouty. She was a Parisian model with dark hair, neat catlike features, a compact dancer's body and skin so tanned and glowing that Matisse's pupils nicknamed her 'the Italian sunset'. Amélie got on well with her, as she generally did with her husband's models. Brouty fitted easily into the family, playing with the children, learning to swim from Matisse and providing company for his wife in an isolated fishing community where the only other outsiders were occasional visiting painters. Cavalière was even more cut off than Collioure. The weather was poor and Jean caught mumps. Matisse complained he couldn't work but he remained in excellent spirits, learning to swim underwater and posting off a sketch to Sarah Stein's friend Harriet Levy (who had bought his *Girl with Green Eyes*), showing himself in striped bathing pants poised to plunge overboard from an absurdly flimsy dinghy. The painter and his doings always emerge from Matisse's impromptu sketches as intrinsically ludicrous. He pictured himself at Cavalière in letters to Manguin as a cartoon character, tentative, quizzical and myopic, hidden waist deep in water or disappearing beneath the surface with nothing showing but a pair of big bare feet. His naked model meanwhile stands on the beach beside his abandoned easel, or sprawls casually on her back in a patch of scrub with legs spread wide and arms folded behind her head.

Matisse had exchanged jokey shorthand messages like these – a more sophisticated French equivalent of the saucy British seaside postcard – with Manguin and Marquet since student

days. In fact Brouty possessed Matisse's imagination that summer in far less conventional ways than this kind of standard male fantasy. She posed for him standing, sitting or leaning on her hand under the pine trees on the foreshore. His brush swooped and darted round her body with apparently effortless confidence, trapping sunshine and shadow on small luminous canvases organized in pools and patches of unlikely colour. Matisse liberated painting at Cavalière in precisely the way he had described, before he left Paris, to the journalist from *Les Nouvelles*. The harmonies of form and colour he brought back in September were incomprehensible even to his boldest admirers. Marcel Sembat and his wife Georgette, leafing through the summer's work one day after lunch at Issy-les-Moulineaux, shrieked aloud when they reached the study of Brouty called *Seated Nude*: 'We had come across a strange little canvas, something gripping, unheard of, frighteningly new: something that very nearly frightened its maker himself. On a harsh pink ground, flaming against dark blue shadows reminiscent of Chinese or Japanese masters, was the seated figure of a violet-coloured woman. We stared at her, stupefied, astounded, all four of us, for the master himself seemed as unfamiliar as any of us with his own creation.' At first the picture made no sense but, as soon as Sembat started sorting out what he saw, he realized that this composition of green, blue, pink and indigo had to be read as a design in its entirety. 'You see, I wasn't just trying to paint a woman,' Matisse explained: 'I wanted to paint my overall impression of the south.' Sembat bought the picture, because he recognized it as what he called 'an egg': the forerunner in embryo of the great synthetic canvases that would follow over the next decade.

Apart from a brief break the following spring, Matisse spent the next twelve months working on Shchukin's two panels in the specially built studio at Issy. Those who saw the first version of the *Dance* described it as pale, delicate, even dream-like, painted in colours that were heightened – 'hitched and hoisted up as it were on the back of the previous work' – in the second version into a fierce, flat frieze of vermilion figures vibrating

against bands of bright green and sky blue. It was the uprush of violence as much as the earthy physicality of the finished work that shocked people. Matisse said he himself took fright, like the Douanier Rousseau, who sometimes had to open a window to let out the elemental force of his own painting. In *Dance* and *Music*, Matisse attempted simultaneously to release and contain that force. 'At the precise moment when raging bands were milling about in front of his huge canvases, tearing him to pieces and cursing at him,' wrote Sembat, 'he confessed coolly to us: "What I want is an art of balance, of purity, an art that won't disturb or trouble people. I want anyone tired, worn down, driven to the limits of endurance, to find calm and repose in my painting."' Contemporaries responded to this kind of statement by assuming that Matisse was playing tricks, if not actually insane. Even his supporters found it hard at the time to credit that he meant exactly what he said. Matisse aimed to achieve the great destructive and constructive goals of Modernism by imposing the even-handed clarity and order of the central French tradition inherited from his masters, Nicolas Poussin and Paul Cézanne.

The effort took everything he had to give. It devoured his days, invaded his dreams at night and put increasing strain on his private life. The family's daily round at Issy was driven by it. This was the obsessive passion that had wrecked Matisse's relationship with Marguerite's mother. He had stirred Amélie to the core almost as soon as they met with the warning that, dearly as he loved her, he would always love painting more. They had tried even on their honeymoon to tread the stony sacrificial path of art. Matisse told a friend long afterwards that sexual abstinence had been his goal ever since the Fauve summer of 1905. Some form of abnegation certainly lay behind the painting he called *The Conversation*, begun at the convent of the Sacré Coeur and completed at Issy. On one level it is a formal colour harmony of Byzantine simplicity and splendour. On a more humdrum human level, it depicts Amélie in a green housecoat one spring morning sternly confronting her husband

in the striped pyjamas he wore for work. Pyjamas, still an exotic import from India, sold as leisurewear rather than sleepwear before the First World War, replaced workmen's cords as the standard working-gear in which Matisse painted himself with his models over the next twenty years and more. To the outside world they represented moral laxity and self-indulgence. To Matisse and his studio aides they meant austerity, hard work and dedication.

In October 1909, Meerson visited Matisse regularly to pose for a sculpted clay nude in the studio at Issy where he was working on the *Dance*. The new world he entered that autumn absorbed and exhilarated them both. This was a realm where Amélie could not follow, but in the end it wasn't Olga she had to fear, or fresh young girls like Vassilieff, or the long succession of professional models that would fill her husband's studio to the day he died. Amélie had a more powerful rival. She was competing with the seductress who had monopolized Matisse's two great predecessors: the mistress who obsessed and absorbed Cézanne; the lifelong companion Poussin included in the background of a strange self-portrait made the year before he died. Poussin identified her as Painting in person, picturing her as a beautiful golden-haired woman embraced by two passionate male arms. She was jealous, demanding and possessive to the exclusion of all others. It was Painting whose arms closed fast around Matisse – and his round her – in an embrace that would never let him go.

7. *Revelation from the East (1910–11)*

The move to Issy-les-Moulineaux in the autumn of 1909 was part of a larger strategy of disengagement and withdrawal. 'If my story were ever to be told in full . . .' Matisse wrote more than thirty years later, 'it would amaze everyone who reads it. When I was dragged through the mud, I never protested. As time goes on, I realize more and more how completely I was misunderstood, and how unjustly I was treated.' Ostracism made him stubborn. 'The whole world turned its back on him,' said Lydia Delectorskaya, the companion to whom Matisse talked more freely than to anyone else in his last years. 'Everyone clustered round the Cubists, there was a whole court centred on Picasso. It was a question of pride. He never wanted to make a show of himself, to reveal how much it hurt him.'

The incident that confirmed Matisse's outcast status, at any rate in his own mind, came one day when he turned into one of the artist's cafés in Montparnasse for a drink with Picasso and his band, who refused to speak to him. Matisse never forgot sitting alone at the next table in a café full of fellow painters, none of whom returned his greeting. 'All my life I've been in quarantine,' he said when he recalled the scene. His ally, André Derain, had transferred allegiance to Picasso together with Georges Braque and various lesser Fauves but, if their defection was painful, it was also in some sense a relief to Matisse, who had never seen himself as the leader of a party. Art for him had no political dimension. 'He was interested neither in fending off opposition, nor in competing for the favour of wayward friends,' wrote Françoise Gilot, the painter who long afterwards became Picasso's companion. 'His only competition was with himself.' The Cubists were now the liveliest and most warlike of all the competing art-world factions, and Matisse (who was

their favourite target) responded by dismantling his own power base, decamping to Issy and preparing to wind up his school. 'I rolled myself into a ball in my corner as an observer, and waited to see what would happen.'

But he dreaded as much as he needed the seclusion Issy gave him. The new house was medium-sized, solid and unpretentious, surrounded by high walls at the top of a steep hill above factories strung out along the banks of the Seine. 92 route de Clamart looked out over fields already parcelled up into speculative building plots, halfway along the road linking the town to the new railway station at Clamart, which was still a small country village on the edge of woods stretching southwards to Versailles. All supplies had to be fetched on foot from the shops below. The family knew no one, and had no immediate neighbours in an area so isolated that Matisse kept a gun handy, and warned his sons not to walk home alone after dark. He begged old friends to visit, but for the circle he and his wife had left behind in Paris, Issy was well beyond the limits of the known world. Money was a constant worry in those first years. Matisse could never have afforded to rent a place of his own if he hadn't signed a contract that autumn with Josse and Gaston Bernheim-Jeune, which gave him in his fortieth year for the first time in his life some hope of a regular income. The Bernheims agreed to buy everything he painted for a fixed price, ranging from 1,875 francs for a large painting down to 450 for the smallest size, together with a royalty of 25 per cent on sales. Even so, the rent of 3,000 francs a year overstretched the family budget, so that it was often hard to scrape up the next instalment at the end of each quarter, or pay for extras like doctors' bills.

The move that was to have provided a fresh start for the whole family sometimes felt more like a disaster. Household responsibilities weighed heavily on the Matisses, who had always travelled light, living simply in cheap lodgings with little in the way of personal belongings beyond Henri's paintings and his textile collection. A school had to be organized for the boys, a doctor found for Marguerite, the garden dug and

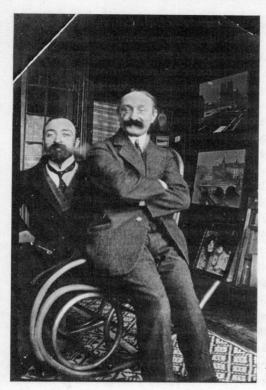

*Matisse's old friends,
Camoin and Marquet,
paying him a rare visit
at Issy*

planted. Matisse drew up an orderly schedule. Sunday was set
aside for private relaxation, Monday for visitors and correspond-
ence, Friday and Saturday for teaching the class in Paris. Tuesday,
Wednesday and Thursday were to be spent in the huge prefab-
ricated studio erected at the far end of the garden. Even when
it ran smoothly, the timetable left less than half the week for
work. This was the core of Matisse's trouble. The intense,
unremitting, solitary effort required by *Dance* and *Music* set up
a state of tension that gave way to mounting panic. Prolonged
insomnia frightened him, and wore him down. He felt inca-
pable, frustrated, full of foreboding. Snow in the New Year was
followed by the worst floods at Issy in living memory. Rain

fell unceasingly from the grey leaden skies that always paralysed the painter.

One of the inducements held out by the Bernheims for him to join their gallery was the offer of a retrospective exhibition. The show, which opened on 14 February 1910, was the most comprehensive showing his work had ever had, and he hoped it would demonstrate steady, logical progress towards a stripped-down and reinvigorated modern art. The critics responded with a dismissive brutality that even Matisse had scarcely encountered on this scale before. They accused him of vulgar excess, wilful confusion and gratuitous barbarity. Even the more serious reviewers found him incapable of following any consistent line, or evolving a style of his own. One after another they attributed their inability to comprehend what Matisse was doing to his shortcomings rather than their own. Attacks came from all quarters. The young and progressive were as splenetic as the elderly and conservative. Much play was made of the vast income Matisse supposedly gained from exploitation of his credulous foreign students, and the fictitious laurel wreath (some claimed it was a golden crown) that he was said to wear for teaching. The show attracted so much attention that its run had to be extended by ten days. When it finally closed in March, Matisse fled Paris, travelling south alone to take refuge with Amélie's father and sister at Perpignan. He said he was a wreck, sleepless, exhausted and demoralized. From Perpignan he moved on to Collioure, where over the next month Maillol and Terrus slowly rebuilt his confidence in himself.

The only public defence of his work in Paris that spring came, to Matisse's disgust, from Apollinaire, but support behind the scenes was mobilized directly or indirectly by the Steins, and in particular by Sarah. Her collection was a learning ground for most of Matisse's early admirers, from Shchukin himself to Berenson and the young American photographer Edward Steichen (who organized the first two Matisse shows in New York). Visitors to the Michael Steins' apartment generally fell back in disgust before discovering to their surprise that they

couldn't tear themselves away from the canvases that lined the walls frame to frame three or four deep. 'An astonishing sight, glaring and gay, crude but great beauty of line,' wrote Lady Ottoline Morell, the society hostess and champion of the avant-garde in London, whose own taste for gaudy colours, barbaric jewellery and stupendous hats made her more receptive than most, although she didn't care for the solemn hush Mrs Stein also managed to impose. 'No one dared to talk, silenced perhaps by the clamour that seemed to shout from the walls.'

Lady Ottoline's guide in Paris was Matthew Prichard, himself a regular at 58 rue Madame. Prichard was a self-appointed prophet who held no official post, avoided the academic world, rarely if ever lectured in public and published virtually nothing. But he possessed, in T. S. Eliot's phrase, 'an influence out of all proportion to his public fame', and exerted it in these years exclusively on Matisse's behalf. Oxford-educated, trained as a lawyer and aesthetically self-taught, Prichard had abandoned a promising career as an oriental specialist at the Boston Museum of Fine Arts in 1908 to move to Paris in pursuit of modern art instead. His transfer of allegiance was vehement and whole-hearted. Told that Matisse's painting had been dismissed as worthless by the fashionable sub-Impressionist John Singer Sargent, Prichard snapped back 'that if Mr S. knew the truth he would commit hara-kiri before one of his own portraits'.

All through the spring and summer of 1910 Prichard paid regular visits to the studio at Issy, bringing his eager young disciples and a handful of older, wealthier admirers, mostly Americans who had followed him from Boston. Prichard's well-stocked, well-cultivated and essentially philosophical mind lent intellectual weight – 'a thoroughly Oxonian respectability' – to the strange course Matisse was taking. The Englishman's invincible certainty, together with the fresh sources he opened up and the discomfort he fomented, came at precisely the right moment. Prichard's rigorous intellectual approach corresponded to the disciplined side of Matisse, the side that struggled, as he said himself, 'to get some order into my brain'. This was the

workmanlike character in buttoned-up white overalls photo-graphed by Steichen in the studio at Issy.

But art for Prichard was primarily instinctive and emotional. Like many intense and rigidly controlled ascetics, he needed help to break through to a more intuitive level. 'Much of what Matisse gives us is to be found in our unconscious life,' he wrote in his notebook. 'To find what it is we must plunge there in a state of trance or ecstasy, we must swim along the bottom of the stream of our existence.' Matisse used more violent language to describe his efforts to kick down the barrier between himself and painting. The struggle was at its most ferocious over the ring of dancers Prichard had first seen sketched out in April 1909. Matisse spent the rest of that year concentrating succes-sively on one thing at a time: the fierce clashing movement of the elements in the incoming tide whipped by wind and trapped by rocks at Cassis; the vibrating bands of light, heat and colour under the pine trees at Cavalière; the plastic possibilities of the human figure, explored in a series of extraordinary clay figures modelled during the first months at Issy.

The attempt to exploit his findings within the framework of his original design began as soon as the first of two enormous canvases was finally erected in his new studio. Each of the panels was eight and a half feet high and well over twelve feet long. Matisse painted from stepladders, slapping away with big brushes, shaping and reshaping figures taller than himself. Purrmann, who acted as studio assistant, was amazed to see how the alteration of one line upset the balance of the whole vast composition ('He . . . manipulated the entire group as if it were one single figure with eight legs and eight arms'). Matisse painted intuitively, without thought or premeditation, like a dancer or an athlete. Months of preparation and practice meant that calculation translated directly into spontaneous action. 'A picture is like a game of cards,' he told Purrmann. 'You must figure out from the very beginning what you will have at the end; everything must be worked backwards and always be finished before it is begun.'

The process was intensely physical. Matisse hummed dance-hall tunes as he worked on the plunging rhythms of *Dance*, which went back before he ever saw the Catalan fishermen at Collioure to his memories of workmen whirling their sweethearts round the floor at the Moulin de la Galette in Montmartre. The dancers on his canvas grew beneath his brush into a great elemental surge of liberation, unleashing forces that, according to Purrmann, 'frightened even him'. As an image of thrusting, pulsing life being pumped back into a dead classical tradition, this ring of larger-than-lifesize figures, with their pointed satyrs' ears, muscular red bodies and prehensile feet, could hardly be more graphic. Here was the animal uprush of feeling Matisse had experienced as a boy of twenty when his mother gave him his first paint-box, and he responded 'like a beast that plunges towards the thing it loves'.

Its bestial aspect was the first thing that struck Matisse's contemporaries about *Dance*. They said it was primitive, diabolical, barbaric, even cannibalistic. He repeated that peace and harmony had been his aim, pointing out that the rapt absorption of the figures in *Music* provides a counterweight to the delirious abandon of his dancers. He had worked on the two panels alternately, switching from the bodies levering themselves into the air and hurling themselves earthwards on the first canvas to the engrossed and softly rounded shapes strung across the second like notes in music. The violin he had played as a boy remained ever afterwards a stand-in for the artist in his work, and the rudimentary body of the violin player in *Music* seems no more than a conduit for the feeling flowing through his instrument (the same thing would happen again almost a decade later in *Violinist at the Window* of 1918, another pivotal point in Matisse's career).

Matisse finally gave up his school in June 1910 ('What a relief!' he told a friend. 'I took it far too seriously'). Teaching had become a burden, student numbers unmanageable, the rumours racing round Paris about his crackpot tuition steadily more absurd. Matisse confided in Prichard that what most of

his pupils needed was spiritual makeover rather than technical instruction. But the students who went home speaking a new visual language produced long-term results. All the countries represented by sizeable numbers – Scandinavia, the United States, Germany and Russia – acquired substantial holdings of Matisse's work in his lifetime (Germany's would be disposed of under Hitler, Soviet Russia's successively confiscated by Lenin and incarcerated by Stalin), unlike France, Britain and the rest of Europe, whose citizens stayed away (Matthew Smith, Matisse's only English pupil, said he had been too shy even to catch the master's eye, let alone speak to him).

Matisse worked steadily on *Dance* and *Music*, escaping for a few days to visit Léon Vassaux in June and for a painting trip with Marquet in August. This was their first summer in the new house, and the whole family stayed with him. A year after her operation, Marguerite's health seemed on the mend at last. Jean had settled into the nearby Lycée Michelet, where Pierre would join him in the autumn, and both boys ran wild in the garden. Tall trees and tangled shrubberies enclosed rough lawns with twisting paths leading to a clump of lilacs, a fruit orchard, two ponds and a greenhouse where Amélie raised seedlings. Beds of brilliant flowers bordered the path leading to Henri's studio. There were steps and a shady porch at the front of the house, a table and chairs under the nut trees beside the pool at the back.

The garden was a delight, but rural isolation was beginning to weigh heavily on Amélie, shut up behind high walls, surrounded by building sites, missing the comings and goings of painters and their wives or girlfriends, who had made up her whole world until now. At Issy there was nobody for company except the cook and the fifteen-year-old Marguerite. Instead of retrieving her place at the centre of her husband's life and work, Amélie now seemed in danger of losing him altogether. When he wasn't away in Paris on business, he spent days on end shut away in his studio at the far side of the garden, desperate to make up for lost time. The procession of

inquisitive art-world grandees arriving from Paris treated Amélie, when they noticed her at all, as a dim, silent housewife. Domesticity was the fate she had dreaded from girlhood, and at Issy it threatened to overwhelm her.

Visitors to the studio that summer were almost uniformly discouraging. When the English critic Roger Fry came with a couple of American colleagues, all three were reduced to uneasy disbelief by the two huge canvases that looked like an embarrassing joke. Fry privately put Matisse's painting on a par with the work of his own seven-year-old daughter, and his published review of *Dance* and *Music* was cold and uncomprehending. He had gone to Issy to invite Matisse to take part in a mixed show of contemporary French painting, and he retained his suspicions until well after the opening of what became the first Post-Impressionist show in London. *Dance* and *Music* made their public début at the Autumn Salon in Paris on 1 October 1910. The response was devastating. Crowds collected, shouting insults in front of the two panels as they had done for three years running at the height of the Fauve upheaval. Old friends were dismayed by the new works, fellow artists were outraged. The reviews were so damning that Amélie had to hide them.

This time her husband was better prepared than he had been in February. Within a week of the opening, he left Paris for Munich to catch the last ten days of a major exhibition, 'Masterpieces of Islamic Art'. Marquet travelled with him, and Prichard, who had already spent six weeks studying the show, was waiting for them in Munich, where Purrmann joined them. Matisse's three friends did their best to lift his depression. He went drinking in the beer cellars with Purrmann and, accompanied by Marquet, inspected the private collection of his first and only supporter in the museum world, the director of Munich's Staatsgalerie, Baron von Tschudi. But it was Prichard who supplied the most effective antidote. This was the opportunity he had been waiting for ever since they had first met to confront Matisse with the power of oriental art. The show provided an unprecedented display of Islamic carpets, carvings, tiles, ceramics,

enamelled glass and illuminated manuscripts as well as Byzan-
tine metalwork and coins. The pair spent hours looking at the
exhibition, talking about its implications, and deploring the
obtuseness of the contemporary art establishment. 'A picture
by Matisse is like the blast of the trumpet of the last judgement
to them,' Prichard jotted down in his notebook. Their week
together in Munich cemented their alliance as nothing else
could have done. What Matisse called 'the revelation of the
Orient' would inform his work and direct his travels over the
next three years.

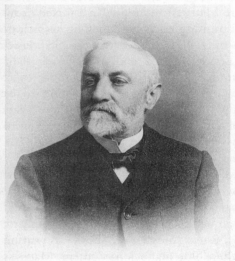

Hippolyte Henri Matisse,
the painter's father

On the evening of 15 October, Matisse's father died suddenly
of a heart attack. Matisse left Munich immediately for Bohain,
where funeral bells tolled throughout the town. The painter
needed courage to walk behind the coffin at a moment when
his notoriety had once again brought public shame on the
family name, and soured the last years of his father's life. Matisse
said that by the end communication had shrunk to 'How's it
going?' when Hippolyte Henri met him with a trap at the

station, and 'Come again soon,' when he took him back to
catch the train to Paris. But the elder Matisse had seen the
younger through years of penury and hunger, enduring derisive
comments from the neighbours with a baffled sense that his
son was neither dishonest nor mad, and certainly not stupid.
As Matisse's own two sons grew older, he found it easier to
recognize his own unbudgeable determination in his father, and
realize that his father had respected the same in him. They were
proud, laconic, obdurate people, who habitually covered emotion
with the dry wit of their native north. When Matisse finally
made good – or at any rate felt sufficiently secure at forty to
rent his own place in an industrial suburb – he had shown his
parents round the house and garden at Issy, drawing his father's
attention with particular satisfaction to the newly planted flower-
beds. 'Why not grow something useful, like potatoes?' asked the
seed-merchant. It remained a source of bitterness ever after that
Henri Matisse senior died too soon to see his son justified, or
to admit that a potato crop was not the only one worth growing.
At the time, his death was a shattering blow. 'I have been
completely crushed ever since,' Matisse told a friend the week
after the funeral.

Five days later, he forced himself to look at his reviews. 'How
much rage they show . . .' he said sadly. 'How far away it all
seems – I only hope this indifference is genuine.' The cuttings
were intended for Shchukin, who reached Paris, already
extremely worried, on 1 November, a week before the Salon
closed. He was used to people in Moscow saying that his
abnormal taste in art had driven two of his sons to suicide, but
he must have known that displaying *Dance* and *Music* on his
stairs would provoke a scandal worse than anything his family
had yet endured. Matisse blamed the Bernheims for what
happened next. They came specially to Issy to tell him that
Shchukin was considering abandoning *Dance* and *Music* in favour
of a work by Puvis de Chavannes so large that it could only
be adequately displayed in all its glory to its prospective owner
in Matisse's studio. He agreed at once. To have Shchukin reject

his panels after nearly two years during which he had thought
of little else, at a moment when he was still reeling from the
impact of his father's death, was almost more than he could
credit. Anguish possessed him day and night. To his daughter
he seemed 'like a man stunned by a knockout blow who gets
up again by sheer willpower, using more of it than even he
had ever needed to exert before'. The rival painting was Puvis's
The Muses Greeting Genius: The Herald of Light. Its ghostly pallor
and elegant, etiolated figures shocked Marguerite, who had
grown up knowing only the uncompromising colour of the
Fauves, but this confrontation between the art of the past and
the future in Matisse's studio brought home to Shchukin the
full enormity of what he had commissioned. He chose Puvis,
and left at once for Moscow.

Two days later he reversed his decision in a telegram
dispatched from Warsaw station, following it up with a long,
brave, honest letter explaining that he was ashamed of his
momentary weakness. 'One should not quit the field of battle
without attempting combat.' The newly purchased painting no
longer meant anything to him, and he wanted Matisse's two
panels dispatched immediately. Purrmann, who came to help
roll and pack them, said that Matisse sprang back in panic when
the figures on the two huge canvases laid out on the studio
floor seemed to heave and stir beneath the baleful gaze of
Puvis's muses. Matisse still couldn't take in what had happened.
'If you remember, I didn't fall to pieces,' he wrote, recalling the
first shock a month later to his wife. 'I made myself go numb.'
The whole family was deeply shaken by this affair, and by
Matisse's inability to absorb it. His misery was compounded by
the opening on 8 November of the London Post-Impressionist
show, which drew startled and aggrieved vituperation from press
and public. For the third time that year, Matisse fled Paris,
boarding a train for Spain, where he planned to visit the
Alhambra, taking in on the way the Moorish palaces and
mosques of Cordova and Seville.

He reached Madrid on Thursday, 17 November, in cold, wet

weather, with his head spinning after twenty-six hours on the
train. He said the people in the streets all looked like curés, or
alternatively like lean, dark and handsome Henri Manguins.
Two days later he rushed through the Prado, firing off a series
of exuberant postcards to old friends. On the 24th he moved
on via Cordova to Seville, where the sun came out. He bought
a fine piece of antique glass for Amélie, and a cream and blue,
pomegranate-patterned rug for himself ('It caught my eye in
an antique shop in Madrid ... it's not in a very good state, but
I'll be able to work a lot with it, I think ... I've never seen
anything like it'). In Seville, he found a hospitable old friend,
Auguste Bréal, installed in an apartment built round a pillared
courtyard with palm trees and a fountain. Bréal showed him
round the town, introduced him to flamenco, and booked him
a room in his club, the only adequately heated quarters in the
whole of Seville, according to Matisse, who grumbled mildly
to his wife about the lack of stoves and the fact that no one
ever dreamed of closing doors or windows. The snag about this
elegant club was that he felt so out of place in his shabby old
clothes that he had to ask Amélie to post him his one decent
coat (taking the precaution of having it relined first, so that he
wouldn't stand out too much among the chic and beautifully
groomed Spaniards).

The reality behind his cheerful letters home was very
different. Matisse was functioning on autopilot. The various
accounts he gave at the end of his life describe almost complete
physical and emotional breakdown in his first weeks in Spain.
He said he had been living on clenched nerves for so long
that they could not be unwound. The last straw had been the
shock of the Bernheims' betrayal, which only began to sink
in once he reached Madrid, where, to his surprise, he failed
to sleep on his first night. From then on insomnia exacerbated
his inner turmoil. He had not slept for more than a week by
the time he reached Seville in a state of near collapse. After
the first few days, the weather deteriorated into torrential
rainstorms. The chill that gripped him body and soul made

him tremble so violently that his metal bedstead drummed on the tiled floor of his room. 'My bed shook, and from my throat came a little high-pitched cry that I could not stop.' He stayed indoors, sick and feverish, dosing himself with laudanum until Bréal removed him bodily, taking the patient home to be nursed back to health in his house on the Calle Imperial. Matisse owed much to Bréal's shrewd Spanish doctor, who explained that there was nothing clinically wrong with him, that black despair would inevitably follow bouts of intense nervous pressure, and that all he could do was learn to manage his condition by sticking to a regular work schedule, and by being less exacting towards himself. The first part of this advice became Matisse's rule for the rest of his life, but he failed, if he ever tried, to follow the second.

The worst of the crisis was now over. 'My dear Mélo,' he wrote on 8 December, using his wife's pet name and describing his recovery ('it's as if I'd been saved') in terms he normally reserved for the great symbolic liberations of his youth, like his first paint-box or his first sight of the southern sun. He felt a familiar surge of energy and release. Free at last to pursue the purpose of his journey, he left for Granada the next day. The train had a special glass viewing compartment, where Matisse sat alone from ten in the morning until eight o'clock at night, entranced by the fertile Andalusian plain and by the harsh dry mountains of the Sierra Nevada. He reached Granada in another howling downpour and stayed indoors, waiting for the storm to pass. On Sunday, 11 December, he reached his goal. 'The Alhambra is a marvel,' he wrote to his wife that night. 'I felt the greatest emotion there.' Matisse said he was possessed by a love of line and of the arabesque – 'those givers of life' – that stirred his senses and appeased his spirit.

Amélie had forwarded to Granada an urgent request for a pair of large still lifes from Shchukin, who hoped that something relatively straightforward and easy on the eye might lessen the inevitable public outcry over *Dance* and *Music*. Arriving in that place at that moment, the commission affected Matisse like a

starting pistol. 'Ideas have come to me here ...' he wrote on Sunday to Amélie. 'I could see the two of them already complete, but done here.' He allowed himself only one more full day at Granada to continue the exploration begun with Prichard in Munich. The brevity of this encounter if anything intensified its impact. The courts and palaces of the Alhambra, its pierced screens and shuttered spaces, its rhythmic variations on the theme of inside/outside, its counterpoint of form and colour, dark and light, riotous pattern and restful intervals of sky or water, found echoes ever afterwards in Matisse's imagination. Part fortress, part paradise on earth, constructed at the time of the Crusades when the medieval collision between East and West reached its height over a century of almost unimaginable violence, the Alhambra embodies Islam's dream of harmony and peace. A parallel vision lies at the core of Matisse's work. He first encapsulated it in the notorious image of an armchair designed to soothe a harassed businessman, telling Prichard the man he had in mind was Shchukin, who found relief from tension at the end of each day's work by contemplating Matisse's pictures in his drawing room.

On Tuesday, 13 December, he caught the train back to Seville, arriving late at night, still cold and wet, still plagued intermittently by sleeplessness, but with his weakness shot through by elation. He hired a studio next day, laid out pottery and textiles (including the cream-and-blue quilt that had captivated him in Madrid), and set to work without waiting for the brushes, palette knife and paints he had sent for from home. European and oriental concepts of decoration confront one another in the two Seville still lifes Matisse conceived in the Alhambra for Shchukin. The layout and its components – fruit, flowers, vegetables, a green-glazed local pot and half a dozen newly acquired textiles – represent the standard still-life paraphernalia of Western painting, but the rhythmic overall fluidity of swirling line and brilliant colour belong to another world. 'In Eastern friezes the drawing combines with the background in a single ornamental design, a decorative whole, a great vibrating carpet,' wrote the

Russian critic Jacob Tugendhold, assessing Shchukin's collection a few years later: 'and it is just this lack of distinction between the "design" and the background that is the characteristic feature of Matisse's work ... Matisse's painting has none of the solemnity of High Art, but it has a gaiety of its own that has less to do with the decorative-architectonic Renaissance tradition than with decorative purity in the oriental sense.'

Matisse had borrowed paints and brushes from an old friend, the Spaniard Francisco Iturrino, who shared his studio and his model, a dancer with black hair, high cheekbones and strong, expressive features called Joaquina. The gypsy dancers of Seville were a revelation to Matisse, especially a sixteen-year-old called Dora, 'a miracle of suppleness and rhythm', unlike the toast of Paris, Isadora Duncan, 'whose gestures cut across the flow of the music, where Dora by contrast prolonged the sound with her arabesques'. A small portrait of Joaquina was one of only three canvases Matisse produced in Spain. Looking back afterwards, he reckoned that his crisis of 'fatigue and revulsion' lasted for one and a half months. He saw everything in Seville through a haze of exhaustion. Although he reached his studio every morning at ten, palpitations and rising fever forced him to stop work after half an hour, or forty-five minutes at the most. It was only back in Paris that his two still lifes surprised him: 'I saw they weren't too bad ... they were the product of nervous tension.'

Insomnia dogged him until the last night of the year, which was his forty-first birthday. Feeling old as well as lonely, missing his friends, thinking sadly of his widowed mother at Issy, he begged his wife to write, and get the children to write too ('The little wretches couldn't care less about their father, or his forties'). The old year had ended with the most vicious of a crescendo of attacks whose ferocity surprised even their subject. 'The Prince of the Fauves' by an aggressive young Picassoite, Roland Dorgelès, repeated all the old racist slurs and taunts ('he paints like a nigger while talking like a Magus') that stabbed Matisse, and stayed with him for years. He marked

the New Year of 1911 with a sombre resolution to have nothing more to do with the manipulative world of art politics. He knew that his only hope of survival as an artist lay in stripping down his life as he had stripped down his work, centring his existence on the studio and establishing a working rhythm that would enable him to live with the hostility of others, and above all to endure the ravages of his own unquiet temperament. 'The public is against you,' Shchukin wrote from Moscow, reporting the arrival of the two panels that winter, 'but the future is yours.'

Matisse wrote almost daily to his wife from Spain, where fine weather in the first few days in Seville reminded him of the sun shining on their Corsican honeymoon. He urged her to send news once a day, as he did ('The hour you spend writing to me you'll be with me . . . You'll see how it will make our separation easier to bear'). He missed her even more as the turmoil of his nights spilt over and threatened to engulf his days, drawing him down into an all too familiar cycle of panic and collapse. What clinched his recovery was Shchukin's letter, shortly followed by a still more ambitious proposal for a large group portrait of the painter's family. A fortnight later, the Russian offered to set aside a whole room in his palace, small and dimly lit but big enough to hold three full-scale wall panels. Matisse sent prompt businesslike letters of acceptance in each case. In private, he responded like a man coming back to life again, or a lover receiving the advances of an irresistibly seductive mistress. Shchukin's first commission released a flood of images. Rapturous longing gave way to the kind of headlong pursuit that can take account of nothing and no one else. His letters to his wife remained affectionate and solicitous, but he no longer talked of catching the first train back to Paris. He bought Amélie presents, and wished they could afford the fare for her to join him, but from now on his tone grew more peremptory. 'Believe me, I'm right to stay on. We'll be much happier together when I've got some work done,' he wrote on 14 December, overriding her reproaches. 'Don't talk to me like

that again, it's the last thing I need . . . You'll see, you'll tell me I did well to stay when you see what I bring back.'

But his wife had already had as much as she could take. Stranded in the suburbs with her mother-in-law and three children, facing a second bitterly cold winter in a wilderness of half-built houses and frozen market gardens with the studio closed down, few visitors and no distractions, Amélie relieved her feelings in a series of terse postcards. She conjured up the cloud of boredom lying over the whole household, and accused her husband of having forgotten all about the distant outpost at Issy-les-Moulineaux, whose inmates counted the days till his return. Henri was stung by this last charge ('It cut me to the heart,' he wrote; 'it was devastating'). The family was his base of operations. His wife supplied essential life support, but he understood her discouragement, and perhaps already recognized warning signals of the depressive patterns that would increasingly shadow and distort their marriage. He sent her a daily checklist of simple practical tasks – to keep an eye on the boys' homework, to supervise their regular use of antiseptic mouthwash, to check that Marguerite had changed the tube inserted in her windpipe, and that the odd-job man had walked the dog – which suggest he was familiar with the inertia of full-scale depression.

This was the first time they had confronted their separate demons apart. Up till now Henri had depended on Amélie to counter the desperation that forced him in her absence to consult a doctor. But his new found self-reliance was no consolation to his wife. Amélie felt unwanted and excluded, retreating into the mute passivity of wounded pride, interpreting his attempts to manage without her as a rejection. The final straw seems to have been his decision, after he had been away a month, to settle down on his own in Seville for a second month of solid work. Amélie, who had been expecting him home in mid-December, left Issy at this point without telling her husband she was going, or where. Puzzled by her silence, anxious about money, worrying over how to pay the next rent cheque, he telegraphed home and got a cable back from Marguerite, saying her mother was

with the Parayres in Perpignan. Amélie's official explanation was
that she had gone to help her sister Berthe settle into a new
post at Cahors as principal of the Ecole Normale. But in her
last indignant letter to her husband, she seems to have accused
him of being indifferent and unfaithful.

Amélie's father and sister knew her well enough for Henri
to rely on them to take his part. 'Dear Father-in-law, dear
Sister-in-law, dear wife,' he wrote on 22 December, setting out
the situation and appealing to their judgement as calmly as he
could. 'I count on you to convince Amélie, who is absolutely
furious with me, that I came here for the sole purpose of
working, and that nothing in my past life could give reason
to suppose I stayed on in Seville in order to spend my nights
on the tiles.' He explained that Seville out of season was far
from the romantic and permissive pleasure ground of Italian
opera. For him the city wore a frowning aspect, cold, harsh,
and so repressive in its sexual mores that models were virtually
unobtainable. 'Contain yourself, Amélie, work has to be taken
into account,' he wrote wearily, pointing out that he could
hardly abandon Shchukin's well-paid still lifes unfinished. 'I'm
counting on Berthe to persuade you that your resentment is
somewhat excessive.'

Berthe Parayre understood the gulf that lay behind Henri's
protests and Amélie's bitterness. Perhaps she also recognized that
Amélie's suspicions, however groundless in literal fact, were only
too well justified on another level. Henri's kind, fond, reassuring
letters from Seville spelt out with painful clarity truths about
their marriage his wife may have feared but had failed to face
until now. He had meant exactly what he said when he warned
her all those years ago that painting had first claim on him. As
far as work went, theirs was not, and never could be, an equal
partnership. The sense of purpose and high drama with which
she had started out on marriage had dwindled, leaving her to
face the fact that for the moment he needed little more from
her than long-distance domestic back-up.

Things would be patched up again between them. Henri

made efforts to modify his single-minded absorption in his
work, or at any rate to include his wife on future painting trips,
but after this unsettling episode Amélie never fully regained her
old assurance. In the short term her father and sister defused
her anger sufficiently for her to return alone to Paris, where
people drew the obvious conclusion about Matisse's reasons for
wanting to get away to a sunny Mediterranean country full of
dancing girls. He began his long, slow, frequently disrupted
journey homewards in mid-January, stopping off to see the
Grecos at Toledo, where he was held up by snow lying four
feet deep on the railway line. When he eventually left Spain,
travelling via Barcelona along the Mediterranean coast, he broke
the journey once again to visit Etienne Terrus, who was espe-
cially attached to Amélie and who must have known or suspected
something was up. Even after he boarded the Paris train at
Toulouse on 25 January, Matisse got off briefly again to consult
the Parayres at Cahors.

What passed between him and his wife when he finally
reached Issy is impossible to say. The trip that was to have taken
a month at the outside had lasted more than twice as long, and
produced nothing significant apart from two still lifes (which
were immediately dispatched to Moscow). Otherwise, all he had
to show was the portrait of Joaquina, more likely to stoke up
than damp down his wife's suspicions. Matisse called his picture
Gypsy, and showed it at the Salon des Indépendants that spring
with a bigger canvas called the *Spanish Woman*. Amélie posed
for this second painting, wearing a brilliant orange and green
embroidered shawl, which her husband had brought back from
Spain, pulled tight across her breast, not so much draped as
flaunted like a flag, with her head held high, eyes averted and
arms thrust out akimbo in a gesture of assertion or repudiation.
The composition is, as Alfred Barr observed, a sumptuous deco-
rative synthesis in which the painter has reduced his wife to
little more than a sketchy, two-dimensional paper doll ('Though
what a magnificent paper doll!'). On another level, the fierce,
taut, emblazoned figure looks like a human ultimatum.

This was almost the last time Amélie modelled for her husband. She had dressed up in Spanish costume for him once before, at another crisis nearly ten years earlier when the couple reached the lowest point of their fortunes with nothing to live on, nowhere to go and no way out in sight. Amélie had tried to save the situation with characteristic dash by putting on toreador pants and strumming a guitar, urging Henri to turn out a slick product for quick sale. In a tense atmosphere, with tempers running high on both sides, he averted a blazing row only by kicking the easel over, after which both of them burst out laughing. 'If one day you manage to get out of this mess, all our troubles will be over,' she said. 'Troubles are never over,' he replied in the dour flat northern way that always exasperated her stormy southern temperament. But public exposure of the *Spanish Woman* seems to have been more than even Matisse could stand. The Indépendants opened on 21 April 1911, and within five days he had snatched back his wife's portrait, taking it away by cab and leaving in its place the *Pink Studio*, a canvas so newly finished that visitors amused themselves by smearing their fingers in its sticky paint.

The kidnap caused hardly even a minor sensation in a year when people were more agitated about Picasso's cubist followers than about Matisse, whose scandal quotient had fallen behind one of his own pupils. 'They recoil in horror before the monstrous images of Olga Meerson,' reported the *Journal*, citing her as the worst of the Salon's outrages, which included works by Picabia, Van Dongen and Vlaminck, 'not to mention the frightful *Spanish Woman* of M. Henri Matisse'. It was three years since Meerson had put her career on hold to follow Matisse. She had learned fast, shedding her old skills, retaining her sense of colour and design, enriching the gift for portraiture Matisse had urged her not to put at risk at their first meeting. Meerson remained closer to him than any other former pupil (apart from Sarah Stein and Hans Purrmann, who retained their respective roles as cheerleader and dogsbody). He modelled her in clay as a *Seated Nude*, painting her portrait as well as his wife's in 1911.

Meerson also painted him, exhibiting the result at the Autumn
Salon where, according to Guillaume Apollinaire, it dominated
the Fauve section. Her new style was rougher, bolder, more
expressive than before, making up in attack what it had lost in
subtlety and polish. Matisse relaxed for her as he rarely did for
the camera, or for the various interviewers who tried over the
next forty years to portray him in words. He was a wary and
defensive sitter but with Meerson, in the summer of 1911, he
lowered his guard, something he never did for any other fellow
artist. The semi-official portrait admired by Apollinaire has
disappeared, but Meerson kept her small preliminary oil sketch
to the end of her life.

Olga Meerson, 'Henri Matisse', 1911

She painted Matisse lying on his own studio couch, looking
younger and more relaxed than in any photograph. What
provoked the *Journal*'s art critic was presumably the artist's
confident, even humorous elimination of inessentials. Colour
in her picture is restricted to the basic complementary red and
green suggested by her subject's red-brown hair and work-
clothes of bottle-green corduroy. The canvas, adapting the
standard format of a classical reclining nude, is diagonally bisected

by Matisse's solid compact body, sprawled with a book on a red check counterpane in the kind of casual, almost catlike pose he would encourage in the girls who posed for him a decade later in Nice. Modelling is rudimentary. The brush picks out its subject's suntanned skin, reddish hair, slender, tapering fingers and unexpectedly long legs. The result is very different from Matisse's various versions of himself. It has none of the fierce brooding interrogation of his early self-portraits, nor the comic overtones he invariably took on in his own pencil sketches. Meerson's eye is gentle but not innocent. Her sunny, observant little portrait demonstrates, with touching honesty and simplicity, the central precept Matisse taught his students, that truth of emotion matters more than anything else in a painting.

She was in love with him by this time, but his response is not at all straightforward to assess. Matisse singled Meerson out, inviting her to Issy, where she lunched at the house, went shopping with Amélie and was generally accepted – like all his regular models – as part of the family. Olga was thirty-three years old in 1911, living on the meagre income she could still earn from Old Master copies, and finding it next to impossible to support herself by painting. 'As she says, she can't do what she used to do any more, and she can't do what she would like to do either,' wrote Matisse, confirming her own bleak diagnosis. 'She despises what she could do naturally, but nonetheless she isn't able to do anything else.' He and his wife, desperately hard up for so long themselves, did what they could to help by feeding her and finding her odd jobs. Apart from Amélie and the occasional professional model, Olga was the only woman reckless enough to pose nude for Matisse in the years before the First World War. She had cut her home ties early, exchanging her respectable, affluent, mercantile family for the restless, rootless, cosmopolitan society of artists intent on dismantling all conventional constraints. In terms of personal liberty she had already shaken off the past more thoroughly than would ever be possible for Matisse, who remained enmeshed in bonds of family feeling, need and obligation to the day he died.

Their difference in outlook perhaps explains an extraordinary note he sent after bursting unannounced into Olga's room at the boulevard des Invalides, withdrawing at once (as he had done before, after surprising Marie Vassilieff in similar circumstances), and following his withdrawal with an almost incoherent plea for forgiveness: 'I can only think of it as an impulse of madness. Nothing gave me the right to do it. My suspicions were imaginary.' This undated letter is baffling on several counts. Matisse, who had clearly lost control, pleaded with Olga to tell no one, explaining that he had said nothing at home, and adding that, even if she forgave him, he wasn't sure he could forgive himself ('Can things really become irreparable so quickly! Couldn't you allow for a moment of unreason, of irresponsibility . . . I think I was mad'). Art historians have generally assumed that the letter dates from the beginning of their acquaintance, when Matisse was working on *Nymph and Satyr*, but according to Matisse's daughter the crisis between them came much later. The tone of this message is quite different from the painter's other casual friendly notes to Olga, fixing meetings or sending holiday greetings, nearly all dated, or datable, to 1910 or earlier. In any case, if Matisse was having an affair or hoping to start one, his suspicions are a puzzle. All accounts agree that Olga had eyes for no one else. She threw herself at him almost from the start, according to Alice B. Toklas, and she confided her feelings for him freely in letters to her best friend in Russia, Lilia Efron. The only plausible alternative is that Matisse's imaginary suspicions were not sexual at all. He certainly feared that Olga was ruining her life and jeopardizing her work by taking drugs. The possibility maddened him, and perhaps his instinct told him to confront her with the evidence so as to shock her into giving up.

This would account for the otherwise surprising testimony of Matisse's letters from Spain, which leave no doubt that he was still in love with his wife at this stage. They are punctuated on almost every page with his longing for her. He pleaded, urged and cajoled her to write back. Abstinence may have been

his ideal in theory, but in practice he missed Amélie's physical presence, especially in the early morning after yet another debilitating sleepless night. '*Ma chère biche,*' he wrote fondly from his hotel bed on 6 December 1910. 'Don't be too surprised at this endearment. It just slipped out naturally because I'm a bit drowsy in the mornings when I haven't slept properly for a couple of nights. You know how gentle I can be at these moments, and you too most especially.' Matisse's marriage was grounded in longstanding intimacy and mutual dependence. It is easy to understand that he might have wanted to safeguard it by concealing a moment of madness from his wife, but difficult to see why he should have been suspicious of someone who made no secret of her feelings for him, and who came from an intellectual milieu where sexual liberation went hand in hand with artistic freedom. Olga told Lilia Efron that the physical side of lovemaking was not particularly important to her, but her letters make it clear that she had no moral inhibitions. She had been friends in Munich with Gabriele Münter and Marianne Werefkin, painters who shared their lives and studios respectively with Wassily Kandinsky and Alexei Jawlensky. Kandinsky had promised Münter that their bond would prove stronger than marriage vows, and perhaps Olga dreamed of something of the sort with Matisse.

It would have been an uncomfortable dream, if so. Life with Matisse was never easy. Sometimes it came close to unendurable. When painting tormented him, he vented his frustration on anyone or anything that came between him and his work. It brought out a side of him that was jealous, exacting and propri-etary. To the end of his life, he made impossible demands on those closest to him. Lydia Delectorskaya said that, after living with him for his last two decades, she recognized only too well the kind of tyrannical scene he had made before the First World War in Olga's room on the boulevard des Invalides. All its elements – his 'impulse of madness', his unreasoning fury, his groundless suspicions – would recur, throughout the years she knew him, in periodic tirades against the girls who posed for

him in Nice. His complaints took no account of human frailty, his own or anyone else's. He felt his models should be prepared to submit to a higher cause, as he was. Whatever their needs or wants, he allowed no exceptions to the rule that painting took precedence.

Even in his sixties and seventies, Matisse's single-mindedness could be terrifying, but it had acquired a kind of ritual absurdity by then. His young models learned to cope, patiently and humorously, with accusations of slackness and frivolity whenever they wanted to take a weekend off or go dancing with their boyfriends. Matisse, who had given up everything for his art, still found it hard to see why their devotion should be less absolute than his, but his indignation was better controlled than it had been in youth or middle age. In 1935, the year she began sitting for him, Delectorskaya posed for a painting of a nymph with a piping faun or satyr. This time the girl is being lulled to sleep instead of facing violation as in the first *Nymph and Satyr*, painted twenty-seven years earlier. 'It was brutal for her,' she said of Matisse and Meerson. 'With me, he knew how to be gentle and soothing.' She meant that she, too, had found herself engulfed, enthralled, at times appalled by the passion that, for Matisse, overwhelmed everything else, including sexual desire. But even Delectorskaya could not be sure to what extent that desire had been sublimated, or superseded by the urge to paint, in 1910 or 1911. She thought it unlikely but possible that Matisse had been Meerson's lover. 'He might not have been able to help himself,' she said.

Whatever her relations with him as a woman, Meerson's progress as an artist was a source of constant friction. She had been a precocious teenager when she began her academic training alongside male students much older than herself, going on to take her first steps in modern art under the personal tuition of Kandinsky, and, by the time she neared the end of her journey in Matisse's class, she seems to have gone too far too fast. He was increasingly dismayed by what looked to him like lack of stamina. He complained that she failed to concentrate, that she

let herself be too easily distracted by money worries, and that she refused to reconcile herself to the kind of goal she could reasonably hope to achieve. Perfectionism, and the self-castigation that went with it, were problems Matisse struggled with himself. He had been responsible, at any rate involuntarily, for Meerson's change of course, and her sense of failure was his failure too. He contemplated her shortcomings with the asperity always uppermost in his dealings with pupils whose sacrifices in the name of art were less ruthless than his own. Matisse's reproaches compounded Meerson's self-doubt. Although there is no way of dating his outburst in her room at the convent, it seems most likely to have erupted at the end of 1910. He wrote to her from Spain on 24 November, hoping she was feeling better and had taken medical advice. By December Meerson had entered a Neuilly clinic for treatment. There can be no doubt that Matisse felt deeply uneasy about her at this point. His correspondence with his wife then and later is full of concern for Olga, queries about her activities and suggestions for occupying her time, expressed in terms that make her sound more like a member of the family than a potential threat to its fabric. Matisse's wife certainly went out of her way to offer support. Perhaps Olga even stirred a pang of pity in Amélie, who, whatever else she might have to put up with, never had to face the crushing weight of her husband's dissatisfaction with her as a painter.

The challenge posed by Shchukin's commissions absorbed the combined energies of husband and wife for most of 1911. Matisse's intense nervous concentration provoked gruelling anxiety attacks, and Amélie dealt with them as she always had by taking him on long exhausting walks (family legend said that once they got as far as St-Germain-en-Laye, which is fifteen miles from Issy), and by reading aloud through the small hours night after night. The project that consumed him took the form of a dialogue with himself sparked off by Shchukin's request for three allegorical wall panels ('What do you think of youth, maturity and old age, or spring, summer and winter?'). The first

two of the three canvases might initially have fitted the spring/
summer/winter sequence. *The Pink Studio* is full of cool spring
sunlight that washes evenly across the canvas, turning the studio's
white walls and wooden floor pale pink, flattening them out
and incorporating them in a decorative scheme of sharp greens,
dark blues and ochres, which takes its keynote from the green-
glazed pot and the cream-and-blue pomegranate quilt Matisse
had started working with in Seville. The impression of clear
light and calm space contrasts strongly with the next painting
in the series, the *Painter's Family*, a densely packed design in
hot summery reds, oranges and yellows. But if Matisse began
with some idea of illustrating the kind of trite tripartite allegory
Shchukin had proposed, he soon dropped it. *The Red Studio*
works on a deeper, more ambivalent level of meaning, and so
does the *Interior with Aubergines* (painted towards the end of the
summer at Collioure), which is the last of what Alfred Barr
called the four great symphonic interiors of 1911.

These paintings are among the most impersonal and at the
same time the most insistently autobiographical Matisse ever
made. In the two *Studios*, he painted the tools of his trade (easel,
frames, model stands, a box of sharpened crayons), his workplace,
and the works he produced in it. The models and studio
managers on whom that work depended posed for the *Painter's
Family*. Matisse, who had been alone in Seville when he first
sketched his family portrait for Shchukin, must have staged the
scene when he got home – his wife sewing on a sofa, his two
sons playing chess, his daughter holding a yellow paperback
novel – like a director organizing a theatrical production in the
living room at Issy. He himself described the aim of his strange,
synthetic, four-part experiment with characteristic plainness by
invoking Cézanne. 'Look at Cézanne: never an uneven or weak
spot in his pictures. Everything has to be brought within the
same picture plane in the painter's mind.' No one has painted
the view from his or her mind's eye more directly or with less
fuss than Matisse.

Colour, which for him meant feeling, showed the way. He

found signposts in the oriental tradition encountered in Spain and Munich. 'This art has devices to suggest a greater space, a truly plastic space,' he said, in a much-quoted discussion of Persian miniatures. Chief among the devices he borrowed for the *Painter's Family* was the richly patterned surface decorated with stylized floral motifs and laid out in compartments, like a carpet, to represent a space where everything beyond the reach of the mind's eye is insubstantial, missing or impossible to apprehend. All the elements in these pictures (including the four family members with faces reduced to masks) sink their individual identities in what became a prolonged meditation on art and life, space, time, perception and the nature of reality itself: a great central statement to which Matisse would return again and again from different directions all his life. These four works stand at a crossroads for Western painting, where the classic outward-looking, predominantly representational art of the immediate past met the provisional, internalized and self-referential ethos of the future: 'a confrontation', in Dominique Fourcade's phrase, 'to which Matisse would never call a halt'.

Visitors to Issy in 1911 grasped immediately that no one had seen or imagined anything like this before. People were brought up short especially by the biggest and most baffling of the four canvases, the *Red Studio*, which looked like a detached wall segment with rudimentary objects floating in or suspended on it. 'The colours of the things in one inexplicable way or other made the wall come alive,' said a Danish painter, examining the *Red Studio* and trying to relate it to what he saw around him in the actual studio. 'You're looking for the red wall,' Matisse said amiably, explaining as he regularly did to puzzled colleagues, critics and collectors, 'that wall simply doesn't exist.' From now on, he painted realities that existed only in his mind. It would be nearly thirty years before the *Red Studio* crossed the Atlantic to America, where it would transform the vision of a whole generation of New York artists, led by Jackson Pollock, who felt their way towards abstraction through Matisse.

Shchukin came to Paris for a few days in July to see the

Pink Studio and the *Painter's Family*. He bought both, but they made him understandably dubious about the small, dimly lit room he had set aside at home to house Matisse's decorative panels. His solution was to invite the painter to Moscow that winter to inspect the space available. Meanwhile Matisse headed south again for a stint of uninterrupted work with his whole family at Collioure. They moved in late July into a house on the edge of town, with a studio made out of the space under the roof where Matisse had stored his painting things ever since 1906. Here they kept open house for family and friends. Amélie's father came from Cahors, Jean Puy arrived along with Hans Purrmann, and all the artists of the Roussillon dropped in too. Puy never forgot the warm and simple hospitality he found that summer in the studio, and round the Matisses' table at Collioure. All their guests carried away a memory of long, sunny days and convivial evenings presided over by the majestic presence of the work that absorbed Matisse throughout August and the greater part of September.

This was *Interior with Aubergines*, the last of the four great paintings of 1911 that realigned the chaotic, crude, disruptive elements of ordinary life according to another order of reality. It started with three small, blue-black aubergines arranged on a fancy tablecloth before a florid screen between a heavy gilt-edged looking-glass and the studio window framing sky and hills beyond. The picture's patterned surfaces endlessly echo, reflect and open into or out of one another like a hall of mirrors. Everything about Collioure – from its abundant light and colour to its landscape, its market produce, the purple-flowered bindweed growing up the wall outside Matisse's studio and the Paris/Barcelona express puffing past his window – falls into place within the kind of riotously decorated, miraculously ordered whole that was in large part what Matisse took from the marvel of the Alhambra.

It would be many decades before the painting was publicly acknowledged as one of the twentieth century's great leaps forward into modernism, but its importance was immediately apparent

to fellow painters, including Georges Braque, who walked twenty miles across the Pyrenees to see it. Simon Bussy, who had for years found his old friend's work incomprehensible, if not actively repulsive, capitulated almost against his will to the simplicity, sobriety and power of the new work. Sarah and Michael Stein, who bought it, rehung their entire apartment so as to give *Interior with Aubergines* pride of place. Eleven years later, Matisse re-acquired the painting and presented it to the museum at Grenoble, where it remained, the only one of the four symphonic interiors to find a permanent home in France, largely forgotten, increasingly dilapidated, eventually recognized long after the painter's death as a key work in his imaginative evolution.

The only snag that nearly spoilt the companionable summer of 1911 at Collioure was that Olga Meerson turned up, too, without Matisse having warned his wife beforehand. Her arrival revived Amélie's old resentful feelings of exclusion. Olga, more dubious than ever about herself and her work, complained of the heat in a postscript to a letter from Matisse to Marquet on 30 July. The atmosphere of tension – at its height, by Marguerite's account, while her father was working on his *Aubergines* – is palpable in a group photograph, taken in front of the big canvas in the studio, in which everyone gazes at the camera except for the two women seated one on either side of the painter. Olga looks directly across at Amélie Matisse, who looks down at her lap. But once again Amélie's sense of being slighted collapsed in face of her husband's evident bewilderment. Furious outbursts were followed by reassurance and reconciliation. In another photo, taken over lunch on the shady terrace outside Terrus's studio at Elne, Olga stares straight at the camera from a seat on the right hand of their host, while Amélie on his left hugs him affectionately, and her husband flings his arm out over her from the other side. However indignant she had been at the start of the summer, Amélie returned to Paris at the end of it in radiant health and spirits, taking the boys with her, and leaving Henri behind with his daughter and his Russian pupil. When the three of them finally returned to Paris a week later,

Olga would be reinstated on the old friendly terms at Issy as a kind of honorary daughter of the house. 'The storm had passed,' said Marguerite.

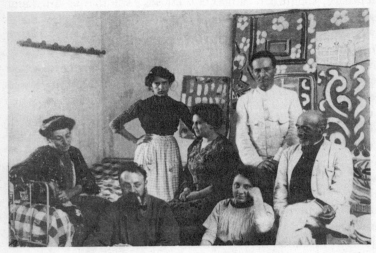

The studio at Collioure, summer 1911: Matisse flanked by his wife and Olga, with Marguerite and Armand Parayre on right in front

Meerson's portrait of Matisse, exhibited at the Autumn Salon, was presumably painted (like her little picture of him lying on the checked bedspread) in the studio at Collioure, where she also posed for him. Olga was naturally statuesque, not tall but upright, like the plumb line, which remained for Matisse the measure of order and balance in any composition. She is always erect and often wary in photographs, in the clay *Seated Nude (Olga)* – which seems to grow upwards, like a plant, centred on the spine dividing the figure's elegant long straight back – and in the beautiful *Portrait of Olga Meerson*. For this last canvas Matisse chose a low-keyed palette of tender greens, soft blues, pink and russet brown. The sitter's unassertive poise, emphasized by her modest, round-necked dress, neatly rolled sleeves and meekly folded hands, gives her a self-contained stillness at odds

with the way the face seems to shiver and dissolve beneath the painter's brush. But, for all her air of primness, her body curves in harmony with the two fierce black arcs – plunging respectively from neck to thigh, and armpit to buttock – that slash through it like scimitar strokes, as Alfred Barr observed, destroying its reality on one level, and heightening it on another.

Matisse presented Meerson with his palette and a sketch of herself wearing a bathing towel wrapped round her head like a turban. She came as close as she ever would to happiness with him in this brief interlude of calm and contentment when they painted one another at Collioure. If they also became lovers, it can only have been, for him at any rate, a brief and casual connection compared to the intensity of their exchange on canvas. If Meerson ever allowed herself to hope for a continuing liaison with Matisse, she mistook the essential nature of French marriage, which is a business contract with binding legal and financial obligations on both sides. She also seriously underestimated the strength of his feelings for his wife.

Matisse got back to Paris that autumn in time to board the train with Shchukin for Russia, where his host promised him he would encounter Asia for the first time: 'Because Moscow is Asia.' When they finally arrived on 6 November (24 October by the Russian calendar), after four days on the train, Moscow looked to Matisse like a European city grafted on to a huge, gaudy Asiatic village with gaily painted wooden houses, modern luxury shop fronts and filthy, unpaved streets. Shchukin had by now all but turned his home over to his collection, which was regularly open to the public, and already bequeathed to the city in his will. The salons hung with choice works by French painters from the Impressionists to Cézanne, Gauguin and van Gogh were still used for concerts and parties, but essentially the old Trubetskoy Palace on Znamensky Lane was now the world's first permanent museum of modern art. It was a long, low, eighteenth-century building with offices on the ground floor and reception rooms above, reached by the notorious staircase for which Matisse had painted his two panels. Shchukin was nervously aware as they

approached the stairs of the dab of red paint with which he had covered up the flautist's genitals in *Music* but, to his acute relief, Matisse blandly announced that it made no difference (twenty-three years later he would try without success to persuade the Soviet authorities to clean it off).

He knew well enough that he was entering a field of battle, and he soon grasped, if he hadn't before, what a superlative strategist he had found in Shchukin. On the arrival of the two panels almost a year earlier, their new owner had been as horrified as his friend, the collector Ilya Ostroukhov, who unpacked them with him. Ostroukhov considered Shchukin half-cracked when, instead of sending his new canvases straight back, he shut himself up with them to undergo a long solitary re-education. He said afterwards that he spent weeks cursing himself for buying them in the first place, sometimes almost weeping with misery and rage, knowing that he must subdue his own violent misgivings before he could begin to cope with other people's. But he can't have been in doubt about the outcome, because he almost immediately embarked on a two-pronged plan of action. On the one hand, he fired off a series of further commissions to Matisse in Spain. On the other, he started showing the panels privately to some of Moscow's brightest young critics, describing the patience needed to make a difficult painting open up – 'You have to live with a picture in order to understand it . . . You have to let it become part of you' – until what initially seemed arbitrary, offensive or grotesque revealed its own natural sense and rhythm. He took particular pains to explain the process to his more conservative friends, like Ostroukhov and Alexander Benois, whose cautious advocacy went far to defuse the indignation of fashionable Moscow. By the time Matisse arrived, people still habitually made fun of Shchukin, but his more sophisticated dinner-party guests were beginning to relish the piquancy of *Dance* and *Music* in this elegant palace with its pale silk furnishings, rococo plasterwork and liveried doorman ('Matisse is such a contrast he has the effect of strong pepper').

On Matisse's first day in Moscow, Shchukin took him to the Morozovs' house, where it was clear that even the owner now recognized Denis' *History of Psyche* as a mistake. The two Russian collectors were friends, but the contrast between Shchukin's boldness and Morozov's relatively safe choices that afternoon was glaring. Next morning Shchukin arranged for a correspondent from the Moscow *Times* to call on his guest, who set out his aims, explaining the background to his work and describing how he had fallen in love at sight with Russian icons, in an interview that set the tone for the whole visit. Matisse became a celebrity overnight. People could not get enough of him. The cast at a private performance of Tchaikovsky's *Queen of Spades* held a reception for him afterwards. Poets and philosophers clapped when he entered the hall at the Free Aesthetics Society. The art-world assembled at the smartest of Moscow cabarets, Nikita Baliev's The Bat, for an uproarious celebration that ended in the small hours with the presentation of a painting showing the guest of honour on a pedestal receiving homage from a ring of half-naked ladies under the caption: ADORATION DU GRAND HENRI. Matisse did his best to retain his northern cool ('I'm not going to get carried away,' he wrote home on his third day: 'You know me'). He was baffled, touched and well aware who was responsible for his reception. 'Shchukin is more moved than me — for him it's a triumph.'

This Moscow visit turned the commercial transaction between painter and collector into something more like a collaboration. Almost before he had time to settle in, Matisse reported to his wife that Shchukin had proposed a further commission on an unprecedented scale for a whole row of decorative paintings to go 'above the still lifes' in his drawing room. Within a week, they had finalized the details, measured up the spaces and agreed on eleven paintings, eight of them large enough to be outside the terms of Matisse's contract with the Bernheims. Shchukin would pay 6,000 francs per canvas, leaving the choice of subject to Matisse, who sketched out ideas

on huge sheets of paper pinned directly to the wall. This was a princely way of doing business. 'It frees me completely with regard to the Bs,' wrote Matisse, whose attitude to his dealers had been permanently soured by the shabby opportunism of the Puvis affair. Shchukin by contrast stated his goal unequivocally – 'I want the Russian people to understand that you are a great painter' – and planned to achieve it with the nerve and vision that had turned his father's trading company into Russia's leading textile enterprise.

Matisse had never met organizing ability of this order before. Nor had he seen anything quite like the contagious excitement described by visitors to whom Shchukin personally showed his collection, stammering in his eagerness, running ahead through the rooms, flinging open doors, making them screw up their eyes on the threshold of a darkened antechamber and squint across the landing at the *Dance*. 'Just look! What colours! The staircase is lit up by this panel, isn't it?' he cried with sparkling eyes to one young journalist. 'Something fantastic happens, like in a fairy-tale,' wrote another in a passage that comes as near as it is possible to get to Shchukin speaking. 'Everything comes to life, and moves and whirls about in a wild irrepressible surge. This is the best thing Matisse has done, and perhaps the best thing the twentieth century has given us so far.'

The enthusiasm Matisse met everywhere he went was mutual. He said it was only in Moscow that he found connoisseurs capable of keeping up with the latest developments in modern art, and he repeated again and again that it was the riches of Russia's past that enabled them to understand the future. The icons that captivated him at sight belonged to Ostroukhov, whose collection was among the best in Russia. Taken to dine with him by Shchukin, Matisse spent the whole evening marvelling at it, declaring as he left that 'for the icons alone it would have been worth coming from a city even further away than Paris'. Excitement kept him awake all night. Ostroukhov responded by showing him round the Tretyakov Gallery, and opening the cases in the icon rooms. 'I have spent ten years

searching for something your artists discovered in the fourteenth century,' Matisse said that day.

Ostroukhov's reservations about Matisse could not withstand the way he trembled with delight in front of normally despised and neglected works from the Russian past. 'I find Matisse extraordinarily likeable, he's such a subtle, cultivated and original man,' he wrote, dropping everything to act as guide on a tour that enthralled them both: 'I'm still spending all my time with Matisse, who absorbs me more and more.' They visited the cathedrals of the Kremlin, and the Novedivichi convent with its gold-topped palaces and bell-towers set high above the Moskva river. They examined the rare icons of the Iverskaya chapel, listened to old Russian plainsong at the Synodal College, and drove out through woods of birch and beech to the rarely visited treasure-houses of the Old Believer churches tucked away in ancient, mossy, carved and coloured fretwork houses along the riverbank. They visited the Nikolsky monastery, and spent a whole day at the Rogozhky cemetery.

Matisse's regular bulletins from Moscow were full of energy and vigour, with no trace of the chasms of loneliness and despair that had opened up in his letters from Spain. Amélie, left behind again at Issy, must have recognized the signs that, unlike the last two winters, the one ahead promised to be productive. The Moscow visit was planned to last no more than a fortnight (in the end Shchukin insisted on an extra week), during which Amélie had company in the form of Olga, who was constantly on tap to attend dress fittings or translate press cuttings from Moscow. Husband and wife both now apparently agreed that, far from posing any kind of threat, Olga needed looking after. Matisse had taken a trunk of her things to Moscow, and he sent back a rousing message inspired by a dismal exhibition of contemporary Russian art: 'Tell Olga I send her my compliments, and the assurance that, if she wanted to, she could be the best painter in Russia.' He saw one of her two older sisters, Sophia Adel, a fashionable lawyer's wife, on the day of his arrival, and dined two days later with the other, the pianist Raissa

Sudavskaya. If Matisse was taken aback by the attention he attracted in Moscow, so were Olga's sisters, who had regarded him as a disastrous influence up till then ('It's a shame he ever took up painting' was Mme Adel's view). They took him to the Moscow Arts Theatre, invited him to an opera at the Bolshoi, and crowned their hospitality by throwing a party for him, attended by everyone who was anyone on Moscow's cultural scene. Radical young artists turned out in force, including Michail Larionov, Natalya Goncharova and David Burliuk. Next day Mme Adel's party guests officially founded the avant-garde group called Jack of Diamonds, electing Shchukin its first honorary member.

Matisse approved a scheme proposed by Olga's sisters for her to divide her time between France and Russia, earning enough from rich Moscow patrons to subsidize six months a year at the cutting edge of developments in Paris. But the rescue plan came too late. Isolated, anxious and deeply depressed, Olga felt herself disintegrating. The last straw was the news that Matisse had talked about her behind her back with her sisters, whose meddling she detested. 'Olga ... says she's feeling better since she discovered something which stupefies her in the daytime, and that she lives as if in a dream,' Matisse wrote to his wife. 'She tells me that you know nothing, and nor does anyone else, that she's doing her best to conceal it – and that I should say nothing about it to her sisters. What can it be, morphine probably.' He told his wife to warn Olga that he could do nothing more for her if she was taking drugs ('She's going to ruin her life completely'). He said he would feel it his duty to tell her sisters, and advise them to put her in a clinic. He begged Amélie's help ('Look after Olga, if you can'), but by the time he got back from Moscow in late November Mme Adel or her sister had arranged for Olga to enter a Swiss sanatorium run by Dr Paul Dubois, celebrated throughout Europe for his work with neurasthenic patients. At the end of November 1911, Dr Dubois received two long letters about his patient from Matisse, emphasizing her outstanding quality as a painter, and setting out her

professional history in the light of the forebodings he had felt
at their first meeting three years earlier.

Olga never forgave him. For her this was an unconditional
betrayal from the man she had loved, looked up to and trusted
to support her and her work against a hostile world in general,
and the interference of her family in particular. She felt she
could never have faith in anyone again. 'Of course you under-
stand what the real trouble is,' she wrote six months later to
Lilia Efron, describing a brief return to Paris where she discussed
what had happened with Efron's own therapist, Dr Majerzak.
'The doctor explained a lot to me about Matisse: there is no
end to his baseness and cowardice. I recall every detail with
pain.' Amélie also felt betrayed. In three weeks alone at Issy with
Olga as her only adult companion, she had had enough of the
Russian's problems and of her dark hints about a special rela-
tionship with Matisse. 'Olga amused herself, while I was away
in Moscow, by pestering my wife, who has been so good to her
this summer, with insinuations as clear as they were malicious
(perhaps unconsciously malicious) . . .' Matisse explained to Mme
Adel. 'Admittedly, I know that Olga is ill, irresponsible, but even
so the harm she's doing won't heal her.'

Matisse's iron determination to subordinate life to work had
foundered in conflicting currents of passionate emotion. Always
a clumsy liar who could never hope to keep anything from his
wife for long, he now made things worse by attempting conceal-
ment. Amélie intercepted a message from Efron telling him to
collect an envelope from the post office and, having insisted
on accompanying him herself, collapsed when she read the
letter. 'My wife found out about the feelings Olga has for me
from a letter addressed to me poste restante by Dr Dubois . . .
My wife has been ill ever since, and I have to leave my work
and take her to the Midi,' Matisse wrote to Olga's sister. The
household at Issy was in turmoil. 'Madame Matisse slammed
the door shut,' said Marguerite. Amélie's instinct was for flight,
as it had been twelve months earlier. This time there would be
no more concessions on her part, and no further hesitation on

her husband's. He broke off relations with Olga, abandoned work in progress, and accompanied his wife south in an attempt to repair the damage.

Olga remained in Dubois' clinic at Berne until the spring of 1912, when she emerged to rebuild her life in Munich. The break with Matisse, and with her own family, left her nowhere else to go. 'I suffer a great deal,' she wrote to Efron. 'I am truly in anguish.' She picked up an old friendship with Thomas Mann's brother-in-law, the conductor Heinz Pringsheim, who did much to restore her confidence over the next year. Eventually she would acquire a reputation as a portrait painter, well known in musical circles in Munich and Berlin in the 1920s, painting Otto Klemperer's brother and Wilhelm Furtwängler's wife, exhibiting in a mixed show of women painters alongside Marie Laurencin and Greta Moll. She showed at the Paris Autumn Salon for the last time in 1913. She had married Pringsheim by then, and borne him a daughter. Matisse sent a wedding present (an early Corsican landscape, the kind of picture Olga's sisters would have no trouble understanding). He kept her portrait, and she kept his, to the end of their respective lives, but the two never met again.

The affair was decisive for Matisse, and perhaps also for his wife. As a rival for his attention, Olga had come uncomfortably close to embodying painting in person, but from now on no one would ever again stand between him and his work. On 27 January 1912, the Matisses caught the steamer from Marseille, as they had done on their honeymoon fourteen years earlier almost to the day, heading this time for the coast of Morocco on the southern shore of the Mediterranean. They landed in torrential rain at Tangier where, as one door slammed shut, another opened for Matisse that spring.

8. *Henry Hairmattress (1912–14)*

The last thing Matisse did before leaving Russia was to stage a retrospective for himself in Shchukin's drawing room in the Trubetskoy Palace. Over the past six years the collector had bought twenty-seven paintings from him, all from periods of radical experiment, many of them commissions that stretched him to the limit, others snatched from the studio before the painter himself had time to grasp what he had done, let alone absorb its implications. 'He always picked the best,' Matisse explained, adding that once Shchukin's eye settled on a canvas it was useless to protest that the work was not for sale or had turned out a failure ('I'll take the failure,' said Shchukin).

This was Matisse's first chance to see where he had come from, and how far he had got, before starting the next leg of his journey into unknown territory. He took down the paintings by Cézanne and Degas in the drawing room, collected his own works from all over the house and hung them two deep, directly beneath the richly moulded cornice and jutting out over the plasterwork projecting from the walls. All accounts agree that the impact was unlike anything ever seen before. Reversing the principle of the two *Studios*, where he had sucked the life out of a room to recreate its essence on canvas, Matisse now drew a whole room after him as if by magic into the world of his imagination. 'I did not fully know Matisse until I saw Shchukin's house,' wrote the young Russian art critic, Jacob Tugendhold, describing the transformation that overtook this eighteenth-century drawing room with its gilt-legged Louis XVI chairs, rose-patterned silk upholstery and gilded chandelier hanging from a vaulted ceiling painted with birds and garlands:

Here we have in Shchukin's home a hothouse, an apotheosis of Matisse's paintings . . . You appreciate them together with the environment that surrounds them – the pale green paper on the walls, the rose-pink ceiling, the cherry-coloured carpet on the floor – among all of which the blues and cherry-reds and emerald-greens of Matisse blaze out so brilliantly and joyfully. Indeed you cannot actually tell who is reponsible for what: whether it is the room that does things for Matisse, or Matisse for the room. You have only the overall impression that the whole ensemble – the walls, the carpet, the ceiling and the pictures – is the work of Matisse's hands . . . the true metaphysical life of his art is revealed only in this drawing room.

Shchukin himself compared the room to a perfumed hothouse, 'sometimes poisonous, but always filled with beautiful orchids'. Over the next two years – as the canvases Matisse painted in Morocco reached Moscow to take their places on the walls – the room's enchantment grew, and so did the underlying scent of risk and danger. Fruit, flowers, fabrics, even people gave up their solid separate existence in these pictures, becoming dematerialized and abstracted. 'Not things, but the essence of things,' wrote Tugendhold. Individually each work produced a powerful effect, but together their impact was of another order: 'This is not decoration in the European sense, but decoration as it is understood in the East.' The gilt-framed canvases hung side by side one above another from floor to ceiling like the kind of sumptuous iconostasis Matisse had seen in Moscow churches, constructed from three or four tiers of painted icons in gold or silver cases. 'Here is the true source of all creative search,' Matisse said of Moscow's icons. 'Russians do not realize what treasures they possess . . . everywhere the same vividness and strength of feeling . . . Such wealth and purity of colour, such spontaneity of expression I have never seen anywhere before.' Even Shchukin could not have foreseen the intensity of the painter's response, although it confirmed the faith each now had in the other. Among the many artists he collected, Matisse was the only one with whom Shchukin formed a

personal relationship, the only one whose work he bought directly from the studio, and the only one to whom he gave commissions: 'For me Matisse is above all the rest, better than them all, closest to my heart.'

Matisse landed in Tangier on 29 January 1912, ready to start work on the extra tier of paintings destined for the secular iconostasis in Shchukin's drawing room. Although the collector had given no specific instructions, he had a clear preference for figure paintings (and proved it by declining an offer of the *Red Studio* that February), but there were no models to be had in the Muslim city of Tangier. It would be many anxious weeks before Matisse finally began recruiting the mixed bag of locals – a hotel boy, a teenage prostitute, a street pick-up and a mountain bandit – who agreed more or less reluctantly to let themselves be painted. On his canvases, each of them turned into the kind of grave hieratic figure he had seen in Moscow icons: prophets, apostles and slender stylized saints painted in sharp spring colours, all with small heads, long sensitive fingers and bare or delicately shod feet emerging from their robes, each poised lightly like a flower on a flat ground of turquoise, gold or black.

But the painter's initial impulse was to pack up and sail straight home. He and his wife had checked into room number 38 at the Hotel de France, which turned out to be cramped, dirty and overpriced in spite of the spectacular view from their window looking down over the roofs and terraces of the old town, and out to sea across the bay. Rain filled the unpaved streets with foul-smelling liquid mud, and swelled the rivers so that the interior was cut off. Unable to leave the hotel, let alone work out of doors, Matisse painted flowers in his small, bare room darkened by rain lashing at the windows. In clear intervals he painted the view of the bay under lowering clouds, with black boats bobbing on choppy waters. On 6 February he started work on a bunch of lively, luminous purple irises tossing on long green stems against the black depths of his bedroom mirror (this was the first of many variations played

on the same theme by Matisse, whose sole luxury when trav-
elling was always fresh flowers jammed into landladies' jars on
the humble washstands and dressing tables of countless cheap
hotels). Next he painted a basket of oranges from the souk
arranged on a square of white flower-patterned silk from Bohain,
orchestrating a palette of pink, orange, turquoise, purple, lemon-
yellow and plum-red with voluptuous delight and consummate
lucidity. More than thirty years later Picasso bought the *Basket
of Oranges*, and his young lover, Françoise Gilot, enchanted by
its warmth and vigour, was astonished to learn from Matisse
himself that he had been penniless in Tangier and seriously
contemplating suicide at the time. 'It was born of misery,' he
said. Weeks seemed like months cooped up in the Hotel de
France, whose 'famous Room Number 38' remained ever after-
wards Matisse family shorthand for a pit of panic and despair.

 On 12 February the downpour dried up sufficiently for the
Matisses to ride out together along the beach and up beyond
the town through fields of iris and asphodel. Amélie reported
blue morning glories everywhere, with purple heliotrope and
flame-coloured nasturtiums.'Once the rain stopped, there sprang
from the ground a marvel of flowering bulbs and greenery,' said
Matisse. 'All the hills round Tangier, which had been the colour
of a lion's skin, were covered with an extraordinary green under
turbulent skies as in a painting by Delacroix.' For him the
'melting light, quite different from the Côte d'Azur' made
everything look new. His immediate need was a shady and
secluded place to work. Matisse consulted Walter Harris, the
Moroccan correspondent of the London *Times*, who knew
everyone and could fix anything in Tangier from a treaty with
the Sultan to a man to tile the patio. Harris arranged for him
to paint in the luxuriant private gardens of the Villa Brooks.
'The property ... was immense, with meadows stretching as
far as the eye could see. I worked in a corner planted with
very tall trees which spread their foliage high and wide,' said
Matisse, who was fascinated by the carpet of glossy green acan-
thus counterpointing the rich canopy of leaves above. He settled

down to paint acanthus on a daily basis for the next month and a half with Amélie at his side.

This was the first time they had been free to concentrate on his work alone together for any stretch of time since their honeymoon, when Henri had painted olive trees and peach blossom in the garden of the Old Mill at Ajaccio. Now, as then, he was breaking new ground. Amélie's confidence in him reinforced his absorption, which in turn confirmed her sense of purpose. Their partnership regained its old balance and resilience in Tangier. 'Your mother is looking young again,' Matisse told Marguerite. Amélie, who was afraid of horses, made a special effort to please him by agreeing to go riding on muleback. After two years at Issy, they had finally decided to buy their rented home that January, but the down payment of 25,000 francs took all they had, and the impossibility of finding models in Tangier made Shchukin's prospective payment look remote. Financially as well as pictorially, this winter in Morocco was a gamble. It had the backing of the couple's entire family, who had banded together on both sides to prevent a repetition of the previous year's Spanish fiasco by ensuring that on this trip Amélie could go too. The problem then had been the children. This time the youngest – ten-year-old Pierre – went to his Aunt Berthe, who had just moved to Corsica to head the Ecole Normale in Ajaccio. Marguerite, left in sole charge of the household at Issy, poured out her loneliness and anxiety in letters to her parents, who were sympathetic but bracing. Her father advised her to get out more, draw up a regular timetable, and practise the piano. Her mother sent hugs and kisses, and urged her to be brave.

Tangier was a shock, at any rate to Amélie, who had hardly ever left France, and never even glimpsed the Muslim world before. European-style shops, cafés and hotels made the foreign quarter look, as Matisse said himself, like seedy suburban Paris. The Great Souk was as picturesque as any romantic painting, with its camel trains straight from the desert, its flute-players, sorcerers and snake charmers. But Arab society remained closed

to infidels. Unveiled European women were treated as degraded and unclean outside Tangier. Apart from merchants selling silks and carpets in the bazaar, the town itself had little to show of the wonders of the Orient that had mesmerized Matisse in Munich and Granada. The mosques were closed to Christians, there were no museums or galleries, and foreigners had no access to the great houses with their gleaming mosaics, latticed marble screens and intricately patterned tiles. Matisse faithfully reflected his own and his compatriots' situation when he sketched himself as a tourist on a flimsy folding stool with a collapsible easel balanced precariously on his knee, or wearing a straw sunbonnet and perched astride a disproportionately small mule. Towards the end of March the French management of his hotel finally found him a girl willing to pose, although young enough to be still under her family's protection (ten or twelve was the normal age for girls to marry or, at worst, support themselves by prostitution). Matisse painted Zorah fast and lightly, seating her on the ground in a soft, billowing yellow robe against a pale turquoise wall, and emphasizing the decorative quality of his picture by enclosing her body in a graceful curving line offset by the smaller oval of her face. But these risky and illicit sittings had to stop almost at once. 'Her brother has been with her,' Matisse reported on 6 April. 'Apparently he would kill her if he knew that she was posing.'

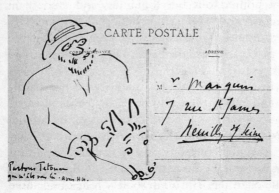

Matisse, self-portrait on muleback

Morocco was still a fanatically strict, fundamentalist, male-oriented society. The ferocious aspect of the civilization Matisse had glimpsed in Spain lived on in a country that had remained in many ways unchanged since the Moors ruled Seville and Granada. Violence was in the air. Travellers like Harris reported severed heads still exhibited on palace walls, and atrocious medieval tortures inflicted on captives in public places. Successive sultans had infuriated their people by the series of concessions they had been forced to make to France as Africa was split piece by piece among European colonial powers. Popular anger culminated in 1911 in a widespread revolt put down by a French expeditionary force. By the time the Matisses arrived at the end of January 1912, the Sultan was besieged in Fez by his own tribesmen. French troops were dispatched from Casablanca, and the Matisses prudently abandoned plans to visit Fez, which would have meant riding for ten days along unmarked tracks (there were no paved roads in the interior, and no wheeled vehicles) through country criss-crossed by streams in spate, at constant risk of ambush from vengeful Arabs.

Instead they settled for a day's ride with a small party to the Riffian village of Tetuan, setting out soon after dawn through a valley full of tall grasses mixed with buttercups and daisies that came up over their saddles. 'We rode in among this sea of flowers as if no human being had ever set foot there before,' said Matisse, for whom this paradisal meadow in the radiant light of early morning stood out among his two or three indelible memories of Morocco. Their expedition up stony mountain trails through disturbed tribal territory in time of mounting tension impressed the two Matisses in very different ways. Amélie would entertain her grandson long afterwards with dramatic stories of being held up in Tetuan for three whole days by armed tribesmen. For Henri, all memory of physical danger was blotted out by the exaltation of the ride through the valley, which took him back to the day his life was changed forever by the gift of his first paint-box ('It was a tremendous attraction, a sort of paradise found in which I was completely free,

alone, at peace'). As soon as he got back from Tetuan on 28 March, Matisse arranged further secret sessions with Zorah. He also returned to the garden of the Villa Brooks, hoping to recreate his feelings in the flowery valley that he described in prelapsarian terms as exquisitely pure and free from people.

In the three luminous canvases he produced in Brooks's garden – *Acanthus, Periwinkles (Moroccan Garden)* and *Palm Leaf, Tangier* – Matisse painted the complex layers of greenery for which Pierre Loti said you would need colours unknown on any palette, colours that would incorporate the strange sounds, the rustlings and above all the silences of Africa, its thundery undertones, its darkness and its translucent delicacy. In these paintings Matisse came close to pure abstraction, 'not things but the essence of things', in Tugendhold's phrase. All three canvases are shaped or framed by the slanting shafts of tree boles rising through the dappled half-light beneath the leaf canopy. Within this scaffolding of uprights, the underwood becomes a patchwork of grey, turquoise or lime green and orangey-pink, ornamented sparsely here and there by stylized coils of ruffled creeper, drooping swathes or fan-shaped spurts of foliage, serrated acanthus leaves or tiny star-shaped periwinkles.

Amélie stayed just long enough to see her husband fixed up with a model before sailing for home on 31 March by mailboat to Marseille. Already strained and sleepless, Henri spoiled their parting with an angry outburst on board the steamer in Tangier harbour. As his wife slowly steamed away from him, he grew increasingly agitated, cursing his own explosive temper and picturing her alone with her dismal thoughts in stifling heat. In fact Amélie reached home in good spirits (and wrote two long letters to tell him so), but Henri was haunted by their row on shipboard. He said he had achieved nothing in Tangier, and only stayed on in hopes of finishing two landscapes commissioned by Ivan Morozov that would redeem an otherwise wasted trip. He consulted a doctor and sent daily telegrams to his wife reporting his previous night's sleep (by 5 April he had managed an unprecedented seven hours twice running) as a kind of

gauge or sleep-meter for measuring his work-rate next day. He announced that his underlying problem was pictorial, diagnosing the source of his disturbance as two misplaced spots of sunlight on the trunk of the pine tree in *Acanthus* ('If only I'd realized sooner, I wouldn't have been so desperate just before you left'). He explained that he could not live with himself without self-knowledge and that, although he produced results unconsciously, he always needed to know and understand what he had done ('To give yourself completely to what you're doing while simultaneously watching yourself do it – that's the hardest of all for those who work by instinct'). Squeezed in apologetically, between the lines of this candid self-analysis, was a confession – 'I get worked up too easily' – that ran through their marriage like a refrain.

In the first two weeks of April Matisse finally burst through the barrier that had blocked his path for weeks, bringing him to the verge of collapse and ruining his last hour with his wife. But it is clear from his letters to her afterwards that this crisis freed him, like a fever breaking. He said he was enchanted all over again each time he went back to the Villa Brooks, recalling long afterwards that his *Palm Leaf, Tangier* came easily and sweetly 'in a burst of spontaneous creation – like a flame'. Barely a week before he left Tangier he found a second model, a sharp, bright, hotel-trained, thoroughly Westernized boy called Amido, who posed so gracefully and well that Matisse completed in a few rapid sessions the figure painting he had despaired of producing for Shchukin, working with a freedom of touch that gives the picture the same captivating youth and freshness as its subject.

This last fortnight was darkened by catastrophe in Tangier. On 30 March the Sultan in Fez had finally signed the treaty that would turn his country into a French protectorate. Sporadic fighting culminated on 7 April in a pitched battle that lasted thirteen hours before the Moroccans were decisively defeated by the French. Matisse sailed for Marseille on 14 April, three days before mayhem was finally unleashed in Fez. Moroccan

Matisse, 'The Moroccan
Amido', *1912*

soldiers mutinied and massacred the Christians, raging through
the streets with the severed heads of Frenchmen on pikes. The
killing continued for two days until three squadrons of French
cavalry stormed the gates at dawn on 19 April. Among the bodies
that had been decapitated and burned or thrown into the river
were the French hotel proprietress, the correspondent of *Le
Monde*, and the entire staff of the telegraph office. Matisse did
not discuss these horrors when he reminisced afterwards about
Morocco, but he could not rid his memory of them. Death and
destruction were inextricably linked to the Islamic vision of
paradise that he had first glimpsed in the Alhambra, and now

they quickened his pursuit of the same purity and intensity in Tangier. A craving for peace was the driving force behind Matisse's Moroccan paintings, according to an essay by Marcel Sembat, who talked to him at length on his return to France. Matisse told Sembat that he found himself instinctively simplifying or abstracting his work in order to come closer to capturing a sense of ecstasy, adding disarmingly that at any rate it calmed him down. 'Calm!' wrote Sembat, developing his theme with the zest and brio of a crack parliamentary speechmaker:

How many times, and for how many years, has he said that over and over again to me! Calm is what he longs for! Calm is what he needs! Calm is what he wants to convey! ... Matisse keeps his troubles to himself! He has no desire to share them round. He has no wish to offer other people anything but calm.

Sembat and his wife bought one small painting from Tangier, and commissioned another that spring. Issy was within easy reach of their house on the river at Bonnières, and Sembat was surprised to find that growing understanding of Matisse's work increased his liking for the complex character who made it. Behind the popular image of the painter as frightening, sick or mad, he found a thoughtful and unassuming man, unexpectedly open and only too anxious to demystify his public image by emphasizing his normality in private. Georgette Sembat, who was herself a painter, liked both Amélie and her daughter, admiring the unconditional support they gave Matisse, and understanding better than most people how much it sometimes cost them. For all their boredom in his absence, they could never count on family life at Issy running smoothly for long. Matisse's strenuous energy could be irresistible, but his sights as an artist were set so high ('He's rising up towards the eternal, the sublime,' Sembat told his readers, 'and he means you to go with him') that he had trouble adjusting them to an everyday human level. Failure to master a new technique – whether it was painting a pine tree or simpler skills like handwriting and

horseback riding – infuriated him in himself or anybody else. Marguerite's despairing appeals from Issy earlier that year had touched his heart, but compassion didn't stop him posting back four excoriating pages itemizing the spelling mistakes, grammatical faults, poor calligraphy and weak composition in her letters, even enclosing one of them inked over with corrections. He demanded too much from himself, and could not see why he should expect less from other people. His wife said that, for all his good intentions, her husband had no idea when to stop. His withering remarks about her own inexperience on muleback put paid forever to her dream of riding with him in the woods at Issy.

In the summer of 1912 Matisse completed the seven-foot-long and nearly six-foot-high painting called *The Conversation*, based on a stone stele in the Louvre, showing an Assyrian king greeting a seated goddess. Matisse borrowed this hieratic image for a double portrait of himself and his wife, posing Amélie in her black-and-green housecoat on a throne-like armchair at one side of the drawing-room window overlooking their back garden at Issy, with himself standing on the other side in the striped pyjama suit he wore for work. The painting looks like a graphic version of the scenario outlined in his last apologetic letters to his wife from Tangier ('How sorry I am to have tormented you like that'). It commemorates a domestic spat or grievance in the sense that a pearl is the end product of a speck of grit. Matisse emphasized the gravity and stillness of the two figures, and the brilliance of the luxuriant green garden that separates them, by flooding the rest of the canvas with the rich expansive blue of a Moroccan sky. Discussing luminosity long afterwards with his son-in-law, he said that a picture should have the power to generate light. Shchukin, who first saw the painting at Issy in July, wrote that it glowed in his memory like a Byzantine enamel.

Archaeological finds from Egypt, Russian icons and Islamic decorative art all suggested ways of revitalizing the failing and restricted vision of tired Western eyes. In the summer of 1912

Matisse gave a new meaning to the concept of decoration, painting his studio (which now contained a bowl of goldfish) with tremendous gaiety and vigour in a series of related works that mix life and art in perpetually surprising permutations. Each canvas is powerfully absorbent, drawing the viewer into an enfolding element, like air or water, which seems to be the medium of Matisse's mind. Individual entities – fish, flowers, textiles, painted canvases and patterned screens – dissolve or take on one another's characteristics, pictorial realities melt and merge, inanimate objects seem to breathe and stir. In *Corner of the Studio*, a current of air lifts the deckchair canvas and whisks round the edge of a windswept blue curtain whose woven arabesques appear to grow like big pink blossoms from the foliage of a pot-plant spurting up and cascading down the translucent, green-glazed jar from Seville. In *Goldfish*, the spade-and spear-shaped leaves of plants dancing in concentric rings across the canvas circle the fish, themselves circling in their cylindrical glass tank on the flat disc of a tabletop, the whole painted in exuberant hothouse colours – scarlet, emerald green, cyclamen pink and black – that give off an almost palpable powdery warmth and light.

In *Goldfish and Sculpture*, the most extreme of four variations on the same theme, a plaster *Reclining Nude* (for which Amélie had posed six years before) takes on the casual sensuality of a real woman stretching in a microcosm containing the fishbowl and the vase of flowers arranged beside her, an animated still life suspended against a blur of blue representing the studio beyond the focus of the artist's eye. Matisse made two successive paintings of a segment of *Dance I* propped up against the studio wall so close to his easel that, apart from a triangle of floor space, the canvas of one painting is entirely given up to the canvas of another. In all these pictures the familiar studio props of life at Issy are woven into the fabric of the parallel painted world – a calm, stable, mysteriously potent alternative reality – where Matisse felt completely free, alone, at peace.

Shchukin arrived in July to inspect the first fruits of the

creative energy set free in Russia. 'It was in front of the icons of Moscow that this art touched me, and I understood Byzantine painting,' Matisse said, analysing not only the plastic and spatial pointers but the moral courage he got from oriental design. 'You surrender yourself that much better when you see your effort confirmed by such an ancient tradition. It helps you jump the ditch.' He celebrated their partnership that summer with a drawing of Shchukin, intended as a preliminary sketch for a full-scale portrait. The collector chose five canvases: *The Conversation, Nasturtiums with the 'Dance', Corner of the Studio, Goldfish* and *Amido*, earmarking the first three to hang on the end wall of his panelled dining room in Moscow, which already contained sixteen paintings by Gauguin. The effect, by Tugendhold's account, was a modern equivalent of the shining visions embodied by medieval craftsmen in the polychrome nave of a cathedral, or the mosaic dome of a basilica:

This becomes especially clear when you first glimpse, from the doorway of Shchukin's drawing room, *Nasturtiums and the 'Dance'* and *The Conversation*. The orangey-pink bodies in the first picture flare out from their blue ground like arabesques of glass. Look at Gauguin's paintings, and then back at Matisse's *Nasturtiums*: the former will seem like a matt fresco, the latter more like a translucent stained-glass window. Matisse's palette is richer, more complex and grander than Gauguin's. Matisse is the greatest colourist of our time, and the most cultivated: he has absorbed into himself all the luxury of the East and of Byzantium.

At the end of September, Matisse returned alone to Tangier, intending to stay just long enough to complete outstanding commissions from Shchukin and Morozov before settling down with Amélie for another productive winter in somewhere less likely to be deluged than Morocco. Last year's experiment had worked so well that this year all three young Matisses left home. Jean started as a boarder at the Collège de Noyon near Bohain, while Pierre returned to his Aunt Berthe in Ajaccio, accompanied

by Marguerite, hoping to make up at last under her aunt's tute-
lage for the formal schooling she had never had in her disrupted
childhood. Their father spent his evenings writing to them all.
He sent daily four-page bulletins to Amélie, long letters to Ajaccio,
and a stream of comforting postcards to Jean, distracting him
with jokes, advising him gently not to give in to unhappiness,
remembering his own schooldays at boarding school as wintry
rain, ice and freezing fog closed in on the north.

With the weather on his side and sleep for once under
control, Matisse was calm, confident and full of projects. Work
went well from the start. Tangier itself seemed smaller than the
space it had grown to fill in his imagination, but the extreme
clarity and precision of the light gave great satisfaction, and this
time he had Amido to act as guide and middleman with poten-
tial models. Matisse came across one by chance almost
immediately, lounging in a doorway, 'stretched out like a panther,
a mulatto in Moroccan costume that showed off the slender,
supple elegance of her young body'. Fatma was more African
than Arab, bold and tough with a catlike self-reliance and
panache. Matisse painted her out of doors in a stiff breeze,
organizing his long narrow canvas round the emphatic thrust
of jawline, shoulder, elbow, wrist and the slim, straight legs
outlined in green inside her purple-frogged, pink-flowered
turquoise caftan. In a second, much smaller canvas (painted
specifically for the Sembats), she sits cross-legged against a rich
blue ground in plum-red blouse and pants with sumptuous
orange embroidery and a patterned sash. Fatma intrigued him
and she knew it, upping her charges day by day, and threatening
to stop posing altogether if he failed to pay up. In the end her
complaints and his exasperation added their own tension, like
the wind, to the electric brilliance of both pictures.

Fatma's abrasive personality contrasted sharply with the soft-
ness and compliance of Matisse's other model, Zorah, whom
he had great difficulty finding on this second trip to Tangier,
tracking her down eventually with Amido's help in a local
brothel. Inmates were forbidden by police regulations to work

elsewhere, so he arranged for her to pose for him on the brothel's flat roof between jobs downstairs (after the few minutes she spent attending to each client, the painter got her back, looking flushed and munching petit-beurre biscuits). Matisse had now liberated himself from standard visual preconceptions so thoroughly that, without being either provocative or absurd, he could paint a Tangerine prostitute kneeling between her sole possessions (a pair of slippers and a bowl of goldfish) in a pose of iconic purity and simplicity used for centuries in Western art to convey the innocence of the Virgin Mary. He borrowed another sacred image to express the innate authority of the Riff tribesman ('magnificent and savage as a jackal'), who reminded him of Christ's head on a Byzantine coin. Matisse placed his subject at the centre of a flat, geometrical composition of ochre, blue and emerald green, adding a broad expanse of deep cherry-pink in a second version. The abstract simplicity of both paintings intensifies the natural majesty of the model. 'Isn't he splendid, that great devil of a Riffian with his rugged face and fighter's build,' wrote Sembat, for whom this contemporary Moroccan bandit belonged with the chivalric warrior Moors from the twelfth-century *Chanson de Roland*.

The modernity of these images is still startling today. Matisse painted each of his three models twice in the winter of 1912–13, conjuring up their solid physical presence by magical techniques of suggestion and sleight-of-hand. Each retains a sharply individual identity within an overall pattern structured by his or her gaudy carapace or costume (Matisse was fascinated by Zorah's gold-braided caftan, the only one she had, designed to be discarded when it wore out and replaced, like a snakeskin). All these figures have rudimentary features in highly expressive faces, slippered feet represented by streaks of yellow paint, and hands even more cursorily indicated (in the grave and beautiful *On the Terrace*, Zorah's clasped hands are, in Rémi Labrusse's phrase, 'a stupefying absence').

Within a month it was clear that Matisse would not be beating a quick retreat to Paris. Once again ominous letters

started arriving from his wife. He begged her to resist sinking back into her old apathy, to get dressed, go out, see friends, force herself to take the train to Paris, but her only response was to stop writing altogether, which alarmed him even more. It was Amélie who had insisted, in spite of protests from her husband, that she could manage perfectly well alone at Issy. 'I won't listen to her another time,' Matisse promised his daughter on 21 November, 'and I won't leave without her.' By this time he had telegraphed his wife to take ship for Tangier. She arrived at the end of the month escorted by the couple's old friend Charles Camoin, who had enthusiastically accepted Matisse's offer to negotiate special terms for a winter's board and lodging at the Hotel de France. Amélie now found herself back where she had always been happiest, in the company of artists and their work. She fell in readily with the two painters' routine, exploring the old town with them in search of motifs, joining them after work for games of dominoes, drawing the line only when it came to galloping with them through the narrow alleys of the Arab quarter. Family legend said that Amélie even accompanied her husband in search of Zorah, causing consternation in the bawdy house, whose inmates had no idea how to treat a Frenchman who brought his wife along with him.

Not that Matisse was an ordinary client. Brothels were a standard resource for painters, supplying models along with other services in every Mediterranean seaport. Camoin, who certainly checked out the local talent on arrival in Tangier, reported with amusement Matisse's reminder at the brothel door that they were present in a strictly professional capacity, 'like doctors'. Much has been made of this remark by people who assume that the only reason Mme Matisse could have wanted to see Zorah again was to check on what her husband was getting up to with a girl at least five years younger than his own daughter. But the comic point of Camoin's story was precisely that Matisse drew the line between work and leisure differently from other people. His male friends knew well enough that his adherence to their bawdy sub-culture of racy

jokes and saucy postcards was largely vicarious. He enjoyed
their rackety stories about the brothels of Marseille or Tangier
('It's as real to me as if I'd been there'), and kept up a running
gag with Marquet about his own bashfulness and inadequacy
in this sort of situation. 'In Tangier . . . we're out on the tiles
the whole time,' he wrote, urging Marquet to join them for
the winter. 'Camoin and I can hardly stand upright, you can
easily picture the scene – in bed every night by ten.'

In fact Matisse's sobriety was legendary. In Marquet's or
Camoin's terms he was an innocent, leading a life of monastic
regularity, going nowhere and seeing virtually no one apart
from the hotel staff. 'Except on my canvases, it's always pretty
much the same here,' he wrote to his daughter from Tangier,
'one meal follows another, and one night the next.' For Matisse
none of the standard forms of addiction or debauch could
hope to match the risk and lure of painting. His abstemious-
ness, and even more his capacity for work, inspired a kind of
awe – part envious, part appalled – in restless, rootless bachelors
like Camoin and the Canadian painter James Morrice, who
shared a studio with the other two in Tangier. The company
of fellow painters was crucial for Matisse in phases of reckless
experiment, whenever he felt impelled to jump another ditch,
to launch himself into nothingness as he had done with Derain
in 1905, and as he did once again in 1912–13 in Tangier. This
time neither of his two relatively conventional colleagues could
follow Matisse's relentless drive towards abstraction, although
they talked at length about the need to push beyond natural-
istic conventions towards a simpler, sterner, more concentrated
expression of reality. Camoin said afterwards that the best thing
about the whole winter was that Matisse had renewed his
flagging will to paint, 'something I couldn't help but find again
in your company'. Matisse, for his part, seems to have felt that
his solitary struggles would have been unendurable without
his friends' support.

The painter most vividly present in his mind in Tangier was
Delacroix, who had recharged his own vision eighty years before

under the brilliant soft light of the Moroccan sun, drawing strength, like Matisse, from the power and harmony of oriental design and colour. Matisse saw Delacroix everywhere in the landscape, even recognizing the background to *The Capture of Constantinople by the Crusaders* as the view from the terrace of the Casbah café. When he sketched the same headland from the same spot, he added a galloping horseman in salute to his great predecessor. Travel was for both a means of cleansing the eye. Matisse needed an unfamiliar world and a new light for the same reason that he needed the alien decorative discipline of oriental art, so as to break through to a fresh way of seeing. Jacob Tugendhold, who left by far the best contemporary assessment of the paintings Shchukin collected, saw Matisse's work as construction by pure colour:

From this further conclusions follow, the first being the high degree of abstraction in his work. Objects rendered by Matisse – whether it is a tablecloth, a vase or, in exactly the same way, a human face – are dematerialized, transformed into coloured silhouettes, distillations of colour that spill in ornamental streaks and splashes over the canvas. Not things but the essence of things ... In his canvases there is an ornamental harmony which is not so much contained as projected upwards and outwards ... It is this fluidity ... that gives his paintings a kind of life that reaches out from the walls beyond the boundaries of their gilt frames. And here we come up against the essential nature of his decoration: Matisse's paintings seem not so much separate entities as parts of a non-existent frieze, in other words an oriental frieze.

Within a few weeks of his return to Morocco in the autumn of 1912, Matisse jotted down ideas for 'two Tangier panels', clearly intended for Shchukin. Both started out as café scenes. A quick sketch of Arabs drinking on the flat roof of the Casbah café contained the germ of *The Moroccans*, one of the most uncompromising of the great, austere, semi-abstract canvases Matisse produced in isolation and turmoil in Paris during the

First World War. The second panel, *Moroccan Café*, was painted in his Tangier studio from sketches of another favourite coffee-house, this time a single room with one small window overlooking the bay, blue-painted walls and twelve cages of singing birds hanging from the ceiling. Matisse discovered the place in his first weeks alone in Tangier, when he heard someone playing the violin one evening after work. He went inside, took the instrument from the Arab fiddler and began to play music that held the half dozen customers spellbound.

The violin had provided an escape route for Matisse ever since his schooldays, and now it catapulted him once again into another world. He and Camoin both based paintings on sketches of the café with the violin and the caged canaries. 'It's a quiet café full of serious people,' said Matisse, who drew the customers talking, standing at the window, reclining dreamily full-length or squatting on the ground to play cards and smoke hashish. *Moroccan Café* shows two of them bent meditatively over a bowl of goldfish and a single pink flower drawn up before them on the floor. But, where both café and customers retain their picturesque appeal in Camoin's canvases, Matisse systematically suppressed everything that makes his sketchbooks so lively and engaging, stripping the features from the faces of his human figures, eliminating their long pipes and their slippers lined up at the door, reducing even their canaries to an invisible pres-ence. 'Matisse took care not to paint the cages,' wrote Sembat, 'but a little of the sweetness of the birdsong passed into his picture.' The people in it are no more than flat grey, white and ochre shapes on a pale blue-green ground with two goldfish and a flower reduced respectively to a couple of ochre slashes and three crimson blobs. 'That's what struck me,' Matisse told Sembat, 'those great devils who remain for hours lost in contem-plation of a flower and some goldfish.'

The Matisses left Tangier in mid-February, travelling via Ajaccio for a brief family reunion and stopping off on the mainland to see Henri's widowed mother, who was wintering in Menton with a companion from Bohain. Photographs of

Matisse buttoned into Edwardian travelling gear of frock coat and leather leggings, or muffled up on the rocks at Menton with his party in voluminous skirts and stately hats, seem to inhabit a different world from the revolutionary works he brought back from Morocco. They went on show for just six days, 14–19 April 1913, at the Bernheim-Jeune gallery in Paris. 'No one who saw it will ever forget that show,' wrote Sembat. Virtually all the paintings in it (except for the Sembats' two small canvases) already belonged to either Shchukin or Morozov. 'Soon your pictures won't ever be seen again except in Moscow,' Sembat's wife wrote sadly to Matisse. 'How many of them are already there, alas, including some of the most beautiful, which no French artist has even seen? It's a great shame for the development of taste in France.'

Shchukin overhauled his collection in 1913, rehanging his drawing room to accommodate the new works from Tangier, documenting the hang in photographs, and hiring Tugendhold

Shchukin's drawing room rehung in 1913

to compile a catalogue. Matisse now had a museum to house his paintings, with an enthusiastic young curator and a director passionately committed to a programme of expansion and public education. Shchukin had taken delivery of all but four of the eleven canvases specifically commissioned for his drawing room, together with three even larger, decorative panels (*Conversation, Corner of the Studio* and *Nasturtiums with 'Dance I'*). That summer in Paris he bought *Moroccan Café* on the spot. Over the past twelve months he had more than established his credentials as a working partner, providing Matisse not just with a livelihood but with a future for his work, and the hope of comprehension. He told the painter that, when *Moroccan Café* reached Moscow, he hung it in a small dressing room where he could look at it alone for at least an hour a day, coming in the end to like it best of all his paintings. With this canvas Matisse had broken through to a new visual level of reality where few of his contemporaries could follow him. It took faith as well as courage and imagination on the part of both painter and collector to make their joint leap into the future.

'It was in 1913 that the first full-throated roar rose from America in opposition to modern European art,' wrote Janet Flanner, describing the exhibition that exposed New York, Chicago and Boston for the first time to the shock of what was happening in Paris. Traffic jammed Lexington Avenue outside the disused armoury in Manhattan where the show opened in February, and queues formed inside the building. Matisse was generally agreed to be the ringleader in this den of lewdness. In Chicago he was tried for treason under the name of Henry Hairmattress, and hanged in effigy by art students. 'We are going to put a mark on American thought that will be simply indelible,' Walter Pach wrote happily to Gertrude Stein. By the time he and his fellow organizers had finished, a quarter of a million people had visited the Armory Show in New York alone, and the disruptive energy of modern art was firmly established in the public mind. 'I work entirely for America, England and Russia,' Matisse had said in 1911,

already well aware that he was being sidelined at home. His brief preview of late twentieth-century abstraction in the Moroccan show at Bernheim-Jeune roused little or no interest in an art scene mesmerized by the Cubist take on nineteenth-century realism. Cubism was fast becoming mandatory in Paris. To the public and the art establishment, Matisse's work still looked like a freak show. More up-to-date observers tended to write him off as a spent force on the grounds that anyone not lined up alongside the Cubists or the Futurists was against them.

One contemporary who never underestimated Matisse was Picasso, himself increasingly disconcerted by the mass of crude, trite or flashy imitations currently flooding the market under the Cubist label. In the summer of 1913 the two drew closer than they had ever been before. Each had reached the end of one set of experiments and was ready for the next. Picasso's analytical phase – so rigorous that Shchukin said just entering the room where he hung his Cubist canvases made him feel as if he had put his foot in a bucket of broken glass – would be followed that summer by the invention of the Cubist collage. Each felt isolated by his achievements. Picasso was anxious to distance himself from his crowd of followers. Matisse had taken steps to ensure that he had none. No one was better placed to sympathize with Picasso's predicament, which mirrored Matisse's own revulsion a few years earlier at sub-Fauve excesses. Somewhat to their own surprise (as well as other people's), the two found themselves comparing notes. When Picasso went down with fever in July, Matisse came into Paris to sit with him, bringing fruit, flowers and funny stories. In August, Picasso took the train to Clamart to join Matisse on his daily ride through the woods. For Picasso, who was no horseman and detested appearing at a disadvantage, this was the equivalent of a public gesture of reconciliation between leaders of two warring countries. Each promptly wrote to inform Gertrude Stein, who had done more than anyone to foment and publicize rivalry between them.

Sembat said it was round about this time that he heard one or other of them – 'Whether it was Picasso, or whether it was Matisse, I don't know or care' – make a much-quoted remark: 'We are both searching for the same thing by opposite means.' In the summer of 1913 their ways and means briefly converged. Matisse had arrived at what was always a turning point in his internal battles, the climax when feeling seized control of his work. He had reached it in Toulouse in 1899, in Collioure in 1905, in Tangier in 1912–13. What both repelled and attracted him about analytical Cubism was its cerebral aspect. 'Of course Cubism interested me,' he said long afterwards, 'but it did not speak directly to my deeply sensuous nature, to such a great lover as I am of line and of the arabesque, those two life-givers . . .' In Morocco he had pushed the emotional and intuitive side of himself as far as it could go. Now it was time for a drastic change of course. The four major projects he worked on through the summer at Issy looked to other people like wilful exercises in human disfigurement and deformity. All but one were serial experiments started three or four years earlier, and each of these proved such tough going that it had to be set aside to be continued later. The earliest was *Bathers by a River*, initially sketched out as a companion for Shchukin's *Dance* and *Music*, now recast as a Moroccan beach scene. Matisse erected a gigantic canvas that filled a whole wall in his studio, but got no further than repositioning his four larger-than-lifesize bathers in a provisional layout finalized only three years later. Perhaps he was waylaid by a related work, the massive plaster nude *Back I*, exhibited at the Armory Show and succeeded on its return by a still more monolithic *Back II* ('Vast neo-Assyrian bas reliefs which Matisse cuts out of enormous planks of plaster').

Matisse's third project was more worrying than either of the other two at this stage. He returned to a set of busts of Jeanne Vaderin, a family friend whose portrait he had painted as the *Girl with Tulips* of 1910. The first two busts were inoffensive, semi-impressionistic studies of a perfectly conventional young

lady, but in the next two he recklessly exaggerated the liberties he had taken in his painted portrait with her hair, nose and the tilt of her head ('The sculptor goes after the gargoyle in human nature,' said the *New York Evening Post*). In 1913 Matisse began to pummel the clay for a *Jeannette V* of such extreme distortion that even the most sophisticated customers found it hard to stomach. 'I confess to you in a small voice, M. Matisse,' wrote one of them, 'that I could not follow you when you said: "This profile, apparently so unformed, even horse-like – viewed from here, from this angle, doesn't it suggest to you the idea of freshness and youth?" I became evasive.' The diplomatic young visitor was Robert Rey (who went on to become successively curator at the Luxembourg Museum, professor at the Louvre and Inspector General for the Ministry of Beaux-Arts). He claimed to have expected to find at Issy a savage clothed in hair and animal skins.

Matisse, 'Jeannette (V)', 1916

Pach said people often travelled all the way to Issy just to check out what Matisse looked like ('They were always reassured by his appearance'). When bewildered onlookers protested that no human being resembled the creatures of his imagination, Matisse agreed, adding cheerfully that if he met one in the street, he would probably faint dead away. His whole house was booby-trapped with shocks for the unwary. First-time visitors, already rattled by the bulging foreheads and staring eyes of the African carvings in the drawing room, were nearly always floored, when they crossed the garden to his studio, by the *Bathers* or the *Backs*. Again and again people who reached Issy in the years immediately before 1914 made it sound as if they had stepped into the future: a strange, scary, savage world that filled them with foreboding. 'We see as "frightful" what Matisse sees as suave,' wrote Rey, too subtle and far too intelligent to misunderstand what he had seen, however much he might dislike it. 'The contemplation of extreme novelty cannot please a man whose taste is already formed, because he sees in it signs of an evolution that no longer depends on him, something like an announcement of death.'

Shchukin came in June or July to catch up with developments in the studio, and ask hopefully about the four canvases still needed to complete the top tier of paintings in his drawing room. Matisse set to work to fill the gap with a portrait of Amélie that gave more trouble than the rest of his programme put together. He worked on it throughout the summer without a break. By the time he finished it his nerves had been at snapping point for weeks. 'Saturday with Matisse,' Marcel Sembat wrote in his diary on 21 September. 'Crazy! weeping! By night he recites the Lord's Prayer! By day he quarrels with his wife!' All his life Matisse reverted to the paternosters of his childhood to calm himself when rage and frustration threatened to overwhelm him. His family learned to keep their distance at these times. The portrait of his wife brought on palpitations, high blood pressure and a constant drumming in his ears. Portrait sittings took place daily, and sometimes twice a day.

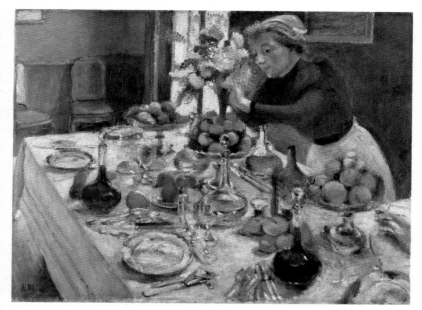

1. Matisse, *The Dinner Table*, 1896–7. Oil on canvas, 39⅜ x 51½" (100 x 131 cm)

2. Matisse, *Swiss Interior (Jane Matisse)*, 1901. Oil on canvas, 14⅛ x 18⅞" (36 x 48 cm)

3. Matisse, *Luxe, calme et volupté*, 1904–5. Oil on canvas, 38½ x 46½" (98.5 x 118 cm)

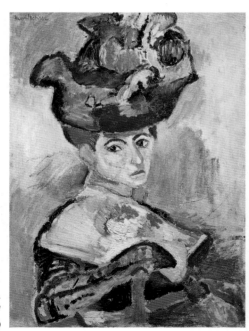

4. Matisse, *Woman in a Hat*, 1905.
Oil on canvas, 31¾ x 23½"
(80.6 x 59.7 cm)

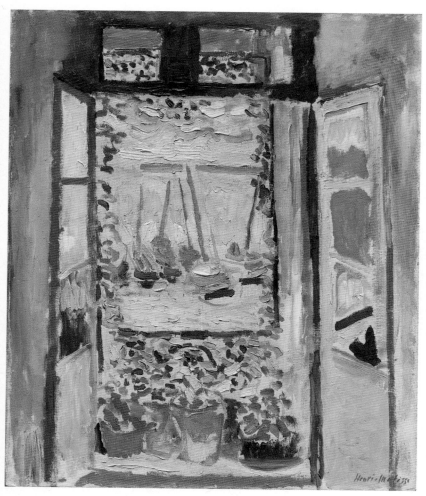

5. Matisse, *The Open Window, Collioure*, 1905. Oil on canvas, 21¾ x 18⅛" (55.2 x 46 cm)

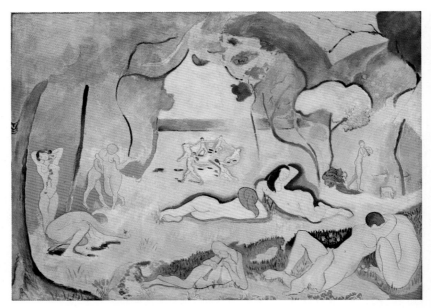

6. Matisse, *Le Bonheur de Vivre*, 1905–6. Oil on canvas, 69⅛ x 94⅞" (175 x 241 cm)

7. Matisse, *Blue Nude: Memory of Biskra*, 1907. Oil on canvas, 36¼ x 55¼" (92.1 x 140.4 cm)

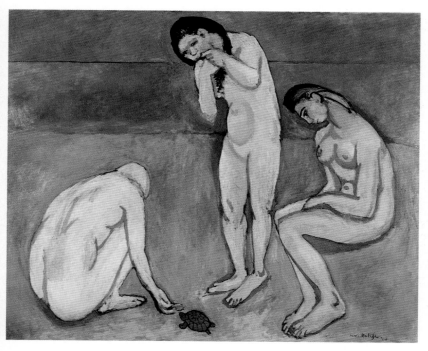

8. Matisse, *Bathers with a Turtle*, 1908. Oil on canvas, 71½ x 87" (181.6 x 221 cm)

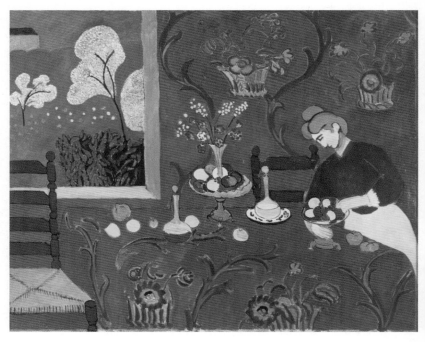

9. Matisse, *Harmony in Red (La Desserte)*, 1908. Oil on canvas, 70⅞ x 86⅝" (180 x 220 cm)

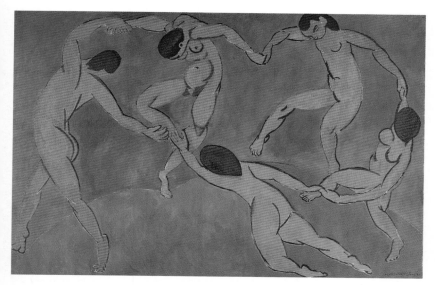

10. Matisse, *Dance (II)*, 1910. Oil on canvas, 111⅝ x 153½" (260 x 391 cm)

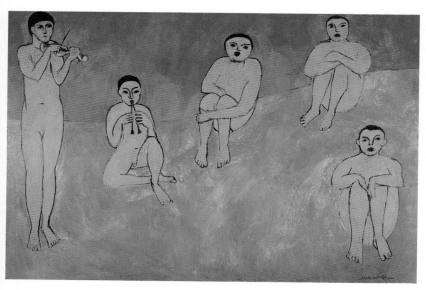

11. Matisse, *Music*, 1910. Oil on canvas, 111⅝ x 153¼" (260 x 389 cm)

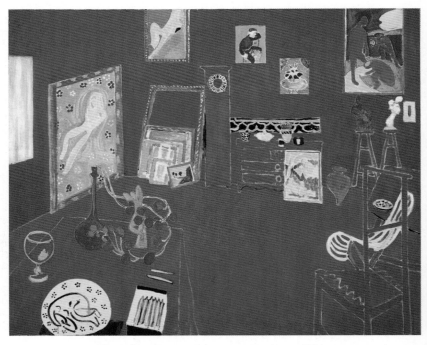

12. Matisse, *The Red Studio*, 1911. Oil on canvas, 71¼ x 86¼" (181 x 219.1 cm)

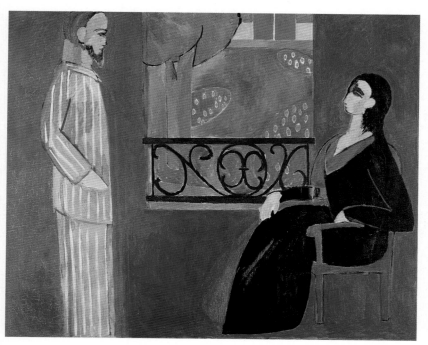

13. Matisse, *The Conversation*, 1908–12. Oil on canvas, 69⅝ x 85⅜" (177 x 217 cm)

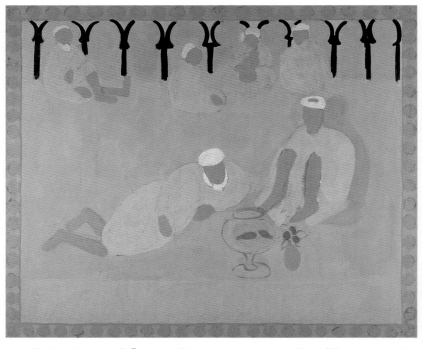

14. Matisse, *Moroccan Café*, 1912–13. Distemper on canvas, 69¼ x 82⅝" (176 x 210 cm)

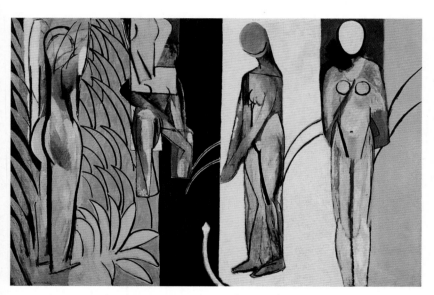

15. Matisse, *Bathers by a River*, 1909, 1913 and 1916. Oil on canvas, 102¼ x 153½"
(259.7 x 389.9 cm)

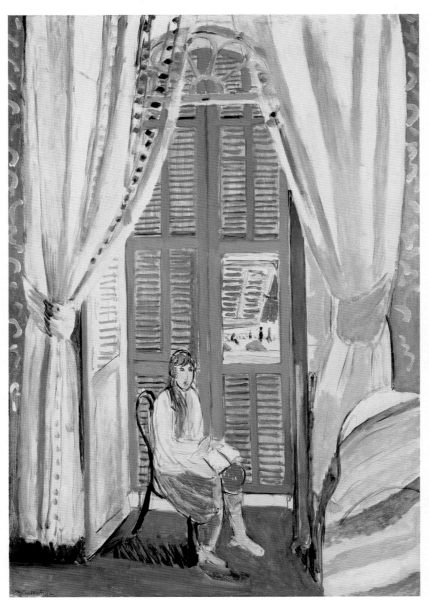

16. Matisse, *French Window at Nice*, 1919. Oil on canvas, 51⅛ x 35" (130 x 89 cm)

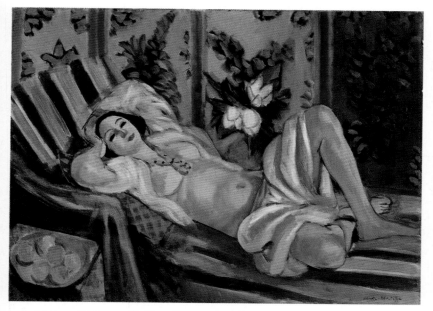

17. Matisse, *Odalisque with Magnolias*, 1923–4. Oil on canvas, 25⅝ x 31⅞" (65 x 81 cm)

18. Matisse, *Decorative Figure on an Ornamental Ground*, 1925–6. Oil on canvas, 51⅛ x 38⅝" (130 x 98 cm)

19. Matisse, *The Fall of Icarus*, 1945. Cut-paper collage, 14⅛ x 10¼" (36 x 26 cm)

20. Matisse, *Blue Nude (IV)*, 1952. Gouache on paper, cut and pasted, and charcoal on white paper, 40½ x 29⅛" (103 x 74 cm)

21. Matisse, *Interior with Egyptian Curtain*, 1948. Oil on canvas, 45¾ x 35⅛"
(116.2 x 89.2 cm)

22. Matisse, *The Tree of Life*, 1949. Final maquette for stained-glass window in the apse of the Chapel of the Rosary in Vence: gouache on paper, cut and pasted, 16' 10¾ x 8' 3⅛" (515 x 252 cm)

Amélie posed for her husband seated in a rattan chair wearing a plain dark suit with a scarf or stole and a chic little ostrich-feather toque topped by a perky feather and a pink flower: a frivolous Parisian hat at the furthest extreme from the austere and sombre gravity of the painting. Matisse, who had seen Cézanne's *Woman in a Yellow Armchair* on show in Paris in May, gave her the same touching composure as Cézanne found in his own wife, a tenderness of feeling inherent in the shell-like oval of the face, and the slight, graceful inclination of the head. But Amélie Matisse, in her husband's portrait, has an elegance and an unyielding, stony stoicism all her own. She leans forward against sharp greens on a blue ground, her head and body painted ash-grey, as if her mask-like face were covered by a grey veil and her hands sheathed in grey suede gloves. The painting expresses perhaps more movingly than any other what Matisse meant when he located emotion at the core of his art. It is suffused with the feelings that had to be mastered, refined and transmitted to canvas where, as he often said, everything of any real importance happened.

It was a harsh and inhuman process, even when the subject was an acquaintance or hired model. In *Portrait of Madame Matisse*, the airy poise and delicacy of the Moroccan figure paintings overlay, perhaps even intensify, a residue of suffering. It took over 100 sittings to reach this clarity and purity of expression. The portrait neared completion as the winter closed in at Issy, a time of year that felt like 'the equivalent of a demi-suicide' to Matisse, who for three years running had fled the country at this point in pursuit of painting. Each of his departures had precipitated a crisis in his marriage. This year the couple stayed at home together so that Matisse could subject his wife to the ruthless scrutiny he brought to bear on *Bathers by a River*, the *Backs* and the *Jeannette* busts. The portrait became a mutual reckoning, demanding intense concentration from both painter and sitter. In fifteen years together, the dynamics of their marriage had shifted irretriev-ably. During that period Matisse had changed from an

unknown young art student into one of the two key innova-
tors to whom the art-world looked for leadership from New
York to Moscow. He had built up a circle of energetic
supporters, radiating out from the Sembats and Sarah Stein in
Paris through Matthew Prichard to movers and shakers like
Fry in London, Purrmann in Germany, Pach and his associates
in the United States. He had a home of his own with ample
working space, a viable income and, in Shchukin, a collector
unequivocally committed to his work. The couple had finally
reached the goal that had seemed virtually unattainable when
Amélie first gave him her backing: the point at which, in
theory at any rate, Matisse's only problems were pictorial.

But Amélie had not foreseen the corollary, which was that
her contribution to the partnership was no longer needed. The
nerve, courage and energy that made her invaluable in any kind
of crisis were largely surplus to requirements in a settled future
centred on children, home and garden. She had been the rock
on which Matisse's work depended, and pride now forbade her
to settle for the lesser role of public consort or studio hostess.
She chose instead to abdicate, delegating the running of the
house and studio from now on more and more to Marguerite.
Accounts by visitors to Issy in these years make virtually no
mention of the painter's wife, who remained invisible, absent,
often ill, obliterated by the renunciations he had warned her
long ago that painting would exact.

Amélie wept when she saw her portrait. Perhaps she remem-
bered sitting for her husband in a toreador outfit early in their
marriage, and the tension that had ended then in tears of fury
followed by laughter and reconciliation. *Portrait of Madame
Matisse* of 1913 commemorates a stillness and withdrawal at the
opposite extreme from the bold, frank, challenging gaze of the
Woman in a Hat of 1905. These two portraits mark the begin-
ning and the end of the heroic years of active collaboration
between husband and wife. Over the next twelve months or
so Matisse produced a fierce sketch of her confronting him in
a helmet-like hat with a striped veil that looks like bars across

her face, and a beautiful, spare etching showing her stooped and sad, clutching her Japanese kimono with her head bent in a gesture of resignation or defeat. The couple would remain together for another quarter of a century, but he never painted her again. It was as if she had given him everything she could, and he had acknowledged the gift in his great elegiac portrait with all the skill and passion at his command. For him, in years to come, the memory of this painting had the valedictory sweetness of a pressed flower: 'the one that made you cry,' he said, reminding his wife a decade later, 'but in which you look so pretty.'

The ordeal of the sittings in the summer and autumn of 1913 drained them both. Amélie left as soon as it was over to join her mother-in-law and the boys assembled in Bohain on 1 November, the feast of All Saints, to lay flowers on their grandfather's grave. Henri stayed behind alone at Issy because, as he told his mother, 'I can do without grief at this moment – especially since it cures nothing, and I don't need a cemetery to make me think of those I have lost.' *Portrait of Madame Matisse* was his only submission to the Autumn Salon, which opened on 15 November. 'It didn't come easily,' the painter wrote the same month to his daughter. 'I could well say, in showing it, this is my flesh and my blood.' Madame Matisse may have slipped away, but the impact of her portrait was immediate and lasting. It impressed both Prichard and Shchukin (who returned to Paris to see it). Apollinaire recognized it as a masterpiece. Although it disappeared to Russia as soon as the Salon closed, it continued to exert a powerful influence on younger painters like Pach, who knew it only from photographs. It represented a bright new world to the next generation in the shape of the precocious schoolboy Louis Aragon, who saw it in a magazine ('If that's the sort of thing that interests you, wretched boy,' said his mother, 'you're lost'), and his friend, the seventeen-year-old André Breton, who cut the reproduction out to pin up above his bed.

Restlessness overtook Matisse that winter. By December, the temperature had fallen to six degrees below freezing, light was

beginning to fade in his studio at Issy by three o'clock in the afternoon, and frost lay on the garden thick and white as snow-fall. He longed to get away, hesitating only between Collioure, Ajaccio and Barcelona. By Christmas he and Amélie had packed their bags for Morocco, only to unpack them again when Matisse dropped in at his old digs on the fifth floor at 19 quai St-Michel, now occupied by Albert Marquet, who told him that the flat below was vacant. 'I visited it. I liked it immediately. The low ceilings gave a particular light, warmed by the sun reflected off the walls opposite (the Prefecture of Police). Instead of leaving for Tangier, the trunks came to quai St-Michel.' The new flat was modest in size but well suited to the relatively small pictures he had in mind to paint. He described it to his daughter on 26 December: 'Main room with two windows opening on the quay, bedroom, dining room, kitchen, hall – well laid out – rent 1300 francs – so I took it, realizing at last that this was what I wanted – your mother, who found the idea extraordinary to start with, is quite happy now.' Considering how lonely and despondent his wife had been at Issy, Matisse was no doubt correct in saying she was glad to get away. But the fact that he made up his mind without apparently consulting her, or even showing her the flat, suggests how far she had already moved towards the periphery of his life. The desire and need to paint were the only things he consulted now.

He and Amélie moved into the new flat on 1 January 1914, the day after his forty-fourth birthday, taking with them their big double bed, their most precious pictures, Henri's violin and the piano, leaving their house in charge of the washerwoman (who moved in as caretaker for 50 francs a week). Matisse felt more at home in this small rented studio flat in the shabby, noisy, crowded heart of Paris than he ever had living in semi-bourgeois state at Issy. After a couple of months he told his mother he was working hard and sleeping better now that he had moved back to the quai. He also spelt out for her the triumphant vindication of modern art by André Level's Peau d'Ours syndicate, which had bought up works for practically

nothing ten years earlier from poor painters like himself, and now resold them at a handsome profit in a well-publicized sale on 2 March. Matisse's *Still Life with Eggs*, painted in his mother's kitchen and sold in 1904 for 400 francs in cash (which had seemed such untold wealth at the time that friends suspected him of having killed to get it), fetched 2,400. Buyers paid 5,000 francs for an early still life, and 1,850 for *Studio under the Eaves*, the small, dark, richly charged canvas painted in a Bohain attic at the height of the Humbert scandal.

The beginning of 1914 was one of the periodic points when Matisse stripped his life back to essentials. He also pared his work down, starting with three teenage girls and a stone subject. The familiar, looming mass of Notre Dame outside his window became evanescent on his canvas, its solidity transformed into a weightless, see-through, floating cube enclosed in black shadows, lines or scratchings on a sky-blue ground. A patch of pink paint in one corner conveys a sudden intense wintry blaze of sunshine on stone far more vividly than the naturalistic canvas, almost identical in size and format, which he painted at the same time. Prichard, who haunted the studio at quai St-Michel as he had at Issy, was in no doubt about the momentous changes taking shape on Matisse's canvases: 'What has happened is that we are being taught a new vision.'

The nature of perception, which preoccupied Matisse, was one of the key questions currently being addressed by the philosopher Henri Bergson in a wildly popular series of public lectures at the Collège de France. Prichard and his young followers, all passionate Bergsonians, shuttled between Matisse's studio and the Sorbonne, laying the philosopher's findings before the painter, who recognized a basic system that might take him further even than masters like Delacroix and Corot. Matisse conceded that Delacroix had been wrong about how useful the invention of photography would be to painters: 'Its real service was in showing that the artist was concerned with something other than external appearance,' he said, pinpointing what that something was in the two views from his window. 'He accepted Bergson's idea that

the artist is concerned with the discovery and expression of reality
. . .' Prichard noted. 'He accepted also the position that a picture
by Corot was meant to be looked at, while his own painting
was meant to be felt and submitted to.'

This was the nub. Matisse's determination to reach places
where photography could not go meant digging down further
than he ever had before towards the innermost source of energy,
what Bergson called 'the vital spark', and Socrates had identified
as the daimon. Matisse was irresistibly drawn, like his whole
generation in these first years of a new century, to the uncon-
scious. At the same time he was tugged back from it by the
artist's need to control and order, 'to give yourself completely
to what you're doing while simultaneously watching yourself
do it', the goal that had struck him in Tangier as almost impos-
sible to achieve for a painter as intuitive as himself. Matisse
needed Prichard's clear, sharp, legal mind now more than ever
if he was to negotiate a new deal between thought and feeling.
In the winter of 1913–14 he set himself to unravel and, with
Prichard's help, to articulate the theory behind everything he
had known and done by instinct in Morocco.

He could not have found a more indefatigable assistant.
Prichard proved invaluable, scrutinizing, probing, prodding,
asking questions, drawing analogies, playing Socrates to Matisse's
Plato in a series of studio dialogues conducted before an audi-
ence of attentive young philosophers. Describing his beautiful
Interior with a Goldfish Bowl, painted in muted purples, greys,
pinky-brown and turquoise in the low light of the New Year,
Matisse said he wanted a sense of movement within an overall
design, and reckoned that this constantly shifting process involved
everything from the fish to the furniture in his painting room.
'Take this chair,' said Prichard. 'Yes,' said Matisse, 'but when I
paint it, I see it in relationship to the wall, to the light in the
room that encloses it and to the objects that surround it. It
would be different if I wanted to buy it: I might perhaps have
a first impression of its beauty, but then I'd check to see if it
was solidly built, etc.' Even the humble, wooden studio chair

– forerunner of more exotic protagonists in a whole series of
love affairs Matisse would conduct over the years with chairs
– had now become a vital element in the effort to re-see and
re-feel reality.

Matisse needed an external response more urgently than ever
as his experiments grew steadily more extreme. On 3 November
1913, Prichard had counted eleven other people crammed into
the big studio at Issy. This was the day the painter unveiled his
wife's newly finished portrait, and plunged immediately into a
fresh engagement with a total stranger, Mabel Bayard Warren,
a friend of Prichard and Sarah Stein, daughter of an American
ambassador and widow of the president of the Boston Museum
of Fine Arts. The intrepid Mrs Warren sat for her portrait three
days later in a session that left both parties thrilled and shaken.
'I couldn't do that every day,' said Matisse. 'It was like travelling
in an aeroplane. I passed two hours of the intensest strain.' The
resulting drawing was so lifelike it resembled not only the sitter
but several of her relatives as well. To Prichard, who was begin-
ning to speak of Matisse as a seer, it seemed as if he could tap
into and transmit deep unconscious tides of feeling. This episode,
which astonished the sitter and her friends like a magic trick,
clearly demonstrated Matisse's ability to grasp and penetrate a
subject by means not always easy to explain. 'There was a
constant movement of her will forwards and backwards, giving
and withdrawing, opening and closing,' he told Prichard after-
wards, sounding like a fisherman tickling a trout, even waggling
his fingers to emphasize the moment when his slippery subject
all but got away: 'There was no change in the features unless
in the light of her eyes, but there was a constant vibration . . .
it was like a rippling lake, like sunshine on water, there was
nothing whatever to seize and there was no point where it
seemed possible for me to begin.'

All the most disturbing portraits of this period secrete within
the final version a first, naturalistic image agreed by observers
to be strikingly like the sitter. The process that led from one
to the other remained mysterious, even to Matisse, who said it

came from a level below conscious thought. His canvases grew darker and more austere as he pushed forward with the programme of progressive elimination begun in his painting of his wife and continued in his next oil portrait, *Grey Nude with Bracelet*. 'My model is a young girl of eighteen from Montmartre but very simple and pure,' he told Prichard, explaining why he had painted her in monochrome. 'There's a breath of innocence about her, and I found colour fought against that feeling.' He was more stringent still in his painting of the young wife of the critic Maurice Raynal. Perched on a studio stool, Germaine Raynal was reduced to a series of flat rectangles — torso, thighs, long narrow skirt — laid out more or less at right angles to one another in straight lines and leaden greys. Splashes of peacock green and blue on her skirt, a tawny red licking along the stool-strut and filling the tabletop behind her, make little headway against a darkness which Matisse said closed in of its own accord without deliberate intervention on his part.

Woman on a High Stool made a funereal impression on Prichard's young friend Bertie Landsberg, who volunteered his nineteen-year-old sister Yvonne as Matisse's next subject in April. Yvonne, who was tall and shy with quirky features and long limbs, had had her ugliness relentlessly dinned into her since childhood by her family. When her brother first brought her to the studio on the Quai, Matisse said Mlle Landsberg reminded him of a magnolia bud, and not surprisingly she flowered for him after that. His drawings suggest a natural poise, grace and frivolity as well as sharply pronounced individuality. He made her feel at ease, sketching her smoking, lounging, pouting and turning away from him with hands on hips. Although nothing could reassure her about her looks, Yvonne clearly liked and trusted Matisse. Mme Landsberg reluctantly agreed to let him paint her daughter's portrait on the same terms he had once proposed to Greta Moll: he would be free to paint what he pleased while the family's right to buy implied no obligation. Prichard and his band came to see the portrait launched on 8 June, and continued to attend sittings throughout the month.

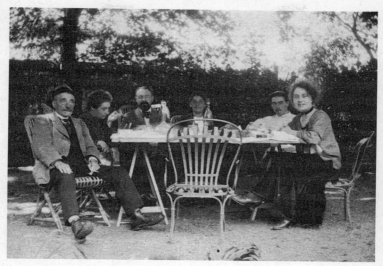

The Matisse family at Issy in the summer of 1914 with Berthe and Armand Parayre

Matisse moved back with his family to Issy for the summer but kept the Paris studio, which was ideal for this kind of small-scale work, handy for Prichard and the Landsbergs, and surrounded by other painters. In May he had bought himself a beautiful and costly violin – a luxury that could only have been justified as necessary for work – and now he played it regularly to calm his nerves after painting sessions. He also acquired round about this time a small, second-hand printing press which he installed at quai St-Michel, practising his skills in rapid etchings, drypoints and lithographs of friends and family that have the casual immediacy of snapshots. He made several etchings of Yvonne, framing her in a garland of magnolias, and a couple of Prichard, looking critical and also surrounded by magnolias, which did not please the sitter. Landsberg said that these images rose spontaneously from the depths of Matisse's imagination, brought to the surface 'while playing, as it were, at the point of his pencil, or etcher's needle, on shield paper or copper plate'.

At some point an envoy from Fritz Gurlitt's gallery in Berlin called on Matisse, who, with help from Purrmann, persuaded the unwilling Sarah and Michael Stein to lend nineteen paintings – the pick of their Matisse collection – to a German retrospective scheduled for July. The Sembats, better informed about the international situation in the summer of 1914, prudently declined to send anything to Berlin. Shchukin, stopping off in July to select the last three canvases still missing from the top tier in his drawing room, chose *Woman on a High Stool*, and agreed on subjects for two new works: a picture of boats to be painted in Collioure (where the Matisses planned to spend August and September), and a self-portrait to go with Matisse's painting of his wife. None of them ever reached their destination. The last of Matisse's paintings to enter Shchukin's collection was the *Portrait of Madame Matisse*, which had arrived at the beginning of the year.

Matisse, 'Portrait of Mlle Yvonne Landsberg', 1914

The *Portrait of Mlle Yvonne Landsberg* contracted and expanded on canvas all through the month of June. 'At the end of the *first* sitting the oil portrait too greatly resembled the sitter,' her brother recalled long afterwards, 'but it became more "abstract" ... At each sitting it became *less* physically like, but – possibly – *more* "spiritually" like my sister.' The charming, lively, funny girl captured so effortlessly in Matisse's drawings disappeared behind mask-like features with black voids for eyes and horn-like protuberances arching from her browbone. Her neck became a fluted column, her body a lace-like carapace or shell in soft, steely greys and black enlivened by flickers of pink and turquoise against a delicately painted ground of dark, feathery brushstrokes. Prichard watched with approval as the painting grew steadily more hieratic and inhuman. In late June or early July Matisse reversed his brush at the end of the final sitting and scratched great white lines in the wet paint, circling the body and swirling out from it like a bud unfurling or wings clapping open. The slight, grave, pale figure within this vortex of whorls and claw marks conveys a poignant sense of human vulnerability and endurance.

Yvonne's mother recoiled from the finished painting, and so initially did Matisse. 'His picture shocks even him a little,' wrote Prichard, 'he feels uneasy and slightly surprised. He seems to me like a sparrow hawk that has hatched an eagle. He feels in himself something greater than himself, a Socratic demon, the enemy.' The demon that looked out of Yvonne Landsberg's blank black eyes on canvas in the summer of 1914 was the same disturbing intuition recognized long afterwards by the American collector Albert Barnes, who said it would be hard to overestimate the significance of the Armory Show: 'The war came from the social malaise expressed in the paintings.'

9. *The Open Window (1914–18)*

People in France had no premonition of disaster until Austria's declaration of war on Serbia on 28 July 1914. The Russians began to mobilize two days later, the French followed suit, and on 3 August Germany declared war on France. Trains had already been commandeered to transport nearly 2 million soldiers towards Alsace and the Swiss border, where a short, sharp war was expected to be over before winter. Buses stopped running in Paris overnight, and taxis disappeared from streets full of men heading for the stations. Gun batteries assembled in the Tuileries, and soldiers with fixed bayonets guarded bridges across the Seine. Theatres closed, food prices rose and queues formed outside the banks. Few Frenchmen seriously questioned that the time had finally come to avenge defeat by Germany in 1871. The mood was calm, resigned, even relieved. Matisse, waiting to be called up by the army, turned to the violin, driving his wife and children distracted with his practising for up to four or five hours a day. After a fortnight or so the whole family moved back to Paris, where two adults cannot have fitted easily with three adolescents into a three-room flat. Foreigners disappeared almost overnight from Paris. Newspapers were censored. There were wild rumours of German armies speeding through Belgium, but no real doubt at this stage about France's ability to send them packing in a month or two at most.

Britain had entered the war the day after France, and the towns and villages of Matisse's native north turned out to welcome British troops marching through Flanders from the Channel ports. Their headquarters in Le Cateau was a stone's throw from Henri's birthplace, and popular confidence was so widespread that on 20 August his mother telegraphed him to send Pierre to her in Bohain for the rest of the holidays (an

offer prudently turned down). The German army took Brussels the same day and Belgium was overrun. The French were decisively defeated in the battle of Charleroi, which lasted three days, 21–3 August, and left 40,000 Frenchmen dead. The Allied armies retreated rapidly in forced marches through Picardy and Flanders before the unstoppable German advance. The first bewildered English stragglers reached Bohain on 24 August, followed by a mass of beaten and exhausted soldiers whose passing left the inhabitants to the mercy of their pursuers. Madame Matisse buried her valuables in the back garden. Le Cateau fell after fierce fighting two days later, and the people of Bohain prepared to receive the German army in silence, with closed shutters and empty streets, as they had done on 1 January 1871, the day after Matisse's first birthday. He had nothing to go on at this point but rumours, and the stories of terror and humiliation he had heard endlessly as a child growing up in the aftermath of the Prussian war.

The second battle of St-Quentin, on 28 August 1914, ended in defeat, like the first, four decades earlier. Once again the invaders paused just long enough to pillage the area before pushing on deeper into France. Communication with the population in occupied territory abruptly ceased. The first definite confirmation Matisse had of his family's situation was a curt communiqué informing the stunned and incredulous French nation on 29 August that from the river Somme to the Vosges mountains their country was now in German hands. Cannon fire could already be heard in Paris. Makeshift barricades were flung up to block the gates. On 1 September the army officially requisitioned the Matisses' property as a military headquarters, strategically placed on the bluff above Issy, near the fort and the airfield. Next day the Germans reached Senlis, less than thirty miles from Notre Dame. Half a million Parisians followed the government when it fled south that night to Bordeaux. There was pandemonium on the roads and at the railway stations.

The Matisses had already sent the children to Amélie's family in Toulouse, and done what they could – rolling and stowing

canvases, burying sculpture in the garden – to clear the house. Somehow they made their way southwards with Marquet, picking up the children in Toulouse, and finally reaching Collioure on 10 September, the day after the Germans received their first defeat, just short of Paris, in the battle of the Marne. The capital had been saved by what many thought of as a miracle. The invaders fled with the Allies in pursuit, halting at the river Aisne. The two armies now turned northwards to the sea, fighting their way across the devastated plains of Picardy and Flanders all through the autumn, digging themselves in along the Somme, facing one another on either side of a line sealing off the regions where Matisse had grown up and gone to school. Having crossed France to fetch up in its furthest south-west corner, he could hardly have been worse placed to hear anything of his mother or his brother, stranded with a wife and two small daughters behind German lines in the north-east.

His own family settled back into their old house at the top of Collioure's avenue de la Gare. A couple of Parisians stranded in the town turned out to be Picasso's young friends, Juan and Josette Gris, overtaken by the war with nothing to live on and no prospect of money coming in now that the Cubists' German dealer, Daniel Kahnweiler, had left France. Matisse and his wife, who remembered well enough how it had felt to face destitution without warning at almost exactly the same age, rallied round to find the couple alternative sponsors and a place to live. Of all the Cubists following Braque and Picasso, Gris was the most rigorous and by far the most imaginative. His ability to transmit feeling through the strict logic of his grid systems suited Matisse, who took up again with him the technical discussions he had begun the year before with Picasso. A solid friendship sprang from this month at Collioure, when the two talked painting so relentlessly that Gris said the unspeculative Marquet could hardly bear to listen to them.

The only work Matisse produced that month was a strange, stripped-down painting which he never exhibited in his lifetime,

and which would have been almost impossible to decipher if he had. Its subject was an open window, a motif he had first sketched as a boy bored out of his mind in his first job as a provincial lawyer's copying clerk. He returned to the same theme all his life whenever he felt blocked or threatened, most notably in *Studio under the Eaves*, painted in 1903 at the height of the Humbert scandal, a canvas almost entirely given over to deep shadow except for a small central window opening on to brilliant sunlight beyond. Now he reversed the formula. He painted a pair of sun-bleached wooden shutters at each side of an open French window, reducing them to vertical bands of soft blue, grey and turquoise framing a black void. The effect is majestic, bleak and sombre, but at the same time suffused with light. The poet Louis Aragon said more than half a century later that *French Window at Collioure* was the most mysterious picture Matisse ever painted:

When we note its date, 1914, and it must have been in summer, this mystery makes me shiver. Whether or not the painter intended it, and whatever that French window once opened on to, it remains open. It was on to the war then, and it's still on to events to come that will plunge the lives of unknown men and women into darkness, the black future, the inhabited silence of the future.

When this canvas was finally shown in 1966, twelve years after the painter's death, it made perfect sense to eyes trained on American abstraction.

Matisse left Collioure reluctantly to travel back alone to Paris on 22 October, breaking his journey in Bordeaux for a gloomy consultation with Marcel Sembat, who had been roped in as a minister in the hastily reconstituted war cabinet. Paris was full of rumours about fellow artists missing or wounded at the front. Shells had fallen on the Left Bank all around the quai St-Michel. The house at Issy was dilapidated but intact. Unable to get word of his mother, tormented by nightmares and crushed by the atmosphere of foreboding in Paris, Matisse longed to be

back in Collioure, where it was still possible to attend to matters other than the daily news bulletin, but his hopes of making a quick getaway were dashed by his failure to drum up funds, either on his own account or for Juan Gris. He persuaded Gertrude Stein to make Gris a modest monthly allowance as an advance on paintings, but her commitment was shakier than he thought. 'To my stupefaction, I learned later from Gris that she had done nothing about it,' said Matisse, who never spoke to Gertrude again.

His attempts to consolidate his own financial position were even more unsuccessful. Plans to extract a substantial sum by putting pressure on Bernheim-Jeune came to nothing when Felix Fénéon courteously explained that there was absolutely no prospect of advancing anything while the war lasted. Matisse was paying for the mutual distrust between himself and his dealers that went back to their attempted double-cross over *Dance* and *Music*. The scheme he had cooked up with Shchukin – to bypass Bernheim-Jeune by producing canvases too big to fall within the terms of their contract – meant that the bulk of his work over the past two years had gone direct to Moscow with no question of the dealers taking a percentage. Matisse telegraphed Shchukin, who replied on 2 November that the Moscow stock exchange had closed and money could no longer be transferred to France. 'This could go on for a long time,' Matisse wrote grimly. His twin sources of income had dried up simultaneously, leaving him with a family to support, no savings and no buyers for his pictures, even supposing he could bring himself to paint again.

One of the reasons for Matisse's return from Collioure was an urgent appeal from Walter Pach, who had turned up from New York to find the house at Issy full of soldiers. Pach had come to organize a Matisse retrospective for the Montross Gallery in Manhattan, explaining that this was the only stand he could make, as an American, against German barbarity. Pach's French friends were astounded and impressed by his refusal to let his plans be deflected by world war. Pach was

mystified in turn by Matisse's inability to paint. The most he could concentrate on at this point was his series of casual, snapshot-style portraits of friends and acquaintances, drawn at top speed directly on to the engraving stone. Matisse made seven etchings of Josette Gris, who with her husband was the only other person he saw regularly in these uneasy weeks when the promised liberation of France seemed to be receding. His letters reflect an almost universal sense of numbness and shock. 'Paris is dismal when you're away,' he told his wife; '. . . give my best to Marquet, who's in luck if he can go on working in the midst of so much suffering.'

This was written on 11 November, the day the last convulsive struggle of the year in Flanders reached its height at Ypres, which was savagely attacked and ferociously defended, before the two opposing sides settled down to shell one another for the next four years across ramparts and trenches running for 350 miles from the Swiss border to the North Sea. Official sources still insisted that the war would soon be won, but premonitions of carnage on an unimaginable scale were beginning to filter through to ordinary people. Sembat told Matisse that the combined losses, in soldiers killed, maimed or captured on both sides, came to well over 3 million in the first three months of war. Twenty-five thousand Frenchmen killed in the battle of the Marne would escalate to twelve times as many by the end of 1914.

Charles Camoin, posted that autumn to the southern tip of the western front, sent word of crops destroyed, fields mined, villages looted and fired. In occupied Flanders civilians infringing German martial law could be shot on sight. Any house suspected of harbouring resistance was burned down in Bohain. Banks closed, shops emptied and supplies dried up. As winter set in, the inhabitants had nothing but their dwindling stores and the produce of their gardens. Matisse's brother had been deported with all other able-bodied men from Bohain to a German prison camp. Their seventy-year-old mother remained in her house alone, in failing health, with one elderly servant and a

daughter-in-law across the street. 'I have no news of my rela-
tions, or my brother,' Matisse reported in December to Camoin.
All their friends (except Marquet, who was too frail, and Span-
iards like Gris and Picasso, who were exempt) were either at
the front or waiting to be posted. By the time Matisse was
finally summoned to a medical examination, he was running a
raging temperature and so obviously unfit for active service
that the board rejected him, relegating his name to the auxiliary
reserve. He tried twice to get the verdict reversed, but was
turned down both times on grounds of age and a weak heart.
All he could do was send regular letters to friends at the front,
run errands for them and keep an eye on their affairs at home.
Quantities of postal packets went out that winter from the
Matisses. Matthew Prichard, arrested on holiday in Germany
and interned from the first week of the war, received food,
warm clothes and (more important to him than either) repro-
ductions of paintings. Camoin got chocolate, sweets, shoes,
gloves, powdered milk, a bicycle and the first volume of *Les
Liaisons dangereuses*.

Paris, with half its population gone, felt like a ghost town.
Matisse said only two things could make him want to stay. One
was the need to remain near enough to reach his mother 'when
Bohain is liberated'. The other was the prospect of earning a
living outside the capital ('The terror of working as a copying
clerk in an office in Perpignan,' he said, picturing himself starting
out again on the alternative career he had escaped by running
away to be a painter). He was clearly relieved when his wife
brought the children back to Issy as soon as the army moved
out in November. The boys resumed their education at the
Lycée Montaigne, Marguerite laid tentative plans to be a painter,
and their father went back to the relentless practising on his
fiddle that drove him to the brink of exhaustion. He arranged
lessons for himself and Pierre from the Belgian violinist Armand
Parent, in exchange for drawings. Music provided the outlet
Matisse could no longer find in painting, as the weeks that
were to have decided the fate of France stretched out into

months, with no end in sight. He made a last attempt to join the army, appealing for help with Marquet to Sembat, who wrote back that the best either of them could do for France was to stay at home and paint.

The last thing Matisse had worked on in July was a sequence of small head-and-shoulders portraits of Marguerite, looking debonair and summery in a striped jacket, a straw boater trimmed with roses or a chic little saucer-shaped leather hat. Now the two resumed sittings with a fresh canvas that quickly abandoned all pretence of naturalism. 'This picture wants to take me somewhere else,' Matisse told his daughter. 'Do you feel up to it?' The sitter's touching human presence was barred out or blocked off behind a striped grid, spreading out from her own jacket to invade a canvas that, alone among Matisse's work, looks as if it had been constructed, as Gris plotted his paintings, with set-square and ruler. Harsh, impersonal and heavily overpainted, *Head, White and Rose* is testimony to everything that simultaneously attracted and repelled Matisse in the work of Picasso, Gris and Marcel Duchamp's brother, the sculptor Raymond Duchamp-Villon (introduced to him by Pach that autumn). 'What he feared in the new group,' Pach reported, 'was the submerging of every sensuous quality in the rising tide of intellectualism.'

He solved the problem in his next painting, intended as the self-portrait he had promised Shchukin at their last meeting. 'It's my picture of goldfish which I'm re-doing with a figure in it, holding a palette in his hand and observing,' he explained to Camoin, sketching himself seated beside the still-life table with goldfish-bowl and pot-plant at his window high above the quai St-Michel. This time he transposed the domestic scale of his earlier goldfish paintings into a register altogether deeper, darker and more powerful. He reconstituted the studio on canvas in flat black-blue-and-whitish strips, folding into and out of one another like stage flats, as Alfred Barr observed, and aerated by lively shreds and patches of soft grassy green, violet and apricot-pink, yellow and warm orange. In the end the human

figure vanished altogether, abstracting itself, leaving nothing but
a thumbprint on the vestigial blank palette at the right. *Goldfish
and Palette* is a Cubist work impregnated with a mysterious,
unmistakeably Matissean intensity of feeling.

Matisse's chosen role – the observer with a palette in his
hand – had been forced on him against his will at a moment
when for the first time he had no heart to play it. In January
1915 he obtained an official permit as a war artist to visit the
ruined quarter of Senlis, shelled, sacked and burned by the
retreating Germans. But excursions like this seemed futile, if
not frivolous, when set beside Camoin's accounts of journeys
to another world – 'The country of the trenches, a nameless
land, filled with mud and snow'– where other painters crouched
in excrement and foul water, cold, hungry, thirsty, plagued by
lice and rats, dodging shellfire and bullets. A steady stream of
them passed through Issy on their way to and from the front.
The house became a haven for soldiers on leave, from Prichard's
philosophical young friend Georges Duthuit to old comrades
like André Derain, who came in the spring to confide his work,
and his wife, to the Matisses' care. Henri was galvanized by a
letter forwarded by the Red Cross that spring from his brother
Auguste, describing German brutality to their half-starved
French prisoners. He made eleven etchings to raise funds for
a relief scheme organized through the Société des Prisonniers
de Guerre. He organized publicity, contacted critics, drew up
lists and canvassed potential subscribers in Paris and the United
States with an energy he could never muster on his own behalf.
By early May he was posting weekly food parcels to his contem-
poraries from Bohain.

Like everyone else, Matisse scoured the official bulletins and
begged friends at the front for information. He feared especially
for Jean Puy, whose health and strength were wretchedly unequal
to the forced marches, alternating with 'violent drenchings from
machine guns, shells, torpedoes and other dirty tricks', described
in his resolutely cheerful letters from the front. 'Are we really
going to have a winter campaign?' Matisse asked in disbelief as

the stalemate in Flanders dragged on towards a second year, adding in a fierce, uncharacteristic outburst to Camoin: 'What has happened to my mother, to whom the doctors gave one or two years to live three years ago, when she had a heart attack? You can see, *mon vieux*, that this war is terrible for everyone.' The western front had become a human abattoir. Matisse said the war made a mockery of civilization, but his own enforced exclusion from it left him with a heavy sense of impotence and unreality. Reports of his New York show at the beginning of the year might as well have been news from another planet.

In the summer of 1915 he came across his student copy of Davidsz de Heem's *Desserte* and copied it on to a second canvas twice as big as the first. 'I'm adding to this copy everything I've seen since,' he wrote to the critic René Jean, adding that he had set himself to counter his sense of helplessness, the horror and revulsion that was beginning to modify civilian approval of the war, by turning once again to Heem's majestic affirmation of peace and plenty. This minor Flemish masterpiece had served Matisse as a turning point or testing-ground twice before. His original, highly accomplished copy had dispelled his fears of being unable to paint like other students in 1893. Three years later he returned to the same subject, grappling with Impressionism in his own *Desserte*. Now he dissected and re-organized the sensuous richness of Heem's canvas – the great fruit platter spilling cherries and grape clusters, the elaborate glass goblet, the embossed bronze chalice with its bird-lid, the crenellated pie, the napery and glassware – in a composition that combines brilliant clear colour with Cubist structural severity. Based on a simple geometrical black grid, and anchored at the centre by a suggestive pair of small, round, red-skinned onions, this second *Still Life after de Heem's 'La Desserte'* exudes vigour and a sharp, spring-like radiance emanating from the central patch of pale, yellowy greens and the harsher turquoise greens in the jagged folds and falls of the white cloth. The canvas embodied the perennial clash between passion and discipline

from which Matisse told Camoin he rarely emerged victorious: 'You have to cross that barrier to reach the light, coloured, soft and pure, the noblest of pleasures.'

The picture took two or three months to complete, leaving him exhausted and ill, but it seems to have dislodged the blockage that had obstructed him since August 1914. Writing to Pach as soon as he was well enough on 20 November, he repeated in more general terms the position he had outlined to Camoin, that the secret of painting was to reconcile thought and instinct, to appease the exacting, analytical self in order to gain free access to the depths and power of feeling. 'I'm leaving tomorrow for Marseille, where I'm going to spend a fortnight so as to recover completely from my bronchitis,' he told Pach. 'I am taking only my violin. I shall resume painting on my return.' Souvenirs of Tangier invaded the two inordinately ambitious works he started when he got back to Issy in December 1915. One was a café scene based on a group of Arabs lounging beneath a striped umbrella on the terrace of the coffee-house inside the Casbah gate, and the other was four women bathing. 'The problem is to dominate reality,' he told the Italian Futurist, Gino Severini, 'and, by extracting its substance, to reveal it to itself.'

For the greater part of 1915, reality had dominated him. Now he reversed the position, wrenching at shape and meaning on his canvases with relentless ferocity. No theory had yet been formulated for this sort of practice, and Matisse had to improvise terms as he went along to explain what he was doing to Severini, Gris and their young, Cubist-orientated friends who had started coming regularly to the Issy studio. 'He said with reason that everything that did not contribute to the balance and rhythm of the work, being of no use and therefore harmful, had to be eliminated. That was his way of working: constantly stripping the work down, as you would prune a tree.' In *The Moroccans* and *Bathers by a River*, reality has been so thoroughly mastered that parts of it, especially in the first painting, remain almost indecipherable. The watermelons in the bottom left-hand corner of the *Moroccans* look more like robed Arab figures,

squatting or praying, than the geometric vestiges standing in for café customers at top right. The human beings have dematerialized, the umbrella's stripes have been transferred to a bunch of stylized flowers, and the medina's turreted ramparts have turned into an abstract design of flat blocks and discs. The effect of light itself has gone into reverse, the clear Tangerine sunshine being replaced by the uniform black ground with which Matisse warms and intensifies his colours. 'He compelled the picture to take on a new form, a structure of analogy and interplay for which there was essentially no precedent,' wrote Lawrence Gowing, analysing the reckless pruning process that reached its height in 1916–17.

What preoccupied Matisse was construction. For Severini, these strange, synthetic versions of a North African setting at the furthest possible remove from wartime France constituted 'an architecture of the will': an art that would be stable, inscrutable, set apart from and uncontaminated by everyday squalor and mortality. 'Utilizing sensations in this way as constituent parts of the work, rather than its sole purpose or point of departure, Matisse rediscovered by means of Cubist theory the liberated architectural approach of the Byzantines ... And his colour became ever more spiritual and abstract, almost independent of the real objects on which it lay.' There was a heavy price to pay for so extreme an act of will. Matisse had begun the *Moroccans* in November with bronchitis, struggling on with it all through January, when the entire family except Marguerite came down with flu. Anguish and suspense tormented him. A continual monotonous music plagued him from an abscess in his ear. He despaired of his picture by the middle of the month.

Matisse exorcized his demons by chopping away at his own life, and the lives of those closest to him. Every cramped Paris flat or seaside lodgings the family ever lived in had become primarily a studio. At Issy Matisse regularly produced major works in the garden, the living room and the bedroom (his wife's dressing table with its hatpin stand and ring saucer was

the subject of a majestic dual response to Cézanne and Cubism, *The Blue Window*). The children fitted their activities round his breaks and work sessions. Silence was essential. Rules were enforced. Life at Issy became a variation, transposed into a different key, on the strict, work-centred, patriarchal household in which Matisse had himself grown up. 'Above all, discipline your children – don't just be a comrade to them – you must remain their father,' he would advise his younger son years later. 'It's hard, but it's your duty.'

Through all the years of dispersion and upheaval, Matisse's canvases represented stability, continuity and cohesion for the whole family. His wife and children provided the first – in wartime sometimes the only – response he got to each fresh breakthrough in his work. He set immense store by their opinions, and all of them took their critical role with corresponding seriousness. Pierre was fifteen years old at the beginning of 1916. The works his father was producing in these years would shape and drive his life. He said he had his first conscious inkling of the power a painting could exert from the family's reaction to a proposal to raise money by selling off their prize possession, Cézanne's *Three Bathers*. Matisse and his wife had launched their marriage by pawning Amélie's emerald ring to buy the *Bathers*, and now it was their children who insisted on finding some other method of retrenchment. Matisse sold his Gauguin, and the boys left school.

Marguerite's constant health problems meant that she had had no formal education apart from a last-minute bid in Ajaccio at the age of seventeen to fulfil her childhood ambition to be a doctor. Although she had high hopes of her Aunt Berthe and the training college, the attempt was hopeless from the start. Marguerite had struggled with physics, chemistry and mathematics, battling fatigue, migraine, rising panic, and eventually collapsing with a bad back (as her father had so often done himself at school) before she could sit her second-year exams. Both parents understood her bitter sense of failure and humiliation, but it was Juan Gris, going through a sticky patch himself

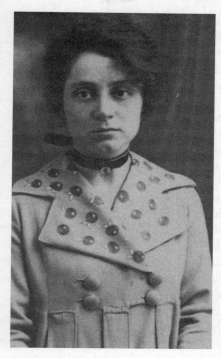

*Marguerite Matisse at
the age of twenty-one*

in Collioure in 1914, who advised her to paint. The solution
was warmly seconded by Matisse, who could never see much
point in any other calling, and by his wife, always unreservedly
in favour of opportunities for girls. Marguerite combined an
innate flair for design with a highly cultivated visual intelligence.
Having lived her entire life at the sharp end of the artistic
avant-garde, she was by now her father's ablest critic, trained
by him to be as hard to please as he was himself. The pent-up
fury of years of setback and frustration poured into Marguerite's
debut as a painter.

Her parents built a studio for her over the garden porch at
the back of the house, but her new career was checked almost
at the outset by an ominous interruption. 'I'm utterly crushed
at the moment,' Matisse wrote to Derain in February 1916,

explaining that Marguerite's doctors had just carried out an alarming in-depth examination of her larynx. Their prognosis was that the damaged trachea would have to be rebuilt although, given the limited surgical techniques available at the time, any attempted reconstruction faced almost certain failure. The only alternative was continued use of the cannula in her throat, combined with repeated attempts to stretch the windpipe by inserting wads of cotton, and regular cauterization to keep the passage open. Marguerite, who had borne these excruciating procedures stoically for years, now faced the terrifying prospect of experimental surgery. All her father's old fears sprang back into action. 'I'm crushed by this affair of Marguerite's,' he repeated at the end of his letter to Derain.

Jean also posed urgent problems in 1916. Long-term prospects were not good for a seventeen-year-old male approaching the third year of a war that consumed men and looked set to last forever. But the chance to fight for his country seemed almost miraculous to a boy who was bright, sensitive and deeply unsure of himself in a family where artistic talent far outranked practical ability. Jean took after his paternal grandfather rather than his father. Matisse could no more grasp his son's fascination with machines than he had understood his father's head for business, and the atmosphere at home grew thick with the kind of suppressed resentments that had poisoned his own adolescence. The painter, whose father had once agreed in bitterness and rancour to let him waste twelve months trying to be an artist, now capitulated himself, reluctantly allowing his own son to fill the interval before conscription at eighteen by taking a job as a trainee mechanic.

Matisse dreamed of artistic success for both his sons, and Jean was the first to face the full force of their father's disappointment. He responded by developing strategies for avoiding head-on collision, cultivating the role of daredevil with a saturnine streak that made him moody, aloof, impervious to correction and dangerous if crossed. Jean played the cello and, when it became clear that he would never make a professional

musician, Matisse switched his attention to his younger son, persuading himself that Pierre would fulfil the destiny his father had turned down by becoming a virtuoso violinist. Pierre was fourteen when his father bought him a Prescendra violin and arranged professional tuition for them both with the celebrated Armand Parent. Innately musical like all the Matisses, Pierre was serious, willing, anxious to give satisfaction but quite unprepared for what happened when his father – always acutely mindful of being handicapped as a painter by his own late start – took him out of school so that he could give himself to music. 'He thought that by working very hard he could catch up with the others,' Pierre said gloomily, 'and so I could do the same.' Father and son worked their way through Mozart, Corelli and Vivaldi, finally graduating together to Bach's Double Concerto in D. 'Father took up the violin as a discipline,' said Pierre. 'That was not a pleasant way to play.'

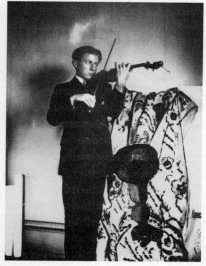

Pierre Matisse playing the violin

Armand Parent pounced mercilessly on Matisse's false notes, and made Pierre's life a torment. 'Each time I went to him, it

was like a purge that had to be swallowed.' At home things were not much better. Trained under martinets himself, Matisse instituted a punishing routine that began with his son rising at six to practice scales on the piano for two hours alone in the salon. Whenever the sound faltered as the child dozed off, he was woken by thunderous knocking on the ceiling from his father upstairs in bed. Marguerite, painting all day in the studio, seemed to have got off lightly by comparison ('Lucky you,' said Pierre, 'at least Papa can't tell when you stop'). Worst of all was Pierre's failure to please his father. He possessed a natural touch that made the fingering come easily, but his belief in himself was systematically squeezed out of him, leaving an abiding sense of inadequacy. It was only long afterwards that he could make sense of the disaster of his adolescence. 'Obviously, if I hadn't mastered these disciplines by sixteen, it was hopeless,' he said, looking back. 'Besides, I had no talent.'

Matisse depicted the deadlock between father and son in *The Piano Lesson* ('Yes, it was me,' Pierre would tell respectful young art historians in front of this canvas half a century later, 'and you have no idea how much I detested those piano lessons'). On one level this is an almost wholly abstract work, constructed from vertical bands and horizontal bars, mostly black or pale blue-grey, which define and articulate the flat, dark grey spaces filling three-quarters of the canvas. The human presence has been reduced to three rudimentary icons strung around the edges of the picture: a diminutive but assertive version of the sculpted nude *Decorative Figure*, sketched or rather scribbled in the lower left-hand corner, and an almost graffiti-style rendering of the *Woman on a High Stool* at top right, reproving presences sternly focused on the small, docile captive behind his keyboard at the bottom. Pierre's face, skewered by a wedge-shaped grey missile and hemmed in by two of his father's works, is surrounded, as John Elderfield and others have pointed out, by the trappings of coercion (the metronome, and the iron grille at the window shutting off a tantalizing green slice of the garden in which he was not allowed to play). The boy looks much

younger than Pierre's actual age, more like six or eight years old, Matisse's own age when he, too, first encountered and rebelled against the rigours of musical discipline. The picture cannot be confined to any single source or meaning. It reflects duress: the authoritarian controls inflicted on father or son when young; the ruthless demands of art closing in on Matisse in his middle years, dehumanizing him and all who shared his life; the crushing forces bearing down on France in 1916. In *The Piano Lesson*, where his domination of the real world is virtually complete, Matisse distills a sense of human pathos sharper than ever before or after. The pruning process that strips the central figure of individuality, flattening and stylizing the soft, unmoulded, childish features, intensifies the impression of human fragility and helplessness at the core of this lucid, limpid painting which, like a Bach concerto, is at once measured, harmonious and steeped in feeling.

The Piano Lesson, The Moroccans and *Bathers by a River* were all painted during the battle of Verdun, which began on 21 February 1916 and came to a climax in July, when the British offensive on the Somme began to relieve pressure on the shattered French army, enabling it to regroup and retake disputed ground before the fighting was finally called off on 18 December with no gains on either side. Hundreds of thousands of Frenchmen disappeared in the shell-storms of Verdun, or died in atrocious holes behind the lines. Matisse, whose impulse was to join them, felt that their loss coloured and tainted his survival. 'How irrelevant the mentality of the rear must appear to those who return from the front,' he wrote to the dealer Léonce Rosenberg on 1 June, at the height of the fighting, describing his work in hand: 'I can't say that it is not a struggle – but it is not the real one ... Painters, and me especially, are not clever at translating their feelings into words – and besides a man not at the front feels good for nothing.'

The feelings that could not be translated into words found expression on canvas, above all in *Bathers by a River*, which Matisse took up again at this point. Initially conceived in 1909

as a scene of Arcadian leisure to go with Shchukin's *Dance* and *Music*, and tentatively re-sited four years later in Morocco, this gigantic canvas measured well over twelve feet wide and eight feet high. Matisse now divided it vertically into roughly equal, hard-edged bands of green, black, white and pale dove-grey, suppressed the waterfall, condensed the foliage and transformed his four columnar bathers – cutting off the head of one, severing another's legs at the ankles – into massive, mutilated, stone-grey caryatids. This canvas marked the reconciliation between reason and intuition that Matisse had been working on ever since he got back from Tangier. He discussed it with the young modern-ists, mostly foreigners or army rejects, who visited him in Issy at least once a week. They included, besides the three main theorists of Cubism – Gris, Severini and their friend Pierre Reverdy – more intermittent visitors like the Mexican Diego Rivera, André Lhote and Le Corbusier's future partner, Amédée Ozenfant, who remembered their host expostulating so vehe-mently that his spectacles bounced on his nose. Matisse's dialogue with Cubism was at its richest and most complicated in these months. 'There was perhaps a concordance between my work and theirs,' he said cautiously when asked later how much he owed the Cubists: 'But perhaps they were trying to find me.'

Picasso had certainly found him the year before, when he responded to *Goldfish and Palette* with a masterly, metaphorical self-portrait in his *Harlequin*. Matisse rated it Picasso's greatest success to date (so did its creator), and openly claimed credit for having given him a launchpad. Picasso did the same for him when he exhibited the *Demoiselles d'Avignon* for the first time at the end of July 1916, in Paul Poiret's new gallery on the rue du Faubourg St-Honoré. Matisse had seen the *Demoi-selles* before, probably soon after the picture was painted in 1908, when it baffled and repelled him. Eight years later there were clear parallels between *Bathers by a River* and Picasso's leering life-sized nudes, strung out across the canvas, confronting the viewer head-on in a paroxysm of rage and derision (which would come to seem to many an eminently sane response to

the carnage of 1914–18). Although one is roughly twice the size of the other, both pictures operate on the same grand public scale. Picasso had turned a sailor's visit to a provincial brothel into a manifesto for the Modern Movement. Now Matisse transposed his bathing beach into a monumental image of grief and stoicism. The mood is lightened only by the sensuous beauty of the paint itself, the fine, feathery brushstrokes and glints of colour – exuberant greens, patches of sky blue, gleaming pinks on belly and breast veiled by translucent grey – that give human warmth to the gravity of the figures and their semi-abstract setting.

Matisse worked as always on a slower fuse than Picasso. At the first showing of his painting in Paris in 1926, the public laughed and the critics were loftily dismissive. Unsaleable for almost forty years, *Bathers by a River* was finally acquired by the Art Institute of Chicago the year before Matisse died, when he ranked it among the five pivotal paintings of his life. It was not until 1990 that one of the work's custodians in Chicago, Catherine Bock, first recognized the poetic, elegiac, perhaps unconscious metaphor underlying *Bathers by a River*, with its stately movement from left to right regulated by bands of colour – 'as percussive and insistent as a drum beat' – its four grey witnesses or mourners, its lively greens on one side of the canvas separated from the funereal shades on the other by 'an impassable trench or black maw, dividing past from present'. What Matisse called 'the modern method of construction' enabled him to draw on ancient myths of the passage from light to dark, earth to underworld, in a canvas impregnated (like Cézanne's *Bathers*) with nobility and passion. There is something heroic about his sombre, solitary effort to confront a reality that remained unfaceable for most of his contemporaries. 'This work could only have been painted in 1916,' wrote Bock, 'at the moment when the enormity of World War One was finally realized, but before the disillusionment and cynicism of 1917 had set in.'

At the time the *Bathers* scarcely registered with the steady stream of soldiers, exiles and refugees who flowed through the

house at Issy. Prichard's young friend, Georges Duthuit, spoke for many when he wrote to thank Madame Matisse for everything – 'Your kind welcome, the pictures that always give confidence, the table surrounded by friends, the whole room brimming with happiness and sympathy' – which made a return to army life easier to endure. Matisse sketched his visitors, especially the women. Alice Derain, Josette Gris, his own and his friends' daughters all materialized at the tip of his etching nib or pencil. 'In the 14–18 war it was the women who emerged with new assurance,' he said in retrospect, 'because they had to take on responsibility, and they didn't forget it.' Amélie presided over this busy and hospitable household, organizing support systems, dispensing comforts, clocking up record totals of knitted gloves and socks. Hampers were packed up and posted off on a regular basis. Pictures were dispatched to fund-raising tombolas. Matisse's wife and daughter became pin-ups for people who had never even met them. Duthuit's contemporaries, Louis Aragon and André Breton, hung reproductions above their army bunks of *Woman in a Hat* and *Portrait of Madame Matisse*. Prichard and his fellow prisoners constructed a shrine in their freezing German barracks around a painting of Marguerite.

All through the summer and autumn, the thumping of guns on the Somme could be heard in and around Paris as Flanders became a graveyard for the British army. There was still no word from Matisse's mother, or his brother, who had been repatriated along with all the other deportees to a routine of forced labour on starvation rations. Bohain was twenty miles inside enemy lines. As the campaign dragged on, the region was squeezed dry to feed and fuel German fighting divisions. Bread rations for the French in Bohain had been reduced the year before to just over four ounces a day, vegetables were requisitioned, and there was no meat. Elderly or disabled civilians who could not work in the fields were forced to take to the roads as vagabonds (Matisse's mother was sentenced to four days in gaol for refusing to leave her home). The coming winter promised to be exceptionally severe.

Matisse's anxiety made him particularly sensitive to other painters' troubles in wartime, when he went out of his way to visit younger colleagues, and buy their work. Severini, turned down by the Italian army on health grounds, struggling to support a wife and two babies (one died in 1916), never forgot the Frenchman arriving in his studio to pay cash for a picture in the nick of time on rent-day. Matisse organized fund-raising shows, supported concerts by young musicians, attended rackety parties given for wounded soldiers like Apollinaire and Braque.

In the company of younger artists Matisse was always conscious of the age gap that set him apart from his fellows. He reacted to what was happening at the front with none of the scabrous defiance and black humour of a younger generation. His response was sadder and more sombre. He expressed it for the last time in the winter of 1916–17 in a portrait commissioned by the great Impressionist collector Auguste Pellerin, who owned some eighty canvases by Cézanne, many of them bought directly from the artist. Matisse had been visiting Pellerin's collection at Neuilly for at least ten years. Emile Gérard, the painter's uncle and only patron in his native region, had made a fortune out of margarine, like Pellerin, who promised to find a job after the war for Matisse's brother (Auguste became a salesman in 1919 for Tip, the brand that had enabled the Margarine King to become Cézanne's greatest collector). Memories of the past fed into the extraordinary, virtually abstract variation on a Renaissance model Matisse produced for Pellerin: a full frontal, formal portrait of male pride and power, reinforced by the red ribbon of the Legion d'Honneur, the heavy gold-framed Renoir on the wall, and the modern magnate's desktop trappings of hooded typewriter and blotter.

This is the most impersonal and strictly geometric portrait Matisse ever painted. He might have used a compass to plot the circular dome of the sitter's bald head bisected by symmetrical arcs of eyebrow, cheekbone and curled moustache, with the black shadow of his chin precisely centred over the black rhomboid of his tie and the clasped hands below. But the rigid

plumb line of Pellerin's body and the dark pools of his eyes could hardly be more expressive. This relentless, bleak, black figure invokes shades of all the bearded patriarchs who from his youth had reined the painter in and spurred him on, starting with the two hard-headed northern businessmen, Henri Matisse senior and his brother-in-law, Emile Gérard. The portrait invokes forces that shaped the painter's life in a format that echoes a celebrated photograph of Cézanne in front of his *Grandes Baigneuses*, Ingres's even more famous *Portrait of Monsieur Bertin*, and Manet's portrait of Georges Clemenceau, the old tiger who was about to become his country's greatest wartime prime minister. Clemenceau embodied for many what he himself called 'France bleeding in all her glory', and it is this savage, tenacious and heroic, even tragic aspect of his countrymen that Matisse painted.

Pellerin's was the last of a series of dark wintry portraits painted in the wake of *Bathers by a River*. This was the first time in six years that Matisse had not gone south when the days darkened and the cold closed down in Paris. On 12 January 1917, in a letter thanking the dealer Paul Rosenberg for a New Year box of mandarins ('It's the only sun we've seen'), the painter reported rainstorms, floodwaters rising and coal so scarce it was impossible to heat the studio. Jean's eighteenth birthday on 10 January put the whole family in a state of suspense, which dragged on into early summer as his call-up papers were repeatedly delayed. France seemed to be disintegrating into anarchy, with civilian strikes, political turmoil and mutiny at the front after the loss of another 100,000 men in a last desperate assault on the virtually impregnable Hindenberg Line. All through the time Jean waited at home to join the army, Matisse worked on the Pellerin commission, pushing steadily further and deeper into his own feelings as a son and as a father. He had initially produced a more naturalistic and far less imposing portrait that was rejected by the sitter (who bought both in the end, paying up in full when the painter refused him a reduction for bulk purchase). The second version, completed in May 1917, finally

solved the problem Matisse identified for Severini: how to dominate and reveal reality through a process of abstraction.

This was the logical conclusion of the kind of formal and human interrogation begun in the Tangier portraits. He had painted Michael Stein that autumn in the relatively conventional mode of the first Pellerin canvas, and Sarah with something closer to the boldness of the second. Neither portrait is wholly satisfactory, partly perhaps because the Steins' interest in Matisse had slackened now that they had lost the bulk of their collection (still held hostage in Berlin). He also painted a young actress, Greta Prozor, the fiancée of his friend and former pupil Walter Halvorsen. Slight, angular and arresting in a strictly Nordic style, Mlle Prozor specialized in Ibsen and the modernists. She emerges from Matisse's preliminary sketches as a relaxed and humorous individual, but in the oil painting she moves to another level of reality, becoming insubstantial, even ghostly, with black lips and a flower like a dead beetle in her hat, her head just clearing the top of the canvas and the tips of her elegant, slender shoes skimming the bottom as if poised for flight.

The Parisian model pool had all but dried up in wartime, but Georgette Sembat recommended an Italian that winter. Her name was Lorette, and she posed in November 1916 for the first of a series of canvases that would increasingly absorb Matisse over the next twelve months. Not that there was anything particularly seductive to start with about this *Italian Woman* with her tight lips and reticent gaze. The model's hollow cheeks, stick-like bare arms and cheap, flimsy blouse suggest an almost nun-like austerity reinforced by the black cowl of her hair and her drab, sack-coloured skirt. Soft, feathery brushstrokes lick at the edges of the figure as they do in the portrait of Prozor, whose body seems about to dissolve into the tide of browny-orange colour flowing across the right side of the canvas, invading her blue dress in shadowy strips and triangles, spurting up beneath her armpits and occupying both her shoes. The painting of Lorette shows precisely what Matisse meant when he said he needed the friendly human presence of a model to help him

break through to a wholly detached, impersonal level of picture-making. The pathos that evidently touched him in this sad and wary Italian girl dressed in an outfit hopelessly unsuited to the freezing temperatures of a Parisian winter still lingers faintly in the severe black lines and angular folds of the geometrical composition enclosed by the ovoid of her head and hands. But the *Italian Woman* goes further than any other in a long line of portraits, from Landsberg to Prozor and Pellerin, in which the fabric of the paint itself has all but absorbed its human subject, blurring outlines, merging forms, deconstructing arms and hands, eliminating Lorette's right shoulder altogether beneath a swathe of encroaching, lively, grey-brown brushstrokes.

Pictures like this looked as uningratiating to contemporaries as any Cubist canvas. Matisse had finally stripped away everything that was of no use, and therefore harmful, to him in the pursuit of modernism's strange new inner realities. At the height of his powers in the darkest period of the war, he reached the end of a process begun twenty years before by bringing painting to the verge of pure abstraction. He had emerged triumphantly from the most gruelling phase of his career with a batch of works so far ahead of public taste and critical comprehension that some of them would not be fully understood, even by other artists, for decades to come. But he had simultaneously painted himself into a corner from which there was no obvious way out. Early paintings of the Italian model suggest how hard he found it to move forward. *The Painter in His Studio* of 1916 shows Lorette bundled in a corner in a shapeless green robe while the artist in the centre of the canvas, seen from the back and painted in a kind of shorthand, is barely more than a tense, naked, brooding presence at the easel. A companion painting, *The Studio, Quai St Michel*, looks back directly to the *Studio under the Eaves* of 1902–3, painted in a Bohain attic with the same drab walls, dark ceiling and bare wooden floor, also empty except for the work in progress tilted on its easel to catch the sunlight streaming through the window. Each canvas powerfully evokes the absent artist. The general sense of being imprisoned conveyed by the

earlier painting has been transferred in the second to the nude model, Lorette, trussed up on the narrow studio bed in what looks like a net of thick black strokes or bindings.

It was Lorette who liberated (or was liberated by) Matisse. Together they embarked on a series of experiments that would open up new directions in his work for another decade and more. She reached his studio at a moment of transition when he turned for help to other painters, in this case his immediate predecessors rather than the classical masters in the Louvre. He went through the Cézannes in Pellerin's collection three or four times in the winter of 1916–17. He visited Monet at Giverny, incorporated part of Renoir's *Portrait of Rapha Maître* into his own portrait of Pellerin, and wrote wistfully to Paul Rosenberg to say how much he would have liked to meet Renoir himself. Matisse bought his first painting by Gustave Courbet in November, going on to acquire four more in 1917, including a sketch for the richly sensual *Demoiselles beside the Seine* and the lovely *Sleeping Blonde*. He looked again at J. B. Corot's *View of Fontainebleau Forest*, with the girl lying in a patch of daisies in the foreground that had first captivated him as a student. 'The picture makes a strong decorative effect,' Matisse told Walter Pach three months after his first session with Lorette: 'The figure of the young girl lying reading beside the water on the flowery grass is delightful.'

The model lying ready to be painted in *The Studio, Quai St Michel* is depicted in short slashing brushstrokes as a baleful human challenge. But the canvas-within-a-canvas barely sketched out in that painting turned into a pastoral idyll – *Lorette Reclining* – with the red daisy-patterned studio bedspread transformed into a floral meadow, and the clenched black figure on it reconstituted as a graceful sleeping nude, more Courbet than Corot. For once the finished painting retains the fluidity and humour of the thick black line that leaps and glides across the paper in Matisse's preliminary pencil sketches, greasy, sensuous and caressing, emphasizing the supple curves of breast, belly, hip and haunch, catching two comically alert black eyes peering

out from under the plump, rounded pillow of an arm, blocking in the vivid, swirling tress of hair that pins down the whole decorative composition.

From now on Lorette unfolded, becoming confident, expressive and adaptable. She had a theatrical gift for impersonation, switching from ethereal purity to luxuriant abandon, seeming to change mood, age, even size as readily as she tried on costumes. She could sleep at will like a cat, retaining a regal dignity even when slumped, dozing, in her green robe and Moroccan leather slippers against a purple shape that might as easily be a throne as the bulging, comfortable studio armchair. Whatever her professional past, she was perfectly at home with the Salon painter's standard repertoire of teasing and provocative sexual disguises. She dressed up for Matisse as a Spanish señorita in a black lace mantilla, put on a turban and a Turkish robe to become the distinctly European inmate of an oriental harem, and sprawled on her back at the painter's feet as a Parisian cocotte with her shift hitched up to show the frilly garters clasping her white cotton stocking-tops.

Nothing like this had ever happened in Matisse's studio before. The nearest he had come to this sort of frivolity was when he tried to relieve the family's abject poverty in 1902 by kitting out his faithful model Bevilacqua in toreador pants for the tourist market, and painting the actor Lucien Guitry in costume as Cyrano de Bergerac with melancholy results. Now he responded to Lorette's expert lead as spontaneously as a dancer taking to the floor. She released in him an observant gaiety and speedy, casual attack suppressed in years of strenuous sacrificial effort. He painted her energetically from odd angles and in exotic outfits, but mostly he returned to her simplest pose, seating her facing him in a plain, long-sleeved top and improvising endlessly inventive rhythmic variations on the central theme of her strong features, heart-shaped face and the black ropes of her hair. Sometimes he multiplied his decorative possibilities by importing a second figure: Lorette's younger sister Annette, an exotic North African called Aicha Goblot, or

a much blander hired model who posed with the two Italians for the majestic *Three Sisters Triptych*. Matisse painted Lorette almost fifty times, or more than once a week, over ten months. She released a surge of erotic energy that would transform his work for the next ten years and more. But if theirs was a sexual as well as professional partnership, it produced no apparent repercussions at the time within the painter's family, and no gossip outside it among his highly observant contemporaries. His absorption in Lorette had none of the emotional overtones associated with his wife and daughter (or even Olga Meerson), who had been his principal sitters up till now. She set a pattern for successive relationships with hired models in the future, each of which took on the obsessive, exhaustive intimacy of a love affair played out with maximum intensity on canvas.

Matisse himself said long afterwards that it was his son Jean who fell madly in love with Lorette, and dreamed of marrying her. Jean's mobilization orders finally arrived in early summer, giving him forty-eight hours to join his regiment at Dijon. Matisse seized his last chance to dash off a second family portrait, borrowing the format of *The Piano Lesson* and dramatically reversing its mood in two days flat. *The Music Lesson* recreates the living room at Issy as a lacy linear pattern, lightheartedly embracing the radiator and the music stand alongside the human occupants: Marguerite supervising Pierre at the keyboard, Amélie hunched over her sewing outside the open window, and Jean himself, viewed with a sardonic paternal eye as a truculent adolescent already turning into a jaunty adult male, signalling his independence with his generation's key accessories of cigarette, paperback and stylish moustache. The picture does not attempt to explore the underlying strains in a family facing break-up and potential loss. Rather it suggests an exuberant fresh start, embodied by the jungly garden growth that seems about to burst in through the window and engulf the household, especially Amélie, dwarfed on the back porch by a wild, pneumatic, blown-up version of the clay *Reclining Nude* she herself had posed for ten years earlier.

Jean Matisse was drafted into an army more demoralized in the summer of 1917 than at any point in the war. Over 20,000 men deserted after a wave of revolt in May, when whole regiments had to be secretly pacified, ringleaders shot and public access temporarily barred to Parisian stations receiving soldiers from the front. Jean, who had longed to go to war, found his jauntiness knocked out of him almost at once. His father was badly shocked, on a visit a few months later, to find the young conscripts hungry, cold and dirty in a training-camp ankle-deep in mud without latrines or anywhere to wash except, once a week, in an icy stream. 'They live like pigs,' he told his wife, giving his son his own shirt, buying him an army greatcoat, and posting after it a tin washbasin and a woollen jumper.

By 1917 civilian responses had been numbed and coarsened by the impossibility of relating official communiqués to the reality they suppressed. Relentlessly upbeat reporting of guns captured and troops advancing on the western front had to be reckoned against the pitifully small parcels of ground gained, and the illimitable casualty lists. There was devastation in Matisse's home region, where the Germans systematically blew up bridges, destroyed crops, and reduced whole villages to rubble. St-Quentin became a ghost town that spring, and starvation loomed in Bohain. Measured by the general scale of destruction, the fate of Matisse's paintings seemed, as he said, relatively insignificant. But the Steins' pictures in Berlin were for all practical purposes lost, and the survival of either Shchukin or his collection looked uncertain in the light of reports of revolution engulfing Russia.

Parisians had long since learned to carry on living with guns booming on the Somme as routine background noise. Matisse bought his first motor car and learned to drive in the summer of 1917, trying out his second-hand Renault on painting expeditions along the banks of the Seine, or through the woodlands linking Clamart, Meudon and Versailles. He still sometimes applied a terse structural geometry to corners of the garden at Issy – a flower-bed, a small pink marble table – or to the play

of sunlight and shade in a series of beautiful, semi–abstract paintings based on the woods at Trivaux. But more often he stopped the car, propped his canvas against the steering-wheel, and painted whatever he could see through the windscreen with something of Courbet's vigour and directness. Half a dozen or more of these small, unassertive pictures show a road or river stretching ahead into the distance. Matisse said landscape allowed his hand and eye free play at a time when the future held only uncertainty and confusion.

In mid-December he left Paris in haste, travelling southwards to Marseille without even waiting to hear the outcome of the latest of Marguerite's periodic throat operations. His departure put an end to his sessions with Lorette, who, after ten months of intensive collaboration, stopped posing for him that autumn and never sat for him again. The reason for his leaving home has been widely assumed to be some sort of showdown with his wife, but the regular journal-letters he sent Amélie from the day of his arrival in the south show no sign of conflict or tension between them. In fact both were desperately worried about their eldest son, newly posted to a camp at Istres on salt marshes west of Marseille. Matisse caught the overnight train on 13 December, but had to wait four days for permission to see Jean. He calmed his impatience by experimenting with a new portable paint-box, producing two views of the port and two tiny portraits of the critic George Besson, who was staying in a neighbouring hotel. The state of the young soldiers at Istres confirmed Matisse's worst fears ('All of them long to get to the front. It's a prison camp'). He took Jean back to Marseille on a twenty-four-hour pass and treated him to the civilian delights of shops, cafés and a night at the music hall, sending him back to camp by the dawn train next day full of good food and wearing clean, warm clothes. 'His heart was heavy when he left me,' Matisse wrote to his wife. He himself had caught a chill on the windswept flatlands round Istres, and proposed to cure it by retreating along the coast to the sheltered bay of Nice, when he would be within easy reach in case Jean's

posting came through (survival of young soldiers at the front
was likely to be a matter of months if not weeks by this time).
Meanwhile he sent cigarettes, organized food parcels and fired
off letters in hopes of getting his son transferred to a mechanic's
job behind the lines.

Matisse reached Nice on Christmas Day, 1917, meaning to
stay for a few days at most and taking a room on the sea-front
in the modest Hotel du Beau Rivage. The town was bleak,
windy and deserted ('It's freezing in this pig of a place,' he told
his wife). His hands would scarcely hold a brush, and he had
to wear sheepskin foot-warmers to paint views of the castle
above the old town. When it snowed on his forty-eighth birthday,
31 December, he bought himself a new canvas and stayed indoors,
painting his room at the Beau Rivage in sunshine reflected off
snow and sea: 'From my open window you can see the top of
a palm tree – white lace curtains – coat-rack on the left – armchair
with white lace cover on the back – on the right a red table
with my suitcase on it – sky and sea blue – blue – blue.' He
had used identical words to his wife on their honeymoon twenty
years before to describe a blue that pierced his heart in a butter-
fly's wing. 'Me, I'm from the north,' he said long afterwards,
looking back to that first week in Nice when the weather almost
sent him packing. 'What made me stay was the great coloured
reflections of January, the luminosity of the days.'

On 1 January 1918 rain poured down all day. Matisse took
a wet walk to the post office to send his wife a telegram, and
sat down again to work on a second canvas with rain lashing
at the window and surf crashing on the beach below. 'I painted
myself in the wardrobe mirror,' he wrote home next day. This
was the last self-portrait he ever painted. It shows him at work,
gripping his palette with a paint-smudged thumb, sitting on a
hard chair in glasses and a shabby suit in his dark, narrow hotel
room with an umbrella dripping into a bucket beside the
washstand. The painter fills the canvas, his head pushing at its
top edge, one leg cut off by the bottom, his back against the
left-hand side, his hands and eyes busy with that other canvas

holding the work-in-progress just visible on the right. The painting monopolized him for the next fortnight. It is a powerful, anti-heroic, oddly provisional image for a man approaching fifty with an international reputation and a key show coming up that would consolidate his position as one of the two leaders of the Western world in painting.

This was the first two-man exhibition to set Matisse along-side Picasso. It was brilliantly orchestrated by Apollinaire in collaboration with an ambitious young Parisian dealer, Paul Guillaume, who announced his intentions in a letter on 16 January, a week before the show was due to open, by which time it was too late for Matisse to do more than protest angrily that it was against his principles to make any kind of major showing in wartime. In private he suspected the pair of setting him up in a contest loaded in Picasso's favour. The affair confirmed his view of Apollinaire as an unscrupulous hustler, and reinforced his mistrust of dealers in general, especially his own (several pictures had been supplied by the Bernheim-Jeunes, with whom Matisse had agreed to renew his contract on highly favourable terms the previous October). The show made head-lines, achieving an unprecedented slot on Gaumont News in cinemas all over Paris, but its sensational repercussions seemed like the echo of another world to Matisse, whose life had settled into the same monastic routine in Nice as in Tangier. He rose early and worked all morning with a second work session after lunch, followed by violin practice, a frugal supper (vegetable soup, two hard-boiled eggs, salad and a glass of wine) and an early bedtime. He paid a formal call in his first week on Renoir, dropping in regularly afterwards at the older painter's house along the coast at Cagnes, but otherwise seeing virtually no one. Even Matisse was taken aback to find himself safely tucked up in bed by half past eight most nights ('In Nice of all places, it's shameful').

'Forgive me, I've been completely ensnared by a woman,' he wrote to Marquet, who was wintering in Marseille and laying plans with Besson to lure Matisse into joining their regular

rounds of the local brothels. 'I'm spending all my time with her, and I think I'll definitely be staying here for the rest of the winter.' The temptress who engrossed Matisse turned out to be a plaster cast in the local art school of the greatest of all Renaissance nudes, Michelangelo's *Night*. By mid-January, she was beginning to absorb him as exclusively as Lorette had done the year before. Looking back thirty years later, he remembered a month's solid rain before a sudden sunburst changed his life ('I decided not to leave Nice, and I've been there practically ever since'). In fact, the sun came out much sooner. He told his wife on 13 January that he was strolling out without a coat, and that work was going so well it would be a mistake to budge. Jean had been granted leave by this time at Issy, Pierre was toiling over his violin, and Marguerite was resting after one of the surgical cauterizations she now needed once a month. Matisse reckoned she could count on three clear weeks between treatments, and telegraphed his wife and daughter to join him in Nice. 'Hurry up!' he begged Amélie.

He spent afternoons drawing at the art school ('I'm trying to absorb into myself the clear and complex concept of Michelangelo's construction,' he wrote to Camoin). In the mornings he painted his room with light streaming through the window and no sign of human habitation except for the few possessions he had brought with him: a battered suitcase, a canvas propped against the wall, the violin or its empty case lying on a chair. 'Remember the *Interior with Violin*,' Marguerite wrote later, recalling the work awaiting inspection when she and Amélie came south in February. 'Remember the state it was in when we reached Nice, and the discussion we all three had together ... You set out once more from a canvas already marvellously balanced by your natural gifts ... to attack the hard place, the high rock from which you either discover a new horizon, or destroy the canvas.'

All her life Marguerite had heard her father insisting that it was better to risk ruining a painting than to be satisfied with quick results, however easy on the eye ('It's always necessary to

force your whole being beyond this level because it's only then that you start to make discoveries, and tear yourself apart in the process'). *Interior with Violin* in its first stage showed a vase of flowers in a room with wooden shutters barred against the sun, except for a small flap opening on to a strip of beach, blue sea and palm fronds. The stand-off between father and daughter at this point passed into family legend. Marguerite's description of the first version as pretty was enough, according to a friend, 'for Matisse to take up the canvas again and bring it to the tense, violent state we know today'. He cut out the flowers, suppressed his soft pinks and ochres, and intensified the light licking through the shutter like a flame by repainting the interior black. This work was pivotal: 'In it I have combined all that I've gained recently with what I knew and could do before.'

Matisse's wife and daughter were in no doubt about the significance of this turning point, or the inner perturbation it exacted. The painter was practising the violin obsessively again (and so loudly that the management banished him to a distant bathroom to forestall complaints from other guests). When Amélie asked what had put him in this musical frenzy, he said it was terror of going blind, which made him determined to perfect his playing so that, if he lost the power to paint, he could always provide a living for herself and Margot by fiddling on the street. The chances of Matisse ever having to earn his keep as a strolling musician were remote. But his fearful fantasy suggests he already recognized the move to Nice as a gamble that meant staking everything – his settled life, his family's income, his achievement so far as a painter – against an unknown future.

In fact it was Matisse's elder son whose sight was threatened at the beginning of 1918. Jean, still in camp at Istres, developed abscesses on his leg, arm and eye. His mother and sister visited him on 6 March before catching the train back to Paris, where Marguerite's doctors refused to answer for the consequences if she missed her treatment for longer than a month. Soon after their arrival the bombing changed pace. 'There's a wave of panic in Nice just now,' Matisse wrote in the last week of March,

when the Germans began shelling Paris with new artillery of such unimaginable power and range that incredulous citizens all over France assumed there had been some mistake in the radio transmission. 'So it wasn't a false rumour,' Matisse wrote grimly after reading the communiqué next day, which also brought news of fresh assaults on the front near Bohain between St-Quentin and Cambrai. The Allied armies fell back, unprepared for the speed and scale of an onslaught intended by the Germans to bring final victory in Picardy and Flanders. Matisse rose before dawn each day to scour the papers. Communications were disrupted or agonizingly slow. Telegrams took days to get through, and telephone calls meant waiting for hours, often with no connection at the end. Matisse, who had had no word from his wife except a telegram requesting money, appealed to his bank manager and begged the editor of the local paper for information. Bitter cold gripped Nice. The bombardment reached its height on Good Friday, 29 March, with a direct hit during Mass on a Paris church. Once again the inhabitants fled the city. Cars were banned on the exit roads on orders from Clemenceau himself. Amélie dismantled the house and studio, methodically sorting and packing in a hail of postal advice from Nice, where her husband was driven nearly frantic by his inability to reach or help her.

'I've been within a hair's-breadth of leaving,' he told Marquet. 'My wife tells me to stay. While waiting, I work.' He spent Easter Sunday alone in the art school, modelling a little clay *Crouching Venus* based on Michelangelo, while his wife dispatched all but his biggest canvases by train, in the care of Marguerite and Pierre, to the Parayre family home in Toulouse. By the following week the Allied retreat had halted, and panic died down in Paris. Brother and sister took the train along the coast to Nice, arriving on 7 April to help their father move into a rented apartment at 105 quai du Midi, next door to his hotel. He described the three of them to his wife, settling down companionably together in the comfort of their own fireside while fierce winds lashed the sea. Both children thoroughly

approved of his newly completed *Interior with Violin*. Marguerite posed for him each day, well wrapped against the cold, on their balcony above the bay. Matisse also made a drawing of Pierre playing the violin, and used it as the basis for a strange, stripped-down painting of a standing figure outlined against the light which he called *The Violinist at the Window*.

After Marguerite's return to Paris on 18 April, Pierre surprised his father by adapting cheerfully to a routine of domestic chores, hard work and early nights. Landscape was beginning to pre-occupy Matisse again and, when his apartment was requisitioned by the army, he found lodgings on Mont Boron, the stony escarpment above Nice, where he painted wild roses, pines and olive trees. They took the second floor of the Villa des Alliés, a small, plain suburban house standing in spiny scrub, with panoramic views along the coast to Cagnes and across the old town to the mountains beyond. Matisse rose at dawn each day to watch the sun come up. 'I feel like a human being again,' he wrote on their first day in the new quarters, 16 May, swearing never again to let himself be stuck for months on end in a hotel. Father and son lived simply, like students, fiddling, painting. (Pierre was beginning to think he too might like to be an artist) and taking it in turns to do the housework. Jean came over from Istres on forty-eight hours leave and, after a delicious lunch cooked by the boys, they walked high in the hills above the town.

Matisse made the most of this brief peaceful interlude of family reunion and contentment. He sent Amélie a drawing of canna lilies that spring with white petals pearled like a grain of rice, explaining that he drew them especially for her. He decorated another letter with a little sketch in the margin showing himself, all bristly beard and thrusting lips, planting a kiss on his wife's cheek while she presents her profile, looking young and firm with her hair pinned up on the nape of her neck in the style he found particularly charming. It was a graphic image of a partnership that always functioned best at times when the absorption and isolation required by Henri's

work imposed the greatest demands on Amélie. The practical difficulties and dangers that reduced him to dithering indecision only made her more unflappable. 'My dear Amélie, you in Paris are astonishing . . .' Henri wrote in an ecstasy of admiration on 21 May, after two shells exploded on the roof of his studio at Issy. 'We're more frightened here than you are. Just as I'm about to depart from one moment to the next, you write: "Carry on painting quietly, everything's under control."'This was the tough, cool Amélie, as dauntless as she was resourceful, whom he had loved from the day they met.

On 27 May the Germans launched a further massive offensive in the north, sweeping forward in three days to the Marne. By 3 June they were within thirty miles of Paris. 'It's dreadful to be here when I know you're at your wits' end,' Henri wrote, 'the only way I could ever be as brave as you is in my work.' But even painting could not distract him now. He caught the tram into Nice to wait for the communiqué posted every afternoon in the avenue de la Gare. Marguerite left for Toulouse again with a second batch of canvases, while Amélie prepared the house for final evacuation. Henri packed his bag to join her, sending instructions as to what to save: his big Courbet was to be rolled ('better with cracks in the surface than left behind'), his antique sculpture buried in the garden, and his *Moroccans* chopped in half and posted (he enclosed a diagram with a dotted line showing where to cut the canvas with a razor). A telegram from Amélie telling him to stay put was followed by another announcing her own departure. Henri wrote daily, distracted by anxiety for his wife, for France, and for the artworks that would have to be abandoned to the enemy. 'But I think of my big paintings, which surely can't be left behind at Issy, especially the *Bathers* on which I spent so long,' he wrote sadly. 'Courage, my brave Amélie, and be prudent.'

At the height of the crisis, when the German advance was already faltering but had not yet been decisively stalled, Pierre had his eighteenth birthday, on 13 June. 'I was saved by the war,' he said long afterwards. For three years he had endured

the drudgery of daily music practice with a sense of futility heightened in Nice by contrast with his father's passionate commitment to his work. Pierre had counted the days all summer until he would be old enough to enlist. Without waiting to be called up, he left alone for Paris to join an army desperately mustering reserves for a second battle of the Marne that summer. The Matisses' fears for their sons were compounded by worry about lack of medical back-up for Marguerite now that Paris hospitals had been evacuated. Surgeons from all over France had been drafted to operating theatres near the front, and Matisse's plan was to follow them. He proposed to rejoin his wife in the north and look for a temporary base where the family could sit out the fighting if Paris fell, establishing Marguerite meanwhile in a rented room behind the lines, within reach of one or other of her two Parisian surgeons. A card from Auguste Matisse at the beginning of the year had reported sick or elderly civilians leaving Bohain. Now word came that their mother had at last consented to join the refugees straggling across Flanders on foot with bundles and handcarts, but Matisse knew her too well to hurry back. 'I'm glad *maman* is getting ready but counting on her to be late ...' he wrote to Amélie on 23 June. 'She's going to want to clean her house before she leaves.'

In the end it was his daughter who fetched him back from Nice. Alarmed by the news that Marguerite had been too weak for her regular cauterization when she got back from Toulouse, Matisse booked the first available seat on a train, arriving in Paris on 30 June to confront her doctors. The shelling of the capital resumed next day. Matisse spent several nights with his family in the cellar at Issy, and swept up the glass in his and Marquet's studios when bombs shattered the windows at 19 quai St-Michel. Amélie planned to retreat to Maintenon, just north of Chartres, and after nine days of bombardment Henri himself moved there to reconnoitre, painting the aqueduct to the sound of cannon fire, and narrowly escaping death when the train immediately after his own was wrecked at St-Cyr. In

August, the French launched an initial counter-attack on the western front from Amiens. Jean was serving behind the lines as a ground mechanic. Pierre, training at Cherbourg as a driver in an artillery regiment, was about to be posted to the front. When his younger son fell ill in a cholera outbreak on the north-west seaboard, Matisse left immediately for Cherbourg, reporting that seven of Pierre's contemporaries had died on 12 September, and another ten the day before. Pierre himself turned out to have flu, but Matisse, advised by another grieving father to run no risks, managed to get leave to take him home.

At the end of the month successive waves of Allied forces swept eastwards, pushing the Germans back across Flanders. British troops retook St-Quentin on 29 September, and entered Bohain on 8 October. Matisse was one of the first civilians to reach the town, making his way through an unrecognizable country of mud, craters, blasted trees, dead horses, skeletal towns and gutted villages. Roads had been mined in Bohain, buildings sacked and the town hall set on fire. People had been living under shellfire in their cellars for two months, surviving on turnips, black bread and dried beans. Auguste Matisse was packed and ready to flee with his wife, his two small daughters and his seventy-four-year-old mother, taking only as much as they could carry. Forced to work twelve hours a day unloading German shells and shifting crates, Auguste had collapsed with tuberculosis, but his mother remained unbiddable and unbowed. Her home was the inheritance she and her husband had built from scratch to hand on intact to their descendants. 'It was absolutely impossible to make her leave for France, in spite of all our pleading . . .' Auguste told his brother. 'We hurled ourselves against her obstinacy. She would not abandon her house to be pillaged.'

She had sold her piano for food, and used the sheet music to wrap provisions. Henri found her, as he had known he would, preparing to bring out the treasures buried for four years in her garden, and embark on a stiff programme of washing, scrubbing and mending what was left. 'I'd rather have them spoilt than know the Germans had got their hands on them,' she said,

protesting vigorously that the first English soldiers to liberate Bohain had made off with both her clothes brushes. She had sworn to live long enough to see her eldest son again but, though she thanked him kindly for the gifts he brought, nothing he could say would make her return with him to Issy until her house had been comprehensively scoured out.

Matisse's mother was indomitable, like his wife and daughter. The three of them framed and shaped his life, pointing him towards the stern and sacrificial path he followed to the day he died. Picasso's lover Françoise Gilot described Madame Matisse and Marguerite long afterwards as two caryatids or columns supporting the entrance to Matisse's temple. The painter himself always insisted that he was by nature feckless, disorganized and chaotically undisciplined. On 11 November, the night the armistice was signed to bacchanalian rejoicing all over Europe, he brought out his violin and played a wild fandango on a café table ('Phew,' said Marquet, 'well, *mon vieux*, if Amélie could see you now . . .'). Just over a month later he headed south again to Nice in pursuit of painting. At the very end of Matisse's life, Picasso would evoke his presence in a ghostly painting called *The Shadow*, which echoes his old rival's *The Violinist at the Window* of 1918, showing the artist as a spare, taut, concentrated figure at an open window. It perfectly expresses the provisional quality of Matisse's life at this point: the sense of stepping out, travelling light, starting a journey in which reality would find new forms and meanings in the world of his imagination.

Painter of the South

10. *The Hermit of the Promenade des Anglais (1919–22)*

All through the spring of 1919 in Nice, Matisse visited Auguste Renoir, who lay dying in his house, Les Collettes, at Cagnes. Renoir was in his late seventies, widowed during the war and so pitifully wasted he had to be shifted from his bed to the studio in a carrying chair. 'He slumped in it like a corpse,' said Matisse, who made a habit of calling in at Les Collettes after a day's work on the surrounding landscape. Frail, gaunt, swathed in bandages and too crippled by arthritis to hold a brush, Renoir lived only to paint, which he still did every day with his brush-handle padded and wedged between right thumb and forefinger. 'His eyes held all the life of his body,' said Matisse, 'his eyes and his tongue and his poor, twisted, deformed, bleeding paw.' Seeing the old man wince and grimace at the start of each painting session was like watching the dead come back to life. 'The pain passes, Matisse, but the beauty remains,' Renoir said with a radiant smile, explaining that he meant to live until he had finished *The Bathers*, his latest love song to health, strength and physical well-being, on a canvas so big it had to be wound on rollers so as to bring each section close enough for him to paint.

Matisse had tears in his voice when he described Renoir at Cagnes: a tiny mummified figure stripped of everything but intelligence, memory and the passionate will to transfer what he saw in front of him – two girls lolling on a grassy bank – to a deeper and more stable reality in paint. Renoir's example marked Matisse indelibly. He would look back to it long afterwards when old age capsized him in turn and, in the periodic desperation of his early years in Nice, he always found courage at Cagnes. His first visit, on 31 December 1917 – his forty-eighth birthday – had been a sticky affair, according to his companion Georges Besson, who remembered the older

painter's amazement at the younger's extreme formality ('It was rather like Rubens in the role of ambassador presenting his credentials to some aged Pope,' Besson wrote cattily). In fact Matisse had been paralysed by nerves. It was months before he plucked up courage to bring a batch of his own work for inspection, and even then he almost gave up the idea, tossing a coin in the street to decide whether or not to set out for Cagnes with his roll of canvases.

Matisse's lack of confidence, inconceivable to an ambitious young hustler like Besson, was only too obvious to Renoir. 'You're talking to someone who hasn't perhaps achieved anything much,' he said reassuringly, 'but who has managed to produce something that's absolutely his own. I worked with Monet, and with Cézanne for years, and I've always remained myself.' Matisse confessed that however great his self-doubt, he always knew he hadn't a hope of painting any other way. 'Well,' said Renoir, 'that's exactly what I like about you.' Before he left for Paris at the end of his first painting season in Nice, Matisse brought over a batch of his most precious possessions, feeling, as he said himself, like a Nawab spreading out his treasures before his host. They included Cézanne's little *Bathers*, a couple of Renoir's own canvases, and Courbet's *Sleeping Blonde*. Renoir responded by proposing an exchange of canvases when the younger artist tentatively asked if he might buy one of his host's paintings. 'I'm truly touched,' Matisse replied, 'but I can't accept. I'm not worth it.' He had learned much as a student from Pissarro and Monet, and he revered Cézanne all his life as a god of painting, but the Impressionists still belonged for him to another world. Even in his prime Matisse could not quite put himself on an equal footing with Renoir.

Les Collettes was the nearest he got to a second home in these first unsettled years in Nice when he came in the early evenings to sit with the old man, who was gripped as the light faded by dread of the night's suffering ahead. They swapped gossip, told risky stories, compared notes about the poverty of their beginnings. Two of Renoir's three sons had been gravely

wounded in the first months of the war. Matisse, who had one son waiting to be posted to the front when they first met, and another about to be mobilized, understood the helpless fury behind his friend's sardonic solution: 'Renoir said it should be the old and infirm sent to die in holes, not the young with their lives before them.' Painting was all they could do. They discussed technique, reputation, posterity, the whole question of shifting focus and vision that had been the main battlefield for their two generations. Matisse described his misgivings, and the panic attacks which his host assured him never let up. Renoir objected to Matisse's pure, strong colours, and was especially indignant about a preposterous slash of black paint, representing the curtain-rod in a hotel bedroom, which stayed in place when it ought by Impressionist rules to have disrupted the whole composition. Matisse explained that he was constructing space from a convergence of forces that had nothing to do with the direct copying of nature. This was something he could only do instinctively and, as always when instinct took over, he needed someone to help him stand back and assess his work critically. Renoir forced him to articulate what he was doing as he tried once again to tear himself free of the immediate past.

Matisse settled after the war in the little old Hotel de la Méditerranée on the promenade des Anglais. After four years of chaos he had no time to waste. The exuberant New Year greetings he sent his wife at the start of 1919 already included a sketch of the basic elements – the dressing table, the balustrade and the swagged muslin curtains framing the bedroom window – with which he was about to construct and reconstruct painted spaces that broke all known rules of pictorial correctness. On 2 January a freak storm broke over Nice. Seas pounded up on to the front, pouring across the promenade and turning the street into a rushing grey river. Winds tore off the hotel shutters, smashed the windows and shattered a big mirror in the entrance hall. 'It's so extraordinary that I haven't enough eyes to take it all in,' Matisse wrote to his wife next day, painting

the scene from his window with hands that still shook from elation and shock. The luminous, rain-washed atmosphere after a storm always exhilarated him. The main reason he gave afterwards for coming to Nice was the sunlight: clear, silvery and soft in spite of its phenomenal brilliance. He said he couldn't believe his luck when he first realized he would open his eyes every morning on the same light.

That fierce symbolic storm came to seem to Matisse cleansing and liberating. Nice, with its steady, unchanging light, gave him the pictorial equivalent of laboratory conditions in which to reshape the future. Culturally isolated, physically intact, geographically cut off by mountains from both France and Italy, the town seemed to have slept through the war. To most Parisians, this was an outpost at the back of beyond but its remoteness suited Matisse. 'Nice is utterly *Niçois*,' Matisse told his son Jean, 'I feel myself a complete foreigner here.' His sense of unreality was heightened by the old-fashioned décor of his hotel room: pink-tiled floor, rococo plasterwork and an Italianate painted ceiling lit from below by sun reflected off water, intensified and directed through shutters like stage lighting. Its artificiality ('Everything was fake, absurd, amazing, delicious') was what he needed. 'Matisse is always the great devil who jumps up out of the box again as good as new,' wrote Besson, who watched him start the process of re-inventing himself as an artist in Nice. Impressionism, which had effectively blocked off the future in the Fauve years, now suggested a way forward. 'Renoir's work saves us from the drying-up effect of pure abstraction,' said Matisse, explaining to an interviewer that once you have explored as far as you can go in a particular direction, you have to change course. From now on the problems resolved with such labour in the great radical canvases of 1916–17 ceased to interest him.

By 1919 external forces had drastically extended Matisse's own instinctive stripping back. Of his key pre-war supporters who survived the war in Europe, Prichard was a spent force, Sembat had only a few years to live, and the faithful Purrmann

found himself stranded on the far side of a gulf almost impossible for Germans to cross in the first years of a precarious peace. Purrmann's last great service at the end of the war was to try to retrieve the Berlin canvases for Sarah and Michael Stein, but his efforts came too late. The Steins had secretly sold the paintings in 1918, apparently in a fit of financial panic, at a knockdown price to an elderly Dane, Christian Tetzen-Lund, whose persistence matched his shrewd eye for a bargain. The transaction meant that the only place in Europe to see a representative collection of Matisse's work in the run-up to Modernism was now a private apartment belonging to a retired feed-and-grain merchant in Copenhagen. The Steins' embarrassment, when Matisse visited them, was as dismal as the spaces on their half-empty walls.

There was worse news from Russia, where *Dance* and *Music* were said to have been destroyed or burnt after the Revolution of 1917. In fact, Shchukin's house and its contents had been confiscated by Lenin, to be reopened as a Soviet museum, with the former owner installed in a servant's bedroom and employed as guide to his own collections. Shchukin himself left Russia a year later, slipping out of Moscow to rejoin his family in exile in Nice. Matisse welcomed him warmly, taking him to see Renoir at Cagnes, calling on him at his hotel and hoping for a return visit. But a chance encounter on the street, when the collector turned his head away to avoid meeting the painter's eye, made it painfully clear that this new, one-sided relationship could never replace their old, active, working collaboration. The two men were at loggerheads. Shchukin, believing like most Russian émigrés that the Soviet regime could only be temporary, was dismayed to find Matisse too absorbed in his present work to pay attention to the fate of a collection from which he had no more to learn. Matisse for his part felt hurt by Shchukin's failure to respond to the struggle that consumed him in Nice.

Work monopolized him from the start. He complained that he was toiling uphill like a carthorse, exhausted and worn down by his labours, but he had no doubt that he was on to some-

thing. 'As for telling you what it will be like,' he wrote to his wife on 9 January 1919, 'that I couldn't say since it hasn't happened yet, but my idea is to push further and deeper into true painting.' Four days later he acquired a new model. Young women prepared to pose were in such short supply that the head of the art school infuriated Matisse by offering her simultaneously to all the leading local painters, including Renoir. Pale, slender, and supple, with a quintessentially urban, indoor chic, quite unlike Renoir's ample, apple-cheeked models, the nineteen-year-old Antoinette Arnoud had the kind of responsive intelligence that mattered above all to Matisse. Over the next two years the pair would collaborate on a steady stream of paintings, and an even more remarkable series of drawings.

Matisse drew Arnoud dressed and undressed, reading or lounging through their work sessions, but mostly gazing gravely straight at him. In his paintings he added local accessories – a vase of anemones, a couple of lemons, a loaded paintbrush – laid out on the frilled muslin dressing-table top with its oval mirror sometimes blank and black-faced, sometimes projecting reflections from odd angles in close-up, at others opening on to sky and sea beyond the windows of the narrow hotel room. He started a series of canvases on the theme of his model and himself at the easel ('A pale grey day, very tender pinks –' he reported excitedly to Amélie on 25 January, 'and a pink rug on the floor – everything else is pearl grey, you can even see me in pearl-grey with my palette in the mirror'). In another series, he posed Arnoud on an upright chair in the open door of the balcony wearing a fashionably short, loose tunic with a green umbrella, mauve stockings and big bows on her chunky high heels. In the most extreme of this sequence, *Woman with a Green Parasol on a Balcony*, light spills and splashes in streaks of muted grey, blue and black paint, enveloping an almost geometric composition – the highly stylized woman, the doorway, the balustrade, vertical strips of the beach and the sea beyond – in an austere, self-sufficient space of its own.

This was one of those major transitional phases when Matisse

needed a model to humanize the ordeal of painting. He took on Arnoud initially as a stand-in for his daughter, whose poor health prevented her joining him in Nice at the beginning of 1919 to continue a series of paintings started at Issy. Marguerite had dressed up for him in designer outfits and stylish Parisian hats: a fur-trimmed cap, a smart little toque of blue feathers, an absurd velvet bonnet shaped like a giant puffball. Now he himself produced a sumptuous confection made from a cheap Italian straw hat with a single white ostrich plume curling and frothing over the brim and yards of blue-black ribbon looped underneath. Arnoud wore it with a panache that made her simple white peignoir seem like a ballgown. By turns stylish, seductive and demure as a schoolgirl, she could look stately wearing nothing but her new hat. As summer drew on, Matisse trimmed a second hat with flowers and took her round the headland to the Bay of Villefranche, where she posed beneath a pink parasol in an old-fashioned, high-necked, long-sleeved white frock on a hotel terrace with a blue balustrade.

Daily painting sessions alternated with hours on end devoted to drawing, a corrective Matisse would use from now on whenever he felt his work in danger of losing its balance between colour and feeling on the one hand, and line and form on the other. Having been forced to give up so much for the sake of simplicity and concentration, he now hoped to find a way of retaining clarity, concision and force without sacrificing volume, spatial depth, the individual character and texture of fur, feathers, fluff, fabric or flowers. He returned over and over again to a lace collar, drawing it first in minute detail ('each mesh, yes, almost each thread') until he had got it by heart and could translate it at will with two swift lines 'into an ornament, an arabesque, without losing the character of lace, and of that particular lace'. The same procedure was repeated with Arnoud's embroidered tunic, her hat, hair, hands and face. Matisse was evolving methods he would use for the rest of his life. A surge of renewed energy pulses between the lines of the letters he wrote home as he worked on these drawings.

Living, sleeping and working in one small room, he had finally succeeded in narrowing his existence down to painting alone. 'I'm the hermit of the promenade des Anglais,' he wrote to his wife, well aware how penitential his routine looked to outsiders, 'that would make a good title for Max Jacob.' He broke off work to select pictures and supervise their hanging by post for his first one-man show in six years at Bernheim-Jeune, returning so eagerly to his easel that he forgot all about the opening in Paris on 2 May 1919. Apart from Arnoud, Renoir and the staff at the art school, Matisse saw virtually no one save a few transient Parisians like the Bessons, the Halvorsens (visiting Greta's retired father, Count Prozor) and an old Montparnasse neighbour, the novelist Jules Romains. As usual the painter missed his family and followed their doings by post, urging his mother to move to Issy, fixing up his brother with an agency for Pellerin's margarine, entreating Pierre to restart violin lessons and Jean to cut down on smoking.

But bleaker anxieties underlay the optimism in Matisse's letters that spring. Decisions about Marguerite's future could not be postponed. She herself was tormented by fears that even her habitual stoicism could no longer conceal. Her father sent encouragement, advice, instructions to read less and paint more, and reminders to submit to the periodic ordeal of having her tube changed. The alternatives outlined by her doctors in March 1919 were either to do nothing, or to perform a final laryngo-tracheotomy in an attempt to rebuild her damaged windpipe. The first meant steadily increasing constriction, almost inevitably ending in suffocation. The second relied on high-risk pioneering techniques made possible only because of unprecedented surgical advances in wartime. An operation was eventually scheduled for late May but, in the uncertain event of a successful outcome, the subsequent healing process would be problematic in an age without antibiotics. It was agreed that Matisse, always apt to make himself sick with fright where Marguerite was concerned, should stay well away, returning only once she was safely convalescent. 'Until very soon, dear

Marguerite,' he wrote in May. 'I dearly hope this will be the last station of your Calvary – say that to yourself over and over.'

Amélie kept the exact timing of the operation from Henri, contacting him the same day to let him know things had gone well so far. Apprehension was swamped by tidal waves of relief. Marguerite still had to breathe through a temporary tube due for removal, if all went according to plan, once her throat had healed sufficiently for a further graft of cartilage to close the hole in the windpipe. But incredulous delight was still uppermost when Matisse returned home at last, having paid what he must have suspected was his final visit to Renoir, who told him he meant to finish his *Bathers* before he died ('And, in fact, that's what happened,' Matisse said with approval long afterwards). He reached Paris in the week of the official victory celebrations that engulfed the city on 28 June. 'I'm the happiest man in the world,' he told an interviewer who caught him at his sunniest and most expansive that month. He gloried in the flowers in his garden, painting poppies going off like fireworks and a brilliant bouquet for Bastille Day on 14 July.

The whole family regrouped, including the dog and the accommodating young model Matisse had brought back from Nice. He captured their mood of serenity in the last great work he ever made at Issy, a painting of his daughter, gentle and relaxed in a summery frock, cradling the cat and drinking lemonade with Antoinette Arnoud at a pink marble table under the nut trees in the back garden. *Tea in the Garden* is a pastoral idyll full of rustling movement and dappled light. Matisse picked a canvas roughly similar in size and shape to the other great decorative compositions set at Issy over the past decade, from *Harmony in Red* to *The Painter's Family* and *The Music Lesson*. The grouping is informal, the palette soft and low-keyed, the treatment straightforward except that, when the painter came to his daughter's face, his brush jerked back to the old, fierce, expressive habit of abstraction. Like practically everything he did, Matisse's *Tea* was at once too literal-minded and too

sophisticated to please its public. Bernheim-Jeune claimed they
could have sold the picture forty times over if it weren't for
the dog looking up from scratching her fleas, and the unsightly
blur distorting Marguerite's features. Perhaps potential customers
sensed the elegiac undertones in a picture that marked multiple
farewells: to a style of painting that had served its purpose (the
tea table – up-ended, flattened and severely dysfunctional in the
Pink Marble Table of 1917 – now resumed its familiar three-
dimensional format); to the house and garden that had
generated so many masterpieces; and to the life the family had
led there together.

Serge Diaghilev and Igor Stravinsky turned up at Issy one
day in early summer to commission sets for the Ballets Russes.
Matisse, who had no intention whatsoever of accepting their
proposal, was seduced in his own living room, partly by Diaghilev
– a man whose charm could revive a corpse, according to the
London impresario Charles B. Cochran – but partly also by
the images projected on his internal screen as he listened to
Stravinsky strumming out themes at the piano from *Le Chant
du rossignol* [*The Song of the Nightingale*]. The Russians envisaged
something richly oriental, preferably barbaric, probably in black
and gold, but Matisse saw Hans Christian Andersen's Chinese
fairy tale as a myth about resuscitation and renewal, 'spring-like,
very fresh and youthful, and I couldn't see what on earth that
had to do with black-and-gold sumptuosity'. He imagined the
central confrontation between Death and the Nightingale in
terms of simple shapes, clear light and pure colour. 'Well, that's
it!' cried Diaghilev. 'There's your décor all settled ... It's abso-
lutely essential you do it ... there's no one but you who could
do it.' Diaghilev swept out in triumph, ignoring his host's feeble
protests, but over the next few weeks Matisse was haunted in
spite of himself by his vision of the life-giving Nightingale.

The upshot was that he agreed to design the *Rossignol* ballet
for an opening at the Paris Opéra in the New Year alongside
Picasso's *Tricorne* and André Derain's *Boutique fantasque*, a spec-
tacular triple coup to mark the Ballets Russes' peacetime

comeback. Diaghilev left to prepare for the start of the company's autumn season in London, and Matisse heard nothing more until he was peremptorily summoned by telegram. He crossed the Channel on 12 October to be confronted with an ultimatum: either he stayed put in London long enough to design and deliver the *Rossignol* sets, or the company would manage without him. He and Diaghilev went through the same routine as before, a pattern of outrageous demands, determined resistance and rapid capitulation that set the tone for a collaboration rooted, on Matisse's side, in resentment rising to crescendos of rage and loathing. 'Diaghilev is Louis XIV,' was his final verdict, delivered with hindsight in the relative calm of old age. Overruled, unprepared and disorientated, Matisse seemed to himself at the time to be lost in a thick London fog that was both actual and metaphysical. Speaking virtually no English ('Tell Pierre I daren't even say *yes*'), unable to buy a stamp or ask his way back to his room at the Savoy Hotel, fuming at his own folly, cursing the Ballets Russes, he was consumed by the sense that each day given to the *Rossignol* was stolen from his real work, a sacrifice no man on earth could have forced him to make but Diaghilev.

'You've no idea what he's like, that man,' he complained to Amélie. 'He's charming and maddening at the same time – he's a real snake – he slips through your fingers – at bottom the only thing that counts is himself and his affairs.' Matisse had met his match in point of obstinacy, but he also recognized a creative will that, like his own, acknowledged no limits to the power of imagination. It was his own vision that Matisse could not resist, and Diaghilev knew it. The painter had come with no set designs, no precise idea where to start, nothing but an unformed concept at the back of his mind. He told his wife he felt the same blind panic as had paralysed him initially on his first trip to Morocco. What saved him was intuition. He built himself a toy theatre as he had done more than thirty years before as a schoolboy in Bohain, but this time the packing case was a scale model of the Empire Theatre, Leicester Square,

with state-of-the-art electric lighting fitted in the lid by the stage carpenter. Matisse chose sky-blue as before for his décor, essentially a brightly lit space with props and costumes once again cut out of coloured paper. Diaghilev's Russian set-painter was amazed by the Frenchman's methods ('He set to work in the studio, scissors in hand, cutting out and piecing together a model'), and by his ignorance of orthodox stage design.

Matisse said he conceived his décor 'like a painting, only with colours that move'. The moving colours were the costumes, embroidered with strips of silver or dotted with yellow flowers to act as what he called light splashes. His lighting effects were painterly rather than mechanical, relying relatively little on the still crude and primitive resources of electricity. He devised what the only surviving detailed, first-hand account of this ballet described as 'a hundred ingenious, elegant and logical ways' of using colour to make light. The curtain rose on sixteen dancers with painted lanterns, vermilion outside and lemon yellow inside to render them luminous ('more so than an electric light-bulb') against the turquoise backdrop. The warriors' armour was black ('the blue-black of a crow's wing, since a pure black would look reddish'). The mourners in the final scene on a darkened stage wore light-absorbent white felt robes decorated by midnight-blue velvet triangles, 'which spread gloom over the whole décor'. The final *coup de théâtre* was a more sophisticated modern equivalent of the burning sulphur of Matisse's boyhood. Andersen's story ends with the song of the nightingale breathing life back into the dying Chinese Emperor. Matisse proposed that the Emperor should rise from his dimly-lit deathbed and reverse his black cloak to unroll a gold-embroidered crimson lining twelve feet long on a stage inundated by a blaze of electricity under a billowing white skycloth cut in great black-edged festoons to give, in the painter's own words, 'the impression of a crystal ceiling lit by the full white light of day'.

By the end of his first week, Matisse was on the job from nine in the morning until late at night. He worked in the

company's scene-shop at the top of the basket store belonging to the Covent Garden fruit-and-vegetable market. Diaghilev and his choreographer, Léonide Massine, called daily to inspect the work, take Matisse out to lunch, calm his fears and test out his ideas in the theatre itself. Matisse got on well with Massine, and now his distrust of Diaghilev was overlaid by unwilling admiration. 'You can't imagine what it's like, the Ballets Russes – there's absolutely no fooling about here – it's an organization where no one thinks of anything but his or her work – I'd never have guessed this is how it would be.' His ordeal ended with a six-hour session in the scene-shop. 'They're enchanted,' Matisse wrote home on 24 October. 'Now all that remains is to paint it to scale, and do the costumes.'

He returned to Paris with Diaghilev at the beginning of November to consult one of France's top theatrical costumiers, who announced that the Emperor's cloak alone would take her team of embroiderers three months to complete. Matisse replied that he could do it himself in three days by laying the red stuff on the floor, cutting his pieces out of ready-made gold cloth and improvising an imperial dragon by eye on the spot. The only professional in Paris prepared to connive at this monstrous violation of the laws of *haute couture* was Paul Poiret, roped in by Diaghilev, who found himself worsted for the first and only time by Matisse on their first day in Poiret's workshop. The painter picked a costly roll of rich red velvet, ruthlessly over-riding the impresario's pleas that he had already bought the fabric ('You showed me a sample of cotton velvet in a fake red, a dark velvet, a dead velvet that didn't sing at all'). Matisse took his shoes off and mounted a vast cutting table 'like a trampoline', with the velvet spread out beneath his bare feet, shaping and placing his scraps of gold stuff, attended by four or five of Poiret's assistants to pin and stitch at his direction. The great cloak was finished in two days flat. Matisse always looked back with pride on this feat, adapting the method for the huge wall paintings commissioned twelve years later by the Barnes Foundation in America, and reverting to it again at

the end of his life for the stained-glass windows at Vence and the majestic cut-paper works that followed.

He returned to London for an opening of his own on 15 November at the Leicester Galleries, which put on a show of recent small paintings that sold out almost immediately, to everyone's surprise. 'These English are mad,' said Matisse, as he watched one of them buy seven of his works in two swoops. All London came, from Vanessa and Clive Bell, Duncan Grant, Maynard Keynes and the rest of what was about to become the Bloomsbury set to pillars of the artistic establishment like Arnold Bennett (who bought a drawing), and the future head of the National Gallery, Kenneth Clark (then a seventeen-year-old schoolboy unable to sleep for excitement). Over the next few days the gallery provided a haven of refuge from Diaghilev, who now precipitated a final explosive showdown that began with Matisse threatening to walk out, and ended with him meekly submitting to demands for a painted drop-curtain nineteen metres wide.

He got back to Nice at last on 12 December, just too late to see Renoir, who had died the previous week. The Hotel de la Méditerranée had let his old room, so he had to move into another with no balcony. At the end of the month Arnoud found a better job and gave up posing, leaving him to make do with her larger, plainer, more unreliable sister, who had none of her sibling's finesse. Matisse's mother fell ill, and his daughter's condition grew increasingly precarious. The ballet continued to give trouble, forcing him back to the capital to supervise costumes for the Paris première, which was postponed at the last minute by an orchestra strike. When it finally opened on 2 February 1920, the *Chant du rossignol* fell flat. The fashionable Parisian public, enchanted by the absurd throwaway wit of Derain's *Boutique fantasque*, beginning to get the hang of Picasso's crazy Cubistic visual wisecracking in *Parade*, could make nothing of dancers treated as moving colours in Matisse's bare, light-filled, sky-coloured space. Looking back later, Matisse identified the *Rossignol* première as the first time the Cubists

ganged up on him ('All the people who usually said hello to me turned their backs'). Diaghilev was furious on his designer's behalf. Although Matisse refused ever to work with him again, he would do justice later to Diaghilev's courage, and his horror of taking the easy way out. Each of them understood only too well the fate of the Chinese Emperor, who loved the true song of the nightingale so much that he pined to death when his courtiers insisted on substituting a more impressive, jewelled and gilded mechanical bird whose song was reliably bland and always the same.

*Anna Matisse, the
painter's mother*

At the time, the *Rossignol* fiasco was overshadowed by worse catastrophes. On 25 January, a week before the opening, Matisse's mother died in Bohain. It was exactly fifty years since she and her husband had first opened the seed-store with a section selling paints, where the young Henri watched his mother weighing out coloured pigment for her customers before mixing it with turpentine and linseed oil. Her love of colour had launched him as a painter, and her support had been unconditional ever since. Matisse's grief was intensified that winter by his daughter's struggle for survival. Marguerite endured constant pain, dizziness,

chokings and swellings that blocked the airway as her body successively rejected the contraptions intended to keep her breathing hole open long enough for the reconstructed larynx to stabilize. She had been waiting in growing desperation since the previous summer for the hole to be closed. When her father went back to Nice at the end of February, Marguerite hoped against hope that the crisis might be over before his return. Mother and daughter retreated into themselves, huddled together in the apartment on the quai St-Michel, filled with foreboding, concealing their worst fears from each other. After endless cat-and-mouse postponements, her surgeon finally performed the operation in late spring, monitoring her even more closely afterwards for fear the larynx might contract again.

The year 1920 saw the end of an era for the whole family. Maman Matisse's house was to be sold, her possessions cleared out and the seed-store given up so that Auguste, always a lack-lustre businessman, could retire on the proceeds. Henri Matisse never went back to Bohain, nor to his birthplace of Le Cateau. It was his wife who stayed on to wind up her mother-in-law's affairs after the funeral, and his daughter who from now on would pay regular visits to oversee the family's remaining prop-erty. Matisse would build a new life in the south. Not that his plans were clear-cut at this stage. When he returned alone to the Hotel de la Méditérranée in February, he meant to stay just long enough to finish off his disrupted season, having already discussed with his wife the possibility of moving the whole family south, if work forced him to come back next year. 'Nice gets more and more boring, and I'm alone here when I ought to be with you all – I hope this will be the last time,' he wrote plaintively in March. 'I have to remind myself how little I should get done in Paris, so as to get up the patience to stay here.' He persuaded Arnoud to pose for him again but, although he drove himself to the brink of exhaustion, he was dissatisfied and still unsure what sort of turning point he had reached in his work. He said that before he could come home, he needed to make sufficient progress to be clear about the route ahead.

At the end of April he posted off seven canvases, all but one so out of character that the family had no idea how to respond. These pretty girls in brightly coloured interiors with frilly curtains and sun pouring through the window mystified even Matisse himself at first. But by the time he left Nice in May, he had recognized an underlying consistency that would continue to elude the rest of the world for decades to come. Among the objects that resurfaced at Issy from his mother's house in Bohain were the first two pictures he had ever painted, homely little still lifes of books and candles in the earthen colours of his native Flemish palette. Far from feeling that his switch to the south marked a total break with the past, Matisse said it gave him the shock of his life to see them and realize that, after twenty years of unremitting exertion, his essential identity as a painter had not changed in the slightest.

Marguerite's recovery was the family priority that summer. As soon as her doctors let her leave Paris, Matisse took his wife and daughter to recuperate in sea air at Etretat in Normandy on the Channel coast, where they booked into a beach hotel for a month. Matisse produced rapid oil sketches of exultant vitality, painting fish, boats and bay, especially its curious cliff formation, which had appealed to the Impressionists before him. But the canvas that reveals most about his feelings at Etretat is a little painting of Marguerite, whose exhaustion was frightening. After living under threat for so long, she allowed herself to collapse at last and be put to bed, where her father painted her for the first time without the black band she had worn since childhood to conceal the opening in her throat. She lies asleep, looking like an illustration from a child's fairy-tale – rounded swan-like neck, long lashes outlined on a pale cheek, dark hair spread on the pillow – in a canvas whose surface sweetness is undercut by the troubling mauve pallor and the dark patches circling the eyes of this real-life sleeping beauty. The artless innocence of *Portrait of Marguerite Asleep* contains the same fierce emotion as the first picture Matisse ever made of his daughter, the 1901 *Portrait*

showing her as a vulnerable six-year-old with staring black eyes in a white face. When they got back to Paris in August, Henri and Amélie hung the new painting over their bed.

Matisse drove his wife and daughter down to take a cure at the Alpine resort of Aix-les-Bains, returning himself to complete unfinished business in Normandy before heading south again. At the end of September 1920, he and Amélie moved together into roomier quarters on the first floor of the Hotel de la Méditerranée with French windows and a terrace above the Bay of Nice. She was near collapse herself by this time. Mother and daughter were paying the price for two years of mutual strain, fear and deception ('we couldn't admit what we were going through, even to each other'). Amélie, who had coped so effortlessly with the stress of war, who had dismantled a whole way of life in Bohain, and provided Marguerite with years of intensive care, now sank back into depression. Marguerite meanwhile was moving slowly and shakily towards full recovery. She was right when she told her son long afterwards that the 1914–18 war had saved her life. Patients who survived serious damage to the breathing mechanism, let alone resumed anything approaching a normal existence, were virtually unheard of in previous medical history. For her surgeon, Dr Hautant, her recovery was a triumph: he called her *l'enfant chéri*, or the precious child, and treated her, as she said, like a flower in his buttonhole.

The three young Matisses now took over the apartment on the quai St-Michel. Pierre already had his first day job, working in Clemenceau's private secretariat. Jean, newly discharged from the army and looking for work, enrolled for a part-time course at the Ecole des Arts et Métiers. Marguerite took charge of the household, running her brothers as she always had done and beginning at last to catch up with the pleasures of being young in peacetime, dancing, dressing up, going out with the boys and their friends. Over the next few years all three set about painting in earnest, starting out in the same place at the same age to follow in their father's footsteps. Family life fell into a regular

pattern based on Matisse's season in Nice, which lasted from early autumn to late spring or early summer interspersed with visits from his children working in Paris, while Amélie shuttled between the two households, and everyone migrated each summer to Issy.

Henri was disconsolate each time his wife left him. But though he complained bitterly about his solitude in Nice, he never seriously reckoned it too high a price to pay for the richness and intensity of the life he was leading on canvas. Other people, at the time and since, detected frivolity, weakness and backsliding where Matisse saw only a steady push forward, with periods of exploration and experiment followed by consolidation. 'As for my work, there's only one thing I can say,' he told Amélie on New Year's Day, 1921, 'I'm searching for the density of things – instead of reducing what I see to a silhouette, I'm trying to convey volume and modelling.' He discussed each stage with his wife and children, especially his daughter, whose sharp eye missed nothing. It was Marguerite who pointed out that each phase of strenuous, studious observation paid off in a burst of almost inconceivably audacious colour; and Marguerite who first grasped that the mysterious power of *French Window at Nice* (one of the batch of paintings that had baffled the family in the spring of 1920) had to do with the strength and softness of the light investing the hotel room and everything in it with what J. D. Flam called 'an almost gothic splendour'.

This majestic canvas, which shows Arnoud flanked by tied-back grey curtains like pillars at the foot of a tall, blue-shuttered window towering above her like a vault, was known in the Matisse family as 'the Cathedral'. It is the grandest of all the Nice hotel paintings. Where once the windows in Matisse's pictures opened on to an unattainable world of light and colour, here the sunlit sea-front with its palm trees and passers-by glimpsed through wooden shutters is undeniably real. It is the interior that has taken on magical qualities. 'This room was smaller than I had supposed,' wrote the poet Charles Vildrac, describing his surprise on meeting Matisse at the Méditérranée.

'From certain of his pictures, I had formed the impression that you could walk freely in it, with long strides, or dance with ease. The painter ... had lent it a soul that in reality it did not have. Certainly it was a pleasant hotel room, but with the soul of a hotel room.'

With Arnoud – sometimes solemn, sometimes coquettish, but often bored, listless, even mutinous in these canvases – there was clearly a limit to how far the spiritual transformation could go. For the public, the abstract compositional quality of Matisse's paintings at this stage was more or less completely obscured by the lifestyle they depict. *French Window at Nice* shows a young girl with bare legs and long loose hair, wearing a transparent top and scarlet harem pants, seated beside the bed in the painter's hotel room. People drew the obvious conclusion from the fact that Matisse posed Arnoud and her two or three substitutes amid all the trappings of an affair, endlessly painting one or other of them wearing a slip at the dressing table, seated in a wrapper over a coffee tray, or newly emerged from the bath clutching a towel with her hair in a turban. From the *Conversation* onwards, Matisse had painted himself wearing the striped pyjamas that were his normal working gear at home in Issy, and in his improvised studios in Nice. Posterity has confidently discounted the painter's own statement that these Nice interiors are suffused with sublimated sexual pleasure, and that his intense state of arousal discharged itself not so much through the model's body as through the lines and forms orchestrated on canvas around that body.

In Arnoud's case, the evidence suggests that Matisse's explanation was true. In all the weekly, sometimes daily letters he exchanged throughout their collaboration with his wife and children, there is nothing to suggest more than the usual professional tensions on his part, and no hint of friction, resentment or jealousy on theirs. Matisse and his family referred to Arnoud by her surname, and treated her as a work colleague. He painted her for the last time in *The Painter and His Model*, posting off a sketch to his wife and daughter in triumph the day after the

picture was finished, 24 April 1921. It shows him backview, seated bolt upright at the easel, pyjama'd and bespectacled, in the act of sizing up his composition: an image of concentration, severe and straight as a plumb line, which he had painted before in *The Violinist at the Window*. The model sprawling naked at his side contributes a note of indifference and anomie to this unsentimental valediction. Arnoud not only had a boyfriend of her own but had been visibly pregnant by him since the beginning of March, when Marguerite reported her condition to Amélie. Later that spring she gave birth to a stillborn baby.

No one who knew him well at the time ever doubted that, for Matisse, models were working partners, not sexual captives. Sex was one of the things he grumbled about having to do without in Nice, quoting his doctor friend Elie Faure, who warned him that excess of chastity could be as much of an abuse as its opposite. But Matisse maintained that, so far as modelling went, the same rules applied to human beings as to a plate of pastries or a fish dinner. Pressing your nose up against the cake-shop window made your saliva run far more than slaking your appetite. 'I've never sampled anything edible that had served me as a model, even when posing didn't affect its freshness,' he said, explaining that the oysters he painted at intervals throughout his life were brought round each morning by a café waiter, who fetched them again to serve to his customers at midday ('Although I savour their smell, it never occurred to me to have them for lunch – it was others who ate them. Posing had made them different for me from their equivalents on a restaurant table').

Arnoud's place was filled by Henriette Darricarrère, who had been posing intermittently for Matisse for the past six months. He had first noticed her working as a film extra at the newly opened Studios de la Victorine on the western outskirts of Nice, where Charles Pathé and the Gaumont brothers built lots on a site intended at the start of the 1920s to become the European Hollywood. He picked her out initially for her innate dignity, her athlete's carriage, the graceful way her head sat on

her neck. Henriette was younger but steadier and less worldly than her predecessor, which meant she fitted in far more easily with the Matisses' highly unconventional existence. She was a trained dancer and violinist with natural gifts as a painter, talents Matisse encouraged in her as in his own children. Amélie got on well with Henriette, and so did Marguerite, who had moved down to Nice at the end of January 1921 for another dose of health-giving sea air. The two girls posed together, playing chess, making music, wrapped warmly in Spanish shawls to watch the procession of the *Fête des fleurs* from the balcony. Henriette's poise and fluidity, her regular features and oval face, her air of being at ease in her body, added up to a kind of physical perfection that delighted Marguerite, and made her even more determined to stop being an invalid herself.

Henriette for her part looked up to Marguerite, who was six years older and incomparably more sophisticated, but so run down after a winter in Paris that at first she could only pose lying down. Both parents were still exceedingly anxious about their daughter, whose physical torpor too often looked like despair. Her father filled her room with red roses, hung eleven of his latest paintings on the walls, and went dancing with her at the casino. 'Papa does the fox-trot like his sons,' Marguerite told Amélie, 'not quite so light on his feet, but not bad. You can see he's doing everything to stop me getting bored.' Within a few weeks she was eating better, losing the dark smudges under her eyes, looking, to his critical eye, plump, pretty and rested. Marguerite said he was as proud of her regained health and spirits as of any of his own canvases. He took her to a carnival fancy-dress party at Cagnes hosted by Renoir's son Jean, who cast himself as a decadent Roman playboy to the local police chief's severe Roman judge. There was a toreador, a Charlie Chaplin, a Japanese in a kimono but, of all the couples who danced till three in the morning, perhaps the most significant, from posterity's point of view, were the two Matisses, who went as an Arab potentate and a young beauty from the harem.

'Papa wore the green-and-gold robe with a turban on his head of gold silk striped in red and green . . .' Marguerite wrote home. 'As for me, I had loose trousers made from a length of folded stuff, an Algerian muslin top from Ibrahim, the jacket in turquoise blue silk I brought with me, and the white turban.' She posed next morning, still drooping with tiredness in her improvised costume, alongside Henriette, bare-breasted in loose red trousers, for a painting called *The Arabs*, later retitled *The Terrace* or *Odalisque on a Terrace*. Matisse had been collecting oriental bits and pieces — waistcoats, jackets, silk robes, rugs, lamps, trays, a little inlaid table — for years from a Lebanese couple called Ibrahim, who kept a boutique on the rue Royale in Paris. He used them to improvise the kind of settings women made for themselves in Tangier harems from carpets, cushions, textiles and small portable tables or stools. Both Lorette and Antoinette Arnoud had been painted in the same white turban before Marguerite. Matisse had sent home for it, along with an oriental chaise longue and a Persian robe, on his return to Nice after his session in the Ballets Russes' scene-shop, which seems to have opened his eyes to the potential of sets and costume. From then on he experimented enthusiastically with Middle Eastern trousers and tops, Spanish shawls, combs and mantillas, a Venetian robe, and the outfits designed for his wife and daughter by Paul Poiret's sister, Germaine Bongard. But none of his earlier models ever made an oriental costume look like anything but fancy dress. It was Henriette, so neat, even prim, in her street clothes, who wore the filmy open blouses and billowing low-slung pants without inhibition, becoming at once luxuriant, sensual and calmly authoritative.

The Arabs released something in Henriette that opened up new pictorial possibilities for Matisse. In early April he drove both girls along the coast to try out their costumes in the open air beside the mosque at Antibes. They took the precaution of wearing coats to hide their exotic outfits, but they needn't have bothered, since the first thing they saw on entering the simple little fishing village of Cagnes was an Arab caravan with three

camels and a film crew. The mysterious Orient was the setting for a whole string of post-war screen hits produced at the Studios de la Victorine, including Rex Ingram's *Garden of Allah* and Alexander Wollkoff's *Shéhérezade*. Throughout the 1920s, while the silent cinema invented its own powerful daydreams at one end of the Bay of Nice, Matisse was working with similar ingredients on quite different pictorial illusions at the other. He drove over to the Ballets Russes' headquarters at Monte Carlo in late April to see Diaghilev, who lent him one of Léon Bakst's odalisque costumes for the ballet *Shéhérezade*. It was too tight for Henriette, but the painter got what he needed ('I saw how it was made, and I could make one like it myself').

By this time his plans had clarified. The season was over and the hotels shutting down, but from now on he no longer talked of resuming the old routines at Issy. His base had shifted. He hoped to persuade his wife to spend next winter with him in Nice in a two-roomed flat he had already rented ready for his return. It was on the third floor of 1 Place Charles Félix, strategically placed at the head of the flower market in the heart of the old town within a stone's throw of the sea. For the next two decades Matisse's existence outside the studio would be largely confined to an area roughly a mile square, bounded to the east by the rocky outcrop of the castle hill, to the south by the beach with fishing boats drawn up on the stones, and to the north by the art school on the far side of the river Paillon, where washerwomen still worked along the banks. It was like another country after the late-nineteenth-century new town he had left behind on the promenade des Anglais. As the post-war tide of fashion receded from Nice, its imperial winter pleasure grounds stood empty, its sumptuous palaces went on sale, and its sea-front hotels shut down. The melancholy stagnation of the visitors' quarter contrasted sharply with the noise and activity on the steep twisting lanes behind Matisse's new flat, where the native *Niçois* lived jammed together in tall old houses with no piped water, sanitation, gas lighting or heating. There were cages of canaries and bedding hung out to air at

the windows. Shopkeepers sold chickens, wine, olives and groceries in dark, narrow, windowless hutches opening off the sunlit street like an Arab souk. Painting was a job like any other to the flower-sellers, fishmongers and café waiters who were Matisse's neighbours on the market place.

He marked the start of his new life by taking an unprecedented summer break, a long leisurely drive with his wife and daughter to Aix-les-Bains, where he sampled the waters before leaving the other two to complete the cure while he drove back to Nice to take possession of the new flat at the end of August 1921. Matisse had worked for four seasons running in hotels, painting interiors whose decoration he could not alter except by draping textiles over the tables and chairs. Now he needed a space he could control and manipulate. The studio he set up at Place Charles Félix in two rented rooms opening into one another was organized, quite unlike any previous workplace, to enable him to change the scenery as easily as in a theatre. Trunks of props, costumes and backcloths travelled down from Issy by rail. He bought nine yards of cotton material, dyed it himself and lined it with hessian to make a border for a decorative window-grille supplied by Ibrahim. One of the first things he did in the new studio was to pose Henriette against it, wearing a turban and harem pants, the long, graceful, curving line of her body accentuated by the window's rectangular grid.

He found a local carpenter to make him a folding screen from an Arab curtain, printed with round-headed, lattice-filled archways that would feature in countless paintings over the next few years. Henriette posed again and again in front of it, sometimes nude, more often wearing the exotic outfits that suited her so well, standing, sitting or sprawled at full length, alone or with a second model. *The Moorish Screen* of 1921 combines the stylized patterns of the screen itself, the rug, the carpet and at least two wallpapers with the flowers, the two girls in pale summer frocks and the painter's violin case on the brass bedstead behind them, interweaving colours and shapes in a single flat,

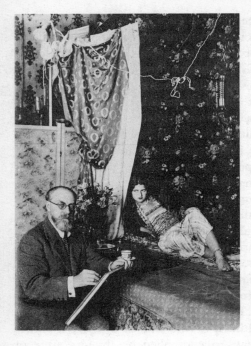

*Matisse and model on one
of the improvised stage sets
that became his prime work
tool in the 1920s*

patterned surface contiguous with the canvas itself. This was
the fusion Matisse set himself to explore between realism and
abstraction, a fusion that retained its subjects' identity while at
the same time absorbing them within an essentially abstract,
wholly invented alternative reality.

Matisse's apartment opened out on canvas, expanding or
contracting as if by magic, like theatrical or cinematic space. In
it he could adjust his gaze like a tracking camera, switching
filters, plunging from long to close focus, creating colour and
light effects that correspond less to anything in front of him
than to an invisible synthesis in his mind's eye. These unreal
interiors matched the essential theatricality of Nice, a city that
had always valued décor above architecture, where the 1920s
saw the invention of an entirely new medium based on unre-
ality. Matisse got used to coming across a caravanserai of sheikhs

on location, or a freak rainstorm laid on for a film team by local firemen with hoses. He recruited models at the film studios, or the café on the Place Masséna where extras collected each morning in search of work. Like the silent cinema, he borrowed the make-believe settings of French painterly orientalizing for ends of his own. Contemporaries who accused Matisse of slipping back into reactionary mode missed the point. So do posthumous charges of colonial exploitation, since Matisse, like the popular film-makers, positively emphasized the fact that his odalisques, with their up-to-date hair-dos and frank body language, came neither from North Africa nor the Middle East but from contemporary France. Their blatant modernity intensifies the erotic charge that distracts attention, as Matisse said himself, from less obvious explorations going on in the same canvas.

Chief of these was his attempt to make colour create light by exploiting what he called a thirst for rhythmic abstraction. To do this he consulted predominantly two disparate sources. For at least six years after Renoir's death, Matisse continued to visit Les Collettes to paint in the garden, and go through the canvases in the studio ('I examined Renoir's paintings at leisure, and it helped me a lot'). What chiefly interested him was the way Renoir abolished the distinction between figures and background, merging the two in great surging waves of colour on canvases that hum and glow with sensuality. Matisse accompanied this chromatic crash course with structural tuition from Michelangelo, regularly visiting the plaster casts from the Medici chapel at the art school, and getting Pierre to order him a cast of the *Dying Slave* from the Louvre. In the late spring of 1922, Matisse spent mornings painting Henriette and afternoons drawing Michelangelo's *Night* ('This drawing marks real progress in my study of form, and I hope that tomorrow my painting will feel the benefit'). He said that what mattered with each new model was finding the pose that made her most comfortable ('and then I become the slave of that pose'). Henriette, who had trained as a ballet dancer, had an athletic body quite

unlike Antoinette's. Marguerite maintained that the main reason her father switched models was the contrast between Antoinette's soft curves ('Antoinette was flabby, and her body did not catch the light') and Henriette's lithe, well-toned figure, which took and gave back light like a sculpture. Henriette fell easily into Michelangelo's poses, relaxing quite naturally with one leg drawn up and one or both arms raised over her head.

In the seven years they worked together, Matisse multiplied variations on the same theme in paintings, drawings and prints which use straight lines (as Michelangelo used architectural detail) to offset the roundness of belly and breast against window frames, screen edges, hanging panels, the angle between wall and floor. The model stares back in moods which range from almost feral abandon to quizzical composure or the mask-like impassivity of the astonishing *Moorish Woman* and *Seated Odalisque with a Raised Knee*. Few would identify Michelangelo's muscular nudes as an obvious source for this big-breasted, soft-bellied houri in a transparent skirt, with rouged nipples and a fake tattoo on her forehead. Now, as then, many may well feel too bemused to look closely at the exquisitely observed and miraculously painted texture of her body and legs, set against pink striped upholstery, seen through embroidered silk gauze, and outlined with flicks of turquoise green which stabilize the composition, establishing what Matisse called its architectural underpinning, interacting with the turquoise turban and the purples and pinky-mauves of the floral backcloth in a pulsing, shimmering framework of colour.

The process drove him to black gulfs of despair, when his work revolted him and he longed to destroy it. 'You know the state,' Amélie wrote to Marguerite after putting up with one of these moods in Nice for three days on end. Matisse, never easy to live with, could be almost unbearable at close quarters in two cramped rooms, when his wife could do nothing but tidy the studio with him buzzing round her like an angry fly, or sawing away as loudly as he could on his violin. Amélie's visits in these years were constantly promised, and constantly

postponed or cut short on account of Marguerite's health or her own. She would arrive from Paris, often preoccupied with troubles she had left behind, to find him obsessed by whichever big nude was currently demanding all he had to give ('The big nude, after surviving various tragic periods, has regained its serenity, and I tremble to see it change,' Amélie reported tartly. 'If ever I had any say, I'd make sure it stays as is, for I like it a lot'). Work now claimed him so insistently that the life his wife represented outside it came to seem less and less real. He had left her to cope with his family's affairs in Bohain after his mother's death, and when her father died suddenly in Ajaccio in November 1922, Matisse could not tear himself away from the studio even for a few days to attend the funeral.

He longed for news, begged for visits, missed his wife desperately. But his schemes for returning to Paris in mid-season to see the family and catch up with one or other of his annual one-man shows at Bernheim-Jeune invariably fell through. In the end he missed five of these shows in a row. The paintings he sent back to Paris – mostly fruit, flowers and nudes in cushioned and carpeted interiors – gave an impression of ease and comfort that would condition the way people looked at Matisse's work for the rest of his life and long afterwards. But, to the painter himself, this fresh start in Nice felt like a more inhuman version of his harsh beginnings as a student thirty years earlier. The more generous painting's rewards, the bleaker his existence became out of working hours. He bought himself a pair of goldfish for company and painted all day, with reluctant stops for a frugal lunch of cold ham or hard-boiled eggs, and a solitary dinner at a teashop or café followed by a nightly session of letter-writing. Cold weather set in hard in his first winter in the Place Charles Félix, with two feet of snow on the ground by early December. Matisse bought wooden sabots, wrote home for blankets and an overcoat, and froze at night when he had to let his stove go out for fear of poisoning the model next morning with a build-up of noxious fumes.

If his paintings occupied a space and time of their own, so

did he. Most years he barely noticed Christmas ('For me it was a day like any other'), and paid scant attention to his own birthday a week later ('In twenty-four hours I'm going to be fifty-two,' he wrote in an agitated postscript to Marguerite on 30 December, 1921, '*fifty-two* already!!!!'). Occasionally he took time off to attend the young Renoirs' New Year's Eve parties, but mostly he wrote letters after supper as usual before going early to bed. One cold winter's night he sketched himself looking like an off-duty magician in a striped woolly dressing gown and checked carpet slippers, with a pot of tea on the table, spectacles propped on his nose and an absurd sausage-shaped rabbit-skin nightcap on his head in which, as he said, even his goldfish didn't recognize him.

His few friends were all in one way or another fugitives like himself: Jules Romains, the Halvorsens, painters like Bussy and Bonnard for whom Nice provided a refuge or hideout. Occasional dinner invitations from friends' wives provided his only female company outside the studio. Living alone for long stretches for the first time in his life, he put himself on a strict regime. A late riser who loved food and seldom took exercise outside the studio, Matisse in his early fifties reversed the habits of a lifetime by forcing himself to rise at six, swim before breakfast and cut back on his lunches. In the same precautionary mode, he even accompanied one of his neighbours – an American painter called Charles Thorndike – to the brothels he had so stubbornly resisted with Marquet ('They're not much fun, to be frank, and always the same'). He told Lydia Delectorskaya long afterwards that he patronized them throughout the years Henriette modelled for him, fitting them in dutifully and without enthusiasm ('*Tiens*, I forgot to go to the brothel again'), in the pragmatic French spirit that treats sex without the rituals of courtship or chase as a bodily function no more romantic than any other. Matisse recommended abstinence to Romains (himself about to split up with one wife and take another), who responded with baffled respect.

For Henriette, too, Matisse's schedule was gruelling. She

worked with him all day every day except Sunday, shut up in the studio except for a two-hour lunch break when the whole town closed down at midday ('She can't even go shopping,' Matisse said ruefully). Studio chores like running errands, washing brushes and making the tea were part of her routine. It was a kind of bondage, but it was also an apprenticeship. Henriette's parents were poor working people from the north, and proud of it. Like Arnoud, she had a lover, an educated, middle-class boy with whom she had already been walking out for twelve months before coming to work for Matisse. She concealed the affair from her parents, who were outraged when they found out after three years, not so much by her having a lover as by his bourgeois origins. The Matisses opened doors for her, taking her for drives, or to the opera at Monte Carlo. She brought her two younger brothers to watch the carnival fireworks from the studio window, and accompanied Amélie on shopping trips and outings. Marguerite sent her parcels of clothes, the boys asked after her in their letters, and Matisse practised duets with her when the day's work had gone well. When she fell ill, he took her to a doctor for the first time in her life. Born in 1901, a year younger than Pierre Matisse, Henriette became in some ways a substitute daughter for the Matisses as their own children prepared to leave home. She responded to their warmth as eagerly as to the opportunities they offered. 'Oh! It's so nice to see a happy family like yours,' she told Marguerite in 1922.

By this time the flat that was to have provided the Matisses with a home of their own in Nice had been entirely taken over by the studio, and the painter and his wife were living out of suitcases again in a modest hotel round the corner. Painting as always remained the pivot on which the family turned. Matisse's canvases consoled his daughter in sickness, and roused his wife from depression when nothing else could. The arrival of a crate of new canvases, sent up from Nice each spring in time for Matisse's show at Bernheim-Jeune, caused wild excitement at Issy. The annual ritual of unpacking, stretching,

framing and hanging ended with the whole family settling
down to respond to the paintings. These private picture shows,
lasting at most a few days before the dealers arrived to take
their pick, became the high point of the family year. If Matisse
was increasingly absent in person, his presence still filled the
whole house. This was the cause and purpose of his sequestra-
tion in Nice. 'There's nothing to be done but to live in and
for yourself – to work towards becoming a real force that can't
be dismissed,' he wrote, when his wife and daughter complained
about the slights of the art world, '– today you're a great genius
– tomorrow they'll despise you – It's only natural . . . We have
a genuine collection of pictures – I'm working with the courage
of independence, my pictures have a market value etc, I've quite
a reputation even with those who know nothing of painting
. . . We are one of those rare large families whose members live
in unity – don't you think that's enough to make people envious
and jealous?'

11. *Le Vieux Solitaire (1923–8)*

Matisse's reputation split in two at the beginning of the 1920s (and has continued ever since to produce powerful and opposite reactions). On the one hand, the art establishment and the public of two continents recoiled in shock from the work of his pre-war period. 'It . . . provoked a strange, unknown horror, something akin to an image of the cadaver of reason, the decomposing corpse of Intelligence,' wrote a Spanish critic. The Matisse canvases in a mixed show at the Metropolitan Museum of New York in 1921 were denounced as pathological and, when the Detroit Institute of Arts bought a semi-abstract painting the year after, the museum's journal was obliged to defend its scandalous purchase on the grounds that the artist had a nice, clean house and a thoroughly respectable lifestyle.

Matisse's latest work, on the other hand, was selling as never before, which did him no good at all with informed opinion in Paris. Pictures that people had no problem in liking looked tame and unimportant to admirers of heroic insurrection, like Marcel Sembat, whose *Henri Matisse* launched a popular series published by the influential *Nouvelle Revue française* in 1920. Sembat's fiery and incisive defence stopped short in 1913 with *Arab Café*, which (along with all the other key paintings in Russia) would not be seen again in the West until nearly forty years after the painter's death. For Matisse, who read it alone on his fiftieth birthday in Nice, the book came as a shock. 'First of all, he denies me any future – by claiming I've already won,' he wrote home bitterly, 'then he makes all sorts of blunders – is this the moment to say I look like a German professor? And to drag in Nietszche?'

Matisse correctly foresaw that Sembat's approach, with its damaging gaps and its emphasis on a largely inaccessible past,

would set the tone of response to his work for decades to come. The text passed over the great sombre wartime paintings in silence, apparently because Sembat (like most other people) had never seen them. Journalists interviewing the painter throughout the 1920s would inevitably insist on re-fighting the Fauve campaign and its immediate aftermath. 'These people are honest, I grant you,' Matisse wrote home wearily when asked to justify yet again the battles of twenty years earlier, 'but if one isn't hurt by their malice, one is by their stupidity.'

In his own view, he had already moved on to a new phase of the struggle that would end only with the cut-paper compositions constructed directly from colour in the last decade of his life. But the sexy subjects and harem connotations of his chromatic experiments in Nice made them seem to contemporaries more like capitulation. 'He's given in, he's calmed down, the public is on his side,' Sembat wrote in disgust to Signac when the French state bought its second Matisse canvas, *Odalisque in Red Culottes*, in 1922. Matisse found no new advocate to compare with the pre-war collectors who had campaigned so effectively on his behalf. Sembat himself died of a heart attack in September 1922, closely followed by his wife, who shot herself twelve hours later. She left instructions for their collection to go to the nearest museum to Paris that had the courage to take it (this proved to be Grenoble, under the enterprising Andry Farcy, who had already been given the *Interior with Aubergines* by the painter himself, and now acquired the only serious collection of Matisse's work in France).

Sarah Stein sold a Renoir in 1924 to buy *Tea in the Garden*, but Matisse, who still eagerly awaited her comments each year, was repeatedly disappointed by her blank response to his more recent work. Most of the major paintings she and her husband had assembled were sold off piecemeal in the 1920s in Copenhagen (many would end up in Denmark's national museum, which owns to this day Western Europe's finest collection from Matisse's first revolutionary period). In

1923 the couturier Jacques Doucet bought *Goldfish and Palette*, pairing it with Picasso's *Demoiselles d'Avignon* in what might have become a unique French Modernist collection if Doucet's adviser, André Breton, had not almost immediately parted company with the collector, who died shortly afterwards. Another formidable collector, the American John Quinn, whose sights had been trained on Matisse since 1915, wrote to propose a more formal version of the ad hoc pre-war arrangement with Shchukin, but Quinn, too, died suddenly in 1925. Félix Fénéon, the only person whose eye inspired confidence at Bernheim-Jeune, retired in 1924, leaving Matisse for the first time with no external back-up except for commercial dealers whose judgement he did not trust, whose manoeuvres he aimed to outwit, and whose sole long-term goal appeared to be to maximize profit.

Matisse's isolation was more nearly complete than it had ever been before in these years when for long periods he cut himself off from even the support of his family. 'You say I'm leading a nice peaceful existence down here,' he wrote when his wife reproached him in the autumn of 1923 for leaving her to cope alone with the turmoil of family life, '– don't forget that my storms take place in my work, which is the rudder that steers our whole house.' Dissatisfaction at home was the only thing that seriously threatened to knock him off course. Complaints that he rated human concerns second to painting fed his perennial sense of being excluded, misunderstood and unjustly blamed for sacrifices that were greater for him than for anyone else.

The event causing commotion at Issy in 1923 was Marguerite's marriage. She had dismayed her father and delighted the rest of the family by accepting one of her brothers' companions, the most brilliant of Prichard's pre-war disciples, Georges Duthuit, who had formed the habit of dropping in at Issy as a conscript on wartime leaves. Amélie liked him, and the two boys were fascinated by his knowledge of the world (born in 1891, eight years older than Jean Matisse, Duthuit had completed

three years' military service before being sent to the front in 1914). Clever, disrespectful and exceedingly funny, he contributed a note of irreverent gaiety that lightened the atmosphere at Issy. He combined impeccable old-fashioned French upper-class manners with casual English chic. Orphaned early and handed over to a rapacious uncle who was also his guardian, Duthuit had learned young to live by his wits. He knew everyone who counted for anything, intellectually speaking, in anarchic young post-war Paris, and his background was sufficiently mysterious to give rise to endless stories. Women were captivated by him, men were intrigued and impressed.

This kind of urbanity, so remote from anything Marguerite knew or cared about, left her indifferent. She had no intention of becoming anybody's conquest. But for all his glamour and good looks, Duthuit had darker attractions. He could be as mercilessly self-critical as she could, and as capable of driving himself to extremes. He courted Marguerite, with a nervous intensity that matched her own, by telling her the story of his life. The child of an unhappy marriage between a successful Parisian architect and the daughter of landowners in the Auvergne, young Georges had grown up in the capital acting as his father's alibi on nightly excursions backstage at the theatre, and watching his mother succumb to corrosive loneliness and depression. After both parents died young of tuberculosis, and his only ally, a much loved elder brother, drowned accidentally at school, Georges had been brought up by his guardian with such brutal indifference that eight years in the army seemed to him like salvation. He belonged to the same subversive generation as Aragon and Breton and, like them, he discovered Matisse for himself as a schoolboy, responding unconditionally to the explosive power of the *Blue Nude* at the Salon des Indépendants in 1907. His beauty and brains charmed Prichard, who gave him a solid Bergsonian base for believing that art and artists could redeem the worn-out spiritual heritage of a corrupt and cynical world.

Marguerite lived by this faith, and was touched by the

unshakeable, at times almost desperate conviction with which Duthuit clung to it. He had idolized Prichard, and he approached her father with awe. He said that his generation confronted a fractured civilization in which traditional rules and concepts no longer made sense, 'a situation with no precedent since the sack of Constantinople by the Franks'. Matisse's paintings had shaped him at a formative stage. With Marguerite's help, he hoped to pass on the new ways of thinking and feeling absorbed in front of canvases that now formed part of what he called his spiritual baggage. It was the kind of destiny for which each of them had been born.

Duthuit was the only one of Marguerite's suitors who talked in the same uncompromising terms as she did herself. He was also probably the one who needed her most. The winning grace and sweetness of her childhood returned with an inner radiance that shone from her dark eyes and lit up her pale, almost transparent skin. Even Prichard found Marguerite adorable at this stage. To Duthuit she was irresistible. The social inexperience that could make her seem awkward, even gauche, seemed to him a purity untouched by gross material reality. He relied on her underlying toughness but he was enchanted by her delicacy, and by the fastidious discernment she brought to everything from her moral code to her style in frocks and hats ('She is lovely as the day,' he wrote to her brother Jean). For Duthuit, Marguerite would always remain on some level one of those magical beings who had dazzled and transformed his vision in paintings like the *Family Portrait* and the *Piano Lesson*, inhabitants of a world so heady with possibilities that it brought him, in his own words, 'to the brink of overthrow, total upset, conversion, vertigo'.

Only Matisse remained dubious about Duthuit's practical prospects. Many fathers might have hesitated to entrust an only daughter to a perpetual student in his early thirties who had abandoned plans to be an architect, like his father and grandfather, in favour of switching to aesthetic theory, with nothing to live on, no outlet in view except little magazines, and no

immediate plans for working on anything but a putative thesis on the lost art of the Byzantine Copts. There were sticky interviews that summer with this potential son-in-law whose reverence for the artist as seer stopped well short of filial deference. Even Matisse was daunted by Duthuit's boundless self-confidence ('I should have liked him, when I told him what provision I was making for Marguerite, to have talked to me about what he had,' he admitted to Amélie, '– he told me nothing, and I didn't dare ask').

He took refuge as usual in painting, interrupting his summer vacation at Issy to escape back to Nice for three weeks in July, accompanied by Jean, who was beginning to make progress on canvas ('I've hung Jean's studies in my room and I look at them often with pleasure,' Matisse told his wife). All three young Matisses followed a schedule designed to give them a smoother ride than their father's by eliminating any taint of Beaux-Arts contamination. All showed pictures at the Indépendants, and the two boys regularly posted off batches of work for long-distance monitoring in Nice. But at the end of this troubled summer Pierre returned from holiday in Ajaccio with his Aunt Berthe to announce that he, too, had found the love of his life and meant to marry her. She was one of his aunt's students, Clorinde Peretti, the daughter of a Corsican engineer who kept her in seclusion at home according to the custom of the country, allowing her out unchaperoned only to cross the road to the training college opposite the Perettis' house. Pierre had secretly wooed and won her over the garden wall. Matisse did not oppose the match, though he made its consequences relentlessly plain. Mlle Peretti could have no inkling of what life with a penniless artist entailed and, since she had clearly aroused in Pierre the consuming passion that painting had failed to ignite, his father told him flatly to pick another profession. He suggested dealing instead, and found an opening for his son with Barbazanges, Hodebert et Cie on the Faubourg St-Honoré. It turned out to be shrewd and affectionate advice but, given Matisse's ineradicable contempt for the dealer's trade, it planted a knife

between father and son that retained a cutting edge for the rest of their lives.

Preparations for Marguerite's wedding at the end of the year were fraught with still sharper misgiving. Matisse, who retired thankfully to Nice in September, received alarming bulletins about her health as she grew steadily paler, slighter and more fine-drawn (by November she was on a milk diet, and so fragile that her father hoped against hope for a postponement). Amélie directed operations with military precision, organizing civil and religious ceremonies, drawing up guest-lists, planning a hand-stitched trousseau. The whole affair struck her husband as over-elaborate, but his wife and daughter ignored his protests. This was, after all, precisely how Amélie had been married herself: for love in great haste at short notice, with a splendid send-off and nothing in prospect but romantic poverty and years of struggle stretching ahead. The couple were married on 10 December in a civil ceremony at the *mairie* followed by a service in Notre-Dame with musicians, flowers, a reception and six car-loads of guests. Matisse chose the music, and the bride looked so lovely that the great orientalist Charles Vignier insisted her father must have designed the wedding dress himself. Next day, while the new M. and Mme Duthuit began their honey-moon in Venice, the guests reassembled full of compliments for another party at Issy. Matisse dined with the Steins that night ('Your father was very happy and showed it, which enchanted everyone,' Amélie reported to Marguerite). On 12 December he returned to Nice with a framed photograph of his daughter, specially commissioned from the young American Man Ray, to hang in his studio.

Marguerite's marriage had looked at one point as if it might split the family apart. Battle lines were drawn up over Duthuit, with Matisse on one side confronting solid opposition from his wife and daughter on the other ('Don't thank me, dear Margot, for all I've done for you,' Amélie wrote to her adoptive daughter after the wedding, 'you have given me nothing but joy and tenderness ever since I've served as your mother – I'm the one

who should be grateful to you'). But when Marguerite wrote tentatively to ask if she and her husband might stop off in Nice on their way home from Venice, Matisse welcomed them warmly. He even laid on a concert, consisting of a string duet performed in their honour by Henriette and himself. His fury and foreboding had evaporated, clearing the air all round. The upheaval that had driven them apart now drew the painter and his wife together, turning their thoughts back to their own honeymoon, and eliciting a rare declaration of love and faith from Amélie in a letter to Marguerite. 'I had the best, it's true there aren't many men like your father, and my dearest wish is that you, too, may know the best,' she wrote, describing the mutual trust that had rooted itself naturally in her own marriage from its first days: 'I can say that, if I had to start all over again, I wouldn't change my life for anything in the world.'

When Amélie joined Henri in Nice, arriving at the end of March to avoid the noise and crowds of the carnival, she found him run down and fretful, pining for company, weakened by winter flu and complaining of stomach-ache. In previous years it was Amélie who had found it hard to get through the days with no one to talk to and nothing to do in Nice, but in the spring of 1924 the couple returned to the simple routines laid down at the start of their life together. Amélie presided over the studio again and accompanied Henri on painting expeditions, sitting beside the easel beneath shady trees on Mont Boron, with a writing pad on her knees and the bay spread out at her feet. Sometimes she pottered round the antique shops, picking up patterned plates or a painted screen for her husband. Each morning she shopped in the market beneath the studio windows, and had to prevent herself forcibly from posting off daily parcels to Paris full of strawberries, cherries, asparagus, artichokes, tender young peas and beans. Young Mme Duthuit, settling down to married life at 19 quai St-Michel, received enough flowers – arum lilies, blood-red tulips, irises, roses and a whole box of carnations – to fill every vase in the place. Matisse, who still thought of himself as a temporary resident

in Nice, proposed retaining his flat for another year and acquiring a second to live in instead of putting up at hotels. His wife liked the idea of two flats in the same building with enough room for family visits. That summer Matisse signed a lease for the flat immediately above his own, and amazed Amélie by agreeing without protest to take an Italian holiday with the Duthuits, so that he and his new son-in-law could iron out any initial misconceptions.

He returned to Paris on 6 July, three weeks before Pierre was due to marry Clorinde Peretti. She was unlike anyone the high-minded, hard-working Matisses had ever harboured at Issy before. Born in 1901 in Bolivia (where her father had gone to build bridges), she had spent the first half of her life running wild in South America, and the second half secluded in her father's house in Ajaccio, watched over and cultivated like a prize orchid. She looked like a luxuriant hothouse flower, and moved with a Spanish dancer's contained energy and suppleness. Pierre called her his Inca princess. He had played tennis, climbed trees and gone swimming with her brothers on visits to his aunt from childhood and, in a male-centred society where a girl was never left alone with a man until she had married him, he remained the only boy she had ever met outside her family. Any slur on female honour was still commonly settled in Corsica by the knife or the gun. Matisse, always a prudent parent, had made Pierre return to Ajaccio to submit a formal request for Clorinde's hand in marriage. But her father, who had already arranged a match with a middle-aged doctor, rejected this twenty-two-year-old trainee art-dealer from Paris on the perfectly reasonable grounds that he had no qualifications of any sort, and no means of supporting a wife. 'My father was terrible,' said Clorinde, 'so I abandoned my studies to marry Pierre Matisse.'

She came to the wedding in Paris alone, with no dowry, bringing nothing but her clothes. The Matisses organized the ceremony, supplied a lawyer to draw up a marriage contract and provided a home at Issy for the young couple with a

monthly allowance of 500 francs. Clorinde approached them warily, deferring to Pierre's mother with elaborate formality and treating his father as an ogre. The couple were married quietly on 31 July in a side chapel of Notre-Dame, with none of the fanfare of the year before. Matisse lent his car and his flat in Nice for the honeymoon, while he and Amélie travelled south with the Duthuits to Capri, Salerno, Positano and the bay of Naples. But the trip did not revolve around the archae-ological sites or the gallery-going Duthuit had dreamed of, nor did it cement the alliance Marguerite longed for between her father and husband. Matisse left the other three to explore the Blue Grotto, while he returned to Nice, where things had not gone well in the apartment on the Place Charles Félix either.

A series of sobering shocks had shaken confidence on both sides. Pierre was enthralled by his wife's grace and daring, which she displayed to stunning effect at a time when sea- and sunbathing were still practically unheard of in Nice. Clorinde could arch her body over in reverse like an acrobat, walk on her hands and launch herself backwards off the Casino pier, describing an effortless curve and somersaulting twice in the air before entering the sea like an arrow. She never forgot her father-in-law's incredulous delight in her diving ('He could not get over it'). Perhaps he remembered it too, when he invented dives and backflips for his blue acrobats quarter of a century later. But on all other levels it was as if the new husband and wife came from different centuries. Brought up with a house full of staff, a carriage, and a lady's-maid to dress her and do her hair in the mornings, Clorinde had never in her life shopped for food or set foot in the kitchen at home. In her world, a lady wore net gloves to protect her hands and waited for the maid to answer the bell. She had defied her father and aban-doned her family to marry Pierre, but his way of life was as inconceivable to her as being stranded among ape-men or aliens. 'It's not possible,' she said on her first day in Nice, when he explained that there were no servants.

Born into a family that saw painting as an integral part of

a honeymoon, Pierre had packed his paint-box, and was as bewildered as his wife when he emerged from the studio at midday to find there were no plans for lunch. Everyone in Pierre's family, including his father, could fetch coal, lay and light a fire, buy provisions and prepare a meal, sweep floors and make beds at a pinch. His mother and sister not only did their own hair and designed their own clothes but ran the business side of the studio, dealing with galleries and framers, briefing collectors, arranging sales and filling in tax returns. In their company Clorinde was hopelessly out of her depth. She seemed cold, unfeeling, hellbent on making her husband conform to conventions rejected by his family as intrinsically futile. She was pictorially illiterate and her key values, based on security, status and material possessions, struck them as flimsy and insipid. Everything the Matisses did or said repudiated her and the bourgeois background she came from. Both Clorinde and Pierre had mistaken her fierce desire to escape from a tyrannical father and an arranged marriage for genuine revolt. To Matisse her attitudes embodied a smug, repressive, philistine narrowness that had revolted him all his life. Pierre was intoxicated by Clorinde, but there were times on his honeymoon when he wanted to flee from her.

Once the couple moved in with the household at Issy, the situation got worse. The family closed ranks to save Pierre. Clorinde felt herself under hostile surveillance, criticized and corrected at every turn. Nothing had prepared her for the upside-down world she now inhabited, where everyone painted and no one thought seriously of earning a living or felt in the least ashamed of flagrant violations of social decency, from the absence of staff to Marguerite's illegitimacy. 'I was dazed and disoriented,' Clorinde said in retrospect. She dreaded her new sister-in-law's raised eyebrows and sarcastic comments, and she still could not bring herself after two months to address her mother-in-law as anything but 'Madame'. Pierre was torn between the two factions, and immobilized by pressure from both sides. Neither of her new brothers-in-law intervened to

protect Clorinde. Knowing no one else in Paris, she finally appealed for help to the wife of Pierre's employer, Mme Hodebert, who said that even when she took her in her arms to comfort her, Clorinde was too frozen to weep. She was a casualty in a much larger battle that threatened to defeat Pierre too, if the marriage lasted much longer. 'The more I think about it, the more sure I am that, whatever the cost, he must break if off,' wrote Matisse, whose relationship with Marguerite's mother, Camille Joblaud, had foundered on the same clash between artistic freedom and bourgeois conformity.

The couple split up in October after only two months of marriage. Clorinde left Issy, returning her ring and confiding only in Berthe, who loved Pierre as if he had been her own son, but understood and sympathized with his wife as well (a disloyalty for which Amélie never forgave her). Pierre also moved out, to live in a rented room on his own. He saw himself from now on in his father's eyes and his own as a failure who, having already come to grief as a violinist and a painter, had somehow managed to turn even his marriage into a fiasco. But Matisse had not forgotten a similar confrontation between his parents and himself at the same age, involving shame and disappointment on one side, and smashed pride on the other. The painter who had been known by neighbours in Bohain as the *triple raté* (three-times failure) now focused his formidable will on extricating his son, and mounting a strategy of damage limitation. Matisse arranged an allowance for Clorinde to live on and proposed a getaway to the United States for Pierre (Nice had to be ruled out as a bolthole – 'too close to Ajaccio' – for fear of retribution from the Perettis). Meanwhile he engaged a divorce lawyer, and sent Pierre back to Corsica to explain what had gone wrong to Clorinde's father, who had turned him down in the first place, and whose daughter's future he had now effectively ruined.

Divorce was not an option in Corsica. Revenge was a way of life. But Pierre's abject despair touched even Père Peretti, who put away his revolver and grudgingly conceded that at

least his son–in–law had courage. Overwhelmed once again by his feelings for Clorinde, Pierre caught the ferry back to Nice, and broke down in tears halfway through a string duet in the studio. Father and son talked at length. Matisse described the wretched compromises and the self–contempt that could only be avoided by a clean break at this stage, and Pierre agreed to leave France at once. The unprecedented intimacy and openness of this exchange radically affected their relationship, establishing a mutual confidence and a sensitivity to one another's suffering that would survive even the worst upsets ahead. Matisse took his son to the theatre, never leaving his side and giving up work next day. Fear of intervention from Corsica added urgency to the family's haste and confusion. Matisse joined the others in Paris at the end of November to prepare for Pierre's journey, supplying him with fifty engravings and 10,000 francs, pressing the Bernheims to help, applying to the Steins for advice and to Pach for support in New York. Pierre sailed on 9 December, leaving his family in a state of collective shock. He landed in Manhattan, like thousands before him, speaking rudimentary English, with no fixed plan and only the vaguest idea of what to do next.

This was the third major upheaval in twelve months in a family that was, as Marguerite said, as close in foul moods or fair as the five fingers of one hand. Matisse spent Christmas Day, 1924, in bed with flu. His work had been disrupted all season, and his new apartment upstairs was still in the hands of plumbers and decorators. Amélie, too, was close to collapse. 'I'm afraid the last thread holding her back from depression may snap before we leave,' wrote Marguerite, preparing to escort her south with Duthuit, accompanied by trunkloads of household linen and furnishings. The three of them reached Nice on 5 January, the same day as Pierre's first letter to his parents, and Marguerite wrote back at once to report them snatching it from one another in their haste to read what was in it. Matisse, who could not talk of his son's departure without tears in his eyes, was exhausted. 'From that comes an uneasiness

that spreads over everything,' Marguerite wrote to Pierre. 'It latches on to the uneasiness caused by his work – an uneasiness that seems to be growing – and so everything that comes up fills him with dread.'

The fourth-floor apartment on the Place Charles Félix was bigger than the work space below, with a newly installed bathroom and superb views over the bay, but this was not an auspicious start. Amélie suffered severely from rheumatism, followed by a bad back, kidney trouble and recurrent depression. Henri's fatigue slowed and hampered his work. Their doctor diagnosed their troubles as nervous in origin. Private stress was exacerbated by unrest in the country at large. France had now waited six years to reconstruct her devastated northern heartlands and rebuild her industrial infrastructure with the compensation Germany had promised but failed to pay. The whole nation seemed to be lurching unsteadily towards bankruptcy, breakdown or war. Matisse had worried about the possibility of Pierre having to fight against Soviet forces in Poland in 1920, and Jean being remobilized as France prepared to invade Germany the year after. 'Better not to think about it too much,' said Marguerite, when French troops occupied the Ruhr in 1923, 'for the future looks like the abyss.' By 1925 the country was struggling to cope with political and financial chaos while ministers and prime ministers tumbled, taxes rose and the value of the franc spiralled downwards.

The new paintings Matisse posted home in the spring of 1925 gave no overt sign of disquiet. Their subjects – nudes, fruit and flowers posed against various striped or floral stuffs – could hardly have been simpler, or the overall impression more richly sensual. 'We've just received the canvases, which as always have lit up the big room,' Marguerite wrote to her father on 7 April: 'the subtlety in tone of the new canvases in harmonies of mauve and pink is extraordinary, it's the light sliding over and caressing the objects – and, in spite of their insubstantiality, setting up a solid equilibrium on the wall – that constantly astonishes you.' Six out of eleven works were still

lifes or flowers, including the resplendent mauve and pink, scarlet, purple and gold *Anemones in a Terracotta Pot*. This pot of anemones was one of the flower arrangements Matisse said he kept for emergencies, meaning Henriette's requests for an afternoon off. Henriette was a living sculpture. The finely modelled planes of her torso and limbs caught the light as her body articulated itself like a cat's into compact rounded volumes – breast, belly, haunch, hip, calf, knee – flowing smoothly into and out of one another from the regular oval of her face to the balls and heels of her bare feet.

But Henriette was also more subtly alert than any previous professional model to the growing uneasiness behind Matisse's gaze. In the early stages of their partnership, he had bought a second-hand piano and painted her playing it, with her two younger brothers crouched over a chessboard, recreating the group portrait for which he had once posed his own children. There is nothing restful or reassuring about the predominant heavy reds in these canvases, and the harsh emphatic patterns of the fabrics flattening walls, floor, table, even the boys themselves in their black-and-white striped tunics poring over a board whose invasive checks reappear even on the pedestal of Michelangelo's *Slave*. It is as if the realities behind the seductive artifice of Nice were becoming increasingly insistent.

Henriette watched Matisse intently, following his brush with her eyes and grasping more fully than anyone else outside his family the consequences of total commitment to what he was doing. She was a perfectionist who set herself almost unattainable goals, and paid for driving herself towards them with periodic anaemia, exhaustion and crippling discouragement. She had no more idea of relaxation than Matisse himself. The two shared a violin master, François Eréna, a leading figure in Nice's highly active musical life. Eréna was a disciplinarian and, when he chose Henriette at twenty-one as the soloist in a violin concerto at one of his public Sunday concerts, she needed the combined support of Matisse and his wife to see her through the months of rehearsal. Once she fainted during a posing

session, worrying them so much that both of them accompanied
her home and made her promise to rest. In the event, in spite
of agonizing stage-fright, Henriette played brilliantly. But the
whole experience had shaken her so deeply that she left Eréna
after the concert to become Matisse's pupil instead. He painted
her at the easel, looking earnest and effortful, stripped of the
poise and detachment she took on in her role as odalisque. In
1925, she showed four paintings in Nice, going on to exhibit
the year after at the Indépendants in Paris, where she sold a
painting to the Society of Friends of the Beaux-Arts at her
first attempt. Matisse predicted a brighter future for her than
for any other young painter at work on the Mediterranean.

Henriette's father had a history of alcoholism, she and her
mother were regularly brought down by bouts of sickness, and
her highly musical younger brothers could find only short-term
jobs as pastry-cook and lift-boy respectively. The young Darri-
carrères, even more than the young Matisses, belonged to the
rootless and disintegrating world reflected in Matisse's painting
after the First World War in Nice. 'Obsessions filter through
and anguish emanates from the succession of images these fifteen
years of painting offer us,' wrote Dominique Fourcade, intro-
ducing a show at the National Gallery in Washington three
decades after the painter's death, when for the first time these
works were looked at without prejudice or preconception,
presented in context, and allowed to speak on their own terms:
'The depicted world is one of waiting and sadness; a world of
heavy eroticism, almost a world of the voyeur. A distant world
in which communication seems impossible, or futile; besides,
human beings have become painted things in this world, colour
events in view of obtaining light on the painting's surface – they
are dispossessed of all but their chromatic lives.'

It would take sixty years or more for this hidden emotional
residue – the disturbed and disturbing feelings described in
Matisse's correspondence at the time – to become palpable in
paintings that portray on the surface a carefree existence of ease
and leisure. The Matisse of the 1920s, for so long dismissed as

facile and complacent, looks very different in retrospect. The models lounging in make-believe harem costumes on improvised divans in the studio were drawn from the tide of human flotsam washed up in Nice between the wars, transients or immigrants struggling to earn enough to rent rooms or keep families afloat with short-term jobs as film extras, dancers, musicians. Many were harassed, distracted, unreliable. One fell sick and spat blood. Another was unable to raise her train fare back to Paris. All were in some sense seeking asylum, like the painter himself. 'In these Nice portraits of a handful of models, he recorded the restless anxiety of women gazing at the sea, pining at open windows, neither dressed nor nude, going nowhere, twisting in their chairs, inert on their couches with unread books and unplayed instruments in their hands, never facing themselves in the omnipresent mirrored vanity table, indifferent to bouquets, absorbed in their own mute presence,' wrote Catherine Bock in 1986. 'These are the women one finds in post-war novels, the women described by Jean Rhys or Paul Morand, available, bored in their self-absorption, and adrift.'

But the underlying ambivalence of these canvases remained invisible to Matisse's contemporaries, who saw only a return to comfortable, familiar methods of ordering reality. By progressive Parisian standards, the wrong people now increasingly admired Matisse. He was made a chevalier of the Légion d'Honneur in the summer of 1925, going on to be voted one of France's most popular artists by *L'Art Vivant*, and to enter English *Vogue*'s hall of fame the same year. This kind of success confirmed the suspicions of those who detected the taint of cowardice and self-indulgence in Matisse's paintings of women and flowers. Former admirers responded with more or less embarrassed disclaimers. Picasso's dealer Daniel Kahnweiler elaborated a philosophical programme for Cubism that made 'decoration' and 'ornament' dirty words, writing off Matisse's work by implication as not proper painting at all. Breton issued a public recantation in *La Révolution surréaliste*, denouncing all painters who had strayed from the true path to succumb to

the snares of bourgeois reaction, and famously singling out Matisse and Derain for the full force of his anathema ('They are lost for all eternity to others as to themselves ... I should bear a grudge against myself if I paid any further attention to such a dead loss').

Georges Braque, brought by Halvorsen to the apartment on the Place Charles Félix in 1925, made no attempt to conceal his discomfort. 'Braque didn't condescend to look at what I've done,' Matisse wrote home, reporting that Braque's only comment on the sculpture in progress was to say that the clay was a pretty colour. 'As for the paintings he avoided looking at them ... he turned his head away whenever his eyes would have fallen on them ... All he wanted to see was Renoir and Courbet.' Episodes like this dismayed Matisse, and emphasized the gulf that was opening once again between himself and his most able contemporaries. The two sculptures Braque thought it best to ignore were a massive bust of *Henriette* – the first of a sequence of three as startlingly innovative as the five *Heads of Jeannette* – and the *Large Seated Nude*, which Matisse reckoned the most important piece he had ever made (he had already been struggling with it for three years, and it would take him another four to complete). By this time he had so little expectation of being understood by critics or public that he called off his annual exhibitions with Bernheim-Jeune, having already told them he would not be renewing his contract when it ran out in 1926.

He could have done with an enthusiast of acute and refined visual perception like Georges Duthuit, who would have liked nothing better than to mediate between his father-in-law and an uncomprehending world. But Matisse, unwilling to take on the role of Socratic mentor to a disciple whose fervour bordered by his own account on delirium, advised him instead, in the spring of 1925, to accept an offer from Charles Vignier, who wanted to retire and hand over his business. Matisse and Vignier agreed that Duthuit possessed the three key gifts for a dealer – intelligence, intuition and charisma – but the scheme foundered

on vehement opposition from Marguerite, who felt that the purity of her husband's objectives would be fatally compromised by contact with commerce. It was Pierre, back in France for the summer after mounting a small but successful mixed show in Manhattan, who confounded his family's misgivings by revealing an unsuspected talent for business ('He had arrived in New York as almost nobody,' wrote John Russell, 'and when he sailed for France in May 1925, left as almost somebody').

The whole family regrouped at Issy except for Matisse, who was detained in the Midi by his sculpture until mid-July. The Duthuits promptly moved out to take over the empty flat in Nice so that Georges (preparing for a temporary job at the Louvre, obtained on his father-in-law's recommendation) could work in peace. Matisse sold a batch of drawings to buy another second-hand car and set out in it with Jean for Holland. Their route lay through Flanders, skirting Bohain and Le Cateau, with blasted trees and fields of newly dug soldiers' graves stretching to the horizon on all sides. The trip was planned to suit Jean, who drove the open-topped Buick ('You've touched the heart of the mechanic he still has inside him, and made it beat faster,' said Marguerite). Jean's ambition was 'to become a Dutch Chardin' – a master of the arts of grey like his father before him at his age – and Matisse gave him the kind of intensive Dutch painting course he would have liked for himself thirty years earlier. But the mutual enthusiasm of father and son was damped by Matisse's crushing disappointment when Jean's own work showed no immediate profit from all they had seen. 'Thunder was in the air,' Amélie wrote to Marguerite on their return, describing the kind of electric atmosphere that frayed everyone's nerves, generally ending in an explosion on her husband's part and obstinate silence or tearful threats to walk out on her own. The summer was not proving the tranquil interval of rest and relaxation Matisse had anticipated. Jean was on the defensive, Duthuit wounded and brooding in Nice, Marguerite dejected, and Pierre, for all his newfound confidence, still in danger from Corsican plots.

The Matisses' lawyer warned at the end of the year that any overt move towards divorce was liable to provoke death threats. The rift deepened between Amélie and Berthe, whose support for Clorinde made her a monster in her sister's eyes. The two had not spoken since Pierre's marriage had broken down and, although Amélie made a special trip to confront Berthe in a new post as head of the teacher-training college at Pau, the sisters parted without either ever mentioning the subject they had met to discuss. Pierre would continue to run a genuine risk on his return to France each summer until M. Peretti finally died in 1927 ('My father died of grief,' said Clorinde. 'He came to Paris with a revolver to kill Pierre Matisse'). Enforced separation on the far side of the Atlantic turned Pierre in these years into a family counsellor, a part he played with a tact beyond his years, keeping in touch with his aunt, urging his mother to be more conciliatory, cheering Jean up, cracking jokes with Duthuit and explaining Marguerite's divided loyalties to their father. 'If no one is prepared to disarm, the house will become a living hell, and we'll reach the point at which we can't see one another any more,' he wrote with a frankness he could never have used to Matisse's face, 'and what good will that do?' His letters show him growing rapidly from a strained, apprehensive twenty-three-year-old trying hard to put on a good front into his father's chief confidant. Pierre was so shocked by the impression of unrelieved loneliness he got from Matisse in Nice in these years that he begged his mother to take pity and move down from Paris.

In the autumn of 1925, Matisse consoled himself by acquiring a dog, a lively, affectionate young bitch called Gika who could be even more sensitive than he was himself. She trembled for a whole hour when Matisse complained about her wetting the carpet, and she could not bring herself to touch food at all after he rebuked her for being late for dinner. He had been so tired when he left for Paris in July that he said he would have liked to sleep for a month and, back in Nice, he felt wearier still. The most he could manage was a single work session a

day, and soon even that was beyond him. He prescribed himself a fortnight's rest in October, retreating to a hotel in the mountains at St Martin de Vésubie, where he spent his days dozing or walking the dog ('It's a bit like a prisoner's exercise round,' he told his wife). In November he suffered from high tension, cold sweats, nosebleeds and lassitude ('an empty head with no desire to do anything whatsoever') coupled with such anxiety that he had to take another whole week off work.

Amélie, whose own health was so shaky she hesitated to risk a train journey, finally arrived on 5 December 1925, after which both of them felt better. They treated one another's infirmities with attentive concern, and for the first time engaged a couple to come in to look after them. Amélie began to feel at home in the upstairs flat – 'Little by little my household is sorting itself out' – and less of an outsider in Nice itself. She not only brought her own sewing, but also sent for her dressmaker from Issy to work on her spring outfits, an annual ritual that normally retained her in Paris until Easter. Matisse, who said inactivity was making him flabby and fat, stopped smoking and took up exercise in the New Year, working out twice a week with a gym instructor, and sticking to a strict schedule of swimming or foxtrotting alone to the gramophone, followed by sunbathing and a stroll along the front.

1926, which would bring convulsive upheaval for the whole family, started quietly enough. In the first week of January, Matisse's *Still Life after de Heem* went on show at a Quinn memorial exhibition in New York. 'Your still life lights up the whole room . . . It's splendid, the colours have remained as fresh as when you first painted the canvas. It gave me quite a jolt to see it again,' wrote Pierre, who had been fifteen when this picture was painted, and who found himself swept away on a tide of family patriotism that made the work of all other painters look flat. The Duthuits left the Matisse apartment in Paris in January to move into a cheap pension in Toulon. Jean stayed behind alone to run the family business at Issy, sending aggrieved and incredulous reports to his sister listing people to be seen,

bills settled, proofs checked, photographs taken, pictures framed and sculpture supervised at the foundry. After three months he said he was so worn out he could barely stand upright. When Marguerite eventually returned to take charge again at the end of April, Jean had to retreat to Duthuit's family house in the country to recover.

Jean's predicament was made worse by the nerve-racking pressure exerted, without conscious effort, by the absent Matisse. When it came to minding the office, all three of his children lived in fear of offending their implacable, inaccessible, inscrutable Papa, who issued instructions by letter or telegram, sometimes remaining ominously silent for weeks, at others erupting volcanically to dispense favours or, more often, hurl thunderbolts from Nice. All three seemed to themselves to expend endless time and effort on attempts to placate a capricious and irascible deity who sent them scurrying this way and that in New York and Paris, simultaneously patronized and fawned on, and painfully conscious of their own equivocal footing in the art world. The name of Matisse was a burden as much as a benefit. It made the painter's children perpetually vulnerable to exploitation by people currying favour, critics expecting preferential treatment, dealers demanding appointments for their clients. Museum officials, gallery owners, exhibition organizers and art editors required Matisse to donate work, lend pictures, supply texts or illustrations. Marguerite and her brothers, fielding this unending stream of demands, dreaded overstepping their authority, giving wrong decisions, making rash promises or disclosing information that would cause trouble in Nice. The best they could do was shore one another up (and sometimes their father as well).

Matisse, for his part, learned slowly in these years to adjust to what felt on bad days like solitary confinement. Shut up in his studio, sucked dry by his work and missing his family's support, he was often exasperated by their incompetence, and wounded by their callous indifference to sufferings that could only be exacerbated by endless petty queries, disputes and

complaints from Paris. At times, he wished he had never bought Issy or had any truck with dealers who made outrageous profits on his work while blaming him for driving up prices. But, in a generation for whom post-war disruption had more or less wiped out the job market, none of his children (apart from Pierre, whose foothold in New York still looked desperately precarious) had any actual or prospective source of income beyond the allowances he made them. By 1926, the struggle for survival had scattered the Matisses in all directions. At times, they seemed to be pursued by furies, breaking out in blisters and boils, collapsing with kidney trouble, dogged by exhaustion, depression, headaches, nervous tremors, swollen feet, stomach problems, spinal torsions. It felt to the painter as if the further he got from his family's problems, the greater their need for attention and guidance. The refrain of his early letters from Nice was plaintive and wistful: 'I'm alone ... my life doesn't change,' 'Write to me, Amélie,' 'Have pity on *le vieux solitaire*' (which, as he pointed out, could mean not only a hermit or recluse but also a lone wild boar). As the years passed, his tone changed, becoming sterner and more peremptory.

Of all the observers who tried to unravel the mystery of Matisse and his work in these years, the one who came closest to its core was Georges Duthuit. He was an outsider himself, on intimate terms from earliest years with self-doubt and trepidation. He understood what he was seeing when he watched his father-in-law undergo the torments of the damned, preparing himself with suffering and fasting each time he started a new work. 'The resistance he encountered was so great – I've witnessed it myself – that Matisse put himself into a veritable state of trance with tears, groans and shuddering. It was a matter for him as a man of immersing himself, each time, in the darkness of his most disturbed and confused perceptions and feelings ... and galvanizing every particle of his being to go through with it.' Duthuit knew more than most about the paralysing power of inner impediments and vacillations. But neither he nor his father-in-law could dismantle

the mutual mistrust engendered by their personal relations, and aggravated as much by Matisse's lack of interest in Duthuit's new book about Byzantium as by Duthuit's incomprehension of Matisse's own work in progress.

In the spring of 1926 Matisse set himself to repair relations with the Duthuits, coming alone to Toulon, where Georges was working on his thesis and Marguerite had sent for her sewing machine, determined at last to develop her considerable gifts (never fully approved by her father) as a dress designer. Both felt hurt and rebuffed. Duthuit said it was as if a nightmare had lifted when Matisse arrived – relaxed and expansive, full of interest in their projects – to invite them to visit him in Nice. His son-in-law responded with an extraordinary ten-page typed letter that reads more like a peace treaty, setting out the causes of his discontent, acknowledging the irritation he knew his bombastic effusions provoked in Matisse, and proposing himself nonetheless as the painter's public champion in future.

The offer was part apology, part ultimatum, and Matisse accepted both. When the Duthuits reached Nice on 14 April, Georges found himself for the first time included in the casual studio intimacy Matisse had only ever shared up till now with his family, his models and his fellow painters. The next few days were instructive all round. Marguerite contributed a practical expertise very different from her husband's speculative and theoretical approach. Duthuit learned fast, asking questions, making conjectures and drawing Matisse into areas he had rarely, if ever, tried to put into words before. The visit proved a success. Matisse encouraged his son-in-law to take photographs and write about his latest work. He even pulled strings so that Marguerite could present her collection to a head of department at one of the grandest of Parisian couture houses, Maison Worth.

One of the works Matisse hoped to complete in time for the Duthuits' arrival was *Large Seated Nude*, the sculpture he said he worked on for hours at a time in a kind of trance,

without making a single false move and without conscious control over what he was doing. 'It goes like a game of chess, and I'm so sunk in my work that I shrink back in shock if I catch sight of myself in the mirror, and I don't even notice until the end of a three-hour séance that my feet are bleeding.' These strenuous sessions, for which Matisse had been limbering up with an exercise programme ever since January, were the direct outcome of the affair with Michelangelo's *Night* begun in 1918. The *Large Seated Nude* leans back with hands clasped behind her head in Henriette's favourite pose, sleek, taut and unmistakably modern, but the muscular balance and thrust of her body recall, more openly than any of the odalisque paintings, the figures on the Medici tomb that presided over Matisse's first decade in Nice.

'Large Seated Nude'
with Matisse at work in the
studio next door on a bust
of Henriette Darricarrère

The *Large Seated Nude* grew and changed from one day to the next, acquiring a severity after the Duthuits left that it lost again in the summer. Matisse pictured himself as a kind of Pygmalion in reverse, enslaved by a statue whose living will dominated its creator. Every year he fetched a skilled workman from Marseille to mould his statue in plaster at the end of the season, every year he postponed his departure hoping to finish it before he left for Paris, and every year it defeated him. The amount of time and effort expended already struck him as ridiculous in July 1925. Two years later, he swore to either finish his statue or ditch it for good. It was not until March 1929 that he fell on it again in a final frenzy, working six or seven hours a day with the trance-like assurance which he recognized as the culmination of everything he had ever done as a sculptor. From his earliest days as a student, Matisse needed the physical release of pummelling clay as a counterpoint to painting. In Nice, drawings and clay figures based on Michelangelo enriched and invigorated his work on canvas. 'I shall go back to painting transformed, I'm sure of that,' he wrote during his last combat with the *Large Seated Nude* (which was cast in bronze from a plaster mould made in July 1929, at the end of its seventh season in Nice).

In the spring of 1926 Matisse completed *Henriette II*, a second radically simplified bust with something of the primal power that he said distinguished Michelangelo from sculptors like Donatello, who relied on surface modelling ('The Michelangelo could be rolled down a hill until most of the surface elements were knocked off, and the form would still remain'). *Henriette III* closed the sequence three years later. The model's innate steadiness and gravity – her clear-cut features, straight nose, chiselled brows, firm chin and columnar neck – are accentuated in these massively compacted bronze heads, which are as much icons of female strength and authority as Matisse's early Fauve portraits of his wife. He rose to a climactic peak at the beginning of 1926 with a painting of Henriette, *Decorative Figure on an Ornamental Background*, that combined riotous colour and

pattern with the sobriety of the *Large Nude*. The statuesque nude in this painting is hard and unyielding – more like a woodcarving than a clay model – vertical, impassive, totemic. It is the textiles that surge and swell round her: the soft white wrap billowing between her thighs, the tipsy patterning and blowsy curves of the wallpaper with its floppy red blobs signifying flower petals. This is a last spurt of diffused sensuality, a world away from the flirty, curvaceous odalisques once impersonated by the same model in see-through boleros and embroidered satin pants. The contrast was underlined by Matisse's astute old friend Jules Flandrin when the *Decorative Figure* went on show at the Tuileries Salon in May 1926: 'Flowered wallpaper leaping off the wall ... in the middle a vague shapeless form, vaguely feminine, deliberately mishandled, in opposition to the trompe-l'oeil wallpaper flowers; on the carpet a plate of lemons. All this in order to look strong, ugliness being a sign of strength. But I can't begin to convey the brilliantly successful contrast between the wallpaper flowers and the woman so skilfully mishandled. Above all she has one side of her body running straight from her upper arm to her thigh like a side of meat on a butcher's hook ...'

The long, laborious effort that led to this climax left both Matisse and his model worn out. 'Can Papa really have aged so much?' Jean asked in alarm when he saw Duthuit's photos of his father in April. Henriette was pale, drawn and so debilitated she had to leave Nice for a rest cure that summer. At the end of May, Matisse escorted his wife on the first stage of her own annual cure (this year it was a course of twenty-one mud baths at Dax, on the northern tip of the Pyrenees), seeing her on to the train at Marseille and returning to Nice alone to take stock. He was fifty-six years old, and felt himself as much out of step with his contemporaries as he had been in the years of scandal and vilification before the war. He set out his position in a long letter to his daughter: 'It's not the good life with no cares, believe me ... It's still a harsh life, Marguerite, at nearly sixty years old – surrounded by almost

total incomprehension – I would rate the chances of success for even my best exhibition in the future no higher than the toss of a coin – that shows how little confidence I have in public reaction at all levels – they'll come round in the end, I daresay, but only when I'm far away and can't hear them any more – my life is as hard, believe me, as it's always been.'

Circumstances might change ('Putting food on the table is no longer a problem, it's true') but not the underlying situation. Now that pictures were selling well at last, money had gone mad. The franc, which had more than halved in value in the last three years, lost almost as much again in the first three weeks of July 1926. The nation was virtually bankrupt, with cabinets resigning every few days and panic-stricken crowds besieging the banks, hoping to withdraw savings in time to switch to gold bars or property. The Matisses had already decided to buy themselves a second apartment in central Paris, so as to free quai St-Michel for the Duthuits, and to sell or let Issy. Matisse plunged into the task of clearance, marshalling house agents, lawyers, builders and decorators all summer at Issy with a renewed surge of the joyful energy always released in him when it was time to move on. His wife reacted as if it were her life as well as her home that was being dismantled, starting each day with storms of weeping before sinking into a torpor neither she nor anyone else could do anything to lift. Matisse was bewildered, and perplexity made him peremptory. In September, Amélie left to recover at a rest home in the mountains at Bourbonnes, where her husband joined her briefly before taking the train on to Nice to find that his landlady had put up the rent, and that builders' scaffolding was blocking his studio window on the Place Charles Félix.

Matisse financed the repairs and repainting at Issy, and the purchase of a new apartment on the Boulevard du Montparnasse, through the sale of four paintings in September 1926 to Paul Guillaume. They included *The Piano Lesson* and *Bathers by a River*, which Guillaume talked of presenting to the Louvre (something he was quite safe in doing, as Marguerite told him

tartly, since there was no way the Louvre would accept). He planned to maximize impact by devoting a whole show to these two monumental precursors of the modernist movement that had never been seen in public before (in the end he also borrowed from Pierre the smaller and slighter *Branch of Lilac* of 1914). The opening on 8 October was introduced by Duthuit in a gallery emptied of everything except the three paintings and a piano, on which the pianist Marcelle Meyer played pieces by Stravinsky, Satie and Georges Auric ('Music as clear-cut and brilliant as silver and crystal,' said Duthuit).

This was Duthuit's first public appearance in the role of Matisse's official champion. Speaking on behalf of disillusioned modern youth – 'the men of my generation' – he began by analysing the incoherence and lack of commitment endemic in the contemporary art-world, and ended with a ringing affirmation of faith in a future that would one day open its heart to paintings like these. The text of his lecture is remarkable as much for its perceptiveness as for the insights contributed at first-hand by the painter himself. A listener to Beethoven responds not so much to the sounds themselves as to the force of emotion they convey, Duthuit once said to Matisse, playing him one of the late string quartets. His account of *Bathers by a River* is an intensely musical evocation, starting from the painting's distant origins in Matisse's memory of a mountain glade on a country walk in the Roussillon, exploring the ways in which the original concept adapted to the constraints of time and space, transforming itself, acquiring new levels, proceeding by apparently haphazard suppressions and accretions to the majestic generosity and inclusiveness characteristic of all Matisse's most nearly abstract works. Guillaume had invited him to defend Matisse's paintings against charges of being too abstract (a word used by contemporaries to mean dry, cerebral and unfeeling), but Duthuit ended up delivering a defence of abstraction itself at a time when the concept in painterly terms had barely yet been invented. No previous commentator had analysed Matisse's work with anything like this degree of sophistication,

which invokes a scale of values wholly alien to the combative factions of 1920s avant-garde Paris.

It was an impressive performance ('His text was brilliant, young, lucid, new,' said Paul Guillaume), and drew unexpected congratulations even from Picasso's chief spokesman, André Salmon. To an invited audience that included Marc Chagall, Jacques Lipschitz, Francis Picabia and Marie Laurencin in the front row, it must have been perfectly clear that Matisse had withdrawn from the polemics of the day. Guillaume had a loaded revolver ready in his desk drawer and four policemen posted at the door, in case the Surrealists decided to raid the gallery. In the event their only overt response came from Picasso, who (like Matisse) had stayed away from the opening, but shortly afterwards started painting savage surrealist nudes leering and writhing in striped or flower-patterned armchairs. It was a characteristically direct expression of his lifelong principle that the best defence tactic is always attack.

But the Guillaume show was overshadowed by another crisis for the Matisses, who were already beginning in the first week of October to pack up at Issy for a move that would absorb their energies over the next three months. Marguerite and Jean took charge of operations. Amélie retired to bed, obliterated by what Pierre called a veil of heaviness, a protective veil covering depths of anger and loss that spurted out at intervals in tirades of complaint. The Matisses' doctor, François Audistère, attributed her sudden violent spasms as well as her underlying depression to nervous aggravation, advising the whole family, and especially her husband, to avoid topics that might upset his patient. Audistère, who came to understand probably more than any other outsider about the workings of the painter's family, blamed this latest collapse in large part on Matisse, whose passion for painting now raged virtually unchecked. The diagnosis disturbed Matisse far more than armed Surrealists ('If it's really me who's responsible,' he wrote sadly to Amélie the day before his show opened, 'I ask you to forgive me, and promise you it won't happen again'). Amélie, installed by December at 132 boulevard du Montparnasse,

stayed in bed, plaintive and apathetic, visited daily by Marguerite and tended by the faithful Marie, who had moved with her after nearly twenty years of looking after the household at Issy. Everyone caught colds. 'We've scarcely yet completed this terrible uprooting,' Marguerite wrote to Pierre on 26 December. 'Luckily the blood of Maman Matisse runs in my veins.'

Matisse marked the New Year of 1927 by laying out his hopes and fears in a painfully frank appeal to his wife, begging her to believe he did not want to distress her or make her do anything against her will. 'We're too old for that — but I can't resign myself to believing that we are to live separately — and that you will no longer be with me here where my work calls me. Dear Amélie, I'm not reproaching you, just telling you of my very great distress ... it's the only thing I want — that we should put our lives back together again ... we lived as one before, why couldn't we again, if I haven't lost all merit in your eyes?' The letter articulated a habitual pattern of retreat and advance, flight or rejection on her part, protestations and pleading on his, and it provided Amélie with the reassurance she needed. By late January, when Henri came up from Nice to view the new flat and plead his cause in person, the crisis had passed. They spent the week amicably interviewing prospective brides for Jean, who had tired of temporary alliances with girls more interested in art than domesticity, and asked his parents to pick out a wife for him in the traditional French way. None of the girls came up to scratch, and the project had to be shelved. Meanwhile Pierre, who had acquired a business partner with a gallery of his own in New York, mounted a Matisse retrospective presided over by *The Moroccans*, making its first public appearance since it was painted in 1916. It was a major success, and Pierre celebrated by buying a Bugatti. Even the problem of his divorce looked soluble after the death of his father-in-law in February. But the idea of exchanging paintings for money ('This horror of dismembering the family, of dispersing, bit by bit, everything that bound our family together') still cost him un-American pangs of shame and remorse.

*Henri and Amélie
Matisse with their dog in
their Nice apartment*

Amélie finally moved south in February, by which time her husband was contemplating a painting that would mark the end of his collaboration with Henriette. Both painter and model had been forced to accept that her collapse the previous summer meant she might have to give up posing altogether. Matisse had even investigated the possibility of her making a screen career, like Renoir's ex-model, Catherine Hessling, who married Jean Renoir and starred in his first feature films. Henriette herself hoped to regain strength but, in the paintings for which she posed that winter, the reclining odalisque is scarcely more than a compact rectangular shape placed horizontally to balance the verticals in complex constructions of red, white and yellow or sharp greens and purply plum pinks. Henriette, in filmy grey culottes, lies prone, almost inert, in these canvases. It is as if both painter and model mourned her infirmity, the ruthless

erosion of energy slackening her body so that its volumes and surfaces no longer responded to light like a sculpture. Her prospective film career came to nothing, and it would be years before Matisse found anyone to match her as a model. The two families remained on friendly terms, maintaining contact long after Henriette married a schoolteacher and bore him a daughter (who would grow up to pose in turn for Matisse).

In 1927 Matisse painted a last small, powerful, valedictory portrait in which Henriette gazes gravely back at him, dressed formally in a loose, flowing two-piece outfit and a close-fitting hat with a veil. The sittings left the painter distraught. *Woman with a Veil* is the saddest and perhaps the most deeply felt painting Matisse ever made of Henriette. She sits huddled up, her chin propped on one hand, her face darkened and distorted by the veil itself, which seems to refract one side of her head as if it loomed through thick glass or water. Behind her is the length of toile de Jouy that had seen service in so many key paintings of twenty years before. Henriette's veiled eyes, her head-on pose, the uncompromising mass of her body muffled rather than revealed by the bright, heavy folds of her dress, all recall the 1913 *Portrait of Mme Matisse*, but where that was a tragic confrontation, this rich and sombre canvas – impersonal, austere, charged with the taint of grief and loss – marks a last mutual salute between two former partners, each with nothing left to give. At their final sitting, Matisse reversed his paintbrush as he had done once before in the *Portrait of Yvonne Landsberg*, lightly scratching fine white lines in the paint to outline Henriette's eyes, lips and bare arm, emphasize the fall of her scarf and create a flurry of agitation round her fingers.

The Guillaume show led to a commission from the Bern-heims for a lavishly illustrated book about his father-in-law by Duthuit. Initial resistance on the painter's part was swiftly defeated by a family line-up headed by Amélie and, when Matisse's misgivings about the Bernheims turned out to be right, the project was transferred first to Guillaume (whose initial enthusiasm also evaporated), and next to the founder of

the new and ambitious *Cahiers d'Art*, Christian Zervos, who broadened the brief to take in all the other Fauve painters as well. But it was still far too soon for paintings from the Fauve period to be taken seriously and, from the point of view of critical or public awareness, much of Matisse's subsequent work might as well never have existed. His *Blue Nude* of 1908 created a sensation when it resurfaced briefly in Paris at the Quinn sale in 1926, and the *Red Studio* of 1911 was finally bought the same year to decorate a London nightclub. Both dropped out of sight again like the great ground-breaking wartime canvases, *The Moroccans* and *Bathers by a River*, which had each waited a decade for their respective first public showings.

Even Matisse's supporters disapproved of his most recent pictures. Duthuit told his father-in-law to his face that much of what he was doing was pointless, going on to publish a survey of Matisse's recent work in *Cahiers d'Art* without mentioning a single one of the paintings in question, except for a passing reference to *Odalisque with Tambourine*. 'I've re-read your prose poem with pleasure,' Matisse wrote politely when the article reached Nice, 'and accept it without demur as one would a ceremonial costume intended to show off one's few discernible good points.' In the summer of 1927, the last of the annual family gatherings at Issy, Matisse said he learned to keep his mouth shut when his son-in-law insisted on thrashing out their differences. Matisse refused to take on Duthuit or Breton or any of the other excitable young spin doctors spoiling for a fight in Paris. 'I don't want any more struggles in my life,' he told his daughter, 'I've got quite enough in my work.'

He made some of his most serenely beautiful paintings in the winter season of 1927–8, when he was already nerving himself for a fresh start. 'I don't feel up to work . . .' he admitted to his wife. 'It seems so difficult and complicated that afterwards I'm a wreck . . . Probably I'll need a complete physical overhaul before I can stand the major effort of setting off in a new direction all over again.' The Matisses had rented a second fourth-floor flat, which meant that they now possessed the

entire top storey of no 1 Place Charles Félix, with superb views
commanding the bay, the town, the mountains and the coastline
as far as Antibes and beyond. Workmen moved in that autumn.
When Amélie reached Nice at the end of December, after a
cure at Aix and a course of injections in Paris, the couple settled
down cheerfully to await completion of their new home. 'I get
out a bit, I sew, the time passes peacefully,' Amélie reported to
Marguerite, '... your father adores my toque with the grey
feathers ... my new dresses please your father.'

In February 1928, Matisse accompanied his wife across France
to settle her into the sanatorium for another cure at Dax,
following her progress and ticking off her mud baths day by
day in letters from cold, wet, wintry Nice ('All quiet here except
that I miss you'). Pierre, newly arrived from the United States,
escorted her back again in March. 'The new apartment's making
progress, it's superb, you'll all be bowled over when you see it,'
Amélie wrote to Marguerite in May. There was ample living
space, storage, spare bedrooms, a big kitchen and room for a
live-in couple to run the place. Amélie's large room looked out
to sea next to the dining room, Henri's smaller bedroom, and
the double studio with a huge glass window giving on to a
balcony running right round two sides of the building. 'Shan't
we go back to being the two inseparables of the good old days?'
Henri wrote hopefully of their new life together.

He was experimenting with compositions constructed round
two or three figures, notably a vivid, dark-haired Italian girl
with a long plait called Zita who posed with other ballet dancers
from the Compagnie de Paris. There was still no sign of anything
to match the sustained concentration of Matisse's seven-year
partnership with Henriette when Amélie returned to Paris at
the end of June, leaving her husband to finish a refractory still
life. He worked on it through the sweltering heat of midsummer,
beginning to sense a future opening out of his unpretentious
arrangement of a jug, a plate of peaches and a checked tea
towel on top of a simple wooden cupboard. 'This will extricate
me from the odalisques,' he wrote to his wife, 'I can feel it

inside myself, like a release. I had pretty well come to the end of what I could do with construction based exclusively on the balancing of coloured masses.'

He worked on, scrubbing out and repainting, stupefied by the heat and by the possibilities of his new canvas. 'At the moment I'm completely gripped by fruit,' he wrote on 14 July, '– and I couldn't go back to figures, this is a hand-to-hand encounter with painting – I'm really pleased with the effort I'm making in this still life, it's going to renew me.' By 17 July it was so hot he said he stayed indoors all day, drawing fruit, reading or dozing on the studio couch, feeling his feet swell and thinking about his *Still Life on a Green Sideboard*. It was the one painting he took with him when he left by train for Paris five days later. He had reached the moment captured by Duthuit in a beautiful passage about the emergence of the Fauve palette, which describes what happened each time Matisse discarded an old way of painting or seeing: 'A secret fire devours it from within, then bites its way to the surface in incandescent trails, and finally bursts out freely.'

12. *In the South Seas (1929–33)*

When Charlie Chaplin released *The Circus* in 1928, Matisse saw it twice in Nice, and was struck by its extreme simplicity: 'Nothing picturesque about it, no flourishes . . . it's like someone who talks as simply as possible using only very few words to express himself.' Chaplin himself seemed to have aged, and his playing of the tramp had moved on from captivating charm to something sterner and more touching: 'From start to finish you're glued to what he's doing, you can't miss anything because nothing is unnecessary.' This was the kind of streamlined fluidity Matisse wanted in his own work. He responded both as a painter and as a man to the extraordinary gravity he found in Chaplin's film, which ends with the tramp turning down a fairy-tale ending – the girl of his dreams, top billing as a circus star – in favour of a solitary and uncertain freedom. Matisse would be sixty in 1929. A painting of his entered the Louvre that year. He had already won first prize at the 1927 Carnegie International Exhibition in Pittsburgh. Success, public honour and a comfortable old age lay within his grasp. Rumours circulated in Paris that he intended to retire and take up religion. A New York journalist turned up in Nice to ask if it was true that Matisse had told his disciples to announce that he was abandoning modern art.

He declined to comment on the contemporary art-world to a sympathetic young interviewer, Efstratios Tériade, in January 1929. Matisse, briefly in Paris to fetch his wife home after a course of injections, said he could no longer stand the frenetic atmosphere of the capital, 'the noise, the movement, the latest news and trends you're supposed to follow'. He insisted that the only show that interested him was the Boat Show. Rowing had become a passion in the last two years. He

rowed across the bay in his own skiff most days, winning a medal for taking his boat out more often than any other member of the Sailing Club in Nice. He grew tanned and fit, showing Tériade his calloused palms as if he were in training for some unspecified event.

Back in Nice, he couldn't settle. When Amélie returned to Paris to complete her treatment, Henri was disconsolate ('My dear Amélie Noélie, Come back as soon as you've finished your injections for I'm miserably bored all on my own ... there's no reason to go out and nothing interests me'). The dog did her best to fill the blank – 'Gika treats me with a touching tenderness' – but the highlight of his day outside working hours remained his nightly walk to the station to post a letter to his wife before bed. Amélie was on top form that spring, coordinating a last tremendous onslaught on the Nice apartment by builders, plumbers, carpenters and tiling specialists ('Your father and I have sworn we'll never build ourselves a house: we'd go mad'). She suffered recurrent bouts of the back trouble that always incapacitated her in a crisis, complicated by kidney problems, and she still spent up to three days out of six in bed, but the depression itself had evaporated. Marguerite said she watched her mother click out of it one day as if a switch had flipped.

Matisse had finally found another dancer to replace Henriette. He had spotted Lisette Löwengard trying with her widowed mother to sell a few things in an antique shop. Lisette turned out to be the daughter of one leading Parisian antiquarian and the niece of another, each well known to the Matisses, a link that immediately reassured both families. When Lisette's mother went back to Paris, she left her seventeen-year-old daughter in the care of the painter and his wife, who employed her first as Matisse's model, then as a companion for Amélie. Lively and capable, Lisette knew how to tend an invalid and make her comfortable. Soon she was massaging Matisse's painful arms as well, and tucking him up in a rug for his siesta on the balcony after lunch. Full of plans for the future, Amélie talked of putting

the Montparnasse apartment up for sale and finding another *pied à terre* in Paris to replace the one on the quai St-Michel (finally given up that year when the Duthuits moved out). 'She's never been so happy here before,' wrote Matisse. For a few months in 1929 the couple showed every sign of settling down into a contented old age. Amélie decided to learn to type and Henri entertained her as he used to do in his student days, with energetic antics to the latest pop tunes. 'He's playing jazz and all the most suggestive tangos on the gramophone,' she reported cheerfully at the end of May; 'at the moment he's dancing the tango "*Poule de luxe*" in his dressing-gown and his black silk night-cap.'

Three weeks later the painter booked a double cabin to the South Seas aboard a steamship called *Tahiti*, leaving the following spring from San Francisco. When people asked why, then and later, Matisse gave one of two reasons. The first was that his doctor had ordered a complete rest, and forbidden him to use a brush on account of acute neuritis in his painting arm. The second – that he was looking for a new light – was closely connected to the first. Matisse's periodic flights southwards towards the sun were driven by the need to simplify his work and make it more expressive. Physical and moral compulsion came to much the same thing in these upheavals. His body had always reacted violently to anything that came between him and painting, starting with the mysterious back pains that crippled him as a teenager whenever his father mentioned alternative careers. Knife-like cramps plagued him as he approached his sixtieth birthday, together with nosebleeds so copious he hardly dared move, let alone paint. The birthday itself would be marked by a small sculpture show in Paris, and various public tributes which, as Matisse correctly predicted, deplored his latest work, consigned his achievements firmly to the past and wrote him off as a spent force in the present. Worse still was his own growing suspicion that painting had indeed abandoned him. For twelve months he tried without success to call it back. Neither his new model nor the great glass-walled,

white-tiled studio filled with gleaming reflected light from sky
and sea could ignite a spark in his imagination. He said he got
so sick of invoking colour which refused to come that he
switched to prints instead. 'Painting is going nowhere,' he wrote.
'I force myself for nothing – but lithos flow of their own
accord.'

He was half delighted, half appalled by the ease and spon-
taneity with which he drew straight on to copperplate or stone,
producing 300 works in five months ('They're astonishing,
incredibly full of life – it's as if you used the etching point and
copper like pencil and paper,' Marguerite wrote from Paris.
'They're a joy to see'). He divided his days between printmaking
and sculpture, completing the *Large Seated Nude* and the last of
three small, harshly distorted and exquisitely sensuous *Reclining
Nudes*. In the summer, the Matisses retreated from the heat and
glare of the Mediterranean to the cool, dim, quiet Hotel Lutétia
in Paris, where Henri attended to another piece of unfinished
business at Issy. This was *Back IV*, his final variation on a theme
from the *Bathers* by Cézanne that exerted peculiar power over
the entire Matisse family. Over twenty years Matisse successively
transposed Cézanne's small, sturdy bathers, each with a long
straight tress of hair hanging down her spine, into four massive,
elemental, sculpted *Backs* that remained virtually unknown in
his lifetime. Their plain rough surfaces and simple geometric
volumes embody a repeated private affirmation of steadiness
and purpose. 'If you let yourself respond fully to them,' said the
sculptor's eldest grandson, 'you will find in them the whole life
of Henri Matisse: an extraordinary equilibrium, returning always
to the plumb line.'

It was as if he needed to touch base before veering blindly
in a fresh direction with no clear idea what he was looking
for, or whether he would find it. Doubts and nightmares
assailed Matisse now that, no matter what he tried, painting
had come to a full stop. Flight seemed the only option. 'The
retina tires of the same old methods,' he had told Tériade in
January. 'It demands surprises.' When Maillol came in March

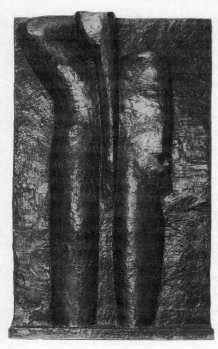

Matisse, 'Back IV', 1929–30

to inspect the new studio, Matisse felt they belonged to different worlds. 'What harmed Maillol a good deal as a sculptor is that he so often called a halt as soon as his work reached a *satisfactory stage*,' Matisse wrote long afterwards to his daughter. 'And what has helped me a lot is pushing on beyond that point, in spite of the high risk.' Having for years found it almost impossible to take a few days off work, even for his father-in-law's funeral or his own shows in Paris, Matisse now planned a journey that would last five months without so much as a portable easel in his baggage. His original idea of a visit to Tahiti expanded into a world tour, crossing America on the way out and returning by sea through the Panama Canal. He read Robert Louis Stevenson's *In the South Seas* and Marc Chadourne's best-selling novel *Vasco*. Pierre sent his

father a Maori grammar. Chadourne, a former administrator
of the Leeward Islands, arranged for his Tahitian ex-girlfriend,
the heroine of *Vasco*, to book a hotel in Papeete.

Amélie spent a wretched summer punctuated by kidney
trouble and spinal problems so severe that she had to stay
behind in Paris for further treatment instead of joining her
husband in Nice. He had booked a cabin for two on the *Tahiti*,
but the chances of her being fit to travel looked slim. When
she more or less stopped writing to him, he composed a batch
of sample letters for her to sign, describing her calm, orderly
progress towards recovery, and declaring her willingness to
accompany him round the world: strange documents in which
the painter enthusiastically impersonates the fond, supportive,
miraculously reinvigorated wife he hoped to take with him to
Tahiti. The gap between daydream and reality was wide, and
growing wider. Henri's desperation, now that he could no
longer paint, had done nothing to draw the two together.
Where once Amélie would have taken charge, treating his
setbacks as a joint defeat, recklessly expending her own resources
to dislodge obstacles and shore up defences, now she no longer
had the energy or will.

Their brief domestic interlude in early summer had been
for her a form of make-believe at a point when the dispersal
of the family left her own lack of purpose painfully exposed.
Marguerite was due to accompany her husband on an educa-
tional posting to Cairo. Jean had finally found the companion
he was looking for, a fellow painter in process of divorce whom
he planned to marry as soon as she was free. Pierre, himself
divorced at last and moving towards opening his own New
York gallery, was about to make a second marriage to an
American, Alexina Satler. Amélie's heroic mission had petered
out. Her husband's latest project contrasted sadly with the first
time the couple had set off together in pursuit of painting on
honeymoon. It had been Amélie who initiated that legendary
'Revelation of the South'. This time, even if she went with
him, she would be at best a passive companion, at worst an

encumbrance. Marguerite, reviewing her parents' marriage with characteristic trenchancy, recognized that Amélie had always acted as its safety valve. Her explosions of anger, and her querulous laments as her health deteriorated, were a way of relieving intolerable pressure. Still her father's severest critic, Marguerite warned him that he was in danger of forgetting the essential generosity and breadth of his wife's vision:

It comes from the ability to see things in a large context, a quality that was necessary, indeed indispensable to you for twenty years of your life together – her capacity for optimism was for you the happy counterweight to your fundamentally pessimistic nature. When you felt crushed, your spirit was lightened by her moral sanity and balance, and by the inner force she possessed at thirty.

Amélie's vision launched and shaped her husband's career, but the constant tension under which he operated bore down on everyone who worked with him, especially on her. At the beginning of October 1929 she collapsed so completely that Dr Audistère had to be called to the Paris hotel to administer morphine. Over the next few weeks, he was in constant attendance. Both her sons came every day. Pierre hired day and night nurses. Matisse sent telegrams, telephoned each night for news and offered to come up himself from Nice. Marguerite returned from holiday to find her mother pitifully wan and shaky. This was the kind of crisis the family tried at all costs to avoid. From adolescence Amélie had suffered frightening attacks that gripped her whole body in convulsive writhing and vomiting. For the better part of her marriage she had been free from these excruciating spasms, which began to recur with the onset of depression, causing cumulative damage to her spine, placing grave strain on her kidneys, leaving her physically battered and emotionally drained. She dreaded them, and so did everybody else. Amélie's breakdowns precipitated a release of feelings that had built up for months or years in brooding silence, and could no longer be contained. At times like this, engulfed by ancient

rancour, the whole family briskly traded insults with marksman-
ship and verve. Far away in Nice, in the grip of a different
panic, Matisse felt his lifelong sense of being excluded and
misunderstood rising up in him again, this time with his own
children ranged accusingly against him.

The commotion subsided as quickly as it had arisen. Amélie
revived as always under her husband's genuine affection and
concern ('Your phone calls are the sweeteners in Maman's days,'
Marguerite told her father). But by the time she was well
enough to make the journey down to Nice in December, there
was no longer any question of her setting sail for the Pacific
in the New Year. She could not even leave her bed. Her doctors
ordered her to spend the next few months immobile in the
sickroom, where a bed had also been prepared for Lisette, with
the cook and her husband to look after them. Pierre and his
new wife, spending their honeymoon in France, were due to
visit, and the Duthuits would follow for a week at Easter. Berthe
was on full alert in Aix. Local friends like Simon Bussy at
Roquebrune and Pierre Bonnard at Le Cannet were standing
by. Henri promised to keep a journal in the form of letters,
posting off instalments so that Amélie could feel he was talking
to her every day. His last letter before he embarked included a
sketch of his wife in a frilly jacket, reclining on her pillows
with arms crossed behind her head, looking more like a lithe,
frivolous young model than a chronic elderly invalid.

Matisse had done everything he could think of to make her
incarceration bearable when he finally sailed for New York on
25 February 1930, aboard the *Ile de France*. Gloomy and appre-
hensive on the crossing, unable to tear his thoughts away from
Nice, half tempted to turn round and take the same boat back,
he remained full of misgiving until, sailing slowly up the Hudson
River on the evening of 4 March, he saw Manhattan – 'this
block of black and gold mirrored by night on the water' – and
was bewitched. He wrote to his wife next day to say his impulse
was to cancel all other plans and go no further than New York.
The city electrified him. He had told virtually no one he was

coming but he made a friend on the ship, who blew his cover. New Yorkers did their best at short notice to lay on parties, press coverage and sightseeing. In seventy-two hours in town, Matisse rose at dawn to watch the sun rise over the sleeping city, went up the Woolworth Building, toured the Metropolitan Museum, took in a Broadway show and another at a black theatre in Harlem. He was interviewed by Henry McBride for the *Sun* and photographed by Edward Steichen for *Vogue*.

Matisse in New York, 1930

Apart from Broadway ('Absolutely infernal, hideous, the only thing I've seen that I can't stand'), Matisse loved everything, from his first ice-cream soda to the traffic system on Park Avenue (his letter home included a helpful diagram). Prodigious energy flowed into him. He was enchanted by the light ('so dry, so crystalline, like no other'), by the combination of order, clarity and proportion he found everywhere, and by a quintessentially modern, wholly un-European sense of space and freedom that struck him the moment he looked out of his window on the thirty-ninth floor of the Ritz Tower Hotel. He said that if he were young again he would relocate to the

United States. His journey westwards continued via Chicago to California by the Santa Fe Railroad, two nights and three days in transit with stopovers en route. American architecture impressed him as much as the architects' readiness to tear things down and start again. Wherever he went, he marvelled at the infinite variety of skyscrapers, filling the distance, modelling the sky, tapering upwards until they assumed the quality of light itself. America made Matisse feel like Rip van Winkle in reverse: as if he had just woken, after sixty years on a continent littered and encumbered by the past, to find himself in a purpose-built, twentieth-century environment where for the first time he felt that he belonged.

Light changed from Chicago's velvet softness to an atmosphere more like the Côte d'Azur as Matisse passed from cowboy country, dotted with grim reminders of resistance and assault ('The poor Indians have paid heavily for it since'), to the endless, pale, bright California desert full of colours and a light he had never seen before ('Is it already the light of the Pacific?'). He allowed himself two days in Los Angeles, amazed by the Pasadena landscape, and bemused by the studios of Metro-Goldwyn-Mayer. For almost a week he prided himself on travelling incognito but when his train pulled into San Francisco – the first city in the United States ever to see a Matisse painting, thanks to Sarah Stein – there was a reception party waiting on the platform with a list of official functions that made their visitor's heart sink. 'You must see that with a worldwide reputation like yours there is a price to pay,' his hosts told him, sternly brushing aside his protests. He visited the art school, enjoyed a dinner given in his honour by local artists, and took tea with his old friend Harriet Levy. A crowd came to see him off on 20 March, packing his cabin with fruit and flower baskets and waving from the quayside as buglers played a farewell lament.

RMS *Tahiti* turned out to be a battered old English mailboat with a surly captain, dismal food, and dull company consisting largely of Australian sheep traders. The best part of the ten-day passage came as they approached the equator, when the colour

of the sea lightened from blue-black to the richer, rarer blue – 'a blue like the blue of the morpho butterfly' – that had possessed talismanic properties for Matisse all his life. The voyage ended with the captain docking an hour early in pitch dark so that Matisse was cheated of the sunrise over Papeete, which he had crossed the world to see. But the whole town turned out to meet the boat, including Chadourne's beautiful former girl-friend Pauline, who took charge of the painter and his baggage, settling him into the newest of Papeete's three hotels, the Stuart, at the far end of the tree-lined sea-front.

Within a few hours of coming ashore on Tahiti, Matisse had acquired the basics he needed for survival: a room, a view, a shady veranda and a guide only too happy to place herself at his disposal. 'What haven't I seen since yesterday,' he wrote on 30 March, the day after he landed. 'Everything is so new to me – in spite of all I've read and seen in photographs, and Gauguin – I find everything marvellous – landscape, trees, flowers, people – and I've seen nothing yet.' He rose at five so as not to miss the cool of the morning when the traders in the covered market at the centre of the town set out an unimaginable profusion of fresh fruit, flowers and fish ('lumpfish, huge sea-bream, orangey red mullets, purply crimson mullets, Prussian blue and emerald green fish streaked with white ... extraordinary tones virtually impossible to describe'). Soon his pen abandoned the effort to translate sensation into words, swooping round the burgeoning top of a banana palm before the whole page burst into a riotous dance of fruit and foliage. 'It all makes an earthly paradise you can't imagine,' he added up the margin of the next page, entirely filled with an exuberant breadfruit tree.

Matisse's first move in a strange place was always to look out for a shady, secluded garden within easy walking distance of his lodgings. On his first day in Papeete Pauline took him to the gardens of the Bishop's Palace at the back of the little town, past leafy streets and palm-thatched houses, through an imposing gateway and across an old stone bridge over the river Papeava. From now on he came every morning, alone with his

drawing pad ('If I go on like this I shall run out of paper,' he wrote after a fortnight), to wander among groves of elegant coconut palms, mango, papaya, avocado and spreading breadfruit trees with pale, glimmering, yellowy-green fruit, each cupped by a ruff of serrated foliage whose decorative perfection almost overpowered him ('It's lovely, lovely, lovely . . . each part is lovely and the whole is extraordinary'). He drew continually, as much to relieve as to formulate his feelings. His sketchbooks filled up with tumultuous foliage, feathery palm fronds, silky banana leaves, tall, tufted coconuts, the tentacles of pandanus and blunt, stumpy limbs of banyan.

The shapes and rhythms of trees preoccupied Matisse more even than the flowers – fragile, short-lived, fantastically shaped – growing wild, or plaited into garlands by Tahitian women, who dressed themselves and their houses every morning with fresh blossom as a European woman might make up her face. Flowers were everywhere, festooning town gardens, spilling across front porches and tumbling down the mountainside, many of them familiar from French florists' relatively spindly pot-plants: hibiscus, bougainvillea, bird-of-paradise flower, croton and philodendron, the Tahitian gardenia called *tiare*. 'Giant cala-diums grow here like couchgrass at home,' Matisse reported on his first day: 'Curly ferns . . . poinsettias, pink, white and yellow jasmine, and an undergrowth of pelargoniums white instead of pink.' The whole island sometimes seemed to him a luxuriant outdoor conservatory, extravagantly planted and imaginatively designed. 'Everything's close-packed,' he said, 'as it would be in a bouquet.'

Matisse's morning walk to the Bishop's Garden became a familiar beat, so regular that local people looked out for him returning in time to catch the market, which packed up at nine. Before the sun rose too high for comfort, he was back in his hotel room: the kind of bare provisional space in which he had lived and worked at the four main pivotal points of his career in Ajaccio, Collioure, Tangier and Nice. At the start of his voyage, he told his wife he watched images unroll in

front of him with as little involvement as if he were at the cinema. For much of the next three months he felt he had been relegated to a limbo of enforced idleness and apathy, although he also recognized at some level that his drawing was a form of registration, stocking first impressions for attention later. He photographed the trees, the sea and the waterfront, but his densely detailed prints dissatisfied him. What he looked for and found in his rapid linear sketches were the underlying patterns of growth and movement.

'On first contact that landscape was dead for me,' he said later. 'At first it was a disillusionment I didn't want to admit even to myself.' In this mood the vegetation seemed overwhelming, the heat intolerable, the light implacable and without gradation. 'You don't react immediately, which means you have to relax through working.' Eventually he learned to accept and revel in the light of the South Seas, characterizing it as pulpy, pithy and caressing, telling different people on several occasions that it felt like plunging your eye into a golden goblet. But in the first few weeks he fought off fears that his journey had been pointless by throwing himself into a programme of relentless, almost feverish activity.

Every morning Pauline reported to discuss plans for the day: a round of local visits followed by lunch and a drawing session from three to five, until the searing midday heat had passed, when they set out to see the island. 'I took him everywhere,' she said. 'He wanted to see *everything*.' Pauline had considerable experience of initiating Frenchmen on Tahiti, many of them recommended by former lovers, but Matisse was unlike any other visitor she had ever known. In the first place, he had been appalled on the night of his arrival by the party laid on to welcome passengers from the mailboat, mostly middle-aged white males who paired off with local girls in an erotic free-for-all that seemed to him to exploit traditional Tahitian generosity and lack of inhibition with European avidity and lewdness. Matisse, who drank only water and declined to dance or flirt, found the spectacle crude, rowdy and depressing, and

made a point of dining early so as to avoid feast nights in future. It left him with a dismal view of European colonial life ('In order to stick it out here, you have to stupefy yourself with an addictive vice – opium, alcohol or women'), which he never essentially revised.

Pauline was impressed, even overawed to start with, by this portly, bearded old gentleman who treated her with old-fashioned politeness, and demanded services no one had ever asked of her before. Occasional eccentrics might want to know about ethnic artefacts and folklore, but she had never met anyone as inquisitive as Matisse about the current life of the island and its people. 'He was endlessly curious at the market, *oh là là*,' said Pauline, 'he missed *nothing*.' Tourists rarely visited Tahiti. Access to its legendary beauty spots was still difficult or impossible, and Papeete had neither comfortable hotels nor curio boutiques. Matisse at sixty walked Pauline (who was twenty-six) all over town, talking to the shopkeepers and market traders, examining their wares, visiting workshops and design studios to see traditional skills in practice from the making of bark-cloth, or *tapa*, to the weaving of pandanus leaf hats (so striking and effective that the painter abandoned his pith helmet and wore Tahitian sunhats for the rest of his life, with fresh supplies forwarded to Nice at intervals by Pauline). He sampled the local cuisine with a gourmet's relish, describing a Polynesian feast in appreciative detail for his wife. Pauline was captivated by his stories ('He could be *so* funny'), puzzled by his curiosity, and taken aback by his disapproval of the smart young Tahitian women who cropped their hair, hung out in bars and read nothing but Parisian fashion catalogues ('They behave like tourists,' said Matisse).

Once she got over her perplexity, Pauline proved a highly intelligent and resourceful guide. Child of a Tahitian mother and a French father, brought up initially as a European and educated at a French school, she was living when she met Matisse with a new partner, Etienne Schyle, handsome, energetic, a year older than herself and owner of the Union Garage in

Papeete. It was Etienne who drove them round the island in his big blue Buick, sending the car with another chauffeur when he couldn't come himself. The young couple were intrigued by Matisse's aloofness from a colonial world where hardly anyone yet questioned the supremacy of white power and values. Pauline herself had a dual allegiance and many names. Matisse knew her as Pauline Chadourne (it was the custom in Tahiti for girls to take the surname of a prestigious lover). She had grown up as Pauline Adams, and she would become Pauline Schyle when she eventually married Etienne, but she was born Pauline Oturau Aitamai. She had lived as a teenager on her mother's vanilla plantation on the island of Moorea, listening to the songs and legends Matisse made her recount for him, and learning to weave the flower garlands she brought him every morning.

She had been eighteen when she first met Chadourne, who called her his lioness on account of the thick springy mane of blue-black hair falling to her hips that contrasted dramatically with the almost conventual pallor of her skin. Matisse made pen-and-ink sketches of Pauline, reclining on a daybed and flashing him a barbaric, toothy grin, looking every inch the sultry heroine of Chadourne's *Vasco* 'with her shining eyes and gleaming teeth, her fiery glance, the tossing motion of her head that sent waves rippling through her hair'. But a tentative offer to supply illustrations for the novel foundered on Matisse's inability to reconcile romantic fiction with the reality he saw around him. 'I've never seen men or women better built or more vigorous,' he wrote home, comparing a party of Paumotu or Tuamotu islanders to sea-gods, or mythic beings out of paintings by Leonardo or Raphael. Matisse said it would be hard to convey without parody to Western eyes the authentic alien splendour of Tahitians, with their red–gold skins, their solid bodies and high foreheads surmounted by crown-like hairdos buttressed with braided flowers. 'You have to come here to understand,' he explained to Amélie. 'Their reality would seem like clumsiness on the part of the artist.'

Apart from Pauline, there was in any case no question of any Tahitian woman posing for him, clothed or unclothed. Matisse was baffled by the combination of sexual freedom and a prudishness implanted by Catholic missionaries that reversed European concepts of modesty and shame. By ancient Polynesian rules of hospitality, making love to a stranger and bearing his child, especially a white man's, was an honourable practice conferring status on the child, the mother and her husband. Pauline had two sons, one apiece by two former French lovers, and introduced them with pride to Matisse, who found it hard to grasp that, in a town where no one minded who you slept with, people would be outraged if you walked down the street in shirt-sleeves: 'They bathe more chastely than at Cannes – and when I tell them about sunbathing and swimsuits, they won't believe me.' In the end, he managed to persuade a waitress to sit for him, producing a series of strong and stylish heads, which was as much as she would let him draw. Matisse's perennial, barely contained anxiety was eased by Pauline's warmth and gaiety. He advised her to marry Etienne, and offered to help educate her son by Chadourne in France. Alone in the evenings, he dropped in at the Cinéma Bambou two or three nights a week to watch old American films and even older newsreels, entertained not so much by the screen as by the running commentary of the man hired to translate the subtitles, and the audience's keen participation in every gunfight, clinch and car chase.

A Frenchman who wore pandanus hats, spent his evenings at the local fleapit and put in only token appearances at the Governor's residence inevitably invited comment from the European colony. Papeete's function from a government point of view was to make France's presence in the Pacific as conspicuous as possible, but the social protocol separating white from black and mixed-race communities grated on Matisse. When he overheard the Governor's wife gossiping with her friends about him and Pauline at a dinner-party, he unleashed his formidable powers of righteous indignation in a tirade that

would have gone down well in his home town, rebuking their foul tongues, ordering them to cease their slander, and announcing that Pauline's relationship to him was that of a devoted daughter. 'That shut their traps,' he told her with satisfaction next morning. Pauline was touched and bewildered by the vehemence of his denial. Flattered by the allegation that she was his mistress – a position that would have raised rather than lowered her status in Tahitian terms – she could not comprehend the rancour it stirred up in Matisse, who had spent his life escaping from the scandalmongering snobbery of narrow, inturned communities like Papeete.

The colonists had not yet got over the mistake they had made with Gauguin, and complained vigorously about the staggering prices currently being paid in Paris for canvases they or their predecessors could have picked up for nothing. In later years, Matisse was as irritated by the assumption that he trailed after Gauguin to Tahiti as he had been by people taking it for granted he followed Delacroix to Tangier. His own sights were trained on the future, not on debts he had once owed in the past, but he took some trouble to track down Gauguin's son, living as a fisherman a few miles outside Papeete ('That should please his father, if he knows,' said Matisse). Gentle, powerful and illiterate, easily recognizable on account of his heavy eyelids and hawk-beak nose, Emile Gauguin explained that he had no memories of his father, and no desire to change the life he led ('watching coconuts ripen and fishing at night,' said Matisse, impressed by the son's un-Gauguin-like contentment). Impatient with his compatriots, enervated by the steamy heat, exhausted and dissatisfied after three weeks on the island, Matisse opened his travelling paint-box for the first and last time on Easter Sunday to sketch a tree. 'I've been here almost a month now …' he wrote on 28 April, posting a mammoth bulletin home by the monthly mailboat. 'This country means nothing to me, pictorially speaking. So I give up.'

A week later he started a fresh letter with a sketch of himself as a bearded castaway seated on the trunk of a coconut palm

on a deserted beach beside an empty ocean. He was photographed writing home on this tree trunk by F. W. Murnau, the great German film director, in a break from filming the final sequences of his Tahitian masterpiece, *Taboo*. Murnau's co-director had invited Matisse to watch the shoot on the peninsula of Taiarapu, the wildest part of the island, primal, uninhabited and accessible only by canoe. The painter spent a week there, 3–9 May, living in a grass hut at the edge of the lagoon, lying awake at night on a rusty bedstead with rock-hard pillows and a mouldy mattress, listening to the roaring of the surf as the wind rattled the hut's loosely woven walls and drummed on its low tin roof like rain. This was literally the untamed jungle Matisse had set out to find. Every morning he rose before dawn to breakfast with the film crew before crossing the lagoon to a tiny island, where Murnau filmed and Matisse drew among tangled layers of trees. The painter would see *Taboo* three times after its release in France but, at the time, he had eyes for nothing but the new world of pristine light and rampant energy before him.

Back in Papeete, Matisse felt so sure he had got what he came for that he longed to leave for France at once instead of waiting another month for the ship on which he had booked his passage home. Within the week he set out again aboard the government schooner carrying supplies to the Tuamotu Islands, an alarming voyage of one day and two nights on rough seas in a small, leaky, heavily laden boat ('It rolls, it tangos,' wrote Matisse, who was seasick the whole way) manned by convicts. His landing on 17 May on the coral island of Apataki was a magical reprieve. The administrator of the Tuamotus, François Hervé, proved only too glad to welcome a painter from Paris into the comfortable, cultured French household he had established with his wife at the end of an irregular supply chain on a tiny, windswept, largely uninhabited coral atoll, barren except for tufts of coconut, with nothing to drink but rainwater and no fresh food but fish. An ex-sea captain and pioneer pearl-farmer, Hervé was

entertaining, well read and intimately acquainted with his archipelago. Every evening the Hervés and their guest walked right round their island, a leisurely stroll of just under a mile. Matisse drew the party seated on a bench to watch the sun go down at six, subsiding in shimmering silver over the desert islet of Pakaka and casting towards the watchers on the shore a scarf of lilac blue, shading from pale to dark with a rippled silver edging of waves along the water. Matisse described sunsets for Amélie like a collector bringing out his choicest treasures: 'I've also seen here at night an ash-blue sky alive with stars, brilliant and very close, on the side of the sunset – while the side of the rising sun was crimson purple. It was at midnight, this lingering pale crimson reflection of the sun – which had in fact set at six o'clock on the opposite side from the sky that was crimson (and so clear).'

After a few days Hervé left for a tour of the atolls, depositing his guest on Fakarava, not so much an island as a circular rim of land, eighty miles round and two or three hundred yards wide – 'a coral towpath' in Stevenson's expressive phrase – enclosing an inland sea so big its far side remained invisible. Matisse stayed with two hospitable young Polynesians, Gustave Terorotua and his wife Madeleine (a school contemporary of Pauline's), whose simple, frugal, hardworking way of life made him feel at home. The painter had been deeply impressed, before he left France, by Stevenson's account of the fish – 'stained and striped, and even beaked like parrots' – cruising among coral thickets in the phenomenally deep, still, clear lagoon of Fakarava. Stevenson had watched them from the deck of his yacht, but Matisse dived in after them, gliding with Gustave Terorotua down through transparent water the colour of grey-green jade shading to absinthe, peppermint green and blue, among fish glinting like enamel or Chinese porcelain, minute, jewelled specks and streaks of colour swarming round his legs, outsize sea-trout drifting by like huge dark airships, the whole shifting, swirling composition punctuated and pinned down by the inert black accents of sea cucumbers.

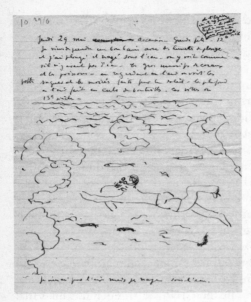

Matisse, sketch of himself exploring underwater in the lagoon at Fakarava

Matisse gazed into the lagoon all day every day, alone or with Gustave. Once they watched a pearl-fisher diving far below them ('He's so supple and slow he's like a fish – he swims alongside the fish, who have no fear of him – he moves like a slow motion film – he makes you think of a vast seaweed floating gently in the water'). Matisse drew himself swimming underwater in wooden goggles, or perched precariously on spiky clumps of coral to peer through a glass-bottomed viewing box. As usual, he saw himself as comically clumsy and absurd, but his concentration had never been more ferocious than in this brief interlude when he strained to grasp the duality of Fakarava: the fresh, shining, unpolluted air filling the hemisphere that stretched to the horizon, and the strange, muted brilliance of another world beneath it, 'that undersea light which is like a second sky'. He experimented with focus, depth and angle, staring down from above into the green floor of the lagoon, looking up from below at a watery ceiling opaque and wavery as medieval glass,

plunging repeatedly between the two, schooling the retina to compare the different luminosities of sky and sea.

Matisse spent four days on Fakarava, but he would draw in retrospect on what he saw in those four days to the end of his life. 'Pure light, pure air, pure colour: diamond, sapphire, emerald, turquoise,' he wrote laconically to Bonnard, 'stupendous fish.' On 26 May he returned reluctantly with Hervé to spend a final fortnight on Apataki, where he slept like an angel and soaked up impressions like a sponge. His chief memories later were the quivering of the waters, the continuous susurration of the trade winds rustling the coco palms like silk, and 'the overall impression it gave of power, youth, fullness and completion'. Matisse insisted afterwards that it was not the fleshpots of Papeete, nor the hothouse luxuriance of the jungle, but the austere simplicity of this bleak, bleached outpost that tuned his responses to their highest pitch. He said no visitor to the South Seas should miss it: 'He will see sky and sea, coconut palms and fish – that's all there is to see – with a pure radiance that makes them incomparably precious.' Matisse's voyage to Tahiti, and its culmination on the Tuamotus, marked the last of the dramatic shifts of vision that liberated him at intervals all his life. On the shore at Apataki he was repossessed 'by the profound emotion born of solitude' that had shaken him as a boy in the high, Gothic nave of the cathedral at Amiens, 'where the rumbling of the surf is replaced by the music of the organ'.

Matisse spent his last week in Papeete in a fever to be gone, packing, paying farewell calls and devouring mail from home, decorating his own last letter from dry land with a sketch of himself in his Tahitian sunhat running to the post. He sailed aboard the *Ville de Verdun* on 15 June, loaded down after another splendid send-off with leaf hats, *tapa* cloths, dried bananas and vanilla pods. Pauline wept to see him go. The six-week monotony of the voyage was relieved only by reading, sipping rum and sunbathing in a deckchair on the poop. Steaming homewards through the Panama Canal ('glaucous green like the rivers of France') and on under shadowy grey skies towards Atlantic

waters ('the texture of black grape-skins'), Matisse pondered the purpose of his journey. The problems he had left behind in France were still with him, a basic fact from which he logically concluded that he could not live without them. 'That is the great lesson I brought back from the South Seas,' he wrote long afterwards, at a moment of terror and desolation in the Second World War. Looking back, it seemed to him that the torpor of the tropics insulated Europeans, and brought them face to face with their own inadequacies ('In Tahiti there's nothing, no troubles of any sort, except the inner trouble that makes the European long for five o'clock, when he can get drunk or inject a dose of morphine'). The island that had entranced him on his first day – an earthly paradise of unremitting sunshine and unrestricted sexual availability – led back ultimately to the same code of practice as his northern roots: toil, abstinence and the discipline of the plumb line. 'I got fed up there in the end,' he said, 'but I had learned the meaning of the horizontal and the vertical from the shoreline and the coco palms.'

Pictorially speaking, he said he returned empty-handed ('Strange, isn't it, that all those enchantments of sky and sea elicited no response at all from me at the time'). He landed at Marseille on 31 July, and went back to work the day after he reached home on *The Yellow Dress*, a painting he had started before leaving Nice. Matisse posed Lisette bolt upright at the dead centre of his canvas, stiff as a poker, with five symmetrical bows down the front of her dress, against a background frieze of slatted shutters, corrugated curtain folds, window frames and veranda bars which is practically a hymn to the horizontal and the vertical. The whole elaborate construction becomes an instrument for catching the play of light and colour, grey bars of sunlight sifting through the shutters, refracted in the pane of glass, picked up in the pale turquoise window frame and the soft blue strips of curtain, expanding across the red-tiled floor and dissolving in the watery greens, dappled greys and ochres of the dress itself. Matisse said the painting accompanied him at

the back of his mind throughout his travels. Sometimes it seemed more vivid than the reality before his eyes, as if it opened a window for him in the tropics on to the subtle, nuanced, constantly shifting luminosity of the northern hemisphere.

Matisse wrote longingly of his *Yellow Dress* to Amélie, who had also circled the islands with him in his imagination. He treated his letters home as an extended conversation with her, dashing down everything that caught his eye and posting off batches of up to seventy-four pages by the monthly mailboat. Her absence haunted him. 'Shadows are rare here,' said Murnau, photographing Matisse writing home on Taiarapu, 'there's sunshine everywhere except on you.' 'That's just what I'm saying to my wife,' replied the painter. Amélie's prostration exposed and sharpened his own grief and guilt. At a low point on Tahiti he had sworn never again to leave her side, but preparations for departure engulfed him almost as soon as he reached Nice.

As a former Carnegie Prize winner, he had agreed to sit on the prize jury himself in 1930, which meant catching a boat back to New York on 12 September. All his old troubles had closed around him by then. The brief bonanza when buyers on both sides of the Atlantic competed for his canvases had ended with the Wall Street crash. Prices tumbled as his stock of pictures dwindled. Matisse now had an invalid wife to support as well as allowances to find for three anything but prosperous children and their partners (Duthuit's Cairo posting had come to nothing, Jean and his new wife were struggling to survive as artists, Pierre's future as a dealer looked more precarious than it had ever been). When Matisse set out again for the United States, he had painted virtually nothing for two years, apart from the still unfinished *Yellow Dress*. He had nothing in prospect except a potentially disastrous collaboration with the brilliant but perennially underfunded Swiss dreamer Albert Skira, who chose the start of a global slump to launch his first two luxury art books: Ovid's *Metamorphoses* and the poems of Stéphane Mallarmé, illustrated respectively by Picasso and Matisse.

Pierre, who had inherited his mother's steely optimism, intended to dig in for the duration in New York, and treat financial viability as a minor issue. 'Whenever you get too worried by it, just do a little sum in your head,' he had advised his father on 25 October 1929, the day after the crash, 'and count up all the canvases ... you could part from without distress. You'll see that you haven't really anything to worry about.' A year later, the United States art market had reached a virtual standstill. Matisse's most serious collectors in the past decade had been Americans, chief among them the infamous Dr Albert C. Barnes, whose aggressive bulk buying and apparently inexhaustible resources had secured him a collection of modern French painting equalled only by the holdings of Shchukin and Morozov (recently combined to form the Soviet Museum of Modern Western Art in Moscow). On 20 September, his first day in New York, Matisse telegraphed Dr Barnes to ask if he might visit his Foundation at Merion in suburban Philadelphia.

The Carnegie International Prize was awarded by an essentially academic institution gingerly feeling its way towards the contemporary world. Matisse, who had been the first modernist winner, awarded the prize with his fellow jurors to Picasso in 1930. He stopped off on his way back in Philadelphia, interrupting the junketings laid on by his hosts, to see Barnes, who had made himself feared and loathed throughout the art-world, but especially by his closest neighbours ('There is no use entering into a pissing contest with a skunk,' wrote the director of the Philadelphia Museum of Art, goaded beyond bearing by some fresh piece of skulduggery on Barnes's part). Barnes habitually used his massive chequebook and unerring visual judgement to outwit and taunt his rivals. On buying trips to Paris, he liked to start the day with a mob of hungry artists lined up outside his hotel, each proffering a rolled-up canvas. A chemist by training, self-taught in the art field and inordinately sensitive to slights, he had made a fortune out of an antiseptic called Argyrol, selling his company with characteristic timing three months before Wall Street's collapse. Bullying, spiteful and vindictive, he imported

the strategies that had made him a first-class businessman into a world that crumpled before his innovative brashness and bulldozer drive. People told innumerable stories of the humiliations he routinely inflicted on curators, dealers, painters and fellow art-lovers, above all on anyone rash enough to ask to visit his collection.

But Barnes had another side. He watched out for pictures like a hawk, swooping to snatch his prey before more hesitant and less clear-sighted operators got off the ground. He had built up single-handed at great speed a collection so far ahead of its time and place that Philadelphia confidently dismissed him with mockery and rebuff. Barnes's arrogance was a function of his intelligence and originality. He loved painting more than he loved people, explaining that the pursuit of art had infected him like rabies. He said he talked to his pictures, and they talked back to him, with none of the turmoil and fury that characterized his human conversations. By the time of Matisse's visit he owned nearly 200 Renoirs and eighty Cézannes, and had been accumulating canvases by his visitor for almost a decade, including *Bonheur de Vivre*, and the *Three Sisters* snapped up from Tetzen-Lund in Copenhagen. Alone with his pictures he was judicious, unassuming and receptive. Matisse, who had met this combination of humility with passion once before in Shchukin, could have found no one more apt than Barnes in this mood to release the creative energy dormant in him since his voyage to Tahiti. At the first encounter between the two men on 27 September, Barnes asked Matisse to decorate the central hall of his newly built museum at Merion.

Matisse felt dubious but sorely tempted as he resumed his official sightseeing that afternoon ('the tomb of masterpieces,' he wrote grimly in his diary, comparing the reverential gloom of Philadelphia's Widener collection with the open and informal installation designed by Barnes for what he called his 'old masters of the future'). He described America as an ideal home for artists in an interview with *Time* magazine, which marked Picasso's Carnegie triumph by putting 'grizzle-chinned,

wrinkle-browed Henri Matisse' on the cover. By this time, the
painter was back in Paris. He had stayed an extra day to fit in
a second visit to Merion, sailing for home on 3 October hotly
pursued by Barnes, determined to finalize the contract. Both
men had set their hearts on this commission, both were noto-
riously tough bargainers, and both emerged well satisfied from
the deal. Barnes was to get a wall painting three times the size
of Shchukin's *Dance* and *Music* put together, involving at least
twelve months' work, for $30,000 in three instalments (just
twice the price he had paid earlier the same year for a single
moderately sized canvas). Pierre's amazement outstripped even
indignation when he heard these terms, but his father rated loss
of earnings well below the chance to raise his profile and reach
out to a new public in America.

He returned for a site conference at Merion in December,
making his fifth Atlantic crossing in twelve months. This time
the trip included a visit to the only other collector whose Matisse
acquisitions in the 1920s came anywhere near matching Barnes's
in either quantity or quality, Miss Etta Cone of Baltimore. Etta
had bought a first small Matisse canvas through her friend Sarah
Stein before the 1914–18 war, going on to acquire two dozen
more in tandem with her older, bolder and far more brilliant
sister, the majestic Dr Claribel Cone. Affluent, independent,
extravagant in every sense, the two bought lavishly and well
without premeditation or advice on colossal annual shopping
sprees in Paris. It was Claribel who bought the *Blue Nude* from
the Quinn sale, an astonishing purchase for an elderly maiden
lady from the solid conservative upper crust of the American
South. But in 1929 Claribel Cone died suddenly, leaving her
collection to her sister. Shy, retiring, to Matisse always the more
touching of the two, Etta was crushed by grief and shock. At
the time of Matisse's visit in December 1930, she was sixty years
old, tentatively beginning to emerge from the ample shadow of
her sibling and take control for the first time of a collection as
individual, and in its own way as imposing, as the contents of
Shchukin's palace or Barnes's purpose-built museum.

The sisters had occupied next-door apartments crammed with statues, ornaments, textiles, old Italian furniture and contemporary French art. As soon as he stepped through the door into Etta's narrow hall, Matisse was surrounded by his pictures, hanging everywhere including the bathroom, their power and sensuality intensified at close quarters in these small, dark, cluttered spaces. To visitors this eighth-floor apartment seemed like a time capsule ('One looked at the walls and saw the future,' said a young friend) suspended above the roofs and towers of sleepy, unsuspecting, still largely nineteenth-century Baltimore. For the painter, the collection was a private ark. 'In our home he was like a member of my family,' said Etta, commissioning him to make a posthumous portrait drawing of her sister. Out of this encounter grew a collaboration whose fruits would outlast them both in the shape of the only collection of his work Matisse could be sure would survive into the future.

His weekend in Baltimore was squeezed between four successive visits to Merion, where he engaged for the first and last time in a calm, rational and constructive dialogue with Barnes. Both were still exalted at this stage by mutual anticipation ('We have many points in common,' the painter told his wife, 'but I'm not so brutal'). They spent Christmas week taking measurements and working on a template for Matisse to use in Nice. The space Barnes wanted him to fill was not promising: a surface roughly forty-five feet long by seventeen feet high, divided by projecting shafts of masonry into three round-headed arches, obscured both from above by the shadow of the ceiling vaults, and from below by sunlight pouring in through three tall glass doors opening on to the garden. It was awkward, abominably lit and impossible to see fully from ground level. None of this deterred Matisse. 'I'm full of hope and eager to get going ...' he wrote to his wife on 26 December. 'I sense that my year of rest has brought great progress in clarity of mind.'

Before he left Nice, Matisse had hired a garage and laid down a strict exercise regime for Lisette, who was to model for both Barnes's decoration and Skira's Mallarmé illustrations.

Lisette was slender but not supple or fit enough for Matisse, who had tyrannized over her by post for much of the past twelve months, sending regular instructions to his wife to oversee her diet and gym schedule. Now he became dictatorial in the extreme. He made her pluck her thick black eyebrows and dye her fashionable white fox fur black. In an attempt to calm his nerves before he got to grips in earnest with his decoration, he even tried painting Lisette in harem pants, and as a vaguely Indian beauty with blue dots and crosses on her cheeks and forehead. But, however hard he tried, nothing could make Lisette, clothed or unclothed, look other than what she was: a stylish young Parisienne with the bobbed hair, neat features, small high breasts, flat belly and narrow hips essential for the boyish figure currently in vogue.

By the spring of 1931, Matisse could think of little but his new commission. From now on, all other wants or needs were secondary. The whole household was under starter's orders. Lisette had to be in early every evening in order to be fresh for the next day's session. She was forbidden to swim after the sun got up for fear of sunburn. Once she was battered by a freak wave and came home badly bruised, only to be severely reprimanded for spoiling the immaculate purity Matisse needed for his work. It required long hours, short breaks and exclusive concentration from both painter and model. They left after breakfast every day for the garage in a back street near the art school, 8 rue Désiré Niel, big enough to hold the three huge canvases destined to fill the hall at Merion. Matisse's punitive programme was hard on his model, harder on himself, hardest of all perhaps on his wife, whose hopes of recovery seemed to be receding. Her only regular visitor was Berthe, who spent holidays in a flat bought for her by Matisse in Nice. Otherwise Amélie's world had drastically contracted. Her doctors still prescribed bed rest. Marooned with a bad back at the top of five flights of stairs, effectively a prisoner for the past twelve months, she now lost both her young companion and her husband to the ineluctable demands of painting.

The choice of form and content for the new work had been
left entirely to Matisse, who never apparently considered painting
anything but a *Dance*. At Merion he rediscovered *Bonheur de
Vivre*, the painting that had inspired Shchukin to commission
the first *Dance* in 1909. Back in Nice, Matisse pinned a repro-
duction of Shchukin's panel to his garage wall, roughed out a
set of small variations on an overall design, and drew his new
Dance freehand ('It was in me like a rhythm that carried me
along') directly on to three adjacent canvases more than twice
his height, using a stick of charcoal tied to a bamboo pole. In
this first sketch he peopled them with immense leaping figures,
plunging and thrusting in a dance that extended far beyond the
three great arches containing his decoration. Heads, arms, legs,
hands disappear off the edges of the canvas to link up with other
unseen bodies, half glimpsed flickering in the curves of the
arcade. The dancers' energy flows from one extremity to another,
surging across the projecting blocks of masonry and out into an
imagined space beyond. Matisse said this was one of those peri-
odic points of departure, like Fauvism, when it was necessary
to turn back from complexity and refinement to pure colour,
shape and movement – 'materials that stir the senses' – elemen-
tary principles that give life by coming alive themselves.

At the end of April he posted photographs of the layout to
Barnes. By June he was beginning to add colour, and was so
confident of having reached a halfway mark that Barnes paid
over the second of three cheques for $10,000. The two met at
the opening of Matisse's first Parisian retrospective in twenty
years, mounted by the Bernheims at the Georges Petit galleries.
This was a dealers' show, prestigious and celebratory, concen-
trating on paintings from the last decade in Nice, with little
attempt to present a coherent survey of what had gone before.
By the time it opened, Matisse had already moved on into
unknown territory. It was three years since he had abandoned
the series of Nice odalisques whose dazzling pyrotechnics
marked him down, for a public currently mesmerized by Sur-
realism and its offshoots, as essentially superficial, a kind of

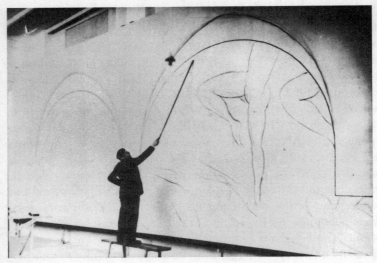

Matisse at work on 'The Dance' with the bamboo stick compared by André Masson to a magician's wand

twentieth-century Fragonard producing suavely titillating confections for rich men's Manhattan apartments and villas in the south of France. Pierre, who hung the Petit show at his father's request, acknowledged afterwards that its limitations played into the hands of those who saw Matisse as at best a minor decorative master with little relevance to the modern world. 'All this so as to end up identifying Picasso as the great renovator etc.,' wrote Pierre, confirming his father's view that the patronizing and largely dismissive homage he had received over the past two years was a way of burying him alive.

The mistake would be triumphantly rectified that autumn in a smaller but more rigorous retrospective put together by a virtually unknown American called Alfred Barr, the young director of the newly founded Museum of Modern Art in New York. 'Barr has done his best, and succeeded beyond my hopes,' Pierre reported to his father. American critics, headed by Henry McBride, rose to the occasion: 'They are delighted to find the

artist better understood and appreciated in New York than in Paris with a show that serves rather than crushes him – and it's true! When you see this show, you get a far greater shock than you did in Paris.' Pierre sent home a detailed assessment of the exhibition, describing its hang and the perspective it imposed on the long march from Matisse's first copy of Chardin in the Louvre through the Fauve years to the *Aubergines* from Grenoble, and the austere wartime abstractions. Groups of relatively small-scale canvases – early works, paintings of Lorette, a handful of more recent odalisques – fell into place as punctuation, pauses to rest and reward the eye in breaks from the effort required by the demanding and disturbing works at the centre of the show. This was MoMA's first full-scale appraisal of a European artist, and it covered every phase of Matisse's career (except the works in Moscow, which the Soviet authorities had refused to lend) with a pellucid sense of structure, pace and growth.

But by this time the damage to Matisse's reputation had been done. The attention focused on him by the Paris show, magnified by national and international coverage, stamped him as facile, self-indulgent and inevitably, in relation to Picasso, the lightweight of the two. From now on Matisse would be dogged by a public image based largely on a misconception of his activity in the 1920s, a view that distorted his overall achievement and made it difficult to look clearly at the work he subsequently produced ('People know nothing of your previous output,' wrote Duthuit in his role of spokesman for the post-war generation in Paris. 'If your decoration were to be exhibited here, it would come as a revelation'). By 1931, the moment when his image as a reactionary crystallized in the popular imagination, Matisse was already struggling with a mural intended by himself and Barnes to bridge the gap between public and private art, a goal that would become a major preoccupation over the next decade in revolutionary Russia, Mexico and France. His isolation at this point came, as Pierre Schneider pointed out, 'not from his conservatism

but from the fact that he had made the transition to the char-
acteristic work of the 1930s before any of his contemporaries'.

As the decoration took shape, Barnes himself – 'part bulwark,
part ball and chain', in John Russell's graphic image – became
ominously proprietorial, harassing the painter with demands to
see the work in progress, threatening to descend on Nice, boasting
about his own rapid progress with a book that in his view would
be the greatest ever written on Matisse's work. After six months,
the *Dance* was no longer flowing as smoothly as its creator had
anticipated. At the beginning of September, Matisse took a break
from his partly painted mural at the Italian resort of Abano
Bagni, where he treated his bad arm with a water cure each
morning, and refreshed his eye each afternoon with a drive to
Padua to see the frescos by Giotto that had renewed his power
of attack in the Fauve years a quarter of a century before. On
his return to Nice, he adopted a new method. Setting aside his
brushes, he hired a professional house painter to cover sheets of
paper in flat, uninflected black, grey, pink and blue. Matisse now
drew and redrew his entire design, outlining shapes on coloured
paper for an assistant to cut out and pin on to canvas. After
posing all morning, Lisette put her clothes back on and spent
the rest of the day pinning, shifting and repinning a composition
that was perpetually on the move. 'Nothing comparable was
ever invented, before or afterwards, to resolve the problem of
form and colour,' said the Surrealist painter André Masson, who
watched Matisse using his bamboo pointer – 'truly a magician's
wand' – to direct an extraordinary performance of shapes and
figures emerging from his imagination only to dissolve and
reform in endless fluid, filmic permutations.

Desperate for some kind of informed response, Matisse had
driven over to Grasse to look for Masson (who was a friend
of the Duthuits), surprising the younger man by paying close
attention to his work and inviting him back to inspect progress
in the garage. Whenever panic loomed in Nice, Bussy received
a telegram in Roquebrune: DECORATION IN TERRIBLE STATE
COMPOSITION COMPLETELY OUT OF HAND AM IN DESPAIR

LIGHT SUITABLE THIS AFTERNOON FOR GODS SAKE COME AT
ONCE MATISSE. Throughout the long, slow evolution of the
Dance, Bussy regularly arrived to find his old comrade fraught
and frantic. Matisse's problems were compounded by the
Mallarmé etchings, which paralleled on a small scale the
complexity of his decoration. Both projects demanded surgical
precision and the calculation of a chess-player. Matisse divided
his time between book and mural in a state of continuous high
alert, attempting to produce unity by juggling almost infinite
combinations of variable page margins, borders, typographical
texture, scale and spacing on the one hand, and the twenty-four
limbs of his six gigantic dancers on the other. 'I could proceed
only by groping my way forward,' he said of the *Dance*.

The coordination of mind, hand and eye required by this
double balancing act was intimately connected for Matisse with
the disruptions of the year before. He said that travel rests parts
of the brain that have been overused, and releases others previ-
ously repressed by the will, acknowledging even his intervals
of boredom and discontent in Tahiti or Tangier as essential signs
of something stirring at levels far below the conscious mind.
He told Pauline Schyle that space had expanded for him on
his return from Tahiti and, by the winter of 1931–2, he had
externalized the sensation and transferred it to his decoration.
'Papa says every so often that he's very happy with it, when
he's not in complete torment,' Marguerite wrote to Pierre from
Paris. 'Tante Berthe talks of lightness and grandeur – Skira says
it is magnificent – Masson is astonished each time by the latest
developments.'

Masson stood godfather to Marguerite's son, Claude, whose
birth in Paris in November 1931, a few months after Pierre's
daughter, Jacqueline, and Jean's son, Gérard, completed a trio
of grandchildren born that year to the Matisses. The financial
havoc threatening to engulf both America and Europe was offset
for the whole family by private and professional optimism. The
opening of the Pierre Matisse Gallery in Manhattan produced
a substantial impact in spite of the state of the stock market,

which made it impossible to sell anything, even at famine prices.
Barnes's decoration, nearing completion more or less on time,
was due for its first public showing in Paris at the Petit galleries,
with specially installed lighting and opening hours extended
until midnight so that it could be seen by ordinary working
people before it was shipped to the United States. The Amer-
ican press was already preparing a noisy reception for it, when
Matisse made the horrible discovery that he had been working
for twelve months from measurements miscalculated by almost
a metre. An exchange of telegrams confirmed his fears. Barnes
responded angrily – YOU HAVE MADE AN ENORMOUS MISTAKE
– and sailed at once for France. At their meeting in Paris on
4 March 1932, he was sufficiently mollified to agree that, instead
of attempting a salvage operation, Matisse should start all over
again on a second *Dance*.

Habits of drudgery and persistence drummed into him from
childhood carried the painter through the next twelve months.
He completed his first abortive decoration (whose six tumbling
figures became increasingly agitated and aggressive) before
turning to a second set of three freshly stretched canvases on
which, at the beginning of July, he sketched out a new, looser
and more lyrical *Dance* with impressive speed and confidence.
By the end of the summer, he was ready to start the laborious
and exacting job of marrying form to colour, using scissors and
a stack of painted paper in place of brush and palette. Lisette
could no longer be spared as Amélie's sickroom attendant, so
Matisse had to manage as best he could with hired help. In late
September he took on a young Russian film extra called Mme
Omeltchenko, who proved unexpectedly reliable at cutting,
trimming and pinning his shapes in place. Matisse was simul-
taneously correcting the proofs of his *Poésies de Stéphane
Mallarmé*, incorporating innumerable, infinitesimal, last-minute
adjustments that drove his printer to distraction. Images of the
Dance tormented his waking hours and invaded his sleep at
night. In the intervals of drawing and redrawing, while he
waited to see his latest changes implemented, Matisse eased his

feelings at a nearby shooting booth. He said his only relief from tension came in the moment when he raised and levelled his rifle at the target.

In January 1933, Matisse travelled to Mallorca for what proved a nightmarish confrontation with Barnes, who followed him back to Nice at the end of the month to inspect the *Dance* for the first time. Barnes approved of what he saw, but could not prevent himself capitalizing on the fact that, in a collapsing art market ruled by panic and stagnation, he was now Matisse's only potential source of income. Being treated like a junior employee at a time when he was already exhausted and discouraged did nothing to restore the painter's confidence. After Barnes left, Matisse worked with feverish concentration in a state of heightened awareness that blocked out everything except his decoration. By 20 March, the design emerged complete at last, the studio assistant left, and the house painter returned to spend the next month painting in the outlines of the *Dance* on canvas.

André Masson was working in Monte Carlo that spring on the ballet *Les Presages*, which he redesigned four times in a state of such violent frustration that Matisse invited him to stay to calm him down. The two spent mornings in the Nice workshop, or watching the corps de ballet rehearse in Monte Carlo, distancing one another from their respective frenzies in long walks and talks each afternoon. At this point Marguerite arrived with Claude from Paris to find her father in despair ('His philosophy is very close to that which advises taking to your bed and awaiting death,' she wrote to Pierre). Matisse attended the dress rehearsal of Masson's ballet on 12 April, and finished his own *Dance* just over a week later. For the next ten days the painter and his dog held an informal preview at 8 rue Désiré Niel. Léonide Massine was one of the first arrivals, declaring that Matisse had embodied his dream of what the dance should be. Duthuit arrived, André Gide came over from Roquebrune with the Bussys, and Matisse sent his car to fetch young Mme Omeltchenko. By this stage it was almost more than he could do to organize packing and shipment. Plans to exhibit *The*

Dance in Paris had to be dropped in spite of an accurate forecast from Duthuit that Parisians would never forgive the slight: 'Your abstention will seem to many an act of deliberate hostility or contempt.'

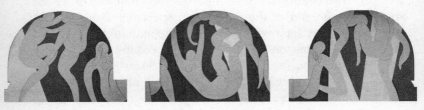

Matisse, 'The Dance', 1932–3

Matisse sailed for New York on 4 May with his crated decoration in the ship's hold. On Friday, 12 May, the day after he landed, he was driven down to Merion by Pierre (who was dismissed with Barnes's habitual brutality on the doorstep). On Saturday the first of the three canvases was fixed in place in an atmosphere so tense that Matisse suffered a minor heart attack, turning blue and being revived by Barnes with whisky. A heart specialist, backed by three other doctors, prescribed total rest for the next few months. Matisse told his daughter that overwork had placed irreparable strain on his heart, and warned her to say nothing to her mother, but his own anxiety was swallowed up in the overwhelming relief of seeing his decoration installed at last. 'It has a splendour you can't imagine without seeing it,' he wrote immediately to Bussy, reporting that Barnes had compared the radiant light and colour streaming through his hall to the effect of the rose window in a cathedral.

But their mutual jubilation was shortlived. Barnes, whose newly published book on Matisse had been comprehensively mauled by the critics, announced that he had no intention of letting anyone see his decoration. To Matisse, his behaviour seemed almost unhinged. Pierre, who drove down again early on Tuesday morning to fetch his father, was allowed into the hall just long enough to take two photographs of the *Dance*

before being hustled out. When Matisse telegraphed to arrange a second viewing on Friday, Barnes had already locked up the museum and left for Europe. 'He's *ill*,' Matisse reported to his daughter. 'He's a monster of egotism – no one but *him* exists ... nothing can be allowed to interfere with him! Above all not now, when he's bruised black and blue by the failure of his book ... All this between ourselves, because what counts is that he gave me the chance to express myself on a grand scale, and that he recognizes as best he can the excellence of the result.'

Matisse never saw his *Dance* again. Its ten days on display to close friends in a Nice garage turned out to be the nearest it ever got to a public showing. Having left home expecting a rowdy reception in America, Matisse returned to Nice still barely able to take in what had actually happened. For the rest of his life, and Matisse's, Barnes ensured that the decoration remained for all practical purposes unknown. No one was ever admitted to the Foundation without his personal permission, which he refused on principle not only to the press but to collectors, curators, art lovers, anyone suspected of the faintest connection with the art-world (the list of people turned away eventually extended from T. S. Eliot and Le Corbusier to visitors arriving with notes from Matisse requesting that they might be allowed to see his decoration). Colour reproduction of the *Dance* was forbidden.

Matisse was never again commissioned to make a mural, although he told Gide he would happily live on bread and water if he had another wall to decorate. The blow Barnes dealt him left him impotent and helpless, sprawling upended on his back like the figure in his illustration to Mallarmé's poem *Le Pitre chatié* (*The Clown Punished*). This was not the comical clownish self-projection of his letters to his wife, more like the private nightmare of a boy who dreamed of becoming a circus clown and grew up to be treated by the neighbours as a village idiot, *le sot Matisse*, the fool whose paintings made no sense to anyone. Matisse rarely talked about his private bitterness and humiliation, except to his son Pierre, but he did insist that no

artist could exist without a public ('Painting is a way of communicating, like language'). One of the things he liked about Chaplin's film *The Circus* was that it embodied his own image of the artist as the little man trying to entertain a fairground crowd, who would slink away with his hands in his pockets if you took away his audience.

13. *The Blinded Giant (1934–9)*

At the beginning of 1934, Matisse agreed to illustrate James Joyce's *Ulysses* on the advice of his son Pierre, who predicted an enthusiastic welcome in America for this rare conjunction of two prime modernists. Having discovered from the Bussys that the novel's structure was based loosely on the *Odyssey*, Matisse proposed to bypass Joyce's text (which he had not read), and accompany it with scenes from Homer instead. He picked six Homeric episodes to work on, all but one involving women, starting with the various nymphs and seductresses Odysseus encountered on his travels and ending with the patient wife he left behind him. The first sample illustration submitted to the publisher George Macy in New York showed 'two women quarrelling to represent the disorder in Odysseus' household', an image that had more to do with the artist's own home life that summer than with either Joyce or Homer.

Matisse's marriage had been under pressure ever since he started work on Barnes's *Dance*. When the twelve months initially envisaged for this project stretched out to three times as long, Amélie responded by putting her life on hold. She spent the entire period immobilized in her room high above the sea, busy with her embroidery, going nowhere and seeing no one except her sister and the doctor. Her husband reflected ruefully on the contrast between her lethargy and the relentless over-exertion that had weakened his own heart, lowered his resistance and now tortured him with kidney pain. He was taking an enforced break at Vittel for a water cure on doctors' orders when his daughter posted him an even more drastic prescription of her own. Pierre had complained for years of his family's tendency to hold their tongues for fear of saying too much whenever they came face to face, but on paper all of them could speak

their minds with devastating frankness. Marguerite's long letter itemized her father's failings and urged him to correct them, warning that his exclusive absorption in himself and in his work threatened the fabric of his marriage.

Marguerite was well aware that her father felt he had been abandoned in his time of greatest need by a wife so sunk in her own troubles that she could no longer even oversee the smooth running of his household. Far from relying on Amélie to calm his inner torment, he was obliged by her doctors to conceal all problems from her. His perennial anxiety consumed him, fuelling a sense of injury that made him exacting, over-bearing and intolerant. In an impassioned rebuke which was also a personal manifesto, Marguerite reminded her father that his very existence as a painter depended on Amélie's ability to look beyond childrearing and housekeeping, that her courage and elasticity had been worn out in pursuit of a larger goal, and that their loss now condemned her to the lonely inferiority of an invalid routine. The letter ended with stinging contempt for Matisse's efforts to insulate himself in Nice from the conflicts threatening to tear France apart: 'this ... is not a healthy way to live − above all not at a time when the entire world is in convulsion'.

Matisse remained defensive but immovable. He would tacitly acknowledge the accuracy of Marguerite's perception long after-wards, when he found something very like it in the writings of her contemporary Pearl Buck, another intrepid and observant daughter whose whole life might be seen as a response to her father's iron will. Matisse had recognized his own compulsions in Buck's novel *The Patriot*, and he would be even more disturbed by *The Fighting Angel*, a biography of Buck's missionary father, whose wife and children paid a heavy price for subjection to a lofty but inhuman cause. Like Odysseus' Penelope, or the mute, stormy, stone-faced missionary wives struggling to discharge an innate sense of grievance through their knitting needles in *The Fighting Angel*, Amélie had for years stitched feelings that could find no other outlet into tapestries, cushions,

soldiers' socks in wartime, fine silk lingerie and baby clothes in the interlude that followed. At Issy she knew how to hold the whole family to ransom with her brooding silence, but in Nice the balance of her marriage shifted. Painting had been Matisse's first love, and his involvement in his early sixties was as intense as it had ever been. Even after his final return from Merion, Matisse could think of little but his first, unfinished and abandoned version of the *Dance*. In spite of heart trouble and a kidney crisis, he sneaked back for another look at the original design, still waiting to be transferred to canvas in his garage workshop. 'It's like an old stallion sniffing the mare,' he wrote to Bussy, explaining what he meant to do to his *Dance* as soon as he was well again.

Isolated and excluded from the life of the studio that monopolized her husband, Amélie's anger erupted in dramatic scenes whose vehemence frightened both of them. Four months after he got back, she moved out, decamping without warning to her sister's flat on the western outskirts of town. Her old energizing vision of a brave new world had dwindled to dreams of acquiring an apartment of her own. 'If only I could win the lottery,' she cried, raising clenched fists above her head in a characteristic gesture of defiance. 'But, Amélie, you already won it,' Berthe said calmly. 'It's Henri.' Berthe, newly retired after a remarkable career as a pioneer of women's education in France, was renowned as a peacemaker able to restore order, quell mutiny and reverse decline in failing or demoralized institutions by sheer power of personality. Berthe was her family's lifeline. She had looked after both parents, making a home for her father until the day he died and, when Amélie required support, abandoning her carefully planned retirement in a stone house in her native Roussillon for a small apartment in suburban Nice. Now she put her skills as a mediator at the disposal of her brother-in-law, who arrived on her doorstep every afternoon, baffled and contrite, bearing chocolates or books for his wife.

In mid-November, when Henri finally completed the second *Dance*, and unrolled it 'like a theatre curtain' on the wall of his

big studio at Place Charles Félix, Amélie came home too. Her husband made strenuous efforts to give satisfaction, offering every concession short of modifying his work habits. He had the whole apartment fitted up to suit an invalid, moving the gramophone and radio from the studio to her room, which was bigger and more comfortable than any other. The day revolved around her morning outing, when she would be carried down five flights of stairs to the car in a throne-like armchair with the whole household in attendance, bearing rugs and cushions. Matisse had exchanged his small bumpy Renault for a big American car with impeccable suspension that would not jar or jolt his wife's back. Now that she could no longer visit the downstairs painting studio, he climbed up instead twice a day to report progress at her bedside. Lisette had been dismissed by Matisse that summer on his wife's insistence and, when the next two attendants left in swift succession, it was Amélie who suggested replacing them with the Russian who had proved the most dependable of all her husband's studio assistants, Lydia Omeltchenko.

Lydia was young and beautiful but also, unlike previous hired helps, so efficient that Amélie planned to retreat with her that summer to Berthe's house in their home village of Beauzelle. The escape would not have been possible without Lydia to fetch and carry for a household that included the two sisters, their elderly aunt, and the Matisses' two-year-old grandson, Claude Duthuit. Amélie relied on her new companion's health and strength, and approved of the tenacity that made Lydia a battler like herself. Born in Siberia in 1910, the only child of a leading paediatrician in the city of Tomsk, Lydia had been orphaned by the age of twelve, when both her parents died in epidemics that swept the country after the Revolution. She was brought up by an aunt who fled with her via Harbin to Paris, where their arrival coincided with the slump that swallowed the family's remaining capital and left them facing ruin. Lydia gave up her plans to study medicine at the Sorbonne and become a doctor like her father, making a brief disastrous marriage instead to the much older Boris Omeltchenko.

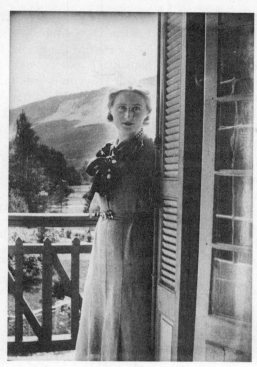

*Lydia Delectorskaya
photographed by Henri
Matisse in 1935*

By the time she met Matisse, she had resumed her maiden
name of Delectorskaya and run away with a handsome, dashing,
irresistibly confident young compatriot, whose imagination
conjured up a dazzling future for the pair of them. The couple
planned to seek their fortune among the large community of
Russian exiles surviving precariously in Nice at a time when
a tide of right-wing xenophobia was rising all over Europe,
backed in France by stringent regulations that made it illegal
to employ foreign immigrants for anything but casual unskilled
labour. Lydia joined the pool of looks and talent on hire in
Nice as film extras, artists' models and casino dancers. She was
twenty-two years old, penniless, half-starved, beginning to
suspect that her lover's ambitious schemes might never find a

footing in reality, when she found a part-time job for six months as studio assistant to an elderly painter whose name she had never heard before.

Matisse, well used to making sure his models got enough to eat, regularly paid Lydia overtime so that she could buy a steak for lunch at the café opposite his workshop. When her six months was up, he dismissed her with a modest loan as starter capital for a scheme to take over a small Russian tearoom with her partner. 'If we give her the 500 francs, we'll never see them back again,' Matisse warned his wife, 'but we can't very well do anything else.' His prediction was correct in so far as Lydia's lover staked and lost the entire sum the same night at the Casino. But Matisse had misjudged Lydia, who immediately took a two-month engagement as an extra in a foot-of-the-bill nightclub act at Cannes for 300 francs a month (the monthly salary of Mme Matisse's attendant at this point was just under 1,000 francs with free board and lodging). After four weeks, she handed over a first repayment of 200 francs to Matisse, who invited her to view his completed *Dance*, currently awaiting shipment to the United States in the garage on the rue Désiré Niel.

Here she met Georges Duthuit, who was intrigued to discover that this striking stranger had entered herself for a four-day dance marathon at the Casino (an endurance stunt for which the management paid twenty-five francs per twenty-four hours with a bonus for anyone managing to last the full course, as Lydia meant to do in order to pay back what she owed). Matisse was appalled by his son-in-law's disclosure. A veteran insomniac himself, he had seen dazed and stupefied young women, sleepless, grey-faced, blank-eyed, propped up by the sailors who volunteered as their partners, stumbling round the ballroom floor in a parody of the dance, a gruesome freak show with undertones of sexual subjugation laid on for the benefit of the Casino's patrons. He sent his driver to fetch Lydia, who found herself hauled up before him the same afternoon, hatless and dishevelled, too startled to deny her

intentions, and too intimidated by his anger to refuse the cancellation of her debt. The episode revolted Matisse, but the stony pride behind it impressed his wife. Amélie understood this way of thinking and warmed to Lydia, whose resourcefulness would become steadily more useful to her in the next few years.

In March 1934, when Matisse's household seemed to be disintegrating round him, he told Pierre that his life was drawing to a close amid troubles worse than any he had ever known before. He said he stood at his window, staring out to sea like someone on an interminable ocean crossing. Painting offered no way out. The first picture he produced after Barnes's decoration, *Interior with Dog*, dissatisfied him ('I need something richer'), and brought him up against the barrier that had for so long blocked his way forward as a painter. Sometimes Matisse feared his critics were right in assuming that, at his age, he had no future. He said mortal dread pursued him night and day. Worry about his work underlay other worries about his wife, and provision for his family. He had already made plans for retrenchment, cutting back on expenses, selling one or both cars, and reducing the substantial allowances he paid his children. Apart from Pierre, whose business was at a standstill, none of the young Matisses or their spouses had yet found regular jobs. Their father in Nice prophesied ruin, as their grandfather in Bohain had done before him. 'Unfortunately these days we're not just living in a house that's cracking up . . .' Marguerite wrote tartly, pointing out that the problems of Matisse's youth had little bearing on current developments in Hitler's Germany, or the political explosions detonated by economic calamity in France: 'we're living through an earthquake on an altogether different scale, and it has to be said that energy, hard work, courage aren't going to produce the results one could have counted on before – now it's a raging storm and all we can do is try to keep our heads above water.'

The predicament of Matisse's children was in a sense a mirror image of his own. Art was for all of them the only calling worth considering. Exposed from birth to extreme and exhilarating

pictorial risk-taking, his children rejected all substitute thrills, and shared their father's horror of anything facile, imitative or second-hand. Their problem was internal, not external, prohibition. Jean, who persisted as an artist longer than either of his siblings, summed it up with poignant clarity during a painting summer at Collioure: 'I have to force myself not to fall back on turning out "Matisses". It's as if Papa has seized the essence of any impressions you could experience in front of this landscape, and there's nothing left to do . . . it's been done so often and so thoroughly you end up stupid and discouraged . . .' Where art was concerned, the whole family was implacable. Matisse's duty as an artist and a father required him to be mercilessly honest. For well over a decade Jean remained his pupil, switching from painting to sculpture and submitting work by post to Nice, waiting each week with sickening apprehension for a response that too often justified his worst expectations when it came. Contact between them was a replay of Matisse's relationship with his own father, who had gone to the grave believing his eldest son a failure.

Pierre grumbled in later life that parental intervention had cut short his own career as a painter, but he must have known at some level that flight had saved him from the corrosive self-contempt inevitable for anyone who, as his father put it, was not strong enough or sufficiently convinced of his own purpose to withstand demolition on a weekly basis. The correspondence they kept up from either side of the Atlantic expressed profound mutual affection and concern, taking on a deeper tone in the early 1930s, when outbursts of grief on Matisse's part were answered by almost fatherly reassurance on Pierre's. But in person their exchanges were often harsh and grating. They clashed painfully on almost everything, from the annual quota of pictures Pierre could have to sell in the United States to the unfortunate affair of his wife's dog, Rowdy. A cheerful, friendly, entertaining schnauzer, left behind in Nice in the care of the senior Matisses while Pierre and Alexina (always known as Teeny) went on honeymoon, the dog had changed his name

to Raudi by the time they returned to fetch him, and established himself as a companion from whom Teeny's father-in-law could not be parted. Inability to get his wife's dog back for her rankled with Pierre as yet another private humiliation that could not be effaced by even the most phenomenal public success.

Marguerite had stopped posing when she married, and gave up painting shortly afterwards for much the same reasons as her brothers, although she remained her father's personal assistant, running his Paris office and regularly representing him abroad. She was also in a sense his conscience, maintaining a strict grip on quality control, a gruelling, time-consuming, often thankless task, whether it meant informing Matisse that he was producing substandard work, insisting on rehanging his pictures at exhibitions, or seeing his etchings through the press. From the *Poésies de Stéphane Mallarmé* onwards, printers trembled at her coming. Marguerite was still the closest to her father of his three children, but the constraint and conflict of a permanent supporting role became harder to accept after her marriage. Older, more outgoing and unhampered by the close bonds of her upbringing, Georges Duthuit brought with him a witty, worldly gaiety that subverted the arduous virtues – sacrifice, dedication, exaltation – of Matisse's studio. At times, his breezy disrespect seemed like sedition, and his casual, offhand manner like outright revolt. It was Duthuit who told Matisse to his face in the late 1920s that his work was going nowhere, and perhaps her husband's scepticism sharpened Marguerite's severity towards her father. She had always stood up to him more directly than her brothers, and in these years, she grew sterner still.

In the early years of their marriage, Duthuit pursued his studies on frequent trips abroad, visiting Egypt, Spain, Germany and England, becoming almost as much at home in London as he was in Paris. Duthuit was a key member of the Gargoyle Club in Soho and a close friend of its founder, the Hon. David Tennant, one of the last disciples of Matthew Prichard (who had finally returned to England after his release from a German prison camp in 1918). Tennant ran his nightclub as

an enclave where the more raffish reaches of the British upper class could fraternize with the ritzier end of the literary and artistic avant-garde. Duthuit contributed Gallic chic, Prichard was the club's spiritual guru, and its presiding genius was Matisse. His *Harmony in Red* hung in the dining room, and his semi-abstract *Studio, Quai St Michel* of 1914 at the foot of the stairs leading to the Club's third glory, its glittering glass ballroom, designed by Tennant in consultation with Matisse as a homage to the Alhambra. It was in the bar of the Gargoyle, among broken glasses left over from the night before, that Prichard educated the young John Pope-Hennessy – future head of the Metropolitan Museum in New York – and other prospective magnates of the Anglo-Saxon art-world by continuing in the 1930s the seminars on aesthetics he had once held in Matisse's Paris studio.

The loose-living, high-thinking Gargoyle was Duthuit's natural habitat in London. He lectured at the brand new Courtauld Institute of Art, but he had neither the stamina nor the training for the stony path laid down from birth for his wife, who embodied an ideal of purity that became for him increasingly unattainable. Faced with the gap between aspiration and performance that had defeated Jean and forced Pierre to build a career on the far side of the Atlantic, Duthuit consoled himself with less exacting conquests in London. When Marguerite discovered in the winter of 1933 that her husband had been having an affair with the wife of the youngest of the celebrated Sitwell siblings, she reacted with excoriating heat and vigour. Later she would come to feel that the attempt to live on her father's all-or-nothing terms had corroded and undermined her marriage. At the time, its break-up was a shattering blow. She said it felt as if her whole house had gone up in flames. Her parents watched the conflagration in helpless consternation, united in their efforts to avert disaster. They provided shelter, sympathy and support for Marguerite in Nice that winter and the next. Amélie mourned to see another ideal partnership cracking apart in the gulf between reality and dream. Matisse

attempted a salvage operation by finding Duthuit a job, appealing to the Bussys, and interceding himself with the authorities at the Louvre in a final energetic effort to secure the Cairo teaching post for which his son-in-law had been in line for years.

Simon Bussy, for so long a tower of sanity and strength in Matisse's troubles, was struck down himself in the spring of 1934 after a minor operation that went badly wrong in London. In the first week of May, when Bussy lay close to death in hospital, his wife and daughter posted daily bulletins to Matisse, who responded, as his old friend slowly rallied, with a steady stream of letters full of affection, encouragement, jokes and plans to visit him in London. Amélie had by this time left Nice to move into her sister's house at Beauzelle, taking her little grandson Claude Duthuit with her. Claude's parents were in process of separating their lives and dismantling their apartment in Paris. A will of steel had enabled Marguerite to survive the physical ordeals of her youth, but even she could not live on nervous energy forever. When her husband finally left Paris, she collapsed in a high fever, unable to eat or sleep, alone in her parents' apartment on the Boulevard du Montparnasse. A new and agonizing health crisis overtook Amélie at this point in Beauzelle. Matisse went from his wife's sickbed to his daughter's, finding a doctor for Amélie in Toulouse, and moving on in mid-June to organize home nursing for Marguerite in Paris. As soon as she was well enough, Marguerite sailed for the United States to recuperate with Pierre's American in-laws on the coast of Maine. When she left in early August, Matissse was still making daily telephone calls to check on his wife's precarious condition in Beauzelle.

In these turbulent months, Matisse turned to his illustrations for Joyce's *Ulysses*. All through the six weeks he spent in Paris with his daughter, he was working on *Calypso*, 'a scene of chaotic disorder' embodied by two struggling women, followed by Odysseus' confrontation with the princess Nausicaa and two of her companions, a trio not unlike three nubile young models auditioning for Barnes's *Dance*. There was trouble as soon as

proofs of these engravings reached New York. George Macy at the Limited Editions Club responded by demanding the relevant page numbers in Joyce's text. Matisse posted off references to the *Odyssey*, and refused to continue without a down payment. He had already telephoned Joyce from Paris and claimed to have secured his backing, although the author himself got the impression from their phone call that his illustrator was working closely from the French translation of *Ulysses*. Joyce was eventually mollified, but Macy remained doubtful, plaintively demanding page numbers and withholding payment until well into the New Year.

Matisse told Joyce in August 1934 that he was working on Aeolus, the wind-god whose tempests battered Odysseus' boat, knocking him off course and driving him back the way he came. The episode occupied him on his return to Nice until he left to fetch his wife home from Beauzelle at the end of the month. By the beginning of September, he had moved on to the blinding of the Cyclops. He based his composition on a small painting by Antonio Pollaiuolo, showing Hercules crushing the life out of an opponent in a ferocious deathlock, a scene Matisse drew and redrew over the next few years, when he felt himself under attack from all directions. The thrust of his *Blinding of Polyphemus* lies not with the puny assailant plunging his long stake into the Cyclops' eye, but with the body of the giant himself, prone and powerless, arching to receive the impact, back taut and limbs braced against all four edges of the paper. Matisse's final engraving is an image of contained shock, violence, male strength and impotence: 'the only true image of pain in all his work', said Louis Aragon.

He extracted or abstracted it from a raw agony of clawing hands and contorted legs jabbed down in a flurry of stabbing movement, scarifying lines and spurts of ink like black blood. 'I do not reason when I draw,' Matisse explained, when asked afterwards about his method. 'I don't know where I'm going. I rely on my unconscious self.' Terror of blindness, or inability to paint, returned to haunt him all his life in time of danger

or disruption. Matisse compared the images dredged up from his subconscious by his pencil or engraver's pen to bubbles rising from a pond, or ripples fanning out from a stone dropped into deep water. When he finally completed his Joyce illustrations with an engraving of Odysseus' homecoming, Matisse's Ithaca looked less like a classical Mediterranean palace than the long straight path between waist-high bushes leading to the door of the studio at Issy.

By the beginning of 1935, he had done virtually no easel painting for six years. He had been trying for many months to regain what he called his 'coloured vision', but the few canvases he produced seemed to him to be marking time or going backwards. His home life had at last resumed something like its normal pattern, although his wife remained frail and too weak to walk. Marguerite was beginning to rebuild her life in Paris, leaving her small son in Nice with his grandparents. In January, the whole household contracted a virulent strain of flu. Lydia Delectorskaya, who had been coming in daily for the past year as Mme Matisse's companion and her grandson's nanny, moved into the apartment to nurse the invalids, and promptly caught flu herself. Many people died of it in Nice in a New Year marked by tempests and snowfall. Matisse, who remained more or less bedridden for six weeks, was kept indoors by his doctor until mid-March. 'I've aged a great deal,' he told Pierre.

One day he opened his sketchbook and drew the nanny ('Don't move!'), who sat half listening, half daydreaming, with her head leaning on her arms while her employers chatted in a break between work sessions. After this first sketch, Matisse asked Lydia to sit for him in the studio. He had admitted to Pierre at the end of January that he still had no clear idea where he was heading, but a few weeks later he invited Bussy with evident excitement to come and inspect a canvas that would surprise him. This first painting of Lydia in her favourite pose, *The Blue Eyes*, was the signal he had been waiting for. Matisse looked back on it later as the first shot in an experimental

campaign that could not be judged except in the context of his entire work. Marguerite saw its simplicity as deceptive, concealing a density that took time to decipher, 'charged with everything that went before like a distant fire'. It initiated a period of intense and sustained activity that gathered momentum over the next few months, accelerated by a single brief trip to Paris to see a Cubist retrospective containing a couple of Picassos that reverberated 'like two cannon bursts'.

Throughout the first year Lydia spent working under his roof, Matisse had paid her scant attention. She remained a dim figure in the background, 'the Russian who looks after my wife', remarkable only for punctually discharging duties that enabled him to retreat thankfully to the studio. He drew her once or twice, then lost interest. 'When after several months or perhaps a year, Matisse's grim and penetrating stare began focusing on me, I did not attribute anything particular to it . . .' Lydia wrote in retrospect. 'I was not "his type". With the exception of his daughter, most of the models who had inspired him were southern types. But I was a blonde, very blonde. It was probably for this reason that, after something about me caught his eye, he had been studying me with a meditative, dour look.'

Lydia was twenty-four years old in February 1935. She had long golden hair, blue eyes, white skin and clear-cut, classically regular features set in a heart-shaped face. Hers were the looks of an ice princess, as Matisse said himself, but her beauty had been overlaid when they first met by a protective mask assumed during years of exposure to the kind of treatment commonly encountered by refugees from Eastern Europe in the xenophobic climate that followed the 1914–18 war in France. Lydia was used to being categorized with other Russian exiles under the heading *l'âme Slav* as primitive, uncouth and temperamental ('As for me, I was an immigrant who didn't know a thing, who understood nothing,' she said drily afterwards). She spoke very little French at that stage. It would be some time before Matisse discovered that, unlike himself or any of his children, Lydia had easily qualified for a university place. But academic brilliance

was no help in earning the only kind of living now open to her on the margins of survival as film extra, nightclub performer, *au pair* or artist's model. The last was by far the worst. 'From the time that I had work as a companion on a steady basis, I wanted to think I was forever through with modelling, which I had found detestable.' Working for Matisse was a relief because, unlike the first three artists who employed her, he did not paw at her or assume an automatic right to take off her clothes. In the first drawing he ever made of her, at the end of 1933, she might be any wary, watchful hired help, dressed in a drab work-shirt, with unsmiling face and scraped-back hair.

It was so long since she had encountered routine politeness or consideration that for many months she was chiefly thankful to have landed up in a family whose own early experience made them automatically aware of hardship in others. Amélie, always on excellent terms with her husband's models, picked out clothes for Lydia and enjoyed watching her regain confidence as she wore them. Matisse made it easy for her to accept money for a new jacket ('After all, it's for when you go out with Mme Matisse'), and to charge professional posing fees ('I'm not going to exploit household help by saving money on a model!'). She thought of him as *un vieux monsieur*, a kindly old gentleman with the formal manners of her father's generation. 'Gradually I began to adapt and feel less "shackled"; in the end, I even began to take an interest in his work.' In 1935, she agreed to live in on a regular annual salary (a common but strictly illegal arrangement under French immigration rules). She had had enough of make-believe after five years of living with a gambler whose moneymaking schemes grew wilder as the couple's prospects dwindled downwards into penury and squalor. Lydia's lover left to seek his elusive fortune in Bordeaux, and she settled down to work for an employer whose honesty she could respect, and who needed basic domestic services she could supply. Matisse's innate fairness and delicacy appealed to her. Lydia may have entered his studio knowing nothing about either the painter or his work, but on this human level they understood

each other perfectly. He was a man of the North but she came from Siberia, and there was nothing he could teach her about stubbornness, pride or reticence.

She recognized the desperation behind his methodical, matter-of-fact approach. On 15 March 1935, Matisse told her the story of Hercules and Antaeus, showing her the reproduction of Pollaiuolo's painting pinned up in his studio, and explaining that the victim being choked to death in his killer's arms would regain strength and power only if he managed to put his foot to the ground. *Corsage bleu*, the pastel Matisse produced the same day, was the last time he ever portrayed Lydia looking sad, preoccupied or bored. Next day she posed for a painting called *Nu rose crevette [Shrimp-pink Nude]*, whose progress Matisse recorded in photographs that show her serene and radiantly assured, wearing nothing but a necklace, seated knee to knee with the painter in shirt-sleeves and spectacles, both of them reflected in the studio mirror that so often stands in, with Matisse, for the world of the imagination entered through his painting. Bonnard, who particularly liked this picture, was shocked to find it scrubbed out a month later. Matisse moved on to *The Dream*, another deceptively simple, almost geometrical study of Lydia with her head pillowed on her arms, which brought him to a frightening pitch of anger and frustration. The only way she could think of to relieve pressure in the studio was by telling him stories of her Siberian childhood. All through April and May, as Matisse worked on a succession of nudes in Mediterranean heat, Lydia described the great stove that warmed the carved wooden house where she grew up in Tomsk, the high, hard-packed walls of snow between which she walked to school, and the larder outside the kitchen window filled with deep-frozen bricks of milk and dead rabbits stacked stiff and straight like rifles in a gun-case.

Through Matisse's eyes, she looked back for the first time to the life that lay behind her. She said her earliest memories were of lying awake as a small child waiting for her father to return late at night from his hospital laboratory with bedtime

stories that enthralled her, about microbes, and the magical new bacillus that would eliminate tuberculosis. The security of her childhood had ended when Tomsk was overrun after the Revolution by running battles between Bolsheviks and anti-Bolsheviks. Lydia could remember walking across the town's main boulevard in the month of her eighth birthday, holding her father's hand in a ceasefire agreed by both sides so that Dr Delectorski (who ran the region's military hospitals) could cross from one front line to the other. He died a few years later of typhus, and cholera killed his wife. Lydia, who had been forced to give up her place at the medical faculty in Paris, rediscovered in Matisse's studio the sense of purpose that had marked her indelibly as a child. 'He was like a doctor,' she said of the painter, 'completely bound up in himself and his concerns.' Over the next twenty years, Lydia would find a cause worth serving and an outlet for her own childhood ambition in a role recorded by Father Couturier, one of the few outside observers ever admitted to Matisse's studio during working hours:

Matisse (*a drawing session*). His incredible stress in the moment before starting his little pen sketches. Lydia told him: 'Come on now, don't let yourself get so upset.' His violent response: 'I'm not upset. It's nerves.' The atmosphere of an operating theatre. Lydia holding up one instrument after another – the bottle of India ink, the sheets of paper – and arranging the adjustable table. And Matisse drawing without a word, without the slightest sign of agitation but, within this immobility, an extreme tension.

His first period of concentrated work with Lydia culminated in the *Pink Nude*, begun in early May 1935 and completed six months later, on 31 October. Matisse said he was trying to integrate the linear clarity and boldness acquired in six years' steady drawing with his old instinctive ability to compose spontaneously in colour. He used the technique of pins and paper that he had invented to give cinematic fluidity to the *Dance*, photographing successive stages of his *Pink Nude* in images that

unfold like a film sequence. Day by day the nude seized posses-
sion of the picture surface, twisting and sprawling, extending
and retracting rubbery, elongated limbs, establishing a constantly
changing rhythm between the body's restless curves and the
straight lines of checked fabric, tiled walls and the edges of the
canvas. The model remained absolutely still throughout. It was
Matisse who manipulated arms and legs, pushing the elements
of his relatively simple composition to the furthest limits of
distortion, but never losing contact with the reality represented
by Lydia posing for him on a blue-and-white checked coverlet
with legs bent and one arm folded behind her head ('My pose
didn't change,' she said; 'it was comfortable and always the same').
When Pierre arrived from the United States in June for his
annual inspection of his father's work, he focused immediately
on *The Pink Nude*, still a bare canvas with its design worked out
in outline and its paper colours pinned on ready to be painted.
'It's the one in which you've renewed yourself,' he told Matisse;
'it's a sequel to the great decorations.'

Matisse, 'The Pink Nude', 1935

The sequel had taken shape in a surge of energy released by superhuman effort after what seemed to Matisse the blackest torment of his life, and he marked it with a break for resting and regrouping. Pierre had brought his wife, his daughter and his infant son to France that summer, landing in the south in order to introduce the two-year-old Paul to his grandparents and his cousin Claude. Grandchildren were a joy to both Henri and Amélie. All the children learned very young to practise their best behaviour in Nice, drilled by their parents to be seen and not heard according to the code of an earlier generation. But for all his belief in discipline, even Matisse could seldom bring himself to be strict with Claude, who was a comical child, witty, astute and tender-hearted like his Uncle Pierre as a small boy. Matisse taught him his colours, and took him on outdoor sketching expeditions with Raudi and Lydia. Like his Matisse ancestors, Claude was born and bred to the rhythm of a life shaped by its work patterns. He spent much time in a swimsuit playing on the beach, but indoors he had to observe the adults' rule of silence in and around the studio, broken by occasional bouts of mayhem when Matisse produced a drum for him to beat as the pair marched around the table in the dining room. At bedtime, Matisse dealt with signs of the family restlessness by playing low music on the radio until the child fell asleep holding his grandfather's finger.

'The two of them get along very happily,' Amélie wrote reassuringly to Marguerite, who was designing a couture collection in Paris. Astonished and impressed on her trip to the United States the year before by the independece of American women, she planned to set up her own business, financed by the sale of a suite of lithographs (one of three presented to each of his children by Matisse) to the Victoria and Albert Museum in London. While Marguerite worked on her designs that summer, Claude moved with his grandparents to the resort of Beauvezer, which offered sunny days, cool nights and spectacular scenery in the foothills of the Alps. Amélie recovered something of her

Matisse with Claude Duthuit in his arms

old vitality in the fresh mountain air, sewing or reading in the hotel garden with Claude playing nearby supervised by Lydia. Matisse used this six weeks of rest at Beauvezer for stock-taking, both professional and personal.

Pierre sent his father a severe and detailed analysis of the paintings he had seen in Nice, singling out *The Pink Nude* but dismissing the rest as ineffectual or backward-looking. His letter was followed by a mordant assessment from Marguerite, explaining that she, too, felt it her duty to point out that her father was fundamentally mistaken if he thought his recent work anything more than a recapitulation with no discernible forward movement. Pierre talked of facility, Marguerite of repetition and exhaustion. Both reflected widespread assumptions about Matisse's work in Paris and elsewhere. He wrote back philosophically, describing *The Pink Nude* as 'a many-layered work following on a whole season's effort', and explaining that he found himself at the start of a journey whose destination even he could not foresee at this point. 'I know the *Dream* contains much but it's part of a route – like, alas, many of my paintings,' he wrote to Marguerite. 'Things must always be

judged by the goal they aim at, and by their future,' he told Pierre, who had particularly objected to a series of small, bright, gleaming canvases in which Matisse said he was trying to compose in colour as fast and fluently as he could with line in drawing.

Matisse was badly shaken by his children's findings. He said they made him realize that, like all artists who offer their contemporaries a new way of seeing, he could expect no mercy at this stage. He remembered his own contempt as a young painter for Impressionists like Renoir, with whom he felt increasing sympathy now that he, too, had been discarded by succeeding generations who saw no use in anything he might still try to do. He even offered to submit his latest experiments to the judgement of a younger colourist, asking Pierre to appeal to Joan Miró (who had just joined the Pierre Matisse Gallery in New York) to act as a kind of umpire: 'I'm not ashamed of my work . . . I put myself into everything I do . . . I'm not trying to protect myself.' Matisse's divergence from his peers seemed more conspicuous than ever in the 1930s. As other artists were drawn increasingly to politics, meeting social disintegration with a disintegrating art, evolving a whole new pictorial vocabulary to parallel surrealist actuality in Nazi Germany and Fascist Spain, Matisse – still doggedly painting nudes in Nice – appeared even to his supporters to be cut off from reality.

To Matisse himself it seemed the other way about. He donated canvases and signed occasional petitions, protesting about the rise of Fascism or the plight of refugees, but he had little faith in political solutions. His deepest instinct in the face of erupting violence and destruction was to respond with an affirmation of everything that made life worth living. He said he could not consciously control the force that drove him forward, but he made no effort to resist whatever propulsion had him in its grip. Intimations of the Soviet reign of terror had reached him early through an indiscreet emissary from the Museum of Modern Western Art in Moscow. A few years later, the predicament of

Jews in Germany hit him hard with the news that Olga Meerson – 'the beautiful Russian Jew who was once so much in love with me' – had killed herself in Berlin. By the late 1930s, in a world uneasily aware of heading for disaster, Matisse was once again approaching in his work a concentrated purity of expression comparable to the intensity he had achieved at the height of the 1914–18 war.

Throughout this period, he worked against a background of family upheaval, estrangement and distress. Like all the Matisses, he was appalled by the extent of his daughter's continued suffering ('how to help her when her spirit is so tormented', wrote Pierre, '. . . her constitution must be made of iron, morally and physically, to stand so many blows'). When all hope of an official Beaux-Arts posting finally fell through, Duthuit left France, spending the greater part of the next decade abroad with a variety of female companions, returning for brief, painful encounters with his wife which punctuated a separation neither could in the end bear to make permanent. Marguerite blamed her parents, and especially her father, for undermining her marriage by taking up too much of her attention. When she threatened to give up managing her father's affairs in Paris, Amélie decided to resume control herself. Her intervention was dramatic as always. She revoked her backing for Duthuit as vehemently as she had scorned her husband's doubts about him in the first place, denouncing both the marriage and Marguerite's reluctance to dismantle it ('I've tried to make excuses for her, but you know how absolute your mother is,' Matisse wrote unhappily to Pierre).

In the autumn of 1935, the painter exacerbated a tense and complicated situation by formally requesting his son-in-law to stop writing about his work. The ban would be relaxed with time, but the two never spoke to one another again. Marguerite, still struggling to make a late start in a new career with insufficient backing, regarded this or any other attempt to intervene on her behalf as gross interference. For nearly twenty years she had been her father's eyes and ears in Paris, keeping

him posted about prices, sales, collectors and the activity of other painters. When she picked out a Parisian show that he could not afford to miss, Matisse obeyed her summons, and he relied heavily on her to oversee his own exhibitions. But from now on contact between them became intermittent, drying up almost completely after Claude returned in the spring of 1936 to live with his mother in Paris. Matisse, who missed them both dreadfully, kept up a semi-clandestine correspondence, but his wife was inexorable. The handling of his affairs meanwhile shifted definitively to Nice.

Amélie's insistence on taking charge meant, in practice, that routine work devolved on Lydia, who added secretarial help to her duties as companion, nanny and model. She typed her employer's letters, translated articles on his work, and taught him enough English to find his way round London when he finally paid his long-postponed visit to Bussy. Matisse's prime appeal for Lydia, at any rate to start with, was the urgency and directness of his need. She said her father had implanted in her as a small girl an instinct for emergency relief ('I'm basically a stretcher-bearer: first-aid is written on my heart'). The *Dance* had reduced Matisse to desperation by the time of their first meeting in 1932, and he was very nearly frantic with frustration when she began posing for him nearly two and a half years later. The way he cursed and swore in the studio that spring surprised her. On their return from Beauvezer in mid-August, he said the break had only intensified his apprehension, and by the end of the year he was once again a martyr to insomnia and night sweats, 'panics that seize me when I'm assailed by worries that I can only envisage getting worse ... I'm wearing myself out floundering like a drowning man, and I don't see how I can work in this state,' he complained to Pierre, mixing self-pity with a shrewd pinch of self-knowledge, 'unless it's work that's going to save me, and I can begin and continue it without being interrupted.'

The atmosphere Lydia established in the studio was impersonal, calm and orderly. She adapted the techniques of her

scientific training, taking methodical notes on Matisse's work in progress, keeping track of his experiments, dating and preserving a photographic record. When he realized what she was doing, he was sceptical at first ('YOU HAVEN'T UNDERSTOOD A THING. Just like the art critics'), but almost immediately switched to dictating notes himself at the end of every work session, a practice abandoned only because both parties found it altogether too exhausting. 'He knew how to take possession of people, and make them feel they were indispensable,' she said. 'That was how it was for me, and that was how it had been for Mme Matisse.'

Matisse recorded this act of possession by returning to the theme of nymph and satyr that he had first broached more than a quarter of a century before. Preliminary sketches in the spring of 1935 led that autumn to *Faun Charming a Sleeping Nymph*, a five-foot-high charcoal drawing of a hairy faun crouching over a smooth young nymph and blowing purposefully down his panpipes. In September, Matisse transferred the couple to a woodland glade at the foot of a canvas eight feet high by six feet wide, to make a tapestry design called *Nymph in the Forest*, or *La Verdure*. He told Marguerite a year later that the composition had particular significance for him, although he could not tell if he was in fact in charge of it, or it was in charge of him. He reworked the same theme at intervals over eight years, ending with another enormous charcoal drawing, *Nymph and Faun*, finally completed in 1943. The picture marks an active collaboration very different from the rape depicted in the *Nymph and Satyr* of 1908. There is nothing passive or inert about any of the nymphs modelled by Lydia, least of all this one, sprawling on her back with one knee cocked, one arm flung wide and the other cradling firm, round breasts. The piping faun leans over her, wiry and taut, bringing his full force to bear in a flurry of blurred fingers and powerful forearms on a partner who conveys an energetic response in every strong, supple curve of breast, hip, haunch and belly.

Matisse, 'Faun Charming a Sleeping Nymph', *1935*

Lydia said that the first time Matisse played this theme for Olga Meerson, it was crude and brutal, unlike the tune he played in the studio for her. 'With me, he knew how to be gentle and seductive. He was charming, and so touching. He knew how to tame me.' Lydia felt her pride and power revive in daily contact with a man who did not require from her the sort of sexual transaction that had been until very recently her only realistic prospect of survival. Over the next two decades Matisse said he came to know her face and body by heart, like the alphabet. He drew her in order to slow down his racing brain, and he drew her again to restart his imagination. But in his late sixties and seventies he needed more than ever to expend every last reserve of energy on his work. He told her a cautionary tale about a friend in Nice who wrecked his chances of becoming a serious painter by ending every session in bed with his model. If Matisse made love to Lydia, it was on canvas. For her, *Nymph and Faun*, and the variations that preceded it, represented a deep

and durable exchange of confidence and commitment. For him, it was a final resolution of the theme through which he expressed the mystery of his relationship with painting: a rape in which, as Pierre Schneider pointed out, 'there is no way of telling who is the rapist and who the victim'.

Studies for *Nymph in the Forest* in the autumn of 1935 led directly to a beautiful, free and boldly patterned series of pen-and-ink drawings of Lydia lying naked among cushions on a striped floral bedspread, contemplating herself in the mirror or more often gazing coolly back at the painter. The drawings were exhibited in February 1936 at the Leicester Galleries, in spite of a warning from Mme Bussy not to show them in London. 'She said there could be absolutely no question of it,' Matisse reported in perplexity to Marguerite. 'People might read erotic intentions into them, which were not there in my case.' Dorothy Bussy turned out to be right. When Marguerite reached London with Matisse's sexy pictures, the gallery directors became so nervous they were reluctant to hang the show at all ('No other gallery would have done it'), and had to be forced to put a nude in the window.

The problem was the painter's usual combination of absolute literalness with extreme aesthetic rigour. There was no mistaking the sensuality of his crisp humorous dancing line, swooping round the body's mounds and hollows, pausing appreciatively to outline suggestive fingers, florid nipples, lively swirls of pubic hair. But there could be no doubt either of Matisse's genuine indignation when his wife and daughter tackled him about the possibility of toning down details. So far as he was concerned, any suppression of his explicitly sexual imagery meant radically compromising his artistic freedom. In the week of the show's opening, he dictated a defensive note to Lydia, explaining the technique he used 'to relieve me of my passionate emotion', and pointing out with some complacency that he had achieved in the process 'a very rare voluptuousness and elegance of line'.

The show made a satisfactory stir in London. No passer-by complained of indecency to the police, and many of the pictures

sold, even though, as Matisse freely admitted, none of them could properly be hung in a respectable family home. Keepers came from the British Museum and the Victoria and Albert Museum (which put on a special showing of its own newly acquired prints). Kenneth Clark of the National Gallery bought a drawing, and Clive Bell published an enthusiastic review. Both had been introduced to Matisse by the Bussys, who played a key role in these years in shaping Matisse's reputation. Their support was generous and practical. They put their unique range of contacts on both sides of the Channel at Matisse's disposal, steering not only Gide but Paul Valéry, the young André Malraux and any number of English critics, painters and collectors towards him in Nice. They organized the offer of a studio from Gide when Matisse needed one in Paris, and described the fiasco of his Barnes commission to the former Cabinet Minister Gabriel Hanotaux, who arranged an official placing in the summer of 1936 for the second, homeless version of the *Dance*.

There was, however, a price to pay for attracting patronage from the Bussys. Although they lived on next to nothing (Bussy's initial triumphs as a painter had been almost totally forgotten by this time in France), their villa at Roquebrune was the main French outpost of the highly efficient intellectual pressure group named for its headquarters in London's university district of Bloomsbury. Dorothy and Simon Bussy rented rooms each summer in Bloomsbury's Gordon Square alongside Virginia and Leonard Woolf, Vanessa and Clive Bell, assorted Stephenses and Stracheys. Roquebrune became in turn a favourite winter watering-hole for London visitors, who revered Matisse as an artist, and returned home bearing endless funny stories about his bottomless conceit, pomposity and dullness as a man.

The stories came from Bussy's wife and daughter, who were increasingly exasperated by the amount of time Simon spent apparently dancing attendance on his prosperous old friend. Janie Bussy especially resented the contrast between Matisse's international standing and her father's extreme obscurity. Acutely intelligent and exceedingly well read, the two formidable Bussy

ladies were chronically under-occupied. Dorothy made English translations for Gide (with whom she was for thirty years hopelessly in love), while Janie produced mild, unassertive paintings of landscape and flowers. Both amused themselves by including a mocking commentary on Matisse's latest doings in their voluminous correspondence with some of the finest minds and best gossips in London and Paris. Painting, which consumed Bussy as it did Matisse, meant little to his wife. At home in Roquebrune, surrounded by Dorothy's predominantly literary, English-speaking friends, Simon seldom spoke. In London he retired to the zoo to paint small, subtle, marvellously composed and coloured portraits of birds, fish, butterflies and chameleons, whose combative character appealed to him ('Solitude is the only state they can endure,' he said, 'because the sight of their fellows drives them to inconceivable fury').

Matisse sympathized strongly with his old friend, sidelined in his own house by relays of eminent, forceful and opinionated writers (the Bussys' visitors included four Nobel laureates – Kipling, Gide, Romain Rolland and Roger Martin du Gard – besides the cream of Bloomsbury headed by Dorothy's younger brother, Lytton Strachey). Bussy remained for most of them an enigmatic, brooding presence shut up in his studio except at mealtimes. Matisse came over regularly from Nice to show solidarity as a fellow Frenchman and a painter ('His visits were made out of friendship for Bussy,' said Lydia, 'to give him some moral backing, now that he was no longer "Bussy the painter" but "the husband of *Madame*"'). Over the years they supported one another through successive crises, from Matisse's long struggle with the *Dance* and Bussy's near-fatal operation to the annual crop of liver complaints, bronchial upsets and winter fevers, when each urged the other to wrap up warm and keep his windows sealed.

When either felt neglected or misunderstood, he looked for reassurance to the other. Matisse said a note from Bussy was like a ray of sunshine in his prison. Bussy described himself waiting and watching at his window, like Sister Anne in the

fairy tale, for a sign from Matisse. There was no one else for whom Bussy's opinions still carried the weight and authority he had possessed in their youth, when he was a legendary figure: the only art student in Paris who wore a fur coat, owned more than a single pair of shoes and exhibited his pictures at the most fashionable gallery in town, crowning a brilliant career by leaving for England to marry a cousin of the Viceroy of India. Matisse repeated this fantasy to Lydia with a relish undimmed by the fact that Bussy's wife (who was no relation of the Viceroy) actually belonged to a family of hard-up, leftward-leaning intellectuals. Matisse respected Mme Bussy's cultivated mind and critical acumen, but he never felt comfortable in her company or her daughter's. He showed up at her tea-table for Simon's sake, making solemn small talk and wearing the thick reddish-brown tweed suit he kept for polite occasions of this sort.

But his attempts at conformity backfired. Like Gide and almost all their French friends, Dorothy and Janie were keen Communists by the early 1930s, reading the *Daily Worker*, revering Leon Trotsky, and locating all hope of future human progress in Soviet Russia. One of their favourite private games was to make fun of Matisse behind his back by casting him as the epitome of the bourgeois complacency they despised. Janie Bussy's portrait-sketch of Matisse, 'A Great Man', written to be read aloud at a meeting of Bloomsbury's Memoir Club, is a small masterpiece of deflationary wit and absurdist comic vision. Matisse emerges as a fictive monster of insufferable vanity, banality and pretension. This was a wilder and more extravagant version of the portrait in the *Autobiography of Alice B. Toklas*, Gertude Stein's brilliant, gossipy, self-serving reminiscences that caused a sensation in the United States in 1934, and shaped romantic Anglo-Saxon attitudes to Bohemian Paris for the next half-century and more. The book's findings were disputed in the transatlantic literary review *transition* by a group of Frenchmen headed by Matisse and Braque, who pointed out factual errors and distortions caused by Stein's inadequate grasp of French, and her basic incomprehension of modern painting.

Matisse was especially distressed by her patronizing picture of his wife as a horse-faced housewife, which drew from him an impassioned defence of Mme Matisse's beauty, gentleness and unassuming dignity when he first knew her.

But public protest only fed and watered seeds sown by the Bussys, who 'took the view that Matisse was the greatest living painter, the greatest living egotist and the greatest living bore'. Their cartoon version of the painter fuelled jealousy and resent- ment even among those who didn't know him, like Virginia Woolf, who refused to attend a party given in Matisse's honour by the Bussys, out of a kind of vicarious pique: 'He's the great god of the young; only so vain, so respectable, so slow I'm told, in his wits, that the entertainment is a horrid burden.' Lurid stories flew round London. What had begun as a harmless tease insidiously coloured attitudes to Matisse's painting. Part of the trouble was that, from Bloomsbury's point of view, the wrong people liked him. The fact that his pictures increasingly hung on the walls of the rich, smart and sophisticated, like David Tennant and the Clarks, only reinforced assumptions about the superficiality and irrelevance of his work.

In 1936 he signed a three-year contract with the dealer Paul Rosenberg, who showed, for the first time for a decade in Paris, a selection of Matisse's recent canvases, including *Nymph in the Forest* and several of the tiny, brilliantly coloured exper- iments that had baffled Pierre the year before. The formation of a Communist-oriented, Popular Front government that May released a tidal wave of strikes and demonstrations in the ominous interlude between Hitler's invasion of the Rhineland in March and the outbreak of the Spanish civil war in July. A feverish conviction of the need to respond or intervene gripped the intellectual community. Matisse signed a telegram with Picasso sending support to the Republican government in Catalonia. But widespread anger and frustration over the situ- ation in Spain, coupled with growing anxiety about German aggression and European rearmament over the next few years, produced a steadily more politicized climate in which the

long-term agenda of Matisse's latest work – so apparently simplistic, so patently apolitical, so transparently clear in form and colour – became almost literally invisible to his contemporaries. Roger Fry and Alfred Barr had both predicted as early as 1931 that Matisse was once again about to call his whole art in question. But Barr had other claims on his attention and, when Fry died in 1934, he was succeeded as Bloomsbury's unofficial spokesman on contemporary French art by the relatively conventional Clive Bell, who did as much as anyone in these years to reinforce the prevailing view of Matisse as a lightweight by comparison with Picasso.

A dismissive caricature of the Frenchman as a hedonist incurably preoccupied by blue skies and odalisques took root so deeply in the 1930s that it would be another half-century and more before it could even begin to be dislodged. 'Matisse ... is painting rapturously as a bird sings,' wrote Bell, using the mindless frivolity of birdsong to encapsulate the reasons why what had once looked like becoming an Age of Matisse had turned out in the end to be the Age of Picasso. Ever since the *Dance*, Matisse had been groping towards a simpler and more streamlined way of working, using traditional components – models in striped robes or embroidered blouses posing in the studio against bold, synthetic backgrounds of patterned fabrics, chequered tiling, the serrated leaves of philodendron – to invent a new dynamic of flat shapes and strong colour. He experimented with tapestry design, starting with *Window at Tahiti*, and following it up with *Nymph in the Forest*, reporting hopefully to Pierre that Dr Barnes was prepared to take both (Barnes changed his mind, and bought a tapestry from Picasso instead). He longed for larger spaces to decorate in a style accessible to a wider public. 'Don't assume all painters are against working collectively ...' Matisse said angrily when Gide described the marvels commissioned from Soviet artists by the authorities in Moscow. 'I'm ready to paint as many frescos as you like, only remember, it's no good asking me to paint hammers and sickles all day long.'

In the summer of 1936, Matisse discovered with considerable bitterness that he was the only major French artist not offered a commission by the state in preparation for the international exhibition to be held the following year in Paris. He had to be content with an offer from the City of Paris to buy the alternative version of the Merion *Dance*, and show it for the first time in a major show of contemporary art at the Petit Palais, planned to coincide with the great exhibition. In the late spring and early summer of 1937, Matisse visited Picasso several times to inspect progress on *Guernica*, which was to hang in the exhibition's Spanish pavilion, but in the end the public had no chance to set *Guernica*'s ferocious vision of destruction against the expansive leaping energy of the *Dance*. Matisse's wall painting was bought but not shown, spending most of the next forty years in store and re-emerging to find a place on the walls of the city's Museum of Modern Art only in 1977, nearly a quarter of a century after the artist's death. Matisse remained for the rest of his life one of the few French artists never invited to embellish any public building. 'I would have done many other decorations if anyone had asked me,' he said resignedly in retrospect.

At the time, he expressed his anger and contempt for state patronage with a characteristically munificent gesture suggested by his wife. At the end of 1936 the couple presented their most precious possession to Raymond Escholier's Museum of Modern Art of the City of Paris as a gift. 'What better way to teach the state a lesson?' asked Amélie. It would be hard to overestimate the public or private significance for herself and her husband of the donation of Cézanne's *Bathers*, which for nearly forty years had symbolized the deepest meaning of their marriage, constantly replenishing Matisse's moral and pictorial courage, and binding the whole family together as the pledge of a common purpose. Matisse seldom looked backwards, but when he did at this point, there was not a lot to show for four decades of struggle. 'The worry that haunts me,' he told Marguerite, 'is that I'll end up being forgotten.' Sales had been more

or less at a standstill for years in France, where, apart from two paintings owned by the state and the Sembats' collection in the Grenoble museum, his work had become difficult, if not impossible, to see. In America, Dr Barnes had virtually stopped buying Matisses, and the fifty or sixty prime canvases at Merion remained largely inaccessible, with a long-term future that was at best problematic.

The same was true, for different reasons, of the works exhibited in Soviet Russia as examples of degenerate Western art. Sergei Shchukin died in exile in 1936 with no regrets for the loss of a collection that he had always intended to present to his country ('It is a Tzar's gift,' said Alexander Benois), but the museum containing his and Morozov's combined collections closed to the public three years later (it would be abolished altogether in 1948). Meanwhile Matisse's work had been purged on almost identical grounds from all museums in Germany. Several canvases (including *Bathers with a Turtle* of 1908 and the *Blue Window* of 1909) would be 'virtually bootlegged', in Barr's words, by Pierre Matisse and others at public sales or in private negotiations with the Nazis on the eve of war. Sarah Stein had left France the year before Shchukin's death, moving back to the United States to settle in California and taking the remains of her collection with her. Of all the great collectors Matisse had known and trusted, the only one still active was Etta Cone of Baltimore.

Since her sister's death, Etta had directed her collection with unexpected confidence and determination. It gave meaning and purpose to her life, and she in turn treated it, and above all the Matisses in it, with professional seriousness. Her first independent initiative was to oversee production of a sumptuously illustrated catalogue. In 1932 she acquired a Mallarmé portfolio which Matisse prepared especially for her, a kind of working library including all his preparatory sketches, proofs and copper plates, used and unused, many of them preserving images that never reached the published *Poésies*. In Etta's company Matisse himself was gallant and avuncular, laying on entertainment for her,

accompanying her on outings, and performing tricks to amuse one or other of her nephews ('This was behaviour expected from Picasso, not Matisse,' wrote a Cone great-niece). The Cones' purchases had been abundant, careless and largely random in Claribel's day (she said she didn't even realize she had a collection until the time came to make provision for it in her will), but Etta developed an orderly acquisitions policy based on consolidating existing holdings, filling gaps and keeping pace year by year with work in progress. She began by acquiring Matisse's two major transitional works of the early 1930s almost as soon as each was painted: *Yellow Dress* and *Interior with Dog*. From then on, he prepared a spectacular annual display of paintings and drawings for Etta, who took precedence over any other collector, picking a major painting almost every year from the two or three Matisse set aside for her to choose from. In 1935 it was *Blue Eyes*, followed the year after by the *Pink Nude*, a purchase that became, with Claribel's *Blue Nude*, one of the two cornerstones of the Cone collection. All the works were destined to end up in the Baltimore Museum of Art, an arrangement approved by both artist and collector, each of whom perfectly understood the value of their collaboration for the other. Etta Cone may not have been the boldest, the most forceful or even the most discerning of Matisse's great collectors, but she offered him something nobody else could: stability, security and the certainty of a future for his work at a time when this was a rare and precious gift.

By the late 1930s, Matisse's existence had reverted to its oldest and most basic pattern. He worked and slept in the studio, where he felt himself both captive and set free, as if art had at last consumed his life. Anything that might distract him had been so far as humanly possible eliminated by Lydia, who knew nothing of his past or the work that had grown from it, and who had only the haziest notion of his international reputation in the present. Lydia waited on his wife, handled his routine correspondence and modelled for him in the studio. It was Lydia who oversaw the housekeeping, and made it possible to

resume annual summer migrations to Paris, which required the forward planning of a royal progress, with stretcher bearers laid on to transport Mme Matisse to and from her sleeping compartment on the train, and a separate carriage reserved for Matisse with the two dogs and the growing collection of caged birds that now accompanied him on his travels.

He had begun bringing home fancy birds, five or six at a time, from the merchants along the quays of the Seine in the summer of 1936, and from then on birds invaded his life in increasing numbers. He delighted in their shapes and colours, their plumage and their singing, which reminded him of the musical thrush in the palm trees outside the Hotel Stuart in Papeete, and the caged songbirds of the weavers in his northern boyhood. He said that the songs of his captives both echoed and distanced him from his own predicament. They filled the same place in his life as the inmates of the aviary or the aquarium at London Zoo did in Bussy's. In the summer of 1937, when Matisse finally crossed the Channel to inspect his latest show at Rosenberg's London branch, he had himself dropped off one afternoon at the zoo with a piece of paper written out in capital letters – BUTTERFLIES – so that he could find his way to a rendezvous in the butterfly house with Bussy. Both now in their late sixties, both single-minded as ever in pursuit of painting, both utterly impervious to styles or trends imposed by the outside world, the two old friends renewed the pact of mutual commitment and support formed in Moreau's studio in Paris nearly half a century before, in front of a living, moving, coloured frieze of butterflies.

Back in Nice that winter, Matisse rashly stepped outside with a head cold and contracted flu, which turned to bronchial pneumonia. This was the worst of all the bouts of winter sickness that gripped him year by year. For nine days he lay barely conscious, racked by burning fever, visited night and morning by his doctor and nursed by Lydia, who broke down and wept on the tenth day when his temperature finally began to fall. Matisse said his life had been saved by a massive injection of

disinfectant, which drove the poison infecting his system into a huge swollen abscess that had to be lanced daily. The operation excited the birds, especially an exotic yellow-and-black thrush called a troupiale, whose fluty whistle rose high and clear above the patient's cries. The songthrush that drowned his screams became of all Matisse's birds his favourite ever afterwards. The purity of its song spoke directly to his own will to survive the winter ordeals that came to seem to him a kind of ritual cleansing, from which he emerged deathly weak but purged and purified each spring.

'He came so close to death!' Berthe wrote to Teeny Matisse in December 1937. 'My sister is very well; she is always courageous in a crisis. We all are in our family. *We are plucky people.*' The Matisses had decided to stay on in Nice when their lease at the Place Charles Félix ran out in the summer of 1938, rather than join the flow of people who had been leaving town ever since Mussolini's alliance with Hitler. Pierre had advised his parents to move westwards away from the threat of Italian invasion as early as 1936, but instead Matisse bought two adjacent apartments in the old Excelsior-Regina Palace, the last and grandest of Nice's imperial hotels, perched on the rocks of Cimiez high above the seaside settlement: a fantastic pile occupied by Queen Victoria in the 1890s, already obsolete by 1914, boarded up for years after the war, and finally converted into private apartments at a moment when another impending war made them virtually unsaleable even at bargain prices. In January 1938 Matisse was the first and for a long time the only purchaser. 'Your mother is enchanted,' Berthe told Pierre. 'It's like a renewal of her wretched life! Your father is not so keen.'

By February, Matisse was once again in pain from an abscess in his mouth. Still shaky, frail and limping, he left to consult his dentist in Paris, taking Lydia at his wife's insistence to look after him. The treatment lasted for two weeks in early March. 'Everyone is appalled by Hitler's latest encroachments . . .' Matisse told Pierre when the German army annexed Austria that month, and stood poised to invade Czechoslovakia. 'On the whole,

people don't say much, because they don't know what the future holds, although they fear it.' All over France, civilians were preparing to flee. Matisse returned to sit out developments in Nice, having made his dispositions in the form of half a dozen evening dresses, picked up on a visit to the spring sales with Lydia in the couture district around the rue de Boétie. These six dresses, worn by a succession of different models, would become a staple element – adaptable, easily portable and surprisingly durable – of his basic wartime working kit.

Matisse used them in much the same way as he used sheets of coloured paper pinned to his canvases. Both supplied him with building blocks for the designs constructed from patches of flat colour that preoccupied him long after he had given up hope of ever being invited to decorate a public space. In the spring of 1938, knowing that he would never see his *Dance* fulfil its intended function as a wall painting, Matisse agreed to recreate it for the Ballet Russe de Monte Carlo in response to an urgent plea from Léonide Massine. Together they chose Shostakovich's first symphony, and worked out a scenario that would dramatize the conflict symbolized for Matisse by the song of his troupiale, 'the struggle between white and black, between man's spiritual side and his fleshly side'. Matisse visited rehearsals at Monte Carlo, watching the dancers intently. He made small, chunky, compact dancing figures with limbs like rods or pistons, patched together from rough scraps of coloured paper. The effect was forceful and expressive but clumsy, as if something incoherent were taking shape and thrusting upwards in the depths of his imagination. He built another of his toy theatres, and used it to experiment with a décor based on the three white arches of Barnes's *Dance* against flat geometric expanses of red, black, blue and yellow. Massine's dancers were to move beneath the arches, wearing plain red, black, blue or yellow costumes like bodystockings, in a choreography of coloured bands and splashes ('I have complete confidence in him,' said Matisse). Everything not essential to the dynamics of the dance itself was eliminated from what became, in all but

name, an abstract ballet. *Le Rouge et le Noir*, like the *Chant du Rossignol* of twenty years before, opened up new directions in Matisse's work.

Development of the ballet continued through months of upheaval as the Matisses prepared to move out of Place Charles Félix in June, packing household goods and canvases for storage, and retreating to Paris until their new apartment at Cimiez could be made ready for them. Pierre and Teeny arrived from New York with their children (the third and last, Peter Noel, was eighteen months old). All five grandchildren gathered with their parents at the apartment on the boulevard du Montparnasse that summer in a world on the brink of public and private disintegration. The family must have been aware that this might be their last reunion, given Hitler's threat to march into Czechoslovakia in the autumn. An external sense of dread reinforced internal barricades of silence and misunderstanding. Matisse felt his family no longer had faith in him, or in his latest painting, which came to the same thing. He missed the old solidarity cemented by unconditional commitment to his work, and the emotional intimacy that grew from it. Hurt pride fed a sense of mutual rejection that made him seem harsh and unapproachable. He felt cruelly cut off, especially from Marguerite and her son. The possibility that Pierre might have to apply for American citizenship precipitated painful confrontations, still unresolved when he and Teeny returned earlier than usual to the United States. Back in Nice, Amélie expressed her feelings in a letter so violent that her husband persuaded her not to send it, posting reproaches of his own instead that turned Pierre's heart to ice.

All through September, people poured out of Paris anticipating an imminent German strike, and out of Nice, which came close to being officially evacuated for fear of an Italian attempt to recapture it (Nice had been in French hands for less than a century). Amélie fled in the middle of the month with a nurse and a stash of paintings to the safety of Berthe's house in Beauzelle. Marguerite and Jean followed with their families from Paris. Matisse remained in Nice with Lydia to salvage the

Henri and Amélie Matisse with their children and grandchildren, 1936

contents of the house and studio, still in transit between the dismantled apartment on the Place Charles Félix and the new one at the Regina, only half decorated and now abandoned by the builders in the general panic. Lydia packed baskets of linen and china, crated furniture and rolled canvases, somehow managing to cram herself with half a wagonload of trunks and packing cases on to a train leaving for Montauban, where Jean had arranged storage. She spent a single night at Beauzelle before rejoining Matisse, who had stayed behind alone in Nice, dazed and exhausted, taking chloroform and belladonna to settle his nerves and stomach. At the end of September, the French prime minister, Edouard Daladier, flew to Munich with Neville Chamberlain of Great Britain to negotiate a last-minute reprieve from Hitler. Jubilant crowds greeted his return at Le Bourget. Matisse and Lydia listened in disbelief to Daladier's radio announcement ('If one has to believe in a miracle to save France, then I believe in miracles') that war had been averted.

The country rapidly returned to normal. Builders drifting back to work at the Regina found Matisse waiting at the gates, lodged in the small British Hotel and longing to start work himself on a decorative panel called *Le Chant (The Song)*, commissioned earlier in the year for Nelson Rockefeller's apartment in New York. Lydia cleared a space among the furniture crammed into Matisse's new studio, and cleaned it for him, before setting out again in mid-October to escort his wife back from Beauzelle. Amélie arrived to find the Regina still a building site, her room uninhabitable, and her belongings stacked in a poky hotel bedroom where she was expected to camp out indefinitely. Matisse spent his days in the studio, regretting only that he couldn't spend nights there as well ('I can't sleep with my work as I usually do,' he told Besson, 'which is hampering me a good deal'). He blamed Hitler's game of bluff, and his own folly in taking it seriously, for the catastrophe that followed.

Nothing could have demonstrated more clearly than Lydia's behaviour during the Munich conference that the support Matisse needed as a painter no longer came from his family. Her arrival at Beauzelle precipitated the kind of crisis that always rejuvenated Amélie, who responded energetically by demanding Lydia's immediate dismissal. Matisse insisted that he could not work without her. She was essential to the smooth operation of the cut-paper system invented for Barnes's *Dance*, and now in use again for Rockefeller's decoration. Lydia pinned and repinned the tracing papers, cleaning and recleaning the surface of the canvas as Matisse's colours changed day by day or hour by hour. She also modelled with her friend Hélène Galitzine for the various poses of the four women who sing or listen in *Le Chant*, forming a sombre frieze of black, pink and dark green interlocking bodies. Matisse, who was nearly seventy, pleaded mortality, urging his wife to bear in mind the fragility of his inspiration and the dwindling time at his disposal. But the more vehemently he spoke, the less effect he produced. Every argument he advanced to clinch his overwhelming need of Lydia confirmed his wife's determination that she must go.

The deadlock between them lasted all through the autumn, overshadowing their move to the Regina, which finally took place in mid-November. Matisse's heart trouble returned, and he suffered violent nosebleeds. He started seeing cloudy patches before his eyes, and reinforced his terror of blindness by reading *The Light That Failed*, Kipling's novel about a painter whose loss of sight plunges him into a downward spiral of destruction, despair and death. Lydia was sent away as soon as *Le Chant* was finished on 3 December. But Matisse's plan for her to return in early January, taking lodgings elsewhere and coming in daily to work as his secretary, produced an ultimatum from his wife ('It's me or her'). The choice seemed meaningless to Matisse. Like the hero of Kipling's novel, he no longer made a sharp distinction between art and life. Anything that blocked the one, in his view, destroyed the other. After an explosive interview with Amélie, during which his pulse rate rose from 69 to 100, Bussy removed him bodily from the apartment and walked him round the hillside until his heartbeat returned to normal. Matisse's condition this winter alarmed the small circle of his intimates in Nice. Berthe, who understood the tangled roots of conflict on both sides, tried to reason with her sister. So did the wife of Matisse's American friend Charles Thorndike and the family doctor, who warned Amélie that prolonged strain was putting her husband at risk of a second and more serious stroke. Marguerite arrived at the end of the month, and Jean came twice from Paris, retreating baffled as much by his mother's intransigence as by his father's obstinacy. Even Bussy, who rarely intervened in other people's affairs, took Marguerite aside to deliver 'a severe sermon . . . on the wickedness of driving eminent artists to death in their old age'.

Matisse and his wife seemed to have swapped roles. It was the painter, sleepless, feverish and unable to work, who now needed a night nurse, while the helpless invalid was galvanized by revenge and fury. 'Mme Matisse, after remaining bedridden for the last twenty years, suddenly rose up five months ago,' Dorothy Bussy wrote to Gide in March 1939, 'and has shown

ever since the most terrifying energy, physical and mental, in a
perpetual pitiless struggle with Matisse ...' Bussy's old friend
got no sympathy from his wife and daughter, who listened with
incredulity and stifled giggles to Matisse's despairing account
of the emotional tornado currently unleashed in the Cimiez
apartment. 'Mme Matisse ... made a terrific scene every day
for four months,' Janie reported cheeerfully to Vanessa Bell, who
spread wild stories round London as others were busy doing
in Paris and New York. Matisse dreamed he was accused of
murder, and could find no way to refute the charge.

But the ribald gossip of the art-world was the least of his
problems that winter. 'I was sacked,' said Lydia. 'Madame wanted
me to leave, not from female jealousy – there was no question
of adultery – but because I was running the whole house.' She
moved to a boarding-house in Nice to consider what to do.
Stateless foreigners in France faced a bleak future in the event
of war. Having already lost everything that had once mattered
to her – her home and family, her native language, her country
and her hope of qualifying as a doctor – Lydia felt it was sheer
chance that had brought her against all the odds a job worth
doing which she knew she could do well. Now her life was
purposeless again. After ten days, she posted a farewell note to
Berthe Parayre, explaining that she preferred suicide to an exist-
ence that caused misery to herself and others. Lydia shot herself,
but the bullet lodged against her breastbone. After checking the
gun by firing it out of the window, she found she no longer had
the courage to turn it on herself a second time. She sent a word
of explanation to Mlle Parayre, and left Nice the same day.

Berthe, who had seen her brother-in-law through forty years
of family upheavals beginning with the Humbert scandal,
accepted Lydia's view of the relationship without question. So
did everyone in a position to judge the situation in Nice. Even
Bussy's wife and daughter conceded that Matisse's dealings with
his model were strictly professional. That was the core of the
problem. For Amélie Matisse, there could be no deeper betrayal.
She had given up everything to build her life on the effort and

endurance required by her husband's work, and now found herself excluded from the only world to which she attached significance. In February 1939, her lawyer drew up a deed of separation. One of its key provisions was that everything – paintings, drawings, etchings, sculpture and all other possessions – should be divided equally between the couple. The family met in conclave to preside over its own dissolution. Pierre came from New York to see everything that had held his universe together from childhood torn up at the roots.

Amélie left for an unknown destination in Paris in early March. Matisse felt as if he had been hit by a cyclone. His children had gone, Berthe was preparing to retreat to Beauzelle, the Bussys were leaving for London, even the cook had departed with her husband. The painter remained alone in his double apartment on the seventh floor of the Regina, the only occupant of the whole vast, empty, echoing building looking out on sky and sea high above the town. In one part of his mind, he brooded in a state of profound and poisonous disillusionment on the fifty years of painting that had devoured his life. In another, he revelled in this sudden lull of liberty, calm and solitude. War had become inevitable that month when Hitler finally engulfed Czechoslovakia and turned his sights on Poland. Matisse knew well enough that his respite was temporary. 'The twittering of my birds, which had begun to leave me indifferent, even hostile, takes possession of me again in this great stranded ship at Cimiez, with thunder storms brewing all around to which I pay no attention whatsoever.'

He worked on *Music*, or *The Guitarist*, completing it in three weeks as a companion for Rockefeller's *Song*. 'The canvas has the amplitude, richness and sustained power of an organ peal,' Pierre wrote to his father as soon as he unpacked it in New York, recognizing a solidity and strength that grew from the Barnes' *Dance* and looked back to the great works of 1914. Both agreed it was the best thing Matisse had done for years. 'It sustained me in the cruellest and most painful moment of my life,' the painter wrote, admitting with a brief glint of satisfaction

that, if it had not been for the coming war, he would have shown it in Paris to silence all those who (like Marguerite) believed that his powers were failing.

In May 1939 the Museum of Modern Art in New York opened its doors with Matisse's *Dance I* – the original version of the Moscow mural painted for Shchukin in 1909 – in pride of place in the marble entrance hall of its new building. Matisse attended the premiere of *Le Rouge et le noir* at Monte Carlo on 11 May, and returned to Paris, where the ballet opened at the Théâtre du Chatelet on 5 June. His drawing for the programme was a last variation on Pollaiuolo's image of Hercules wrestling with Antaeus, depicting the captive this time not as a blinded giant but as a dancer surging upwards in a massive spurt of energy and release. 'In all my disarray, I've been sustained by the entire success of the ballet – and by the conception of another they've asked me to do,' he told Bussy, outlining plans for a classical work that would end with a wedding attended by the gods of Olympus ('I've finished with one marriage, and I'm planning another,' he wrote hopefully of a scheme that fell through when the Ballet Russe disbanded on the outbreak of war).

Divorce lawyers and their agents invaded Matisse's studio at the boulevard du Montparnasse. He counted eight at one point, emptying drawers, searching cupboards, counting drawings and compiling inventories. He had appointed his dealer, Paul Rosenberg, to stand in for him at the division of the spoils, with Marguerite as his wife's representative. Shocked by the human rancour and ruthless commercialism of the proceedings, Rosenberg suggested a meeting between the Matisses, each accompanied by an impartial witness, in some neutral public place. They met in the first week of July at a café on the forecourt of the Gare St Lazare. 'My wife never looked at me, but I didn't take my eyes off her – and I couldn't get a word out ...' wrote Matisse, describing how she and Rosenberg made small talk for thirty minutes while he stared numbly at her, unable to move or speak. 'I remained as if carved out of wood, swearing never to be caught that way again.' It was the frozen pose in which he had painted

himself, stiff as a board, confronting his wife twenty years before in the *Conversation*. He told Bussy he dreamed that night that he had been condemned to death and was waiting to be led out to execution. For once, perhaps the only time in Matisse's life, reality had outstripped his imagination, which was powerless to control or contain the chaos and destruction he felt always lapping at the dark edges of his brain.

14. Le Ressuscité (1939–45)

By the middle of August 1939, Matisse's entire output had been counted, classified and stored at the Banque de France in Paris, ready to be split down the middle after the summer holidays. He told Paul Rosenberg he felt demolished, and left for Geneva to visit an exhibition of masterpieces from the Prado. The day after he got there, 23 August, Germany's sudden alliance with Soviet Russia put a stop to the uneasy peace established by the Munich crisis. Matisse returned immediately to Paris. This would be the third war with Germany in his lifetime, and he told Bussy that his elaborate precautions twelve months earlier had exhausted his capacity for flight. On 1 September Hitler's armies invaded Poland. Two days later France followed Britain in declaring war. Matisse joined the river of people heading west next morning with household goods strapped to the roofs of their cars, but stopped after about thirty miles at Rochefort-les-Yvelines.

He spent almost a month in the village inn at Rochefort, watching refugees stream past, reading Gide's collected *Journals* and drawing trees in the forest. He also drew and painted Lydia Delectorskaya, who had fled with him. He had written to ask her to come back as his assistant in Paris once his wife made it clear she had no intention of returning. He told Lydia he already had a model, but needed someone to handle the day-to-day distractions that ate up his working time. Lydia, who had taken refuge with her aunt on the outskirts of Paris, brought Matisse a bunch of garden flowers for his nameday on 15 July. He painted them at the centre of a semi-abstract composition, reducing everything on his canvas – Lydia's bouquet of white daisies and blue cornflowers, the drawing on the wall, the still-life stand, even the model herself – to flat geometric planes of

colour balancing one another on a black ground. *Fleurs pour la St Henri (Flowers for St Henry's Day)* is a sharp, bright, decisive painting, full of light and what Bussy called depersonalized emotion. It commemorates a symbolic gift that became a conscious pact at Rochefort.

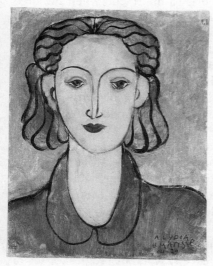

Matisse, 'Young Woman in Blue Blouse (Portrait of Lydia Delectorskaya)', 1939

'It was there that our collaboration for the future was agreed,' Lydia said in retrospect. 'A decision had to be made there – whether or not he was to take me with him. I barely hesitated. I was alone, I had no ties, there were no strings attaching me to life. I realized what people would say about a young beauty and a rich old man, but I wasn't interested in protecting my reputation.' Both knew that, whatever happened, this was a turning point from which there would be no going back. Matisse, who drew himself looking perplexed and quizzical, was characteristically the more cautious of the two. 'He said: "You are young. You have your entire life ahead, a whole road stretches before you." I said: "A road leading where? To what?" "Poor child," he said. And at that moment he knew I was a blank

sheet, which he could take over.' Matisse's drawings of Lydia at Rochefort show her dressed in her travelling hood and cape at the outset of the long, difficult, sometimes dangerous journey they were about to take together. Long afterwards she came to see herself as the life-giving raven in the Russian folk-tales of her childhood, the bird who flies to the rescue when the hero lies wounded or left for dead. She said Matisse made her feel that her life could still be useful.

After the seizure of Poland, there was no further move from either Hitler or Mussolini, who was still widely expected to retake Nice. France mobilized its civilian population. Emergency restrictions meant that Lydia could no longer move without a travel permit, which Matisse eventually obtained with help from the Socialist minister Albert Sarraut. Nice was bristling with troops when the two arrived back at the end of October. A company of Moroccans was quartered in the Regina. Matisse resumed possession of his huge, high-ceilinged studio, thirty feet square, made by knocking two reception rooms together, and filled with rampant philodendrons that had grown in his absence into a tangled indoor jungle. In preparation for the final division of property with his wife, the whole place had been stripped of everything except work in progress, a set of bronze casts and a single headless, limbless stone figure of a girl, an exquisite and much-prized Roman copy of a classical Greek original. Matisse took comfort in his birds, nearly 300 of them, installed in a room tiled specially for them and tended by a birdman who came in daily. The aviary divided the studio from the living quarters: a dining room with a patterned marble floor which the painter had chosen and designed himself, and his wife's cool, airy room looking out northwards to the mountains. Both would become studios in time, but for the moment they stood vacant, eerie reminders of a life that had gone for good. Like virtually everyone all over Europe in these first uneventful months of war, Matisse listened anxiously to news bulletins on the radio, trying to decide what to do, finally resolving to stay put and wait for events to drive him out of Nice.

He settled into a provisional existence of extreme isolation and anonymity, going nowhere, seeing virtually no one except his models, poised for flight at any moment. Outside working hours, Matisse had only the birds for company. Lydia refused to move into the apartment, preferring to sleep in a maid's room in the attic four floors above and report for duty each morning when the models arrived. Her status might look equivocal to other people, but she herself drew a sharp line between what she was and wasn't prepared to do for her employer. 'I always wore an apron,' she said, 'to make it perfectly clear that I was doing a job.' To the end of his life she addressed Matisse formally as '*Vous*', defined herself as his secretary, and never called him anything but '*Patron*'.

Both their families assumed that Lydia was living with Matisse as his mistress. Her aunt, already scandalized by a niece who sued for divorce and allowed nude pictures of herself to be exhibited in public, wanted no more to do with her. His wife and children accused him, just as his father had done half a century before, of dragging the family name through the mud. Lydia's return, presented by Matisse as a simple question of improved working practice, looked like provocation to his family, who felt he had put himself on the far side of an impassable barrier. They thought of her as a grasping, manipulative schemer, and dealt with her presence by acting as if she did not exist. The legal separation process generated accusation and counter-accusation in an atmosphere of extreme tension and pain. Amélie's sense of loss was by now unappeasable, and she wore herself out in relentless pursuit of the settlement that seemed to her husband to be tearing him apart. Marguerite, whose role as go-between placed her squarely in her parents' crossfire, was morally and physically exhausted, fainting several times when she came with a lawyer in the New Year to check the contents of the Nice apartment. Matisse's eyes grew so dim he could not see his canvas properly by the end of a work session. He insisted that spiralling lawyers' costs and a collapsing art market would bring destitution on them all.

Berthe and Pierre, reluctant to take sides and helpless to intervene, both advised Matisse there was nothing to be done except wait for his wife's murderous rage to subside. Berthe was recovering from a major cancer operation with steady support from Matisse (who had flown to Toulouse to be at her hospital bedside the day after his last encounter with his wife in Paris). He had made her an allowance and played the part of an affectionate elder brother for forty years, but now she told him that, although she exonerated Lydia of blame for the separation, loyalty to her sister meant she would not set foot under his roof again so long as the Russian remained part of his household. Amélie, more than ever exasperated by Berthe's evenhandedness, never forgave her for refusing to condemn Lydia altogether. From now on the sisters lived side by side in Beauzelle, Berthe struggling to make ends meet, alone in her cold stone house with her sick and dying Aunt Nine, while Amélie, who had rented a much grander property, refused to speak to her or return her overtures.

Pierre, stranded in France and temporarily conscripted into the army on the outbreak of war, remained his father's closest confidant. Although Matisse did all he could to help his son get back to the United States, he dreaded the prospect of further misunderstanding between them. 'That would be something terrible because, what then?' he wrote the month before Pierre finally secured his military exemption and flew home. 'What would be left to me in life – my work. But all the same that is not enough for me – for in that case you become a prisoner, shut in by invisible walls which don't prevent you from working, since you can still work in prison (look at Courbet). But at times it's unendurable.' This was a grim admission of the ransom Matisse had paid, and still continued to pay, for his work. As the war dragged on with no sign of a military offensive, he planned to distance himself from his troubles with a month-long voyage to Brazil in the summer, a prospect that made it easier to face the property settlement looming over him in the spring. Matisse returned to Paris at

the end of April, and spent the first week of May working several hours a day with Marguerite, exhuming trunks and crates of his work in a cold, damp cellar at the Banque de France. He dreaded bronchitis, and suffered night attacks of such acute stomach pain that the hotel porter had to call a doctor (who could find nothing wrong).

Hitler's armies were finally on the move, invading Norway and Denmark in April, pushing westwards on 10 May and racing through Belgium, Luxembourg and Holland. They crossed the river Meuse into France two days later. Bombs began falling on the capital as Parisians took to the roads yet again, swelling the unprecedented, almost inconceivable exodus of millions of people from Flanders and Belgium. Auguste Matisse arrived by car with his wife from Bohain (overrun as always by the first wave of invaders), and headed south to find shelter with Amélie in Beauzelle. Marguerite sent her son Claude to safety in central France with the head of his school, and Jean's wife Louise fled westwards with her son, Gérard (Jean himself had left months before to rejoin the army). As the Germans poured through the valley of the Somme to the sea, Matisse caught a train to Bordeaux with Lydia, ending up in St-Jean-de-Luz, on the coast near the border with Spain.

On 1 June, when the Dutch and Belgian armies had been smashed and the British expeditionary force was preparing to escape back across the Channel from Dunkirk, Tériade in Paris completed printing what Matisse called 'the war number' of the magazine *Verve*, dedicated to France and wrapped in a sumptuous black jacket designed by Matisse himself. He had spent the final days of suspense before the declaration of war in the magazine's office, cutting letters and shapes out of coloured paper and pasting them on to the cover, watched impassively by Tériade, who put his own and his printers' finest skills into bringing out this first-ever-published of all Matisse's cut-paper compositions. In June 1940 it symbolized the only possible defiance in face of unmitigated, ignominious defeat. German troops entered Paris on 14 June, the government resigned, and

the eighty-four-year-old Marshal Pétain, installed as prime
minister next day, immediately sued for peace.

Matisse was appalled by his country's capitulation, sickened
by the continuing slaughter, and consumed by fear for his family
scattered over the face of France, especially for Marguerite,
when word reached him that she had set out alone just before
the fall of Paris towards the thick of the onslaught in search of
her son. Letters and telegrams over the next two weeks brought
news of the fugitives' safe arrival two by two at Beauzelle:
Auguste and his wife, Louise with Gérard, and finally Margue-
rite with Claude after a hair-raising car journey, fleeing
immediately ahead of the advancing Germans along the byroads
and dirt tracks of the Auvergne. In every village they passed
through, the inhabitants waited for the invading enemy in
stupefaction and shock. 'Never!' cried Marguerite, when told
that France had officially surrendered. 'I'd rather die with a gun
in my hand.' It took her two weeks to reach shelter in the
south-west, where she was eventually joined by Jean, demobi-
lized after the armistice which divided the country into a
northern Occupied Zone and a nominally free zone in the
south under Pétain's government at Vichy. 'So now that's
everyone safe,' Matisse reported thankfully to Pierre on 4 July.

By this time he was on the run again himself, fleeing east-
wards as German troops moved down to occupy the coastal
zone. Mussolini had declared war on France in June, but life
under a probable Italian occupation in Nice seemed a better
bet than waiting for the establishment of Nazi rule in St-Jean.
The town was packed with desperate refugees, pinned between
advancing Germans and Spanish border guards, but Matisse
(who had a valid passport and Brazilian visas in his pocket) said
afterwards that it never occurred to him to try to flee France.
He found one of the few taxis in town with a full petrol tank,
and left with Lydia by one gate as the Germans entered through
another from the north. The taxi-ride ended after 100 miles at
the first inn with vacant rooms, the Hotel Ferrière at St-Gaudens.
With no trains running, Matisse found himself stranded there

for the whole of July, afraid to listen to the radio or open a newspaper in the mornings, and assailed once more by knifelike pains in the gut which mystified the village doctor. From St-Gaudens they got a lift to Carcassonne and a fortnight later, when the railways started running again, they squeezed on to a train leaving for Marseille at two in the morning.

In that blockaded port crowded with fleeing French citizens and hunted foreigners, Matisse was accosted on his first morning by Marguerite's friend Maria Jolas, who ran the school Claude attended, and had escaped with him and his mother in the path of the German army. Now she was about to cross the Atlantic, taking Marguerite's son with her own daughters to safety in the United States. Matisse was cut to the heart by her news. Georges Duthuit was alrady in New York (where he would remain for the rest of the war), but Claude had been brought up from birth by his mother and his grandparents. Matisse said he felt like a limp rag after the three days he spent in Marseille, putting on a calm, cheerful front for Marguerite and drawing his grandson, whom he knew he might never see again. Over the next five years, he would miss the child badly, asking after him often and anxiously, marvelling at the courage this parting cost Marguerite, who fell ill from grief in the autumn of 1940.

By the end of August Matisse was back in Nice, where people gloomily expected Italian fascist forces to occupy the town at any moment. His first move was to put his own private economy on a wartime footing. All his pictures had already gone, and in September he sent his record collection, his last remaining bronzes and most of his furniture to Beauzelle for storage. Now there was little left beyond bare necessities. In an autumn of punitive public cutbacks on food, fuel and transport, Matisse started to sell off his birds. 'It's not the necessity of doing it that concerns me but the uncertainty we live in, and the shame – the shame of a catastrophe one had no part in,' he explained to Pierre, quoting Picasso's derisive comment at their last meeting in Paris in May: 'It's the Ecole des Beaux-Arts

all over again,' said Picasso, when the supposedly impregnable defences erected by France's elderly generals turned out to have been an illusion all along.

The closing of the frontier dividing France in two meant a sudden total shutdown of contact with Paris. News of old friends came from the American Varian Fry, founder of the Emergency Rescue Committee, who had arrived in France with a list compiled by Alfred Barr in New York of distinguished artists at risk from Nazi persecution. Matisse politely refused both Fry's offer of refuge and an invitation to become a visiting professor at Mills College in California that autumn. He said he was too old and frail at seventy to take root elsewhere. The German authorities, who had persecuted his followers and got rid of his work in their own country, now had access to the strongrooms of the Banque de France, which were designed to be proof against theft, fire or bombardment but not official confiscation of the contents. All he could do was wait to hear from Picasso, who had offered to stand in as his key-holder at the bank, and who eventually sent word that his pictures were safe. In September, two German officers called to inspect Matisse's work at the boulevard du Montparnasse. Paul Rosenberg, who had managed to escape to New York, wrote to say there was no news of the collection he had been forced to leave behind in Bordeaux ('I wonder what happened to my latest pictures, which he was going to roll up and take with him,' said Matisse, who had done his best to persuade officials from the Beaux-Arts to intervene on Rosenberg's behalf).

In October Matisse was disturbed to find Georges Bernheim roaming the streets of Nice in a state of shock after his wife's death and the loss of his only surviving son (who was in a German prison camp), declaring that he got no comfort at all from his paintings, which he did not expect to see again in any case because he was Jewish. Pierre had already warned his father that the government in Vichy planned to follow the Nazis in purging the art world of Jews, while vigorously promoting the aesthetic values embodied by the Beaux-Arts administration.

There was little Matisse or any of his friends could do, beyond supplying official testimonials in favour of Georges and his cousin Josse Bernheim, and reiterating in private their abhorrence of Beaux-Arts methods. But in the autumn of 1941, when the Ecole des Beaux-Arts moved its Prix de Rome headquarters to Nice, Matisse publicly expressed his distaste in an interview on Radio Nice, agreeing, after his aspersions were cut from an article in *Paris Soir*, to repeat them more explicitly and at greater length in a second broadcast, on the understanding that this time there would be no censorship of his remarks about the Rome prize. The result was a withering denunciation of a system based on self-aggrandisement, coercion and prejudice, which came as near as was possible in Vichy France to expressing open contempt for the regime itself.

Matisse felt he had aged drastically ('I watch myself changing rapidly, hair and beard growing whiter, features more gaunt, neck scrawnier') in the first year of the war. A permanent haze of collective foreboding polluted the air in Nice. He had reduced his life to eating, sleeping and working, completing that autumn a beautiful, spare, meditative painting in a stripped-down style that he described severely to his Romanian friend, Théodore Pallady, as 'the expressive marriage of differently coloured and proportioned surfaces'. The effort it required was so intense that he placed a regular order with a local agency to send along three or four of its prettiest film extras as models each week, explaining to Pierre that their human presence softened the inhuman austerity of what he was trying to do.

The Dream is built round a sleeping girl, whose image had accompanied Matisse in his mind's eye throughout his travels, on a canvas he eventually finished after twelve months and forty sessions, shifting smoothly, with a change of model at the last minute, from a relatively realistic start to an airy, translucent lyricism, like a motorist changing up into a higher gear. He followed it with a stern and no less reductive *Still Life with Shells*. 'I think I've gone as far as I can in this abstract vein,' Matisse told Pallady on 7 December; 'for the moment I can go

no further.' He said he needed to wind down by letting his hand and eye run free on something more sensual, so he painted three plates of oysters in quick succession. *Still Life with Oysters* is a simple lunch for one – plate, knife, napkin, lemons and water-jug served up on a tray – painted with straightforward gusto, setting out by Matisse's own account from a point somewhere between Manet and Renoir, and performing a remarkable art-historical leapfrog from Impressionism straight into hard-edged abstraction.

Matisse wrote about his work in great detail in an attempt to distract Pallady, who was holed up in a hotel room in Bucharest in December 1941, painting still lifes himself to combat despair in his newly defeated country. The letter said nothing about the sender's own problems. The abdominal pains that had attacked Matisse in Paris in May, and again in July at St-Gaudens, had returned as soon as he got back to Nice, where his doctor wrongly diagnosed heart trouble. A recurrence at the end of November nearly killed the patient, who was transferred in December to a clinic for further tests. On Christmas Day Lydia wrote secretly to Marguerite in Beauzelle to warn her that her father's life was in danger, and that only his daughter could save him from an immediate operation by local doctors.

Marguerite left for Nice the day the letter arrived. The trouble was agreed to be some sort of internal blockage, but Matisse lacked confidence in the facilities and the level of competence available in a medical backwater like Nice. Marguerite organized a rescue operation, contacting a surgeon in Lyon and removing her father bodily from his hospital bed on 7 January 1941, in spite of angry protests from the Nice consultants that he could not survive a twelve-hour train journey through occupied territory in winter. 'Marguerite went into action with all the energy of which she is capable,' Matisse wrote with satisfaction a week later from the Clinique du Parc in Lyon, 'and I ended up here.' He was examined by Marguerite's contact, Professor Wertheimer, and two distinguished colleagues, the venerable Louis Santy and René Leriche of the Collège de France, who

decided on an emergency operation as soon as the patient was strong enough to undergo colonic surgery. The basic cause of the problem was the hernia that had saved Matisse as a boy from becoming a seed-merchant like his father. Half a century later it gave trouble again, causing minor inconvenience in 1937 (when Matisse entered a clinic for treatment), and erupting fiercely in May 1940, as the Germans advanced on Paris. Matisse's condition, undiagnosed and potentially lethal after seven months of neglect, was further complicated by a possible tumour (which turned out to be non-existent) and severely compromised by risk of heart failure. An exploratory operation was scheduled for 16 January.

Matisse spent the interval sorting out his affairs, making up a sealed box of documents to be given to his wife in the event of his death, writing to his family and sending tacit farewells to his friends. Picasso, Bonnard, Bussy, Camoin, Rosenberg, even the museum curator Raymond Escholier all received cheerful notes mentioning incidentally a small routine operation that was nothing to worry about. Matisse broke a lifetime's habit of reserve by telling Duthuit exactly what he thought of him, and posted two remarkable letters to Pierre. The first enclosed a copy of his will with instructions that his estate was to be divided equally between his three children. In the second, written in the small hours the day before his operation, he reviewed the results of the bargain he had made between life and art. It was a dispassionate, honest and accurate reckoning, deploring the suppression and secrecy that had turned his family relationships into a minefield, attributing many of his children's subsequent difficulties to pressures imposed by his work when they were young, and holding the emotional turmoil of the past two years largely responsible for his own physical collapse. He warned Pierre affectionately to avoid his father's mistakes in bringing up his own children, insisted that he felt no fear on his own account ('Don't worry – I'm not planning to die, but it is in my character to take precautions'), and ended by reiterating his deep and abiding love for his family, including

his wife. He added a postscript leaving his two latest paintings – *The Dream* and *Oysters* – to the City of Paris and the French State respectively. A second postscript asked the military censor not to tamper with this last letter to his son from a father about to face major surgery.

Professor Santy, assisted by his two colleagues, performed a successful colostomy in two stages, following the first intervention with a second on 20 January. Two days later, Matisse suffered a pulmonary embolism, which he only narrowly survived. Marguerite and Lydia took it in turns to watch by his bedside. All through January and most of February, Pierre received two or three telegrams a week in New York from his sister, who finally left Lyon on 1 March, only to be recalled two days later by a telegram from Lydia with news of a second, near fatal blood clot on the lung. Matisse lay for eight days in delirium and fever. His wound was infected, and his doctors despaired of his life. Some nights he, too, sensed himself slipping away, wondering in lucid intervals if he wouldn't rather be dead (he said afterwards the answer was definitely no). The energy and determination of the two women never failed him, although in the three months they spent together in Lyon his daughter could barely bring herself to acknowledge his secretary's presence. By the time the patient was out of danger, they were both almost as exhausted as he was. Matisse confessed later to Pierre that he regularly reduced each of the women to tears, bullying Lydia at one point so badly that even Marguerite hissed in his ear: 'Stop that – what if she left you?' He said he had asked his doctors to give him a respite of three years, and that his only way of stifling violent eruptions of fear and anger was to remind himself that from now on he was living in extra time.

By the end of March he was well enough for Marguerite to leave again for Beauzelle, and to be moved himself, on 1 April, to a hotel near the clinic with Lydia. 'Goodbye, I'm leaving,' he said pleasantly to Professor Santy, 'and I'm not going feet first.' He was still so weak that he couldn't even draw his

own coffin, and had to ask Lydia to sketch it in for him after several bosh shots in the margin of a letter to Bussy, explaining that the nuns who staffed the clinic had nicknamed him *le ressuscité*, the man who rose from the dead. Much of the time he lay watching the angry grey floodwaters of the Rhône through the branches of willow trees in bud outside his hotel window. He said he had not known a moment, day or night, since his operation without being intimately aware of his wound. Gradually, as if from a great distance, he rejoined the rest of the world, catching up with the deaths of friends, the fighting in Libya and Greece, and the German invasion of Yugoslavia. 'Napoleon is Hitler's god,' Matisse said on 10 April, the day the German army entered Belgrade; 'the only difference is, Napoleon didn't succeed.' He listened to reports on the radio of troopships torpedoed at sea, and the Luftwaffe reducing British cities to rubble. He wondered if anything would survive the madness in Europe that looked set to destroy what was left of the ancient civilizations of the East as well. On 2 May he sat up in bed and made his first drawing on a flimsy airmail letter to Pierre, who had heard nothing from his father for nearly four months, and now received a sketch of him reflected in his wardrobe mirror, wearing a nightcap and glasses, looking wry and battered but unmistakably alive and in his right senses.

Matisse was seventy-one years old when he returned from the grave in the spring of 1941. Inability to work made him look back for the first time in fifty years over the road he had travelled, trying to piece together a rough map of where he had come from and how far he had got. He entertained Albert Skira (who stopped off in the middle of moving his publishing outfit from Paris to Switzerland) with anecdotes from the past. Skira instantly recognized the makings of a book in the fact that, once started, Matisse couldn't stop talking. 'I was overtaken by a sort of crisis of words,' the painter said afterwards, 'like someone who has lived a long time shut away from the world, and needs to get out.' He agreed to exploit his sudden access of memory in a volume of reminiscences for Skira, who sent

along an enthusiastic interviewer from Geneva to ask questions, and a stenographer to take down the answers. The first session took place on 5 April and was followed in the next three weeks by seven more, ranging over Matisse's background, upbringing, training and early career.

The account he gave Skira's envoy, Pierre Courthion, is unreliable on dates but brilliantly acute and accurate about people and feelings. It revolves round a series of key stories – in particular the successive revelations of the painter's vocation – that give a mythical dimension to his life. Although Matisse had sketched out some of this material before in interviews with journalists, in a book he worked on with Raymond Escholier in 1937, and in a series of dialogues with Tériade, this collaboration with Courthion is the nearest he ever came to an autobiography. The completed typescript – provisionally entitled *Bavardages*, or *Chats with Henri Matisse* – was a more elaborate equivalent in book form of the vivid, uningratiating, private glimpse of himself he drew from the hotel mirror for Pierre. Matisse insisted that he needed above all to confront himself.

Courthion went back to Geneva at the end of the month to work on the corrected and expanded typed transcripts posted after him by Matisse, who finally returned to Nice with Lydia in late May. His aviary was half empty and his birds were dwindling fast for want of the special ants' eggs impossible to obtain in wartime. The pair of songthrushes he prized more than all the rest died soon after he got home. So did his dog Raudi, a touching and faithful companion, always consoling in trouble until he descended into blindness, deafness and death. Meanwhile Hitler's invading armies swept eastwards, deep into Russia, all through the summer and autumn. Matisse's own predicament seemed frivolous by comparison. He adjusted to it with patience and ingenuity, putting up with its limitations, making fun of his own helplessness and humiliation, learning to tolerate the metal-and-rubber contraption he had to wear as a protective girdle whenever he got out of bed. 'This regime

of severe, sometimes excessive pain doesn't suit me too badly,' he wrote to Pierre. 'It acts like a scourge.'

He engaged day and night nurses, and devised routines to restore something like normal functioning as fast as possible. When he found he could no longer manage even his usual five hours' sleep a night, he started getting up before dawn and either dozing in an upright chair or working from three to six in the morning, then taking a stroll and going back to bed until it was time to rise at midday for a second work session. He took immense pleasure in the activities left to him: eating, walking, drawing, seeing friends. Rouault, stranded further along the coast at Golfe-Juan after the Occupation, came over to Nice and insisted on climbing all the way up on foot in great heat to the studio at Cimiez. Bussy resumed regular visits, and when Bonnard couldn't face the interminable journey from Le Cannet by bus and train in wartime conditions, Matisse travelled out to see him instead. He organized supplies of scarce canvas and paints for Bonnard, provided Rouault with oil, and posted a magnificent parcel of goodies to Marquet (who was sitting out the war in Algeria).

Matisse told Marquet and others that the operation had cleared his mind, sharpened his sense of priorities and made him feel young again. He compared himself to a traveller who had packed his bags for the last time. Painting made life worth living even on sharply reduced terms, and he had no intention of wasting the three or four years he had told his doctors he needed to conclude his life's work. He took on new models, and embarked on a series of still lifes culminating that autumn in a majestic *Still Life with Magnolia*: a humdrum collection of ornaments and a kitchen jam-pan, set out symmetrically like ceremonial insignia, reduced to flat shapes and rendered in a palette of acid mauvy-pinks and blue-greens on a rich, saturated red ground. 'Matisse is a magician,' Picasso said crossly when he saw this unprincipled canvas, which conjures extreme sumptuosity out of frugality and rigour in defiance of all Cubist logic: 'his colours are uncanny.'

Matisse urged Rouault to write his memoirs and finalized plans for publication of his own in July, when Courthion arrived at the Regina with the revised typescript, a page layout, and a proof of the jacket design, which featured a specially drawn self-portrait. 'I can see him still, in his tea-planter's pyjamas,' Courthion wrote later, 'just as I saw him then in the dark, cool hall with bookshelves lit by a small lamp. He pushed a door open, and cutting through the blinding daylight came a strident chirping from the huge aviary hopping with birds, whose glinting plumage looked as if it had escaped from his brush ... Spread out on the tables of the great studio ... like a gathering of co-conspirators, lay the objects in which the artist exults, and which I recognized from having seen them magnified in his paintings: lemons lying about on the chair-seats, oranges drying on the tables, bouquets of lilies, shells, vases with necks of all different shapes, and at the back, above the cactus, a forest of lianas.' Courthion was dazzled by the light and heat, by the scent of flowers, by the view of sky and sea and the shimmering red roofs of Nice blocked off beyond the big bay window by a huge plaster cast, a larger-than-life-size, archaic Greek figure with a broken nose and an air of indomitable calm, clarity and power. For a visitor from neutral Switzerland entering a defeated, half-starved, and demoralized France as the war approached a grim climax in the summer of 1941, Matisse's studio and everything in it radiated serenity like the paintings themselves.

But Courthion soon sensed turbulent undercurrents. He was uneasily aware of unspoken constraints and invisible barriers that had not been present in Lyon. 'What you're making me do, or what I am doing here, is idiotic ...' said Matisse, only half joking, in the course of his last conversation with Courthion at the Regina. 'I relive my life, and I can't sleep ... You're putting me through a fearful debauch.' He was overcome by revulsion for the torrent of words that had poured out of him at Lyon. He told Courthion that he had consulted psychiatrists three times in his life. The first had listened without comment for sixty minutes, timing the two or three sessions they had

together with an alarm clock. The second had told his patient there was nothing wrong with him, and the third had explained that his nervous disorders were not a sickness but an essential part of his make-up. Now that he was starting to paint again, Matisse looked back on the episode at Lyon as weakness or self-betrayal.

After ten days spent slogging through Courthion's typescript, removing what he described as the interviewer's facile insertions and his own equally banal replies, Matisse gave the final draft to his jealous and somewhat resentful friend André Rouveyre, an ex-student of Moreau with aspirations as a writer himself. When Rouveyre turned thumbs down, the project was terminated with ruthless speed and finality. Matisse consulted a lawyer in September, Skira's publishing house in Geneva received a telegram cancelling the contract, Courthion wrote in shocked and horrified appeal, and Skira himself arrived, distraught, to be consoled with a proposition he could not resist: a luxury limited edition of the love poems of Pierre Ronsard which Matisse intended to illustrate. Matisse dismissed Courthion as clumsy and intrusive, but the real trouble seems to have been not so much that he probed too deeply as that he stuck strictly to the terms of their agreement, making little attempt to look beyond the surface of the work or its creator. Courthion had glimpsed the underlying mechanism that drove Matisse – 'He lives only in function of the next picture to be done' – without grasping what for, or why. The instructive, entertaining, and gossipy text of *Bavardages* leaves out a whole level of meaning that made sense of everything else for Matisse.

He was as reluctant as most painters to try to express in words what any given work signified, but he made an exception that autumn for the only picture Rouault produced in the Midi, a tragic canvas painted with infinite delicacy in a gamut of bruised blues. 'The subject is *The Circus Girl and the Manager*, seated opposite one another like a lamb confronting a tiger ...' wrote Matisse, who stored the painting for Rouault, explaining to Pierre that it disturbed him so much he had to keep it shut

in a cupboard. 'It is powerfully and poignantly expressive, it is
– the entire picture is – a portrait of Rouault ... A man who
makes pictures like [this] one is an unhappy creature, tormented
day and night. He relieves himself of his passion in his pictures,
but also in spite of himself on the people round him. That is
what normal people never understand. They want to enjoy the
artists' products – as one might enjoy cows' milk – but they
can't put up with the inconvenience, the mud and the flies.'

Courthion was replaced almost at once by an altogether
tougher and more perceptive observer. Louis Aragon wrote to
Matisse in September 1941 to beg a contribution for a little
magazine started up by a friend, and was surprised to receive
not only the pictures he wanted but a pressing invitation to
visit as well. He arrived with his long-time companion, Elsa
Triolet, to call on Matisse at the end of December. On Christmas
Day Aragon submitted for Matisse's approval a brief text designed
to accompany the reproductions, and on New Year's Eve he
and Elsa drove round the town in brilliant sunshine in a
horse-drawn trap with the painter, who took them out to
dinner that night to celebrate his seventy-second birthday.
Matisse's welcome at Cimiez was so friendly that Aragon suspected
some sort of trap. 'Every time I came there were fresh drawings.
Fresh temptations. He saw me coming, and he was ready for
me.' Matisse had papered the walls of his studio from floor to
ceiling with drawings, 100 or so lined up side by side in five
rows, one on top of another. At a time when Paris galleries were
suspect (since any dealer still operating could do so only on
sufferance from the enemy regime), Matisse had mounted his
own exhibition, and was proposing to appeal directly to the
public by publishing it in book form under the title *Thèmes et
Variations*. This was a harvest gathered over the past two years.
Matisse said it was one of the great flowerings of his life ('If I
manage to do in painting what I've done in drawing, I can die
happy'). What he wanted from Aragon was a preface.

Seduced by the concerted force of Matisse's attention,
mesmerized by his 'blue hunter's gaze', Aragon said he could

no more refuse than a mouse can resist a snake. As a schoolboy he had placed Matisse above all other painters, and now he found himself singled out in his turn: 'The painter invited me to write what he had not found in previous writings about him, what he evidently seemed to believe me capable of, and me alone.' A leading member of the French Communist Party, which had been dissolved on the outbreak of war, a veteran of Dunkirk and the Flanders campaign, demobilized at the armistice with the Croix de Guerre, Aragon was on the run that autumn, harassed and tailed by the police in Nice, expecting arrest any day for connections with the evolving underground resistance. He saw Matisse as one of the few ramparts still standing among the ruins of civilization in their 'mute, humiliated country', a guarantee of endurance and intellectual continuity badly needed at that stage of the war: 'It simply seemed to me that the time had come to be aware of the national reality of Matisse ... because he was of France, because he was France.'

Aragon set to work at once on an essay which he secretly hoped would grow into a book, delivering his text as he wrote it a few pages at a time and discussing each fresh batch with Matisse, who returned his visitor's scrutiny with interest ('He, whose portrait I thought I was drawing, had started to draw mine'). Matisse made nearly three dozen portrait sketches of Aragon: 'The pencil flies over the great sheet of paper fast, as fast as possible, as if it were trying to beat a record ... Matisse does not for one moment glance down at his hand.' The sitter did not care for the results at first, claiming they looked nothing like him. Matisse had drawn an invincibly confident interrogator – debonair, fresh-faced, unmistakably boyish – when his subject was in fact forty-five years old, thin to the point of malnutrition like practically everyone in wartime France, permanently anxious about friends missing or murdered by the Gestapo, and harrowed by thoughts of his mother, who lay dying far away in the Lot. It took time for Aragon to recognize anything of himself in these drawings, longer still to realize that they captured not one 'but thirty of my different selves', and longest of all to

acknowledge that Matisse's humorous, glancing, gliding, inimitably casual line had penetrated him to the core.

Painter and poet were haunted that spring by phantoms neither mentioned and both pretended not to see. Aragon, whose mother died on 2 March, returned to Nice after the funeral to find her ghostly presence looking back at him from Matisse's latest drawing, wearing precisely the expression she had worn on her deathbed ('I have exactly my mother's mouth, not my own, the mouth of my mother Matisse had never seen'). His own heightened sensitivity made him aware of another spectral companion, unseen but palpable, a sinister 'character called Pain' who lurked, goading and jabbing, in the painter's shadow. Matisse was often white and drawn, wincing from something worse than routine discomfort. A crisis at the end of March – fever, dizziness, palpitations – left him too weak to hold a pencil. He caught pleurisy, and had trouble with his ears. Aragon said he never looked well again. The preface was completed in late April, a month before Aragon was finally forced to flee Nice with Elsa, taking a portrait drawing as a parting present.

Matisse had been more or less bedridden since March, prevented from painting by recurrent, excruciating spasms of pain in his liver and stomach. His doctors ordered X-rays. 'This year is a write-off,' the patient wrote in disgust to Marguerite on 6 May, reporting ominously at the end of the month: 'I've missed out on the spring just as I did last year at Lyon.' A quarter of a century later Aragon wrote about the time they spent together in Nice in an essay, 'A Character called Pain', part prose poem, part memoir, evoking Matisse's invisible companion, who came to embody not only the painter's immediate danger but a brooding sense of their mutual grief and shame for things that could not be articulated at a time when the entire population of France was intimately acquainted with betrayal, deceit and concealment. The campaign of persecution instituted by the Vichy government against Jews and foreigners was accelerating. There were Fascist rallies in Nice, and checkpoints set up in

the streets. Matisse knew or guessed something of the growing climate of fear and violence ('He was sickened by it,' said Lydia) from Aragon, and his second broadcast attacking the Beaux-Arts system went out at the end of April on a programme directed by Aragon's friend Claude Roy. Officers called several times at the Regina to raise the matter of Matisse's Russian secretary, agreeing provisionally not to molest her provided she kept her head down.

Aragon and Elsa (who was also Russian) found shelter with a friend in Villeneuve-les-Avignon. When the publisher of Matisse's *Thèmes et Variations* objected to the inclusion of a preface signed by a Communist on the run, Aragon refused to adopt a pseudonym – 'because I consider it an honour for me that this text should appear alongside your drawings,' he wrote to Matisse on 11 July, 'and particularly these drawings which have been this year a large part of my life and thoughts, and practically the only human consolation for the life of horror that now surrounds us.' The publisher was the dealer Martin Fabiani, who had arrived in Nice, along with a good many others, after Rosenberg's flight, hoping to sign up Matisse. The dealer got the job for a trial period because he was a Corsican from Ajaccio, had a shrewd eye for pictures, and came with recommendations from Vollard's lawyer. But, in the dispute over Aragon, Matisse overruled Fabiani – who was afraid of compromising his contacts with the Nazi regime in Paris – and the preface appeared in due course under its author's name.

Aragon meanwhile spent the summer in Villeneuve, and was still there when police rounded up the town's Jews on the night of 31 August for deportation to concentration camps. 'There must be a harsh wind blowing through the streets of Villeneuve in a temperature that often drops to freezing,' Matisse wrote next day, improvising the kind of code which was the only way of evading the official censorship that muffled both private and public communication in Vichy France: 'Nice is beguiling on the surface – although it's not like that for everyone these days. What horrors.' One of the things that impressed Aragon most

about Matisse was the turmoil that could be sensed behind his immense power of surface dissimulation. The painter's nights at this point were more tormented than ever. He startled his night nurses with involuntary cries when he slept, and outbursts of rage and despair when he woke. He said that all his life he had dreaded falling asleep for fear of lowering his defences against nameless demons: 'I am inhabited by things that wake me, and don't show themselves.'

He fought by all the means at his disposal to reimpose reason and meaning in a daylight environment of brilliant sunlight where the exotic birds, the palm trees outside the window and the tropical vegetation indoors put him at the furthest possible remove from the shadowy night terrors which, as Aragon points out, he confronted directly only once in his work, through the bellowing, blinded giant in *Ulysses*. 'The magic of the world, the happiness of man, everything from which Matisse would create his universe of splendour, none of this implied ignorance of that cry, of darkness and of horror,' wrote Aragon, who saw the studio at Cimiez as a bastion of defiance. 'Do you think it's easy to pass from those terrible years to the sounds of peace? ... Henri Matisse in 1941, and afterwards, collects his thoughts, not following the scheduled dates in the newspapers, but returning to a moment that was his alone, to Tahiti, his Tahiti of 1930, restoring for himself in France under the Occupation an inner order through this return to Tahiti.'

Aragon was already dreaming of the book he would eventually write about Matisse, 'that other Matisse, the one I have in my head', a Matisse more complex and far more disturbing than the placid escapist pictured by more conventional contemporaries. His premonitions that summer proved correct on all levels. Matisse's spasmodic abdominal crises grew fiercer and more frequent. Abnormally pale, unable to paint, incapable of digesting anything but pap and vegetable broth, he sat up in bed and worked on his drawings for Ronsard. A prospective trip to Switzerland to oversee their printing with Skira was postponed from June to August, then to the autumn, and finally

until the following year. The situation grew so alarming that Marguerite arrived to take charge in July, galvanizing doctors and keeping watch over her father from a hotel in Cannes. Consultants gathered in emergency session in Nice in the first week of August. Wertheimer interrupted his holidays, and a Dr Guttman from Paris replaced Leriche. Both agreed that the patient was unlikely to survive a second operation, and were flatly opposed by Matisse's two local doctors in Nice, who insisted that he faced certain death by starvation if his surgeons refused to intervene. Matisse told Pierre he lay and listened to the two factions snapping and growling over him in the next room. The surgeons eventually won, arguing that this was a liver problem caused by gallstones, nothing to do with hernia (and certainly not cancerous), best treated by diet, bedrest and medication. 'So no operation,' Matisse reported to Pierre. All he could do was struggle on from day to day, praying to be rid of his gallstone, and quoting Ronsard's sexy little sonnet about a mosquito biting his mistress: '*Qu'un rien qu'on ne voit pas, fait souvent un grand mal* (It's nothing, you can't even see it, but it can do great harm).'

By the middle of August Matisse had spent nearly six months in bed. Lydia caught an outsize mosquito with a proboscis like an elephant's trunk, just as in Ronsard's poem, and imprisoned it under an inverted glass by the painter's bed for him to draw. Soon he had other distractions. The mosquito drawing became a tailpiece for the sonnet in its honour, balanced on the far side of a double-page spread by a sketch of Nézy-Hamidé Chawkat, a Turkish princess who had become one of Matisse's favourite models over the past two years. He had spotted her in the street and asked if he might paint her, requesting formal permission from her grandmother like a suitor applying for her hand. But Princess Nézy (who was a great-granddaughter of the last Sultan of Turkey) turned twenty and left to get married in the summer of 1942. Her place was taken by volunteers from her band of friends: bright, bored, cosmo-politan young women, stranded in Nice by the war with little

or nothing to do, amused and intrigued by her account of this singular elderly gentleman with old-fashioned manners who urgently needed their services in the afternoons. Lydia made sure that the whole strange set-up at Cimiez was impeccably correct. Nézy herself had brought a chaperone with her, and her replacements always wore swimsuits when asked to pose in the nude (to impersonate the mistress who reminded Ronsard of a slender young tree, for instance, or, later, the queen seduced by a bull in an illustration for Henri de Montherlant's play, *Pasiphaë*). On 14 August Matisse got out of bed to spend an hour at his easel for the first time, painting tentatively to start with, then with a steady renewal of energy.

He began with Nézy's friend Carla Avogadro, a young Italian countess who posed in an abbreviated dancer's tutu, with her long legs coiled up in a padded armchair on a checked marble floor. *Dancer with Arms Raised in a Yellow Armchair* launched an extraordinary set of variations which Matisse painted that autumn on the theme of girls in chairs on tiled floors, playing with light, multiplying and dividing it, making it glimmer and glow in compositions that reduced the minimal ingredients available – a door, a window, striped fabric, slatted blinds, sometimes a couture dress from his cupboard – to strips, swathes and swatches, broad bands and tilted planes of pure colour. These canvases have something of the speed and spontaneity of drawings. Matisse produced roughly one a week over five months. He told Aragon it was the start of a fresh campaign, one that would strip away all unnecessary external refinements to leave an irreducible core or pictorial essence, which he called 'the colour of ideas'.

The increasingly abstract paintings produced in the course of this campaign eliminated practically everything that made Nézy and her friends so charming. The princess herself (who reminded Matisse of the attendant on the right in Ingres's *Turkish Bath*) emerges from his drawings as a natural flirt, languorous, pert and seductive, with delicate oriental features and a cloud of wavy dark hair, wearing a rose or a twisted

rope of silk scarves or a smart spotted veil. There was something subtle, indefinable, even ethereal about Nézy, and Matisse captured it in *The Dream*, but now he needed a harsher and more exacting spirit. He found it in the student nurse who was supplied by an agency in September as a temporary stand-in for his regular night nurse, and whom he later engaged as a model. Monique Bourgeois was twenty-one years old: a soldier's child, drilled from infancy in military discipline, whose family had been homeless ever since they had been evacuated from Metz in cattle trucks, leaving everything behind, at the start of the war. Her father had died soon afterwards, her mother fell ill, and she herself developed tuberculosis, which was still only partially cured when Matisse gave her the work she urgently needed to support herself and her family. 'I was comfortable with him. I could breathe, I could relax, it was a haven of peace,' she wrote, describing how he and Lydia helped her slowly escape from a prison of timidity, unhappiness and self-mistrust: 'Life had maltreated me so badly in the last few years . . .'

Matisse gave her food coupons and grandfatherly advice about life and work. As a painter he loved the splendid mass of her dark hair and the way her neck rose from her shoulders like a white tower. Monique was a Girl Guide captain who had never worn make-up in her life, nor ever read a book without first asking her mother's permission. Matisse dressed her in a sleeveless chiffon evening frock with a plunging neck-line, emphasized her stately columnar neck with a string of heavy amber beads, and posed her in a straight-backed wooden chair like a throne to bring out her natural authority. Lydia said it was Monique, more than any other model, who renewed his determination to push forward once again as a painter into new and unknown territory. Monique, who had hoped to become an artist herself, was deeply shocked by the first portrait he made of her, a roughly painted composition of earthy yellows, pale grey and dark umber, anchored by the model's black hair and two black shoulder clasps, with her face and figure thickly

outlined in yellow ochre brushstrokes that radiate out like fansticks between the flat planes of her dress.

To most people who saw it this kind of thing looked like a senseless jumble ('It was just lines and blobs of colour,' said the sitter). Even the painter needed time to absorb the implications of what he was doing. In the most radical canvas of the whole sequence, *Interior with Bars of Sunlight*, he expunged his model almost completely, leaving her as a young-woman-shaped space of bare canvas in an otherwise geometrical arrangement of coloured bars and rectangles. He kept this apparently unfinished *Interior* by him, contemplating it from time to time 'as if pondering a problem', finally signing it off as complete in 1945. The painting is a time capsule whose contents would make sense only long afterwards in the light of optical experiments conducted by a generation of abstract artists who had not yet emerged. Matisse wrote a note to any future owners of his picture, urging them not to try colouring in the unpainted figure in the armchair at bottom right of the canvas: 'The figure, just as it is, has its own colour, the colour I wanted, projected by the optical effect caused by the combination of all the other colours in the picture.'

It was as if Matisse had gathered all his forces for a last supreme outburst of energy in the autumn and winter of 1942, which his two local doctors predicted would be his last. Marguerite had been warned that without surgical intervention her father would reach the terminal phase of malnutrition by the following April or May. Having successfully rescued him once, determined not to abandon him a second time to the mercy of doctors who had no confidence in his survival, she remained within call at Cannes, supporting his will with hers, suspending her own life so long as his was in danger, and renewing an uneasy alliance with Lydia for the sake of their common cause. Her efforts were seconded by Jean, who had set up a sculpture studio with his wife and son at Antibes and joined the local Resistance, organizing sabotage, liaising with British Intelligence, and travelling around the region with a suitcase of dynamite

for blowing up bridges. Matisse told Aragon (who came back to Nice in October) that he trembled for his son, knowing he kept explosives concealed in his statues. Aragon had the distinct impression that Matisse, who never openly mentioned his visitor's underground connections, was warning him not to risk his neck for the Resistance.

The German tide of conquest reached its peak that winter when Hitler very nearly defeated Russia, while his Japanese allies swept triumphantly through the Pacific. The United States had entered the war the year before (Matisse's correspondence across the blockaded Atlantic with Pierre ended in October). On 8 November American and British troops landed on the far side of the Mediterranean in French North Africa. Three days later the Germans responded by occupying the whole of France, and the Italians finally invaded Nice. Aragon escaped on the last train with a brown-paper parcel, delivered at the last moment by Lydia, containing proofs of *Thèmes et Variations* with his name intact on the title page. Matisse and his little group of elderly friends on the coast – Rouveyre in Cannes, Bussy at Roquebrune, and Bonnard (whose wife had died earlier that year) at Le Cannet – were now potentially on a front line. Civilians were required to observe a curfew and forbidden to move without a permit. There was constant troop movement along the Mediterranean as fishing ports and seaside resorts filled up with enemy soldiers.

By the end of the year Matisse was beginning to justify his surgeons' belief in him, eating more, suffering less, and ticking off the days one by one since his last liver attack. He celebrated New Year, 1943, by ringing Dr Wertheimer in Lyon to say he had been free from pain and fever for fifty-six days. He remained pitifully frail that spring, more prone than ever to chill, bronchitis and pleurisy, and still not strong enough to get up for more than a couple of hours a day. His eyes, always troublesome in time of stress or over-exertion, began to cloud over again, although his doctor assured him he was at greater risk of a stroke than of losing his sight. He maintained a precarious

equilibrium, thanks to meticulous nursing and constant vigilance from Lydia, but he found himself forced to paint less and eventually to give up altogether. 'He would have painted all day if he could,' Lydia said, 'but it was too demanding.' For most of the central years of the war, in the starvation economy imposed throughout France by German depredations, Matisse said that he hungered above all to paint.

He made do with drawing instead, falling back on Ronsard, whose music entranced and sustained him ('He helps me keep my moral balance,' Matisse told Rouveyre in the dreadful summer of 1942). He filled the wall where he lay with a 'private cinema' of constantly changing illustrations, merging and dissolving into one another like a film sequence he could direct from his bed, cutting, adjusting and redesigning images in his head when he was too weak to work. The twenty or thirty illustrations he had initially proposed grew in the end to the 126 lithographs of the *Florilège des Amours de Ronsard*, which took eight years to complete. When he felt he had gone far enough for the moment with Ronsard, Matisse moved on to the medieval court poet Charles d'Orléans. He said he gulped down the poems like the great gulps of fresh air that used to fill his lungs when he could still jump out of bed in the mornings. His drawings took on even greater freedom and fluency now that he could no longer sustain the physical and mental labour of painting.

Gaiety and good humour pervade Matisse's voluminous correspondence with Rouveyre, who served him all through the years he devoted to illustration as an unofficial editor-cum-literary-consultant. Sensitive, meticulous and tirelessly attentive, inexhaustibly knowledgeable on everything from prosody to layout and typeface, Rouveyre advised on the selection of authors to illustrate, which edition to work from, what title to choose, and whether or not Matisse's drawings of sprawled, entwined and eagerly interlocking bodies were too overtly erotic ('I never know how to do things by halves'). The painter himself was well aware of the element of compensation and consolation

in these supple and elastic young lovers, who make an unmistakably Matissean music of their own as sensuous and passionate as Ronsard's. 'Why, if my sensation of freshness, of beauty, of youth remains the same as it was thirty years ago in front of flowers, a fine sky or an elegant tree – why should it be different with a young girl? Even if I can't lay my hands on her . . .' he asked Rouveyre. 'It's probably what made Delacroix say, "I've reached the happy age of impotence."'

Rouveyre had once compared his friend to an electric light bulb, and Matisse now responded as if he had been switched on. He copied out whole poems in his own handwriting, or got Lydia to type them out for him, posting them off to Rouveyre decorated, looped and tied with coloured crayon, ribbons and bows, like parcels done up in gift-wrap. These letters led directly to the lightness and throwaway elegance of Matisse's *Poèmes de Charles d'Orléans*, a homage from one master to another, both specialists in anxiety, care and melancholy – '*Soussy, soing et mérencolie*' – and the art of keeping all three at bay. Rouveyre said he loved to watch Matisse's sap rising in response to Orléans. The two old friends readily reverted to their younger, simpler student selves in a correspondence that is cajoling and flattering on one side, flirtatious, even coquettish on the other.

The exuberant vitality of these letters, written when Matisse was in his seventies – physically disabled, often gravely ill, hampered by chronic weakness, eye strain, and the distressing side-effects of his bowel reconstruction – gives some indication of the terrifying pressure his energy must have exerted on his immediate entourage in his prime, and the inordinate amount of back-up and servicing required from his family to cope with it. Now they monitored his progress from a distance with gloom and misgiving. Marguerite, who spent nine months camping out in a hotel in Cannes, found it increasingly hard to maintain even a token alliance with Lydia, whose name she refused to use and whose existence she would have preferred not to recognize. The situation was complicated for both sides by the

presence of Amélie in Cannes, miraculously recovered from her own disability, still unreconciled to her husband but reluctant to desert Marguerite, at whose side she had fought long and hard in the past. Relations with Cimiez were strained. 'They think they've got so many rights over me that they can be irritating ...' Matisse grumbled about his family to Rouveyre. 'My life doesn't seem normal to them, especially the fact that I've adapted to it so well.'

One of his surgeons had compared Matisse to a crystal vase holding a sharp, heavy stone that was liable to shatter its container if shaken. Lydia took this image literally, turning the entire household into a protective shell designed to conserve the painter's resources and shield him from the slightest annoyance. Marguerite was dismayed by what struck her as the climate of indulgence and unhealthy adulation at Cimiez. Her father seemed cocooned and cut off from anyone brave enough to speak out and tell him the truth. At the end of May 1943, a month after she returned to Paris, she sent Matisse a stern call to order, warning against laxity, complacency and the onset of failing powers. She reminded him that the path of duty was arduous, and that she had his best interests at heart. Above all she deplored the influence of his secretary, who had inadequate experience of managing his affairs, and whose untrained eye could not hope to provide the rigorous critical appraisal which alone could stave off decline.

Matisse put off replying to her letter for almost two months. Nice was expecting bombardment and possible invasion by the Allies in the wake of German capitulation in North Africa at the beginning of May. There was talk of evacuating children and anyone over the age of seventy. Matisse decided to retreat inland, following Rouveyre, who had moved a few miles away to a small hotel in Vence, and now found him a place to rent for a year on the rocky, terraced hillside just above the old town. The Villa le Rêve was a plain, modest house with an overhanging red-tiled roof and yellow ochre walls, standing alone below crags on a south-facing stone platform cut out of

the hill. Lydia inspected the premises and organized the move, going ahead with Josette, the cook from Cimiez, to prepare for the arrival of Matisse and his night nurse on 30 June. This was the first time he had left home for two and a half years, and he could still walk no further than a few hundred yards, wearing dark glasses to protect his eyes. He intended to follow his doctor's prescription of two months' complete rest, planning to use the time to reflect and compose in his head now that he could no longer paint, nor be sure that he ever would again. His room on the ground floor of the villa opened on to a terrace with steps leading down to a garden full of palm, olive and orange trees. Lydia bought a wheelchair, and arranged with the local butcher to supply vegetables from his own garden for the simple, largely meatless diet that suited Matisse. There was no telephone at the villa, no car, and a silence so deep he said he felt as if he had moved to another country.

Here he finally composed a reply to Marguerite's letter, reviewing his position as much for himself as for her in a mood of exhaustion and deep discouragement. He said that, even though he had no illusions about ever regaining the vigour he had possessed at the height of his powers, he felt he had completed a lifetime's experimentation, and meant to make use of his discoveries no matter how unsatisfactory they seemed to others. As he considered the future, a familiar sense of injustice took over ('I've had enough of being hunted all my life, finding refuge in working like a galley slave'), and he cited the great predecessors – Rembrandt, Beethoven, Monet, Cézanne, Renoir – whose contemporaries had abandoned them in old age as he felt himself discarded now. 'Must I stop work even if the quality deteriorates? Each age has its own beauty – in any case I still work with interest and pleasure. It is the only thing I have left . . .' Matisse's long letter, which had taken so many weeks to formulate, was part self-defence, part passionate, painful appeal to the past, to posterity, and to his daughter, of all people the one he most wished to reach: 'Understand me – you know how.'

One of the complaints Marguerite felt it imperative to lay before her father was that his work remained in these years hopelessly out of touch with reality. In Paris, rumour said he was dying or senile, and that his recent canvases were worth buying only for the sake of the signature. *Thèmes et Variations*, through which he had hoped to appeal to a student market, had sold virtually nothing (500 copies – half the entire edition – remained stored in boxes for years in a mice-ridden cupboard at Vence). Wartime conditions had forced Skira to postpone his edition of Ronsard indefinitely, and there was as yet no prospect of a publisher for *Charles d'Orléans*. Matisse set to work on an illustrated edition of Henri de Montherlant's *Pasiphaë*, switching from the children's crayons he had used for d'Orléans' poems to another despised, childish medium, experimenting with linocuts, which enabled him to reverse expectation by drawing in dazzling white lines on a ground as black as the night sky. 'This is the book of a man who can't sleep,' said Aragon, when he saw Matisse's *Pasiphaë*. Matisse drew the heroine transfixed, with her head flung back in a silent shriek: 'a single white stroke against the black background, like a jagged flash of lightning,' wrote Aragon, singling out an image that seemed to him to carry a resonance beyond anything in Montherlant's text. 'Perhaps in reality it was other *sufferings*, taking place beyond the walls of his house, that turned this ancient story, at any rate in our eyes, into a cry, like an echo of things that no one talked about in Matisse's presence.'

Drawing on paper, copper plate or linoleum was a way of dredging up images from below the surface of the conscious mind, whose significance was not always obvious even to Matisse himself. He worked more and more by night, or indoors with the shutters closed, in these months when he found it hard to see properly by daylight (the eye specialist he eventually consulted diagnosed tension, prescribed rest, and advised him to stop listening to radio bulletins and avoid talking about the war). Linocuts gave him the spontaneity and directness he wanted, and so did the scissors-and-paper technique he had used for the 'war number' of *Verve*. Just before Matisse left

Cimiez in June, as Lydia dismantled his home and Allied warships patrolled the Mediterranean preparing to invade Europe, he picked up his scissors and started cutting out shapes as he had done four years earlier while waiting in Tériade's office for the war to begin.

'It was in the summer of 1943, the darkest point of that whole period, that he made an Icarus . . .' wrote Aragon. 'The *Fall of Icarus* . . . between two bands of deepest blue, consists of a central shaft of black light with Icarus laid out against it in white like a corpse, and, from what Matisse said himself, it seems that the splashes of yellow – suns or stars if you want to be mythological – were exploding shells in 1943.' Tériade, who had been pressing Matisse for years to embark on a second collaboration even more ambitious than the first, was deeply impressed when the painter showed him this cut-paper collage together with another design of white dancers and bursting shells or stars on a green ground. The two would become respectively the frontispiece and the cover of a special Matisse number published as part of *Verve*'s celebrations the year the war ended. This *Fall of Icarus* also led directly to one of the twentieth century's most extraordinary printed books, the triumphant cut-paper inventions of *Jazz*, which Matisse worked on all through his first winter at Vence.

Allied armies landed in Sicily in early July, bombing Rome and Naples, and finally invading Italy after six weeks' ferocious fighting. On 9 September, the day after the Italians surrendered, the Germans entered Nice. Matisse's basement at the Villa le Rêve was commandeered as a canteen for German soldiers heading down to the Italian front. Vence became part of a military support zone on pre-alert, expecting orders at any moment for civilians to leave. Flight seemed almost impossible, given Matisse's colostomy, which was still so capricious and difficult to manage that he told Marguerite he would not wish his worst enemy to go through the miseries it imposed on him daily. He said he was not sick, but wounded, 'like someone hit by a shell blast, for instance, with the wall of his stomach blown

away'. Air-raid sirens broke the silence in Vence as Allied bombers strafed the Côte d'Azur. Posts were disrupted, roads blocked, and trains derailed by the local maquis trained by Jean to use firearms and dynamite bridges.

'Courage, my dear Marguerite,' Matisse wrote in October. 'I often take courage myself from remembering how you have suffered all your life.' He worried about Marguerite's health, her journeys and her long silences now that she had gone back to Paris. Perhaps he already suspected that she had joined the Resistance, like Jean (also back in Paris that autumn, having got out just before his network was rounded up by the police in Antibes). Matisse had substantially increased the family's allowances twice since the start of the war, and he now provided large sums in case of emergency for his daughter and for his wife, who had stoutly refused Marguerite's suggestion that it was too dangerous for them to stay together. 'It's only when the house burns down that I'm at my best,' said Amélie, snapping back into her old heroic form. 'We've gone through so many campaigns together that I'm not giving up on you now. So what is there for me to do!'

In the months leading up to the Allies' long-planned assault on the French Channel coast, Marguerite acted as a courier for the *Francs-Tireurs et Partisans*, the military section of the underground Communist Party, carrying messages hidden in her glove to and from Paris, Bordeaux and Rennes in Brittany. Amélie spent much of her seventy-second year typing out reports with two fingers on a battered typewriter for the FTP to pass on to British Intelligence in London. 'As for me, I am made of the stuff of warriors, fanatics and all those consumed by ardour,' Marguerite wrote to her father, declaring she could no longer stand back as he did from the spectacle of destruction and death, 'even if I get my wings clipped for it – and even if I can no longer write calmly, now that most things seem to me so utterly without importance.' Matisse watched RAF bombers pass over Vence, heading east towards Nice and returning by Cannes, where the sky was lit up when a bomb

fell on the gasworks in November. Snow fell that month. An explosion outside the Villa le Rêve battered the front door and injured two passers-by. The painter arranged to escape if necessary with Lydia by ambulance to a hotel in Annecy, leaving everything behind but his work.

Matisse celebrated his seventy-fourth birthday with Rouveyre. Snow lay thick on the hillside at Vence. Word came from Bussy, hanging on at Roquebrune, and Bonnard, holed up with a broken leg and a sack of beans at Le Cannet. Matisse himself spent much of the winter in bed, working on his *Jazz* illustrations, and reminding Bonnard's nephew of Winston Churchill, who was said to be conducting the war from his bed in London with writing materials, a radio and telephones within reach of his hand. Keeping Matisse and his studio going on a bare mountainside so close to the firing line required phenomenal perseverance and ingenuity. Lydia had no help at home except for the cook, no outside support apart from the local doctor, and no recourse to the illicit supplies peddled by a thriving black market, which Matisse refused to patronize. For two years the whole country had been bled dry to supply the German army. By the beginning of 1944 the basic necessary minimum – food, heating, transport, communication – was virtually unobtainable. 'But Matisse's survival depended on it, and Lydia set herself to solve the problems,' wrote Annelies Nelck, a young Dutch painter who tapped on the door of the Villa le Rêve in February to ask for help with her work. Nelck was astonished by Matisse's studio – 'a strange space, luminous, full of flowers and greenery, furniture, undulating objects and moving colours, exotic creations' – and even more by the majestic apparition seated in the centre of a big wrought-iron bed, propped up against a mass of white pillows 'like God-the-Father emerging from whipped-cream stucco clouds above the altar in one of the little baroque churches in the country round about'. Nelck posed for Matisse that spring, slowly coming to realize, as she became almost part of his household, how much effort went into preserving his health and safety intact.

Cold was a greater enemy than bombs or shells, now that fuel for the fire was even harder to come by than food for the table. Lydia, mindful of her Siberian childhood, heated the studio with a wood-burning stove and hung thick, heavy rugs at doors and windows to block the icy wind from the mountains. She scoured the countryside on her bike for provisions, negotiated with the tradespeople of Vence, and took boxing lessons to give her confidence in dealing with marauding soldiers. She became adept at studio management, countering the painter's spleen and despair as patiently as his practical difficulties. She had a knack of defusing outbursts so skilfully that Matisse became literally speechless, 'like a pot of boiling water removed from the fire', in Nelck's expressive phrase. As a last resort Lydia threatened to go back to her homeland to serve as cannon fodder on the Russian Front ('And, you know, she'd be quite capable of it,' Matisse observed to his night nurse). The serenity that struck Nelck and others in Matisse's studio, the impression of Jove-like calm and Churchillian control, was bought by a daily, unremitting, mutual campaign to subdue and control the inner turbulence that broke out at intervals in cries and palpitations when his heart raced and he struggled for breath. 'His feelings were very strong,' said Lydia.

Bombs were still rattling the doors and windows of the Villa le Rêve in April, when Matisse received a hurried, anxious note from his daughter written on Easter Monday, 10 April. Three days later she was arrested by the Gestapo as she stepped off the Paris train on to the station at Rennes. Amélie was taken to Gestapo headquarters in Paris for interrogation the same day. 'I've just had the worst shock of my life,' Matisse wrote to Charles Camoin, describing what had happened, explaining that he had been warned to tell no one, and urging his friend to destroy the letter as soon as he had read it. Attempts to discover more were blocked on all sides in the climate of terror that had intensified throughout France as denunciations and police round-ups became part of normal routine. People regularly disappeared without explanation, imprisoned, deported, or shot.

Questions were met with closed doors and shut mouths. Matisse appealed to anyone he could think of who might provide information, sending copious funds for Jean to disburse in the search. Any possible leads were muffled in suspicion and secrecy. 'Even the high-up Germans were afraid,' Matisse reported, 'because over them was the Gestapo.'

Apart from Lydia, almost the only person Matisse talked to about his family was Nelck, who had escaped from Holland when she discovered she was pregnant, leaving the child's father behind to work for the Dutch Resistance. 'Things are difficult for everyone at the moment,' Matisse said gently, telling Nelck of his own trouble, when news came at the end of May that her lover had been arrested and was being held in a prison hospital, awaiting deportation to Belsen. In the first week of June the Allies landed in Normandy to begin advancing south and east, driving the Germans before them through France. Matisse had plunged back into work, attempting to blot out his feelings by illustrating Baudelaire's *Fleurs du Mal*. 'I know he scarcely sleeps any more,' Nelck wrote in her diary in June. 'Anguish for his wife and his daughter gnaws at him ceaselessly, but he allows nothing to show.' After three months without news Matisse finally learned that Amélie was serving a sentence of six months in the prison at Fresnes. 'I daren't think of Marguerite, about whom we know nothing. Nobody even knows where she is.'

Matisse collapsed in a fever with symptoms that made his doctor fear a recurrence of the liver problems of two years before. It was the middle of August before he could set foot out of bed. By this time Allied forces were landing along the coast between Marseille and Nice, and beginning to sweep up through the Rhône valley to meet the armies marching down from the north. Paris was liberated on 24 August. Nelck, posing three days later for a drawing for the *Fleurs du Mal*, cried out when she saw a troop of enemy occupants march past the window, but Matisse did not even turn his head. 'Never let it be said that I stopped work to watch the Germans depart,' he

said grimly. Vence was liberated without incident, except for three stray shells falling round the Villa le Rêve (Matisse descended with Lydia and the terrified cook to a shelter in the garden, where he spent thirty-six hours reading Bergson with concentrated attention for the first time in his life). The Red Cross headquarters in Switzerland, to whom Matisse had appealed for news of his daughter, sent word too late that she had been imprisoned in Rennes all along. Matisse's money order arrived only after the Germans had loaded Marguerite along with their other prisoners on to cattle trucks destined for the Ravensbrück concentration camp in Germany. Nothing could be done or found out.

The country erupted in delirious rejoicing, with dancing in the streets and flags everywhere. A fever of vengeance swept France, producing girls with shaven heads even in Vence, and heaping public disgrace on the band of artists headed by Derain and Vlaminck, who had rashly accepted official invitations to tour Germany two years before. Derain's reputation was ruined for ever, and Vlaminck was arrested for publishing a series of venomous attacks during the Occupation on fellow artists (including Picasso, who now chaired the national committee busy purging the art-world of suspected collaborators). 'At bottom I don't believe it's up to any of us to torment people with ideas different from our own,' Matisse wrote, as the hysteria of Liberation turned sour. By this time Picasso had joined the Communist Party, announcing his decision with fanfares on 3 October in the same week as the opening of the post-Liberation Salon d'Automne, largely dedicated to himself and his work.

Amélie was released at the beginning of October. A few days later a postcard from Camoin reached Vence, announcing that Marguerite was free. This was followed by a card from Marguerite herself. 'In spite of everything, I always knew you would survive,' wrote Matisse in a letter full of love, incredulous relief and passionate longing to be with her again: 'Oh why can I not get to Paris?' Over the next few weeks Marguerite wrote several

times to her father, calmly and clearly describing her experiences in the five months of her disappearance. She had been tortured to the brink of death at Rennes in April. German Intelligence, suspecting that the Allies planned to land their invading armies in Brittany, urgently needed names and information. Marguerite was interrogated by Gestapo agents who beat her with their fists, bursting her eardrum, then shackled her by wrists and ankles to a table while two other men beat her alternately with a steel flail and a triple-thonged rawhide whip. She was suspended by her wrists for a second beating by fists, then repeatedly immersed in a bath of ice-cold water and held under until she lost consciousness. She told her tormentors nothing but, locked up alone in a cellar without treatment – for two days without even water – Marguerite feared that she would not be able to resist further torture, and tried unsuccessfully to kill herself by slitting her wrists with a splinter of broken glass.

She was saved by her fellow political prisoners, who had been assured by the Red Cross that there would be no more deaths under interrogation, and who reacted so violently when word got round that a woman was being tortured to the furthest limits that the prison commander had no alternative but to reprieve Marguerite. After four months she was transported eastwards on the last train to leave Brittany, which was strafed by Allied bombers, held up by impassable bridges over the Loire, and finally halted just before the German border at Belfort. In the ensuing chaos she was released almost at random, without money or papers, into a town whose inhabitants had locked their doors and windows against an influx of fleeing collaborators who were behaving like wild animals in their frenzy to get out of France. Marguerite was found hiding in the woods by members of the local Resistance, who looked after her until the Liberation. The doctor she saw on her return to Paris said she had survived by a miracle. The surgeon who had operated on her throat in 1919 found her windpipe still in working order. Her experiences had left her without nightmares, able

to eat and sleep normally. She was haunted by thoughts of the companions she had left behind, who were now in a German death camp, but she said that the horrors she had gone through herself had fallen from her as if she had stepped out of a coat she refused to wear. 'I always wanted to master my body, and the sufferings it imposed on me ...' she told her father. 'You have to show yourself in face of everything, and against everything, tough enough to stay upright.'

Matisse recognized the philosophy of endurance he had taught his daughter carried to lengths even he had never imagined. Appalled by her account, astounded by the power of her will, he begged her to look after herself, sending long letters of encouragement, advice and admiration, and small packets of luxuries. Christian Zervos, seeing Marguerite at a concert in Paris, said she glowed with an inner radiance that gave her an almost unearthly beauty. Rouveyre said the same ('How touching she is, and how lovely, after that terrible ordeal. It didn't kill her, but it has ringed her with light'). She came south after three months' recuperation, in the middle of January 1945, travelling by plane with priority treatment arranged by her father, who sent a taxi to meet her at Cannes airport and booked her a room in Rouveyre's small, warm hotel in Vence. For two weeks they spent every afternoon alone together. Matisse said he was literally hypnotized by what she told him: 'I saw in reality, materially, the atrocious scenes she described and acted out for me. I couldn't have said if I still belonged to myself ... I was aware several times in her presence of taking part in the greatest of all human dramas − in a side of the existence of others which it is rare to be able to live through with such intensity, to the point where you no longer feel yourself existing separately.' For much of the time he was powerless even to draw her.

At the end of the month two neighbours in Vence, the dealer Aimé Maeght and his wife, drove her in their comfortable car through snow and blizzard back to Paris. Matisse was knocked flat for three days when she left. Work was no help to him now.

He told Marguerite it was almost a fortnight after their journey to hell and back before he could even begin to function again. People all over France were intent on celebration, levelling old scores and laying foundations for the brave new purged and liberated world of the future. 'As for me, I'm caught up in the agonizing whirlwind of my daughter's memories of captivity,' Matisse wrote to Rouveyre at the end of January. 'I've been demolished by it.'

15. *The Old Magician (1945–54)*

People who visited Matisse in Vence after the war commonly reported two successive surprises. The first was to find him living in such a box-like little house: the Villa le Rêve was so plain and unassuming that Picasso initially knocked at the door of a more picturesque place further up the road, and had to be escorted back by a neighbour to the right front gate. The second surprise was stepping over the threshold from the sunlit garden into a pitch-black entrance hall. 'We entered one room and then another,' wrote Françoise Gilot, describing her own first visit to the villa with Picasso. 'All shutters were closed, and everything stood in obscurity. As our eyes accommodated to the darkness, the objects gradually emerged from the shadows.' In one room light filtered dimly through the tracery of a *moucharabieh*, or Arab screen. White doves flew freely in another. Pots, plants, ornaments and oranges scattered on chairs or tables appeared to come to life, and to be even more alive in the still lifes hanging behind them in the gloaming. 'A date tree swinging its palms in the garden outside was framed by the window's colourful Tahitian curtains, and repeated, larger than life, on the wall, as if the strength of this painting allowed reality to become a mere reflection . . .'

Gilot was not the only one who came to think of Matisse in these years as a magician, expanding or contracting space at will. Many people felt in his studios at Vence or Cimiez as if they had entered another world, or crossed into a different dimension of the one they knew. Matisse, who said that every drawing or painting was a morsel of himself, seemed in the closing decade of his life to have turned even his physical environment into an extension of his own way of seeing. He was operating literally as well as metaphysically on the borders

of perception. 'I'm out of action because of having flirted for too long, more or less nonstop, with these enchanted colours,' he wrote to Rouveyre at the end of 1943, when the paper cut-outs he made for *Jazz* brought his lifelong confrontation with colour to a climax. His Nice oculist (who had treated Monet in his last years in Paris) explained that the eye could not fabricate pigment fast enough to keep up with the speed and intensity of Matisse's response to colour. The painter said he had achieved the same intensity before without being able to sustain it, like a juggler throwing his clubs so high he couldn't catch them. Now he cut or carved directly into colour, using scissors and sheets of painted paper, working all day and much of the night, covering his walls with a display of unprecedented brilliance and fluidity. 'He lived in and for it,' said Lydia. Warnings that this kind of strain might permanently damage his sight could no more stop him than his father's insistence that he would starve had stopped him becoming a painter in the first place. Matisse lived in darkened rooms, and even took a kind of pride in the fact that his eyes required protection from his latest work.

At the beginning of 1945, he told his daughter he had gone as far as he could with oil and canvas. 'Paintings seem to be finished for me now ... I'm for decoration – there I give everything I can – I put into it all the acquisitions of my life. In pictures, I can only go back over the same ground ... but in design and decoration, I have the mastery, I'm sure of it.' He felt the same surge of energy he had experienced as a boy when he held his first paint-box in his hands. Now as then he had no time to lose. 'I asked my doctors in Lyon for three years' respite in order to bring my work to a conclusion – that was four years ago, and there are still things I haven't said.' This was the last great liberation of his life. He plunged headlong – 'without thought, especially without afterthought' – into a new world of decoration whose patterns corresponded to the inner movements of his mind. Its infinite possibilities embraced both strength and weakness (or rather, as he said, eliminated distinctions between

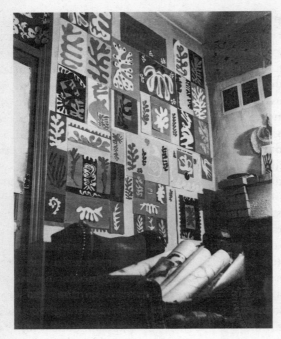

*A wall of cut-outs in
the studio at Vence*

the two). Its rhythms freed him finally from the inhibitions of
the conscious will. Spontaneity was its greatest gift.

 'When we arrived we found Matisse armed with a huge pair
of scissors, carving boldly into sheets of paper painted in all
kinds of bright colours,' wrote Gilot, describing another of her
visits to the villa with Picasso, when their host sat up in bed
holding the paper delicately in his left hand, winding and turning
it beneath the blades in his right, which released a steady stream
of cut-outs dropping on to the coverlet below. 'There is nothing
to resist the passage of the scissors,' said Annelies Nelck, 'nothing
to demand the concentrated attention of painting or drawing,
there are no juxtapositions or borders to be borne in mind.
And the little creatures extracted from their element fall from
the scissors in quivering spirals, and subside like those fragile
organisms the sea leaves washed up on the sand.' Matisse worked

without fumbling or hesitation, comparing himself repeatedly in these years to an acrobat or juggler. Mind, hand and eye flowed effortlessly together ('It's like a dance,' he said). People who watched him found themselves hypnotized by his gliding fingers. Once, Gilot and Picasso brought a real magician to Matisse's bedside as a tribute. Matisse returned the compliment by making abstract portraits of them both, one after the other, cutting out, sorting and combining shapes on a coloured ground 'until finally the entire assemblage started to interact and bloom', ready to be pinned in place by Lydia. 'We were spellbound, in a state of suspended breathing . . .' wrote Gilot, describing a performance that reduced Picasso to stunned silence. 'We sat there like stones, slowly emerging from a trance.'

Every barrier Matisse had broken through in the past had cost him fearful pain and labour. In his seventieth year, he said he still felt the urge to strangle someone before he could begin to paint, and likened the act itself to slitting an abscess with a penknife. It was only when shape and colour began to interest him to the exclusion of all else that he started experimenting with speedy new techniques – scissors-and-paper, linocuts, children's crayons – all aimed at eliminating friction. 'I would say it's the graphic, linear equivalent of the sensation of flight,' he said of his cut-paper work, explaining that scissors in his hands became as sensitive as pens, pencils or charcoal sticks ('perhaps even more so'). Drawing with scissors effectively abolished the frontiers between thought, feeling and expression. It allowed him to concentrate on overall effect, a knack perfected in more traditional ways of drawing where he no longer worried about inessentials, 'any more than a juggler in action thinks about rain or tobacco or beer as his umbrella, his pack of cigarette papers and his beer mug spin through his fingers'. The new technique capitalized on the elasticity and confidence acquired initially from etching, and developed in the illustrated books that came out at intervals after the war: *Les Fleurs du Mal* in 1947, the sumptuously simple *Florilèges des Amours de Ronsard* in 1948 and *Poèmes de Charles d'Orléans* in 1950. All of them caused misery

to editors, printers and their workmen, who learned to dread Matisse's fastidious and exacting supervision as much as they relished the phenomenal boldness and precision of his hand in action. Drawing on highly polished copper plates, swerving and swooping over a surface less resistant than paper (which swallows the ink and slows the pen), produced a crisp, decisive, calligraphic style that flowed directly into the breathtaking condensations and abbreviations of his large-scale late work in cut-paper.

At the time, Matisse said he had no specific aim in mind when he covered the walls of his studio with coloured cut-outs. In retrospect, he saw the years of solitude and wartime privation in Vence as a period of preparation, the equivalent of a musician practising scales, or an acrobat rehearsing balancing techniques before walking out on the high wire. He said he had been mistaken all his life in measuring the significance of any given work by the struggles that went into it. In his mid-seventies he felt himself approaching the clarity, power and purpose evoked by Paul Valéry in a passage Camoin copied out for Matisse at the end of 1945: 'Perhaps what we call perfection in art . . . is no more than the sense of wanting or finding in a human work that certainty of execution, that inner necessity, that indissoluble, reciprocal union between design and matter, which I find in the humblest sea-shell.'

Matisse had come as close as he ever would to dissolving the demarcation lines between art and life. 'Everything was for his work,' said Lydia. 'He ate sparingly so as not to have problems with digestion, he took a siesta in order to be rested for the next work session, he hired a night nurse in hopes of claiming as many hours' sleep as possible.' The process was simplified by Lydia, who defined her secretarial duties in the same terms as Diaghilev: 'A secretary must know how to make himself indispensable.' Matisse's visitors never tired of speculating about Lydia's status – 'she gave the impression of a slave, a very beautiful slave' – and the precise functions she performed. But her air of oriental mystery concealed impressive, if unconventional administrative

talent. She typed, kept records, paid bills and drew up meticulous accounts, organized Matisse's correspondence and coordinated his business affairs with steely efficiency. Her will was indomitable, and her exploits legendary. One summer's day in 1945 Lydia set out to dispatch an urgent package to a publisher in Paris only to find rail services unexpectedly disrupted in Vence, so she raced down the mountain on foot, walking fifteen miles in broiling heat before picking up a local train further along the line in time to reach Nice and deliver her packet to the guard of the Paris express with seconds to spare. Matisse kept up a running joke with Rouveyre about Lydia's real and imagined capacities in all departments, whether it was solving problems of logistics, subduing resistance from unruly editors, or simply piloting an aeroplane ('It would surprise me if she didn't know how to fly one'). His entire household came to a standstill in her absence. Lydia for her part never modified her allegiance to Matisse, who had given her life a purpose, and trained her to fulfil it. 'Without insisting or explaining anything, he made me useful,' she said, 'and little by little, I became even more useful than he'd hoped.'

Matisse left a graphic record of her progress in two very different portraits. The first – *Young Woman in Blue Blouse*, a tiny canvas gleaming with spring-like gaiety and freshness, painted in the autumn of 1939 (see page 465) – shows Lydia with straight nose, pink cheeks and yellow hair in a dove-blue dress, looking childishly neat and simple, even prim, but upright and centred like the plumb line. 'I was a dimwit in those days,' she said long afterwards, 'totally ignorant of anything to do with painting.' In 1947, Matisse reviewed their partnership again, painting her this time with deep green hair and clear-cut, authoritative features sharply divided by geometrical zones of blue and yellow in what he called the *Bi-coloured Portrait*. 'I had changed during those years,' said Lydia. 'Responsibility made me like that. I felt my personality completely altered. Before I was shy and inward-looking. But it was necessary for me to go into action, to see to everything, to give orders.' Lydia had

acquired very nearly mythical status by this time in the envious eyes of other painters. She washed Matisse's brushes, cleaned his palette, pinned his paper shapes in place with a deftness and accuracy even he could not fault. Her prowess in the studio was matched by her reputation as the dragon guarding his privacy against encroachment from the outside world. She kept track of appointments, dealt with workmen and suppliers, engaged and managed models and assistants in the atmosphere of disciplined tranquillity that struck everyone who visited his studio.

All these routines were first established on a solid footing in the years of wartime seclusion that she and Matisse spent together at Cimiez and Vence. The two people who encountered them daily at this time – André Rouveyre and Annelies Nelck – both thought of Matisse and Lydia as a single unit. Rouveyre said he found it hard to see them as separate entities. To Nelck, who had turned up in desperation on their doorstep, they showed a concerted front of tolerance, kindness and concern. 'I was a child, in a catastrophic state when I came to them, and instead of throwing me out, they gave me, both in their different ways, the most precious thing they had: their time and their attention.' She was by her own account ill, poor, malnourished, unstable, at times almost frantic with misery and foreboding. All she knew about Matisse at that stage was that local people said he was a painter. Between them he and Lydia slowly and patiently calmed her perturbed and angry spirit ('What is so marvellous about these two,' she told her diary in 1944, 'is that they under-stand everything without ever passing judgement').

Over the next six years Nelck became for all practical purposes an adopted daughter of the house, posing, running errands and helping Lydia in the studio. Matisse took charge of her education as a painter, gave her employment as a model, found buyers for her work ('I told them your usual price was 1,000 francs for a portrait'), and presented her with occasional drawings of his own ('so that, in case you ever need it, you have a little reserve to dip into,' Lydia explained). Nelck said he taught her as much about order and balance in her life as

in her painting. Her testimony as to how he and Lydia functioned in private as a couple remains unique. Like Aragon, she saw their exclusive absorption in Matisse's work as a form of defiance, a stubborn refusal to be outfaced by potentially disastrous odds. 'I was a witness of the daily unobtrusive exercise of heroism and virtue, and I could recognize its results,' she wrote, describing an ascetic regime stripped of superfluous social or domestic content.

He and his doctors knew well enough that in the last resort his life depended on Lydia. He had no illusions about his own chances of survival as he watched his friends claimed one after another in the next few years by infirmity and death. The first to leave was Aristide Maillol. 'He ranked senior to us all and now he's gone ...' Matisse reported in one of his first letters to Pierre after the Liberation. 'I hope his lieutenants will have better luck – they're rather shaky, but I hope they'll hold the fort for a bit. You know who I mean by the lieutenants – there's Bonnard, who's seventy-nine and can still get about ... then there's me, hoping with minute care to keep going a while longer.' Berthe Parayre, who had sworn to live long enough to see France liberated, lay dying from cancer at Beauzelle that spring. 'Berthe, poor Berthe, ending her life so unjustly after a life entirely given to others,' Matisse wrote to Pierre, who reached France just too late to see his aunt alive. She died on 4 June 1945, a month after the German armies surrendered unconditionally in Europe. Amélie, who had refused for years to acknowledge Berthe's existence, spent the final weeks at her sister's side. In the six years since Matisse had last seen his wife, their roles had been dramatically reversed. Whereas he would spend the rest of his life more or less bedridden, she had sailed through the ordeals of arrest, interrogation and incarceration, emerging with aplomb in excellent health to face a prosperous old age surrounded by the pictures which, as she reminded her husband, had been at the core of her life as well as his.

In the spring of 1945, Matisse's oldest friend, Léon Vassaux, came to stay with him in Vence, looking unrecognizably bent,

frail and worn. The two reverted to an easy, companionable intimacy, exchanging news, relaxing over good food, wine and music, capping one another's stories of their Bohain boyhood and their student escapades on the Left Bank. They sampled the hearty onion soup and sipped the strangely flavoured nips of neat spirit peculiar to their native north, carefully prepared and served to them by Lydia. She said Vassaux released a side of Matisse – buoyant, jokey, uninhibited – he showed no one else. The second time Vassaux came to stay, he brought with him Matisse's first sculpture, a clay medallion of the girl they had both loved as students more than half a century before. Camille Joblaud, Marguerite's mother, was now also in her seventies, married to a retired schoolmaster in Brittany, and consoled by the golden recollected glow of her short reign as the toast of the artists' quarter in Paris. Matisse, who sent money and received news of her through their daughter, hung her plaster portrait on his wall in valediction.

He returned to painting for the last time at this point, producing a final astonishing set of variations on a theme first painted in Camille's living presence, the studio interior. Her sculpted profile appears in three of these canvases – *Red Interior with a Blue Table, Still Life with Pomegranates*, and *Still Life with Pomegranates on a Ground of Venetian Red*, all produced in 1947 – paintings that incorporate the claims of the past without nostalgia or false sentiment in the patterns of the present. They belong to a group of nearly thirty views of the studio at Vence, which project light and colour with a vitality so intense it seems almost independent of its physical origins. They look forward to new forms of pictorial abstraction while recapitulating a mood of inner contemplation that goes back to Matisse's earliest work, a Proustian sense of time, telescopic and infinitely adjustable, like space.

On 3 July 1945, Matisse returned to Paris, travelling by sleeper on the train with ambulances laid on at either end, to prepare for the joys and strains of a complicated family reunion. Jean had settled at Issy, working in his father's garden studio and

living with his family in the town. Marguerite was installed in her apartment on the rue de Miromesnil that summer, awaiting the return of her husband and son from wartime exile in New York with Amélie, who had moved back into the Duthuits' spare room. Pierre was the first to reach France, flying in at the end of July to resume in person the postal conversation with his father interrupted in the past six years only by Matisse's operation and the Atlantic blockade.

Throughout the public and private dramas of the war, Matisse had articulated his hopes, doubts and fears in weekly letters of up to twenty pages, written on both sides of transparent airmail paper, sometimes with extra lines crammed in at right angles across the top of the original message, as if he could scarcely bear to break contact with Pierre. The letters convey on both sides a depth and tenderness of feeling neither party could find words for face to face. Father and son alternated roles, offering one another sound advice and sensitive consolation, occasionally enlivening their civilized exchange with tirades of Racinean fury or reproach, in a correspondence that combines a diary's scope and freedom with the frankness of the confessional. Like the confessional, it would retain its secrets to the end of both their lifetimes. In public, Matisse's treatment of his son was often wounding or dismissive. Pierre grumbled loud and long about his father. Neither family nor friends suspected the hidden side of a relationship poisoned on the surface, as post-war prices rose and stocks of paintings dwindled, by Matisse's ingrained mistrust of the dealers' trade.

Terms had to be renegotiated all round in the summer of 1945, as the family slowly adjusted to new positions at the margin of Matisse's life and work. He himself was wary and on edge. This was the first time since the official separation from his wife that he had confronted the outside world with 'Madame Lydia' at his side. They settled into the family apartment on the boulevard du Montparnasse with a night nurse and the cook from Vence, but although neither studio nor household could function without her, Lydia's position was painfully equivocal.

No one knew what to call her, how to treat her, whether or not to take seriously a secretary who combined the role of chief executive with the duties of model, nurse, companion, studio aide and office dogsbody. Male visitors re-establishing official links with Matisse after the war were intrigued by her virtually invisible presence in his apartment. Married couples could not receive her, and her professional credentials would take years to establish with the Paris art-world. Privacy was impossible, since Matisse scheduled appointments at home and ran his affairs through Lydia.

'I'm going to try to isolate myself by behaving as if I were still absent,' Matisse had announced before he even reached the capital, but his hopes were dashed by a regular tide of journalists, government envoys, exhibition organizers, dealers and curators washing through the apartment every afternoon. 'Paris is hell,' he wrote after a fortnight to Rouveyre. Publishers and the dentist took up such time as he had left. After a month, he caught bronchitis. Exhaustion was compounded by official attempts to requisition his apartment, and by a failure of the heating system in the vaults of the Banque de France that disastrously affected the work in storage. The ten weeks or so initially set aside for Paris lengthened to a stay of four months, much of it spent assessing damage, relining canvases and drying out hundreds of waterlogged, often mildewed etchings. Matisse lurked in his room as if it were a hole or cave, rarely leaving the apartment except for visits to the cinema (his first colour film, starring Danny Kaye, was a revelation), or trips to a shooting booth on the boulevard du Montparnasse, where he and Lydia hired rifles to relieve their feelings.

Marguerite had warned her father about the campaign of persecution and denunciation raging in liberated Paris against anyone accused, with or without reason, of having collaborated with the Germans. Fabiani was arrested, and Skira was refused permission to re-enter France. Matisse himself would eventually be forced to drop a scheme to erect a memorial in the Midi to Maillol, whose name had been tainted by the Vichy regime's

attempt to rebrand him as France's equivalent to the Nazis' 'sculptor of the future', Arno Breker. The mindless virulence of these witch-hunts dismayed Matisse. 'I don't see what good my protests would do,' he said when Mme Marquet urged him to speak out against the wartime delegation headed by Derain and Vlaminck. 'You know that those who went to Germany were driven to it by a kind of fright, and they've already suffered for it.' Political involvement was not in Matisse's nature, but neither would he criticize Picasso, whose public pronouncements made him the popular embodiment of the patriotic pride – *la Gloire* – in whose name so many excesses were committed. 'I don't think like him,' Matisse told his daughter, who had endured too much real suffering to be impressed by Picasso's posturing, 'but it's difficult for me to judge him – he has let himself get caught up in it like Zola before him, and Anatole France. I think an artist has so great a need of solitude, especially at the end of his life, that he should close his doors to everyone, and not waste a single hour.'

For all his reservations, Matisse, too, was currently in process of being promoted to the rank of national treasure. Official attitudes changed drastically in this post-war period, when, as Pierre pointed out, the only aspect of France's immediate past in which she could still take unqualified pride was the achievement of her artists. In the first four and a half decades of the twentieth century, the State had bought two paintings from Matisse. In 1945, it bought seven more. This solid nucleus of a collection was earmarked for the new Museum of Modern Art, due to open in 1947 with a room apiece devoted to Matisse and Picasso. Meanwhile a grateful nation acknowledged the debt owed to its liberators across the Channel by exporting twin shows of Matisse and Picasso to the Victoria and Albert Museum in London. A film about Matisse was in the pipeline, and the Salon d'Automne put on a special display in his honour. Tériade's resplendent Matisse issue of *Verve* came out in November, followed by an exhibition of recent paintings to inaugurate Maeght's new gallery in Paris.

Matisse escaped a month before Maeght's opening to sink back thankfully into the monotony of Vence. He painted studio interiors by day and drew by night with pencils, pens or scissors. Lydia found him two unlikely models. The first was the daughter of a Russian shopkeeper in Nice, Doucia Retinsky, who posed for illustrations to a book of love letters written by a medieval nun, *Les Lettres Portuguaises*. Recruited to replace Lydia ('I was too austere,' she said), Doucia at fourteen had a plump, peachy bloom that suited the mix of innocence with passion in this fizzy little text. The second model was the slender young Mme Franz Hift, a Belgian lawyer's wife more than happy to relieve the boredom of convalescence in Vence by flirting with Matisse. After twelve months of painting virtually nothing, he put Mme Hift at the centre of two of the richest decorative compositions he ever made. Everything in *Young Woman in White* – the floor, the walls, the black doorway, the model in her long skirt and mantle of white tigerskin, the striped chair-back behind her and the pot-plant at her side – retains and simultaneously dissolves its own identity in the fabric of the painting. The effect is even more pronounced in *L'Asie*, where the broad, flat, tawny oval of the model's face is repeated in the sensuous patterns of right shoulder, left arm, and the wrap that appears to float in soft, feathery, mauve-and-blue curves above the anchorage of a geometrical ground.

Early in 1946, Aragon turned up in Vence, seeking refuge from the Communist purges of post-war Paris, to find the Villa le Rêve hung with 'pictures more beautiful than ever, young, fresh, luminous, full of gaiety, more so than ever before, and more confident in light and life'. Matisse's work seemed to breathe a different air from the harsh, drab, materially and spiritually impoverished Europe of the 1940s. 'I do it in self-defence,' the painter explained bleakly. He sent Lydia to Le Cannet with *L'Asie* and *Young Woman in White* on extended loan to Bonnard, who had lent him a *Basket of Flowers* in his late style. Each was mystified by the other's approach to colour ('I'd like to be able to do what he's doing,' Matisse told Nelck,

'and he'd like to do what I do'). Matisse said Bonnard's canvases gave him the same charge of feeling he got from Goya's, a sense of 'being confronted with something passionate and alive'. Bonnard for his part admitted defeat, in almost exactly the same words as Renoir had used before him, in front of Matisse's expanses of flat uninflected colour ('How can you just put them down like that, and make them stick?'). He hung the borrowed paintings on the ochre walls of his dining room, checking up on them at intervals throughout the day and noting how the evening light brought out the magnificent reds of *L'Asie*. 'By day it's the blue that plays the major role. What an intense and changeable life colours live in different lights!'

Pierre said much the same when he unpacked a consignment of canvases that spring and watched them respond to the luminous atmosphere of Manhattan. Pierre's post-war showing of his father's recent work made a resounding impact, especially on young artists of the newly emerging New York School. The arrival in America of Matisse's 1908 *Red Studio* had opened up fresh ground for an inventive generation led by Jackson Pollock, already beginning to explore the formal possibilities of abstraction in ways that would in turn feed back into the mainstream of European art in the 1950s and 60s. André Breton, who spent the war years in the United States, said the painters he met never mentioned Bonnard or any other of his French contemporaries. All they wanted to talk about was Matisse, who used colour in ways no one ever had before.

Very different messages were coming in from a wider public accustomed to look to pictures for reassurance, and wholly unprepared for an art that questioned basic principles of perception. In England both Matisse and Picasso looked frankly grotesque to ungrateful Londoners, who waved rolled umbrellas at the Victoria and Albert, bellowing disapproval of works that seemed to make a mockery of the civilized values for which the war was fought. There were similar scenes in Nice when the mayor invited Maeght to transfer his Matisse show from Paris to the Palais de la Méditérranée on the promenade. The

whole town turned out to pay tribute to an international
celebrity whose name few of his neighbours had so much as
heard of up till now. Pleasurable anticipation evaporated in
incredulity and shock. Students from the art school demonstrated
in protest. A 'Matisse Scandal' erupted in the local press, which
urged its readers not to let themselves be fooled by a blatant
conspiracy between international finance and the spiralling
ambition of a corrupt art market. A film crew arrived to shoot
documentary footage at Vence as well as in Matisse's birthplace
of Le Cateau, where, according to his brother Auguste, nobody
even knew of his existence.

The combination of international stardom with increasingly
hermetic isolation irritated Matisse's contemporaries, who saw
no call for either. His forbidding public manner reinforced the
reputation for pomposity that always accompanied his bursts of
notoriety. Old comrades felt excluded or unwanted. Marquet
never forgot paying a surprise visit with his wife to Nice only
to find Matisse distant, dazed and blinking as if he hardly knew
them, 'like an owl dragged brutally from its element of night'.
The Marquets left immediately, swearing never to return, and
were only partly mollified when Matisse rang to explain he
had been immersed in work, and begged them to come back
next day. Much the same sequence was repeated with Rouveyre
and Jean Puy, but, however hurt or angry his friends might be,
few could resist Matisse's fond, contrite messages accompanied
by scatty little drawings showing him peering out from behind
pebble glasses with tufts of hair sprouting from his big bald
head and an absurd frill of beard beneath his chin.

Matisse realized there was something monstrous about the
consuming passion that drove him inexorably into areas where
few if any of his friends could follow. 'The creators of a new
language are always fifty years ahead of their time,' he told
Nelck. The only artist he knew who operated on anything like
the same long timescale as himself was Picasso, and the two
drew closer than ever after their joint London showing in spite
of initial misgivings, at any rate on Matisse's part. 'His relations

with Picasso were roughly those of one crowned head with another,' said Bussy's daughter. But formalities loosened up after the war when Picasso came often to Vence with Gilot, who had the impression the two were refighting old battles for her benefit, and through her for posterity. 'What do you think they have incorporated from us?' Matisse asked, producing American catalogues of Pollock and Robert Motherwell: 'And in a generation or two, who among the painters will still carry a part of us in his heart, as we do Manet and Cézanne?'

They swapped notes and compared problems. Picasso complained about the effortless sense of beauty, balance and proportion against which he had fought all his life. Matisse lamented the lack of natural facility that had made his entire career a relentless uphill struggle. Each grumbled freely in private about the other, but Matisse allowed no criticism of his old rival from anyone but himself. He presided with amusement and affection over Picasso's affair with Gilot, and the birth of their first child. 'Picasso was very fond of him,' said the engraver Fernand Mourlot, who worked closely with both artists, 'he looked on him as an elder brother.' But Matisse knew perfectly well that what drew Picasso back year after year was not fraternal feeling, but the work emerging slowly as its creator groped his way towards an unexpected way out of his apparently unnavigable maze: 'He'd seen what he wanted, my paper cut-outs, my new pictures,' Matisse reported, '. . . all of it will ferment in his mind to his advantage.'

To others in Vence and elsewhere, Matisse appeared to be heading for a second childhood, sitting up in bed cutting shapes out of coloured paper, or playing with the fallen leaves he collected every autumn and brought home to draw. The toothy, softly incised leaves of oak, the serrated fronds of cineraria, the spiky foliage of castor-oil plants and acanthus growing wild along the road outside his gate all captivated Matisse. Vence gave him the distance and detachment essential – in Ajaccio, Collioure, Tangiers, Nice, Tahiti – at moments of transit in his work. His isolation increased as each winter laid him low with

fever, flu and bronchial congestion. In the spring of 1946, nervous
tension brought a return of the old intestinal spasms, this time
so acute the patient said grimly that his screams could be heard
half a mile away. He slept at most three or four hours a night.
'Luckily I lead two very distinct lives, one by day and one by
night. They don't mix. What else can I do at my age, you have
to accept what you've got left, and put up with what upsets
you.' A nurse was always on hand to massage his legs or make
him a tisane, anything to head off the nightmares that contam-
inated his brief sleep with convulsive cries and movements. He
reverted to the strategies of childhood, doing sums in his head,
counting aloud in English or German, even reciting paternos-
ters. He wrote letters, filled notebooks, took dictation or talked
in undertones to the night nurse ('The night was the time for
confidences,' said one of them). More often his attendants read
aloud for hours on end, since the slightest pause would rouse
the patient from his drowsy state. He drew, and continued
drawing in his sleep, groaning and rubbing out invisible mistakes
with his left hand. In this half-life, his imagination stirred,
stretching out to a space that would release him from the
confines of the canvas, an expanded pictorial space 'beyond me,
beyond any subject or motif, beyond the studio, beyond even
the house . . . a cosmic space in which I was no more aware
of walls than a fish in the sea'.

The fish in the sea, the new space and the light it invoked
were all associated in Matisse's mind with his voyage to the
South Seas. Memories he had soaked up like a sponge in Tahiti
fifteen years before began to resurface in the twilight zone
between sleep and waking. It was in this state, after his return
to Paris in June 1946, that he started transforming his bedroom
walls with cut-outs quite different from the brightly coloured,
separately mounted, largely abstract images that filled the Vence
studio. In Paris, he cut white shapes out of writing paper, which
was the only material available. He began almost at random,
producing a paper swallow and handing it to his night nurse
to pin over a dirty patch on the wall. Matisse's room at the

boulevard du Montparnasse was covered with a pale lining material that had darkened over the years to a warm sandy brown. The white swallow was succeeded by a fish. 'Then, whenever he suffered from insomnia, he told the nurse to pass him a sheet of paper which he would cut up, telling her "Put it there!" And so on,' said Lydia. 'The next night there were another two or three, then four or five, until, little by little, they made a whole ensemble. The wall ended up covered.'

By early autumn, all the blemishes and scuffmarks had disappeared under fish from the imaginary lagoon that materialized beneath Matisse's scissors. The design spread across a wall almost four metres wide, eventually spilling along the top of the doorway and round the corner, to flood out over a second wall in a rhythmic tidal swell, bearing in its depths and on its surface, like the sea itself, every kind of marine life: loops and trailing fronds of seaweed, swooping seabirds, dolphins, sharks, jellyfish and starfish, the whole fragile dreamlike pattern punctuated by lines of foam and the tracery of coral. Matisse, who had attempted nothing on this scale since Barnes's *Dance*, had dived without thought or afterthought into an art more concerned with states of consciousness than with any specific visual allusion.

Before he even left Vence, he had turned down the offer of a contract from Paul Rosenberg on the grounds that he was giving up painting for decoration. So far his only concrete project was a request for a tapestry cartoon from the state-owned Gobelins workshops, whose envoys decided that the pattern on Matisse's bedroom walls was too tricky to weave, and the colour impossible to match. But Matisse received a visit that summer from a young Czech textile manufacturer starting up a new business in England, who hoped to produce silk scarves designed by leading modern artists. Zika Ascher, confident, inventive and resourceful, immediately proposed to translate Matisse's walls into a pair of silk-screen panels printed in white on linen exactly the same shade as the soft sandy ground.

Matisse finalized both panels – *Oceania, The Sky* and *Oceania,*

The Sea – in roughly two months, setting up a studio in his salon where he designed a second pair of tapestries for the Gobelins. Blue was their recommended colour, so he improvised a background from two garish shades of cheap wrapping paper, which was all Lydia could find after scouring every stationer in post-war Paris. He treated it as a test of his ability to transform the most unpromising materials, pinning up alternate sheets of turquoise and verdigris, and explaining afterwards that the more formal of his two designs – *Polynesia, The Sky* – was 'inspired by the wheeling mass of seagulls above the outlet of the pavilion on the Promenade at Nice'. All four designs for *Oceania* and *Polynesia* were completed by the end of the year. Over the same period, work on the illustrated books imposed a punishing schedule at the printers. Tériade brought out *Les Lettres Portugaises* in October. After fearful obstacles, *Les Fleurs du Mal* was finally approaching publication in 1947, and so was the most prodigious flowering of Matisse's partnership with Tériade, the album *Jazz*. Matisse spent part of the winter compiling a text to accompany these 'lively and violent prints', which he described as a kind of pop art crystallizing out of nowhere – 'from memories of the circus, folk tales, voyages' – to focus a wholly twentieth-century sensibility so sharply that even their creator took time to absorb the shift of viewpoint.

The bitter winter of 1946–7 was the first Matisse had spent in Paris for ten years or more, and it very nearly killed him. The usual crop of fevers and congestions was compounded by his violent reaction to experimental doses of a new drug called penicillin. Tempests of ice and snow brought Europe to a standstill, with coal stocks exhausted in temperatures lower than ever before in living memory. Bonnard died at Le Cannet at the end of January. Marquet entered hospital for an operation the same month, coming home in a snowstorm, which he promptly painted. Matisse, more than ever convinced that Marquet needed looking after, went round to spell out basic tactics for survival: warmth, bed rest, special diet, unceasing vigilance against cold or draughts, and perpetual surveillance by nurses day and night.

'Tell me,' Marquet asked his wife, after their guest had gone, 'is it really worth living under those conditions?' The two old friends said goodbye on 5 April, just before Matisse's return to Vence. When news came of Marquet's death two months later, Matisse said sadly that he would not have wished to prolong a life made as wretched as his own by sleeplessness and pain.

His greatest human consolation in these years came from his five grandchildren, whose progress he followed closely and whose visits he awaited with the fond, proud impatience of a lover. He drew them repeatedly, subjecting each in turn to a strange, penetrating, in the final stages almost blind scrutiny that astounded them. 'He was listening to form rather than content . . .' said Pierre's son Paul, describing how his grandfather asked him to tell the story of a recent film at one of their first portrait sessions after the war. 'He was looking with an intensity that would have robbed the most brilliant discourse of meaning, and then suddenly I was free. I remember clearly the inner joy of discovering that we were coexisting on a level that was quite new to me . . . I too was momentarily swept up into an existence in which quality rather than quantity held the master place.' These encounters were as nerve-racking as they were exhilarating for the sitters. 'His concentration then is terrifying,' Paul's sister, Jacqueline, told a friend. 'He acts as if he were stone deaf. His talent is a physical thing, which lies in his hand . . . His hand leads him after he has absorbed the object, and he doesn't look at it any more. He just draws the result of it that is in him, like a film negative.'

Even without a pencil in hand, the weight of Matisse's presence and his uncompromising expectations could be alarming. He made no disciplinary concessions, and his affection was not openly expressed. But he watched over his grandchildren with understanding, sometimes with apprehension, describing their separate personalities in perceptive detail to Vassaux, reliving his own adolescence – illness, examinations, love affairs, career prospects – through theirs, and occasionally interceding in favour of mildness and forbearance with their parents. When they were

small, he marked their height on his wall, and pinned their drawings up above his bed. Now he organized lunch parties and excursions for them in Paris, and invited them to stay with him in the south. He was still deeply attached to Claude, a tall, handsome teenager in stylish American blue jeans, who retained for his grandfather something of the gallantry and vulnerability Matisse had painted in Claude's mother as a child. He was enchanted by Jackie, his only granddaughter – who had inherited his own extreme sensitivity along with his delicate complexion and red-gold hair – and by the exuberantly expressive artworks of Jackie's youngest brother, Peter. But of all his grandchildren it was Jean's son, Gérard, in whom Matisse acknowledged exceptional ability as an artist, discussing his potential with friends like Rouveyre and the founder of Surrealism, André Breton (an unexpected confidant, stranded for two months at Antibes after his post-war return to France). Over the next few years, Matisse arranged for Gérard to attend art school in Montparnasse, giving him regular tuition ('He was a teacher of rare severity,' said his grandson), and sending him at seventeen on a voyage to New York and the Caribbean which he said would have transformed his own life at that age.

Lonely and more isolated than ever in Vence in the summer of 1947, Matisse found warmth and comfort in the uncomplicated affection of a former model, Monique Bourgeois, who had been by her own account an honorary granddaughter until her defection three years earlier, when she had left Nice without warning to enter a convent. Matisse was scandalized, as he would be again, a few years later, when Nelck announced her intention of marrying a fellow artist. Neither marriage nor the veil seemed to him adequate reasons for compromising a serious vocation as an artist, but he could not resist Monique in her new role as Sister Jacques Marie. He was captivated all over again by her combination of unworldly innocence, strength of character and surprisingly flirtatious wit. Sister Jacques was working as a novice at the nearby Foyer Lacordaire, a nursing home run by Dominican nuns who had set up a makeshift

chapel in a derelict garage for which she sketched out a little stained-glass window. When she brought her watercolour round to show Matisse, she knew him well enough to be alarmed by his disproportionately enthusiastic response to her perfectly banal madonna.

Matisse painted more pictures in the twelve months after he got back to Vence in April 1947 than in the previous three years put together. 'It was a veritable explosion,' said Lydia. Contemporaries were often mystified by the powerful, even raucous colours and abbreviated forms of these studio interiors, which weave everything within the painter's field of vision into a whole so dazzlingly bold and simple that the canvas itself seems to be part of the inner fabric of his mind. But nothing he painted could appease a growing sense of dissatisfaction. Neither *Jazz* (which made a small but striking impact when it was published in September) nor the tapestries led to further commissions. 'The fact is, nobody approached Matisse to make anything monumental,' said Lydia, 'but that is what he dreamed of.' By the end of 1947, he was sufficiently frustrated to contemplate asking Aragon if the Communist Party would give him a lecture-hall to decorate. Instead, he showed Sister Jacques' watercolour to one of her fellow Dominicans, a young monk convalescing at the nursing home, who insisted that the window should be designed by Matisse himself.

Brother Louis Bertrand Rayssiguier ranked almost as low as it was possible to get in the church hierarchy. He was twenty-seven years old, a diffident, idealistic, inexperienced philosophy graduate from the Sorbonne, who had no art-world connections and had never seen a painting by Matisse. But he was also an enthusiast, an instinctive modernist and admirer of Le Corbusier, overwhelmed, like far more sophisticated visitors before him, by the Villa le Rêve and its occupant's magnetic power. Matisse showed him *Jazz*, explaining that the only difference between cut-paper and stained glass was that one reflected while the other transmitted light, and citing the polychromatic brilliance of Chartres cathedral as a model of true spirituality. Rayssiguier

readily agreed: 'I should be very comfortable saying my prayers in your studio, indeed more comfortable than in many churches.' By the end of their first meeting on 4 December 1947, the two had roughed out a format not just for a window but for a chapel. When Rayssiguier returned after five days with a scale plan, Matisse asked for a working model, which Sister Jacques made and delivered two months later. Matisse wrote to Rayssiguier the same day to say he could see the chapel complete in his head.

The scheme was crazily impractical. Matisse might be a major figure on the international stage, but his fame cut no ice with the lower echelons of the Roman Catholic Church. The Mother Superior at the nursing home, knowing his local reputation for frivolity and nudes or worse, refused even to mention his scheme to any higher authority. The nuns laughed at the model ('You couldn't pray in that, it's going to look like a shoe-shop'). Matisse himself talked of an unspecified upheaval about to take place in his work, and wrote gloomily to his daughter: 'Artists are like plants whose growth in the thickets of the jungle depends on the air they breathe, and the mud or stones among which they grow by chance and without choice.' Only Sister Jacques realized with foreboding at this stage that, once started, Matisse could not be stopped. Brother Rayssiguier returned to Vence in April, when he and Matisse planned the entire chapel down to its last detail in four hectic sessions.

Matisse installed a coloured-paper maquette on the wall opposite his bed so that he could work day and night on the two long windows for the hypothetical chapel's west wall. He had been impressed in March by Picasso's wildly inventive painted plates and pots, 600 of them on display at Antibes, where Matisse went twice, alone, to make notes with sketchbook and pencil. Now he consulted Picasso's potter about a weird scheme of his own for a wall of white glazed ceramic tiles, to be covered with 'graffiti-style' drawings in black paint, and placed opposite the chapel windows to reflect their play of coloured light. Rayssiguier had doubts but, for this most ambitious of all his

decorative projects, Matisse treated himself as in effect the commissioning agent. This time there would be no question of compromise, and no complaints that what he wanted done was unorthodox or infeasible. Expense was no object. 'Of course we're spending money like millionaires,' he wrote cheerfully to Rayssiguier before anyone else had seen or approved plans for the chapel, let alone raised a sou to finance it, 'even though we're rich only in dreams.'

Back in Paris in June, Matisse acquired a powerful champion, Father Marie-Alain Couturier, himself a specialist in stained glass and France's leading modernizer in the battle raging over the future of religious art. A cosmopolitan operator, thoroughly at home in ecclesiastical and secular high society, Couturier was a realist about the Church ('The mission of Catholicism is not only to give but to take everything'), and about the artists who might be induced to serve it ('We must accept them as they are ... barely Christian at all'). Within weeks he had secured approval for the chapel from all the relevant church authorities. Matisse sent for Skira, announcing airily that the publisher would finance the project by bringing out a book. Rayssiguier wrote sternly to the recalcitrant nuns of Vence: 'What has to happen now is for your congregation to accept ... this gift. And quickly, without giving an impression of indifference which would – without a doubt – wreck everything.'

Matisse already spoke of the chapel as the crown of his life's work. He overruled a proposal to seek architectural input from Le Corbusier, producing instead a more biddable consultant of his own, the Parisian academician Auguste Perret ('He'll do as I say,' said Matisse). West and south windows were designed in the apartment on the boulevard du Montparnasse, where working conferences assembled two or three times a week beside Matisse's bed. Couturier was constantly at his side, escorting him to the glassworks, or to Notre-Dame to check that blue and pink make violet in the southern rose window. They formed a stately pair, Matisse's commanding compact bulk offset by the height of his companion, who was strikingly ascetic

and so elegant that rumour said he ordered his white habit from Balenciaga (the painter asked him to model for Saint Dominic that summer). The news that Matisse was about to build a chapel, and could be seen going about town with a priest in tow, caused ribald disbelief in Paris at a time when it was increasingly accepted by the intellectual community that the best hope for the future, not just of France but of humanity itself, lay with the Communist Party. Picasso came round to inspect the model and recommended building a fruit-and-vegetable market instead, in a scene reported with gusto by Matisse, who snapped back that his greens were greener and his oranges more orange than any actual fruit. Family legend preserved a pithier version of this celebrated exchange: 'Why not a brothel, Matisse?' 'Because nobody asked me, Picasso.'

The apartment on the boulevard du Montparnasse had now been swallowed up by studios, like the apartment at Cimiez and the house at Vence. The family paid rare and formal visits. Matisse entertained his grandchildren, and relied on Marguerite as go-between in dealings with his wife, who no longer communicated directly with him. Nor did Georges Duthuit, in spite of the fact that his father-in-law had appointed him joint author with Marguerite of a comprehensive *catalogue raisonné*, a massive undertaking that would outlast all their lifetimes. Marguerite set about compiling records, contacting collectors, becoming the custodian of her father's past, while Matisse himself worked with Duthuit on various current projects, providing illustrations for his text *Une Fête en Cimmérie*, and supplying key material, together with a book-jacket, for his pioneering work on the Fauves. The two collaborated without ever seeing or speaking to one another, negotiating through Marguerite in an atmosphere of simmering, at times explosive, tension.

Jean's marriage had come apart by the summer of 1948, and his wife was dying of cancer. Pierre, who had divided his life between two continents for years, giving the major part of his attention to his artists, was also heading for divorce, writing to announce his intention at the end of the year, to his father's

acute distress. Matisse, who had always been close to Teeny, admiring her courage and independence, loving her generosity, gentleness and humour, was torn between sympathy with her and fellow-feeling for his son. Images of breakdown and destruction tormented him at night. He told Pierre he dreamed that he saw his family lined up like targets at a fairground, ready to be picked off with rifles one by one.

Matisse turned back to his model of the chapel, working on window designs of cut-and-coloured paper with more than usually terrifying concentration. 'Matisse in Vence drove himself to exhaustion,' said Jacqueline Duhême, a young assistant taken on that autumn to help with the endless, intricate adjustment of paper pattern pieces. 'His will always got the better of fatigue.' He defined the chapel as a place where people could leave their burdens behind, 'as Muslims leave the dust of the streets on the soles of the sandals lined up at the door of a mosque'. The model was essentially a machine for making coloured light: a plain rectangular box like the wooden models constructed for the ballets, *Rossignol* in 1919 and *Le Rouge et le noir* in 1939. All three go back to the earliest of all Matisse's decorative projects, the toy theatre in which he staged the eruption of Vesuvius with coloured paper cut-outs and spectacular lighting effects as a fifteen-year-old schoolboy in Bohain. He told Rayssiguier that the sulphuric flame of that volcano was the pure blue light he had looked for all his life, and finally achieved in the chapel windows. 'What interests me is to give space and light to a place that is characterless in itself,' he said, explaining that the model was like a blank book waiting to be written in. 'I don't need to build churches. There are others who can do that . . . I'm doing something more like a theatre décor . . . the point is to create a special atmosphere: to sublimate, to lift people out of their everyday concerns and preoccupations.'

Matisse said that, even if he could have done as a boy what he was doing now – 'and it is what I dreamed of then' – he would not have dared. Now he had both confidence and courage. All he had to do was fill his empty box (as he had filled the

Villa le Rêve) with the contents of his imagination. The only serious problem he anticipated was mortality. 'He'd been in a hurry all his life,' said Nelck. 'Now he had to economize his forces. It was a race, an endurance course, which he was running with death.' In this race, the church supplied skilled back-up. Matisse, who had always felt driven by a power beyond his control, now found himself for the first time in his life among people who naturally spoke the language of dedication, sublimity and submission that he used to make sense of his own experience as an artist. Rayssiguier told him he was more genuinely monastic than many real monks. Matisse had no difficulty with religious doctrines of sacrifice and penance, or the ruthless imposition of a divine will that coincided at all points with the will of its interpreters ('We want what God wants,' Rayssiguier explained, 'and we do what we believe He wants from us'). Both Rayssiguier and Couturier were happy to accept the painter's will as absolute in this sense. When Sister Jacques protested that she had understood Matisse to be directly inspired by God Almighty, he said gently, 'Yes, but that god is me.'

After nine months of intensive planning, the chapel had outgrown the Vence workshop. Matisse decided to transfer operations to Cimiez, returning with his household to the Regina in the first week of January 1949, the start of his eightieth year. His first move was to strip the big studio, sending away the gigantic philodendron that had served him faithfully for nearly twenty years ('It pains my heart to know that plant must go') to make way for full-sized stained-glass designs: a range of fifteen tall, slender windows in the south wall of the chapel set at right angles to a larger, double west window behind the altar. The apartment became, as Matisse said himself, more like a factory. Scaffolds, steps and platforms built of packing crates held the chair in which he sat with a brush strapped to a bamboo cane to paint the ceramic wall panels laid out beneath him on the floor. He moved between his three studios in what he called his taxi-bed, a bed on wheels with a tray to hold drawing materials, and a padded chairback to support him during working hours.

The high, bare, impersonal spaces of the main studio were animated by a constant traffic of specialist suppliers, deliverymen and porters. Assistants starting work each morning entered a high-energy zone, hazardous but efficient and crackling with emotion. 'The atmosphere was always vibrant, stimulating, filled with cries of rage or pleasure,' said Paule Martin, another young studio aide who worked on the ladders, pinning papers into place, or helping to unpack the heavy, fragile, hand-made tiles ready to be painted. Matisse reorganized his three studios from top to bottom every few weeks, repositioning his taxi-bed and turning the whole place upside down as he focused successively on the separate components of his design, abandoning one window maquette to start another, switching from stained-glass to ceramic panels, constantly returning to any completed element to alter or recast it altogether in the light of progress on another. His aim was to give the whole ensemble the fluidity of an oil painting. This provisional approach continued to the end, driving builders, glaziers and roofers to distraction once the chapel started rising from its building site in Vence. Looking back afterwards, Rayssiguier said the ideal solution would have been 'to raze the chapel to the ground at intervals so that Matisse could manipulate walls, windows and ceramic tiles as readily as he did his paintings and cut-paper collages'.

Rayssiguier was astonished, even appalled by the way Matisse worked, especially by how calmly he accepted setbacks. He made two entirely different sets of designs for the seventeen windows ('It was like a precious stone in its natural untouched state,' he said of the first set, which had cost him four months' work. 'The new one is the same stone after it's been cut'). It was only on completion of the second version in February, 1949, that Matisse realized he had forgotten to include provision for an armature of black glazing bars, which meant beginning all over again for the third time. 'He's not in the least upset at having to redo them,' Rayssiguier noted in his diary. Each fresh start enriched and refined the end result. The windows were completed by mid-March in marathon work sessions of up to

eleven hours on end. Unlike the previous two, this final version – *The Tree of Life* – contains no red, a change of key that brought an extraordinary clarity, serenity and stillness to the visual music of the chapel.

By April Matisse was choosing glass samples. Over the next two years, he considered the properties of glass, tiles, stone and metal, undeterred by experts who assured him that what he proposed had never been, nor ever could be, done the way he wanted. He caused mayhem at the Parisian firm of Boney, accustomed to producing huge and splendid stained-glass windows from small gouache sketches supplied by artists like Rouault. Matisse visited Boney's workshop in person, demanding information about every stage of production, paying extreme attention to thickness, translucency and finish, before finally submitting full-scale designs with meticulous specifications (including an impossible lemon yellow that had to be tracked throughout France and beyond). The same relentless precision went into everything from doorknobs and roof tiles to lighting, heating, ventilation, marble samples for the altar and the five different kinds of slate sent specially from the Ardennes for an almost invisible play of colour in the decorative rim edging the altar platform. Georges and Suzanne Ramié, who had turned their pottery at Vallauris into an unofficial studio annexe for Picasso, now embarked on a fresh set of perilous and sometimes catastrophic experiments with Matisse. His ceramic wall-tiles were largely spoilt in a first firing in June, and so comprehensively smashed on a second attempt in August that both the Ramiés arrived at Cimiez with Gilot and Picasso, all four more shocked than Matisse, who felt, like an athlete in training, that failure and distress were part of routine preparation for further trials.

These trials were conducted against a constant groundswell of publicity. The story of the celebrated painter of odalisques enticed by a pure young nun into the embraces of the Catholic Church made headlines from New York to Tokyo. The French press reprinted an article from *Vogue* alongside a romantic picture

of Sister Jacques looking, as she said herself, like a Hollywood starlet with long lashes and pert button nose. For her, this was only one of many private miseries in four years of steadily increasing friction. Her fellow nuns at the Foyer Lacordaire, who had resisted the chapel from the start, and who believed (like most of their neighbours) that any child could paint better than Matisse, reacted with bewilderment to his successive assaults on everything they held familiar and sacred. To the conservative majority in the Church, his inventions seemed not simply monstrous but blasphemous as well. 'I was panic-stricken,' said Sister Jacques, describing the day she first saw Matisse's Stations of the Cross, scrawled freehand in thick black paint on shiny white tiles in a violent sequence of clotted, caricatural, in places almost unintelligible images. This was the one element of the chapel that Picasso unequivocally approved (later, when he saw the butterfly brilliance of Matisse's chasubles, he admitted that he liked them, too). Sister Jacques now found herself blamed by her entire community for an enterprise that privately appalled her. 'How on earth was I to get them to accept these drawings? I stood there, stock-still, utterly crushed.' She appealed at intervals for help, only to be told austerely by her novice mistress that a chapel destined for the sacrificial Mass inevitably demands suffering from those involved ('The builders of churches have never achieved anything good or beautiful without being crucified for it').

Rayssiguier, too, came under severe strain. Eager, honest, single-minded and as stubborn as he was undiplomatic, his attempts to mediate between the painter, the nuns and the builders often exasperated all parties. Rayssiguier had tendered his resignation once already to Matisse, who refused it with peremptory and touching frankness: 'I am an invalid, even if I do my best to disguise it. I need a second-in-command, I can do nothing without you.' Rayssiguier supplied essential liaison, but it was Lydia who ran the operation from day to day. She organized supply lines, maintained relations with the art-world and managed the permanent, live-in, female workforce at

Cimiez: cook, laundry-maid, two nurses on day and night shifts, at least one model and successive studio aides. Between them they met all studio requirements, apart from posing for Christ (who was modelled by a couple of art students, Paule's brother Jean Martin, and Nelck's boyfriend, Victor Crosals), and the Virgin (whose oval face and slender upright stance came from the fourteen-year-old daughter of Henriette Darricarrère, now married to an asthma specialist in Nice). Many of Matisse's assistants were prospective artists themselves: bright, tough, energetic young women, eager to see the world and escape from family constraints. They were well paid and generously treated, always included in lunch or tea parties, and introduced to visiting celebrities who came to inspect the studio. The work schedule was gruelling, but it was broken up by Lydia with small treats and presents, boxes of chocolates, ballet tickets, trips to Paris. There were frequent festive occasions for opening a bottle of champagne, and at the end of each day's work, everyone gathered in the studio to drink a glass of muscat and look at the latest book from Paris, or play with the four cats who treated Matisse's territory as their own.

All routines revolved around the painter, who exercised dominion – part oriental pasha, part Victorian martinet – from his bed. Models and assistants were jealously guarded, cut off from outside contact and more or less confined to the premises ('There were no Sundays off with Matisse'). Bold spirits who crept out in the evenings or smuggled boyfriends into their rooms faced furious inquisitions next morning. Matisse had no patience with their frivolous objections to disciplines he had observed himself for years ('Poor things, they don't understand anything,' he said indulgently, 'but still, I can hardly give up my Sundays for the sake of these young creatures, just because they fancy time out with their lovers'). The price was high but in retrospect worth paying. Even those who bitterly resented his exactions at the time agreed afterwards that Matisse took much but gave more. He opened doors, changed lives, provided access to unimagined riches. 'The work became a

passion for me, too,' said Paule Martin. Artists like Nelck and Duhême, both of whom learnt to draw from Matisse, were marked indelibly for life. 'He had a hard exacting side ... a sort of absolute rigour,' Duhême wrote fifty years later. 'For me that was his greatest lesson.'

But the pressures of this way of living were punitive in practice. 'It was slavery,' said Paule, 'slavery above all for Lydia.' In the enclosed world of Matisse's household Lydia maintained order, humour and proportion, retaining her robust good sense in face of incipient mutiny and sometimes barely suppressed hysteria. In the last resort, everything fell on her. She protected Matisse from intruders – admirers, lobbyists, supplicants, the crowds of Sunday sightseers who strolled up to Cimiez 'to see the painter' – and preserved contact with reality for the inmates of his studio. Lydia had no holidays, no evenings off, no escape except for occasional trips to Paris on studio business. Her only time alone was when she shut the door of her room at night, poured herself a stiff drink of neat spirit, and opened a pack of cigarettes. Her authority was cool and unassertive, but under extreme provocation, her face could turn black with rage, according to Matisse. He called her his snow princess, talked constantly about her incomparable qualities, and could hardly bear to let her out of his sight. But he also knew how to tease her until she lost control and swore aloud in French.

He himself kept up a steady flow of curses under his breath as he drew or painted, but it was at night, when he could no longer work, that exhaustion made him vengeful and malignant. He brooded grimly on his own helpless incapacity, venting his frustration on the captive models, or on the night nurses, who rarely lasted more than a few months. Lydia herself complained to no one, but there were days when her milk-white pallor intensified and her eyes looked red from weeping. The whole household knew that she kept a small suitcase ready packed in her wardrobe, and no one doubted that she would leave without warning or appeal, if ever Matisse's depredations became unendurable. But younger women like Paule Martin or Annelies

Nelck who took her part, protesting indignantly about his tyranny and her silent subjugation, slowly came to realize that Lydia, who had a will as strong as her employer's, was by her own decision as much a prisoner of Matisse's work as he was.

On 12 December 1949 the first stone of the chapel was laid at Vence in a ceremony Matisse was too frail to attend. He spent his eightieth birthday quietly with his three eldest grand-children, drawing them with a long-handled brush to keep him company at night on the ceiling above his bed. Cimiez was awash with tributes, flowers and gifts. Advance celebrations had kicked off almost two years earlier with a major retrospective at the Philadelphia Museum of Art, followed by a show of new work at the Pierre Matisse Gallery in New York. The critic Clement Greenberg proclaimed Matisse the greatest of all living painters, and the gallery remained packed so tight throughout the run that Pierre said he only had to open his windows for a mass of art-lovers to fall out on to the street below. French opinion was less enthusiastic about a showing of recent work at the Museum of Modern Art in Paris in the summer of 1949, when the cut-paper inventions were more or less openly dismissed as evidence that Matisse had grown too old and childish to be taken seriously.

Reports of his chapel-building increased art-world disdain. For the rest of Matisse's life rumours that he had abandoned the atheism of a lifetime to become a practising Catholic vied with counter-claims that he was about to join the Communist Party. Matisse, who would have been happy to decorate a public space for either institution, accepted overtures from both on his own terms. He provided recent work for an exhibition put on in January 1950 by Nice's pro-Communist town council and heavily patronized by the Church ('I have never seen so many curés gathered together in my life,' Janie Bussy reported to Vanessa Bell). Five months later he completed his designs for the chapel – 'which means that I am free to die now,' he told Couturier – and celebrated by displaying them in public for the first time at the Communist-backed Maison de la Pensée

Française in Paris. It was a statement of position that exasperated Picasso (who had persuaded Matisse to show there in the first place), embarrassed Aragon (who installed the exhibition) and frankly mystified the public.

Matisse replaced the window maquettes on his walls that summer with cut-paper compositions in the same tall format. *The Thousand and One Nights, The Beasts of the Sea* and *The Creole Dancer* revelled in the colours he had withheld from the chapel. The *Dancer*, made in a single day in June, seems to implode and explode simultaneously against a brilliant chequerboard of red, blue, pink, orange, black and yellow, leaving nothing but her head, her green ribbons and two spiky blue-and-white ruffs which might be a corsage above a swirling skirt in rapid motion, like the wings of a bird flashing open in flight. Matisse recognized something exceptional about this *Dancer*, and refused to part with it to Pierre on the grounds that he could not be sure he would ever produce anything of the same calibre again.

The manufacture of the windows in Paris precipitated a mass of technical and financial problems. Forced to drop various more unrealistic fund-raising schemes (including the notion of a luxury book from Skira), Matisse had opened a bank account in the chapel's name and invited contributions, giving his own services free, underwriting the account himself, and topping it up whenever funds ran low by producing lithographs or selling a painting. His liability alarmed him, but half-hearted attempts at cutback were overtaken by trouble at the glassworks. Matisse's stay in Paris dragged out in the end to four months, mid-July to mid-November, spent supervising production in a state of simmering frustration at times dangerously close to boiling over ('You know I have given everything to this chapel,' he wrote sharply to Couturier, 'and it will all have been useless if it isn't *perfect*'). Meanwhile tension between builders, nuns and the unfortunate Rayssiguier reached new levels as the chapel roof went on in Vence. When the windows were finally installed, Matisse pronounced the effect better than he had hoped, with

the same curiously impersonal satisfaction he had felt twenty years before, watching Barnes's *Dance* hoisted into place at Merion in an atmosphere of barely suppressed violence. 'It's very odd, it feels as if the start of my eighty-second year marks a gateway to the unknown . . .' he wrote to Vassaux on 6 January 1951. 'I was the one who set the whole thing in motion, and the result is sublime, but I feel almost totally detached from it.' For his oldest friend, he summed up his reaction to the chapel in a metaphor that goes back to the rigid small-town hierarchy of their youth: 'Imagine a simple postman confronted with his son, who has become a general.'

In February, Gérard Matisse was knocked down by a lorry in Paris, and remained critically ill for three months. He eventually made a full recovery, but the episode left all his relations deeply shaken. Matisse's feelings for his family, always intense and often painful, found free play in his attachment to his grandchildren, who stayed regularly with him in Nice, bringing news of their parents and their grandmother. Amélie had finally settled in a substantial property of her own at Aix-en-Provence, finding an outlet for her considerable energy in working with Marguerite to establish lost or non-existent records for the heroic early decades of her husband's work. Matisse's wife and daughter, with no further part to play in the continuing operation of his studio, became in these years joint custodians of his posthumous reputation. Jean had remarried, and rarely saw his father. Pierre – also remarried, to Patricia Matta, the young ex-wife of one of his former artists – was the only one who remained in close, warm, difficult contact with Matisse's life and work at Cimiez.

It was Pierre who represented his father at the consecration of the chapel on 25 June 1951, a ceremony conducted by the Archbishop of Nice, Monsignor Rémond, in the presence of the socialist city's deputy mayor, the formidable Jean Médecin. The chapel's initial impact, as so often with Matisse's work, was the opposite of what he had intended. Conservative forces within the Church responded to the glare of worldwide publicity

with a virulence that echoed the uproar provoked nearly half a century before by *Dance* and *Music*. Charges of sacrilege and scandal brought magisterial rebuke from the Vatican itself. The nuns were the first to succumb to the atmospheric power of their new chapel. Within twelve months the entire congregation, led by their Mother Superior, had reversed position, abandoning their attacks on the chapel to rally in unanimous defence of its consoling and contemplative calm. 'Mother Gilles and the sisters are content, and stand up courageously to those who come to jeer and mock,' Lydia reported to Rayssiguier. From now on, indignant or derisive sightseers demanding to know the meaning of the Stations of the Cross received a firm response from the nun in charge: 'It means modern.'

Matisse's own condition after four years of unremitting strain was nicely summed up by his homeopathic doctor: 'There is a saying, "to give yourself to something with all your heart." You can say more – you have given your heart for the chapel.' Cardiac fatigue was compounded by the usual insomnia, breathing difficulties and a deterioration in eyesight so severe that by the end of the year there were times when the painter could hardly see at all. He started work on an immense cut-paper composition, larger in scale than any canvas he had ever painted, working on it with a young night nurse brought back from Paris in the autumn of 1951. Denise Arokas was nineteen years old, slender, dark and supple. Matisse put flowers in her hair and drew her in the pose of the figure on the right of Delacroix's *Femmes d'Alger*, who lent grace and poignancy to the dancing girl on the right of his own *Tristesse du Roi*. Matisse himself described the three central figures in this work for Couturier: 'the sorrowful king, a seductive dancer, and a fellow strumming on some sort of guitar which releases a shower of flying saucers, the colour of gold, to go streaming round the top of the composition and end up in a mass around the dancer in action'.

Whenever Matisse looked back over his career in the closing years of his life, he insisted that he had been in search of the

same goals ever since he started as a painter. Here for the last time he invoked his alter ego – the musician with a guitar or violin – in a setting that goes back to the Bible stories of his youth as well as to the northern fairgrounds with their exotic gypsy dancers, which had given him his first inkling as a boy of a wider, richer, stranger world of the imagination. *Tristesse du Roi* draws on the same popular imagery as *Jazz*, but there is a new grandeur and pathos in this fable of art, life and mortality represented by the guitarist with powerfully expressive hands playing for a lithe young dancer while the aged king, huddled at their feet, stretches out a hand in farewell or salute. Its brilliant elegiac energy was recognized at once by the young artists on the selection committee of the Salon du Mai in 1952, and even before that by Georges Salles, the director general of French museums, who saw it in the studio at Cimiez and immediately arranged to buy it for the nation.

Matisse had persuaded Skira over the past decade to commission successively an account of his life and work from Aragon, the Duthuits' *catalogue raisonné*, and an album on the chapel. None of these projects came to anything in his lifetime (the first and last would eventually appear decades later; the catalogue, which split into many volumes, is still under way). The only serious survey to appear in the painter's lifetime was Alfred Barr's lucid, eloquent and scholarly *Matisse: His Art and His Public*, written to accompany a retrospective exhibition at the Museum of Modern Art in New York at the end of 1951. But this first attempt to establish a basic historical framework dismayed both its subject and his family, reactivating a reticence ingrained ever since the Humbert scandal. In spite of patient prodding from Pierre, who took the American view that knowledge should be free, neither his parents nor his sister responded with anything but suspicion to Barr's written questionnaires, or to the personal envoys who arrived at intervals from New York with increasingly urgent appeals for information. The situation was further complicated by the fact that so many key works had for all practical purposes gone missing. In an impassioned

speech at the opening of the MoMA show, Barr outlined the ravages inflicted by half a century of war, revolution and total-itarian dictatorship, highlighting the disappearance of the Moscow paintings, which no one had seen since 1947.

Lydia had reopened contact with the USSR after the war by buying a batch of drawings from Matisse and posting them to the Museum of Modern Western Art in Moscow, in token of solidarity with the sufferings of her fellow Russians (over the next three decades she would follow this first gift with others, donating in the end all the paintings and drawings given her by Matisse as a provision for her future). In June 1947 the painter himself sent a further drawing, but neither his gift nor Barr's efforts to bring pressure through the American ambas-sador brought news of the pre-1914 pictures, which would remain locked in Soviet cellars until after both Stalin's death and Matisse's. The paintings in Dr Barnes's custody at Merion had been inaccessible for years. Apart from the Sembats' legacy at Grenoble, the only representative collection to have passed intact into public ownership came from Etta Cone, who left more than forty paintings, eighteen sculptures and countless drawings to the Baltimore Museum on her death in 1949. Matisse had treated the Cone Collection as a kind of personal ark, and now he opened a second depository, initially more symbolic than actual, a Matisse Museum in his birthplace of Le Cateau. Founded on the initiative of the mayor and a group of local shopkeepers, launched by a donation of drawings from Matisse himself, and installed on the first floor of the little Renaissance town hall (where his parents had been married more than eighty years before), it was inaugurated in November 1952 in the presence of the painter's three children, whose generosity would ensure that it eventually became the treasure-house their father had envisaged.

By this time Matisse was apprehensive even for his chapel. Worries about compulsory closure ('He talked of possible changes of government, of persecutions and expulsions') were exacerbated by Aragon's confident assurance that the building

would become a dancehall as soon as the Communists came to power in France. Public perception of Matisse's work as relatively shallow by comparison with Picasso's intensified as the two drew closer in private. Picasso painted violence and devastation. Matisse required from art the serenity and stability life could not give. But the main reason why his reputation would be temporarily eclipsed by Picasso's in the second half of the twentieth century was that whole areas of Matisse's output remained virtually unknown. A series of major acquisitions by MoMA of works from before and during the First World War – the *Red Studio* of 1908, the alternative version of Shchukin's *Dance* of 1909, the *Piano Lesson* of 1914 and the *Moroccans* of 1916 – produced a powerful delayed impact on successive generations of American artists after the Second World War. But what Matisse estimated as a time lag of fifty years was still in operation. A single small show of his cut-outs at the Berggruen Gallery in Paris in 1953 was followed by a gap of two or three decades before either the art-world or the public started to make sense of the work of his last years.

Visitors in the early 1950s were hard put to find words to describe the studio at Cimiez. 'A gigantic white bedroom like no other on earth,' said a young English painter sent by the Bussys with a gift of lemons from their garden. 'A fantastic laboratory,' wrote Georges Salles, who sensed invisible high-tension wires criss-crossing the whole space. 'The vibrations are so close in these paintings, the forces are held in such a fragile balance that it seems as though the slightest mistake of calculation would have caused a catastrophe. The retina is pushed to the limit of its potentialities.' Matisse explained to newcomers that the whole apartment had once been so filled with greenery and birds that it made him feel he was inside a forest. Now he had got rid of his plants, and given the last of his fancy pigeons to Picasso (who drew its portrait on a famous poster, the *Dove of Peace*, sent round the world to advertise a Communist conference in 1949). Matisse filled his white walls instead with cut-paper leaves, flowers, fronds and

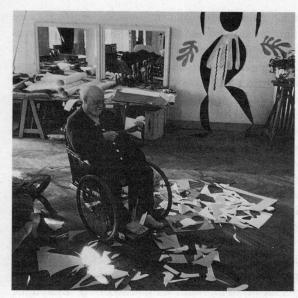

Matisse in the studio at Cimiez

fruit from imaginary forests. Blue and white figures – acrobats, dancers, swimmers – looped and plunged into synthetic seas. Disembodied colour seemed to emanate not so much from any particular image as from the space itself. 'A limpid scattering of colour bathes the whole room,' wrote André Verdet, 'glowing like a rainbow, flaring like lightning, becoming soft and supple, then iridescent again . . . blue, orange, violet, almond green, leaf green, orderly, organized, each finding its own shape and place in the ensemble of forms.'

As Matisse's race with death accelerated, he feared each work might be his last. He was carving into colour with a superabundant vitality and speed that wore out his young assistants. The gruelling pace of work on four successive *Blue Nudes* left Paule Martin stupefied with exhaustion. Pierre, who produced a flow of American decorative commissions, found himself struggling to keep up with his father's production rate. In 1952 Matisse designed a stained-glass window for Tériade's villa and

another for the Christmas issue of *Life* magazine, starting work
on a third for Pierre himself as well as producing plans for a
mausoleum and three alternative layouts for a tiled patio in
California ('Picasso, who never makes any comment, said spon-
taneously that . . . only Matisse could have done anything like
that'). For himself he made the huge *Swimming Pool*, running
right round two sides of his studio, and the even grander *Para-
keet and Mermaid*. He told an interviewer that he felt more
detached than ever from the troubles that threatened to drag
him down. He was working now as he had once heard the
great violinist Eugène Ysaye play, barely articulating the separate
phrases of a Mozart sonata, caressing the strings of his instru-
ment so lightly 'that it seemed as if only the essence of each
musical phrase remained. This was how he played at the end
of his life. The violinist gave the impression of murmuring with
an ease that seemed a little careless. He appeared to be playing
for nobody but himself . . .'

Towards the end of 1952, Matisse's handwriting faltered for
the first time. He composed a message to Marguerite in elegant,
tottery capital letters in September, and often switched to
dictation after that. He suffered from intestinal spasms, asth-
matic crises and fits of giddiness. Great waves of despondency
threatened to engulf him. His doctors tended him 'with their
fingertips', according to René Leriche, the surgeon who had
saved his life in Lyon more than ten years earlier and to
whom he still sent a book or drawing every year in gratitude.
Marguerite spent the bulk of her time in these years watching
over her father in Nice, with side trips to Aix to look after her
mother. Matisse no longer visited Paris, spending the summers
of 1953 and 1954 in a villa near Vence, resting 'in silence and
the greatest incognito'. It was a return to the isolation of his
first years with Lydia, who could no longer bear to leave him,
even for an evening ('It wasn't that he stopped me, but his
sorrow and anxiety were so great that I lost all desire to go').
She had learned to sleep intermittently, getting up three or four
times to relieve the misery of the painter's nights, so that he

might find strength to work again for a few hours next day. Simon Bussy died early in 1954. Sister Jacques tried unsuccessfully to persuade Matisse to agree to be buried in his own chapel, provoking a rare spurt of anger from Lydia, who pointed out that the offer disturbed his peace while he lived, and would damage his reputation when he died ('The chapel ... would cease to be a disinterested piece of work and become testimony to an immense vanity').

'I am beginning to take Renoir's place on the Côte d'Azur,' Matisse had written after his operation, knowing that his only prospect of survival was to accept the half-life of a permanent invalid. He had drawn courage from Renoir in his first years in Nice, and now he followed the example of their last meetings at Cagnes, when he watched life and energy flow back into the dying painter through the brush strapped to his bandaged hands. 'I have never seen a man so happy,' said Matisse. 'And I promised myself then, that when my time came, I would not be a coward either.' Alberto Giacometti, one of the few artists of his Paris-based generation who unreservedly admired Matisse's chapel, came to draw his portrait in the spring, and again in the autumn of 1954. Giacometti drew Matisse in bed, exploring with delicacy and feeling the skull beneath the skin, the curves and puckers of cheek and neck, the strong lines of browbone, nose and chin. He told Françoise Gilot that what moved him most at these encounters was to see 'a great artist still so absorbed in trying to create when death was at his doorstep ... when there was no longer time'.

Matisse's last work was a stained-glass window commissioned by Nelson Rockefeller in memory of his mother, Abby Aldrich Rockefeller, one of the founders of the Museum of Modern Art in New York. On 1 November, Matisse wrote to Alfred Barr to say that his design of ivy in flower was finished and ready for production. The same day he suffered a mini-stroke. 'He stopped working,' wrote his doctor, 'and applied himself to dying. His worn-out heart slowly ceased to beat. It took three days.' Marguerite was with her father. On the second day Lydia

came to his bedside with her hair newly washed and wound in a towel turban, accentuating the classical severity and purity of the profile Matisse had so often drawn and painted. He asked for drawing things, and sketched her with a ballpoint pen on sheets of writing paper, holding the fourth and final sketch out at arm's length to assess its quality before pronouncing gravely, 'It will do.' 'I remember above all its perfect placing on the page,' Lydia wrote of this last drawing, 'and the impression it gave of lightness and nobility.' Matisse died the next day, 3 November 1954, at four o'clock in the afternoon in the studio at Cimiez, with his daughter and Lydia at his side.

Lydia left immediately with the suitcase she had kept packed for fifteen years. Amélie Matisse returned to resume charge of her husband's work for posterity. Matisse's public position remained even-handed to the end. The family arranged a funeral mass, which was celebrated in the church at Cimiez by the Archbishop and attended by the Republican mayor, Jean Médecin, who spoke at the church door. The corporation of Nice gave the plot of ground on the hill above the town where the painter lies buried, according to his wishes, with no monument except a plain stone slab carved by his son Jean, beneath a fig tree and an olive to which time and chance added a wild bay tree fifty years after his death.

Index

Figures in italics indicate integrated black and white images; the colour plate sections are indcated by *colour fig.* with its number. 'HM' indicates Henri Matisse.